art history and its methods
a critical anthology

selection and commentary by eric fernie

Phaidon Press Limited
Regent's Wharf
All Saints Street
London N1 9PA

First published 1995
© Phaidon Press Limited

ISBN 0 7148 2991 9

A CIP catalogue record for this book
is available from the British Library

Printed in Hong Kong

Contents

Preface

My aim in writing and compiling this book has been to present a view of the methods which art historians have found appropriate or productive in studying the objects and ideas which constitute their discipline. Given the scrutiny which the history of art has attracted over the last twenty years it seemed that undergraduates might welcome a discussion of the range of approaches available to them for the study of their subject, including a consideration of concepts such as quality, the canon of great artists, art in its social context, the uses and misuses of stylistic analysis and the relationship between art history and movements such as feminism and poststructuralism.

The book consists of three very different parts: an introductory essay on the history of methods, texts concerning methods and a glossary of concepts relevant to the study of art history.

The introductory historical essay describes the sequence in which the various methods were invented, developed or adopted. It is brief and general in character and without either illustrations or references, to enable it to be read as a framework for the other two parts. In addition to being historical, it tries to be synoptic, analytical and evaluative, while dealing with an immense reservoir of data, with the result that it can only present a very particular point of view.

The selected texts are ones in which authors articulate approaches to the history of art, on which grounds I have excluded the writings of authors such as Roger de Piles, Joshua Reynolds, Gotthold Lessing and John Ruskin, who deal primarily with art theory or art criticism. The texts are arranged in chronological order and each is accompanied by an introduction, consisting of an outline of the author's life and work, a précis of the main points of the text and a brief commentary. An anthology has the advantage of grouping together texts which appear to the compiler to be related and which might not otherwise be considered in conjunction with one another. It has the disadvantage of taking the texts out of their original contexts and setting them in what is in some cases a more permanent one. Putting such pieces into a book may lend their phrases a much more uncompromising character than was intended at the time. The texts of the following authors were originally published with footnotes, which have been omitted here: Burckhardt, Wölfflin, Panofsky, Hauser, Fagg, Baldwin, Harrison and Ramsden, Alpers and Pollock.

The third part is a glossary, arranged alphabetically and containing discussions of the main concepts involved, including a number which are not raised in the texts but which should form part of a

study of the methods of art history. Where reference to a headword might be useful the term or its variants (as *cyclical for 'cycle')* is marked in the text with an *asterisk. If space had permitted the number of these headwords could easily have been increased, to include entries on subjects such as criticism, exhibitions, gallery/museum, interpretation, 'isms', nature, paradigm shifts, relativity, scientific method and sociology, to name but a few. Constructing a section such as this is a method in itself, one best exemplified by Raymond Williams's *Keywords*. This triple structure causes some repetition, but this seemed acceptable in the interests of clarity.

The volume is, then, a study of methods and is in no sense a history of art history. I have worked with the loosest possible definition of methods, asking only whether art historians have found an idea useful for dealing with their subject. The concepts involved range from the very broadest of all-inclusive philosophical approaches such as humanism or poststructuralism and academic disciplines such as anthropology and archaeology, to more narrowly defined tools like iconography or the notion of a cycle. The broader terms may sound more like academic subjects than methods, but in practice it is impossible to distinguish neatly between the two different categories. 'Subjects' may appear to be what you choose to study and 'methods' what you study them with, but the choosing is already part of the method. Subject matter is not an inert 'given' to which methods are applied, but something which fundamentally affects the approach which the researcher brings to the activity. Thus any model for dividing up the past, such as the concepts of the Renaissance or modernity, are as much methods, as much things which affect what we are working on, as any system of documentary, stylistic, or sociological analysis.

9

I owe a special debt of gratitude to John House, Lorraine Fernie, Jonathan Harris and Paul Crossley for their help with the preparation of this book. I would also like to record my thanks to numerous other friends and colleagues who answered queries and discussed problems, including Jill Franklin, Roger Mercer, Dory Scaltsas, Tony Cohen, Sandy Heslop, Shearer West, Frances Dow, Elisabeth de Bièvre, Michael Bury, Peter Jones, Liz Cowling, Martin Hammer, John Higgitt, Robert Hillenbrand, Janet Kennish, Walter Grasskamp, Fil Hearn, Hilary Green, Roy Pinkerton, Penny Carter and Stefan Muthesius; to students and ex-students of a number of universities, including Abigail Youngman, Elizabeth Reisner, Nick Bridgland, Sarah Cummings and Jessica Fernie; I am also indebted to the staff of the Department of Fine Art at the University of Edinburgh for enabling me to take sabbatical leave. Finally, I am very grateful to all the copyright holders for their permission to reprint the excerpts which make up the anthology, and to reproduce a number of illustrations.

Introduction
A History of Methods

FROM ANTIQUITY TO THE RENAISSANCE PIECEMEAL BEGINNINGS

There are numerous references in the literature of ancient Greece and Rome, as well as in the Chinese and Islamic traditions, to objects such as paintings, statues and buildings which today we classify as art. Writers such as Pliny the Elder (23–79 AD), acting as *antiquarians, described them and provided accounts of how they were made, their size (especially if they were very large), their cost (especially if very high), the artists who made them (especially if very famous), where appropriate their degree of lifelikeness, whether they were the first of their kind and the extent to which they were considered beautiful. Cicero (106–44 BC) and Quintillian (30–100 AD) describe a systematic development of four stages in painting and sculpture from the early fifth century BC on, moving from a hard, rude, early style to one of perfection in the form of a naturalism which is restrained by ideal beauty, as in the work of Phidias, then to a refinement and a softness, and finally to a naturalism which is taken too far. Most of these ways of writing about art continued without a break from antiquity into the Byzantine period and the Western Middle Ages, from which survive accounts of the building activities of famous individuals, anecdotal descriptions of sites, and manuals of the techniques of the various arts.

The art history of the Renaissance differs from what has just been described in three ways. Comments on art in the writers of antiquity are all embedded in accounts of other subjects, whereas with the Renaissance art becomes a subject in its own right. There is a continuous tradition of writers on the history of art from the Renaissance to the present day, but not from those in antiquity. Thirdly and most importantly, the cyclical image formulated by Petrarch (1304–74) of a peak of civilization in antiquity, followed by a decline for a thousand years, and then the sign of a revival in the mid-fourteenth century, is one of the most formative ideas in the history of European culture, since on it are based the twin concepts of the Middle Ages and the Renaissance. A century later, in the 1450s, the Florentine artist Lorenzo Ghiberti (1378–1455) applied Petrarch's model to the history of art: as a result of the rise of Christianity all statues and pictures of nobility and perfection were destroyed, and art itself ceased until the talent of Giotto began to revive it. Along with this idea of a *cycle of ages the identifying mark of the Renaissance approach to the history of art is the *ideology of *humanism, which places humanity at the centre of attempts to understand the world and uses it as 'the measure of all things'. This leads to a stress on the achievements of individuals and the ways in which they have made an impact on their sphere of activity.

THE SIXTEENTH AND SEVENTEENTH CENTURIES BIOGRAPHIES

The Lives of the Artists by the Italian artist Giorgio Vasari (1511–74), published in 1550 with an expanded edition in 1568, is the first text on the visual arts extensive and consistent enough to be called a proper history. Vasari set out ground rules for the history of art as a discipline that were to be followed for at least two centuries. The chief elements of his approach can be grouped under the headings of *connoisseurship and *humanism, both of which accord a central role to genius and the achievements of the individual painter, sculptor or architect. This connoisseurship involved the making of judgements about the *quality of artists' works for purposes of attribution and to decide whether they should form part of the *canon of great works of art. Quality was assessed on the degree of naturalism or illusion attained in the representation, the technical advances which made it possible and on the closely associated notion of ideal *beauty as the selecting and combining of the most beautiful parts of nature. In particular *connoisseurship required a sensitivity to form and a close examination and analysis of the works of art, leading to the identification of *styles both of artists and of schools and *periods, and the tracing of *sources and of influences between them. Vasari, as an artist himself, stressed the importance of looking at works with an artist's eye, and the use of contrasts such as that between drawn line and painted colour (or *disegno e colore*). These methods were supplemented by documentary evidence and the study of *patronage and *iconography, or the study of the meaning of images, to produce the *biography as the standard form of Vasari's presentation.

Vasari's chief model for the passage of historical time was the *cycle of ages proposed by Petrarch and Ghiberti, but with the addition of the specifically biological concepts of rise, maturity and decay. He applied this to the art of antiquity, describing what he saw as its rise from distant beginnings, its golden age in Greece and under the Caesars, and its decline in the fourth and fifth centuries AD, and then drew close parallels between the achievements of antiquity and what was happening in his own time. For this, however, he omitted any mention of the phase of decay and instead proposed three stages of childhood, youth, and maturity, represented by Giotto, Masaccio and Michelangelo respectively. The closest he came to confronting the problem of decay was his acknowledgement that a regression was possible after his own day if artists and patrons were not vigilant. He paid almost no attention to the historical and social context of what he was writing about, saying for instance that the barbarian invasions of the Roman Empire in the fourth and fifth centuries did no more than seal the fate of the arts of antiquity, which had declined because of forces internal to themselves. The stress in the *Lives* is therefore on the achievements of individual artists and their place in a cyclical development, assessed by the study of the documentary evidence and the techniques of connoisseurship (text 1, 1568).

The extent to which Vasari's methods set a standard is indicated by the way in which succeeding writers followed his methods, even where they were obviously inapplicable. This is evident in Karel van Mander's lives of the Netherlandish painters of 1604. Van Mander (1548–1606) used Vasari's cycle, but, because there is no overall pattern of stylistic change in Netherlandish art to match it, he found it necessary to stress the progress made by each individual artist rather than the shape of the whole period. Because he was discussing a style in which the naturalistic rendering of the visual world takes precedence over most other concerns, Italy also provided him with a singularly inappropriate model of ideal beauty. This is one of the clearest examples of the power which the written word can have over the ways in which art historians choose their working methods (text 2, 1604).

Once writers accepted the model of Vasari's cycle, then the problem of living in what had to be seen as the declining phase of the contemporary cycle caused them to react uncertainly to the treatment of the artists of their own time. Giovanni Bellori (1615–96), who exemplifies the continuation of Vasari's methods into the Baroque era, questioned the value of studying any contemporary artists. In so far as he did use the cycle, it is not surprising that he supported those using classical styles against those using the Baroque, that is, the styles identifiable with the ages of maturity and with that of decay respectively (text 3, 1672). Other writers whose approach was primarily biographical in the Vasarian mould are Filippo Baldinucci (1624–97), who specifically described his work as an attempt to bring Vasari up to date, Joachim von Sandrart (1606–88), who in the late seventeenth century wrote a history of German painting, and Horace Walpole (1717–97), who produced a series of biographies of English painters in the late eighteenth century.

12

THE EIGHTEENTH CENTURY CULTURAL HISTORY, AND THE CYCLE

The first major innovation in the methods of art history after Vasari was Johann Joachim Winckelmann's development of *cultural history, that is, the use of all relevant sources of information to place the arts in the context of the *cultures which produced them. Winckelmann (1717–68) in effect wrote the first history of art as opposed to a history of artists (text 4, 1764). He makes the break with the central principle of Vasari's method explicit, saying specifically that individual artists have little bearing on what he aims to do, and that he wishes to adopt a more systematic approach to the organizing of knowledge. This is in keeping with the age of the Enlightenment, when the values of the intellect were prized over those of the chronicler, and the overall ordering of information became one of the main projects of the scholarly world, evident in, for example, the writing of encyclopaedias and the founding of learned societies.

Apart from using culture as his organizing principle in place of the individual artist, Winckelmann's methods of procedure were very similar to Vasari's. They involved the careful examination of the work of art, looking with the artist's eye, analysing technical progress, defining and identifying ideal beauty (that is, the practising of *connoisseurship), and the study of the documentary evidence. He avoided the problem of decline in his own time inherent in Vasari's cyclical model by writing almost exclusively about the art of antiquity.

The other major change in method in the eighteenth century was a rethinking of the *cycle. For Vasari the Gothic and hence the Middle Ages represented decay, that is the nadir and the antithesis of the classical peaks before and after. In the course of the eighteenth century French scholars such as Marc-Antoine Laugier (1713–69) began to stress the inherent logic of the structure of Gothic buildings, a change in attitudes which finds its most dramatic exposition in an essay by Johann Wolfgang von Goethe (1749–1832), in which he argued that Gothic was as worthy of respect as the architecture of any other period. By doing this he denied the polar opposition between the Gothic and the classical and accelerated a process which in the course of the nineteenth century removed Vasari's Renaissance cycle from its position as the linchpin of historical development (text 5, 1772).

THE NINETEENTH CENTURY EMPIRICISM, METAPHYSICS AND CULTURAL HISTORY

The study of history in the nineteenth century was characterized by the two very different approaches of empiricism and idealism. *Empiricism and the inductive method, that is the accumulation of data and its subsequent ordering and analysis, was the guiding principle of the physical sciences. Just as the great scientists of the age founded disciplines like chemistry on this basis so historians proclaimed that it was possible to describe the past as it really was, through the careful accumulation of what they considered to be an incontrovertible mass of fact.

This materialist approach operated in the history of art in the same way as in other aspects of historical study, in the collection of documentary information about individuals and their actions, but it also had a particular effect on the methods which are specifically art-historical. The close examination of the works had of course been part of the standard stock of methods since Vasari and had been extolled by Winckelmann, but now for the first time, in the specializing manner of the nineteenth century, it became acceptable to concentrate entirely on this one aspect.

13

The chief exponent of this approach to the study of images was the Italian Giovanni Morelli (1816–91). Morelli devised a systematic means of establishing the authenticity of attributions by training his eye to recognize minute but characteristic details of style, in a highly concentrated form of scholarship. He thought books on art a distraction and art historians an irrelevance. His method was extremely narrow, involving using his eye rather like a chemist using formulae to test the age of a canvas, practising what might be called scientific *connoisseurship (text 8, 1890). Morelli's contemporary, Giovanni Battista Cavalcaselle (1820–97) applied a similar method, though in a less systematic way, and hence was often criticized by Morelli, while the American Bernard Berenson (1865–1959) was the foremost twentieth-century representative of this method.

This specialized, inductive approach also manifested itself in the history of art, in the development of *antiquarianism. In the nineteenth century this tradition was given a great impetus by the growth of *archaeology as a scientific discipline, manifested in the founding of archaeological societies in the 1840s. The combination of antiquarianism and archaeology produced results of immediate relevance to art historians, for example in the development of *typology, that is, the classification of shapes, and in the study of the buildings of the Middle Ages, which were for the first time understood in a proper chronological framework. This achievement can be exemplified by the work of Robert Willis (1800–75), whose publications established the basic histories of almost all medieval English cathedrals. The practitioners of this approach were largely uninterested in theory, taking it so much for granted that their empiricism constituted the proper historical method that they made no mention of it.

This type of investigation is not unconnected with the attempt, around 1860, by the German writer Gottfried Semper (1803–79) to make the history of art more 'scientific', by proposing that the form of a work of art could be explained as the result of three factors of function, material and technique alone. Given the practical basis of this scheme it is perhaps significant that he was an architect. A related view proposed that certain styles resulted from the rational application of building practices, so that the Gothic could be seen as the high point of medieval building, equal in rationality to the architecture of any age. This development has been most closely identified with the publications of the French architect Eugène-Emanuel Viollet-le-Duc (1814–79) and achieved one of its purest forms of expression in the writings of William Morris (1834–96), the social reformer, (text 7, 1888).

While the physical sciences in the nineteenth century were characterized by empiricism and induction, philosophy tended to the opposite mode, especially in Germany where the central concept involved a metaphysical system based on the principle of idealism, that is that ideas underlie all of reality. The founder of this approach, and one of the most influential figures in the study of history ever since, was G.W.F. Hegel (1770–1831). For Hegel the shape of history was the result of the workings of a world spirit, which realized itself more fully with each successive age. The forms taken by works of art were therefore manifestations of the spirit of the particular age, rather than the result of actions taken by individuals or even of the social forces surrounding their creation. Their development was also, consequently, governed by laws (see *Hegelianism, *progress, *teleology and *evolution).

The tradition of *cultural history as it developed in the nineteenth century stands in many respects between *empiricism and *Hegelianism. Whereas Winckelmann restricted his attention to antiquity, the first scholar to attempt to apply the principles of cultural history to all periods was the Swiss historian Jacob Burckhardt (1818–97). Burckhardt conceived of what he called a vast spiritual map or the projection of an immense ethnography or description of the peoples of the world, embracing both the material and the spiritual spheres. Within this panorama he set the visual arts at or near the centre of the defining characteristics of an age. He acknowledged that Hegelianism had some useful aspects, such as what he called the vistas which it had hewn out of the forest of history, but he set himself firmly against the notion of metaphysical systems. He noted sarcastically that he was unable to follow Hegel's lead because he 'was not privy to the purposes of eternal wisdom', and he described the philosophy of history as a centaur, that is a beast made up of two incompatible parts, one rational and the other irrational.

In distancing himself from the ideas of Hegel in this way he went so far as to call himself an empiricist, but this is misleading if it is taken to mean that like Morelli his approach to the subject was conditioned first and foremost by the collecting of facts: for him empiricism was simply a description of good scholarly practice, a tool needed to ensure accuracy in the construction of the much broader picture of a whole culture. Burckhardt's greatness is indicated by the fact that one can describe him as a cultural historian who understood and used the virtues of both metaphysics and empiricism (text 6, 1872).

Burckhardt's approach was especially influential on the German art historian Aby Warburg (1866–1929). Warburg's project was the provision of no less than a universal history of images and the exploration of culture through psychology. In pursuit of this his interests extended from Botticelli and the mentality of the Italian Renaissance to the cultures of North American indigenous peoples. His famous library, the nucleus of the library of the Warburg Institute in London, contained books on a great variety of subjects, including libraries themselves, economics, costume and folklore, and in seeking an understanding of his material he accepted the importance both of large Hegelian patterns and of the individual.

Hegel's ideas were developed most creatively among art historians by the Austrian Alois Riegl (1858–1905). For Riegl the history of art was governed by universal laws, and each period by its particular version of those laws. Works carry the spiritual hallmarks of their time, as a result of the *Kunstwollen*, that is the 'will to form' or aesthetic urge of the period. This idea was for him far more important than merely auxiliary disciplines such as iconography.

14

Riegl's approach differed from Hegel's chiefly in two ways. First he was much more involved with the objects, denying any distinction between the crafts and the fine arts and using evidence from any visual source to show that the forms were those of a particular age. Secondly, while for Vasari history was a succession of peaks and troughs and for Hegel each age in human history was a step up the ladder towards the fulfilment of the world spirit, for Riegl no "period was more important than any other. Thus the late Roman period, for example, was neither a decline from the peak of antique classicism nor a step on the journey to perfection, but one age among all the others which happened to stand as a period of transition between two great ages of human history, the ancient and the modern (text 9, 1901).

The Swiss art historian Heinrich Wölfflin (1864–1945), like Hegel, considered that laws governed the ways in which "forms changed through time, but, like Riegl, he saw no qualitative difference between the resulting phases. He proposed a cycle consisting of early, "classic and baroque phases, the characteristics of which he defined and analysed with the aid of pairs of concepts such as linear versus painterly and plane versus recession (text 10, 1915). These pairs of forms or formal concepts are the nearest thing to a new art-historical tool which we have met since considering Morelli's connoisseurship.

15

The German art historian Paul Frankl (1889–1963), despite working well into the twentieth century, provides one of the purest statements of the Hegelian model applied to the history of art. "Style developing through time is an organism subject to ideas which transcend human activity, rendering the role of the genius irrelevant. Similarly individual forms take their shape from models in the spiritual sphere, like the relationship between visible and original forms proposed by Plato. Art is a reflection of the rest of society, formed by its philosophy, religion and politics. Frankl extended Vasari's Renaissance cycle and its phases all the way to 1900, though without any sense of growth and decline (text 11, 1914). A variant of these approaches is the 'spiritual history' of Max Dvořák (1874–1921), who regarded the history of art not so much as a history of forms but as a history of ideas.

The aspects of Hegel's approach which influenced these scholars can be summed up as follows: for Riegl the important question was the relationship between change in form and change in society, for Wölfflin it was the mechanism of the internal development of form, for Frankl form as a manifestation of overriding forces, and for Dvořák the relationship between ideas and history.

THE EARLY TWENTIETH CENTURY RESPONSES TO MODERNISM

Most art historians from the seventeenth century onwards, confronted with the possibility that the artists of their own time were representatives of a period of decline, mentioned their contemporaries only sparingly, and by the late nineteenth century they did so hardly at all. The contrast with the early twentieth century, when many art historians made contemporary art the centre of their interest, is striking.

The reasons for this change of attitude are to be found in the character of the period of "modern art itself, as this marks a fundamental break with the past. Since the Renaissance the representation of the visible world constituted one of the underlying principles of painting and sculpture, but with the development of expressionism and abstraction in the early years of the twentieth

century this ceased to be the case. (See Roger Fry, 1866–1934, text 12, 1920, and *avant-garde.)

One of the consequences of defining this dramatic break with the past was that the cyclical theory of history had to be abandoned. Previously the assumed existence of two great *cycles of early, middle and late phases, the first cycle in antiquity and the second beginning in the Renaissance, had permitted historians to fit successive styles into an overall model, with the movements of the seventeenth, eighteenth and nineteenth centuries being seen, in one way or another, as part of one unfolding tradition. Rococo, could, for example, be considered as a form of the Baroque, Neoclassicism as a revival of the central, classic, phase, and Realism as a concentration on one of the strands underlying the whole sequence. This applied whether the cycle was seen in terms of Vasari's biological model of rise and decay, or Riegl's sequence of phases of equal value.

With modernism, art historians were confronted with a movement which was not the result of a slow rise to prominence over centuries: there, sprung up within a few years, was a form of art with no such pedigree. Of course the work of many if not all artists of the period could be related to the art of the past, that of Cézanne, for example, to that of Poussin, and that of Seurat and Gauguin to aspects of the art of the Renaissance and Middle Ages respectively, but the very variety of such links (three artists working in the same decade with their sources in three completely different periods) is in itself an indication that the new art could no longer be seen as the next stage in a broader development.

While the period could therefore not form part of the great cycle of styles of the Renaissance tradition, art historians nevertheless wished to stress the continuity between modernism and earlier art, if for no other reason than that it bestowed a degree of respectability on works which often met with public hostility. In pursuing this aim they excluded three models from the tool-kit of available methods, namely the naturalistic standard (because of abstraction), the cycle (because the material did not fit), and the cultural context (because of their belief in the autonomy of art).

They used all the other established methods in a variety of ways. Contemporary works of art were seen, as by Vasari, as individual achievements of genius which could be compared on a timeless basis to the quality of the paintings of the earlier great masters. This in turn led to a concentration on the lives of individual artists (hence the preponderance of *biographies among publications of the period), their enrolment, if warranted, in the *canon of great names, the identification of their contribution to the internal development of *styles and movements and to the general 'progress' of modernism, the grouping into schools, the search for sources and the application of old polarities such as classical versus romantic (for example to Cubism and Surrealism respectively), or drawing versus colour (for example to Braque and Matisse respectively). *Iconographical analysis was used as before to explore the meaning of works, often with an added psychoanalytical dimension, and *empirical analysis and the techniques of Morellian *connoisseurship continued in use, not only in order to identify authorship (which was still a problem, if a less frequent one), but also to establish accurate stylistic relationships.

While rejecting the basic tenets of the Hegelians, art historians dealing with modernism none the less adopted some of their smaller-scale methods. Wölfflin's in particular proved useful, especially his paired types of *forms and even his cycles, though applied to the lives of individuals or at the

16

most to movements rather than to larger periods. In a similar way writers invoked the notion of styles becoming exhausted, recalling the cycle of rise, maturity and decline, but applied to the smaller scale. Riegl's acceptance of all periods as worthy of study was a useful precedent, and the art of late antiquity could, like aspects of modernism, be seen as offering an alternative aesthetic standard from that of the related ideals of classicism and naturalism.

Only one new method was added to the corpus, but it was the key which enabled order to be brought to an unprecedented welter of disparate styles. This is the diagram encapsulating interrelationships, influences and sequences, something which appears to have been less necessary when artists could be placed in one or other of a few large groups, but which was now essential given the individualism characteristic of contemporary art. These are best exemplified by the diagrams drawn up by the American art historian Alfred H. Barr (1902–79) of the Museum of Modern Art in New York, which consisted of names linked by different types of arrows (text 14, 1936).

Modernist ways of applying art-historical methods in turn affected the study of other periods, by the projection of twentieth-century aesthetic perceptions and other approaches on to the past. There is, for example, Max Dvořák's treatment of El Greco as a proto-expressionist, Meyer Schapiro's *psychoanalytical analysis of a Flemish altarpiece, Kenneth Clark's treatment of Piero della Francesca as a modern formalist, or Willibald Sauerländer's description of Jean Bony's vision of French thirteenth-century architecture as 'Mod Gothic'.

THE MID-TWENTIETH CENTURY CUMULATIVE VARIETY

The changes brought about by the study of modern art contributed extensively to the character of art history as a whole in the middle decades of the twentieth century, including the work of those scholars who were not interested in modernism. This was due to the reduced importance of Hegelianism, the combining of this weakened Hegelianism with a resurgent empiricism and connoisseurship, the overall importance of *cultural history, and finally the social history of art.

On the first point, in addition to the doubt which modernism appeared to cast on the continued applicability of large-scale sequences, *Hegelianism was weakened by other factors. The unprecedented barbarity of Nazism was seen as owing something, however corrupted, to the Hegelian view of the world, as the outcome of the systematic application of an overall theory; and the emigration of scholars from the German-speaking to the English-speaking world in the 1930s led to their exposure to intellectual communities in which the standards of *empiricism held pride of place.

The writings of the German and subsequently American scholar Erwin Panofsky (1892–1968) provide good examples of the pragmatic metaphysics which characterized this period, especially in the classic combinations of stylistic and iconographic analysis which he brought to bear on a very wide variety of subjects (see *iconography and, for related material, text 15, 1940). What might loosely be called this humanizing of Hegelian methods is also exemplified in the work of Henri Focillon (1881–1943), for whom, like Wölfflin, forms were abstract entities changing over time in accordance with the principles of style, but which were equally at the mercy of many other disparate influences (text 13, 1934).

On the second point, the tradition of empiricism represented by Morelli and the antiquarian tradition of architectural historians in the nineteenth century can be represented in the twentieth by Nikolaus Pevsner (1902–83), the German and subsequently British art historian (text 16, 1943). The decline of Hegelianism combined with the effects of modernism on art history gave renewed vigour to the study of the individual artist supported by the techniques of *empiricism and *connoisseurship (including *quality, the *canon, *style, *biography and *sources).

Thirdly, in its diluted form Hegelianism became less easily distinguishable from *cultural history. Unlike Hegelianism, however, cultural history remained untainted by the political extremism of the first half of the century. This factor plus its affinity with humanism and close links with empiricism, enables cultural history to be seen as the defining approach of the period.

18

The art-historical tradition of cultural history can be traced from Winckelmann through Burckhardt and Warburg to E.H. Gombrich (1909–), the Austrian and subsequently British art historian (text 19, 1967), its best-known representative in the twentieth century. Gombrich's work is characterized by variety, both in terms of approaches adopted and of periods and subjects studied, though most of his work has been concerned with the Renaissance and the application of psychology to an understanding of the history of art. He has also involved himself in issues of *theory and as a consequence has played an important part in subsequent analyses of the character of the history of art. He is a cultural historian in the sense that he looks for evidence from all parts of *culture while focusing his research primarily on the objects of high culture. Gombrich's approaches are in many respects closely related to those used in *anthropology and *psychology (see also Fagg, text 20, 1973; Onians, text 22, 1978; and Sontag, text 18, 1964).

On the fourth and final point, the approach known as the social history of art was developed in the 1940s and 1950s, following the pioneering work of the American anthropological art historian Meyer Schapiro (1904–), by such Marxist art historians as the Hungarian Frederick Antal (1887–1954) and the German Arnold Hauser (1892–1978) on the basis of the Marxist thesis that the economic base conditions the cultural superstructure and that as a result styles vary according to the character of the dominant class (text 17, 1959). This innovation was, perhaps surprisingly, received with little enthusiasm and acquired no immediate following, possibly because it was using concepts ultimately derived in a rather crude way from Hegel. Alongside this, however, other aspects of Marxist analysis were being applied in more detailed ways to questions related to the social function of art by writers such as Walter Benjamin (1892–1940) and Theodor Adorno (1903–69), and to the character and status of art by the critic Clement Greenberg (1909–94).

THE LATE TWENTIETH CENTURY NEW ART HISTORIES

In the early 1970s the character of the history of art described in the two previous sections began to be criticized on a number of counts: for the narrowness of its range of subject matter and concentration on individual artists whom it classified as geniuses; for its restricted set of methods, consisting chiefly of *connoisseurship, the analysis of *style and *iconography, *quality, the *canon, dating arguments and *biography; for the uniformity of degree curricula offered by departments of the history of art; for its ignoring not only of the social context of art, artist and public, but also structures of power,

especially those of relations between art historians and the owners of valuable works of art; and, perhaps most important of all, for the lack of attention paid to the changes which had been taking place in the related disciplines of literature and history in the 1960s (see °art history and °history).

The new art historians, as they have sometimes been called, shifted the centre of gravity away from objects and towards social context and °ideology, that is to the structures of social power, and from there to °politics, °feminism, °psychoanalysis and °theory. Thus in one of the earliest statements of intent the British art historian T.J. Clark (1943–) exhorted art historians to cease expending their energy on deciding attributions and cultivating the canon. He wanted them instead to return to questions as large and important as those which had been confronted by their predecessors in the early part of the century. Clark sought the introduction of a social history of art of a superior kind to that of Hauser, one based on Marx but using more sophisticated economic models and more detailed historical evidence (see text 21, 1974, and °Marxism). The desire to find out how ideologies work, especially those of the worlds of °art and °art history, subsequently became one of the chief preoccupations of a number of art historians (see, for example, Baldwin, Harrison and Ramsden, text 23, 1981 and Alpers, text 24, 1983). Ideology also lies, in combination with modernism, at the roots of the development of °design history, which, like architectural history, concentrates more closely than other kinds of art history on technology and function.

The success of these developments, as with similar movements in other disciplines, can probably be associated in part with the extent to which the history of the twentieth century has weakened the case for the °humanist view of the world and the extent to which the culture of the Western world has been fundamentally altered by the cumulative effects of modernism in its broadest sense. The continuity which could be taken for granted a generation ago, extending back apparently to classical Greece and in a way even to ancient Egypt, has gone: the classical myths, the narratives and symbols of Christianity, the canons of literature and works of art, are no longer the property of most members of society as they to a greater or lesser extent once were. Just as empiricism and the inductive method helped assure the citizens of the nineteenth century of material certainties, so the commanding theory of our own, that of relativity, casts doubt on all our assumptions.

The changes taking place in literature and history which influenced the new art historians had themselves been influenced by developments in France in the form of structuralism and °poststructuralism. The structuralist approach looks for meaning at a level below that of surface content, a technique which can be applied to visual material by, for example, ignoring the iconographic identification of the figures in an image and using instead paired concepts such as male/female, nude/clothed and light/dark in order to define and explore the content. This approach was applied by art historians in conjunction with that of °semiotics or the study of signs.

Poststructuralism developed these ideas into a critical analysis of the humanist world view itself. Roland Barthes (1915–80) denied the relevance of authorship, while Jacques Derrida (1930–), at least in one reading of his approach, uses the concept of deconstruction to deny the possibility of communicable meaning, claiming that the intention behind a work cannot be known and that each reading of a text is a re-creation of it. In the visual arts these approaches question the status of the artist as the creative agent and the source of what is present in the art object, and deny the

presence of any clearly ascertainable meaning in the painting, sculpture or other object. Michel Foucault (1926–84) adopted the concept of *discourse analysis to describe his view of the fractured and multifarious character of power relations in a society; in these terms a painting or a building can be seen as the nodal point of an infinite number of discourses, social, artistic, psychological and so on, and used as a means of identifying hidden agendas of power and control. Foucault's approach reminds us that the art of the past is the art of the victors, and that the work of historians is itself conditioned by a web of discourses.

Feminists had a particular interest in these iconoclastic developments, given the exclusion of women from the traditional *canons of art history and the disadvantages which they faced in the contemporary world of employment and career structures. This exclusion led women art historians first, in the early 1970s, to rediscover numbers of women artists and to establish the reputations of others, in part by criticizing the distinction drawn between high art and craft, which was seen as a means of keeping women's art in an inferior place. This approach lay, however, within the boundaries of one of the more traditional ways of studying art, namely the writing of a *biography of the artist and using the techniques of *connoisseurship to assess the *quality and date of the work. In the late 1970s interest moved to challenging both the discipline itself and the patriarchal foundations of society, and finally, using the techniques of *poststructuralism, to calls for revolution. In addition to *political and *Marxist approaches feminists have also used those based on *psychoanalysis, *semiotics and *structuralism. As a result they do not wish to see what they are engaged in as amounting to a single feminist 'approach' (see Pollock, text 26, 1988 and * feminism).

20

Film studies, in publications such as *Sight & Sound*, have underlined the new breadth of the subject matter of the history of art. They have perhaps been more influenced by the new developments in critical Marxism and poststructuralism than the study of any other medium, in part because the exclusively twentieth-century character of their subject matter has left them less conditioned by the traditional methods of the discipline.

All of these developments have come to be grouped under the heading of the new art history, or, as they have been described here because of their diversity, the new art histories. In addition to the issues mentioned, art historians working in these ways have also raised the problems of assessing *quality, of *intention and *reception alongside authorship, of artistic production in place of artistic creation, and of Western-oriented attitudes to race in references to orientalism and colonialism (see Oguibe, text 27, 1993). Working with a broader range of ideas became the norm, with a corresponding change in *vocabulary. Most of those exploring the new approaches started with an assumption of disaffection, a wish to change at least the intellectual direction of the history of art, or its institutional context and even in some cases the form and *ideology of Western society. In these terms the character of T.J. Clark's model can be seen as placing it within the mainstream of humanist art history, while the sociological and even biological aims of feminists such as Chris Weedon and Griselda Pollock place them in another category of philosophical and belief systems.

While the thrust of the new art histories was intended to affect the study of all periods of the history of art, there is little doubt that the force which motivated its adherents was primarily a reaction to the art history of modernism. This represents a kind of back-handed compliment, as it once again underlines the pervasive power of modernism to continue dominating the conceptual land-

scape of the history of art, something which is true even to the extent that the succeeding period has been given the paradoxical label "postmodernism.

THE PRESENT VERSATILITY AND POTENTIAL

The subject may now appear to present a rather fractured image: aesthetes and iconographers on the one hand tending the shrines of genius and antiquity, and revolutionaries on the other, bent on overturning the temples of art, mammon and patriarchy, all set against a backdrop of exhaustion suggested by titles raising the possibility of the end of art history or the end of art theory (see Belting, text 25, 1984).

What this image ignores, however, is the potential of a subject which has as its *first* defining asset the expertise of the *eye* (which, although never innocent and always requiring interpretation, can illuminate aspects of cultures across linguistic and social barriers), and as its *second* the *concrete* character of its subject matter (which, in common with the material studied in related disciplines such as "anthropology, "archaeology and "geography, prevent it ever becoming wholly in thrall to philosophy). (See also "subjects/disciplines and "theory.)

21

In the sixteenth and seventeenth centuries the writing and study of art history was primarily an Italian concern; by the eighteenth the focus had shifted to Germany, and in the nineteenth to all of the German-speaking countries, while the twentieth century has seen the centre move to the English-speaking world, impelled in part on the one hand by the dispersal of scholars from Nazi occupied Europe and on the other by Francophile attitudes among scholars, especially medievalists, in North America. In terms of content, the history of art can be seen as having moved, broadly speaking, from a concentration on the uniqueness of the work of art in Vasari's time, to the work of art as an expression of high culture in Winckelmann's, to its status as a manifestation of spiritual and social forces for the Hegelians, to a multiplicity of aims, including a reaffirmation of the centrality of the work of art and the artist, in the middle part of this century, and to the made image as a register of broad social, ideological and psychological structures in our own period. In seeking to gain from the current situation we need to remember two things in particular. First, the archaeological minutiae really do matter but if they bulk too large in our vision we run the risk of narrowing and therefore trivializing what we are doing. Secondly and conversely, the theoretical, social and political framework is also fundamental, especially to an understanding both of the interrelationship between things and of history as the study of all of the past; but again, if that becomes too prominent, then we cease to deal with the objects, and subjects, with which we started.

We also need to be prepared to use whatever best suits our purpose. Clark and Pollock have both denied (at least in 1974 and 1988 respectively) a wish to promote any reformed 'new art history' and have said that they do not want the methods and insights which they contribute to be domesticated by those who in the 1990s continue to think of themselves as art historians in the traditional sense. However, if there is one thing that poststructuralists such as Barthes have taught us it is not to value intention too greatly over reception, a lesson which frees us, however we define ourselves, to make whatever selection we wish of what has been added to the body of art history in the 1970s and 1980s, along with all the previous contributions from Vasari onwards.

1 ▌**Giorgio Vasari**

The Lives of the Artists, 1568

Giorgio Vasari (1511–74), a pupil of Michelangelo, was one of the most prolific artists of the sixteenth century. His best-known works include the Uffizi Palace (now the Gallery), which he designed and built, and the frescos in the Palazzo Vecchio in Florence, both for his patrons the Medici. He also helped to found one of the earliest academies of art, in Florence in the early 1560s. His renown does not, however, rest primarily on his work as an artist, but on the fact that he wrote extensively on the subject. Showing the same energy and entrepreneurial flair in this pursuit as in his painting and architectural work, he produced his *Lives of the Artists*, a comprehensive collection of biographical material and an account of the history of Italian Renaissance art. The first edition, dedicated to Cosimo de' Medici, was published in 1550 and an enlarged and revised edition, covering many living artists including Vasari himself, appeared in 1568.

The book is divided into three parts, each with a preface, from which the excerpts reprinted here are taken. The preface to the first part offers an outline of the history of the arts from the dawn of antiquity to the first artists of the Renaissance – Cimabue and Giotto. The preface to the second part defines the character of the arts in the fifteenth century, in the work of artists such as Masaccio, Piero della Francesca and Mantegna, and that to the third part presents the context of the lives of the masters whose works Vasari considered constituted the highest peaks of the Renaissance, namely Leonardo, Raphael and Michelangelo.

Three aims can be discerned in the *Lives*, the first being the promotion of Vasari's native Tuscany as the leading centre of artistic excellence alongside ancient Greece and Rome, the second the consolidation of advances in the status of the artist from artisan to figure of note in society, and the third the placing of his own work in the context of what he saw as the greatest art of his time. These aims can be best understood in terms of the audience whom Vasari was addressing, namely artists and patrons. Vasari says that he wishes to provide artists with a sense of their distinguished place in history and the status of their contribution to civilization, as well as a means of maintaining the excellence of the arts in a future age when they might have fallen into decay. As to patrons, both potential and actual, in the preface to the third part of the *Lives* he makes their responsibilities to artists explicit, calling their attention to 'those rare men of genius who create priceless work and who live not merely unrewarded but in circumstances of wretched poverty'. The book is therefore characterized by a special attention to visual effect and technical detail on the one hand, and the prestige of being associated with the arts on the other.

An audience of both artists and patrons goes some way to explaining the choice of the biography as the basic building block of Vasari's history. Artists can identify with the subjects while patrons always welcome a certificate of provenance, a statement of cultural value and a source of anecdote, all of which are easily supplied by the biographical format. The attraction of biography as a means of providing historical explanation is graphically illustrated in Vasari's brief history of the arts from the earliest times in the first preface, in which he attempts to attach *every* work to an artist's name, and where such a name is not available then rulers, Prometheus and even God are commandeered to fill the gaps.

Along with this stress on the primacy of the individual, Vasari proposes that the arts have their own internal cycle which transcends the contribution of any one artist, since architecture, painting and sculpture 'like human beings themselves, are born, grow up, become old, and die'. He exemplifies this biological model of historical development by using the arts of antiquity, which rose from nothing via the conquest of various technical difficulties to a peak of perfection under the Greek and Roman Empires, after which, under the later Caesars in the fourth century, 'their earlier perfection and excellence were not sustained'. This decline continued because '… once human affairs start to deteriorate improvement is impossible until the nadir has been reached.' That is, the next stage in the cycle is inevitable, something which happens as part of the natural order of things, like decay and death, as the biological model proposes.

He ascribes the revival of the arts in the Renaissance to 'some subtle influence in the very air of Italy', in so doing again providing an indefinable cause without any external agency. He traces this revival through three phases, saying 'Now that we have, as it were, taken the … arts away from the arms of their nurse and seen them through their childhood we come to the second period …', when they 'were brought to the flower of their youth, holding out the promise that in the near future they would enter the golden age', in which third period art 'has progressed so far that it has more reason to fear slipping back than to expect ever to make further advances' (figs. 1, 2 and 3).

Since he starts with the kernel of the artist's life and around it hypothesizes a larger formative force controlling the development of the arts over centuries, one might have expected him to set his subjects in their historical context, but this he does not do. He organized the *Lives* using the principles of those he considered the best historians, who 'have not been satisfied just to give a bald narration of the facts but have also … investigated the ways and means and methods used by successful men in forwarding their enterprises … recognizing that history is the true mirror of life', which keeps the motive power of history within the control of the individual. Events in late antiquity, such as the barbarian invasions, the Christian disapproval of images, or the fall of the Western Roman Empire, did no more than help the pattern to its close, and he makes no reference to the effects of political and social circumstances on the development of the arts in Italy from Giotto to Michelangelo.

Each life is underpinned by detailed studies of the works produced by the artist in question using the techniques of *connoisseurship. Vasari also accepts the need 'to distinguish between the good, the better, and the best …', that is to face the difficulties posed by the question of *quality. He concludes that the first artists of the Renaissance, while they 'fell a long way short of perfection … did mark a new beginning … and if only for this reason I have to speak in their favour and to allow them rather more distinction than the work of that time would deserve if judged by the strict rules of art'. There are, then, for Vasari both absolute and relative standards of quality.

24

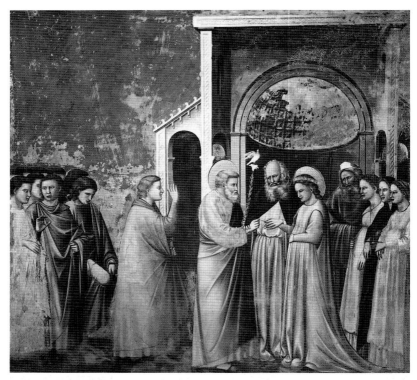

1 Giotto, *Marriage of the Virgin*, c. 1305. Fresco, 2 × 1.85 m. Capella degli Scrovegni, Padua

These frescos by Giotto, Masaccio and Michelangelo (figs. 2 and 3) from the early fourteenth, fifteenth and sixteenth centuries respectively illustrate Vasari's division of the art of the Renaissance into three successive stages. In the Giotto the heavily draped figures stand in profile, their forms sharply outlined. There is little inter-action between the figures, who stand in front of the building which describes where the scene is taking place. In the Masaccio the poses and the drapery are more varied, the outlines more open and the figures more convincingly set in, rather than in front of, the landscape. In the Michelangelo the poses are serpentine, the out-lines even more varied, and the figures integrated into the space in which they move.

In assessing the validity of this sequence three things in particular need to be borne in mind. Firstly, we are looking at these images with eyes trained in the tradition of the Renaissance and influenced by the writings of Vasari, so that the self-evident nature of the sequence may be misleading. Secondly, the subject matter of the three works is different: the Giotto concerns a solemn ritual, the Masaccio a dramatic moment presented as if it were such a ritual, and the Michelangelo a solemn ritual presented as a dramatic moment. Thirdly, while the Giotto and the Masaccio are each on a wall about the same distance from the spectator, the Michelangelo is on a ceiling and much further away – differences which could have influenced the artists in their production of the images.

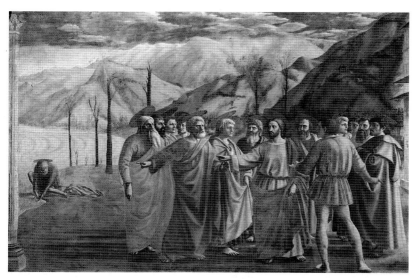

2 Masaccio, *The Tribute Money*, c.1424. Fresco,
2.47 × 5.97 m. Capella Brancacci, Sta Maria del Carmine,
Florence
See fig. 1.

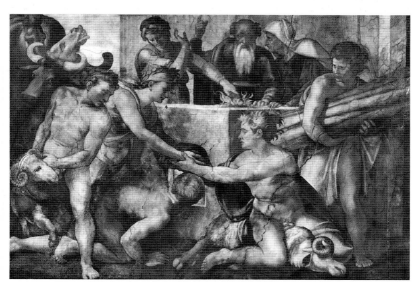

3 Michelangelo, *The Sacrifice of Noah*, 1508–12. Fresco,
1.7 × 2.6 m. Sistine Chapel, Vatican
See fig. 1.

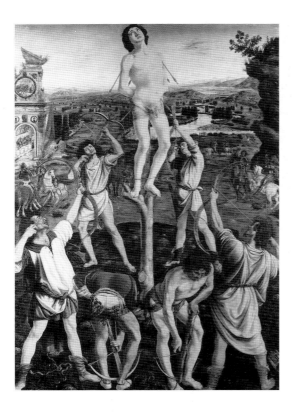

4 Antonio Pollaiuolo, *Martyrdom of St Sebastian*, 1475. Tempera on panel, 2.92 × 2.03 m. National Gallery, London

This image, along with *The Tribute Money* by Masaccio (fig. 2), illustrates Vasari's view that by the second period – the fifteenth century – artists had mastered the problems of depicting nature, but that the result was somewhat dry and stilted. The stage represented by Michelangelo (fig. 3) is therefore beyond the depiction of nature and into the realm of ideal beauty, where the very best elements of nature are distilled in a single figure.

The criterion by which he judged quality was primarily that of truth to nature. This is clear at every point in the text, whether he is considering the art of antiquity or that of the Renaissance, in both of which the drama consists of the heroic conquest of the problems of representation. Here again, as with the question of quality, Vasari's approach is not as straightforward as it might at first seem, as he considers that the products of his third or golden age *transcend* those of nature. He says of Raphael, for instance, that his 'colours were finer than those found in nature', and of Michelangelo that he triumphed 'over nature herself, which has produced nothing, however challenging or extraordinary, that his inspired genius … has not been able to surpass with ease'. What he means by this is evident from his praise and criticism of the immediate forerunners of these masters, fifteenth-century artists such as Verrocchio and Antonio Pollaiuolo, who reached '… the state of complete perfection in which they exactly reproduce the truth of nature', but who maintain '… a dry style which becomes an end in itself … caused by excessive study' (fig. 4). In order to rise above this level one must seek the perfect version of the form 'by copying the most perfect members, hands, head, torso, and legs, to produce the finest possible figure as a model for use in all [the artist's] works'. Forms must therefore rise above naturalism if they are to result in the very best art.

This concept of ideal forms helps to explain Vasari's attitudes towards both architecture and style.

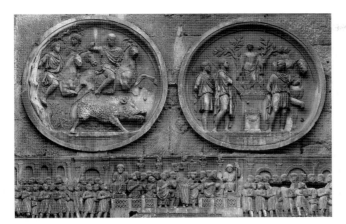

5 Detail of the Arch of Constantine, Rome, 312–15 AD;
roundels reused from the time of Hadrian (117–38 AD);
relief from the time of Constantine (312–37 AD).
Using naturalism as a yardstick of quality, Vasari sees this
arch as indicating the decline of the arts in late antiquity.
He contrasts the naturalistically idealized figures in the
second-century roundels, work comparable with the art
of his own day, with the crudeness of the reliefs made in
the early fourth century, which have doll-like figures in
frontal poses. On the basis of naturalism, Vasari's judge-
ment is unquestionable, but Alois Riegl, for example
(text 9, 1901), argues that the difference in form repre-
sented the different tastes and requirements of a differ-
ent age, without needing to refer to decline.

The use of a naturalistic yardstick as a means of judging quality would seem to exclude architec-
ture from consideration, but Vasari sees no problem and on the contrary gives it pride of place in
almost every discussion. The terms which he uses to describe the painting of, for instance,
Leonardo – 'an understanding of rule, a better knowledge of order, correct proportion, perfect
design, and an inspired grace' – can all be applied without difficulty to buildings, and instead of
being judged for his accuracy in copying nature, the architect can be judged by his skill in using the
works of antiquity as models. There is of course a sleight of hand at work in this second point, as
the very first architects would not have had older buildings to copy, unlike the first painters or
sculptors, for whom nature would always have been available.

Vasari uses the term 'style' with what has become a standard meaning, that is, similarities of treat-
ment which enable objects or artists to be placed into groups. Thus he says, 'I shall endeavour as
far as possible to deal with artists according to schools and styles rather than chronologically.'

He also uses it in a wider and vaguer sense. In this, style is the essence of proper artistic endeavour:
an artist must seek the perfect version of a form by copying the most perfect examples in order to
achieve 'what we know as fine style'. Style is thus a characteristic which art as such has (or at least

art of high quality, which is really synonymous with art). This meaning is consequently not unlike twentieth-century usage as in the claim that someone 'has real style'. He defines objects on a spectrum from poor to excellent, contrasting, for example, the 'crude' sculptures of the fourth century AD on the Arch of Constantine with the 'beautifully fashioned' reliefs of the time of Trajan in the second century re-used on the building (fig. 5). He mentions two other categories of objects which are so lacking in a knowledge of the qualities of art that they barely count as styles at all, the Byzantine 'which was so crude that it suggested the quarry more than the skill of the artist …', and Gothic architecture, which he calls German. They are for him therefore barely worthy of being called styles at all.

It is clear from all of this that while Vasari may not have invented any of them, he combined and clarified a large number of the approaches which have characterized the discipline until well into the twentieth century. They are the concentration on *biography, *patronage and the use of documents, the importance of the individual genius, the centrality of the work of art and hence of the techniques of *connoisseurship, the assessment of *quality, the definition of *style, the identifying of *sources, the criteria of naturalistic representation, *progress and a biological *cyclic model of development internal to the arts. To sum up in his own words, 'I have endeavoured not only to record what the artists have done but also to distinguish between the good, the better, and the best, and to note with some care the methods, manners, styles, behaviour, and ideas of the painters and sculptors … to understand the sources and origins of various styles, and the reasons for the improvement or decline …'

This defining of art-historical method is an impressive enough achievement as it stands, but to it should be added the fact that the artistic reputations which Vasari valued most highly are almost without exception those which have been most respected ever since. From the trio of great masters of the fourteenth, fifteenth and sixteenth centuries, Giotto, Masaccio and Michelangelo respectively, to the trio of Leonardo, Raphael and Michelangelo marking the High Renaissance, his aesthetic judgements have to a very large extent been confirmed by succeeding generations.

In making this observation one must of course acknowledge that the evaluations were not his alone but in many respects those of Italian cultured society of his day. In addition our own assessments may, to a certain extent, be conditioned by Vasari's writings. It is highly likely that the relatively greater prominence achieved by fifteenth- and sixteenth-century Italian painting compared with contemporary painting in the Low Countries is a result of the Italian work having a written pedigree, giving it a narrative cohesion and apparent inevitability lacking in the other school. But it is one thing to acknowledge the power of the written word over the visual image in terms of a general reputation in this way, and quite another to argue that the singling out of particular individuals for greater praise than others will always condition responses across four centuries, without there being qualities in the works themselves which support the judgements.

In other words, however old-fashioned Vasari's work may appear to us to be, he had a sensitive eye, an ability to identify useful categories of analysis, a mastery of anecdote, a persuasive literary style and an honesty about his motives in writing. This combination has earned him the designation 'founder of the history of art' among many art historians and makes him a formidable measure against which to judge later students of the subject.

28

1 Giorgio Vasari

The Lives of the Artists, 1568

Giorgio Vasari, *Le Vite de più eccellenti pittori, scul-
tori ed architetti*, 2nd edn, Venice, 1568. Excerpts
from *The Lives of the Artists*, 2nd edn of 1568,
translated by George Bull, 2 vols.,
Harmondsworth, Penguin Books, 1987, vol. 1,
pp. 25–47, 83–93 and 249–54. Reprinted by per-
mission of Penguin Books Limited; translation ©
George Bull.

I am fully aware that all who have written on the subject firmly and unanimously
assert that the arts of sculpture and painting were first derived from nature by the
people of Egypt. I also realize that there are some who attribute the first rough
pieces in marble and the first reliefs to the Chaldeans, just as they give the Greeks
credit for discovering the brush and the use of colours. Design, however, is the
foundation of both these arts, or rather the animating principle of all creative
processes: and surely design existed in absolute perfection before the Creation
when Almighty God, having made the vast expanse of the universe and adorned
the heavens with His shining lights, directed His creative intellect further, to the
clear air and the solid earth. And then, in the act of creating man, He fashioned the
first forms of painting and sculpture in the sublime grace of created things. It is
undeniable that from man, as from a perfect model, statues and pieces of sculpture
and the challenges of pose and contour were first derived; and for the first paint-
ings, whatever they may have been, the ideas of softness and of unity and the clash-
ing harmony made by light and shadow were derived from the same source …

Let us accept that the arts started to be practised at a late period in Roman
history, if, as is reported, the first figures were the images of Ceres made of metal
taken from the belongings of Spurius Cassius who, because he plotted to make
himself king, was killed without any compunction by his own father. I am sure
that although the arts of sculpture and painting continued to be practised until the
death of the last of the twelve Caesars, their earlier perfection and excellence were
not sustained. We can see from the buildings constructed by the Romans that, as
emperor succeeded emperor, the arts continually declined until gradually they
lost all perfection of design.

There is clear evidence for this in the works of sculpture and architecture pro-
duced in Rome at the time of Constantine, and notably in the triumphal arch
which the Roman people built for him at the Colosseum. This shows how, for
lack of good instructors, they made use not only of marble histories made at the
time of Trajan but also of spoils which had been brought from various parts of the
world [fig. 5]. One can see that the *ex voto* in the medallions, namely, the sculp-

tures in half-relief, and likewise the captives and the great histories and the columns and cornices and other ornaments (which were all either earlier works or else spoils) are beautifully fashioned. On the other hand, one can see that the works made to fill in the gaps, for which contemporary sculptors were solely responsible, are a complete botch, as also are some little histories under the medallions composed of small marble figures, and the pediment, where there are one or two victories. Between the side arches there are some river-gods which are also very crude; indeed, they are so badly made that it is obvious that the art of sculpture had started to decline before that time. Nevertheless, this was before the coming of the Goths and the other barbarian invaders who destroyed the fine arts of Italy, along with Italy itself.

In fact, architecture was not in such a sorry state as the other arts of design. For example, the Baptistery built by Constantine at the entrance to the principal portico of the Lateran (even disregarding the porphyry and marble columns, and double bases, which are beautifully executed and were brought from elsewhere) is as a whole an excellently thought out composition. On the other hand, there is no comparison between the stucco, the mosaic, and some incrustations on the walls, which were all the work of contemporary artists, and the ornaments, which were mostly taken from heathen temples and used by Constantine for the Baptistery. It is said that Constantine proceeded in the same way when he built the temple in the garden of Aequitius, which he later endowed and handed over to the Christian priests. There is further evidence for what I am saying in the magnificent church of San Giovanni in Laterano, which was also built by Constantine. For the sculptures in this church are clearly decadent: the silver statues of the Saviour and the Twelve Apostles, which were made for Constantine, were very inferior works, crudely executed and poorly designed. As well as this, anyone who studies with care the medals and effigies of Constantine and other statues made by sculptors of that period, which are now in the Capitol, can see clearly that they are a long way from the perfection of the medals and statues of the other emperors. All this demonstrates that, a long time before the invasion of Italy by the Goths, the decline of sculpture was well under way.

Architecture, as we said, even if not as perfect as it had been, at least maintained higher standards than sculpture. Not that this is anything to wonder at, because the architects constructed their big buildings almost entirely from spoils and it was a simple matter for them to imitate old edifices which were still standing, when they were building afresh. It was far easier for them to do this than for sculptors who were unskilled to imitate the good statues of the ancient world. The truth of this is demonstrated by the church of the Prince of the Apostles on the Vatican hill, which owed its beauty to columns, bases, capitals, architraves, cornices, doors, and other adornments and incrustations all brought from various parts and taken from magnificent buildings which had been constructed in former times. The same can be said of the church of Santa Croce in Gerusalemme, which Constantine built at the entreaty of his mother, Helen; of San Lorenzo Fuori Le Mura; and of Sant'Agnese, also built by Constantine, at the request of his daughter, Constance. And it is well known that the font at which Constance and one of her sisters were baptized was ornamented with sculptures made a long time

before, notably the porphyry pillar carved with beautiful figures, some marble candelabra exquisitely carved with foliage, and some *putti* in low relief, which are wonderfully beautiful.

To sum up, it is clear that for these and various other reasons by the time of Constantine sculpture had already fallen into decline, together with the other fine arts. And if anything were needed to complete their ruin it was provided decisively when Constantine left Rome to establish the capital of the Empire at Byzantium. For he took with him to Greece not only all the finest sculptors and other artists, such as they were at that time, but also countless statues and other extremely beautiful works of sculpture.

After Constantine had departed, the Caesars whom he left in Italy continually commissioned new buildings, both in Rome and elsewhere. They endeavoured to have the work done as well as possible; but we can see that sculpture and painting and architecture went inexorably from bad to worse. And the most convincing explanation for this is that once human affairs start to deteriorate improvement is impossible until the nadir has been reached …

However, after fortune has carried men to the top of her wheel, she usually, for sport or from regret for what she has done, spins the wheel right round again. Just so, after the events we have described almost all the barbarian nations rose up against the Romans in various parts of the world, and this within a short time led not only to the humbling of their great empire but also to worldwide destruction, notably at Rome itself. This destruction struck equally and decisively at the greatest artists, sculptors, painters, and architects: they and their work were left buried and submerged among the sorry ruins and debris of that renowned city. Painting and sculpture were the first of the arts to fall on evil days, since they existed chiefly to give pleasure. Architecture, being necessary for sheer physical existence, lingered on, but without its former qualities or perfection. Statues and pictures intended to immortalize those in whose honour they had been done could still be seen by succeeding generations; had it not been so, the memory of both sculpture and painting would soon have been destroyed. Some men were commemorated by effigies and inscriptions placed not only on tombs but also on private and public buildings such as amphitheatres and theatres, baths, aqueducts, temples, obelisks and colossi, pyramids, arches, and treasuries. But a great many of these were destroyed by savage and barbarian invaders, who indeed were human only in name and appearance.

Among them were the Visigoths who, under Alaric, assailed Italy and Rome and twice sacked the city mercilessly. The Vandals, coming from Africa under King Genseric, followed their example; and then, content neither with the cruelties he inflicted nor with the booty and plunder he seized, Genseric made slaves of the people of Rome, plunging them into terrible misery. He also enslaved Eudoxia, wife of the Emperor Valentinian who had been murdered a little while previously by his own soldiers. These men had mostly forgotten the ancient valour of the Romans; a long time before, all the best troops had left with Constantine for Byzantium and those who remained were dissolute and corrupt. At one and the same time every true soldier and every kind of military virtue were lost. Laws, customs, names, and language were all changed. All these events brutalized and debased men of fine character and high intelligence.

But what inflicted incomparably greater damage and loss on the arts than the things we have mentioned was the fervent enthusiasm of the new Christian religion. After long and bloody combat, Christianity, aided by a host of miracles and the burning sincerity of its adherents, defeated and wiped out the old faith of the pagans. Then with great fervour and diligence it strove to cast out and utterly destroy every least possible occasion of sin; and in doing so it ruined or demolished all the marvellous statues, besides the other sculptures, the pictures, mosaics and ornaments representing the false pagan gods; and as well as this it destroyed countless memorials and inscriptions left in honour of illustrious persons who had been commemorated by the genius of the ancient world in statues and other public adornments. Moreover, in order to construct churches for their own services the Christians destroyed the sacred temples of the pagan idols. To embellish and heighten the original magnificence of St Peter's they despoiled of its stone columns the mausoleum of Hadrian (today called Castel Sant'Angelo) and they treated in the same way many buildings whose ruins still exist. These things were done by the Christians not out of hatred for the arts but in order to humiliate and overthrow the pagan gods. Nevertheless, their tremendous zeal was responsible for inflicting severe damage on the practice of the arts, which then fell into total confusion ...

Architecture met the same fate as sculpture. Men still had to build, but all sense of form and good style had been lost by the death of good artists and the destruction and decay of their work. Consequently those who practised architecture produced buildings which were totally lacking in grace, design, and judgement as far as style and proportion were concerned. And then new architects came along who built for the barbarians of that time in the kind of style which we nowadays know as German; they put up various buildings which amuse us moderns far more than they could have pleased the people of those days ...

During the period we are discussing good paintings and sculptures remained buried under the ruins in Italy, unknown to the men of that time who were engrossed in contemporary rubbish. For their works they used only the sculptures or paintings produced by a few remaining Byzantine craftsmen, either clay or stone figures or pictures of grotesque figures with only the rough outlines drawn in colour. These Byzantine artists, being the best there were and in fact the only surviving representatives of their profession, were brought to Italy where they introduced their manner of sculpture and painting along with mosaic. Thus, the Italians learned how to copy their clumsy, awkward style and for a certain time continued to employ it, as I shall describe later.

The men of that time had no experience of anything better than those imperfect productions, which were regarded as great works of art, villainous though they were. And yet, helped by some subtle influence in the very air of Italy, the new generations started to purge their minds of the grossness of the past so successfully that in 1250 heaven took pity on the talented men who were being born in Tuscany and led them back to the pristine forms. Before then, during the years after Rome was sacked and devastated and swept by fire, men had been able to see the remains of arches and colossi, statues, pillars, and carved columns; but until the period we are discussing they had no idea how to use or profit from this fine work. However, the artists who came later, being perfectly able to distinguish

between what was good and what was bad, abandoned the old way of doing things and started once again to imitate the works of antiquity as skilfully and carefully as they could.

I want to give a simple definition of what I call old and what I call ancient. Ancient works of art or antiques are those which were produced in Corinth, Athens, Rome, and other famous cities, before the time of Constantine up to the time of Nero, Vespasian, Trajan, Hadrian and Antoninus. Old works of art are those which were produced from the time of St Silvester by a few surviving Greek artists, who were dyers rather than painters. As we described earlier, the great artists of earlier times died out during the years of war, and the few Greeks who survived, belonging to the old not the ancient world, could only trace out-lines on a ground of colour. We have daily evidence in the countless mosaics done by the Greeks which can be seen in every old church in all and every city in Italy, notably in the cathedral of Pisa and St Mark's at Venice. Over and over again they produced figures in the same style, staring as if possessed, with outstretched hands, on the tips of their toes, as can still be seen in San Miniato outside Florence, between the doors of the sacristy and the convent, and in Santo Spirito in the same city, all along the cloister leading to the church, and similarly in Arezzo, in San Giuliano and San Bartolommeo and in other churches, and in old St Peter's at Rome, in the scenes all round the windows; the way they are drawn, they all resemble grotesques rather than what they are meant to represent.

The Greeks also produced countless pieces of sculpture, examples of which we can still see in low relief above the door of San Michele, in the Piazza Padella at Florence, and in Ognissanti, and in many other places. Among examples to be seen on tombs and on the doors of churches are figures, acting as corbels to support the roof, which are so clumsy and ugly and made in so gross a style that it is impossible to imagine anything worse.

So far I have been talking about the origins of sculpture and painting, perhaps at greater length than was called for at this stage. However, the reason for my doing so has been not so much my great love of the arts as the hope that I would say something useful and helpful to our own artists. For from the smallest beginnings art attained the greatest heights, only to decline from its noble position to the most degraded status. Seeing this, artists can also realize the nature of the arts we have been discussing: these, like the other arts and like human beings themselves, are born, grow up, become old, and die. And they will be able to understand more readily the process by which art has been reborn and reached perfection in our own times. And if, which God forbid, because of indifference or evil circum-stances or the ruling of Providence (which always seems to dislike the things of this world proceeding undisturbed) it ever happens at any time that the arts once again fall into the same disastrous decline, then I hope that this work of mine, such as it is, if it proves worthy of a happier fate may, because of what I have already said and what I am going to write, keep the arts alive, or at least may inspire some of the more able among us to give them every possible encouragement. In this way, my good intentions and the work of outstanding men will, I hope, provide the arts with support and adornment of a kind which, if I may be allowed to say this outright, they have been lacking hitherto.

But now it is time to come to the life of Cimabue who, since he originated the new way of drawing and painting, should rightly and properly be the first to be described in my *Lives*, in which I shall endeavour as far as possible to deal with artists according to schools and styles rather than chronologically. I shall not spend much time in describing what artists looked like because their portraits, which I have myself collected diligently with no little expenditure of time and money, are far more revealing as to their appearance than any written description could ever be. If any portrait is missing, this is not my fault but simply because it was impossible to find it anywhere. And if any of the portraits happens to appear dissimilar to others that may have been found, I should remind the reader that a portrait made of someone when he was, say, eighteen or twenty, would never resemble one made fifteen or twenty years later. As well as this, remember that you never get as good a likeness with a black-and-white reproduction as with a painting; and apart from that, engravers, who have little sense of design, always rob the image of something, because of their lack of knowledge and ability regarding those small details which make a good portrait, and their failure to capture the perfection which woodcuts rarely if ever achieve. The reader will appreciate the exertions, the expense, and the care that have gone into this work when he sees that I have as far as possible used only the best originals.

PREFACE TO PART TWO

When I first undertook these *Lives* I did not intend to compile a list of artists with, say, an inventory of their works; and I was far from thinking it a worthwhile objective for my work (which, if not distinguished, has certainly proved long and exhausting) to give details of their numbers and names and places of birth and describe in what city or exact spot their pictures or sculptures or buildings might be found. I could have done this simply by providing a straight-forward list, without offering any opinions of my own. But I have remarked that those historians who are generally agreed to have produced the soundest work have not been satisfied just to give a bald narration of the facts but have also, with great diligence and the utmost curiosity, investigated the ways and means and methods used by successful men in forwarding their enterprises; they have tried to point out their mistakes, as well as the fine strokes, the expedients, and the prudent courses of action they sometimes followed in the management of their affairs. In short, the best historians have tried to show how men have acted wisely or foolishly, with prudence or with compassion and magnanimity; recognizing that history is the true mirror of life, they have not simply given a dry, factual account of what happened to this prince or that republic but have explained the opinions, counsels, decisions, and plans that lead men to successful or unsuccessful action. This is the true spirit of history, which fulfils its real purpose in making men prudent and showing them how to live, apart from the pleasure it brings in presenting past events as if they were in the present. For this reason, having set out to write the history of distinguished artists in order to honour them and to benefit the arts to the best of my ability, I have tried as far as I could to imitate the methods of the

great historians. I have endeavoured not only to record what the artists have done but also to distinguish between the good, the better, and the best, and to note with some care the methods, manners, styles, behaviour, and ideas of the painters and sculptors; I have tried as well as I know how to help people who cannot find out for themselves to understand the sources and origins of various styles, and the reasons for the improvement or decline of the arts at various times and among different people.

At the beginning of the *Lives* I said as much as was necessary about the noble origins and antiquity of the arts; I left out many things from Pliny and other authors which I could have used had I not wanted, perhaps in a controversial way, to leave everyone free to discover other people's ideas for himself in the original sources. It now seems the right place for me to do what I could not do before (if I wanted to avoid writing tediously and at a length fatal to attention) and give a clearer idea of my purpose and intention, explaining my reasons for dividing the contents of these *Lives* into three parts.

It is certainly true that some men become great artists by diligent application and others by study; some by imitation, some by knowledge of the sciences (which are all useful aids to art), and some by combining all or most of these things. However, in my biographies I have spent enough time discussing methods, skills, particular styles, and the reasons for good, superior, or pre-eminent workmanship; so here I shall discuss the matter in general terms, paying more attention to the nature of the times than to the individual artists. In order not to go into too much detail, I have divided the artists into three sections or, shall we say, periods, each with its own recognizably distinct character, running from the time of the rebirth of the arts up to our own times.

In the first and oldest period the three arts evidently fell a long way short of perfection and, although they may have shown some good qualities, were accompanied by so much that was imperfect that they certainly do not deserve a great deal of praise. All the same, they did mark a new beginning, opening the way for the better work which followed; and if only for this reason I have to speak in their favour and to allow them rather more distinction than the work of that time would deserve if judged by the strict rules of art.

Then in the second period there was clearly a considerable improvement in invention and execution, with more design, better style, and a more careful finish; and as a result artists cleaned away the rust of the old style, along with the stiffness and disproportion characteristic of the ineptitude of the first period. Even so, how can one claim that in the second period there was one artist perfect in everything, producing works comparable in invention, design, and colouring to those of today? Who at that time rendered his figures with the shadows softly darkened in, so that the lights remain only on the parts in relief, and who achieved the perforations and various superb finishings seen in the marble statues executed today?

These achievements certainly belong to the third period, when I can say confidently that art has achieved everything possible in the imitation of nature and has progressed so far that it has more reason to fear slipping back than to expect ever to make further advances.

Having very carefully turned all this over in my mind, I have come to the conclusion that it is inherent in the very nature of these arts to progress step by step from modest beginnings, and finally to reach the summit of perfection. And I believe this is so from having seen almost the same progression in other branches of learning; the fact that the liberal arts are all related to each other in some way is a persuasive argument for what I am saying. As for painting and sculpture in former times, they must have developed on such similar lines that the history of one could stand for the history of the other with only a change in their names. We have to trust the word of those who lived soon afterwards and could see and judge the work of the ancient world; and from these we learn that the statues of Canacus were very hard and lifeless, with absolutely no sense of movement, and therefore far from giving a true representation; and the same is said of the statues made by Calamides, though these did possess rather more charm. Then there came Myron who, even if he did not altogether reproduce the truth that we find in nature, nevertheless gave to his works such grace and proportion that they could justifiably be called very beautiful. In the third stage flourished Polyclitus as well as other famous sculptors who, it is credibly reported, produced works that were absolutely perfect. The same progression must have occurred in the art of painting, for it has been said (and surely correctly) that the work of those who used only one colour, the monochromatists, fell a long way short of perfection. Then the works of Zeuxis, Polygnotus, Timanthes, and others, who used only four colours, were enthusiastically praised as linear compositions, though of course still leaving something to be desired. And then we come to Erione, Nicomachus, Protogenes, and Apelles, who produced beautiful work which was perfect in every detail and could not possibly have been improved on; for these artists not only painted superb forms and gestures but also depicted the emotions and passions of the spirit.

However, I shall say no more about them since (though I have gone to the best authors for my remarks) we do have to rely on the opinions of others, whose evaluations and, still more, whose dates sometimes conflict. Let us look at our own times, where we can rely on the guidance and verdict of our own eyes, which is far better than going by hearsay.

Is it not clear, to take one of the arts, that architecture advanced and improved considerably during the period from Buschetto the Greek to the German Arnolfo and Giotto? The buildings of that time show this in their pilasters, columns, bases, capitals, and all the cornices with their deformed members. Examples are provided by Santa Maria del Fiore in Florence, the incrustation of the exterior of San Giovanni, San Miniato sul Monte, in the bishop's palace at Fiesole, the cathedral at Milan, San Vitale in Ravenna, Santa Maria Maggiore in Rome, and the old Duomo outside Arezzo. Except for the fine workmanship of some antique fragments, there are no signs of good style or execution. Arnolfo and Giotto, all the same, certainly improved matters, and under them the art of architecture made reasonable progress. They improved the proportions of their buildings, making them not only stable and strong but also in some measure ornate. To be sure, their ornamentation was muddled and imperfect and, if I may say so, far from ornamental. This was because in their columns they failed to observe the correct measure-

ments and proportions, nor did they distinguish the orders: instead of being distinctively Doric, Corinthian, Ionic, or Tuscan they were all confused and based on some anarchic and improvised rule. They made them extremely thick or extremely slender, just as they thought best. All the designs they invented were copied from antique remains or sprang from their own imaginations. Thus the building plans of that time showed the influence of sound architecture as well as contemporary improvisation, with the result that when the walls were raised the results were very different from the models. Nevertheless, whoever compares the work of that time with what was done previously will see that it was better in every way, even though there were some things that we find displeasing nowadays, such as the little brick churches, covered with stucco, at St John Lateran in Rome.

The same holds true for sculpture. In the first period of its rebirth some very good work was done, for the sculptors had abandoned the stiff Byzantine style which was so crude that it suggested more the quarry than the skill of the artist, and which produced statues, if they can be called that, completely devoid of folds, movement, or pose. After Giotto had improved the quality of design several artists did good work in marble and stone; among them were Andrea Pisano, his son Nino, and other pupils of his, all of whom were far more skilful than their predecessors. Their statues were more plastic and better posed; as we see, for example, in the work of the two Sienese, Agostino and Agnolo, who as I said made the tomb for Guido, bishop of Arezzo, and the Germans who made the façade of Orvieto.

So at that time sculpture made definite progress: the figures were better formed, their folds and draperies flowed more beautifully, their heads were sometimes better posed, and their attitudes less rigid; in short, the sculptors were on the right path. But just as clearly there were innumerable defects, because at that time design still fell a long way short of perfection and there were only too few good works to imitate. Consequently, the artists whom I have placed in the first period deserve to be praised and valued for what they did, if one considers that, like the architects and painters of the day, they had no help from their predecessors and had to find the way forward by themselves; and any beginning, however modest, always deserves more than a little praise ...

Now if the reader reflects on what I have been saying he will realize that up to this point the three arts remained, as it were, very rough and ready and still fell short of the perfection they deserved; indeed, if the story ended here the progress so far recorded would not amount to much and would have been of no great value. I do not want anyone to think me so stupid and lacking in judgement as to ignore the fact that if we compare the work of Giotto, Andrea Pisano, Nino, and all the others whom I have grouped in the first period (because of their similarities in style) with what was done later, the former do not deserve even modest, let alone unqualified, praise. And of course I was well aware of this when I praised them. All the same, if one considers when it was that they lived, the few of them that there were, and the difficulty of obtaining good assistance, one is forced to conclude not that their work was, as I said, excellent but rather that it was downright miraculous. It is surely gratifying in the extreme to discern the first beginnings, the first glimmerings of excellence, as they appeared in painting and sculpture. The victory which Lucius Marcius won in Spain was not so great that

37

the Romans could boast of none greater! But in view of the timing, the place, and the circumstances, and the nature and numbers of those involved, it was considered a stupendous achievement, and even today it is still held to deserve all the praises the historians have lavished on it.

So considering all these things I have decided that the artists in the first period deserve not only a careful record of what they did but also all the warm and enthusiastic praise I have bestowed on them. I do not think that my fellow artists will have found it boring to hear the story of their lives and study their styles and methods, and perhaps they will derive no little benefit from this. This would certainly bring me great pleasure, and I would consider it a wonderful reward for my work, in which my only aim has been to serve and entertain them to the best of my ability.

Now that we have, as it were, taken the three arts away from the arms of their nurse and seen them through their childhood we come to the second period, in the course of which there is a tremendous, overall advance. We shall see compositions being designed with a greater number of figures and richer ornamentation, and design becoming more firmly grounded and more realistic and lifelike. Above all we shall see that even in works of no great quality there is careful organization and purpose: the style is lighter, colours are more charming, and the arts are approaching the state of complete perfection in which they exactly reproduce the truth of nature ...

During this period painting progressed in the same way as sculpture. The superb Masaccio completely freed himself of Giotto's style and adopted a new manner for his heads, his draperies, buildings, and nudes, his colours and foreshortenings. He thus brought into existence the modern style which, beginning during his period, has been employed by all our artists until the present day, enriched and embellished from time to time by new inventions, adornments, and grace. Examples of this will be given in the individual biographies which will reveal the appearance of a new style of colouring and foreshortening, of attitudes that are true to life, a far more accurate interpretation of emotions and physical gestures, and the constant endeavour to reproduce nature more realistically, with facial expressions so beautifully true to life that the men portrayed appear before us just as they were seen by the painter himself.

In this way the artists tried to reproduce neither more nor less than what they saw in nature, and as a result their work began to show more careful observation and understanding. This encouraged them to lay down definite rules for perspective and to make their foreshortenings in the exact form of natural relief, proceeding to the observation of light and shade, shadows, and other problems. They endeavoured to compose their pictures with greater regard for real appearances, attempting to make their landscapes more realistic, along with the trees, the grass, the flowers, the air, the clouds, and the other phenomena of nature. They did this so successfully that the arts were brought to the flower of their youth, holding out the promise that in the near future they would enter the golden age.

And now with God's help I shall start writing the life of Jacopo della Quercia of Siena, and then the lives of the other architects and sculptors until we come to Masaccio, the first of the painters to improve design, when we shall see how

38

greatly he was responsible for the rebirth of painting. I have chosen Jacopo as a worthy beginning for the second part of the *Lives* and I shall group the artists who follow by style, showing in each life-story the problems presented by the beautiful, challenging, and noble arts of design.

PREFACE TO PART THREE

The distinguished artists described in the second part of these *Lives* made an important contribution to architecture, sculpture, and painting, adding to what had been achieved by those of the first period the qualities of good rule, order, proportion, design, and style. Their work was in many ways imperfect, but they showed the way to the artists of the third period (whom I am now going to discuss) and made it possible for them, by following and improving on their example, to reach the perfection evident in the finest and most celebrated modern works.

But to clarify the nature of the progress that these artists made, I would like to define briefly the five qualities that I mentioned above and discuss the origins of the excellence that has made modern art even more glorious than that of the ancient world.

By rule in architecture we mean the method used of measuring antiques and basing modern works on the plans of ancient buildings. Order is the distinction made between one kind of architectural style and another, so that each has the parts appropriate to it and there is no confusion between Doric, Ionic, Corinthian, and Tuscan. Proportion is a universal law of architecture and sculpture (and also of painting) which stipulates that all bodies must be correctly aligned, with their parts properly arranged. Design is the imitation of the most beautiful things in nature, used for the creation of all figures whether in sculpture or painting; and this quality depends on the ability of the artist's hand and mind to reproduce what he sees with his eyes accurately and correctly on to paper or a panel or whatever flat surface he may be using. The same applies to works of relief in sculpture. And then the artist achieves the highest perfection of style by copying the most beautiful things in nature and combining the most perfect members, hands, head, torso, and legs, to produce the finest possible figure as a model for use in all his works; this is how he achieves what we know as fine style.

Now the work of Giotto and the other early craftsmen did not possess these qualities, although they did discover the right principles for solving artistic problems and they applied them as best they could. Their drawing, for example, was more correct and truer to nature than anything done before, as was the way they blended their colours, composed their figures, and made the other advances I have already discussed. However, although the artists of the second period made further progress still, they in turn fell short of complete perfection, since their work lacked that spontaneity which, although based on correct measurement, goes beyond it without conflicting with order and stylistic purity. This spontaneity enables the artist to enhance his work by adding innumerable inventive details

39

and, as it were, a pervasive beauty to what is merely artistically correct. Again, when it came to proportion the early craftsmen lacked that visual judgement which, disregarding measurement, gives the artist's figures, in due relation to their dimensions, a grace that simply cannot be measured. They also failed to realize the full potentialities of design; for example, although their arms were rounded and their legs straight, they missed the finer points when they depicted the muscles, ignoring the charming and graceful facility which is suggested rather than revealed in living subjects. In this respect their figures appeared crude and excoriated, offensive to the eye and harsh in style. Their style lacked the lightness of touch that makes an artist's figures slender and graceful, and particularly those of his women and children, which should be as realistic as the male figures and yet possess a roundness and fullness derived from good judgement and design rather than the coarseness of living bodies. Their works also lacked the abundance of beautiful clothes, the imaginative details, charming colours, many kinds of building and various landscapes in depth that we see depicted today. Certainly many of those artists, such as Andrea Verrocchio, Antonio Pollaiuolo, and others who followed, endeavoured to refine their figures, to improve the composition of their works, and to make them conform more closely to nature. None the less, they fell short of perfection, although indubitably they were going in the right direction, and what they produced certainly invited comparison with the works of the ancient world. This was evident, for instance, when Verrocchio restored the legs and arms of the marble Marsyas for the Casa Medici in Florence, although even so his work lacked polish, and absolute perfection escaped him in the feet, hands, hair, and beard. All the same what he did was consistent with the original and was correctly proportioned. If those craftsmen had mastered the detailed refinements which constitute the greatest achievement of art they would have created strong and robust work, with the delicacy, polish, and superb grace essential to the finest painting and sculpture. However, for all their diligence, their figures lacked these qualities. Indeed, it is not surprising that they never achieved these elusive refinements, seeing that excessive study or diligence tends to produce a dry style when it becomes an end in itself.

Success came to the artists who followed, after they had seen some of the finest works of art mentioned by Pliny dug out of the earth: namely, the Laocoön, the Hercules, the great torso of Belvedere, as well as the Venus, the Cleopatra, the Apollo, and countless others, all possessing the appeal and vigour of living flesh and derived from the finest features of living models. Their attitudes were entirely natural and free, exquisitely graceful and full of movement. And these statues caused the disappearance of the dry, hard, harsh style that art had acquired through the excessive study of Piero della Francesca, Lazzaro Vasari, Alesso Baldovinetti, Andrea del Castagno, Pesello, Ercole Ferrarese, Giovanni Bellini, Cosimo Rosselli, the abbot of San Clemente, Domenico Ghirlandaio, Sandro Botticelli, Andrea Mantegna, Filippino Lippi, and Luca Signorelli. These artists forced themselves to try and do the impossible through their exertions, especially in their ugly foreshortenings and perspectives which were as disagreeable to look at as they were difficult to do. Although the greater part of their work was well designed and free from error, it still lacked any sense of liveliness as well as the

harmonious blending of colours which was first seen in the works of Francia of Bologna and Piero Perugino (and which made the people run like mad to gaze on this new, realistic beauty, as if they would never see the like again).

But how wrong they were was then demonstrated for all to see in the work of Leonardo da Vinci. It was Leonardo who originated the third style or period, which we like to call the modern age; for in addition to the force and robustness of his draughtsmanship and his subtle and exact reproduction of every detail in nature, he showed in his works an understanding of rule, a better knowledge of order, correct proportion, perfect design, and an inspired grace. An artist of great vision and skill and abundant resources, Leonardo may be said to have painted figures that moved and breathed. Somewhat later followed Giorgione of Castel Franco, whose pictures convey a gradual blending of tones and a tremendous impression of movement achieved through the finely handled use of shadow. In no way inferior to his in strength, relief, charm, and grace were the paintings of Fra Bartolommeo of San Marco. But the most graceful of all was Raphael of Urbino, who studied what had been achieved by both the ancient and the modern masters, selected the best qualities from all their works, and by this means so enhanced the art of painting that it equalled the faultless perfection of the figures painted in the ancient world by Apelles and Zeuxis, and might even be said to surpass them were it possible to compare his work with theirs. His colours were finer than those found in nature, and his invention was original and unforced, as anyone can realize by looking at his scenes, which have the narrative flow of a written story. They bring before our eyes sites and buildings, the ways and customs of our own or of foreign peoples, just as Raphael wished to show them. In addition to the graceful qualities of the heads shown in his paintings, whether old or young, men or women, his figures expressed perfectly the character of those they represented, the modest or the bold being shown just as they are. The children in his pictures were depicted now with mischief in their eyes, now in playful attitudes. And his draperies are neither too simple nor too involved but appear wholly realistic.

Raphael's style influenced Andrea del Sarto; and although Andrea's work was less robust and his colours softer, it was remarkably free from error. Similarly, it is almost impossible to describe the charming vivacity of the paintings executed by Antonio Correggio: this artist painted hair, for example, in an altogether new way, for whereas in the works of previous artists it was depicted in a laboured, hard, and dry manner, in his it appears soft and downy, with each golden strand finely distinguished and coloured, so that the result is more beautiful than in real life. Similar effects were achieved by Francesco Mazzola of Parma (Parmigianino), who in several respects – as regards grace and ornamentation, and fine style – even surpassed Correggio, as is shown by many of his pictures, in which the effortless facility of his brush enabled him to depict smiling faces and eloquent eyes, and in which the very pulses seem to beat. And then anyone who examines the wall-paintings done by Polidoro and Maturino will discover figures that are incredibly expressive and will be astonished at how they were able to describe not in speech, which is easy enough, but with the brush scenes that demonstrate tremendous powers of invention, skill, and ingenuity, showing the deeds of the Romans as

they occurred in life. There are countless other artists, now dead, whose colours brought to life the figures they painted: Rosso, Sebastiano, Giulio Romano, Perino del Vaga, not to speak of the many outstanding artists still living. What matters is that these artists have brought their art to such fluent perfection that nowadays a painter who understands design, invention, and colouring can execute six paintings in a year, whereas the earliest artists took six years to finish one painting. I can vouch for this, both from observation and personal experience: and I would add that many works today are more perfect and better finished than were those of the great masters of the past.

But the man whose work transcends and eclipses that of every other artist, living or dead, is the inspired Michelangelo Buonarroti, who is supreme not in one art alone but in all three. He surpasses not only all those whose work can be said to be superior to nature but also the artists of the ancient world, whose superiority is beyond doubt. Michelangelo has triumphed over later artists, over the artists of the ancient world, over nature itself, which has produced nothing, however challenging or extraordinary, that his inspired genius, with its great powers of application, design, artistry, judgement, and grace, has not been able to surpass with ease. He has shown his genius not only in painting and colouring (in which are expressed all possible forms and bodies, straight and curved, tangible and intangible, accessible and inaccessible) but also in the creation of sculptural works in full relief. And his fruitful and inspiring labours have already spread their branches so wide that the world has been filled with an abundance of delectable fruits, and the three fine arts have been brought to a state of complete perfection. He has so enhanced the art of sculpture that we can say without fear of contradiction that his statues are in every aspect far superior to those of the ancient world. For if their work were put side by side, the heads, hands, arms, and feet carved by Michelangelo being compared with those made by the ancients, his would be seen to be fashioned on sounder principles and executed with more grace and perfection: the effortless intensity of his graceful style defies comparison. And the same holds true of Michelangelo's pictures: if it were possible to place them beside the paintings of those celebrated Greeks and Romans they would be even more highly valued and regarded as being as much superior to the antiques as is his sculpture.

We rightly admire the celebrated artists of the past who created great work, knowing their prize would be a happy life and a generous reward. How much more, then, should we praise and exalt those rare men of genius who create priceless work and who live not merely unrewarded but in circumstances of wretched poverty! It is undeniably true that if the artists of our own time were justly rewarded they would produce even greater works of art, far superior to those of the ancient world. Instead, the artist today struggles to ward off famine rather than to win fame, and this crushes and buries his talent and obscures his name. This is a shame and disgrace to those who could come to his help but refuse to do so.

But that is enough on this subject, for it is time to return to the *Lives* and give separate accounts of all those who have done distinguished work in the third period. The first of these, with whom I shall now start, was Leonardo da Vinci.

Karel van Mander

The Painter's Book, 1604

Karel van Mander (1548–1606) has with justification been called the Dutch Vasari, because he was a painter, he founded an academy and his reputation has depended to a large extent on the book which he wrote on artists' lives. *Het Schilderboek, The Painter's Book,* written in Haarlem between 1583 and 1604, consists of three main parts: a didactic poem of practical instruction on the noble art of painting, biographies of artists and a pair of treatises on the writings of Ovid relevant to artists. The central part, the biographies, is itself divided into three sections, dealing respectively with the painters of antiquity, the Italy of his day, and his own region of the Low Countries and Northern Germany. Each section has an introduction and that to the Northern painters, together with excerpts from some of the 175 lives, is reprinted here. Despite, or perhaps because of, its great bulk (over 437 folios) the book deals only with painters. It is therefore both more ambitious than Vasari's *Lives* in setting the biographies in the context of a theory of art, and more restricted in excluding sculptors and architects.[1]

Van Mander's experience differed from that of Vasari in two ways in particular. First, living and working as he did in the southern part of the Low Countries, chiefly in Ghent, Courtrai, Bruges and finally Haarlem, he experienced at first hand the disruption of the wars concerning Spanish control of that part of the Holy Roman Empire. Secondly, while Vasari used the arts of antiquity to measure the achievements of his own culture, Van Mander used as a comparison the Italy of his own day, which he knew from his sojourn in Rome from 1573 to 1577, and which presented a very different and more immediate and demanding kind of alternative experience.

Van Mander used Vasari as a model in almost every aspect of his work. Given the success of Vasari's *Lives* this was probably inevitable, but it also had a highly distorting effect on the resulting account. One of the reasons which can be advanced for the success of Vasari's book is the match which he achieved between the nature of the material and his wish to give Italian art pride of place in the history of Western culture. Northern art and its history since the late fourteenth century offer a completely different picture from Italian art. Its character has nothing to do with the art of antiquity, neither in the sense of continuing a surviving tradition nor in terms of a conscious revival. It showed none of the characteristics of what might be seen as an internal development from an early to a mature phase, discernible between the fifteenth and sixteenth centuries in Italy, and it lacked the close contact and interaction with literature which was

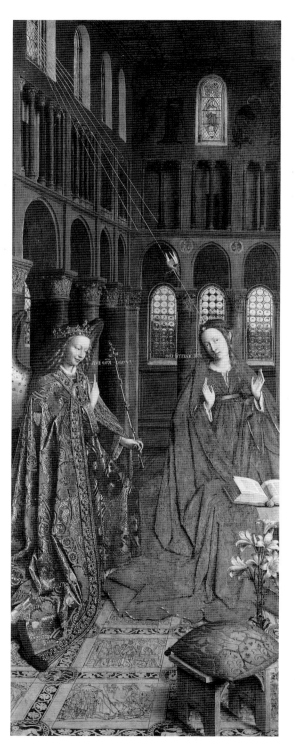

6 Jan van Eyck, *The Annunciation*, c.1425–30. Oil on canvas, transferred from wood, 93 × 37 cm. National Gallery, Washington DC

For Van Mander, Van Eyck's painting represents an achievement in the conquest of naturalism entirely comparable with the work of Masaccio and Pollaiuolo (figs. 2 and 4) who, for Vasari, represent the second stage in Italy. Later scholars such as Wölfflin (text 10, 1915) and Huizinga saw the paintings of Van Eyck and his contemporaries as part of the end of the Middle Ages, which is the very opposite of the role assumed for them by Van Mander.

characteristic of much Italian art. Van Mander was therefore at every turn clearly attempting to fit his material into an unsympathetic format, and while he was aware of the difficulties he did not always succeed in disguising or accommodating them.

The chief parallels between his work and that of Vasari are the central role given to the *biographies of individual artists, the collecting of facts (the importance of which and the difficulty which he had in collecting them being repeatedly stressed in the preface reprinted here), the overall shape which he gives to the past, and his analysis of beauty. The first two of these parallels, concerning biography and facts, are straightforward, but the shape of the past and the analysis of beauty need further comment.

Taking the shape of the past first: Van Mander provides a thumbnail sketch of the quality of art and life in ancient Rome, the decay which set in with the onset of war, and the revival which occurred with the rediscovery of ancient art in Italy at the time of the Renaissance. This is in essentials the same as Vasari's account except for the understandable use of the abstract notion of war instead of the Northern barbarians – his own forebears – as an agent of decay.

Unable to provide a similar pattern for the North, Van Mander simply proposes that an artistic tradition was established later in the Netherlands, with the painting of the Van Eycks. He says nothing about a 'cycle of rise, maturity and decay and instead sees art as progressing from the Van Eycks' day around 1400 to his own, around 1600, with no hint of an inevitable future falling away in quality (fig. 6).

There must have been some resistance among contemporaries to the discussion of the work of living artists, as Van Mander feels the need to defend their inclusion, offering as reasons the greater availability of facts and the precedent set by Vasari. Both of these reasons point to one of the most powerful lessons which Van Mander drew from Vasari, namely that the fame of artists is much more assured if their achievements are documented and explained in writing.

Turning to the analysis of beauty: Van Mander describes the ancients as having selected the most beautiful from the merely beautiful, and the Italians as reviving art by discovering perfection in the living figure, which then leads to a depiction of the 'best appearances' of the poses of human figures. This is an abbreviated version of Vasari's model of beauty. The importance of Italy for Van Mander is thus underlined, because, as with the shape of the past, Northern painters do not in fact fit the model at all well. Van Mander describes the Northerners such as the Van Eycks and Dürer as working from life, and everyday life at that, rather than with any sense of ideal beauty to guide them. But they did this with such intensity that even the Italians were amazed.[2] The way in which Van Mander presents these early painters bears resemblances to Vasari's presentation of Giotto: their achievements are all the more admirable in that they had no forerunners and they even lacked the advantage of having antique models from which to work.

Regardless of the extent to which Van Mander praises the Netherlandish and German artists of the fifteenth and early sixteenth centuries, however, he does not see real enlightenment coming until well into the sixteenth century when Jan van Scorel introduced 'the best manner and appearance of art' from Italy (fig. 7). In addition, in the life of Pieter Cornelis of Delft he says that 'the

45

7 Jan van Scorel, *The Presentation in the Temple*, c.1520. Oil on panel, 114 x 85 cm. Kunsthistorisches Museum, Vienna

Just as Van Eyck (fig. 6) can be considered the Northern equivalent of a painter like Pollaiuolo (fig. 4), so for Van Mander Van Scorel is the counterpart to Michelangelo (fig. 3). However, the relationship between Van Eyck and Van Scorel is completely different from that between the two Italian artists. While it can be argued that there is an internal development from Pollaiuolo to Michelangelo there is nothing similar from Van Eyck to Van Scorel, as the introduction of antique forms in the latter's work is the result of external influence from Italy.

practitioners of our art who remain a long time abroad and especially in Italy, usually return home with a manner or a way of working which surpasses the customary, old, Netherlandish manner in beauty and excellence …'[3]

In conclusion, there is one point of terminology which is worth commenting on. Van Mander characterizes the difference between the two traditions as follows: whereas the Northerners were 'artful without art', the Italians painted with 'learning and study'. What he means by the first is reasonably clear, as it is mentioned along with industriousness, the following of convention or habit and the observation of everyday life, while the second probably means knowledge of a theoretical kind, and is therefore a shorthand way of referring to the Italian approach to beauty by the distilling of perfect forms.

1 For translations of the introduction to the didactic poem and its first chapter, by Charles Ford and Jacqueline Pennial-Boer, see *Dutch Crossing*, 32, 1987, pp. 56–75, and 36, 1988, pp. 39–65. For a translation of the lives of the Northern artists, see *The Lives of the Illustrious Netherlandish and German Painters*, translated by Hessel Miedema, Doornspijk, 1994.

2 As indeed we know they were, from the praise heaped on painters like Jan van Eyck and Roger van der Weyden by the fifteenth-century writer Bartolomeo Fazio and by Vasari. See the biographies of Gentile da Fabriano, John of Gaul, Pisano of Verona and Roger of Gaul in Bartolomeo Fazio, *On Illustrious Men*, c.1455, in E.G. Holt, *A Documentary History of Art, I: The Middle Ages and the Renaissance*, Garden City, NY, 1957, pp. 198–203.

3 *The Lives*, op. cit., p. 450.

2 | Karel van Mander

The Painter's Book, 1604

Karel van Mander, *Het Schilderboeck*, Haarlem,
1604. Excerpts from *The Lives of the Illustrious
Netherlandish and German Painters*, translated by
Hessel Miedema, Doornspijk, 1994, pp.50–61,
70–3, 89–93, 98–102 and 194–205.

It is to be hoped, in some measure, that in future ages the laudable reputation of the most outstanding painters will not readily disappear from people's minds and mouths. Nevertheless it cannot be disputed that the names, lives and works of the most celebrated practitioners of our art will remain more lasting, secure general knowledge for our descendants, and remain also with more completeness and certainty, if by means of a serious account they are preserved and always kept fresh in the mind – lest they be pushed aside and covered up in the pit of oblivion by ever-advancing time with the spade of antiquity. Even so, some, or many, will (I think) be surprised that such a book should be written, and that so much diligence and effort should be spent on it, because of the subject matter which perhaps, or rather certainly, could be judged by some to be too banal or too trivial because they believe that only those renowned in feats of arms were or are worthy of the biographer's pen for their great deeds. And that Marius, Sulla, Catilina and other such fierce devourers of men should be and are more deserving of commemoration than our noble, artistic, world-embellishing spirits of ancient and modern times. But it would be difficult for anyone to impress or imprint such a thing convincingly on my mind – that there were any justice in that. There are anyway plenty of others who learnedly and painstakingly dedicate themselves to descriptions of the chronicles or tragedies of our Netherlandish bloodstained theatre – for which I would not be fitted: firstly on account of the difficulty it would cause me by reason of my inexperience; secondly on account of the anxiety and danger threatened by raging, treacherous discord. So that (if I presumed to do such a thing) I would deserve to have my ear tweaked by Cynthius with the admonition: It is not your task, or: It does not befit you to chronicle heroes, war, or the harsh roar of gunpowder – brushstrokes and paintings are your province. Therefore I have much preferred to take in hand the Book of Painting – and for the labour which I have freely spent on it I expect to receive no one's ingratitude. I recall that in former times my master, Lucas de Heere of Ghent, had embarked on a treatment of this subject in rhyme, the lives of the

famous painters – but that has disappeared and been lost and cannot be expected to come to light again, otherwise it could at least have been of great benefit to me, whereas I have had to track down and obtain much information with great difficulty. It is true that with respect to the Italian painters my task has been made much easier by the writings of Vasari who deals very compr hensively with his compatriots – to which end the name of the illustrious Duke of Florence was of great advantage to him and through his power and prestige he was able to achieve much. But regarding our famous Netherlandish painters, I have done my best to collect them together and arrange them in proper order, each in their own period. In this I was able to obtain less help than my great and fervent zeal or desire led me to hope, for it seemed that either such a thing appealed to very few people or that hardly anyone could bring himself to share my desire because they had turned their hearts towards other, more larder-filling activities. Thus I have not always been able to obtain or produce all the details concerning births, the dates and places of death and suchlike, though to my mind it is nevertheless important to give one's descriptions some adornment and validation with facts of that kind. It is at times so difficult and trying, for even if one asks somebody about their own father, when he was born and when he died, that person sometimes knows little about it – because the facts are carelessly not entrusted to the pen. When it comes to the pinch I can at least say with Varro or Pliny: So and so was alive in such and such a year, or their works were mostly from this or that period, or date from the reign of such and such an emperor, duke or count. Just as the above-mentioned ancients named an Olympiad in which the artist lived and in which their works were made. But my zeal and diligence to be comprehensive in this will nonetheless be very apparent. I shall begin then with the two celebrated brothers from Maaseik, Hubert and Jan, who in their day already performed wonders in our art, handling paint in a reasonably beautiful way, and with a very passable drawing technique, so that it is astonishing that they appeared so perfect and brilliant at such an early date – for nowhere in High or Low Germany do I find earlier painters known or named. Furthermore I shall, as far as I can, give an account of the noble practitioners and spirits who perfected art right up to this, our own time. And if I fail to mention anyone no one must suspect me of doing such a thing in any way knowingly or out of a malicious lack of sympathy – it is due rather to insufficient information or knowledge. For I should not wish to wrong anyone in that way, whether the bodies of those spirits have turned to dust or are still alive and working and astonishing the world with natural gifts bestowed on them by the Almighty. No one should blame me for also describing those still living today, for that can be done with more details, certainty and truth than with those gone many years ago and nearly forgotten, about whom one would very much wish to have more particulars. This too has already been done often enough by other outstanding writers – such as, for example, Vasari, who in his books and descriptions presented to the people Michelangelo and many others during their lifetime and made their names praiseworthy and illustrously famous. Therefore I kindly seek to be thanked rather than censured on that account. Farewell.

THE LIVES OF THE BROTHERS JAN AND HUBERT VAN EYCK, PAINTERS OF MAASEIK

Thanks to various noteworthy, illustrious men who excelled in praiseworthy, virtuous activities and learned pursuits, our sweet and pleasant Netherlands have from ancient times to the present not remained entirely deprived of noble and splendid glory. Leaving aside the triumphs and trophies achieved and attained far and wide with valiant daring by our ancient nobility, as well as the great fame we enjoy since it was from our fragrant herb-garden that the Phoenix of learning, Desiderius Erasmus of Rotterdam – who in these recent centuries has been known as the father of the ancient, noble tongue of Latium – arose on shining wings, generous Heaven has, with a favourable and loving outpouring of nature, blessed us with the highest honour in the art of painting. For what was never granted to either the ingenious Greeks, Romans or other peoples to discover – however hard they tried – was brought to light by the famous Netherlander from Kempen, Jan van Eyck, who was born at Maaseik on the notable river Maas – which on account of this honour can rival the Arno, the Po and the proud Tiber, for on her banks a brilliant light emerged, so resplendent that art-loving Italy could only behold it with complete astonishment and had to send her Pictura there so as to suckle at new breasts in Flanders. From an early age Jan van Eyck was highly intelligent and of very quick and noble mind, and being naturally inclined to the art of drawing he became a pupil of his brother Hubert who was a good few years older than he. This Hubert was a very artful painter, though it is not known from whom he learned. It is to be assumed that there were few painters or good examples of painting known in those early days in that uncultured, isolated backwater; in so far as one can judge Hubert must have been born in about the year 1366 and Jan a number of years later. However that may be, whether or not their father was himself a painter, it seems that their entire household was altogether bathed in and permeated by the artistic spirit of painting, for their sister Margriete van Eyck is also famous because she applied herself to painting with great ability, and as a spiritual Minerva (shunning Hymen and Lucina) remained a virgin to the end of her life. It is evident that the art of painting must have come to our Low Countries from Italy – that is, glue and egg painting – because this technique began first in Italy, in Florence, in the year 1250 as we have related in the life of Jan Cimabue. These brothers, that is Jan and Hubert van Eyck, made many works in glue and egg paint – for no other technique was known, except in Italy where one also worked on fresco. And because the town of Bruges in Flanders overflowed with much wealth in former times, on account of the great commerce which was carried on there by various nations – more so than in any other town in the whole of these Netherlands – and because art likes to be near wealth so as to be maintained with rich rewards, Jan went to live in the aforementioned town of Bruges where all manner of merchants abounded. Here he made many works on wood with glue and egg – and was very famous because of his great art in the various countries to which his works were taken. He was (according to some) also a wise, learned man, very inventive and ingenious in various aspects of art; he investigated numerous kinds of paint and to that end practised alchemy and distillation. He got so far as to succeed in varnishing his egg

or glue paint with a varnish made of various oils which pleased the public very much as it gave the work a clear, brilliant shine. In Italy many had searched for this secret in vain, for they could not find the correct technique. On one occasion Jan made a painting on which he had spent much time, diligence and labour (for he always did things with great fastidiousness and accuracy). When it was finished he varnished the painting according to his new invention in the now usual way and set it to dry in the sun – but whether the planks were not properly joined and glued, or whether the heat of the sun was too great, the picture split along the joints and came apart. Jan was very upset that his work was thus lost and ruined by the sun and determined to ensure that the sun should never again cause him such a loss. Thus, put off using egg paint and varnish, he eventually set about investigating and considering how to make a varnish which could dry indoors and away from the sun. When he had finally thoroughly explored many oils and other natural materials, he found that linseed and nut-oil dried best of all; by boiling these along with other substances which he added, he made the best varnish in the world. And since such industrious, quick-thinking spirits strive toward perfection through continually researching, he discovered by much experimentation that paint mixed with such oils blended very well, dried very hard and when dry resisted water well; and also that the oil made the colours much brighter and shinier in themselves without having to be varnished. And what astonished and delighted him even more was that he noticed that paint made thus with oil spread thinly and handled better than was possible with the wetness of the egg or glue medium and did not demand such a linear technique. Jan was highly delighted with this discovery and with good reason: for an entirely new technique and way of working was created, to the great admiration of many, even in distant Countries where Fame, trumpeting it forth, had already flown so that people came from the land of the Cyclops and ever-smouldering Mount Etna to see such a remarkable invention – as shall be described anon. Our art needed only this noble invention to approximate to, or be more like nature in her forms. Had the ancient Greeks – Apelles, Zeuxis and others – been brought back to life again here and seen this new technique they would certainly have been no less astonished than the warlike Achilles or other warriors of antiquity would have been if they were to hear today's fierce thundering guns of war which the alchemist Bartholdus Schwartz, a monk from Denmark, invented in the year 1354. Or perhaps not less than the ancient writers would be were they to observe the useful art of book-printing which Haarlem, with sufficient justification, prides itself on having first invented. The year that Jan invented oilpaint was 1410, as far as I can discover and ascertain. In this Vasari or his printer erred by describing this invention as having taken place a hundred years later. I have various reasons for this opinion and I also know that Jan did not live nearly as long as Vasari would have it, although Jan did not die young – as one writer has it. Leaving this aside for brevity's sake, these two brothers kept this new discovery carefully hidden and made many handsome pictures together, and separately or individually. But Jan, even though he was the younger, surpassed his brother in art. The largest and most outstanding work which they made was in Ghent, the painting in the Church of St Jan's; this painting was commissioned by Philip of Charolais, 31st

Count of Flanders, son of Duke Jan of Dijon, whose portrait on horseback appears there on the doors. Some believe that Hubert began this picture on his own and that Jan subsequently finished it but I am of the opinion that they began it together and that Hubert died in the year 1426 while the work was in progress – for he is buried in Ghent in that very church; his epitaph, or grave inscription, will follow anon. The innermost panel of this work is from the Revelation of John – depicting the Adoration of the Lamb by the elders. There is an overwhelming amount of detail in it and outstanding precision – as is the case with the work as a whole. Above that panel is an image of Mary who is being crowned by the Father and the Son – Christ holding in his hand a cross painted to look like translucent crystal and decorated with golden studs and other embellishments with precious stones; it is made in such a way that in some painters' opinion at least a month would be needed to paint this staff, or cross, alone. Around Mary are little angels singing, depicted with so much painterly skill that one can easily tell from their attitude who is singing the treble, alto, tenor and bass. Above, in the right-hand shutter is an Adam and Eve, where one sees in Adam a certain trepidation at breaking the commandment: he appears to be horrified because he is being offered by his new bride not the apple (as painters usually depict it) but a fresh fig, from which it appears that Jan had some learning, for Augustine and some other learned people believe that it could well have been a fig which Eve gave to her husband, as Moses does not specify the fruit; for immediately after having sinned and become aware of their nakedness they did not cover themselves with apple leaves but with fig leaves. On the other shutter there is, I believe, a Saint Cecilia. Furthermore, the inner panel has two wings or double doors of which the two parts next to the central scene contain (I believe) figures which are connected with the main panel's narrative. On the other panels are figures on horseback: the Count of Flanders, as has been mentioned, and also the two painters, Hubert and Jan. Hubert sits on the right-hand side of his brother in accordance with his seniority; he looks, compared to his brother, quite old. On his head he wears a strange hat with a raised, turned-back brim at the front of precious fur. Jan wears a very ingenious hat, something like a turban which hangs down behind; and over a black tabard he wears a red rosary with a medal. But to describe this work overall: on account of its draughtsmanship, poses, spirituality, its invention, clarity and precision it is excellent and admirable, considering its time. The rendering of the folds of the draperies is somewhat in the manner of Albrecht Dürer; the colours – blues, reds and purples – are incorruptible and everything is so clear that it looks newly painted, surpassing all other paintings. This accomplished painter was a great observer, and it would seem that with this work he wanted to expose the error of the celebrated writer Pliny when he wrote that painters painting a hundred or so faces always, or usually, paint some which are alike because they can not equal nature where from a thousand one can scarcely find two completely alike – for in this work about 330 complete faces appear, not one of which resembles another. In these faces one sees various emotions, such as a divine sincerity and love or devotion – for example the figure of Mary, whose mouth appears to pronounce some words she is reading from a book. There are many exotic and unusual trees in the landscape; one can distinguish the small plants, and the grasses

on the ground are singularly realistic and precise, as are the hairs on the figures and in the horses' tails and manes which one can almost count – they are so finely and delicately painted that they are admired by all artists, in fact, the whole painting astonishes and stuns them when they look at it …

Some time ago a number of portraits of celebrated Netherlandish painters in copper-plate engraving were published in Antwerp – and in the first place those of these excellent brothers as the earliest accomplished practitioners of the noble art of painting in the Low Countries. Next to them, or rather below, are most artful *carmina*, or poems in Latin, by the most learned poet Dominicus Lampsonius of Bruges, secretary to the Bishop of Liège and not only a very great lover of our art but also having a very great understanding and experience of it. I have also wished to append here those poems in praise of these clever men, in our own language.

52

To Hubert van Eyck, painter:
O Hubert and your brother, should the well-deserved songs of
Praise of our Muse, recently sent to you,
Not please – then add this to them:
That your apprentice, your brother, surpassed you with your help.
Of this we are taught by the work in Ghent,
Which spurred King Philip to such a fiery desire
To have a copy made by Coxcie's skilful hand
To send home to his Spanish fatherland.

Jan van Eyck says, as if speaking himself:
I was the first, together with my brother Hubert,
To demonstrate the science of tempering clear colours with linseed oil;
This new discovery which Apelles in former times perhaps could not have found,
Astonished rich and prosperous Bruges.
After which our clever invention did not fail
To spread itself quickly the length and breadth of the world.

THE LIFE OF ROGER OF BRUGES, PAINTER

[Van Mander presents a separate life of Roger van der Weyden, though he and Roger of Bruges were one and the same person.]

Before the widely celebrated town of Bruges deteriorated and declined on account of the diversion of trade in 1485 from there to Sluis and Antwerp – since luck and fortune are unstable in this world – there were in this flourishing town, during and after the time of Jan, some other clever, fine spirits. Among others someone called Roger who became a pupil of the aforementioned Jan. It does seem, however, that that was at the time when Jan was already fairly old, for Jan kept the art and discovery of his oil paint hidden until his old age and allowed no one near him as he worked – but eventually he imparted his art to his student, Roger. There have been many works by this Roger displayed in churches and houses in Bruges. He was robust in drawing and very gracious in painting – with

glue and egg tempera as well as oil paint. At that time it was customary to paint large canvases with large figures, which were used to span rooms like tapestries and they were painted with egg tempera or glue-paint. He was a good master at this and I do believe that I have seen some of these canvases by him in Bruges which (for that time) were surprisingly worthy of praise and respect. For draughtsmanship and understanding are necessary to make something like that on a large scale, otherwise it would soon come to grief, whereas it does not so readily look unattractive on the small scale. I know nothing to relate about his death, but fame ensures that he still lives through the excellence of his art, which has hallowed his name to immortality …

THE LIFE OF ALBRECHT DÜRER, EXCELLENT PAINTER, ENGRAVER AND ARCHITECT FROM NUREMBERG

When Italy, properly adorned with the excellent perfection of our art of painting became famous and was celebrated and admired by other peoples, Germany too, began rapidly to shed its darkness by means of a most outstanding practitioner who illuminated that period brightly, and most fortunately comprehended all that can be understood or embraced within the art of drawing without having received the light of Italy or being inflamed by the shining, ancient, Greek marbles. This was the all-round Albrecht Dürer, who was born in Nuremberg in 1470. His father was a most artful goldsmith and one can well imagine that he in his youth practised this art with him and learned engraving or cutting copper – for nowhere does one find that he made anything important in our art in his early youth. He learned art with Hupse Marten, namely painting and engraving. I know nothing very important to say about this Hupse Marten – only that he was, for that period, a great master in composition and drawing to which some few prints by him still bear witness. Among others, and in particular, a *Bearing of the Cross*, an *Adoration of the Three Kings*, images of Mary, a *Temptation of Anthony* and such like which one rarely comes across or is able to purchase. There is a delicate old print by Israel van Mentz of three or four nude women, looking just like the Three Graces, above whose heads hangs a round globe without a date. Albrecht Dürer made an engraving after this print, and the globe is dated 1497, when he was already 26 or 27 years old; this is the first dated engraving by him that I have ever seen or of which I have heard. There are, however, some of his prints without a date on them which belong to his early work. The *Wild man with a skull in the coat-of-arms* is dated 1503, the outstanding *Adam and Eve* 1504, two horses both 1505; the *Passion* copper engraving, which is very subtly drawn and astonishingly finely engraved, has various dates: 1507, 1508 and 1512. The *Duke of Saxony* 1524, *Melanchthon* 1526 – which is the latest date to be found on his engravings. I do not, of course, need to deal with all of his pieces in detail – in copper engraving as well as woodcut, which are made very artfully by him – for these are known well enough by the practitioners and lovers of art. Just like his predecessors in his country he applied himself to the imitation of life in all he did but without meticulously seeking or choosing the most beautiful of the beautiful, as did the judicious Greeks and Romans with great discernment in ancient times, which, when

it was perceived in the ancient sculptures, opened the eyes of the Italians in early days. Nevertheless they were greatly surprised at the amazing perfection of his drawing and the pure neatness of his skilful, sharp burin. The best Italian masters have also borrowed much from his work – for the composition of their subjects and for the clothing of the figures and such like. It is most admirable how he brought about or discovered so many particulars of our art from nature or, as it were, from within himself; as much in the good effect of his poses, his compositions, as in the smoothness and beauty of the draperies – as can be seen in some of his last images of Mary in which one sees a distinguished majesty of pose and large lighted areas next to superb shadows and harmonious darks in the rich draperies. Vasari writes that a certain Marcantonio of Bologna copied the 36 small woodcut passion scenes and published them under the mark or the name of Albrecht, and that Albrecht therefore is said to have come to Venice where they were printed and turned to the town dignitaries for protection, achieving only that Marcantonio had to cut away the plagiarized name. One can assume that in his youth too Albrecht spent a lot of time on literature and learning about many arts and sciences, such as geometry, arithmetic, architecture, perspective and many other things as the books left by him – which show great perception, art and diligence – testify. One can observe that for example in that Daedalian work on Analogy or Proportion, the book in which all the kinds of measurements of the human body are very truthfully represented, set forth and explained in writing. Just as worthy of admiration is the didactic book published by him on the subjects of Perspective, Architecture and Military Science. So it was that he was not only held in great regard and admiration by ordinary people, or even by the learned and those knowledgeable in art, but also by great lords. Thus, for example by Emperor Maximilian, grandfather of our Emperor Charles V; for it is said, among other things, that Maximilian had him draw something so large on a wall that Albrecht could not reach high enough, whereupon the Emperor – in order to hurry things along – ordered one of the noblemen who happened to be present, to lie down so that Albrecht could stand on him and in that way finish his drawing. Upon which the nobleman courteously remonstrated with the Emperor that to be stepped upon thus by a painter would mean humiliation and contempt for the nobility. To which the Emperor replied that Albrecht was noble, yes more than a nobleman by virtue of his outstanding art, and that he could make a nobleman out of a peasant or an ordinary person but not such an artist from a nobleman. This Emperor also granted Albrecht the coat of arms for painters, which they could henceforth bear; to wit: three silver or white shields on an azure-blue field. He was also held in high esteem by Emperor Charles the Fifth on account of his great perfection in the art of painting and in other sciences. When he heard of the great fame of his contemporary Raphael of Urbino he sent his portrait to him in Italy, on canvas, done in ink without paint and leaving the highlights blank, as we have recounted in the life of Raphael …

Albrecht Dürer [was] a most virtuous, yes the most perfect man of his time, who was not only the first among the High Germans who increased, brought fame to and captured the art of painting within precise rules, but the one who began to teach that art to its followers with his writings and who for this reason –

but especially also on account of his good manners, intelligence and exceptional ability – was very popular not only with his Nurembergers as well as with all foreigners, but also with the high-born Emperor Maximilian and his grandson Charles; he was also cherished by Ferdinand, the King of Hungary and Bohemia, who accorded him with the highest favour and supported him with a general annual salary. He died, not without being much lamented, on the 8th of April 1528 at 57 years of age.

Bibaldus Pirkeymherus dedicated this to his loyal friend because he deserved it.

THE LIFE OF CORNELIS ENGELBRECHTSEN, PAINTER FROM LEIDEN

Although the art of painting was practised in former times in our Netherlands one could say: artful without art, that is: without learning and study, in other words: not after the best old ways which the Italians subsequently got from the antique sculptures; even so, one has to marvel at the felicitous characterization which our Netherlanders displayed at such a very early date in their figures and their poses – as if learned from nature – and such clever, spirited handling and manner. As it can be seen amongst others but especially in the bold, artful works and interesting, skilful brushstrokes of the Leidener, Cornelis Engelbrechtsz. – born in 1468, in the town of Leiden – he was already active at an early date which made him probably the first, or one of the first, who used oil paint in this, his native town; an art which was nevertheless discovered and brought to light at least 60 years before his time by the crown, the jewel of our Netherlands, Jan van Eyck, as was told above. By whom Cornelis was taught, or whether his father was also a painter, I have not learned; but it is maintained that Lucas Hugensen of Leiden, mentioned hereafter, having lost his father early must have studied under him; Cornelis also had two sons, contemporaries of Lucas, who were painters; another son, his eldest, called Pieter Cornelisz. Kunst, was a glass-painter with whom the aforementioned Lucas associated a great deal in practising the art of drawing so that he became excellent in the art of glass-painting too. More follows concerning his other two sons, mentioned above. Now Cornelis Engelbrechtsz., the subject of this chapter, was a very good draughtsman and an energetic and skilful painter in water- and oil-paint, of which some beautiful, subtle pieces (which were not destroyed in the senseless deluge of the iconoclasm but fortunately still remain preserved) are evidence and an indication. These pieces are kept in the town hall by the Leiden Councillors, for the sake of their merit and in memory of such a distinguished master who was also a citizen of Leiden. But it is a pity that some hang too high, out of sight, so that one can hardly see the neatness and skill from below: these are two altarpieces with shutters which formerly used to be in a monastery church outside Leiden, called Marienpoel. The middle panel of one of the pieces is a *Crucifixion* with the two murderers, the Marys, John and other bystanders on horseback and on foot, very cleverly and well executed; in the right-hand shutter is the *Sacrifice of Abraham* and in the left-hand one a *Brass Serpent*. The other painting is a *Deposition* and added to it are six other Sorrows of Mary in small compartments surrounding it. In the shutters are founders, I believe, and it is all most

55

cleverly and artfully made. In the same town hall, there is also a large canvas in watercolour by Cornelis with large figures representing the *Three Kings* in which is to be seen an imposing, elevated manner of composition and drapery, so that it is easy to see that Lucas van Leiden learned from or trained after his work. But this piece is rather badly decayed which, on account of its craftsmanship, is a great pity. But the most meritorious and excellent work to be seen or to be found from his trained and artful hand is a painting with two shutters which previously served as an epitaph to the Lords of Lockhorst, which they – in remembrance of their lineage – handed over to the St Pieters Church in Leiden where it hung above their place of burial in the Lockhorst chapel. One used to be able to see this piece in Leiden, in the Lockhorst house, but it was moved and is presently in Utrecht at the house of Mr Van den Boogaert, who is married to a daughter of the Lord of Lockhorst. The middle panel of this most noble piece is a scene from the *Revelation of John*, where the Lamb opens the book with the seven seals before the Throne of God and in which the whole heavenly host is portrayed and can be seen with many subtly posed figures and a great variety of handsome, lovely faces, in an astonishingly skilful and beautiful treatment, so that the very best and most experienced in our art are to be filled with wonder and admiration – and yet it is largely finished in one session: a clever, deft technique, which they often employed in those days. There are also praying founders to be seen here, and very well executed portraits of those who commissioned this piece at that time. In short, Cornelis Engelbrechtsz. was an outstanding and clever master who, apart from his great spirit and deftness, put great effort into his works and simultaneously beautified his representations with subtle ornaments. He also took excellent care to depict the emotions or human feelings, in the way the ancients often did. He died in Leiden in the year 1533 when he was 65 years old.

THE LIFE OF JAN VAN SCOREL, PAINTER

It is known that in earlier times the chief among towns, most beautiful Rome – while still flourishing with prosperity and rich in inhabitants – overflowed with people to the same measure as it was rich in artful, excellent statues, or to put it a better way: marbles and bronzes which were, through great ingenuity as if naturally transformed into exquisite and most beautiful human and animal bodies. Also, one knows only too well that crazy war has on various occasions enviously and with gnashing teeth rough-handled this most elevated city, wrought confusion and crushed it with annihilating feet. But when Rome eventually began to feel better under the peaceful rule of the popes, some of the aforementioned beautifully formed marbles and bronzes were rediscovered and taken from her dusty bowels which, when they emerged from the dark, cast a great light upon our art of painting and opened the eyes of its practitioners so as to distinguish between ugliness and beauty, and what was the most beautiful in life or in nature regarding the shape of the human body and various beasts. So that the Italians, who were thus enlightened, touched on the correct essence and the best appearance of figures earlier than we Netherlanders – who with a particular habitual

manner of working, but with incomplete knowledge, constantly and diligently aspired to work better and better, by which means they were content for the greater part with simply working from life and thus (so to speak) rather remained in the dark, or with little illumination; until Jan van Scorel brought from Italy the essence of the best manner or appearance of our art to them and set it before their eyes. And because he was probably the first to visit Italy and bring illumination to the art of painting here, he was (it is said) called the lantern bearer and road-builder of our art by Frans Floris and others, and recognized as such. He was born in the year 1495 on the first day of August in a village called Scorel near Alkmaar in Holland, which supplied him with his surname, and he gave his birthplace widespread fame ...

When Scorel was returning from Jerusalem in the year 1520 – two years before the Turks conquered the city of Rhodes – he was, in this city of Rhodes, well received by the Grand Master of the German Order, who now resides in Malta, and he portrayed the layout of the city. After arriving in Venice, he departed after a short time and while visiting several places in Italy he also came to Rome, where he practised assiduously drawing after all antique things, statues and ruins, as well as the artful paintings of Raphael, and Michelangelo who was then becoming famous, and after the works of various other masters. At about this time Adrian VI, cardinal, was elected during his absence in Spain. He was born in Utrecht, and when he got to Rome Scorel came into contact with the Pope who put him in charge of the entire Belvedere. Here he made some pieces for the Pope, among others a portrait of the Pope from life which today is still in Louvain, in the college which was founded by this same Pope. After this Pope had occupied the Chair for one year and thirty-five weeks he died. And Scorel, after making several more things in Rome and continuing diligently to learn, returned to the Netherlands ...

I cannot conceal that there is in Haarlem, with Mr Geert Willemsz. Schoterbosch, an excellent little piece by him in which Mary presents Christ to Simeon in the temple and in which grand architecture with rich vaulting is to be seen, in which much gilding or golden decorations are painted with colour – which looks wonderfully impressive; besides this it is very subtle in its little figures, which are very attractive to look at [fig.7]. There also used to be a piece by him in Haarlem on the wall in the Grote Hout-poort, but that has been entirely worn away. Antonis Moro, painter of Philip, King of Spain, who in his youth was a pupil of Scorel and who always remained well-disposed towards him, portrayed him about two years before his death, to wit in the year 1560; and he died in the year 1562 on the 6th of December at 67 years of age.

Giovanni Pietro Bellori (1615–96) was one of the earliest writers to make an important contribution to the writing of the history of art without himself being a professional artist. He spent his whole working life in Rome, as a literary figure, *antiquarian and *connoisseur, and as someone who painted for his own enjoyment. He was librarian to Queen Christina of Sweden, who lived in Rome, and he received the accolade 'antiquarian of Rome' from Pope Clement X. His chief publications are an influential monograph on Raphael's paintings in the Vatican (1696),[1] and his *Lives* of 1672, written with the help of Nicolas Poussin. He had a great range of expertise and interests, including a fascination with the minutiae of objects and their preservation, which has led to him being called the father of *archaeological art history. While the *Lives* is modelled directly on Vasari's *Lives*, it differs fundamentally from its model in containing only those artists and works which Bellori considered were of the highest quality, whereas Vasari included many artists whom he considered second or even third rate. The thinking underlying such a principle of selection is closely connected to a belief in the central role of ideal beauty in the arts, the aspect of his approach which he discusses in the text reprinted here. This is the introduction to the *Lives*, originally delivered as a lecture to the Academy of St Luke, the painters' guild, in 1664.[2]

Bellori's main point in this excerpt is that perfect beauty does not exist in nature and must be sought instead in the realm of Ideas. He presents the case in measured tones, beginning, like a catechism, with God's creation of the Ideas in the first place, then moving to the way in which artists follow this model in order to overcome the deformities and disproportions which occur in nature and in the human form in particular: the artist must 'take from diverse bodies all that which in each single one is most perfect ... since it is difficult to find a single one that is perfect'.

*Architecture, as usual, presents a problem for this theory, requiring the sort of special pleading which Bellori otherwise avoids. Bellori attempts to circumvent the difficulty that architecture is not an imitative art with the argument that good buildings imitate other good buildings, saying that 'good architects preserve the most excellent forms of the orders', and that their designs should consist of 'order, arrangement, measure, and eurhythmy of whole and parts'. He adds the more sophisticated argument that the architect meets the criterion of imitating ideal form in that he imitates God in his procedures, that is in drawing up an ideal plan and then transferring it into material form.

8 Donato Bramante, Tempietto, S. Pietro in Montorio, Rome, 1502.
When assessing the quality of architecture, Bellori, following Vasari, applied the standard of accuracy of imitation, substituting antique architecture for the models in nature used by painters and sculptors. For this reason he considered the buildings of Bramante the peak of perfection, while he criticized the Baroque designs of his contemporary Borromini (fig. 9) for breaking the rules of good architecture. That he chose to ignore the fact that the Baroque too had precedents in antiquity only underlines his commitment to the standards of classicism.

9 Francesco Borromini, S. Ivo alla Sapienza, Rome, 1642 ff.
See fig. 8.

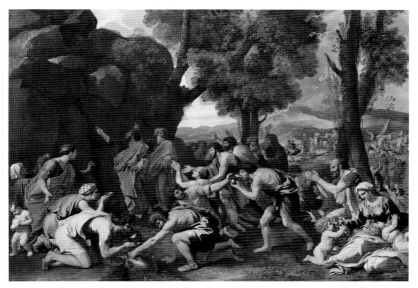

10 Nicolas Poussin, *Moses Striking the Rock*, c.1637. Oil on canvas, 98.5 × 136 cm. National Gallery of Scotland, Edinburgh
Bellori draws the same distinction in painting and sculpture as he does in architecture, praising artists such as Poussin for their classicizing restraint and condemning Baroque artists such as Bernini (fig. 11) for their exhibition of personal feeling.

Bellori describes the decay of the arts after the fall of the Roman Empire and their revival with architects such as Bramante and Raphael, who imitated the ancients (figs. 8 and 33), but he does not specifically refer to a "cycle of growth, maturity and decay, presumably because of the consequence it would have of placing the artists of his own day in a stage of decay. His model is a more flexible one in which artists and movements approach and retreat from perfection, epitomized in the sixteenth century by Raphael and the Mannerists respectively.[3] The closest one gets in this text to an acknowledgement of general decline is in his report of criticisms made by his contemporaries of artists like Raphael and Bramante as being mere imitators of antiquity. He defends them by accusing their accusers of architectural sins such as deforming designs with angles, breaks and distortions, and tearing apart bases, capitals and columns (fig. 9). Since this reads like a catalogue of Baroque design motifs, Bellori is clearly defining himself as a supporter of classicism, and hence implying a special eminence for the artists of the High Renaissance and for at least some of those of his own time. The point is illustrated by his inclusion of Poussin and the Carracci in the *Lives*, and the exclusion of Bernini (figs. 10 and 11).

In arguing that perfect beauty does not exist in nature Bellori was following a number of writers of antiquity as well as Vasari. The importance which he accords to ideal beauty leads directly to his conclusion that the artist must seek out the best works of the best artists to emulate.

1 Giovanni Bellori, *Descrizione delle imagini dipinte da Rafaelle d'Urbino*, Rome, 1696.
2 See the biographical note in E.G. Holt, *A Documentary History of Art, II: Michelangelo and the Mannerists, the Baroque and the Eighteenth Century*, Garden City, NY, 1958, p. 93.
3 Giovanni Bellori, *The Lives of Annibale and Agostino Carracci*, translated by C. Enggass, London, 1968, pp. 5–6.

62

11 Gianlorenzo Bernini, *The Vision of Saint Theresa*,
1644–7. Marble, life-size. Sta Maria della Vittoria, Rome
See fig. 10.

3 | Giovanni Bellori

Lives of the Modern Painters,
Sculptors and Architects, 1672

Giovanni Bellori, *Vite de' pittori, scultori ed
architetti moderni*, Rome, 1672. Excerpts from
the introduction to the *Lives of the Modern
Painters, Sculptors and Architects*, translated by
G. Donahue, in E.G. Holt, *A Documentary
History of Art, II: Michelangelo and the Mannerists,
the Baroque and the Eighteenth Century*, Garden
City, NY, 1958, pp. 94–106. Reprinted by per-
mission of Princeton University Press © 1958
Princeton University Press.

THE IDEA OF THE PAINTER, THE SCULPTOR AND THE ARCHITECT CHOSEN FROM THE HIGHER NATURAL BEAUTIES OF NATURE

When that high and eternal intellect, the creator of nature, made his marvellous works by reflecting deeply within himself, he established the first forms called *Ideas*. Each species was derived from that first *Idea*, and so was formed the admirable web of created things. The celestial bodies above the moon, not being subject to change, remained forever beautiful and in harmony; and because of their measured spheres and because of the splendour of their appearance we recognize them to be in all eternity of the highest perfection and beauty. On the other hand, sublunar bodies are subject to change and to ugliness and, although nature always means to produce excellence in its workings, neverthe-less forms are altered through the inequality of matter, and human beauty in particular is muddled, as we see from the countless deformities and disproportions that are in us.

For this reason the noble painters and sculptors imitate that first creator, and form in their minds also an example of superior beauty and, reflecting on it, improve upon nature until it is without fault of colour or of line.

This *Idea*, or we might say goddess of painting and sculpture, after opening the sacred curtains of the exalted genius of men like Daedalus and Apelles, unveils herself to us, and descends upon the marbles and canvases. Originating from nature, she rises above her origin and becomes herself the original of art; gauged by the compass of the intellect, she becomes the measure of the hand; and ani-mated by imagination, she gives life to the image. Certainly according to the opinions of the greatest philosophers there exist in the souls of artists the Exemplary Causes which without uncertainty and for eternity remain most beau-tiful and most perfect.

The *Idea* of the painter and sculptor is that perfect and excellent exemplar in the mind, with an imagined form, which by imitation, the things that appear to human sight resemble; such is the definition of Cicero in the Book of the *Orator* for Brutus: 'Accordingly, as there is something perfect and surpassing in the case of sculpture and painting – an intellectual ideal by reference to which the artist

represents those objects which themselves appear to the eye – so with our minds we conceive the ideal of perfect eloquence, but with our ears we catch only the copy.' Thus the *Idea* constitutes the perfection of natural beauty, and unites the true to the semblance of things present to the eye; she always aspires to the best and the wonderful, whereby she not only emulates but surpasses nature and manifests to us as elegant and accomplished the creations which nature is not wont to show perfect in every part.

Proclus confirms this high opinion in the *Timaeus*, saying that if you take a man made by nature, and one made by the art of sculpture, the natural one will be less excellent, because art works more accurately. Zeuxis, who selected five virgins to form the famous image of Helen that is proffered as an example by Cicero in the *Orator*, teaches the painter and the sculptor alike to keep in mind the *Idea* of the best natural forms and to make a selection from different bodies, choosing what is most elegant in each. For Zeuxis did not believe that he could find in one body only all the perfections that he sought for the beauty of Helen, because nature does not make any particular thing perfect in all its parts. 'Nor did he think that he could find all that he wanted for beauty in one body, because nature has not created anything perfect in a simple genus.'

Also Maximus Tyrius holds that when the painters create an image by choosing from diverse bodies, a beauty is brought forth that is not to be found in any single natural body, close as this might come to beautiful statues. Parrhasius admitted the same to Socrates, namely, that the painter desiring natural beauty in each form ought to take from diverse bodies all that which in each single one is most perfect, and ought to join it together since it is difficult to find a single one that is perfect.

More than that, nature for this reason is so much inferior to art that the copying artists, that is, those who scrupulously imitate bodies without discrimination and regard to the *Idea*, were reproved. Demetrius was remarked upon for relying too much on nature; Dionysius was blamed for having painted men like unto us, and was commonly called *anthropographos*, that is, painter of men. Pauson and Peiraeikos were condemned, mainly for having depicted the worst and vilest, as Michelangelo da Caravaggio in our times was too naturalistic; he painted men just as they are; and Bamboccio worse than they are.

Lysippus, likewise, used to reprove the mass of sculptors that they made men as they are found in nature, and prided himself on forming them as they ought to be, following the basic precept given by Aristotle to poets as well as to painters. Phidias, on the other hand, was not accused of this failing, who evoked wonder in spectators by the forms of the heroes and gods, in which he imitated the *Idea* rather than nature. And Cicero, speaking of him, affirms that Phidias, when he carved Jupiter and Minerva, did not contemplate any object from which to take the likeness, but considered in his mind a form full of beauty on which he concentrated, and to the likeness of which he directed his mind and hand. 'Nor indeed did that same artist [Phidias], when he made the image of Jupiter or Minerva, contemplate any person of whom he should draw a likeness; but in his own mind there dwelt an exalted species of beauty: staring at which and intent upon it, he directed his art and his hand to produce its likeness.'

Wherefore to Seneca, although a Stoic, and a rigorous judge of our arts, it appeared a fine thing, and he was amazed, that this sculptor, without ever seeing either Jupiter or Minerva, nevertheless was able to conceive in his mind their divine forms. 'Phidias saw not Jupiter, yet he made him as the Thunderer, neither did Minerva stand before his eyes; yet his mind, worthy of that art, conceived the gods and shaped them.'

Apollonius of Tyana teaches us the same, that imagination renders the painter wiser than does imitation, because the latter makes only the things that it sees, while the former makes even the things that it does not see, relating them to those that it sees.

Now, to join to the precepts of the ancient philosophers the best maxims of our modern ones, Leon Battista Alberti teaches that in all things one should love not only the appearance, but principally the beauty, and that one ought to select the most praised parts from the most beautiful bodies. Thus Leonardo da Vinci instructs the painter to form this *Idea*, and to think about what he sees and question himself about it, so as to select the most excellent part of each thing. Raphael of Urbino, the great master of those who know, thus writes to Castiglione of his Galatea: 'In order to paint a beautiful woman, it would be necessary for me to see many beautiful women, but since there is a scarcity of them, I make use of a certain Idea which comes to my mind.'

Likewise Guido Reni, who in grace has surpassed every other artist of our century, when sending to Rome the painting of St Michael the Archangel for the church of the Capuchins, wrote to Monsignor Massani, major-domo of Urban VIII: 'I should like to have had an angelic brush, or forms of Paradise to fashion the Archangel, and to see him in Heaven, but I have not been able to rise so high, and in vain I have searched for him on earth. So that I have looked upon that form which I have established for myself in the *Idea*. The *Idea* of ugliness is also found here, but this I leave to be expressed of the Devil, because I shun it even in thought and I do not care to retain it in my mind'…

Incidentally, not to leave out architecture, it also makes use of its most perfect *Idea*: Philo says that God, as a good architect, contemplating the *Idea* and the pattern which He had conceived, made the empirical world on the model of the ideal and rational world. So that architecture too, because of its dependence on an exemplar, rises above nature; thus Ovid, in describing the cave of Diana, states that nature in making it undertook to imitate art: 'Wrought by no artist's hand. But nature by her own cunning had imitated art.'

Torquato Tasso perhaps had this in mind when he described the garden of Armida: 'It seems nature's own art, and that for her amusement, she playfully imitates her imitator.'

Building, moreover, is so excellent that Aristotle argues that if construction were a thing not unlike the method of architecture, to give it perfection nature would be obliged to use the same rules [the architect does]; just as the very habitations of the gods were depicted by poets as bearing the work of architects, and furnished with arches and columns. Thus were described the Palace of the Sun and of Love, and architecture was carried to the heavens.

The antique cultivators of wisdom formed this *Idea* and deity of beauty in their

minds, always referring to the most beautiful parts of natural things; most ugly and vile however is that other Idea which is generally based on habit. For Plato argues that the Idea should be one perfect cognition of a thing based on nature. Quintillian teaches us that everything perfected by art and by human genius has its beginnings in nature itself, from which the true *Idea* is derived. Therefore, those who do not know the truth, and do everything according to habit, create empty shells instead of figures; nor is it different with those who borrow genius and copy the ideas of others; they make works that are not daughters but bastards of Nature, and appear to have sworn by the brushstrokes of their masters. Combined with this evil is the other that they, through poverty of genius, and not knowing how to select the best parts, choose the defects of their teachers and mold the *Idea* on the worst. On the other hand, those who glory in the name of Naturalists do not carry in mind any *Idea*; they copy the defects of bodies and accustom themselves to ugliness and errors; they also swear by a model as their teacher; if this is withdrawn from their eyes, together with it all art departs from them.

Plato compares these first painters to the Sophists, who take as their foundation not truth but the false fancies of opinion; the second ones are like Leucippus and Democritus, who would compose bodies of vain atoms at random.

Thus the art of painting is degraded by those painters to a matter of personal opinion and a practical device, as Critolaus argued that oratory was a practice of speaking and a skill to please, *tribē* [routine] and *kakotechnia* [poor skill], or rather *atechnia* [lack of skill], a habit without art and without reason, thus negating the function of the mind and leaving everything to the senses. Wherefore they believe to be a merely individual way of working, what really is the highest intelligence and *Idea* of the best painters and thus they would attach ignorance to wisdom; but the highest spirits, who concentrate their thought on the *Idea* of the beautiful, are carried away by it alone, and consider it as a thing divine. The populace refer everything to the sense of the eye; they praise things painted naturalistically because it is usual to see pictures so made; they appreciate beautiful colours but not the beautiful forms which they do not understand; they are bored by elegance and approve of novelty; they disdain reason and follow opinion, and wander far away from the truth of art, on which, as on its own base, is dedicated the most noble image of the *Idea*.

We should now explain that it is necessary to study the most perfect of the antique sculptures, since the antique sculptors, as we have already indicated, used the wonderful *Idea* and therefore can guide us to the improved beauties of nature; we should explain why, for the same reason, it is necessary to direct the eye to the contemplation of other most excellent masters. But this matter we assign to a special treatise on imitation, so as to convince those who condemn the study of antique statues.

As for architecture, we say that the architect ought to conceive a noble *Idea* and to establish an understanding that may serve him as law and reason; since his inventions will consist of order, arrangement, measure, and eurhythmy of whole and parts. But in respect to the decoration and ornaments of the orders, he may be certain to find the *Idea* established and based on the examples of the ancients, who as a result of long study established this art; the Greeks gave it its scope and best

proportions, which are confirmed by the most learned centuries and by the con-
sensus of a succession of learned men, and which became the laws of an admirable
Idea and a final beauty. This beauty, being one only in each species, cannot be
altered without being destroyed. Hence those who with novelty transform it,
regrettably deform it; for ugliness stands close to beauty, as the vices touch the
virtues. Such an evil we observe unfortunately at the fall of the Roman Empire,
with which all the good Arts decayed, and architecture more than any other; the
barbarous builders disdained the models and the *Ideas* of the Greeks and Romans
and the most beautiful monuments of antiquity, and for many centuries frantically
erected so many and such various fantastic phantasies of orders that they rendered
it monstrous with the ugliest disorder. Bramante, Raphael, Baldasarre [Peruzzi],
Giulio Romano, and finally Michelangelo laboured to restore it from its heroic
ruins to its former *Idea* and look, by selecting the most elegant forms of the
antique edifices.

But today instead of receiving thanks these very wise men like the ancients are
ungratefully vilified, almost as if, without genius and without invention, they had
copied one from the other. On the other hand, everyone gets in his head, all by
himself, a new *Idea* and travesty of architecture in his own mode, and displays it in
public squares and upon the façades: they certainly are men void of any knowl-
edge that belongs to the architect, whose name they assume in vain. So much so
that they madly deform buildings and even towns and monuments with angles,
breaks and distortions of lines; they tear apart bases, capitals, and columns by the
introduction of bric-a-brac of stucco, scraps, and disproportions; and this while
Vitruvius condemns similar novelties and puts before us the best examples.

But the good architects preserve the most excellent forms of the orders. The
painters and the sculptors, selecting the most elegant natural beauties, perfect the
Idea, and their works go forward and become superior to nature; this, as we have
proved, is the ultimate excellence of these arts. Here is born the admiration and
the awe of men towards statues and images, here is the reward and honour of
artists; this was the glory of Timanthes, of Apelles, of Phidias, of Lysippus, and of
so many others celebrated by fame, who all rose above human forms and aroused
admiration with the *Ideas* and their works. So one can indeed then call this *Idea*
perfection of nature, miracle of art, foresight of the intellect, example of the mind,
light of fancy, rising Sun that from the East inspires the statue of Memnon, fire
that warms into life the image of Prometheus. This induces Venus, the Graces,
and the Cupids to leave the Idalian garden and the shores of Cythera, and to dwell
in the hardness of marbles and in the vanity of shadows. By her virtue the Muses
on the slopes of Helicon mix immortality into the colours, and for her glory Pallas
disdains Babylonian cloth and proudly boasts of Daedalian linen. But because the
Idea of eloquence falls as far below the *Idea* of painting as sight is more potent than
words, I here lack for speech and am hushed.

67

4 Johann Joachim Winckelmann

The History of Ancient Art, 1764

Johann Joachim Winckelmann (1717–68) is a figure of towering importance in the history of art. He was the first scholar to write a history of art rather than histories of individual artists, and as such he stands at the head of a German tradition which since then has virtually defined the discipline. He was born in Prussia and studied theology and medicine at Halle and Jena. He first became acquainted with Greek art in the 1740s when he worked as a librarian in Dresden, as a result of which, in 1755, he published *Reflections on the Painting and Sculpture of the Greeks*, in which he formulated a Greek cultural ideal.[1] His interest in the classical world caused him to move to Italy and even to convert to catholicism. In Rome, under the patronage of Cardinal Albani, he became Prefect of Pontifical Antiquities and Professor of Greek at the Vatican Library. He played a central role in the formation of the Neoclassical movement, not least through his work *The History of Ancient Art* of 1764.[2] He has been called the father of art history and the father of archaeology, the first for his introduction of a scientific methodology and the second for his catalogues of antique gems and for the control which he introduced into the conduct of excavations.

In the following excerpts from *The History of Ancient Art* Winckelmann sets out his views on the relationship between art and culture. While he was strongly influenced by Bellori's concept of the *Idea*, Winckelmann also made a significant contribution to the development of the subject. This can be most clearly set out, in the context of a book on methods, by first examining his debt to Vasari, and then by analysing his own originality.

The most obvious ways in which he follows Vasari are as follows: First, he adopts Vasari's biological "cycle in his intention to show 'the origin, progress, change and downfall of art'. He applies it with some imagination to Roman art of the second century AD: 'The reign of the Antonines is in art like the apparent improvement shortly before death of persons dangerously ill, when life is reduced to a thin thread of breath; it resembles the flame of a lamp which, before it is entirely extinguished, gathers the remaining oil together, flares up into one bright blaze, and then instantly disappears.'[3]

Secondly, he stresses the importance of the study of the monuments, saying that to write on ancient art one has to be in Rome, and for even longer than two years, and praising the attention given by some historians to 'workmanship, the delicacy of the pencilling, or the polish given by the

12 *Apollo Belvedere*, Roman copy of Greek original
of c.350 BC. Marble, h. 2.23 m. Musei Vaticani, Rome
This statue is one of the works on which Winkelmann
based his study of Greek art. Because of the limitations
of the techniques of connoiseurship which he applied he
did not realize that it was a Roman copy and hence as
much illustrative of Roman attitudes to Greek art as of
Greek art itself.

chisel', that is, an aspect of *connoisseurship.⁴ Conversely, he criticizes other writers for the small part played in their work by art, for their lack of direct experience of works of art and for relying solely on books and hearsay. Thirdly, he criticizes the inability of writers to look at works of art with an artist's eye, something which Vasari as an artist clearly did.⁵

Winckelmann thus indicates the importance of both the experience of the work of art and an understanding of what it is the artist is trying to do – the second being impossible without the first. This is again something fundamental to Vasari's approach. Fourthly, he measures development by technical *progress. Finally, he distinguishes between individual beauty and ideal beauty and says that the second can only be attained by the selection of beautiful parts from individuals and uniting them into one. Since individuals are only beautiful in part, in order for the artist to achieve beauty in the entire figure, 'nature must yield the palm to art' (fig. 12).

The ways in which he differs from Vasari are as follows: First, however well organized Vasari's *Lives* may be, and however much he adhered to his biological model, it is the individual biographies which provide the form of the book. Winckelmann's book was explicitly written in order to present the visual arts in the context of the relevant period and place, including climate, form of government, habits of thought, the status of the artist, the use to which art is put, and the studious application of scientific knowledge by members of the society, that is, in other words, in the context of the *culture as a whole. He states that he is not writing 'a mere chronicle of epochs' and that the 'the history of individual artists has little bearing' on his purpose. In both these respects he has elevated historical structure over individual life, writing what has come to be called *cultural history and in so doing marking a gulf between himself and Vasari.

Secondly, Winckelmann combines this approach with a new version of the model of rise and fall. He proposes a sequence beginning with necessity, moving to the understanding of beauty, and descending into the superfluous. He provides metaphors for the three stages in successful and less successful cultures: all are the same in the earliest stage, just as at birth even the handsomest of human beings are misshapen. In maturity successful cultures (such as the Greek) are like a broad river with clear waters flowing through a fertile valley, while the unsuccessful dissipate their power like a river which divides into rivulets, or rages and crashes against the rocks (like the Etruscan).

In addition, he differs from Vasari in ways which are less significant and more characteristic of his own time. Because of the success of Vasari's application of the biological cycle to the Renaissance, those writing after him had an ambivalent attitude to the art of their contemporaries, as they appeared to be part of a period of decline. Winckelmann says explicitly that ancient art is superior to the art of his own day. He explains this in part by the practice by contemporary artists of realizing the beauty of the individual, which he says can never match ideal beauty. Thus he criticizes the work of Bernini for 'adhering so strictly to nature' which 'undoubtedly misled him'.⁶ His resistance to Bernini can perhaps be associated with his comment that the truly beautiful requires that the image be purified of all personal feelings (fig. 11).⁷ He did however have some heroes of his own age, including Michelangelo, 'that genius of modern sculpture', and, somewhat surprisingly, Rubens, who 'among great artists ... is the most eminent.'⁸

To sum up, while Winckelmann follows aspects of Vasari's method, he also distances himself by

downgrading the importance of the individual artist and by explaining the art of a people with reference to a wide variety of factors, thus acting as a cultural historian.[9]

1 Johann Joachim Winckelmann, *Reflections on the Painting and Sculpture of the Greeks* (1755), translated by Henry Fuseli, London, 1765.

2 Johann Joachim Winckelmann, *The History of Ancient Art* (1764); excerpts in David Irwin, ed., *Winckelmann, Writings on Art*, London, 1972, pp. 104–44.

3 *The History of Ancient Art*, op. cit., p. 143.

4 *Reflections*, op. cit., p. 259.

5 When Winckelmann asks a rhetorical question implying that no one other than himself had looked at art in this way, it is clear from the text that he is referring only to his contemporaries and to all those who have worked on ancient art, which explains why he does not mention Vasari.

6 *Reflections*, op. cit., pp. 18 and 172.

7 *The History of Ancient Art*, quoted below, p.76.

8 *Reflections*, op. cit., pp. 45–6 and 59.

9 For an assessment of Winckelmann's contribution and a placing of his work in the context of the Enlightenment, see Alex Potts, *Flesh and the Ideal: Winckelmann and the Origins of Art History*, New Haven and London, 1994, chapter 1.

4 Johann Joachim Winckelmann

The History of Ancient Art, 1764

Johann Joachim Winckelmann, *Geschichte der Kunst des Altertums,* Dresden, 1764. Excerpts from the Preface, Book I and Book IV of *The History of Ancient Art,* translated by Henry Lodge, Boston, MA, 1880; reprinted in David Irwin, ed., *Winckelmann, Writings on Art,* London, 1972, pp. 104–7 and 113–22.

The history of ancient art which I have undertaken to write is not a mere chronicle of epochs, and of the changes which occurred within them. I use the term history in the more extended signification which it has in the Greek language; and it is my intention to attempt to present a system. In the first part, the treatise on the art of ancient nations, I have sought to execute this design in regard to the art of each nation individually, but specially in reference to that of the Greek. The second part contains the history of art in a more limited sense, that is to say, as far as external circumstances were concerned, but only in reference to the Greeks and Romans. In both parts, however, the principal object is the essential of art, on which the history of the individual artists has little bearing.

The History of Art is intended to show the origin, progress, change, and downfall of art, together with the different styles of nations, periods, and artists, and to prove the whole, as far as it is possible, from the ancient monuments now in existence.

A few works have been published under the title of a *History of Art.* Art, however, had but a small share in them, for their authors were not sufficiently familiar with it, and therefore could communicate nothing more than what they had learned from books or hearsay. There is scarcely one who guides us to the essential of art, and into its interior; and those who treat of antiquities either touch only on those points in which they can exhibit their learning, or, if they speak of art, they do so either in general terms of commendation, or their opinion is based on strange and false grounds.

In the large and valuable works descriptive of ancient statues which have hitherto been published, we seek in vain for research and knowledge in regard to art. The description of a statue ought to show the cause of its beauty, and the peculiarity in its style. It is necessary, therefore, to touch upon particulars in art before it is possible to arrive at a judgement on works of art. But where are we taught the points in which the beauty of a statue consists? What writer has looked at beauty with an artist's eyes?

Descriptions of extant antiquities, of the galleries and villas at Rome, afford quite as little instruction: they rather mislead than instruct.

Richardson has described the palaces and villas in Rome, and the statues in them, like one who had seen them only in a dream. Many palaces he did not see at all, on account of his brief stay in the city, and some, according to his own statement, he visited but once; and yet his work, in despite of its many deficiencies and errors, is the best we have.

Montfaucon, having compiled his work at a distance from the treasuries of ancient art, saw with the eyes of others, and formed his opinions from engravings and drawings, by which he has been led into great errors. *Hercules and Antaeus*, in the Palazzo Pitti, Florence, – a statue of inferior rank, and of which more than one half is of modern restoration, – is, according to him and Maffei, nothing less than a work of Polyclitus. The statue of *Sleep*, of black marble, by Algardi, in the Villa Borghese, he pronounces an antique.

The mistakes of learned men in regard to things of antiquity proceed mostly from inattention to restoration, as many of them have been unable to distinguish the repairs by which mutilated and lost portions have been replaced.

Hence it is difficult, indeed almost impossible, to write in a thorough manner of ancient art, and of unknown antiquities, anywhere but in Rome. Even a residence there of two years is insufficient for the purpose, as I learn by the laborious preparation required in my own case.

From youth upward, a love for art has been my strongest passion; and though education and circumstances led me in quite another direction, still my natural inclination was constantly manifesting itself. All the pictures and statues, as well as engraved gems and coins, which I have adduced as proofs, I have myself seen, and seen frequently, and been able to study; but for the purpose of aiding the reader's conception, I have cited, besides these, both gems and coins from books, whenever the engravings of them were tolerably good.

As Greek art is the principal point which this *History* has in view, I have, consequently, been obliged in the chapter upon it to enter more into detail; yet I should have been able to say more if I had written for the Greeks, and not in a modern tongue, which imposes on me certain restrictions. For this reason, I have, although reluctantly, left out a *Dialogue upon Beauty*, after the manner of the *Phaedrus* of Plato, which would have served to elucidate my remarks when speaking of it theoretically.

The History of Art I dedicate to Art and the Age, and especially to my friend, Anton Raphael Mengs.

BOOK I: THE ORIGIN OF ART, AND THE CAUSES OF ITS DIFFERENCE AMONG DIFFERENT NATIONS

Chapter I: The Shapes with which Art Commenced

The arts which are dependent on drawing have, like all inventions, commenced with the necessary; the next object of research was beauty; and, finally, the superfluous followed: these are the three principal stages in art.

In the infancy of art, its productions are, like the handsomest of human beings at birth, misshapen, and similar one to another, like the seeds of plants of entirely different kinds; but in its bloom and decay, they resemble those mighty streams,

which, at the point where they should be the broadest, either dwindle into small rivulets, or totally disappear.

The art of drawing among the Egyptians is to be compared to a tree which, though well cultivated, has been checked and arrested in its growth by a worm, or other casualties; for it remained unchanged, precisely the same, yet without attaining its perfection, until the period when Greek kings held sway over them; and the case appears to have been the same with Persian art. Etruscan art, when in its bloom, may be compared to a raging stream, rushing furiously along between crags and over rocks; for the characteristics of its drawing are hardness and exaggeration. But, among the Greeks, the art of drawing resembles a river whose clear waters flow in numerous windings through a fertile vale, and fill its channel, yet do not overflow.

As art has been devoted principally to the representation of man, we might say of him more correctly than Protagoras did, that 'he is the measure and rule of all things'. The most ancient records also teach us, that the earliest essays, especially in the drawing of figures, have represented, not the manner in which a man appears to us, but what he is; not a view of his body, but the outline of his shadow. From this simplicity of shape the artist next proceeded to examine proportions; this enquiry taught exactness; the exactness hereby acquired gave confidence, and afterwards success, to his endeavours after grandeur, and at last gradually raised art among the Greeks to the highest beauty. After all the parts constituting grandeur and beauty were united, the artist, in seeking to embellish them, fell into the error of profuseness; art consequently lost its grandeur; and the loss was finally followed by its utter downfall.

In the course of time, increasing knowledge taught the Etruscan and Greek artists how to forsake the stiff and motionless conformations of their earliest essays, to which the Egyptians adhered – compulsorily adhered – and enabled them to express different actions in their figures. But, in art, knowledge precedes beauty; being based on exact, severe rules, its teachings at the beginning have necessarily a precise and vigorous definiteness. Consequently, the style of drawing was regular, but angular; expressive, but hard, and frequently exaggerated – as the Etruscan works show. This is just the way in which sculpture has been improved in modern days by the celebrated Michelangelo. Works in this style have been preserved on reliefs in marble, and on engraved gems ...

BOOK IV: ART AMONG THE GREEKS

Chapter 1: Grounds and Causes of the Progress and Superiority of Greek Art beyond that of Other Nations

The superiority which art acquired among the Greeks is to be ascribed partly to the influence of climate, partly to their constitution and government, and the habits of thinking which originated therefrom, and, in an equal degree also, to respect for the artist, and the use and application of art ...

The arts of sculpture and painting attained among the Greeks a certain excellence earlier than architecture, because the latter has in it more of the ideal than

the two former; it cannot be an imitation of anything actual, and must therefore, of necessity, be based on the general principles and rules of proportion. The two former, which originated in mere imitation, found all the requisite rules determined in man; whereas, architecture was obliged to discover its own rules by repeated trials, and establish them by general approval ...

Chapter II: The Essential of Art

But how has it happened, that, while well-grounded elementary treatises on all other departments of knowledge exist, the principles of art and of beauty have been so little investigated? The fault, reader, lies in our innate indolent unwillingness to think for ourselves, and in scholastic philosophy. On the one hand, the ancient works of art have been regarded as beauties which one can never hope fully to enjoy, and which on this account easily warm some imaginations, but do not touch the heart; and antiquities have given occasion for the display of reading only, but have ministered little nutriment, or absolutely none at all, to the understanding. On the other hand, philosophy has been practised and taught principally by those who, from reading the works of their gloomy predecessors, have but little room left for the feelings, over which they have, as it were, drawn an insensible cuticle, and we have consequently been led through a labyrinth of metaphysical subtlety and wordiness, which have principally served the purpose of producing big books, and disgusting the understanding.

Beauty is one of the great mysteries of nature, whose influence we all see and feel; but a general, distinct idea of its essential must be classed among the truths yet undiscovered. If this idea were geometrically clear, men would not differ in their opinions upon the beautiful, and it would be easy to prove what true beauty is.

[In some nations] the climate has not allowed the gentle feeling of pure beauty to mature; it has either been confirmed in them by art – that is, by constantly and studiously employing their scientific knowledge in the representation of youthful beauties – as in Michelangelo, or become in time utterly corrupted, as was the case with Bernini, by a vulgar flattery of the coarse and uncultivated, in attempting to render everything more intelligible to them. The former busied himself in the contemplation of lofty beauty; Michelangelo, compared with Raphael, is what Thucydides is to Xenophon. The very course which led Michelangelo to impassable places and steep cliffs plunged Bernini, on the contrary, into bogs and pools; for he sought to dignify, as it were, by exaggeration ...

The shape of beauty is either *individual* – that is, confined to an imitation of one individual – or it is a selection of beautiful parts from many individuals, and their union into one, which we call *ideal*, yet with the remark that a thing may be ideal without being beautiful. The form of the Egyptian figures, in which neither muscles, tendons, nor veins are indicated, is ideal, but still it shapes forth no beauty in them; neither can the drapery of Egyptian female figures – which can only be imagined, and consequently is ideal – be termed beautiful ... But nature and the structure of the most beautiful bodies are rarely without fault. They have forms which can either be found more perfect in other bodies, or which may be imagined more perfect. In conformity to this teaching of experience, those wise

artists, the ancients, acted as a skilful gardener does, who ingrafts different shoots of excellent sorts upon the same stock; and, as a bee gathers from many flowers, so were their ideas of beauty not limited to the beautiful in a single individual – as at times are the ideas of both ancient and modern poets, and of the majority of artists of the present day – but they sought to unite the beautiful parts of many beautiful bodies; this we learn also from the dialogue between Socrates and the celebrated painter Parrhasius. They purified their images from all personal feelings, by which the mind is diverted from the truly beautiful.

This selection of the most beautiful parts and their harmonious union in one figure produced ideal beauty – which is therefore no metaphysical abstraction; so that the ideal is not found in every part of the human figure taken separately, but can be ascribed to it only as a whole; for beauties as great as any of those which art has ever produced can be found singly in nature, but, in the entire figure, nature must yield the palm to art …

5 Johann Wolfgang von Goethe

Of German Architecture, 1772

Johann Wolfgang von Goethe (1749–1832) is one of the giants of German culture, being at various times poet, novelist, dramatist, scientist, philosopher, statesman and administrator – a prolific writer whose collected works number over a hundred volumes. He was born in Frankfurt and studied at Leipzig and Strasbourg, after which he lived in Weimar, except for an important visit to Italy in the 1780s. His insight and energy had profound effects in many fields, from the physics of colour theory to the development of the artistic and literary movements of his time. In this last regard his greatest influence was on German Neoclassicism and Romanticism, but his all-encompassing range of interests also included Gothic architecture, which he encountered during a visit to Strasbourg Cathedral in his student days. This is the subject of the essay reprinted here, which was originally published by Johann von Herder (1744–1803), the leading scholar in Goethe's circle of friends whose views on Gothic rendered Goethe sensitive to the style in the first place.[1] Had it been left to Goethe it would almost certainly not have seen the light of day, as within a few months he had rejected the Gothic and moved on to an involvement with the classical. Yet his influence was such that the essay can be considered one of the main causes of the Gothic revival in Germany, discouraging the fantasizing form of the 'Gothick', and encouraging people to approach the style with the same seriousness as they would the classical. Thus the Gothic is as great as the classical, in the same way as, for Herder, Shakespeare is as great as Sophocles, because he is completely different.[2]

The essay is more a hymn of praise to a work of genius than a discussion of the methods of the history of art. It has nevertheless been included here because of the self-awareness with which Goethe contrasts his expectations of the style with his experience of it, and because it marks a fundamental change in the status of the medieval element in Vasari's 'cycle and hence in the shape of art-historical writing. Since the time of Vasari, if not earlier, medieval architecture in the form of the Gothic style had been seen as the epitome of the barbaric, and was rejected (and sometimes supported) accordingly. Goethe's experience before the façade of Strasbourg Cathedral led him to the contrary view that the principles underlying its design were the reverse of barbaric (fig. 13).

The Gothic style which he had expected to encounter at the Cathedral was the embodiment of the irrational, that is, the grotesque, arbitrary, confused, unregulated, unnatural, botched and overladen, like 'some malformed, curly-bristled ogre'. Instead he says he experienced a

78

13 Strasbourg Cathedral, south doorway of the
West façade, late thirteenth century.
This portal is part of the façade which prompted
Goethe's realization that the Gothic was not the
random and irrational style he had expected, but
one of structural logic and clarity.

sensation of wholeness, in which all details were harmonized and all masses present because they were necessary.

The relationship between the concepts of Gothic and of nature is a complicated one in Goethe's text. It is ironic that he exhorts the architect, Erwin, to make his building rise heavenwards like a tree, with boughs, twigs and leaves, since the old view of Gothic as barbaric was closely connected with the belief that it had arisen among the Goths in Spain as a substitute for their abandoned northern forest glades. He also describes the irrational Gothic which he expected to find as 'unnatural', whereas the supporters of the irrational view of Gothic considered the style the epitome of the natural. This contradiction illustrates the protean form which the idea of nature enjoyed in the eighteenth century, being simultaneously the touchstone of beauty and the essence of the functional, the irrational and the non-rational.[3]

1 Johann Wolfgang von Goethe, *Of German Architecture* (1772), translated by Geoffrey Grigson as 'Goethe and Strassburg', *Architectural Review*, 98, 1945, pp. 156–9. Other translations are available in John Gage, *Goethe on Art*, London, 1980, pp. 103–12, and E.G. Holt, *A Documentary History of Art, II: Michelangelo and the Mannerists, the Baroque and the Eighteenth Century*, Garden City, NY, 1958, pp. 361–9.

2 'Goethe and Strassburg', op. cit., p. 156.

3 See Nikolaus Pevsner, 'Goethe and Architecture', in *Studies in Art, Architecture and Design*, vol. 1, London, 1968, p. 167.

Of German Architecture, 1772

Johann Wolfgang von Goethe, *Von deutscher Baukunst*, n.p., 1772. Excerpt from 'Goethe and Strassburg', translated from *Von deutscher Baukunst* by Geoffrey Grigson, *Architectural Review*, 98, 1945, pp. 156–9.

I wandered round thy grave, noble Erwin, and searched for thy tombstone, to have revealed to me 'anno domini 1318 XVI Kal. Feb. obiit Magister Ervinius, Gubernator Fabricae Ecclesiae Argentinensis' [the year of our lord 1318, 17 January, died Master Erwin, director of the fabric of the church of Strasbourg]. And I could not find it, and none of thy countrymen could show it me, that my veneration might be poured out at the holy place; and I was deeply sad in my soul; and my heart, younger, warmer, more innocent, better than now, vowed thee a memorial so soon as I attained the quiet enjoyment of my possessions – of marble or of sandstone as I might afford.

Yet why needst memorial! Thou hast set up to thyself one most glorious. And if the ants crawl round and care not for they name, thou sharest the destiny of that architect who piled mountains into the clouds.

It has been granted to few to create a Babel-thought within their souls, whole and great, and by necessity beautiful to the smallest part, like the trees of God. To fewer it has been granted to meet a thousand proffered hands to carve out the rock-ground, to charm steep cliffs thereon, and then dying, to say to their sons 'I abide with you in the works of my spirit: complete to the clouds that which is begun.'

Why needst memorial! And from me! It is superstition or blasphemy, when the rabble pronounces sacred names. Before thy colossus, the weak mannikins of taste reel giddily, and spirits that are whole will know thee without interpreter. Only, O excellent man, thus, before I venture my patched-up skiff back upon the Ocean, more likely toward death than prize – behold: here in this sacred copse, where all around the names of my beloved are in leaf, I cut thine into a beech-tree rising slenderly like thy spire, and hang up by its four corners this handkerchief with gifts – not unlike that cloth which was let down from the clouds to the holy apostle, full of clean and unclean beasts: so also full of plants, blossoms, leaves, and maybe dry grass and moss and night-grown toadstools – all that I have collected on a walk through insignificant regions, coldly botanising for my pastime – I dedicate in thy honour to decay.

In a small taste, says the Italian, and goes by. Childish things, babbles the Frenchman after him; and clicks open his snuff-box à la Grecque, in triumph.

What have ye done, that ye dare despise! Has not the Genius of the Ancients, rising from its tomb, chained thine, O Latin foreigner! Creeper in the mighty fragments to cadge proportions, cobbler of summer houses out of the holy wreckage, looking upon thyself as guardian of the mysteries of Art because thou canst account, to inch and to fraction, for gigantic buildings! Hadst though but felt, more than measured – had the spirit of the masses thou gapest at come upon thee, then hadst thou not imitated only because they did it and it is beautiful. Then by necessity and truth hadst thou created thy designs, and living beauty might plastically have welled from them.

So upon thy wants thou hast whited a show of truth and beauty. The splendour of the effect of columns struck thee; thou, too, didst want to use them, didst wall them in; thou, too, didst want colonnades, and didst circle the forecourt of St Peter's with marble walks, which lead nowhere from nowhere; so that Mother Nature, who despises the improper and unneccessary, drove thy rabble to prostitute this splendour to public cloacae, so that men turn away their eyes and hold their noses before the Wonder of the World.

This is the way things wag: the artist's whim serves the rich man's wilfulness: the topographer gapes, and our dilettanti, called philosophers, lathe out of protoplastic fables rules and history of the fine arts down to now, and true men are murdered by the evil Genius in the forecourt of the mysteries.

Rules, more than examples, harm the man of genius. Before his day, a few people may have worked our a few parts. He is the first, from whose soul emerge the parts grown together into one eternal whole. But school and rule fetter all power of perceiving and acting. What does it profit us, O neo-French philosophizing connoisseurs, that the first man who sensed his needs, rammed in four tree-trunks, joined up four poles on top, and topped all with branches and moss? From that thou dost decide what is proper for our needs today, as if thy new Babylon were to be ruled by thee with innocent patriarchal fatherliness.

And it is, moreover, wrong, that thy hut is the world's first-born. Two poles crossed at the top at the one end, two at the other, and one pole across, as a ridge, and that indeed, as thou canst see every day in the huts of field and vineyard, is an invention much more primeval, from which thou canst not even deduct thy pig styes' rule.

So not one of thy conclusions can soar into the region of truth: all float in thy system's atmosphere. Thou wouldst teach us that which we should need, because by thy principles that which we do need cannot be justified.

The column thou hast close to thy heart; and in another region of the world wouldst be a prophet. Thou sayest: the column is the first essential component of the building, and the most beautiful. What sublime elegance of form, what pure manifold greatness, when they stand there in rows! But take care not to use them with impropriety. Their nature is, to stand detached. And woe to the wretches who have riveted their slender shoots to lumpish walls!

And yet, my dear Abbé, it seems to me, that repeating often this impropriety of walling columns in, which made the moderns stuff masonry even into the intercolumnia of ancient temples – that his might have roused some thought in thee. If thine ear were not deaf to truth, those stones might yet have sermonized it to thee.

Column in no manner is a component of our dwellings. Rather, it speaks against the essence of all our building. Our houses do not arise out of four columns in four corners; but from four walls and four sides, which are there instead of all columns, exclude all columns, and where men stick them on, they are a burdening superfluity. The very same holds true of our palaces and our churches, a few excepted, which I need not heed.

Your buildings thus describe planes, and the more widely they stretch, the more boldly they rise to heaven, the more unendurably must their uniformity press upon the soul. Ah, but the genius came to our help! That genius which ministered thus to Erwin of Steinbach, saying 'Make variform the vast wall, which thou must carry heavenwards, so that it rises like a most sublime, wide-arching Tree of God, who, with a thousand of boughs, a million of twigs, and leafage like the sands of the sea, tells forth to the neighbourhood and glory of the Lord, his master.'

When for the first time I went towards the Minster, general notions of Taste filled my head. By hearsay, I honoured the harmony of the masses, the purity of the forms, was a sworn enemy of the tangled arbitrarinesses of Gothic ornament. Under the Gothic heading, I piled up, like the article in a dictionary, all the synonymous misunderstandings of the confused, the unregulated, the unnatural, the patched-up, the botched, the overladen, which had ever passed through my head. Foolishly as a people, which calls the foreign world barbaric, I named Gothic all that did not fit into my system, from the neatly-turned, gay-coloured cherub-dolls and painting our bourgeois nobility adorn their houses with, to the solemn remnants of older German Architecture, whose few fantastical frettings made me join in the universal song: 'Quite squashed with ornament.' And so, as I walked towards the Minster, I shuddered in prospect of some malformed, curly-bristled ogre.

With what unlooked-for emotions did the sight surprise me, when I stepped before it! A sensation of wholeness, greatness, filled my soul; which, composed of a thousand harmonizing details, I could savour and enjoy, yet by no means understand or explain. So it is, men say, with the bliss of Heaven. How often have I come back to enjoy this sacredly profane bliss, to enjoy the gigantic spirit of our elder brethren in their works. How often have I come back, to behold, from every side, from far and near, in every differing light, its dignity and glory. Heavy it is on the spirit of Man, when his brother's work is so sublimely reared, that he must only bend and worship. How often has the twilight, with its friendly stillness, refreshed my eye wearied with wide-eyed exploration, when it made the numberless parts melt into whole masses; and now, simple and great, these masses stood before my soul, and my power rapturously unfolded in enjoyment and understanding. Then was manifested in me, in faint diving, the genius of the great master mason. 'Why art thou astonished?' he whispers towards me. 'All these masses are there of necessity, and dost thou not see them in all the older churches of my town? Only I have raised their arbitrary proportions into harmony. How above the main porch, which lords over two smaller ones to either side, the wide rose-window opens, answering to the nave; and commonly but a hole for daylight, how, high above, the bell-loft asked for the smaller windows! All that was necessary; and I shaped it into beauty. But, ah, when I hover through the dark, sublime openings, which seem to gape there empty and vain! In their brave

slender form have I hidden the mysterious forces which were to raise high into the air those two spires, of which, alas, only one now sadly stands, lacking the five-pinnacled crown I destined for it, so that the provinces about should do homage to it and its kingly brother.' And so he parted from me, and I sank down into a sadness of compassion, until the birds of morning, which haunt its thousand openings, made jubilee towards the sun, and roused me from my slumber. How freshly it sparkled in the morning-scented brilliance! How jocundly could I stretch out my arms towards it, open my eyes to the great harmonious masses, quickened into numberless small parts! As in works of eternal Nature, down to the minutest fibril, all is shape, all purposes to the whole. How the firm-grounded gigantic building lightly rears itself into the air! How filagree'd, all of it, and yet for eternity! To thy teaching, genius, I owe it that I reel no longer at thy depths, that into my soul distils a drop of that blissful stillness of the spirit, which can look down upon its own creation, and like God, can say that it is good!

And now shall I not rage, O Holy Erwin, if the German learned in art listens to envious neighbours and misjudges his advantage over them, and misunderstanding the word Gothic, belittles thy work, when he should thank God he can announce loudly: This is German architecture, this is ours, when the Italian can boast none of his, and even less the Frenchman.

And if thou wantest not to concede this advantage, then prove to us that the Goth already built like this – thou wilt have difficulty. And, beyond all, if thou canst not demonstrate that there went a Homer before Homer, willingly will we leave to thee the story of little efforts that succeed or fail, and tread in worship before the work of the master who first created from the scattered elements a living whole. And thou, my dear brother in the spirit of seeking after truth and beauty, shut thine ears to all word-strutting about fine art, come, enjoy, open thine eyes. Beware. Desecrate not the name of thy most noble artist, and hurry, come close, and behold his glorious work. Be the impression on thee loathsome, or none, then fare thee well, harness up, and begone to Paris.

But I join thee, dear youth, standing there moved, unable to blend the contradictions crossing in thy soul, feeling now the resistless might of the great unity, now scolding me for a dreamer who sees beauty where thou seest only strength and roughness. Let no misunderstanding divide us, be not girled for rough greatness by the soft doctrine of modern beauty-lisping, lest thy sick sentiment in the end can hear only with smooth littleness. They would make thee believe the fine arts have sprung from that bent presumed in us for beautifying all things around. Untrue! In that sense by which it might be true, the genteel and the artisan might use the words, but no philosopher.

Art is plastic long before art refines; and yet is great true art, yes, greater and truer than the very fine. For in man is a plastic nature, which at once, when his existence is secure, proves active. As soon as man has nothing to worry him or to make him fear, the demi-god gropes round for matter to breathe his spirit into, quickening in his own peace. And thus with fantastical strokes, with horrid shapes, high colours, the savage decorates his cocoa-shell, his feathers and his body. Let the plastic art be composed of the most arbitrary forms, still it will cohere, without proportions of form; for One Feeling worked it into a characteristic whole.

Now this characteristic art is the only true art. If, out of ardent, united, individual, independent feeling, it quickens, unconcerned, yet, unconscious, of all that is strange, then born whether of rough savageness or civilized sensibility, it is whole and living. Countless degrees of this may be seen among nations and individual men. The more the soul rises to the sense of those proportions which alone are beautiful and of Eternity, whose main chords can be proved, whose secrets only felt, in which alone the life of God-like genius wallows in blessed melodies; the more this beauty enters into the essence of a mind so that mind and beauty appear to have sprung forth together, so that nothing can satisfy them but each other; so that the mind can quicken nothing but out of beauty, the happier is the artist and the more glorious, the deeper do we bend and worship God's anointed.

And from the rung to which Erwin has mounted up none shall push him down. Here stands his work: step hither, and discern the deepest sense of truth and beauty of proportions, quickening out of strong, rough, German soul, out of the strait, gloomy pope-ridden stage of the *medium aevum*.

And our *aevum*? It has renounced its genius, it has sent its sons round to collect strange growths for their damnation. The light Frenchman, who makes still worse a patchwork – he has at least a kind of cunning to fit together his plunder into one whole, he builds out of Greek columns and German vaults his Magdalene's wonder-temple. And from one of our artists, when he was asked to invent a porch for one of our old German churches, has come, to my seeing, a model of stately antique column-work.

I will not recite how hateful are our painters of rouged dummies and cherubs. They have taken the eyes of the women by their stagey postures, their lying complexion, their gay-coloured dress. Manly Albrecht Dürer, jest of our new hands, how dearer to me thy most wooden carved form!

And you, you excellent men, to whom it was given to enjoy the highest beauty, who now have descended to give tidings of your bliss – even you do harm to genius. Genius will not be raised up and taken off on other's wings, even if they be the wings of morning. It is its own powers which matter, which unfold in the dreams of childhood, which work in the life of youth, until, strong and nimble like the mountain-lion, it roves out for its prey. So genius is mostly reared by Nature, since you pedagogues never can counterfeit that manifold arena, wherein genius can act and find enjoyment to the immediate measure of its powers.

Hail to thee, boy, who art born with a sharp eye for proportions, to practise deftly upon every form. When by and by there wakes around thee the joy of life, and when thou feelest the jubilant pleasures of mankind after labour, feelest their fear and hope, feelest the vintager's brave shout when the fullness of the autumn swells his vats, the sickleman's lively dance when he has hung his idle instrument high upon the beam – then when the mighty hour of desires and sufferings lives more manfully in thy brush, when thou hast aspired and suffered enough, enjoyed enough, and art fulfilled with this world's beauty, and worthy to repose in the arms of a goddess, worthy to feel at her breast that by which Hercules was new-born and deified – Then, O thou mediatrix between Gods and men, O Divine Beauty, receive him; and more than Prometheus will he bring down the bliss of the Gods upon the earth.

6 Jacob Burckhardt

Reflections on History, 1872

Jacob Burckhardt (1818–97) is the first of the authors in this collection who can be called a modern university professor. Whereas Vasari and Van Mander were painters and Bellori, Winckelmann and Goethe were employed by the aristocracy or the State, Burckhardt spent his adult life as a member of a university. He studied theology and Greek at Basle in his native Switzerland, followed by the history of art in Berlin under the art historian Franz Kugler (1808–58) and history under the great diplomatic historian Leopold von Ranke (1795–1886). He turned down an offer to succeed Von Ranke as professor of history at Berlin, and instead was appointed professor of history at Basle where he wrote *The Civilization of the Renaissance in Italy* (1860), which is possibly his most influential work.[1] After the 1860s he put his energy into delivering 170 public lectures dealing with all aspects of Western culture from antiquity to his own day, placing particular emphasis on the central importance of the arts to an understanding of the past.

Reflections on History was written during this period of lecturing, but typically was not seen into print by Burckhardt. In the introduction to this book, reprinted here, Burckhardt made it clear that his interests covered the whole of history and that his approach to the subject was practical and empirical. The empirical character of his method is encapsulated in his opening words, which state that the course which he is offering will consist of some historical observations on half-random trains of thought, such as ferment, ruptures, reactions, and condensations of events around the lives of great individuals. He will, he says, take transverse sections of history in as many directions as possible and attempt to reconstruct the past in all its details. He is also a humanist, since he says that his study starts from humanity, 'suffering, striving, doing', and adds that it will therefore 'be pathological in kind', by which he presumably means unsentimentally diagnostic.

He claims he does not have a system and does not intend to abide by any historical principles. He disagrees with Hegel's belief that world history is rational, and dismisses the philosophy of history as a centaur, that is an unnatural beast made up of two incompatible parts. He notes provocatively that he cannot follow Hegel because he, Burckhardt, is not 'privy to the purposes of eternal wisdom'.

He does, on the other hand, make occasional comments which suggest that he values aspects of Hegel's approach. Thus he acknowledges that Hegelian historians have 'hewn some vast vistas in the forest of history', while later in the book he allows himself the almost quintessentially Hegelian

thought that 'from time to time a great event, ardently desired, does not take place because some future time will fulfil it in greater perfection.'[2]

Winckelmann placed the history of art in the context of climate, politics, habits of thought and other aspects of society, that is *culture broadly defined, but restricted himself to the art of antiquity. Burckhardt takes this model beyond the age of the Greeks and Romans on to a world stage and re-examines a vast mass of facts in a variety of different ways. He represents the counterweight to *Hegelianism in the German tradition and can best be described as an *empirical *humanist intent on writing a *cultural history which is as complete as possible, and which therefore includes the history of art along with every other aspect of social life and human achievement.[3]

1 Jacob Burckhardt, *The Civilization of the Renaissance in Italy* (1860), translated by S.G. Middlemore, London, 1929; reprinted, London, 1995.

2 Jacob Burckhardt, *Reflections on History*, translated by M.D.H., London, 1943, p. 217.

3 The omission of the history of art from his *The Civilization of the Renaissance in Italy* of 1860 can be explained by the fact that he had already published a separate guide, to art in Italy, *The Cicerone: an Art Guide to Painting in Italy for the Use of Travellers and Students* (1854), translated by A. Clough, London, 1908. On Burckhardt as a cultural historian see Michael Podro, *The Critical Historians of Art*, New Haven and London, 1982, *passim*.

6 | Jacob Burckhardt

Reflections on History, 1872

Jacob Burckhardt, *Weltgeschichtliche Betrachtungen* (written *c*.1872), n.p., 1906. Excerpts from the introduction to *Reflections on History*, translated by M.D.H., London, 1943, pp. 15–23.

Our work in this course will consist in linking up a number of historical observations and enquiries to a series of half-random trains of thought.

After a general introduction defining what we shall take as falling within the scope of our enquiry, we shall speak of the three great powers, State, Religion and Culture, dealing first with their continuous and gradual interaction, and in particular with the influence of the one variable, Culture, on the two constants. We shall then discuss the accelerated movements of the whole process of history, the theory of crises and revolutions, as also of the occasional abrupt absorption of all other movements, the general ferment of all the rest of life, the ruptures and reactions – in short, everything that might be called the theory of storms. We shall then pass on to the condensations of the historical process, the concentration of movements in those great individuals, their prime movers and chief expression, in whom the old and the new meet for a moment and take on personal form. Finally, in a section on fortune and misfortune in world history, we shall seek to safeguard our impartiality against the invasion of history by desire.

It is not our purpose to give directions for the study of history in the scholar's sense, but merely hints for the study of the historical aspect of the various domains of the intellectual world.

We shall, further, make no attempt at system, nor lay any claim to 'historical principles'. On the contrary, we shall confine ourselves to observation, taking transverse sections of history in as many directions as possible. Above all, we have nothing to do with the philosophy of history.

The philosophy of history is a centaur, a contradiction in terms, for history co-ordinates, and hence is unphilosophical, while philosophy subordinates, and hence is unhistorical.

To deal first with philosophy: if it grapples direct with the great riddle of life, it stands high above history, which at best pursues that goal imperfectly and indirectly.

But then it must be a genuine philosophy, that is a philosophy without bias, working by its own methods.

For the religious solution of the riddle belongs to a special domain and to a special inner faculty of man.

As regards the characteristics of the philosophy of history current hitherto, it followed *in the wake of history*, taking longitudinal sections. It proceeded chronologically.

In this way it sought to elicit a general scheme of world development generally in a highly optimistic sense.

Hegel, in the introduction to his *Philosophy of History*, tells us that the only idea which is 'given' in philosophy is the simple idea of reason, the idea that the world is rationally ordered: hence the history of the world is a rational process, and the conclusion yielded by world history *must* (*sic!*) be that it was the rational, inevitable march of the world spirit – all of which, far from being 'given', should first have been proved. He speaks also of the 'purpose of eternal wisdom', and calls his study a theodicy by virtue of its recognition of the affirmative in which the negative (in popular parlance, evil) vanishes, subjected and overcome. He develops the fundamental idea that history is the record of the process by which mind becomes aware of its own significance; according to him, there is progress towards freedom. In the East, only one man was free, in classical antiquity, only a few, while modern times have set all men free. We even find him cautiously putting forward the doctrine of perfectibility, that is, our old familiar friend called progress.

We are not, however, privy to the purposes of eternal wisdom: they are beyond our ken. This bold assumption of a world plan leads to fallacies because it starts out from false premises.

The danger which lies in wait for all chronologically arranged philosophies of history is that they must, at best, degenerate into histories of civilizations (in which improper sense the term philosophy of history may be allowed to stand); otherwise, though claiming to pursue a world plan, they are coloured by preconceived ideas which the philosophers have imbibed since their infancy.

There is, however, one error which we must not impute to the philosophers alone, namely, that our time is the consummation of all time, or very nearly so, that the whole past may be regarded as fulfilled in us, while it, with us, existed for its own sake, for us, and for the future.

History from the religious standpoint has its special rights. Its great model is St Augustine's *City of God*.

There are also other world forces which may interpret and exploit history for their own ends; socialism, for instance, with its history of the masses. We, however, shall start out from the one point accessible to us, the one eternal centre of all things – man, suffering, striving, doing, as he is and was and ever shall be. Hence our study will, in a certain sense, be pathological in kind.

The philosophers of history regard the past as a contrast to and preliminary stage of our own time as the full development. We shall study the *recurrent*, *constant* and *typical* as echoing in us and intelligible through us.

The philosophers, encumbered with speculations on origins, ought by rights to speak of the future. We can dispense with theories of origins, and no one can expect from us a theory of the end.

All the same, we are deeply indebted to the centaur, and it is a pleasure to come across him now and then on the fringe of the forest of historical study. Whatever

his principles may have been, he has hewn some vast vistas through the forest and lent spice to history. We have only to think of Herder.

For that matter, every method is open to criticism, and none is universally valid. Every individual approaches this huge theme of contemplation in his own way, which may be his spiritual way through life: he may then shape his method as that way leads him.

Our task, therefore, being a modest one inasmuch as our train of thought lays no claim to system, we can (fortunately for us!) be thrifty. Not only may and must we leave out of account all hypothetical primitive conditions, all discussions of origins; we must also confine ourselves to the active races, and among these, to the peoples whose history yields us pictures of civilization which are sufficiently and indisputably distinct. Questions such as the influence of soil and climate, or of the movement of history from east to west, are introductory questions for the philosophers of history, but not for us, and hence quite outside our scope.

The same holds good for all cosmologies, theories of race, the geography of the three ancient continents, and so on.

The study of any other branch of knowledge may begin with origins, but not that of history. After all, our historical pictures are, for the most part, pure construction, as we shall see more particularly when we come to speak of the State. Indeed, they are mere reflections of ourselves. There is little value in conclusions drawn from people to people or from race to race. The origins we imagine we can demonstrate are in any case quite late stages. The Egyptian kingdom of Menes, for instance, points to a long and great previous history. How dark is our vision of our contemporaries and neighbours, and how clear our vision of other races, etc.!

What is absolutely necessary here is a discussion of the great general task of the historian, of what we really have to do.

Since mind, like matter, is mutable, and the changes of time bear away ceaselessly the forms which are the vesture of material as of spiritual life, the task of history as a whole is to show its twin aspects, distinct yet identical, proceeding from the fact that, firstly, the spiritual, in whatever domain it is perceived, has a historical aspect under which it appears as change, as the contingent, as a passing moment which forms part of a vast whole beyond our power to divine, and that, secondly, every event has a spiritual aspect by which it partakes of immortality.

For the spirit knows change, but not mortality.

And beside the mutable there appears the multitudinous, the mosaic of peoples and civilizations, which we see mainly as mutual contrasts or complements. We should like to conceive a vast spiritual map on the projection of an immense ethnography, embracing both the material and the spiritual world and striving to do justice to all races, people, manners and religions together. Nevertheless, in late, derivative times, the pulse of humanity actually or seemingly beats in unison now and then, as it did in the religious movement of the sixth century BC, which spread from China to Ionia, and in the religious movement of Luther's time in Germany and India.

And now the central phenomenon of history. A historical power, supremely justified in its own time, comes into being; all possible forms of earthly life, political organizations, privileged classes, a religion closely knit together with

secular life, great possessions, a complete code of manners, a definite conception of law, are developed out of it or associated with it, and in time came to regard themselves as props of that power or even as the sole possible exponents of the moral forces of the epoch. But the spirit works in the depths. Such forms of life may resist change, but the breach comes, whether by revolution or gradual decay, bringing with it the breakdown of moral systems and religions, the apparent downfall of that power, or even the end of the world. But all the time the spirit is building a new house whose outward casing will, in time, suffer the same fate. Faced with historical forces of such a kind, the contemporary individual feels utterly helpless; as a rule he falls into the bondage either of the aggressor or of the defender. Few are the contemporaries who can attain an Archimedean point outside events, and are able to 'overcome in the spirit'. Nor is the satisfaction of those who do so, perhaps, very great. They can hardly restrain a rueful feeling as they look back on all the rest, whom they have had to leave in bondage. Not until much later can the mind soar in perfect freedom over such a past.

What issues from this main phenomenon is historical life, rolling on in a thousand forms, complex, in all manner of disguises, bond and free, speaking now through the masses, now through individuals, now in hopeful, now in hopeless mood, setting up and destroying states, religions, civilizations, now a dark enigma to itself, moved by inchoate feelings born of imagination rather than thought, now companioned only by thought, or again filled with isolated premonitions of what is fulfilled long afterwards.

While, as men of a definite epoch, we must inevitably pay our passive tribute to historical life, we must at the same time approach it *in a spirit of contemplation*.

And now let us remember all we owe to the past as a spiritual *continuum* which forms part of our supreme spiritual heritage. Anything which can in the remotest way serve our knowledge of it must be collected, whatever toil it may cost and with all the resources at our disposal, until we are able to reconstruct whole spiritual horizons of the past.

The attitude of every century to this heritage is itself knowledge, that is, a *novum* which the next generation will, in its turn, add to its own heritage as something which belongs to history, i.e. which has been superseded ...

Here we must ... consider the relation between the two poles, knowledge and opinion. Even in history, our desire for knowledge is often baulked by a thickset hedge of opinions which seek to pass themselves off as records. Nor can we ever rid ourselves entirely of the views of our own time and personality, and here, perhaps, is the worst enemy of knowledge. The clearest proof of this is this: as soon as history approaches our century and our worthy selves we find everything more 'interesting'; in actual fact it is we who are more 'interested'.

Yet another enemy is the darkness of the future in the fate of the individual and of the community; yet we keep our gaze fixed steadily on that darkness, into which the countless threads of the past stretch out, distinct and evident to our prophetic souls, yet beyond our power to follow.

If history is ever to help us to solve even an infinitesimal part of the great and grievous riddle of life, we must quit the regions of personal and temporal foreboding

for a sphere in which our view is not forthwith dimmed by self. It may be that a calmer consideration from a greater distance may yield a first hint of the true nature of life on earth, and, fortunately for us, ancient history has preserved a few records in which we can closely follow growth, bloom and decay in outstanding historical events and in intellectual, political and economic conditions in every direction. The best example is Athens.

Intentions, however, are particularly prone to make their appearance in the guise of patriotism, so that true knowledge finds its chief rival in our preoccupation with the history of our own country.

There are certainly things in which the history of a man's own country will always take precedence, and it is our bounden duty to occupy ourselves with it.

Yet is should always be balanced by some other great line of study, if only because it is so intimately interwoven with our desires and fears, and because the bias it imparts to our mind is always towards intentions and away from knowledge.

Its greater intelligibility is merely apparent, and arises in part from an optical illusion, namely our own much livelier readiness to understand, which may go hand in hand with great blindness.

Our imagined patriotism is often mere pride towards other peoples, and just for that reason lies outside of the path of truth. Even worse, it may be no more than a kind of partisanship within our own national circle; indeed, it often consists simply in causing pain to others. History of that kind is journalism.

Vehement proclamations of metaphysical notions, vehement definitions of good and right, condemning everything outside their limits as high treason, may subsist side by side with the most platitudinous round of life and money-making. Beyond the blind praise of our country, another and more onerous duty is incumbent upon us as citizens, namely to educate ourselves to be comprehending human beings, for whom truth and the kinship with things of the spirit is the supreme good, and who can elicit our true duty as citizens from that knowledge, even if it were not innate in us.

In the realm of thought, it is supremely just and right that all frontiers should be swept away. There is too little of high spiritual value strewn over the earth for any epoch to say: we are utterly self-sufficient; or even: we prefer our own. That is not even the case with the products of industry, where, given equal quality, and due account being taken of customs dues and freight charges, people simply take the cheaper, or, if the price is the same, the better. In the realm of mind we must simply strive for the higher, the highest we can attain.

The truest study of our national history will be that which considers our own country in parallels and in relation to world history and its laws, as a part of a great whole, illumined by the same heavenly bodies as have shone upon other times and other peoples, threatened with the same pitfalls and one day to be engulfed in the same eternal night and perpetuated in the same great universal tradition.

Ultimately, our pursuit of true knowledge will make it necessary for us to eliminate the notions of fortune and misfortune in history … Our immediate task is to deal with the peculiar qualifications of our times for the study of history, which compensate these defects and dangers.

7 William Morris

'The Revival of Architecture', 1888

William Morris (1834–96) was a utopian socialist with a particular interest in replacing the indus-
trial mode of production with one which acknowledged the dignity of labour and the sanctity of
objects made by hand. In short, he was a political reformer who expressed his ideals not only in his
writings but also, and perhaps especially, in his work as an artist. Morris was a Londoner who
studied theology, architecture and painting at Oxford in the 1850s, where he was influenced by
Anglo-catholicism and the writings of John Ruskin. He worked with Edward Burne-Jones, G.E.
Street and especially Dante Gabriel Rossetti, with whom he established Kelmscott Manor in
Oxfordshire as a centre for the arts, founding the Kelmscott Press in the 1890s and the Society for
the Protection of Ancient Buildings in the same period. One of the foremost members of the Arts
and Crafts movement, he established his own company, Morris and Co., and became one of the
most influential designers of the nineteenth century, specializing in designs for wallpaper, carpets,
books and similar objects, made by hand and decorated with medievalist, two-dimensional
imagery. This experience gave him a highly favourable view of the Middle Ages and led him to see
Gothic architecture as the embodiment of many of his ideals. In the following essay he places these
ideals in a historical perspective. The three related strands of society, history and the Gothic style
run through the length of Morris's argument in this essay.

The arts cannot exist separately from society and so should not be seen in isolation from it, he
contends, and architecture is the primary art because it cannot be divorced from everyday life.
Therefore, as Ruskin points out, art has to be of its time, making true revivals strictly speaking
impossible. The most progressive groups in a society may be responsible for the most developed
art, as in Gothic Europe around 1300, or they may be a hindrance, as with the Utilitarianism of
nineteenth-century English society. The future promises a better art because it will grow from a
better society.

Morris celebrates the power of the study of the past: it 'taught us the evolution of architecture, and
is now teaching us the evolution of society'. Given that society and architecture are inextricably
intertwined, an awareness of historical continuity is important because it enables us to understand
what is happening to us.

He praises the Middle Ages as a great period in human history and the Gothic style as one of its
main manifestations. The sixteenth and seventeenth centuries and the introduction of classicism

14 Horace Walpole, Holbein Chamber,
Strawberry Hill, Twickenham, 1749–76.
The contrast between this room and the great
hall in Street's Law Courts (fig. 15) illustrates the
difference between the rococo Gothic of the
eighteenth century and the antiquarian revival of
the nineteenth. Despite the greater accuracy of the
Street building Morris none the less argues that
since the art of a society will reflect that society,
there can never be a true revival. Architects should
instead be attempting to change society into a form
which produces the kind of architecture they would
wish to see. Morris is thus using methods of art-historical
analysis in order to illustrate the need to change society.

into England are nothing more than a 'death's head of inanity and pedantry', with any worthwhile qualities they may have turning out to be derived in any case from the preceding Gothic period. Whereas Gothic used to be thought of as 'a mere accidental jumble of picturesqueness conse-crated by ruin and the lapse of time', architects in the first half of the nineteenth century realized that it is instead a 'logical and organic style' whose principles are universally applicable and capable of endless development (contrast figs. 14 and 15). Since, however, the principles have to grow out of their own society, architects who believe they are working in tune with the principles of an earlier style will not only be mistaken; they are also likely to restore the buildings of that style in a very inaccurate way.

The change in interpretation of Gothic from a picturesque to a logical manner of building which Morris presents here was first proposed by Goethe (text 5, 1772), but the most noteworthy aspect of Morris's text from our point of view is that he not only raises the status of Gothic but also inverts its standard role in the sequence of the ages. This is Vasari's *cycle with his judgements exactly reversed.

94

15 G.E. Street, Great Hall, Law Courts, Strand, London, 1868–82. See fig. 14.

7 | William Morris

'The Revival of Architecture', 1888

William Morris, 'The Revival of Architecture', *Fortnightly Review*, May 1888. Reprinted in Nikolaus Pevsner, *Some Architectural Writers of the Nineteenth Century*, Oxford, 1972, pp. 315–24.

Among cultivated people at present there is a good deal of interest felt or affected in the ornamental arts and their prospects. Since all these arts are dependent on the master-art of architecture almost for their existence, and cannot be in a healthy condition if it is sick, it may be worthwhile to consider what is the condition of architecture in this country; whether or not we have a living style which can lay claim to a dignity or beauty of its own, or whether our real style is merely a habit of giving certain forms not worth noticing to an all-pervading ugliness and meanness.

In the first place, then, it must be admitted on all sides that there has been in this century something like a revival of architecture; the question follows whether that revival indicates a genuine growth of real vitality which is developing into something else, or whether it merely points to a passing wave of fashion which, when passed, will leave nothing enduring behind it. I can think of no better way of attempting a solution of this question than giving a brief sketch of the history of this revival as far as I have noted it. The revival of the art of architecture in Great Britain may be said to have been a natural consequence of the rise of the romantic school in literature, although it lagged some way behind it, and naturally so, since the art of building has to deal with the prosaic incidents of everyday life, and is limited by the material exigencies of its existence. Up to a period long after the death of Shelley and Keats and Scott, architecture could do nothing but produce on the one hand pedantic imitations of classical architecture of the most revolting ugliness, and ridiculous travesties of Gothic buildings, not quite so ugly, but meaner and sillier; and, on the other hand, the utilitarian brick box with a slate lid which the Anglo-Saxon generally in modern times considers as a good sensible house with no nonsense about it.

The first symptoms of change in this respect were brought about by the Anglo-Catholic movement, which must itself be considered as part of the romantic movement in literature, and was supported by many who had no special theological tendencies, as a protest against the historical position and stupid isolation of Protestantism. Under this influence there arose a genuine study of medieval architecture, and it was slowly discovered that it was not, as was thought in the days of Scott, a mere accidental jumble of picturesqueness consecrated by ruin and the lapse of time, but a logical and organic style evolved as a matter of necessity

from the ancient styles of the classical peoples, and advancing step by step with the changes in the social life of barbarism and feudalism and civilization. Of course it took long to complete this discovery, nor as a matter of fact is it admitted in practice by many of the artists and architects of today, though the best of them feel instinctively, perhaps, the influence of the new school of historians, of whom the late John Richard Green and Professor Freeman may be cited as examples, and who have long been familiar with it.

One unfortunate consequence the study of medieval art brought with it, owing indeed to the want of the admission of its historical evolution just mentioned. When the architects of this country had learned something about the building and ornament of the Middle Ages, and by dint of sympathetic study had more or less grasped the principles on which the design of that period was founded, they had a glimmer of an idea that those principles belonged to the aesthetics of all art in all countries, and were capable of endless development; they saw dimly that Gothic art had been a living organism, but though they knew that it had perished, and that its place had been taken by something else, they did not know why it had perished, and thought it could be artificially replanted in a society totally different from that which gave birth to it. The result of this half-knowledge led them to believe that they had nothing to do but to design on paper according to the principles the existence of which they had divined in Gothic architecture, and that the buildings so designed, when carried out under their superintendence, would be true examples of the ancient style, made alive by those undying principles of the art. On this assumption it was natural that they should attempt with confidence to remedy the injuries and degradations which the ignorance, brutality, and vulgarity of the post-Gothic periods had brought on those priceless treasures of art and history, the buildings yet left to us from the Middle Ages. Hence arose the fatal practice of 'restoration', which in a period of forty years had done more damage to our ancient buildings than the preceding three centuries of revolutionary violence, sordid greed (utilitarianism so called), and pedantic contempt. This side of the subject I have no space to dwell on further here. I can only say that if my subject could be looked on from no other point of view than the relation of modern architecture to the preservation of these relics of the past, it would be most important to face the facts of the present condition of the art among us, lest a mere delusion as to our position should lead us to throw away these treasures which once lost can never be recovered. No doubt, on the other hand, this same half-knowledge gave the new school of architects courage to carry on their work with much spirit, and as a result we have a considerable number of buildings throughout the country which do great credit to the learning and talent of their designers, and some of them even show signs of genius struggling through the difficulties which beset an architect attempting to produce beauty in the midst of the most degrading utilitarianism.

In the early period of this Gothic revival the buildings thus produced were mostly ecclesiastical. The public were easily persuaded that the buildings destined for the use of the Anglican Church, which was obviously in part a survival from the Church of the Middle Ages, should be of the style which obtained in the period to which the greater part of its buildings belonged; and indeed it used to be

customary to use the word 'ecclesiastical' as a synonym for medieval architecture. Of course this absurdity was exploded among the architects at a very early stage of the revival, although it lingered long and perhaps still lingers among the general public. It was soon seen by those who studied the arts of the Middle Ages that there was no difference in style between the domestic and civil and the ecclesiastical architecture of that period, and the full appreciation of this fact marks the second stage in the 'Gothic Revival'.

Then came another advance: those who sympathized with that great period of the development of the human race, the Middle Ages, especially such of them as had the gift of the historical sense which may be said to be a special gift of the nineteenth century, and a kind of compensation for the ugliness which surrounds our lives at present: these men now began not only to understand that the medieval art was no mere piece of reactionary official ecclesiasticism or the expression of an extinct theology, but a popular, living, and progressive art – and that progressive art had died with it; they came to recognize that the art of the sixteenth and seventeenth centuries drew what vigour and beauty it had from the impulse of the period that preceded it, and that when that died out about the middle of the seventeenth century nothing was left but a *caput mortuum* of inanity and pedantry, which demanded perhaps a period of stern utilitarianism to form, as it were, the fallow of the arts before the new seed could be sown.

Both as regards art and history this was an important discovery. Undismayed by their position of isolation from the life of the present, the leaders of this fresh renaissance set themselves to the stupendous task of taking up the link of historical art where the pedants of the older so-called renaissance had dropped it, and tried to prove that the medieval style was capable of new life and fresh development, and that it could adapt itself to the needs of the nineteenth century. On the surface this hope of theirs seemed justified by the marvellous elasticity which the style showed in the period of its real life. Nothing was too great or too little, too commonplace or too sublime for its inclusive embrace; no change dismayed it, no violence seriously checked it; in those older days it was a part of the life of man, the universal, indispensable expression of his joys and sorrows. Could it not be so again? we thought; had not the fallow of the arts lasted long enough? Were the rows of square brown brick boxes which Keats and Shelley had to look on, or the stuccoed villa which enshrined Tennyson's genius, to be the perpetual concomitants of such masters of verbal beauty; was no beauty but the beauty of words to be produced by man in our times; was the intelligence of the age to be for ever so preposterously lopsided? We could see no reason for it, and accordingly our hope was strong; for though we had learned something of the art and history of the Middle Ages, we had not learned enough. It became the fashion among the hopeful artists of the time I am thinking of to say that in order to have beautiful surroundings there was no need to alter any of the conditions and manners of our epoch; that an easy chair, a piano, a steam-engine, a billiard-table, or a hall fit for the meeting of the House of Commons, had nothing essential in them which compelled us to make them ugly, and that if they had existed in the Middle Ages the people of the time would have made them beautiful. Which certainly had an element of truth in it, but was not all the truth. It was indeed true that the

medieval instinct for beauty would have exercised itself on whatsoever fell to its lot to do, but it was also true that the life of the times did not put into the hands of the workman any object which was merely utilitarian, still less vulgar; whereas the life of modern times forces on him the production of many things which can be nothing but utilitarian, as for instance a steam-engine; and of many things in which vulgarity is innate and inevitable, as a gentleman's clubhouse or the ceremonial of our modern bureaucratic monarchy. Anyhow, this period of fresh hope and partial insight produced many interesting buildings and other works of art, and afforded a pleasant time indeed to the hopeful but very small minority engaged in it, in spite of all vexations and disappointments. At last one man, who had done more than anyone else to make this hopeful time possible, drew a line sternly through these hopes founded on imperfect knowledge. This man was John Ruskin. By a marvellous inspiration of genius (I can call it nothing else) he attained at one leap to a true conception of medieval art which years of minute study had not gained for others. In his chapter in *The Stones of Venice*, entitled 'On the Nature of Gothic, and the Function of the Workman therein', he showed us the gulf which lay between us and the Middle Ages. From that time all was changed; ignorance of the spirit of the Middle Ages was henceforth impossible, except to those who wilfully shut their eyes. The aims of the new revival of art grew to be infinitely greater than they had been in those who did not give up all aim, as I fear many did. From that time forth those who could not learn the new knowledge were doomed to become pedants, differing only in the externals of the art they practised or were interested in from the unhistorical bigwigs of the eighteenth century. Yet the essence of what Ruskin then taught us was simple enough, like all great discoveries. It was really nothing more recondite than this, that the art of any epoch must of necessity be the expression of its social life, and that the social life of the Middle Ages allowed the workman freedom of individual expression, which on the other hand our social life forbids him.

I do not say that the change in the Gothic revivalists produced by this discovery was sudden, but it was effective. It has gradually sunk deep into the intelligence of the art and literature of today, and has had a great deal to do with the sundering of the highest culture (if one must use that ugly word) into a peculiarly base form of cynicism on the one hand, and into practical and helpful altruism on the other. The course taken by the Gothic revival in architecture, which, as aforesaid, is the outward manifestation of the Romantic school generally, shows decided tokens of the growing consciousness of the essential difference between our society and that of the Middle Ages. When our architects and archaeologists first mastered, as they supposed, the practice and principles of Gothic art, and began the attempt to reintroduce it as a universal style, they came to the conclusion that they were bound to take it up at the period when it hung balanced between completion and the very first beginnings of degradation. The end of the thirteenth and beginning of the fourteenth century was the time they chose as that best fitted for the foundation of the Neo-Gothic style, which they hoped was destined to conquer the world; and in choosing this period on the verge of transition they showed remarkable insight and appreciation of the qualities of the style. It had by that time assimilated to itself whatever it could use of classical art,

mingled with the various elements gathered from the barbaric ancient monarchies and the northern tribes, while for itself it had no consciousness of them, nor was in any way trammelled by them; it was flexible to a degree yet undreamed of in any previous style of architecture, and had no difficulties in dealing with any useful purpose, any material or climate; and with all this it was undeniably and frankly beautiful, cumbered by no rudeness, and degraded by no whim. The hand and the mind of man, one would think, can carry loveliness (a loveliness, too, that never cloys) no further than in the architectural works of that period, as for instance in the choir and transepts of Westminster Abbey before it had suffered from degradations of later days, which truly make one stand aghast at the pitch of perversity which men can reach at times. It must be remembered too, in estimating the judgement of the Neo-Gothic architects, that the half-century from 1280 to 1320 was the blossoming-time of architecture all over that part of the world which had held fast to historical continuity; and the East as well as the West produced its loveliest works of ornament and art at that period. This development, moreover, was synchronous with the highest point of the purely medieval organization of industry. By that time the Guild-merchants and Lineages of the free towns, which had grown aristocratic, exclusive, and divorced from actual labour, had had to yield to the craft guilds, democratic bodies of actual workmen, which had now taken the position that they had long striven for, and were the masters of all industry. It was not the monasteries, as we used to be told, which were the hives of the art of the fourteenth century, but the free towns with their crafts organized for battle as well as craftsmanship; not the reactionary but the progressive part of the society of the time.

This central period therefore of the Gothic style, which expressed the full development of the social system of the Middle Ages, was undoubtedly the fittest period to choose for the tree on which to graft the young plant of Neo-Gothic; and at the time of which I am now thinking every architect of promise would have repudiated with scorn the suggestion that he should use any later or impurer style for the works he had to carry out. Indeed there was a tendency, natural enough, to undervalue the qualities of the later forms of Gothic, a tendency which was often carried to grotesque extremes, and the semi-Gothic survivals of the late sixteenth and the seventeenth centuries were looked on with mere contempt, in theory at least. But as time passed and the revivalists began to recognize, whether they would or not, the impossibility of bridging the gulf between the fourteenth and the nineteenth centuries; as in spite of their brilliant individual successes they found themselves compelled to admit that the Neo-Gothic graft refused to grow in the commercial air of the Victorian era; as they toiled conscientiously and wearily to reconcile the Podsnappery of modern London with the expression of the life of Simon de Montfort and Philip van Artevelde, they discovered that they had pitched their note too high, and must try again, or give up the game altogether. By that time they had thoroughly learned the merits of the later Gothic styles, and even of the style which in England at least (as in literature so in art) had retained some of the beauty and fitness of the palmy days of Gothic amid the conceits, artificialities, and euphuism of the time of Elizabeth and James the First; nay, they began to overvalue the remains of the inferior styles, not

through pedantry, but rather perhaps from sympathy with the course of history, and repulsion from the pessimism which narrows the period of high aspirations and pleasure in life to the standard of our own passing moods. In the main, however, they were moved in this direction by the hope of finding another stand-point for the new and living style which they still hoped to set on foot; the elastic-ity and adaptability of the style of the fifteenth century, of which every village church in England gives us examples, and the great mass of the work achieved by it, in domestic as well as church architecture, ready to hand for study, as well as the half-conscious feeling of its being nearer to our own times and expressing a gradually-growing complexity of society, captivated the revivalists with a fresh hope. The dream of beauty and romance of the fourteenth century was gone; might not the more workaday 'Perpendicular' give us a chance for the housing of Mr Podsnap's respectability and counting-house, and bosom-of-the-family, and Sunday worship, without too manifest an absurdity?

So the architects began on the fifteenth-century forms, and as by this time they had gained more and more knowledge of medieval aims and methods, they turned out better and better work; but still the new living style would not come. The Neo-Gothic in the fourteenth-century style was often a fair rendering of its original; the fifteenth-century rendering has been often really good, and not seldom has had an air of originality about it that makes one admire the capacity and delicate taste of its designers; but nothing comes of it; it is all hung in the air, so to say. London has not begun to look like a fifteenth-century city, and no flavour of beauty or even of generous building has begun to make itself felt in the numberless houses built in the suburbs.

Meantime from the fifteenth century we have sunk by a natural process to imi-tating something later yet, something so much nearer our own time and our own manners and ways of life, that a success might have been expected to come out of this at least. The brick style in vogue in the time of William the Third and Queen Anne is surely not too sublime for general use; even Podsnap might acknowledge a certain amount of kinship with the knee-breeched, cocked-hatted bourgeois of that period; might not the graft of the new style begin to grow now, when we have abandoned the Gothic altogether, and taken to a style that belongs to the period of the workshop and division of labour, a period when all that was left of the craft guilds was the corruption of them, the mere abuses of the close corpora-tions and companies under whose restrictions of labour the commercial class chafed so sorely, and which they were on the point of sweeping away entirely?

Well, it is true that at first sight the Queen Anne development has seemed to compare modern taste more or less; but in truth it is only the barest shadow of it which has done so. The turn that some of our vigorous young architects (they were young then) took towards this latest of all domestic styles can be accounted for without quarrelling with their good taste or good sense. In truth, with the best of them it was not the differentia of the Queen Anne style that was the attraction; all that is a mere bundle of preposterous whims; it was the fact that in the style there was yet left some feeling of the Gothic, at least in places or under circum-stances where the buildings were remote from the progressive side of the eigh-teenth century.

There I say some of the Gothic feeling was left, joined to forms, such as sash windows, yet possible to be used in our own times. The architects in search of a style might well say:

'We have been driven from ditch to ditch; cannot we yet make a stand? The unapproachable grace and liveliness of the fourteenth century is hull down behind us, the fifteenth century work is too delicate and too rich for the commonplace of today; let us be humble, and begin once more with the style of well-constructed, fairly proportioned brick houses which stand London smoke well, and look snug and comfortable at some village end, or amid the green trees of a squire's park. Besides, our needs as architects are not great; we don't want to build churches any more; the nobility have their palaces in town and country already (I wish them joy of some of them!); the working man cannot afford to live in anything that an architect could design; moderate-sized rabbit-warrens for rich middle-class men, and small ditto for the hanger-on groups to which we belong, is all we have to think of. Perhaps something of a style might arise among us from these lowly beginnings, though indeed we have come down a weary long way from Pugin's *Contrasts*. We agree with him still, but we are driven to admire and imitate some of the very things he cursed, with our enthusiastic approbation.'

Well, a goodish many houses of this sort have been built, to the great comfort of the dwellers in them, I am sure; but the new style is so far from getting under way, that while on the other hand the ordinary builder is covering England with abortions which make us regret the brick box and slate lid of fifty years ago, the cultivated classes are rather inclined to return to the severity (that is to say, the unmitigated expensive ugliness) of the last dregs of would-be Palladian, as exemplified in the stone lumps of the Georgian period. Indeed I have not heard that the 'educated middle classes' had any intention of holding a riotous meeting on the adjacent Trafalgar Square to protest against the carrying out of the designs for the new public offices which the Aedileship of Mr Shaw-Lefevre threatened us with. As to public buildings, Mr Street's Law Courts [fig. 15] are the last attempt we are likely to see of producing anything reasonable or beautiful for that use; the public has resigned itself to any mass of dullness and vulgarity that it may be convenient for a department to impose upon it, probably from a half-conscious impression that at all events it will be good enough for the work (so-called) which will be done in it.

In short we must answer the question with which this paper began by saying that the architectural revival, though not a mere piece of artificial nonsense, is too limited in its scope, too much confined to an educated group, to be a vital growth capable of true development. The important fact in it is that it is founded on the sympathy for history and the art of historical generalization, which, as aforesaid, is a gift of our epoch, but unhappily a gift in which few as yet have a share. Among populations where this gift is absent, not even scattered attempts at beauty in architecture are now possible, and in such places generations may live and die, if society as at present constituted endures, without feeling any craving for beauty in their daily lives; and even under the most favourable circumstances there is no general impulse born out of necessity towards beauty, which impulse alone can produce a universal architectural style, that is to say, a habit of elevating and

beautifying the houses, furniture, and other material surroundings of our life.

All we have that approaches architecture is the result of a quite self-conscious and very laborious eclecticism, and is avowedly imitative of the work of past times, of which we have gained a knowledge far surpassing that of any other period. Meanwhile whatever is done without conscious effort, that is to say the work of the true style of the epoch, is an offence to the sense of beauty and fitness, and is admitted to be so by all men who have any perception of beauty of form. It is no longer passively but actively ugly, since it has added to the dreary utilitarianism of the days of Dr Johnson a vulgarity which is the special invention of the Victorian era. The genuine style of that era is exemplified in the jerry-built houses of our suburbs, the stuccoed marine parades of our watering-places, the flaunting corner public houses of every town in Great Britain, the raw-boned hideousness of the houses that mar the glorious scenery of the Queen's Park at Edinburgh. These form our true Victorian architecture. Such works as Mr Bodley's excellent new buildings at Magdalen College, Mr Norman Shaw's elegantly fantastic Queen Anne houses at Chelsea, or Mr Robson's simple but striking London board-schools, are mere eccentricities with which the public in general has no part or lot.

This is stark pessimism, my readers may say. Far from it. The enthusiasm of the Gothic revivalists died out when they were confronted by the fact that they form part of a society which will not and cannot have a living style, because it is an economical necessity for its existence that the ordinary everyday work of its population shall be mechanical drudgery; and because it is the harmony of the ordinary everyday work of the population which produces Gothic, that is, living architectural art, and mechanical drudgery cannot be harmonized into art. The hope of our ignorance has passed away, but it has given place to the hope born of fresh knowledge. History taught us the evolution of architecture, it is now teaching us the evolution of society; and it is clear to us, and even to many who refuse to acknowledge it, that the society which is developing out of ours will not need or endure mechanical drudgery as the lot of the general population; that the new society will not be hag-ridden as we are by the necessity for producing ever more and more market-wares for a profit, whether any one needs them or not; that it will produce to live, and not live to produce, as we do. Under such conditions architecture, as a part of the life of people in general, will again become possible, and I believe that when it is possible, it will have a real new birth, and add so much to the pleasure of life that we shall wonder how people were ever able to live without it. Meantime we are waiting for that new development of society, some of us in cowardly inaction, some of us amid hopeful work towards the change; but at least we are all waiting for what must be the work, not of the leisure and taste of a few scholars, authors, and artists, but of the necessities and aspirations of the workmen throughout the civilized world.

102

8 Giovanni Morelli

Italian Painters, 1890

Giovanni Morelli (1816–91) was an Italian patriot who made his mark as much in politics as in the attribution of works of art. After serving in the army during the Risorgimento in the 1860s he rose to membership of the Senate in the newly independent Italy in the 1870s, heading a number of commissions on the arts, in particular one which introduced legislation banning the sale of works of art from public institutions and churches. He studied medicine in Switzerland and Germany, as his Protestant upbringing in Bergamo prevented him from attending a university in Italy. This familiarity with the German academic world helped him to argue with the German art historians of his day on their own terms, while the study of medicine led him to develop methods based on the minute examination of the works, like an anatomist or pathologist, in contrast to the more theoretical and academic studies of his art-historical contemporaries, such as the prominent Berlin gallery director Wilhelm von Bode. His reattributions were extensive and met with a large degree of success.

In terms of the analysis of paintings it is no exaggeration to say that the work of Morelli represents the first thorough reassessment of the techniques and standards of ˙connoisseurship since they were established by Vasari in the sixteenth century. Although there had been many developments in the methods of the history of art in the intervening period, these had for the most part concerned the practice of thinking about the subject in broadly philosophical terms, such as constructing new models of history or making new bodies of work, like the Gothic, accessible to study.

Morelli only began publishing his views late in life, after reaching the age of sixty. In 1890 he wrote in German critical accounts of the paintings in the major galleries of Rome, Dresden, Berlin and Rome, published under the pseudonym Ivan Lermolieff (an anagram of his name with a Russian ending), posing as an untutored Russian aristocrat. His real identity was soon revealed, but his disguise forms an integral part of the text reprinted here. This introduction to the book reprinted here is couched in the form of a conversation between himself as Lermolieff, the narrator, and an educated Italian who teaches him the fundamentals of Morellian method. This format permits him to offer unusually uninhibited comments on the worth of art historians, German professors, connoisseurs and critics, as he enjoys himself with numerous asides at the expense of his professional rivals. The reader therefore needs to remember that Morelli is the educated Italian who sets out his real views, and in addition to avoid being misled by the tone of the essay into dismissing the views expressed as lacking in weight.

Morelli's innovation was to analyse paintings with a much greater attention to detail than had previously been the case, that is, by examining aspects which were considered unimportant and which the artist was unlikely to have reassessed for each particular painting, such as the rendering of an ear or fingernail. On this basis Morelli questioned large numbers of universally accepted attributions (see for example fig. 16). The two protagonists, examining works in the Uffizi, provide examples of how this method works, with the Italian reattributing works to Botticelli and Titian, while his Russian pupil reascribes a sheet of drawings in Oxford from Raphael to a Northern master. This last example is argued on the basis of the shape of the thumbnail, 'which we never find in Italian pictures though it frequently occurs in Northern paintings. It resembles a section of an octagon more than anything else, and appears as if it had had three clean cuts with the scissors.'

Morelli's new method can be further understood by examining two criticisms made of it by his contemporaries and his means of rebutting them. The first is the claim that his method is unimportant because it has already been used by other scholars.¹ Morelli's response to this is brief and as 'empirical as the method itself: it may well be that it has been applied by others before him, but if so where are the works which have been successfully reattributed on the basis of its intervention? He makes the fundamental point that almost every question may indeed be reducible to a matter of method, but method is not enough in itself; it has to be applied.

The second criticism approaches his work from the opposite direction and is much more important: Morelli's method is ridiculous because it renders him 'insensible to every deeper quality in a work of art' and takes account only of 'external features', as he quotes his antagonists as saying.² His defence in this case is that his kind of study provides a training which enables him to discern 'the deeper qualities of the mind' and to distinguish fundamental forms from mannerisms. This reply, however, runs counter to his main argument, as it relies on purely intuitive distinctions. He would have been more consistent if he had answered once again that the proof of the pudding is in the eating, and by pointing out that in examining a particular aspect to answer a particular question, he was acting like a scientist testing the age of a canvas.

He is also open to criticism even on his own terms in some of the ways in which he applies his method, as for instance when he reattributes a painting from Italy to Northern Europe because it has a 'hard fixed eye and badly modelled mouth … [a] thumb of the right hand which is completely out of drawing, and … crude colours'. While a hard fixed eye *may* be an independently identifiable characteristic, on what grounds can incompetence be taken as a proof of a non-Italian provenance? Morelli's critics therefore seem to be justified in their second criticism.

The strength of Morelli's method lies in its specificity, in the fact that he examined this physical detail in this particular painting. Speaking as Lermolieff he notes how his Italian mentor's way of identifying a work of art 'by the help of external signs savoured more of an anatomist than of a student of art', and there is a great deal of truth and no shame in the jibe of one of his detractors that, as a former student of medicine, he was 'a mere empiric'.³

Since for Morelli the study of art must be based primarily on the works, he considers reading not only a distraction but something which could be positively inimical to a true understanding of the subject. Thus 'the history of art can only be studied properly before the works of art themselves. Books are apt to warp a man's judgement.' His criticism of reading extends to those who rely on

16 Titian, *Salome with the Head of John the Baptist,*
1512–15. Oil on canvas, 90 × 72 cm. Galleria Doria-
Pamphilj, Rome

This painting, previously thought to be by Pordenone,
is an example of a work reattributed by Morelli on the
basis of comparisons between features such as ear lobes
and fingernails, rather than on the basis of documentary
evidence, the overall character of the style, or the repu-
tation of the piece.

105

the documentary evidence: if there is a conflict between it and the physical evidence of the object,
'the only true record … is the work of art itself.'

He parallels these contrasted approaches with the differences between connoisseurs and art histo-
rians: 'the art historian only needs the testimony of a *written document* to arrive at complete certainty
as to the authorship of a painting'; 'even to look at a painting irritates them'; and 'It is absolutely neces-
sary for a man to be a connoisseur before he can become an art historian, and to lay the foundations
of his history in the gallery and not in the library.' Elsewhere, in an even more dismissive response, he
adds intuition and an awareness of the general impression to the art historian's tools, leading to the
conclusion that art historians are simply expendable, as where he comments that under certain con-
ditions 'your art historian will gradually disappear, no great loss either, you will admit.'

Morelli's approach can therefore be described as narrowly focused, to the extent that he places as
little importance on context as Vasari had done. Lermolieff says of the Pitti Palace that it is hard to
believe so magnificent an edifice could have been built under a Republic, but Morelli replies that
art is not dependent on forms of government. He only allows that historians should consider the
history of civilization alongside the works of art, and that the history of culture does explain some
changes of style, but 'such cases are not so common as is usually asserted.'[4]

1 Giovanni Morelli, *Italian Painters: Critical Studies of their Works* (1890; Preface written in 1889), translated by C.J.
Ffoulkes, London, 1892, Preface, pp. 43–4. For an up-to-date edition of *Italian Painters* see Giovanni Morelli, *Della
Pittura italiana, studi storici-critici: le gallerie Borghese e Doria-Pamphilj in Roma,* Jaynie Anderson, ed., Milan, 1991.

2 *Italian Painters,* op. cit., pp. 44–5.

3 Ibid., p. 46. Morelli's method has been linked to Arthur Conan Doyle's *The Cardboard Box,* in which Sherlock Holmes
receives a package containing two severed ears, from which he deduces important information. Conan Doyle also
published an article on the significance of differences between shapes of ears: see Donald Preziosi, *Rethinking Art
History,* New Haven and London, 1991, p. 93.

4 For a critical assessment of Morelli's method see Richard Wollheim, 'Giovanni Morelli and the Origins of Scientific
Connoisseurship', in his *On Art and the Mind, Essays and Lectures,* London, 1973, pp. 177–201.

8 Giovanni Morelli

Italian Painters, 1890

Giovanni Morelli (Ivan Lermolieff),
*Kunstkritische Studien über italienische Malerei:
die Galerien Borghese und Doria-Pamfilj in Rom,*
Leipzig, 1890. Excerpts from 'Principles and
Method', in *Italian Painters: Critical Studies of
their Works,* translated by C.J. Ffoulkes, London,
1892, pp. 1–58.

PRINCIPLES AND METHOD

As I was leaving the Pitti one afternoon, I found myself descending the stairs in company with an elderly gentleman, apparently an Italian of the better class. I had frequently noticed him in the galleries, either alone or with several younger companions, and his unusual intelligence in observing and discussing pictures had often struck me. On that particular afternoon I was greatly impressed by all I had seen: by the splendour of the rooms, by the masterpieces of art, more especially a landscape by Rubens which I had studied just before leaving, and by the beauty of the gardens with their pines, cypresses, and ilex groves. As we left the palace, I could not refrain from expressing to this gentleman my admiration of Brunelleschi's stately pile.

'I never should have believed', I added, 'that so magnificent an edifice could have been erected under a Republic.'

'And why not?' enquired my companion smiling. 'Do you suppose that art is dependent on the form of government? Provided outward circumstances be favourable, I should imagine that art, like religion, will flourish equally under republican or despotic rule. As you seem to appreciate our great architect,' he continued, 'may I invite you to accompany me to the Villa Rucciano, also built by Brunelleschi for his wealthy fellow-citizen, Luca Pitti? It is not far off, and the evening is fine and balmy.'

I thanked him for his kind proposal, and observed that, being a Russian, and in Italy for the first time, I had never heard of the Villa, which was not even mentioned in my guidebook ...

'I travelled [I said] from Munich to Florence, via Verona and Bologna, and did not stop to see either of these places even superficially, though no doubt they are both full of interest. As an excuse, I must plead that the endless books on art and aesthetics which I read in Germany and Paris had given me such a positive distaste for the subject and all connected with it, that I came to Italy vowing not to visit a single church or picture gallery. Florence, however, soon forced me to abandon this resolution.'

'Then you were formerly an admirer of art, and it was your sojourn in

Germany and Paris which gave rise to this aversion to it?'

'Distaste, perhaps, but scarcely aversion,' I rejoined.

'Brought on probably by too much reading,' said my new friend. 'The truth is, art must be seen, if we are to derive either instruction or pleasure from it.'

'A very different view is taken in Germany, my dear sir,' said I. 'There people will only read, and art must be brought to public notice, not through the medium of brush or chisel, but through that of the printing press.'...

'Don't speak to me of art connoisseurs. I read so many controversial publications about them when in Germany, that I am sick of the subject. You must know', I added, seeing that my friend seemed startled by my vehemence, 'that the professors who bring out volumes on the history of art are the bitterest foes of the connoisseurs, while the painters in their turn abuse both. It has been said, sarcastically, that the art connoisseur is distinguished from the art historian by knowing something of early art. If he happens to be of the better sort he abstains from writing on the subject. On the other hand, the art historian, although writing much upon art, really knows nothing about it; while the painters who boast of their technical knowledge are neither competent critics nor competent historians.'

The Italian, who apparently had never heard of this paper war in Germany, laughed heartily at my description, but observed, as he paused for an instant to muse on the matter, that the subject seemed likely to foster an interesting controversy. Then he went on his way for a time in thoughtful silence, till, reaching a green spot near the Arno, he suggested that we should sit down and rest. It was a beautiful autumn evening; the dark slender tower of the Palazzo Vecchio shot up proudly into the sky; in the distance lay the blue hills of Pistoia and Pescia, bathed in golden light.

As we sat down, he began again: 'You say that in Germany and Paris art historians do not acknowledge art connoisseurs, and vice versa?'

'No, no,' I said, 'art connoisseurs say of art historians that they write about what they do not understand; art historians, on their side, disparage the connoisseurs, and only look upon them as the drudges who collect materials for them, but who personally have not the slightest knowledge of the physiology of art.'

'It appears to me,' said my companion, 'that the French and German professors have been rather hasty in their judgement, and have hardly given the matter due attention. The controversy is one of very long standing, and by no means without interest, but deserves unbiased and impartial criticism. What is an art connoisseur after all,' he added, 'but one who understands art?'

'Decidedly so, to judge by the name,' I said. 'An art historian, on the other hand,' I continued, 'is one who traces the history of art from its earliest development to its final decay, and who describes the process to us. Is it not so?'

'It certainly ought to be,' rejoined the Italian. 'But in order to write or discourse about the development of any subject, we ought first to be thoroughly acquainted with it. No one, for instance, would dream of writing on physiology without having first mastered anatomy.'...

'In former days' ... said the Italian, 'the history of art was then commonly taught by men absolutely devoid of any real feeling for art, mostly aesthetic literati

or pedantic archaeologists, who had gleaned all their information from the writings of their predecessors, or had picked it up from the discourses of the professors in the academies. But nowadays, I hear, things are very different in England and France, and especially in Germany, where every university has its art professorship filled by distinguished and learned men, who year by year train up a certain number of able scholars to follow in their steps.'...

'Really competent professors of the history of art [said the Italian] are very scarce in Europe, and for the simple reason that men still go on in the old groove – studying art from books only, instead of from the works of art themselves.'

'This may be one reason,' I replied; 'the superficial dabbler, who causes confusion and anarchy in science, just as much as in politics, owes his existence to the pernicious influence of many inferior teachers.'

'Very true,' returned my companion; 'I have always felt that men who set up to teach others should first get a clear idea themselves of the works which practically constitute art, should study these works, be they of painting, sculpture, or architecture, with intelligence, analyse them, distinguish between good and bad specimens – in a word, should thoroughly understand them.'

'I suppose you refer to what may be termed "art morphology", that is, to the understanding of the outward forms in a work of art; and in a measure, I allow that you are right. But a German art philosopher would tell you that the idea existed in the mind of the artist long before the visible part of his work took shape; that the task of the art historian is to grasp, fathom, and explain this idea – the main problem he has to solve being how to attain to a fundamental understanding of a work of art. The historian himself would tell you that the history of art should direct attention, not so much to the works of art themselves, as to the culture of the people under whose influence and auspices these works originated.'

'Then, in that case,' rejoined the Italian, 'setting aside the fact that it is almost impossible to penetrate to the inward part of anything without being first acquainted with its outward conditions, the history of art may be said to resolve itself into a physiological treatise on art on the one hand, and a history of civilization on the other; both excellent branches of philosophy in their way, but scarcely adapted to promote a taste for art, or to further its knowledge. I do not deny that the causes of certain changes in style can only be satisfactorily explained by reference to the history of culture, though such cases are not so common as is usually asserted ...

'The study of the works of Raphael or Leonardo [he continued] presupposes a thorough acquaintance with all the other Italian schools. To gain a more intimate knowledge of these two great artists, to form a right judgement of their merits, and to be able to indicate what special benefits they conferred on their schools in point of conception, representation, and technique, we must both study every example of the school whence these masters emanated, and must learn to estimate the merits of their predecessors and contemporaries, as well as of their immediate scholars. Unless our judgement rests on this sure and solid foundation, it will always remain one-sided and deficient, and we cannot lay claim to any real understanding of art.'

'But, my dear sir,' I broke in, 'the elaborate and tedious course of study which you appear to think incumbent on an art-historian would end by turning him into a mere connoisseur, and would leave him no time at all for studying the history of art itself.'

The Italian smiled. 'You have hit the right nail on the head,' he said; 'true enough, your art historian will gradually disappear (no great loss either, you will admit), and in due course of time, as the larva develops into the butterfly, the connoisseur will emerge from his chrysalis state.'

This triumphant rejoinder caused me rather an unpleasant surprise. 'I cannot agree with you here,' I said, 'and as a proof that you are in the wrong, or, at all events, that you expect far too much from art historians, let me mention two of the most recent publications about Raphael, which have appeared respectively in Paris and Berlin – the two great centres of all historical research in matters of art. The first is a magnificent volume, and was received with acclamation, not only in Paris, but I may almost say throughout the whole civilized world. The second, the work of a professor of art at Berlin, was greeted with rapturous applause, at all events on the banks of the Spree. Both writers are art historians of the first water, but by no means connoisseurs; indeed, both would be mortally offended if you were to characterize them as such, for even to look at pictures irritates them.'

The Italian burst out laughing. 'I should never dream of such a thing,' he said. 'No, no, my dear sir,' he continued with growing excitement, 'it is only after profound and earnest study that a lover of art develops, gradually and insensibly, into a connoisseur, and finally into an art historian, provided he has it in him, which of course is a *conditio sine qua non*. Every young man may begin life with the intention of becoming a priest, a lawyer, a professor, an engineer, a land-surveyor, or a doctor; if he be well off he may even aspire to become a deputy to the Parliament; but it would be simply ludicrous if a youth of twenty or twenty-four were to say: 'I am going to be an art critic, or perhaps even an art historian.'

'And yet,' I observed, 'this is what constantly occurs, especially when a man has been unsuccessful in other professions.'

'Such cases are of no great consequence,' said my companion, 'so long as they are the exception and not the rule; they will occur in every department of knowledge, in science as well as in art. But, to resume our discussion. All that I wish to contend is that the germ of the art historian, if it exist at all, can only develop and ripen in the brain of the connoisseur; in other words, it is absolutely necessary for a man to be a connoisseur before he can become an art historian, and to lay the foundations of his history in the gallery and not in the library.'...

'In these days,' he resumed, 'a more intelligent and unbiased method of criticism has done something towards dispelling some of these pointless and even childish fabrications; but much still remains to be done. For the present we may leave this comparatively subordinate study alone, and go back to our former theory – that the history of art can only be studied properly before the works of art themselves. Books are apt to warp a man's judgement, though at the same time I am quite ready to admit that good reproductions and representations of the art of the Egyptians, the Hindus, the Assyrians, Chaldeans, Phœnicians, Persians, etc., and of the earliest examples of Greek art, are of the greatest value from an

educational point of view, and as a means of deepening and increasing our feeling for art. But the art which we can best understand and appreciate is that which stands in the closest relation to our own era of civilization, and books and documents will not suffice for studying it; we must go to the works of art themselves, and, what is more, to the country itself, tread the same soil and breathe the same air, where they were produced and developed. For does not Goethe say? "Wer den Dichter will verstehen muss in Dichters Lande gehen."' [Whoever wishes to understand the poet must go to the poet's land.]

'Your theory, then,' I observed, 'is that a true knowledge of art is only to be attained by a continuous and untiring study of form and technique, that no one should venture into the domain of the history of art without being first an art connoisseur. All your arguments may be correct enough, but my own studies are too elementary for me either to agree with, or to differ from, you at present. One thing, however, I may confidently affirm, namely, that all the art historians and connoisseurs whom I have met in Europe would treat with contempt your theories. They would tell you that he whom Nature had destined for a true art historian or critic, need not think of troubling himself about the details upon which you lay so much stress; in his eyes it would be sheer waste of time, and would simply deaden his intellect to do so. The *general impression* produced upon him by a work of art, be it picture or statue, is quite sufficient to enable him to recognize the master at the first glance, and beyond this general impression or intuition, and tradition, he only needs the testimony of a *written document* to arrive at complete certainty as to its author. All other expedients could, at most, be of service only to those who know nothing of their business – like the lifebelt to the man who cannot swim – if, indeed, they do not make confusion worse confounded in the study of art, and foster "the most fatal dilletantism".'

'The same objections are raised here,' replied the Italian, 'against the study of form and technique – that is, against analytical research; and the loudest protests are made by those who have neither the disposition, nor the capacity, for studying anything thoroughly. I know persons, by no means deficient in intelligence or culture, who consider that understanding a subject means degrading it, and are as violently opposed to the study of form and technique in works of art as are priests, for the most part, to physical science. Let us weigh the matter dispassionately. You say, if I have rightly understood you, that art historians in Germany and Paris only attach importance to intuition, and to documentary evidence, and regard the study of works of art as purposeless and a waste of time. It is quite possible, I admit, that the general impression or intuition may often be sufficient to enable an astute and well-trained eye to *guess* at the authorship of a work of art. But the Italian proverb is frequently verified in these cases: "l'apparenza inganna" – appearances are deceitful. I maintain, therefore, and could support my assertion by any amount of evidence, that, so long as we trust only to the general impression for identifying a work of art, instead of seeking the surer testimony of the forms peculiar to each great master with which observation and experience have made us familiar, we shall continue in the same atmosphere of doubt and uncertainty, and the foundations of the history of art will be built as heretofore on shifting sands ...

'All art historians, from Vasari down to our own day [he went on], have only made use of two tests to aid them in deciding the authorship of a work of art – intuition, or the so-called general impression, and documentary evidence; with what result you have seen for yourself. You say that, after reading much literature on art and art criticism in Paris and Germany, you came to the conclusion that every critic thinks it necessary to set up a theory of his own.'

'Yes, unhappily this is the case,' I replied; 'all these books and pamphlets had the effect of setting me against the study of art.'

'I allow', continued my companion, 'that a general impression is sometimes sufficient to determine whether a work of art be Italian, Flemish, or German; and, if Italian, whether of the Florentine, Venetian, or Umbrian school; and that intuition alone may occasionally enable a practised eye to identify the author of a painting or statue (even the most ordinary art dealer possesses this kind of shrewdness), for in all intellectual matters the general conditions govern the particular. If this main question be settled, and it be assumed that the painting, or drawing, belongs to the early Florentine school, we must then make up our mind whether it be by Fra Filippo Lippi, Pesellino, Sandro Botticelli, or Filippino Lippi, or by one of the many imitators of these masters. Further, if the general impression convinces us that the painting is of the Venetian school, we must then decide if it be of the school of Venice itself or that of Padua, or, again, if it belong to that of Ferrara, or to that of Verona, etc. To arrive at a conclusion (often by no means an easy matter) the general impression is not sufficient … Only by gaining a thorough knowledge of the characteristics of each painter – of his forms and of his colouring – shall we ever succeed in distinguishing the genuine works of the great masters from those of their pupils and imitators, or even from copies; and though this method may not always lead to absolute conviction, it at least brings us to the threshold.'

'That may be,' said I, 'but you must recollect that every human eye sees form differently.'

'Exactly so,' said the Italian, 'and, for this very reason, every great artist sees and represents these forms in his own distinctive manner; hence, for him they become characteristic. For they are by no means the result of accident or caprice, but of internal conditions. You had better say', he continued, smiling, 'that most persons, and pre-eminently art historians, and "art philosophers" as you call them, do not see these various forms at all. Preferring, as their practice is, mere abstract theories to practical examination, it is their wont to look at a picture as if it were a mirror, in which, as a rule, they see nothing but the reflection of their own minds. It is no easy matter, I admit, to see form correctly – I might almost say to feel it aright; this is partly due to the physical conformation of the eye' …

'I am quite of your opinion on that score,' replied my companion quietly. 'The nearer the copyist, who, of course, reproduces the original after his own manner, approaches to the taste and feeling of our own day, the greater will be the appreciation of his work by the public. Correggio's *Magdalen*, and the Holbein *Madonna* at Dresden, are instances of this, and I could cite many others equally striking.'

'I have long had the same opinion', I said warmly, 'of the people one comes across in picture galleries.'

'We have rather drifted away from our subject,' said the Italian as he rose from the bench. 'I think, however, we are pretty well agreed, both as to the value of what is termed "tradition", and as to the state of indecision in which the general impression leaves us when we wish to identify an old picture.'

'Say, rather, we are entirely agreed,' I rejoined. 'I suppose, however, that you respect documentary evidence?'

'Written documents', he replied, 'are only of value in the hands of a scientifically trained and competent critic; in those of a novice in the study of art, or of a keeper of archives who understands nothing of the subject, they are not only useless, but misleading.'

'Do you mean to say', I exclaimed, 'that you are even going to cast doubts upon the value of records which all art historians prize so highly?'

'The only true record for the connoisseur', he replied calmly, 'is the work of art itself. You may think this a bold and sweeping assertion, but I can assure you that it is not so, and I can prove it by several examples. Is there any document more likely to inspire confidence, more apparent to every spectator, than that bearing the master's own name on a picture, which we call in Italian a *cartellino*?'

'Well,' I replied, 'if every painting were signed with its author's name, there would certainly be no great merit in being a connoisseur.'

'There I cannot agree with you,' said the Italian; 'art historians and gallery directors are still duped by records and *cartellini*, just as in the good old days, when passports were an absolute necessity, the police were taken in by the greatest scoundrels. I could mention dozens of forged *cartellini*, of old standing and of recent date, on pictures in some of the principal galleries ... On [a] Ferrarese painting, representing St Sebastian, has been inscribed by some forger the name "Laurentius Costa" in Hebrew characters. Everyone accordingly assigned the picture to this master, though a practised eye would have seen at a glance that it was by Cosimo Tura, of whom, moreover, it is a most characteristic example. I could enumerate many more such "documents" which have been wrongly interpreted by the unlearned, and many signatures which were inscribed upon pictures even centuries ago with intent to deceive. Art historians consider that their antiquity attests their genuineness; and base profound and elaborate dissertations upon them.'

'The less we understand of a subject,' I observed, 'the louder and more emphatic will be the admiration we express for it.'

'Now,' continued my companion, 'I must mention another kind of document – those in archives which are constantly being reclaimed from dust and oblivion by diligent and praiseworthy enquirers. Keepers of archives, in Italy and Belgium especially, have been most indefatigable in their search for documents relating to artists and their works. Many of these records have already been, and no doubt may still be, the means of throwing light on obscure points, and of discovering the names of hitherto unknown artists ... On the other hand, many of these documents, interpreted by archivists in their own way, have been the means of propagating the gravest errors. It is, of course, hardly necessary to add that these records only make mention of large and important works executed for churches, or by order of princes. Paintings in public and private collections are

for the most part small easel pictures, and documents relating to their authorship and pedigrees will scarcely be forthcoming. We are thrown either upon tradition, or upon the general impression when we have to pass judgement on them, and as the intuitive faculties differ in each individual, the conclusions arrived at must necessarily be of the most varied nature. I will cite a few examples to show you that I have not exaggerated. About 1840 a large fresco of the "Last Supper" was discovered at Florence, in the suppressed convent of S. Onofrio, under a coating of whitewash. Writers on art, connoisseurs, and painters formed different opinions with regard to it; some even went so far as to ascribe it to Raphael, and it was engraved as his work by the late Signor Jesi. More judicious critics pronounced it to be of the school of Perugia. One day, however – in the Strozzi library, if I mistake not – a painter came upon a document from which it appeared that, in 1461, Neri di Bicci, an indifferent Florentine artist, had been commissioned to paint a "Last Supper" in the convent of S. Onofrio. *Eureka!* cried the happy finder, and immediately published his precious document. The more intelligent connoisseurs turned the discovery into ridicule. Indeed one of the best-known and most distinguished archivists in Italy considered it so absurd, that he thought it his duty to make an example of the discoverer by publicly taking him to task. At the same time he availed himself of the opportunity to express his own individual opinion that it was the work of Raffaellino del Garbo, a later Florentine painter, and a pupil of Filippino Lippi. But by doing so he showed that his own knowledge of art was on much the same level as that of the painter who, on the strength of his document, had maintained that Neri di Bicci was the author of the fresco.'

'And to whom is the fresco now attributed?' I asked.

'Passavant gave it to Giovanni Spagna, Signor Cavalcaselle to Gerino da Pistoia; both critics therefore considered it to be by a pupil of Perugino ... I should like to draw your attention to two others which are attributed to Fra Filippo Lippi in the catalogue, though I consider one of them to be the work of his pupil Sandro Botticelli.'

I followed my active guide into the next room, where we found a small picture ... representing St Augustine in his study.

'Look at this painting carefully,' he said, as he placed me before it in the best light. 'Among Sandro Botticelli's characteristic forms I will mention the hand, with bony fingers – not beautiful, but always full of life; the nails, which, as you perceive in the thumb here, are square with black outlines, and the short nose with dilated nostrils, which you see exemplified in Botticelli's celebrated and undisputed work hanging close by – *The Calumny of Apelles* ... Note, too, the peculiar lengthened folds of the drapery, and the transparent golden red colour in both pictures. If you like, you may also compare the nimbus round the head of St Augustine, with the glories of other saints in *authentic* works of the same period by the master, and you will, I think, be forced to acknowledge that the painter of the *Calumny*, and of the large *Tondo* ... in the next room, must also have been the author of this St Augustine.'

This matter-of-fact way of identifying works of art by the help of such external signs savoured more of an anatomist, I thought, than of a student of art ...

'To cite a few out of many instances [my companion proceeded], we find in Oxford a sheet containing, among other studies, the head of a young man and a hand, ascribed to Raphael and reproduced as such in the publications of the Grosvenor Gallery ... It is just this hand, however, which reveals the northern master, for the thumbnail is of a form which we never find in Italian pictures, though it frequently occurs in northern paintings. It resembles a section of an octagon more than anything else, and appears as if it had had three clean cuts with the scissors. At Chatsworth we also find a study of two hands, which, notwithstanding their decidedly northern character, are ascribed to Parmigianino ... Look at the hand in this portrait, particularly at the ball of the thumb, which is too strongly developed, and at the round form of the ear. In all his early works, and in most of those of his *middle period* till between 1540 and 1550, Titian adheres to the same round form of ear – for instance, in the *Three Ages*, and the *Holy Family* in the Bridgewater collection (the latter picture being wrongly attributed to Palma Vecchio); in the *Daughter of Herodias* in the Doria-Pamfili gallery ... This peculiarity in the ball of the thumb also frequently occurs in his other paintings and in his drawings ...'

'Suppose we examine this celebrated portrait [of a Cardinal, attributed to Raphael] a little more closely. The liquid character of its painting recalled the method of the German masters to Passavant; he even thought that Raphael might have been under the influence of some of Holbein's pictures when engaged upon it, which, however, I may observe incidentally, was a chronological impossibility. But there can be no doubt that the technique of the painting is not Italian; this must strike every connoisseur. Look at the hard fixed eye and badly modelled mouth, at the thumb of the right hand which is completely out of drawing, and at the crude colours of the book. You must acknowledge that no great master could have painted this portrait. However, to relieve your mind of all uncertainty, I may as well tell you at once, that the original is still in the possession of the Inghirami family at Volterra, and though ruined by modern restoration, it is still recognisable in parts as the work of Raphael.'

Of course there was nothing more to be said after this, and I was forced to give in, though I must confess that my guide's destructive criticism was as displeasing to me as were firearms to Ariosto's Orlando.

'On the opposite wall,' he continued, 'there is another portrait of a Cardinal, which is still given to Raphael, though Passavant rightly pronounced it the work of a scholar.' When I examined it I had no difficulty in perceiving that the eyes and the left hand were badly modelled, and that the ear was not of that round fleshy form which we had been noticing in Raphael's genuine portraits. 'Another similar work of the school, representing Cardinal Passerini, is in the Naples Museum,' he said, as, glancing at his watch, he prepared to leave. And I also was of the opinion that for the present this one lesson was quite enough. So we parted.

I remained in Florence some weeks longer, and made use of the time to follow up the teaching of my guide by studying form in painting, sculpture, and architecture. I soon came to the conclusion, however, that such a dry, uninteresting, and even pedantic, study may be all very well for a 'former student of medicine,' and might even be of service to dealers and experts, but in the end must prove

detrimental to the truer and more elevated conception of art. And so I left Florence dissatisfied.

On my return to Kasan I heard, to my surprise, that Prince Smaranzoff's celebrated collection of pictures, principally Italian of the best period, was shortly to be sold by auction. My first art-studies had been made in this gallery, as the château was only a few versts from the town, and I had often been there in my youth. I still had a lively recollection of the six Madonnas by Raphael which it contained, and I now felt a strong desire to see and study the pictures again before they were scattered to the four winds.

One bright December morning, therefore, I ordered my sleigh and started in high spirits. I found the splendid rooms swarming with Russians and foreigners – dealers, art connoisseurs, and directors of galleries. They were all examining the pictures one by one, with the greatest interest, and, as I thought at first, with immense knowledge, going into raptures first over one, then over another; identifying here a Verrocchio, there a Melozzo da Forli – even a Leonardo da Vinci – at the first glance. I listened curiously to their analytical remarks about the fine technical qualities of the Venetian pictures, and the excellent state of preservation of the Raphaels, and marvelled; but what was my astonishment, when at length I was able to approach, and critically to examine, all these Madonnas, with which I also had been enchanted some years before! The Raphaels in the Pitti were still fresh in my memory, and I could not refrain from testing these works of art by the method the Italian in Florence had taught me. I could hardly believe my eyes, and felt as if scales had suddenly fallen from them. The Madonnas, one and all, now appeared to me equally stiff and uninteresting, the children feeble if not positively absurd; as to the forms, they had not a trace of Raphael. In short, these pictures, which only a few years before had appeared to me admirable works by Raphael himself, did not satisfy me now, and on closer inspection I felt convinced that these much-vaunted productions were nothing but copies, or perhaps even counterfeits. The works attributed to Michaelangelo, Verrocchio, Leonardo da Vinci, Botticelli, Lorenzo Lotto, and Palma Vecchio, made exactly the same impression upon me. I was overjoyed to find how satisfactory were the results of my hitherto short and superficial studies, even though the knowledge I had gained was so far only of a negative character. As I drove home, I determined to leave Gorlaw and return as speedily as possible to Germany, Paris, and Italy, in order to study in the galleries with renewed zeal, in accordance with the method the Italian had indicated to me, and which I had, at first, been inclined to disparage.

9 | Alois Riegl

Late Roman Art Industry, 1901

Alois Riegl (1858–1905) published little, died relatively young, had few pupils, and never worked outside Vienna. Despite this, his ideas have had a profound and lasting influence on the history of art in the twentieth century. The wide applicability of his ideas may in part be due to the fact that he moved between the academic world of teaching and research as professor of the history of art at the university, the world of the object in the Austrian Museum of Applied Arts, and the world of conservation in his role as the reformer of the Central Commission for Art and Historical Monuments. The variety of his approaches ranged from an interest in the most abstract of concepts to the examination of the most minute physical aspects of everyday objects normally considered as craft rather than art, and treated accordingly. His publications include *Problems of Style*, or *Stilfragen*, of 1893, and *Late Roman Art Industry* of 1901, the introduction to which provides the following excerpts.[1]

Riegl makes three main points in this text, concerning the laws of history, the concept of *Kunstwollen* and the relevance of the crafts to the history of art.

LAWS For Riegl universal laws govern the development of art through history, with each period following its particular version of those laws. One of these laws is that art always progresses, with neither regression nor pause. Thus to Riegl the period of late antiquity, far from being one of decay, formed part of this progress, both in its own terms and because the art of the Renaissance and subsequent centuries up to his own day would not have been possible without it (figs. 17 and 18).

Riegl's use of "Hegelian ideas raises a large number of questions. How, for example, are the special laws of a period differentiated from the universal laws of art and, even more important, how are the laws of one period displaced by those of the next? Given this commitment to laws, how can he successfully combine the great breadth of a Burckhardt with his attempts to understand minutiae like the development of tendrils and acanthus forms?[2]

KUNSTWOLLEN Through their form, works of art offer a faithful image of the spiritual conditions of their time, and all carry some hallmark of inner determination whether they are works of highly regarded periods such as antiquity and the Renaissance, or of the late antique and the Middle Ages. Riegl explains this by the existence of the *Kunstwollen* – the artistic or aesthetic urge; it is something which he says he feels instinctively in the objects, rather as in the way he assesses their "style.

This concept has been understood in a variety of different ways. While literally it means that which wills art, it has also been translated as an aesthetic urge by Pächt, will-to-form by Gombrich and artistic intent by Iversen, and has been paraphrased as an active creative process in which new forms arise from the artist's will to solve specific artistic problems by Schapiro.[3] The crux of the matter lies in who or what is doing the urging, willing or intending. Schapiro assumes it is the artist, but Riegl's application of the term suggests that he had a Hegelian idea or principle in mind, which is the main reason for Gombrich's rejection of it. However great the problems which it raises, the word brings out the close link between *form and *style, and addresses a real contradiction between the choices made by the artist and the demands or restraints set by the time in which the artist lives.

Riegl contrasted his idea of the *Kunstwollen* with the theory of Gottfried Semper (1803–79), that is, that a work of art is the result of a combination of its function, its material and its technique. Riegl rejected this as a mistaken attempt to ape the natural sciences, and sets its materialism against the importance of the spiritual to his argument. He does not deny the importance of Semper's three factors, but points out that the introduction of the *Kunstwollen* changes their roles from positive, formative ones to negative ones of resistance which the spirit has to overcome. Similarly, he argues that the value of meaning in the work of art and the study of *iconography have been overrated, at the expense of the significance of its *form.

CRAFTS In contrast to the prejudice of his own day in favour of the figurative arts and the belief that they are governed by their own set of laws, Riegl uses the crafts and decoration as a major part of his thesis, with the conviction that all the arts of a period are subject to the same laws (figs. 19 and 20). This inclusion of the crafts in the concept of *art is perhaps Riegl's most forward-looking suggestion, one which relates him to the late twentieth century.

Finally, in making the claim that his treatment of the later Roman period has filled the last major lacuna in the history of art, bringing closer the goal of a universal history, Riegl was of course acting as a child of his optimistic time, when the belief held by scientists that little remained to be discovered had influenced the outlook of educated society.

117

1 Alois Riegl, *Stilfragen* (1893), translated by Evelyn Kain as *Problems of Style*, Princeton. NJ, 1992. *Late Roman Art Industry* (1901), translated by Rolf Winkes, Rome, 1985, Introduction, pp. 5–17.
2 See also Otto Pächt, 'Art Historians and Art Critics, VI: Alois Riegl', *Burlington Magazine*, 105, 1963, pp. 188–93; and Michael Podro, *The Critical Historians of Art*, New Haven and London, 1982, pp. 71–97.
3 Pächt, op. cit., pp. 190–1; E.H. Gombrich, *Art and Illusion: a Study in the Psychology of Pictorial Representation* (1960), 5th edn, reprinted, London, 1994, p.16; Margaret Iversen, 'Style as Structure: Alois Riegl's Historiography', *Art History*, 2, 1979, p. 66; see also Margaret Iversen, *Alois Riegl: Art History and Theory*, Cambridge, MA, and London, 1993, pp. 2–19 and 152–6; and Meyer Schapiro, 'Style' (1953), in *Anthropology Today: Selections*, S. Tax, ed., Chicago, IL, 1962, p. 293, though Schapiro does not specifically identify his phrase as a definition of the word.

118

17 Theatre scene, Casa di Casca, Pompeii, before 79 AD. Wall-painting.

Riegl uses the difference between this classical wall-painting and the fifth-century Vienna Genesis (fig. 18) to argue that the late antique image does not represent a decline in comparison with the earlier, Graeco-Roman one, but rather a way of seeing appropriate to its time. Riegl makes the same point by comparing the reused earlier Hadrianic roundels with the contemporary reliefs on the Arch of Constantine (fig. 5), in direct contradiction to Vasari.

18 *Joseph before Pharaoh*, Vienna Genesis, fifth century AD. Österreichische Nationalbibliothek, Vienna. See fig. 17.

19 Detail of an Egyptian wall-painting, showing an arcu-
ated band frieze with lotus blossoms and buds.
Necropolis, Thebes

These details of an Egyptian wall-painting and a Greek
vase (fig. 20) illustrate Riegl's willingness to look for evi-
dence in sources which were thought of not as art but
as mere decoration. By tracing the development of
forms over centuries and from Egypt to Greece he
underpinned his principle that all ages are of equal value
in the eyes of the historian of culture.

20 Detail of a Greek vase from Kameiros, showing an
arcuated band frieze. See fig. 19.

9 | ALOIS RIEGL

Late Roman Art Industry, 1901

Alois Riegl, *Die Spätrömische Kunstindustrie*,
Vienna, 1901. Excerpts from the Introduction
to *Late Roman Art Industry*, translated by Rolf
Winkes, Rome, Giorgio Bretschneider, 1985,
pp. 5–17.

I have to offer an explanation why [the content of the book] seems to offer on one side too little and on the other side too much: too little since by no means does it publish and discuss all types of monuments in late Roman art industry; too much since besides art industry it seems to consider equally the other three great art media, especially sculpture.

To explain this apparent inconsistency between title and content, note may be taken first of all of the fact that I directed my attention not so much towards the publication of individual monuments as to the presentation of the laws governing the development of late Roman art industry; these universal laws, however, were also in effect in all media during the late Roman period. Therefore, observations in each single field are valid for all others and thus support and enhance one another.

They never have received a more precise definition even for the architecture, sculpture, and painting of the late Roman period, because rooted prejudices held that it was completely useless to look for positive laws of development in late antiquity. Indeed, whoever undertakes to describe the nature of late Roman art industry nowadays is already forced by this situation to extend his description in the direction of a general characterization of late Roman art.

Indeed, this latest phase of ancient art is the dark continent on the map of art-historical research. Not even its name and its boundaries are determined in a manner which can claim general validity. The reason for this phenomenon does not lie in an external inaccessibility of the field. On the contrary it is open towards all sides and offers a great abundance of material for observation, which to a great extent is published. Missing has been the desire to get involved with it. Such an adventure did not seem to offer sufficient personal satisfaction nor easy appreciation among the public. This reveals a fact which cannot be overlooked: in spite of its seemingly independent objectivity, scholarship takes its direction in the last analysis from the contemporary intellectual atmosphere and the art historian cannot significantly exceed the character of the *Kunstbegehren* [artistic wishes] of his contemporaries.

The following is an attempt to research a field so far neglected at least in its most general and fundamental aspects. It is not undertaken because the author himself

feels above those imperfections of the human mind which he deplores, but rather because he feels that our intellectual development has reached the point where a solution to the question concerning the nature and the underlying forces of the end of antiquity may find general interest and appreciation.

But is it not an exaggeration to describe the fine arts of the end of the Roman Empire as a completely unresearched field? As far as the pagan monuments go, one cannot contradict this assertion. For example, a well-dated major monument, the complex of Diocletian's buildings at Split, has not received a complete publication made for the purpose of scholarly research since the last century. According to the traditional division of study this responsibility would have rested with classical archaeology; however, in a time which has seen Mycenae and Pergamon rise from the dust, who would criticize classical archaeology for lacking an interest in the death-throes of antiquity? When occasionally the decision was made to treat such a late monument, this has usually been done because of its antiquarian-historical content and not for the sake of its artistic aspect. And if there is an exception, this has certainly been due to a scholar whose interests in the fine arts do not stop at the border of classics, thus enabling him to recognize the seeds and buds of new life even in works of the very late antiquity among signs of death and decay. Therefore, the very best of what has been said about the art of the third and fourth centuries of the Roman Empire was said by an art historian of the old school who did not recognize any division of fields of study and who, therefore, became one of the greatest and most knowledgeable of scholars, Jakob Burckhardt ...

Indeed, the large amount of research in early christian art in recent decades is not art historical but antiquarian. This statement should not be understood as criticism of traditional methods in scholarship and their representatives; especially since not only is the success thus attained of fundamental value for a real history of art but also because all currents of scholarship during the last thirty years dictated this tendency towards antiquarianism.

The characteristic feature of scholarship in the field of history in [the period] was the one-sided preference for secondary fields. In the history of art (the ancient as well as the modern) this is manifested by an exclusive cultivation and over estimation of iconography. No doubt that the evaluation of a work of art is essentially weakened if one is uncertain about its content and message. Around the middle of the past century these lacunas began to be felt severely. They could be filled only through a comprehensive marshalling of literary sources, which in essence are not related to the fine arts, and this led to those immense studies in which our art-historical literature of the last three decades to a great extent exhausted itself. No one would deny that there has been thus constructed an indispensable foundation for a solid edifice of future art history: but no one can deny that iconography provided only stronger foundations and that the completion of the building belongs to the history of art.

We presented our justification for considering the christian monuments of late antiquity because they are essentially unstudied at least in regard to their purely artistic character (which is silhouette and colour on the plane or in space). To make a more precise definition of this character comes to no more than what was said a half century ago: that is simply 'unclassical'.

One is used to imagining an unbridgeable gap between late Roman art and the art of preceding classical antiquity. In its natural development, so one thinks, the classical would never have been able to become late Roman art. This notion must appear surprising, especially at a time when the term development has become the principle of all *Weltanschauung* [world-view] and all interpretation of the world. Should the concept of development now be excluded from the art of the end of antiquity? Since such a step was unacceptable, one retreated to the concept of a forceful disruption of natural development by the barbarians. Accordingly, the fine arts were thrown from their high pedestal among the nations of the Mediterragen to which their development had brought them by the destructive action of barbaric nations from the north and east of the Roman Empire. Thus the Mediterranean had to make a new beginning with Charlemagne. The principle of development was thus salvaged, yet violent disruption through catastrophes, as in old-fashioned geology, was also admitted.

It is significant that no one ever undertook to investigate closely the violent process claimed for the destruction of classical art by the barbarians. One only talked in general terms about 'barbarization' and left the details in an invisible fog, the dispersion of which would not have supported the hypothesis. Yet what could one have set in its place, since everyone agreed that late Roman art did not constitute progress but merely decay?

To destroy this prejudice is the principal object of all the studies contained in this book. However, it should be made clear at the outset that this is not the first attempt in this direction, but that there are two precedents: the first made by me in my *Stilfragen* [*Problems of Style*] (1893), the second was made by F. Wickhoff in his introduction to the publication of the *Vienna Genesis* in collaboration with W. v. Hartel (Vienna, 1895).

I believe that I have demonstrated in the *Stilfragen* that Byzantine and Saracen tendril ornament of the Middle Ages was developed directly from classical tendril ornament and that the connecting links are present in the art of the diadochs and the Roman Empire. Accordingly, at least for tendril ornament, the late Roman period does not mean decay, but rather progress, or at least achievement of individual worth. The response to my investigations from scholars interested in this field was clearly divided: the most favourable were those scholars who worked directly with the pertinent works of art such as Otto v. Falke, A. Kisa and others. Scholars of a more theoretical inclination remained passive. Direct contradiction was, to the best of my knowledge, not voiced from any side.

Repeatedly, since 1893 there have been published treatises on Byzantine ornamentation. Apart from my publication they were, as usual, based on the motive and its meaning as object and not (as in my work) on the treatment of the motive as shape and colour on the plane and in space. The avoiding of either agreement or contradiction has an explanation: these authors did not feel at home with my basic perception of development in art and, therefore, were not able to follow my exposition of it. Neither were scholars to whom I refer able to break with the older notion about the nature of the fine arts dominant in the last thirty to forty years.

This is the theory, usually connected with the name of Gottfried Semper, according to which a work of art is nothing else than a mechanical product based

on function, raw material and technique. When this theory appeared, it was justly seen as an essential advance over the completely unclear notions of the immediately preceding Romantic period; today its consignment to history is long overdue. As so many other theories from the middle of the nineteenth century, Semper's art theory was originally thought to be a great triumph of natural science, but it finally turned out to be a dogma of materialistic metaphysics. As opposed to this mechanistic perception of the nature of the work of art I presented for the first time in my *Stilfragen*, a teleological approach by recognizing the art work as the result of a definite and purposeful *Kunstwollen* [artistic urge] which makes its way forward in the struggle with function, raw material, and technique. Thus the latter three factors no longer have those positive creative roles attributed to them by Semper's theory but rather restraining, negative ones: they are, so to say, the coefficients of friction within the entire product.

The idea of *Kunstwollen* introduced a determining factor within the phenomenon of development. The scholars biased by the existing ideas did not know what to do with it; for that reason, I feel that I should explain this persistent position, which the majority of my colleagues in the same areas of art still maintain today seven years later in regard to my views as expressed in the *Stilfragen*. Secondly, there may also have contributed to their opinion the fact that my investigation in the *Stilfragen* was limited exclusively to the decorative field since there is a generally accepted prejudice in the form of perceiving the figurative arts not simply as superior, but also as subject to their own particular laws. Therefore, it was unavoidable that even among those who acknowledged the worth of my studies of the tendril ornament, some were unable to recognize the general consequences of my specific discoveries.

Considering this depiction of decorative arts, an important new step was taken in the direction in which I was moving when F. Wickhoff in his publication of the *Vienna Genesis* irrefutably proved that non–decorative works of art with figurative representations belonging to the late Roman period (generally assumed to begin in the fifth century AD) can no longer be treated like classical art (and consequently be condemned outright)[figs. 17 and 18]. In between these two forms of art there exists a mediating third artistic phenomenon belonging to the beginning of the Roman Empire. No doubt this phenomenon still has to be classed under antiquity, but it also has basic points of connection with a late Roman work such as the *Vienna Genesis*.

Thus the continuity of development in the field of decorative arts was also effectively established. That this pioneering result has not yet found appropriate recognition from all scholars concerned is to be explained by the limited and abrupt definition by which Wickhoff sought to distinguish Roman from Greek art. As for the development of late Roman art out of the art of the earlier Empire, Wickhoff went just half way, obviously because he harboured something of the materialistic concept of art. Where the *Genesis* and Flavian–Trajanic art meet, there Wickhoff finds in the *Genesis* proof of advance over classical art; wherever the *Genesis* differs from the art of the early Empire, there he no longer recognized advance but sees decay. Thus Wickhoff eventually becomes involved with the theory of catastrophe and this inevitably forces him to make his escape to the idea of 'barbarization'.

What is it that so far keeps even unprejudiced scholars such as F. Wickhoff from appreciating the nature of late Roman works of art open-mindedly? It is nothing else than the subjective critique which our modern taste applies to the monuments at hand. From a work of art this taste demands beauty and animation, while the scales incline in turn either to the first or the second. In antiquity both were present before the end of the Antonine period – the classical possessed more of beauty and the Roman Empire more of animation. Late Roman art, however, did not possess either one, at least not to a degree acceptable to us. Hence on the one side our enthusiasm for the classical period, and now recently (and not accidentally) for Wickhoff's favoured Flavian-Trajanic period. However, from the viewpoint of modern taste, it seems absolutely impossible that there should ever have been a positive *Kunstwollen* directed towards ugliness and non-animation, as we seem to see it in late Roman art. But everything depends on understanding that the aim of the fine arts is not completely exhausted with what we call beauty nor with what we call animation, but that *Kunstwollen* may also be directed towards the perception of other forms of objects (according to modern terminology neither beautiful nor animated).

124

This book thus intends to prove that when compared to Flavian-Trajanic art and from the viewpoint of the universal history of the general development of art, the *Vienna Genesis* constitutes progress and nothing else but progress; judged by the limited criterion of modern criticism it appears to be a decay which historically did not exist: indeed modern art, with all its advantages, would have never been possible if late Roman art with its unclassical tendency had not prepared the way.

Accordingly, in this introduction preliminary treatment is given only to those aspects of our subject which because of their factual content are most easily grasped, no matter how extraneous they may appear at first sight. No one doubts that modern conditions in all fields where human *Wollen* [urge] can manifest itself – such as government, religion and scholarship – bestow certain advantages in comparison with the ancient world. However, in order to create modern conditions, the old propositions, on which the ancient situation depended, had to be destroyed and made to give way to transitional modes; though we may in fact like these less than certain ancient counterparts, there can be no doubt that they are important and necessary preconditions of the modern modes ...

The organization of [the] plentiful material [of the period] which is not even exhausted in its best-known examples is based on division by media. Basic laws are as common to all four media, as is *Kunstwollen*, which rules them; but these laws cannot be recognized with the same clarity in all media. The clearest case is architecture, next the crafts, particularly when they do not incorporate figurative motives: often architecture and these crafts reveal the basic laws of *Kunstwollen* with an almost mathematical clarity. However, these laws do not appear in figurative works of sculpture and painting with their basic clarity and this situation does not depend on the motion and apparent asymmetry of the human figure but on the 'content', this is the context of poetic, religious, didactic, patriotic association, which – intentionally or unintentionally – surrounds human figures and distracts the modern viewer, accustomed to art works with a message projected through a *fernsichtig* [distant] transient-optical view of nature and art from the

essentially *bildkünstlerische* [pictorial] in the work of art, which is the appearance of objects as shapes and colour on the plane or in space. Accordingly, the chapter on architecture is put first in order to make clear the basic perception of the late Romans as to the relation of objects towards plane and space.

The second place should be given to the crafts; instead they are placed last, and this requires an explanation. To date there does not exist a generally known and recognized art-historical work on late Roman crafts in spite of individual works in specialized technical fields (such as the excellent contributions of A. Kisa on glass and metalwork from the Rhine). Such a work is the goal of this book. Here we meet again the consequence of that contempt for crafts which theoretical art historians were willing to lay aside only in the case of objects such as Greek vases, where figurative representations are present, or, as in the use of Mycenaean pottery, figurative art is almost or entirely missing from a particular period of art; in the latter case technique at least was considered, but only to explain motifs (an error still practised), and not to understand the *Kunstwollen* which motivated the selection of the technique. Since late Roman craft neither made widespread use of the human figure nor could be excused as primitive, its existence has been largely neglected. Ignorance of late Roman crafts and the aims of its positive *Kunstwollen* are the main roots of misunderstandings and unclear perceptions which hide under slogans such as 'barbarization' and 'elements of the migration period'. Only on rare occasions can an origin within the territory of the Roman Empire be determined with the aid of external criteria, for the individual monuments used in this book as examples of late Roman art industry. Their identification as Roman art is thus mainly based on the recognition that they follow the laws creating such art. Hence one must first demonstrate the existence of the laws peculiar to late Roman art among monuments of undoubted Roman Imperial origin. Therefore, immediately following the discussion on architecture there has been added a section on the two figurative art forms – sculpture and painting, of which the former receives greater attention. The reason for this emphasis is first that sculpture is more familiar through more numerous and better quality reproductions. Of importance also is sculpture's close relation to metalwork which will be the most important element in our discussion of the crafts.

No one will deny that the art discussed in this book belongs to the most important period in the history of the world. Nations which for a thousand and more years held leadership in the development of civilization were about to give it up; in their place there moved nations the names of which were unknown only a few centuries before. Ideas about divinity and its relation to the visible world, which had existed from the beginning of human memory, were now shaken, abandoned and replaced by new ideas which, in turn, would endure another thousand years up to the present day. From this time of turmoil, when two epochs were parting we have a vast number of works of art, mostly anonymous and undated, but offering us a faithful image of the disturbed spiritual conditions of the time. Under such conditions it would be unfair to request from the first scholar investigating this art an exhaustive description of even the most important monuments. But in view of the fact that my commission was limited to the description of the general traits of the period, a considerate reader will never forget that in such a time of

schism as the fourth century AD, development was by no means strictly uniform but moved by spurts of progress mixed with moments of recoil. Though anachronisms abound – archaic survival on one hand, radical anticipation with almost modern perceptions on the other – the development was unmistakable.

Added to difficulties entailed in the commission of the present book is the dispersion of its material over the enormous region of the whole former Roman Empire and beyond it. Here I must admit that considerable portions of this material such as that of the Syrian, Arabic, North-West African, Southern French and English regions were as good as excluded from my examinations by external impediments. In spite of all this I felt that I should hesitate no longer to publish the results of several years of work. I did so with confidence for the success of this attempt, mainly because it is based on the perception that whenever I examined a work of late Roman art its visual appearance carried without exception the same hallmark of inner determination as any work of the classical age or the Renaissance. As for the nature of this inner determination which I feel instinctively in the presence of any work of late Roman art and which one calls 'style', for myself and others I have tried to clarify its character in the several chapters of this book. I am thus presenting an explanation of the nature of late Roman style and its historical origins; I believe I have thus at least filled, even though in a general manner, a somewhat major lacuna, the last in our knowledge of the general history of art of mankind.

10 Heinrich Wölfflin

Principles of Art History, 1915

Heinrich Wölfflin (1864–1945) is the next after Jacob Burckhardt and Alois Riegl in the succession of great professors of art history from the German-speaking world. Having studied art history and philosophy at Munich, Berlin and Basle, he followed his mentor Burckhardt as professor of history at Basle and professor of art history at Berlin, and thereafter professor at Munich and Zurich. His influence on the twentieth century has probably been more wide ranging and at the same time more detailed than that of his earlier colleagues. Whereas Riegl's influence consists on the whole of one or two big ideas, Wölfflin provided a box of tools, such as his pairs of concepts, with which scholars have refined our understanding of the means by which artists achieve particular effects and the way in which styles change through time. His publications include *Renaissance and Baroque* (1888), *Classic Art* (1899), and *Principles of Art History* (1915), from the last of which the following excerpts are taken.[1]

This text has something of the character of a technical manual. It includes the contribution for which Wölfflin is best known, namely the set of five pairs of opposed visual concepts for analysing the phases of the cycle of Renaissance styles. The first element of each pair describes the characteristic in the early or classic (High Renaissance) phase, while the second element describes it in the Baroque (seventeenth-century) phase.

The five pairs are as follows: (i) The linear versus the painterly consists of a contrast between the tangible and the intangible, the limited and the limitless, and the representation of individual material objects as opposed to a shifting semblance (figs. 21 and 22). (ii) Plane versus recession constitutes essentially the same contrast as in (i), but applied to space rather than to flat surfaces. The classic phase is characterized by a sequence of clearly differentiated planes and the Baroque by a mixing of planes which creates a sense of depth (figs. 23 and 24). (iii) Closed versus open form defines a contrast between forms which point back upon themselves and those which point out beyond themselves (figs. 25 and 26). (iv) Multiplicity versus unity contrasts works in which the individual parts read as clear, independent units, even though they are subordinate to a whole, with works which are perceived as a whole (figs. 27 and 28). (v) Absolute versus relative clarity: this pair is closely related to the preceding, the absolute being more explicit and the relative less so, with each part having a life of its own (figs. 29 and 30).[2]

Wölfflin's other chief contribution can be seen as the clarity which he brought to the concept of

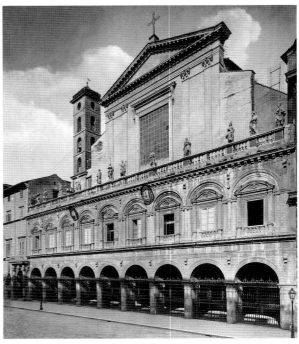

21 Façade of SS Apostoli, Rome, fifteenth century.
The two façades of SS Apostoli and S. Andrea della
Valle in Rome (fig. 22) illustrate the first of Wölfflin's five
pairs of concepts which distinguish the early and the
classic stages of Renaissance style from the Baroque
stage. They represent the contrast between linear and
painterly qualities; the simple, fifteenth-century façade is
legible primarily in terms of the lines of which it is com-
posed, whereas the seventeenth-century façade has so
many more details that line alone is insufficient to define
it, giving it the quality of a surface thick with paint.

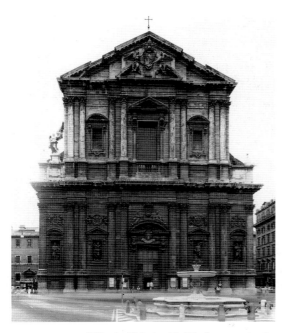

22 Façade of S. Andrea della Valle, Rome, seventeenth
century. See fig. 21.

23 Donatello, *Gattamelata*, 1445–50. Bronze, h. 3.4 m. Padua

Donatello's equestrian statue and Bernini's fountain (fig. 24) illustrate the same contrast as figs. 21 and 22, but here it is stated in terms of plane versus recession. In the *Gattamelata* every part of the horse and rider is closely related to the plane represented by the side of the statue, whereas in the case of the Trevi Fountain there are numerous planes parallel to the plane of the monument and many more receding planes in between.

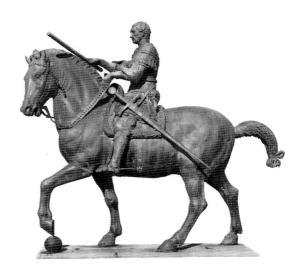

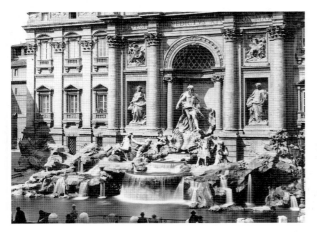

24 Nicola Salvi, Trevi Fountain, Rome, erected 1732–62 to a design by Bernini
See fig. 23.

the "cycle of three phases, early, "classic and baroque.[3] He exemplifies these with the Quattrocento or early Renaissance, the High Renaissance and the Baroque respectively. He is at pains to stress that this sequence has nothing to do with an improvement in "quality, nor should it be confused with the biological model of 'bud, bloom, decay', since that too depends on a judgement of the relative value of immaturity, maturity and decline. His use of the term classic with its clear overtones of superiority does, however, conflict with this aim.

Wölfflin shows how his pairs of opposites and his phases produce some useful results and practical applications. Thus the classic and baroque phases can be distinguished not only in the related

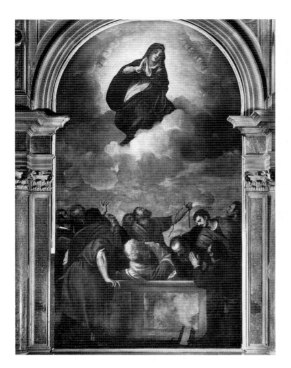

25 Titian, *The Assumption of the Virgin*, 1532. Oil on canvas, 3.94 × 2.22 m. Cathedral, Verona
The two versions of the Assumption by Titian and Rubens (fig. 26) illustrate the contrast between closed and open form, that is between forms which point back in on themselves and those which point out beyond themselves. The gestures of the Virgin in the two paintings make this difference especially clear, as do the poses of the Apostles closest to the picture plane at the bottom of the painting.

26 Rubens, *The Assumption of the Virgin*, 1611–16. Oil on canvas, 5 × 3.4 m. Musées Royaux des Beaux-Arts, Brussels
See fig. 25.

27 Palazzo della Cancelleria, Rome, c.1486.
The façades of the fifteenth- and seventeenth-century
palazzi in figs. 27 and 28 illustrate the contrast between
multiplicity and unity, that is between works in which the
individual parts can be read as a few clear, independent
units, and those in which the increased number of units
requires that they be read as a whole.

28 Bernini, Palazzo Odescalchi, Rome, 1664 ff.
See fig. 27.

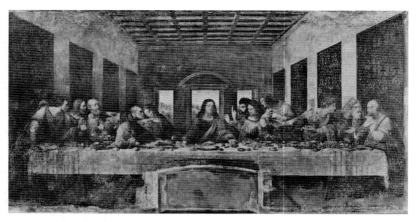

29 Leonardo da Vinci, *Last Supper*, 1498. Fresco,
4.2 × 9.1 m. Sta Maria delle Grazie, Milan
Leonardo's *Last Supper* and a Rembrandt etching of
the *Supper at Emmaus* (fig. 30) illustrate the last of the
pairs, namely the contrast between absolute and relative
clarity, in which the absolute is more explicit and the
relative less so, with each part having a life of its own.
This is the least clear of Wölfflin's contrasts.

30 Rembrandt, *Supper at Emmaus*, 1654. Etching,
21.1 × 16 cm.
See fig. 29.

31 Façade of Chartres Cathedral, mid-twelfth century.
The church façades of the twelfth and fifteenth centuries
in figs. 31 and 32 illustrate the application of Wölfflin's
pairs to monuments of another period or style, in this
case the Gothic in France. The twelfth-century façade
of Chartres Cathedral has characteristics of the early
or the classic phase in that it is linear, composed in easily
identifiable planes and closed forms, with individual ele-
ments easily readable and an absolute sense of clarity.
The fifteenth-century façade of St-Maclou in Rouen has
the characteristics of the baroque phase, being painterly,
composed of many interlocking planes and open forms,
and with such a plethora of detail that the composition
must be read as a whole, with only a relative sense
of overall clarity.

32 Façade of St-Maclou, Rouen, late fifteenth century.
See fig. 31.

periods of antiquity and the Renaissance, but also in a style as substantially different as, for example, the Gothic: the architecture of the High Gothic is clearly classic, linear and composed of identifiable planes, while the late Gothic is baroque, painterly and with frequently unclear planes (see the first pair of opposites, above, and figs. 31 and 32). They are also useful for revealing the character of the phases in architecture in general, because buildings with interiors which can be described as painterly (whether late Gothic or Rococo, etc.) often have more discreet, that is, more classic, exteriors, which leads him to conclude that on the whole interiors 'develop' faster than exteriors, though it is possible that a more rugged appearance was considered more fitting for the exterior.[4]

He argues that late styles provide good examples of developments which are internal to the forms themselves, though the simple label 'late style' is inadequate as, in addition to taking on new forms, such styles can also convey new emotional values. He also observes that *forms never stand still, and what is alive today is not quite completely alive tomorrow. This is partly due to boredom, but also, more positively, to the fact that forms beget other forms: the effect of pictures on pictures as a factor in style is much more important than what comes directly from imitating nature, and the artist always approaches nature with preconceived ideas. We have here an expression of the tension which Wölfflin perceives between internal and external explanations of changes in forms.

His overall model can be described as *Hegelian because he seeks to establish what it is in the spirit of each time which determines the *style of an individual, period or people, and because he describes the architecture and the representational arts of a period as expressing a single cultural spirit. The inclusion of peoples in this list and what he says about the unchanging character of their art over centuries may sound as if it contradicts the phases of the cycle. The two ideas are, however, incorporated in *Hegelianism: the world spirit expresses itself through peoples as well as by other means; when a people represents the will of the spirit, then its style will not be contradicted by the phases.

His Hegelianism is, however, far removed from Hegel's original, almost theological, structure. He notes, for instance, the arbitrariness of the concept of *periods, since time can be convincingly presented as an uninterrupted flow; he counters this view with the thoroughly pragmatic observation that intellectual self-preservation demands that the infinity of events should be given some sort of structure.[5]

1 Heinrich Wölfflin, *Renaissance and Baroque* (1888), translated by K. Simon, Ithaca, 1966; *Classic Art: an Introduction to the Italian Renaissance* (1899), 5th edn, translated by Peter and Linda Murray, London, 1994; *Principles of Art History: the Problem of the Development of Style in Later Art* (1915), 6th edn, translated by M.D. Hottinger, New York, 1960.

2 *Principles*, op. cit., (i) pp. 62–3 and 68–70; (ii) pp. 110–13; (iii) pp. 128, 133, 141–2 and 161–2; (iv) pp. 187–90; (v) pp. 197–202.

3 I have written the term 'baroque' with a lower case initial letter where it describes the late phase of any cycle in any age, and with a capital letter when it refers to the seventeenth-century period. (See also *vocabulary, and Focillon, text 13, 1934.)

4 *Principles*, op. cit., pp. 231–2.

5 For further comment on Wölfflin's methods see, for example, Michael Podro, *The Critical Historians of Art*, New Haven and London, 1982, chapters 6 and 7; and Margaret Iversen, 'Politics and the Historiography of Art History: Wölfflin's *Classic Art*', *Oxford Art Journal*, 4 (1), 1981, pp. 31–4, in which the author explores the way in which Wölfflin implicitly rejects the proletarian content of late nineteenth-century culture.

10 | Heinrich Wölfflin

Principles of Art History, 1915

Heinrich Wölfflin, *Kunstgeschichtliche Grundbegriffe: Das Problem der Stilentwicklung in der neueren Kunst*, Munich, 1915. Excerpts from the Preface, Introduction and Conclusion of *Principles of Art History: the Problem of the Development of Style in Later Art*, 6th edn, translated by M.D. Hottinger, New York, 1960, pp. vii–ix, 9–16 and 226–37.

...The following remarks will serve for general guidance. The *Principles* arose from the need of establishing on a firmer basis the classifications of art history: not the judgement of value – there is no question of that here – but the classifications of style. It is greatly to the interest of the historian of style first and foremost to recognize what mode of imaginative process he has before him in each individual case. (It is preferable to speak of modes of *imagination* rather than of modes of *vision*.) It goes without saying that the mode of imaginative beholding is no outward thing, but is also of decisive importance for the content of the imagination, and so far this history of these concepts also belongs to the history of mind.

The mode of vision, or let us say, of imaginative beholding, is not from the outset and everywhere the same, but, like every manifestation of life, has its development. The historian has to reckon with stages of the imagination. We know primitively immature modes of vision, just as we speak of 'high' and 'late' periods of art. Archaic Greek art, or the style of the sculptures on the west portal at Chartres, must not be interpreted as if it had been created today. Instead of asking 'How do these works affect me, the modern man?' and estimating their expressional content by that standard, the historian must realize what choice of formal possibilities the epoch had at its disposal. An essentially different interpretation will then result.

The course of development of imaginative beholding is, to use an expression of Leibniz, 'virtually' given, but in the actuality of history as lived, it is interrupted, checked, refracted in all kinds of ways. The present book, therefore, is not intended to give an extract from art history; it merely attempts to set up standards by which the historical transformations (and the national types) can be more exactly defined.

Our formulation of the concepts, however, only corresponds to the development in later times. For other periods, they must undergo continual modification. Yet the schema has proved applicable even as far as the domains of Japanese and old Nordic art.

The objection that, by accepting a development of imagination determined by law, the significance of the artistic personality is destroyed, is puerile. Just as the growth of the human body proceeds by absolutely general laws without the individual form being prejudiced, so the law which governs the spiritual structure of mankind by no means conflicts with freedom. And when we say, men have always seen what they wished to see, that is a matter of course. The only question is how far this wish of mankind is subject to a certain inevitability, a question which certainly extends beyond aesthetics into the whole complex of historical life, even eventually into metaphysics.

A further problem, which this book only touches on without examining in detail, is the problem of continuity and periodicity. It is certain that history never returns to the same point, but it is just as certain that, within the total development, certain self-contained developments may be distinguished, and that the course of the development shows a certain parallelism. From our standpoint, namely, the course of development in later times, the problem of periodicity plays no part, but the problem is important, although it cannot be dealt with merely from the standpoint of the art historian.

And the further question of how far old products of vision are carried each time into a new phase of style, how a permanent development is commingled with special developments, can only be elucidated by detailed examination. We arrive thereby at units of very different degrees. Gothic architecture can be taken as a unit, but the whole development of northern medieval style can also be the unit whose curve is to be plotted out, and the results can claim equal validity. Finally, the development is not always synchronous in the different arts: a late style of architecture can continue to exist by the side of new original notions in plastic or painting, cf. the Venetian Quattrocento, until finally everything is reduced to the same visual denominator.

And as the great cross-sections in time yield no quite unified picture, just because the basic visual attitude varies, of its very nature, in the different races, so we must reconcile ourselves to the fact that within the same people – ethnographically united or not – different types of imagination constantly appear side by side. Even in Italy this disunion exists, but it comes most clearly to light in Germany. Grünewald is a different imaginative type from Dürer, although they are contemporaries. But we cannot say that that destroys the significance of the development in time: seen from a longer range, these two types reunite in a common style, i.e. we at once recognize the elements which unite the two as representatives of their generation. It is just this community co-existing with the greatest individual differences which this book sets out to reduce to abstract principles.

Even the most original talent cannot proceed beyond certain limits which are fixed for it by the date of its birth. Not everything is possible at all times, and certain thoughts can only be thought at certain stages of the development.

INTRODUCTION

… Nothing is more natural to art history than to draw parallels between periods of culture and periods of style. The columns and arches of the High Renaissance speak as intelligibly of the spirit of the time as the figures of Raphael, and a baroque building represents the transformation of ideals no less clearly than a comparison between the sweeping gestures of Guido Reni and the noble restraint and dignity of the *Sistine Madonna*.

Let us … remain on strictly architectural ground. The central idea of the Italian Renaissance is that of perfect proportion. In the human figure as in the edifice, this epoch strove to achieve the image of perfection at rest within itself. Every form developed to self-existent being, the whole freely co-ordinated: nothing but independently living parts. The column, the panel, the volume of a single element of a space as of a whole space – nothing here but forms in which the human being may find an existence satisfied in itself, extending beyond human measure, but always accessible to the imagination. With infinite content, the mind apprehends this art as the image of a higher, free existence in which it may participate.

The baroque uses the same system of forms, but in place of the perfect, the completed, gives the restless, the becoming, in place of the limited, the conceivable, gives the limitless, the colossal. The ideal of beautiful proportion vanishes, interest concentrates not on being, but on happening. The masses, heavy and thickset, come into movement. Architecture ceases to be what it was in the Renaissance, an art of articulation, and the composition of the building, which once raised the impression of freedom to its highest pitch, yields to a conglomeration of parts without true independence.

This analysis is certainly not exhaustive, but it will serve to show in what way styles express their epoch. It is obviously a new ideal of life which speaks to us from Italian baroque, and although we have placed architecture first as being the most express embodiment of that ideal, the contemporary painters and sculptors say the same thing in their own language, and whoever tries to reduce the psychic bases of style to abstract principles will probably find the decisive word here more readily than with the architects. The relationship of the individual to the world has changed, a new domain of feeling has opened, the soul aspires to dissolution in the sublimity of the huge, the infinite. 'Emotion and movement at all costs.' Thus does the Cicerone [guide] formulate the nature of this art.

We have, in thus sketching three examples of individual style, national style, and period style, illustrated the aims of an art history which conceives style primarily as expression, expression of the temper of an age and a nation as well as expression of the individual temperament. It is obvious that with all that, the quality of the work of art is not touched: temperament certainly makes no work of art, but it is what we might call the material element of style taken in the broad sense that the particular ideal of beauty (of the individual as of the community) is included in it too. Works of art history of this kind are still far from the perfection they might attain, but the task is inviting and grateful.

Artists are certainly not readily interested in historical questions of style. They take work exclusively from the standpoint of quality – is it good, is it self-

137

sufficing, has nature found a vigorous and clear presentment? Everything else is more or less indifferent. We have but to read Hans van Marées when he writes that he is learning to attach less and less value to schools and personalities in order only to keep in view the solution of the artistic problem, which is ultimately the same for Michelangelo as for Bartholomew van der Helst. Art historians who, on the other hand, take the differences between the finished products as their point of departure have always been exposed to the scorn of the artists: they have taken the detail for the essence: they cling just to the non-artistic side in man in wishing to understand art as expression only. We can very well analyse the temperament of an artist and still not explain how the work came into being, and the description of all the differences between Raphael and Rembrandt is merely an evasion of the main problem, because the important point is not to show the difference between the two but how both, in different ways, produced the same thing – namely, great art.

It is hardly necessary here to take up the cudgels for the art historian and defend his work before a dubious public. The artist quite naturally places the general canon of art in the foreground, but we must not carp at the historical observer with his interest in the variety of forms in which art appears, and it remains no mean problem to discover the conditions which, as material element – call it temperament, *Zeitgeist*, or racial character – determine the style of individuals, periods, and peoples.

Yet an analysis with quality and expression as its objects by no means exhausts the facts. There is a third factor – and here we arrive at the crux of this enquiry – the mode of representation as such. Every artist finds certain visual possibilities before him, to which he is bound. Not everything is possible at all times. Vision itself has its history, and the revelation of these visual strata must be regarded as the primary task of art history.

Let us try to make the matter clear by examples. There are hardly two artists who, although contemporaries, are more widely divergent by temperament than the baroque master Bernini and the Dutch painter Terborch. Confronted with the turbulent figures of Bernini, who will think of the peaceful, delicate little pictures of Terborch? And yet, if we were to lay drawings by the two masters side by side and compare the general features of the technique, we should have to admit that there is here a perfect kinship. In both, there is that manner of seeing in patches instead of lines, something which we can call painterly, which is the distinguishing feature of the seventeenth century in comparison with the sixteenth. We encounter here a kind of vision in which the most heterogeneous artists can participate because it obviously does not bind them to a special mode of expression. Certainly an artist like Bernini needed the painterly style to say what he had to say, and it is absurd to wonder how he would have expressed himself in the draughtsmanly style of the sixteenth century. But we are clearly dealing with other concepts here than when we speak, for instance, of the energy of the baroque handling of masses in contrast to the repose and reserve of the High Renaissance. Greater or less movement are expressional factors which can be measured by one and the same standard: painterly and draughtsmanly, on the other hand, are like two languages, in which everything can be said, although

each has its strength in a different direction and may have proceeded to visibility from a different angle.

Another example. We can analyse Raphael's line from the point of view of expression, describe its great noble gait in contrast to the pettier fussiness of Quattrocento outlines: we can feel in the movement of the line in Giorgione's *Venus* the kinship with the *Sistine Madonna* and, turning to sculpture, discover in Sansovino's youthful Bacchus the new, long, continuous line, and nobody will deny that we feel in this great creation the breath of the new sixteenth-century feeling: it is no mere superficial history-writing to connect in this way form and spirit. But the phenomenon has another side. By explaining great line, we have not explained line. It is by no means a matter of course that Raphael and Giorgione and Sansovino sought expressive force and formal beauty in line. But it is again a question of international connections. The same period is for the north, too, a period of line, and two artists who, as personalities, have little in common, Michelangelo and Hans Holbein the Younger, resemble each other in that they both represent the type of quite strictly linear design. In other words, there can be discovered in the history of style a substratum of concepts referring to representation as such, and one could envisage a history of the development of occidental seeing, for which the variations in individual and national characteristics would cease to have any importance. It is certainly no easy task to reveal this inward visual development, because the representational possibilities of an epoch are never shown in abstract purity but, as is natural, are always bound to a certain expressional content, and the observer is then generally inclined to seek in the expression the explanation of the whole artistic product.

When Raphael erects his pictorial edifices and, by strict observance of rules, achieves the impression of reserve and dignity to an unprecedented degree, we can find in his special problem the impulse and the goal, and yet the tectonics of Raphael are not entirely to be attributed to an intention born of a state of mind: it is rather a question of a representational form of his epoch which he only perfected in a certain way and used for his own ends. Similar solemn ambitions were not lacking later, but it was impossible to revert to his formulas. French classicism of the seventeenth century rests on another visual basis, and hence, with a similar intention, necessarily arrives at other results. By attributing everything to expression alone, we make the false assumption that for every state of mind the same expressional methods were always available.

And when we speak of the progress of imitation, of the new impressions of nature which an epoch produced, that is also a material element which is bound to a *priori* forms of representation. The observations of the seventeenth century were not merely woven into the fabric of Cinquecento art. The whole groundwork changed. It is a mistake for art history to work with the clumsy notion of the imitation of nature, as though it were merely a homogeneous process of increasing perfection. All the increase in the 'surrender to nature' does not explain how a landscape by Ruysdael differs from one by Patenir, and by the 'progressive conquest of reality' we have still not explained the contrast between a head by Frans Hals and one by Dürer. The imitative content, the subject matter, may be as different in itself as possible, the decisive point remains that the conception in

each case is based on a different visual schema – a schema which, however, is far more deeply rooted than in mere questions of the progress of imitation. It conditions the architectural work as well as the work of representative [*darstellenden*: representational] art, and a Roman baroque façade has the same visual denominator as a landscape by Van Goyen.

·This volume is occupied with the discussion of these universal forms of representation. It does not analyse the beauty of Leonardo but the element in which that beauty became manifest. It does not analyse the representation of nature according to its imitational content, and how, for instance, the naturalism of the sixteenth century may be distinguished from that of the seventeenth, but the mode of perception which lies at the root of the representational arts in the various centuries.

Let us try to sift out these basic forms in the domain of more modern art. We denote the series of periods with the names Early Renaissance, High Renaissance, and Baroque, names which mean little and must lead to misunderstanding in their application to south and north, but are hardly to be ousted now. Unfortunately, the symbolic analogy bud, bloom, decay, plays a secondary and misleading part. If there is in fact a qualitative difference between the fifteenth and sixteenth centuries, in the sense that the fifteenth had gradually to acquire by labour the insight into effects which was at the free disposal of the sixteenth, the (classic) art of the Cinquecento and the (baroque) art of the Seicento are equal in point of value. The word classic here denotes no judgement of value, for baroque has its classicism too. Baroque (or, let us say, modern art) is neither a rise nor a decline from classic, but a totally different art. The occidental development of modern times cannot simply be reduced to a curve with rise, height, and decline: it has two culminating points. We can turn our sympathy to one or to the other, but we must realize that that is an arbitrary judgement, just as it is an arbitrary judgement to say that the rose-bush lives its supreme moment in the formation of the flower, the apple-tree in that of the fruit.

For the sake of simplicity, we must speak of the sixteenth and seventeenth centuries as units of style, although these periods signify no homogeneous production, and, in particular, the features of the Seicento had begun to take shape long before the year 1600, just as, on the other hand, they long continued to affect the appearance of the eighteenth century. Our object is to compare type with type, the finished with the finished. Of course, in the strictest sense of the word, there is nothing 'finished': all historical material is subject to continual transformation; but we must make up our minds to establish the distinctions at a fruitful point, and there to let them speak as contrasts, if we are not to let the whole development slip through our fingers. The preliminary stages of the High Renaissance are not to be ignored, but they represent an archaic form of art, an art of primitives, for whom established pictorial form does not yet exist. But to expose the individual differences which lead from the style of the sixteenth century to that of the seventeenth must be left to a detailed historical survey which will, to tell the truth, only

140

do justice to its task when it has the determining concepts at its disposal.

If we are not mistaken, the development can be reduced, as a provisional formulation, to the following five pairs of concepts:

1) The development from the linear to the painterly, i.e. the development of line as the path of vision and guide of the eye, and the gradual depreciation of line: in more general terms, the perception of the object by its tangible character – in outline and surfaces – on the one hand, and on the other, a perception which is by way of surrendering itself to the mere visual appearance and can abandon 'tangible' design. In the former case the stress is laid on the limits of things; in the other the work tends to look limitless. Seeing by volumes and outlines isolates objects: for the painterly eye, they merge. In the one case interest lies more in the perception of individual material objects as solid, tangible bodies; in the other, in the apprehension of the world as a shifting semblance.

2) The development from plane to recession. Classic art reduces the parts of a total form to a sequence of planes, the baroque emphasizes depth. Plane is the element of line, extension in one plane the form of the greatest explicitness: with the discounting of the contour comes the discounting of the plane, and the eye relates objects essentially in the direction of forwards and backwards. This is no qualitative difference: with a greater power of representing spatial depths, the innovation has nothing directly to do: it signifies rather a radically different mode of representation, just as 'plane style' in our sense is not the style of primitive art, but makes its appearance only at the moment at which foreshortening and spatial illusion are completely mastered.

3) The development from closed to open form. Every work of art must be a finite whole, and it is a defect if we do not feel that it is self-contained, but the interpretation of this demand in the sixteenth and seventeenth centuries is so different that, in comparison with the loose form of the baroque, classic design may be taken as *the* form of closed composition. The relaxation of rules, the yielding of tectonic strength, or whatever name we may give to the process, does not merely signify an enhancement of interest, but is a new mode of representation consistently carried out, and hence this factor is to be adopted among the basic forms of representation.

4) The development from multiplicity to unity. In the system of a classic composition, the single parts, however firmly they may be rooted in the whole, maintain a certain independence. It is not the anarchy of primitive art: the part is conditioned by the whole, and yet does not cease to have its own life. For the spectator, that presupposes an articulation, a progress from part to part, which is a very different operation from perception as a whole, such as the seventeenth century applies and demands. In both styles unity is the chief aim (in contrast to the pre-classic period which did not yet understand the idea in its true sense), but in the one case unity is achieved by a harmony of free parts, in the other, by a union of parts in a single theme, or by the subordination, to one unconditioned dominant, of all other elements.

5) The absolute and the relative clarity of the subject. This is a contrast which at first borders on the contrast between linear and painterly. The representation of things as they are, taken singly and accessible to plastic feeling, and the repre-

sentation of things as they look, seen as a whole, and rather by their non-plastic qualities. But it is a special feature of the classic age that it developed an ideal of perfect clarity which the fifteenth century only vaguely suspected, and which the seventeenth voluntarily sacrificed. Not that artistic form had become confused, for that always produces an unpleasing effect, but the explicitness of the subject is no longer the sole purpose of the presentment. Composition, light, and colour no longer merely serve to define form, but have their own life. There are cases in which absolute clarity has been partly abandoned merely to enhance effect, but 'relative' clarity, as a great all-embracing mode of representation, first entered the history of art at the moment at which reality is beheld with an eye to other effects. Even here it is not a difference of quality if the baroque departed from the ideals of the age of Dürer and Raphael, but, as we have said, a different attitude to the world ...

142

CONCLUSION

1 External and Internal History of Art

It is no felicitous metaphor to call art the mirror of life, and a survey which takes the history of art essentially as the history of expression runs the risk of disastrous one-sidedness. We can contribute what we like to the question of subject matter, we must still reckon with the fact that the expressional organism did not always remain the same. Naturally, in the course of time, art manifests very various contents, but that does not determine the variation in its appearance: speech itself changes as well as grammar and syntax. Not only that it is differently pronounced in different places – that we can easily admit – but it has absolutely its own development, and the most powerful individual talent has only been able to win from it a definite form of expression which does not rise very far above general possibilities. Here too the objection will certainly be made that that goes without saying, the means of expression were only gradually achieved. That is not what is meant here. Even when the means of expression are fully developed, the type varies. To put it differently – the content of the world does not crystallize for the beholder into an unchanging form. Or, to return to the first metaphor, beholding is not just a mirror which always remains the same, but a living power of apprehension which has its own inward history and has passed through many stages.

This change of the form of beholding in the contrast between the classic and baroque types has here been described. It is not the art of the sixteenth and seventeenth centuries which was to be analysed – that is something richer and more living – only the schema and the visual and creative possibilities within which art remained in both cases. To illustrate this, we could naturally only proceed by referring to the individual work of art, but everything which was said of Raphael and Titian, of Rembrandt and Velázquez, was only intended to elucidate the general course of things, not to bring to light the special value of the picture chosen. That would have required more extensive and more exact treatment. But, on the other hand, it is inevitable to refer to important

works: the tendency is, after all, most clearly to be seen in the most outstanding works as the real pioneers.

Another question is how far we have the right to speak of two types at all. Everything is transition and it is hard to answer the man who regards history as an endless flow. For us, intellectual self-preservation demands that we should classify the infinity of events with reference to a few results.

In its breadth, the whole process of the transformation of the imagination has been reduced to five pairs of concepts. We can call them categories of beholding without danger of confusion with Kant's categories. Although they clearly run in one direction, they are still not derived from one principle. (To a Kantian mentality they would look merely adventitious.) It is possible that still other categories could be set up – I could not discover them – and those given here are not so closely related that they could not be imagined in a partly different combination. For all that, to a certain extent they involve each other and, provided we do not take the expression literally, we could call them five different views of one and the same thing. The linear-plastic is connected with the compact space-strata of the plane-style, just as the tectonically self-contained has a natural affinity with the independence of the component parts and perfected clarity. On the other hand, incomplete clarity of form and the unity of effect with depreciated component parts will of itself combine with the atectonic flux and find its place best in the impressionist-painterly conception. And if it looks as though the recessional style did not necessarily belong to the same family, we can reply that its recessional tensions are exclusively based on visual effects which appeal to the eye only and not to plastic feeling.

We can make the test. Among the reproductions illustrated there is hardly one which could not be utilized from any of the other points of view.

2 Forms of Imitation and Decoration

All five pairs of concepts can be interpreted both in the decorative and in the imitative sense. There is a beauty of the tectonic and a truth of the tectonic, a beauty of the painterly and a definite content of the world which is manifested in the painterly, and only in the painterly, style, and so on. But we will not forget that our categories are only forms – forms of apprehension and representation – and that they can therefore have no expressional content in themselves. Here it is only a question of the schema within which a definite beauty can manifest itself and only of the vessel in which impressions of nature can be caught and retained. If the apprehensional form of an epoch is tectonic in type, as in the sixteenth century, that is by no means sufficient to explain the tectonic strength of the picture and figures of a Michelangelo and a Fra Bartolommeo. There is a 'bony' feeling which must first have poured its marrow into the schema. That of which we speak was in its (relative) expressionlessness a matter of course for mankind. When Raphael sketched his compositions for the Villa Farnesina there was no other possibility of thought than that the figures in 'closed' form had to fill the surfaces, and when Rubens designed the procession of children with the wreath of fruit the 'open' form – the figures set in space without filling it – was just

143

as much the only possibility, although in both cases the same theme of grace and joy was to be treated.

False judgements enter art history if we judge from the impression which pictures of different epochs, placed side by side, make on us. We must not interpret their various types of expression merely in terms of *Stimmung* [feeling, impression]. They speak a different language. Thus it is false to attempt an immediate comparison of a Bramante with a Bernini in architecture from the point of view of *Stimmung*. Bramante does not only incorporate a different ideal: his mode of thought is from the outset differently organized from Bernini's. Classic architecture appeared to the seventeenth century as no longer quite living. That is not to be attributed to the repose and clarity of the atmosphere but to the way in which it is expressed. Contemporaries of baroque were also able to dwell in the same spheres of feeling and yet be modern, as we can see from French buildings of the seventeenth century.

Every form of beholding and representation will of its very nature incline to one side, to a certain beauty, to a certain type of presentment of nature (we are about to speak of this), and in so far it again appears false to call the categories expressionless. Yet it should not be difficult to eliminate the misunderstanding. What is meant is the form in which the living is seen, without this life being already determined by its *more specific* content.

Whether a picture or a building, a figure or an ornament, is at issue, the impression of the living has its roots, independently of a special tone of feeling, in a different schema in the two cases. But the readjustment of seeing cannot quite be detached from a different orientation of interest. Even when no definite content of feeling is in question, the value and meaning of being is sought in a different sphere. For classic contemplation the essence lies in the solid, enduring figure which is delineated with the greatest definiteness and all-round distinctness; for painterly contemplation the interest and warrant of life lies in movement. The sixteenth century, of course, did not quite abandon the motive of movement, and a drawing by Michelangelo must in this point have seemed unsurpassable, yet only the seeing which aimed at mere appearance, painterly seeing, gave representation the means of producing the impression of movement in the sense of change. That is the decisive contrast between classic and baroque art. Classic ornament has its meaning in the form as it is, baroque ornament changes under the spectator's eyes. Classic colouring is a given harmony of separate colours, baroque colouring is always a movement of colour and is bound up with the impression of becoming. In another sense than of the classic portrait we should have to say of baroque that not the eye but the look was its content, and not the lips but the breath. The body breathes. The whole picture space is filled with movement.

The idea of reality has changed as much as the idea of beauty.

3 The Why of the Development

There is no denying it – the development of the process is psychologically intelligible. It is perfectly comprehensible that the notion of clarity had first to be devel-

oped before an interest could be found in a partially troubled clarity. It is just as comprehensible that the conception of a unity of parts whose independence has been swamped in the total effect could only succeed the system with independently developed parts, that to play with the hidden adherence to rule (atectonic) presupposes the stage of obvious adherence to rule. The development from the linear to the painterly, comprehending all the rest, means the progress from a tactile apprehension of things in space to a type of contemplation which has learned to surrender itself to the mere visual impression, in other words, the relinquishment of the physically tangible for the sake of the mere visual appearance.

The point of departure must, of course, be given. We spoke only of the transformation of a classic art into the baroque. But that a classic art comes into being at all, that the striving for a picture of the world, plastically tectonic, clear, and thought out in all its aspects, exists – that is by no means a matter of course, and only happened at definite times and at certain places in the history of mankind. And though we feel the course of things to be intelligible, that, of course, still does not explain why it takes place at all. For what reasons does this development come about?

Here we encounter the great problem – is the change in the forms of apprehension the result of an inward development, of a development of the apparatus of apprehension fulfilling itself to a certain extent of itself, or is it an impulse from outside, the other interest, the other attitude to the world, which determines the change? The problem leads far beyond the domain of descriptive art history, and we will only indicate what we imagine the solution to be.

Both ways of regarding the problem are admissible, i.e. each regarded for itself alone. Certainly we must not imagine that an internal mechanism runs automatically and produces, in any conditions, the said series of forms of apprehension. For that to happen, life must be experienced in a certain way. But the human imaginative faculty will always make its organization and possibilities of development felt in the history of art. It is true, we only see what we look for, but we only look for what we can see. Doubtless certain forms of beholding pre-exist as possibilities; whether and how they come to development depends on outward circumstances.

The history of generations does not proceed differently from the history of the individual. If a great individual like Titian incorporates perfectly new possibilities in his ultimate style, we can certainly say a new feeling demanded this new style. But these new possibilities of style first appeared for him because he had already left so many old possibilities behind him. No human personality, however mighty, would have sufficed to enable him to conceive these forms if he had not previously been over the ground which contained the necessary preliminary stages. The continuity of the life-feeling was as necessary here as in the generations which combine to form a unit in history.

The history of forms never stands still. There are times of accelerated impulse and times of slow imaginative activity, but even then an ornament continually repeated will gradually alter its physiognomy. Nothing retains its effect. What seems living today is not quite completely living tomorrow. This process is not only to be explained negatively by the theory of the palling of interest and a con-

sequent necessity of a stimulation of interest, but positively also by the fact that every form lives on, begetting, and every style calls to a new one. We see that clearly in the history of decoration and architecture. But even in the history of representational art, the effect of picture on picture as a factor in style is much more important than what comes directly from the imitation of nature. Pictorial imitation developed from decoration – the design as representation once arose from the ornament – and the after-effects of this relation have affected the whole of art history.

It is a dilettantist notion that an artist could ever take up his stand before nature without any preconceived ideas. But what he has taken over as concept of representation, and how this concept goes on working in him, is much more important than anything he takes from direct observation. (At least as long as art is creative and decorative and not scientifically analytic.) The observation of nature is an empty notion as long as we do not know in what forms the observation took place. The whole progress of the 'imitation of nature' is anchored in decorative feeling. Ability only plays a secondary part. While we must not allow our right to pronounce qualitative judgements on the epochs of the past to atrophy, yet it is certainly right that art has always been able to do what it wanted and that it dreaded no theme because 'it could not do it', but that only that was omitted which was not felt to be pictorially interesting. Hence the history of art is not secondarily but absolutely primarily a history of decoration.

All artistic beholding is bound to certain decorative schemas or – to repeat the expression – the visible world is crystallized for the eye in certain forms. In each new crystal form, however, a new facet of the content of the world will come to light.

4 Periodicity of the Development

In these circumstances, it is of great importance that certain permanent developments may be observed in all the architectonic styles of the occident. There is classic and baroque not only in more modern times and not only in antique building, but on so different ground as Gothic. In spite of the fact that the calculation of forces is totally different, High Gothic, in the most general aspect of creation, can be defined by the concepts which we developed for the classic art of the Renaissance. It has a purely 'linear' character. Its beauty is a plane-beauty and is tectonic in so far as it too represents the bound-by-law. The whole can be reduced to a system of independent parts: however little the Gothic ideal coincides with the ideal of the Renaissance, there are in it nothing but parts which look self-contained, and everywhere within this world of forms, absolute clarity is envisaged.

In contrast to this, late Gothic seeks the painterly effect of vibrating forms. Not in the modern sense, but compared with the strict linearity of High Gothic, form has been divorced from the type of plastic rigidity and forced over towards the appearance of movement. The style develops recessional motives, motives of overlapping in the ornament as in space. It plays with the apparently lawless and in places softens into flux. And as now calculations with mass effects come, where

the single form no longer speaks with a quite independent voice, this art delights in the mysterious and unlucid, in other words, in a partial obscuring of clarity.

For, in fact, what else shall we call it but baroque if we – with the realization of a totally different system of structure always in mind – meet exactly the same formal transformations as we know in later times, down to the turning inwards of the frontal towers which break the plane into recession with a quite unprecedented boldness?

On quite general considerations, J. Burckhardt and Dehio supported the view that a periodicity in the history of architecture was to be assumed. That every occidental style, just as it has its classic epoch, has also its baroque, assuming that time is given it to live itself out. We can define baroque in any way we please – Dehio has his own opinion – the decisive point is that he, too, believes in a history of form working itself out inwardly. The development, however, will only fulfil itself where the forms have passed from hand to hand long enough or, better expressed, where the imagination has occupied itself with form actively enough to make it yield up its baroque possibilities.

But that by no means asserts that style in this baroque phase could not be the organ of expression of the mood of an epoch. The new contents to be elicited seek their expression only in the forms of a late style. The late style in itself can take on the most various aspects; as we know, what it primarily gives is only the form of the living. Just the physiognomy of Nordic late Gothic is very strongly affected by new elements of subject matter. But Roman baroque, too, is not to be characterized merely as a late style, but must be understood as conveying new emotional values.

How should such processes of the history of architectonic forms not have their analogy in representational art too? It is really an uncontested fact that, with longer or shorter wave-lengths, certain homonymous [*gleichlautende*: identical] developments from linear to painterly have taken place more than once in the occident. The history of antique art works with the same concepts as the modern and – in essentially different circumstances – the spectacle is repeated in the Middle Ages. French sculpture from the twelfth to the fifteenth centuries offers an extraordinarily clear example of such a development, to which parallels in painting are not lacking. We must only, in reference to modern art, reckon with a fundamentally different point of departure. Medieval design is not the perspective, spatial design of recent times, but more an abstract, plane type which only at the end breaks into the recessions of three-dimensional pictures. We cannot apply our categories immediately to this development, but the total movement obviously runs parallel. And that is the thing that counts, not that the development curves of the various periods of the world should absolutely coincide.

Even within a period, the historian will never be able to reckon with a uniformly progressive element. Peoples and generations diverge. In one case the development is slower, in another quicker. It happens that developments which have been begun are broken off and only later resumed, or the tendencies branch, and beside a progressive style a conservative one asserts itself, receiving a special quality by the contrast. These are things which can properly be left out of consideration here.

Even the parallel between the individual arts is not complete. That they move so completely abreast as in later Italy occurs in parts of the north, but as soon, for instance, as there is anywhere an inclination to foreign models in form, the parallelism is disturbed. Then foreign matter appears on the horizon which immediately brings with it an adaptation of the eye, for which the history of German renaissance architecture offers a striking example.

Another point is that architecture retains fundamentally the elementary stages of the representation of form. When we speak of painterly rococo, we must not forget that beside those interior decorations for which the comparison holds, there is always a much more discreet exterior architecture. Rococo *can* evaporate into the free and imponderable, but it is not obliged to do so and really only did so on rare occasions. In this there lies just the peculiar character of the art of building as compared with all the other arts which, proceeding from it, have gradually quite emancipated themselves. It always retains its own degree of tectonic clarity and tangibility.

148

5 The Problem of Recommencement

The notion of periodicity involves the fact of a cessation and recommencement of developments. We must here too ask for the why. Why does the development ever rebound?

In the whole course of this survey, we have had in mind the renewal of style about 1800. With extraordinarily penetrating definiteness, a new 'linear' mode of vision rises in opposition to the painterly mode of the eighteenth century. The general explanation that every phenomenon must beget its opposite does not help us much. The interruption remains something 'unnatural' and will only happen in connection with profound changes in the spiritual world. If seeing changes from the plastic to the painterly imperceptibly and almost of itself, so that we can ask if it is not in fact just a matter of a purely inward development, in the return from the painterly to the plastic, the main impetus lies certainly in outward circumstances. The proof in our case is not difficult. It is the epoch of a revaluation of being in all spheres. The new line comes to serve a new objectivity. Not the general effect is now desired, but the separate form: not the charm of an approximate appearance, but the shape as it is. The truth and beauty of nature lies in what can be grasped and measured. From the outset criticism expresses this most distinctly. Diderot contests in Boucher not only the artist but the man. This purely human feeling seeks the simple. And now appear the demands we already know: the figures in the picture shall remain isolated and give proof of their beauty by being capable of being carried into the relief, by which, of course, linear relief is meant. In the same sense, later, Friedrich Schlegel said: 'No confused heap of human beings but a few, distinct figures, perfected with industry, grave and austere forms distinctly outlined, standing out resolutely, no painting of clear-obscure and murk in night and shadows, but pure proportions and masses of colours as in clear chords ... but in the faces throughout and everywhere that good-natured simplicity ... which I am inclined to regard as the original character of the human being: that is the style of the old painting,

the only style I love.'

What is expressed here in rather Pre-Raphaelite tone is naturally nothing but what lies at the base of the new reverence for the purity of the antique-classic form, in the domain of a more general humanity.

But the case of the renewal of art about 1800 is unique, as unique as the accompanying conditions were. Within a relatively short span of time, occidental humanity then passed through a process of total regeneration. The new directly opposes the old and at all points. It really seems here as if it had been possible to begin again at the beginning.

A closer inspection certainly soon shows that art even here did not return to the point at which it once stood, but that only a spiral movement would meet the facts. But if we enquire into the beginnings of the preceding development, we look in vain for a corresponding situation where everywhere, and with quick resolution, a will to the linear and austere should have cut off a picturesque-free tradition. Certainly there are analogies in the fifteenth century, and when we denote the Quattrocento as primitive, we mean by that that the beginning of modern art lies there. Yet Masaccio takes his stand on the Trecento and Jan van Eyck's pictures are not the beginning of a tendency, but the efflorescence of a late Gothic painterly tradition reaching far back. In spite of that it is quite in order if, from certain points of view, this art appears to us as the preliminary stage of the classic epoch of the sixteenth century. Old and new, however, so dovetail here that it is difficult to make the section. Thus historians are always uncertain where to make the chapter on modern art history begin. Strict claims for 'clear-cut' period divisions do not carry us very far. In the old form, the new is already contained just as, beside the withering leaves, the bud of the new already exists.

6 National Characteristics

In spite of all deviations and individual movements, the development of style in later occidental art was homogeneous, just as European culture as a whole can be taken as homogeneous. But within this homogeneity, we must reckon with the permanent differences of national types. From the beginning we have made reference to the way in which the modes of vision are refracted by nationality. There is a definite type of Italian or German imagination which asserts itself, always the same in all centuries. Naturally they are not constants in the mathematical sense, but to set up a scheme of a national type of imagination is a necessary aid to the historian. The time will soon come when the historical record of European architecture will no longer be merely subdivided into Gothic, Renaissance, and so on, but will trace out the national physiognomies which cannot quite be effaced even by imported styles. Italian Gothic is an Italian style, just as the German Renaissance can only be understood on the basis of the whole tradition of Nordic-Germanic creation.

In representational art, the relation comes more clearly to light. There is a Germanic imagination which certainly passes through the general development from plastic to painterly, but still, from the very beginning, reacts more strongly to

painterly stimuli than the southern. Not the line but the web of lines. Not the established single form but the movement of form. There is faith even in the things which cannot be grasped with hands.

The form assembled in the pure plane does not long appeal to such people. They plough up the depths, they seek the stream of movement working upward from below.

Even Germanic art had its tectonic age, but not in the sense that the most rigid order was at any time also felt to be the most living. Here there is also room for the flash of inspiration, for the apparently wilful, the indirectly applied rule. The pre-sentment strives to pass beyond the law-bound towards the unbound and unbounded. Rustling woods mean more to the imagination than the self-sufficing tectonic structure.

What is so characteristic for Romanesque feeling – articulated beauty, the transparent system with clear-cut parts – is certainly not unknown to Germanic art as an ideal, but immediately thought seeks the unity, the all-filling, where system is abolished and the independence of the parts is submerged in the whole. That is the case with every figure. Certainly art attempted to set it on its own feet, but in secret there was always a living imaginative impulse to weave it into a more general context, to fuse its separate value into a new total appearance. And just in that fact lie the conditions of northern landscape painting. We do not see tree and hill and cloud for themselves, but everything is absorbed in the breath of the one great scene.

At a remarkably early stage, the imagination yields to those effects which do not proceed from things themselves, but leave the thing out of account – those pic-tures in which not the individual form of objects and their rational connection convey the impression but what, so to speak, rises as an adventitious configuration over the head of the separate form. We refer back to what was discussed above as content of the concept of artistic 'unclearness'.

With this is certainly connected the fact that, in northern architecture, forma-tions were admitted which for the southern imagination could no longer be understood, that is, experienced. In the south, man is the 'measure of all things', and every line, every plane, every cube is the expression of this plastic anthro-pocentric conception. In the north there are no binding standards taken from the human being. Gothic reckons with powers which elude any possibility of human comparison, and when the newer architecture makes use of the apparatus of Italian forms, it seeks effects in a life of the form so mysterious that everyone must immediately recognize the fundamental difference in the demands made on the imitating imagination.

7 Shifting of the Centre of Gravity

It is always a little invidious to play one epoch off against another. Yet we cannot get over the fact that every people has epochs in the history of its art which seem, more than others, the peculiar revelation of its national virtues. For Italy, it was the sixteenth century which was most productive of elements peculiar only to this country; for the Germanic north, it was the period of the baroque. In Italy, a

plastic talent, which shapes its classic art on the basis of linearism; in the north, a painterly faculty which only first expresses itself quite individually in baroque.

That Italy could once become the artistic centre of Europe arises naturally from other causes than those of the history of art, but it is comprehensible that in a homogeneous artistic development of the occident, the centre of gravity must shift according to the particular faculties of the individual peoples. Italy once treated general ideals in a peculiarly clear way. Not the accident of Italian journeys undertaken by Dürer or other artists created Romanesque for the north; the journeys were the result of the attraction which the land, given the contemporary orientation of European vision, was bound to exert on the other nations. However different national characters may be, the general human element which binds is stronger than all that separates. A constant compensation takes place, and this compensation remains fecund even when at first confusion arises and – what is inevitable in every imitation – it also brings with it elements which are not understood and remain foreign.

The connection with Italy did not cease in the seventeenth century, but the most peculiar elements of the north arose without Italy. Rembrandt did not make the customary artistic journey over the Alps, and even if he had, he would hardly have been touched by the Italy of that epoch. It could not have given his imagination anything which he did not already possess in a much higher degree. But we may ask – why did the opposite movement not set in then? Why, in the painterly epoch, did the north not become the master of the south? To that we might answer that the occidental schools all passed through the plastic zone, but that for the further development into the painterly, national limits were set from the beginning.

As every history of vision must lead beyond mere art, it goes without saying that such national differences of the eye are more than a mere question of taste: conditioned and conditioning, they contain the bases of the whole world-picture of a people. That is why the history of art as the doctrine of the modes of vision can claim to be, not only a mere [supernumererary] in the company of historical disciplines, but as necessary as sight itself.

Paul Frankl

Principles of Architectural History,
1914

The German art historian Paul Frankl (1889–1963) began as a student of Heinrich Wölfflin at Munich between 1910 and 1914, working on his master's project of attempting to understand the sequence of styles from the fifteenth century to the nineteenth, but concentrating on architecture. Thereafter he turned his attention to the Middle Ages, on which he produced a series of seminal volumes. In 1921 he became professor of art history at Halle, and on being removed from office by the Nazis in 1934 he went to the United States where he held a professorship at Princeton. His books from this period include a monumental study of the literary sources of the Gothic style.[1]

In the present context the most important fact about Frankl is his close working relationship with Wölfflin; he produced his thesis, from which the introduction is reprinted here, shortly before Wölfflin published his *Principles* in 1915.[2] Frankl's views on the nature of historical ideas, as outlined here, are fundamentally those of Hegel, expressed through the influence of Wölfflin, but so distilled that they almost appear more old-fashioned. The prime movers of history are forms or ideas which transcend and mould human activity. Frankl set himself the goal of describing the whole history of style as if it were an 'organism' and a single 'process'. This process overrides everything else, whether national characteristics or individual artists, even the greatest genius being demoted to no more than its servant. He goes so far as to describe architecture as nothing more than a reflection of other social forms such as philosophy, religion, politics, and science, rejecting the fact that architecture is as much a part of the culture which needs to be expressed as they are.

Change for Frankl is caused by 'immanent' style-forces, which have been identified as the equivalent of Riegl's *Kunstwollen*.[3] On a more technical level, Frankl appears to be following Wölfflin when he describes stylistic elements in terms of two polar opposites. *Style and *form combine to produce a manifestation of a *culture.

Towards the end of his life Frankl developed a model of social change which might be called a mitigated form of *Hegelianism. He likened society to a cylinder proceeding through time along its axis and containing a number of different strands representing all of its specialized fields (such as architecture and philosophy). The core of the society in the centre of the cylinder, which manifests a desire for harmony, keeps the diverging and intertwining evolutionary lines of the specialized fields

parallel to the surface of the cylinder, and hence part of a recognizable whole. This is a diachronic model of the Hegelian system, that is, one extending through time, as opposed to the synchronic wheel used by Gombrich to represent the Hegelian view of the relationship between all aspects of a society at any one time (see the introduction to Gombrich, text 19, 1967).[4]

Finally, it is worth quoting the last sentence in *Principles*, which is visionary in its scope: 'Today we look back over the phases of post-medieval architecture and their inevitable end as a revelation of human history, and we stand expectantly at the beginning of a new development. Despite the revelations of the past, we cannot know what lies in the future. But we do know that we have made a start and that it is once more a pleasure to be alive.' Even if it is a little late, modernism in the visual arts could hardly have wished for a more eloquent herald.[5]

1 Paul Frankl, *Fruehmittelalterliche und Romanische Baukunst*, Wildpark-Potsdam, 1926; *The Gothic: Literary Sources and Interpretations through Eight Centuries*, Princeton, NJ, 1960; see also his *Gothic Architecture*, Harmondsworth, 1962.

2 Following strict chronological order this text should precede Wölfflin's of 1915; this order has been reversed because the precedence of Frankl's text is not significant and indeed is misleading, given that Frankl was a pupil of Wölfflin and acknowledges his immediate debt to his master.

3 James Ackerman, in the foreword to Paul Frankl, *Principles of Architectural History: the Four Phases of Architectural Style, 1420–1900*, translated by J.F. O'Gorman, Cambridge, MA, 1968, p. ix.

4 *The Gothic*, op. cit., pp. 223–4. On Frankl and his position in the tradition stemming from Hegel, see Michael Podro, *The Critical Historians of Art*, New Haven and London, 1982, pp. 145ff.

5 *Principles*, op. cit., p. 195.

Principles of Architectural History, 1914

Paul Frankl, *Die Entwicklungsphasen
der neueren Baukunst*, dissertation, Munich, 1914.
Introduction to *Principles of Architectural History:
the Four Phases of Architectural Style, 1420–1900*,
translated by J.F. O'Gorman, Cambridge, MA,
1968, pp. 1–3.

To study stylistic change in architecture, that is, to establish the polar opposites separating the successive phases of one epoch, which is our main aim here, we must focus upon the comparable elements in the art of building and determine categories of similar features that remain constant over a period of time.

When we compare church façades, we must be aware that this concept is subject to the higher concept of façade in general. As soon as we disregard the special features of a church façade, the common characteristics of all façades (palace, church, villa) will become apparent, and the differences between street and courtyard façades will disappear. Façade itself is only the exterior elevation; it must display characteristics of style that can be observed from inside as well as outside. These general characteristics are also present on the ceiling and on the floor, despite their own peculiarities. Internal and external walls, floors, and roofs can all be included under the general concept of the tectonic shell. Corporeality is their common element; it completely distinguishes them from colour and light, the merely visible, which forms a second category, and from the space they enclose, which forms a third.

The visual impression, the *image* produced by differences of light and colour, is primary in our perception of a building. We empirically reinterpret this image into a conception of *corporeality*, and this defines the form of the *space within*, whether we read it from outside or stand in the interior. But optical appearance, corporeality, and space do not alone make a building. Distinctions between church, palace, villa, and city hall are based upon specific, typical forms, which crystallize for specific purposes. The forms are not retained for specific purposes, but are necessarily the products of purpose. The moulded space is the theatre for certain human activities, and these are the focus of our perception. Once we have reinterpreted the optical image into a conception of space enclosed by mass, we read its *purpose* from the spatial form. We thus grasp its spiritual import, its content, its meaning. The designing architect works in the opposite direction, of course. He begins with the building programme. As he lays out the pattern of activities it demands, he produces a framework of circulation around which the rooms are arranged. When he has found his spatial form for this programme, he begins to model the enclosing mass. Light and colour are his last considerations.

But this sequence can be altered in various ways during the design process. Lighting and the perspective image interact, and this can have a decisive effect upon the ultimate spatial form. The sequence is unimportant. We are interested only in the fact that space, light, corporeality, and purpose are the most general concepts we can find. They best characterize the differences between buildings. They are so different that there is no danger of repetition when we discuss them.

We are looking for the polar opposites of spatial form that separate the successive phases of one epoch and for the polar opposites within the other categories as well. But we are concerned only with the architecture of the post-medieval epoch. I had better explain what I mean by this term.

Renaissance architecture has been defined in many ways, but Geymüller's definition is the broadest. In various works he has described it as a combination of antique and Gothic forms extending in time from Frederick II of Hohenstaufen, in the thirteenth century, up to his own day, say 1900. I must reject part of this description.

In the early fifteenth century Brunelleschi consciously broke with the Gothic tradition and erected whole buildings in imitation of antique forms. He was imitated in turn by contemporary architects, and a new development was born. This new development was possible because the same ideas that led Brunelleschi to a revival of antique architecture were shared by his educated contemporaries. If architecture is the moulded theatre of human activity, of the joys and sorrows of a society, an architectural style can begin only when a culture has reached a state of maturity. Philosophy, religion, politics, and science – the whole of Renaissance culture – had to be ready before the fine arts could give them expression. 'Renaissance Man' preceded the Renaissance artist. Of course Renaissance *culture* did not appear overnight, but the *architectural* historian can leave the problem of its development to other disciplines. The Renaissance begins for him at that moment in the middle of the Gothic tradition when Brunelleschi erected buildings that corresponded to the new spirit.

I cannot accept Geymüller's inclusion of Gothic forms in his definition of Renaissance architecture. Michelangelo's St Peter's in the Vatican is no synthesis of antique orders and Gothic vaulting, no rebirth of ancient or medieval architecture, but an entirely new creation. Although Leonardo and Bramante produced designs for Milan Cathedral, and although Gothic vestiges can be found in the works of Brunelleschi and Michelozzo, the entire development indicates as clearly as do the sources that the Gothic was considered vanquished and was detested.

I agree with Geymüller, however, that after Brunelleschi there is no break in the tradition. The Renaissance began in Florence and spread through Tuscany to Rome, and from there throughout the Christian world. It took on a new aspect each time it crossed a border, of course, but it followed a basically continuous development according to its own inner logic. In the course of time its newly conquered territories became equally important as centres of stylistic development, until finally the crises of change occurred no longer in Rome but in Paris, Antwerp, or the many princely courts in Germany. We can study this development as a whole or in its local variations.

The *development* of style is an intellectual process overriding national characteristics and individual artists. It is a great man who can cope with the problems of his time, but the greatest genius is no more than the servant of this intellectual process.

I think it unnecessary to deal with the peculiarities of geography or race in this book. I shall discuss the entire continuous development from Brunelleschi to the end of the nineteenth century as one unit. I shall include not only Italy and France but the whole of Christianity. Local variations in the development might be of importance in other studies, or in the ultimate narration of the development, but they are unimportant here.

I refuse to call this entire period the Renaissance. This term is now firmly established for the first phase. If I include the Baroque in the Renaissance, I cannot characterize the two as polar opposites. I have chosen to call the entire period of architectural history between 1420 and 1900 simply 'post-medieval'. This seems harmless enough. The terms for the individual phases (Renaissance, Baroque, Rococo, Neoclassicism) are easier to do without than is commonly believed. I shall avoid them until I have defined each phase by stylistic polarity.

The reader now knows what to expect, and what not to expect. I restrict myself to post-medieval architecture in this work because it is provisional. I am investigating older epochs using the same method and hope eventually to achieve insight into the organism of stylistic development by comparing all epochs and their development. I have no doubt that my subsequent studies will be made easier because of this one and that this one will need correction once I have completed them.

12 ROGER FRY

Vision and Design, 1920

Roger Fry (1866–1934) was first and foremost a critic, though he was also an artist and a writer on art in general, and was instrumental in the founding of the *Burlington Magazine* of which he was the first editor. He was cosmopolitan, having studied science at Cambridge and painting in Paris, and having worked in New York as curator of paintings at the Metropolitan Museum of Art. He also visited Italy, where he was influenced by the methods of Giovanni Morelli (text 8, 1890). He was one of the first writers in Britain to come to terms with the modern movement, which he championed by means of exhibitions, articles and books, including his cele-brated Post-Impressionism exhibition of 1911 and his monograph on Cézanne.[1] He was associ-ated with the Bloomsbury Group and founded the Omega Workshops in 1913, designing furniture and textiles. The 'Retrospect' printed here was intended to sum up and place in context a set of essays and lectures written over twenty years from 1901 to 1920, brought together under the title *Vision and Design*.[2] It also represents an attempt to place an understanding of modernism in the visual arts in a historical context and to establish what it is about modernism which makes it at one and the same time different and part of a continuum. In this text Fry analyses works of art in a new way. Taking Raphael's *Transfiguration* (fig. 33) as an example, he treats it first in terms of its content, then by the extent of its truth to nature, and then in terms of the most important element, its 'form, as he would analyse the form of a piece of music. He identifies the structure of High Renaissance works like this one as what is missing in nineteenth-century nat-uralistic art (fig. 34), and conversely what makes the art of Cézanne (fig. 35), Seurat, Van Gogh, Gauguin and the Cubists part of the great tradition. Focillon (text 13, 1934) discusses Raphael's *The School of Athens* in the same terms.

Fry's distrust of the vagueness of first principles and definitions of the ultimate nature of art means that he does not see modern art as the next element in a 'cycle or sequence of 'periods. This assessment fits the character of the works themselves, for while the works of Cézanne, for example, can be related to the classicism of Raphael and Poussin, they cannot be seen as repre-senting a 'classic phase arising out of any supposed primitive or early phase in the nineteenth century. Instead Fry postulates a great tradition whose representatives can belong to any age. Thus his overall approach, like his parallel between a Raphael and a Cézanne, is essentially timeless, that is, he sees works of art as objects in themselves rather than as products of their age. This is evident in his disparaging reference to 'archaeological curiosity, that is, an attitude involving oneself in attention to physical details which can distract from and obscure the work of art itself.

33 Raphael, *Transfiguration*, 1517. Oil on panel, 4.05 × 2.78 m. Musei Vaticani, Rome
Fry approaches the subject matter of this painting in a traditional way, discussing the extent to which it imitates nature and achieves ideal beauty. He also analyses it in terms of its form alone, as if it were an abstract canvas or a piece of music. In so doing he describes the powerful structure underlying the painting, a characteristic which he also identifies in the work of Cézanne (fig. 35), but not in the naturalistic art of the nineteenth century (fig. 34).

158

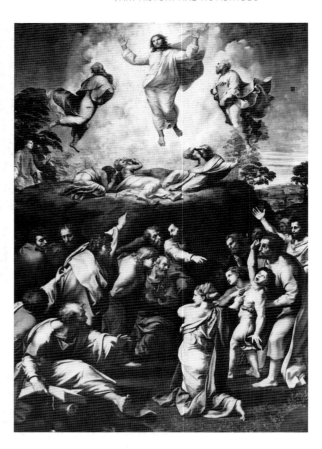

Although he does not use the word, he defines all art in abstract terms, in which any degree of naturalism is incidental. This formal factor renders the relative naturalism of a work of art irrelevant and even allows the possibility that it could be entirely non-representational. This is an epoch-making statement. It may appear to have a parallel in Riegl's analysis of form (text 9, 1901), but Riegl's aims were entirely the opposite of Fry's, namely using 'form in order to understand a period of history, whereas for Fry it is the form which makes the art and which needs no justification beyond itself. It is this which is new. Fry thus approaches his subject more like an artist than an art historian.

1 Roger Fry, *Cézanne, a Study of his Development*, London, 1927.
2 Roger Fry, *Vision and Design* (1920), 5th edn, London, 1957, pp. 284–302.

34 William Holman Hunt, *The Hireling Shepherd*, c. 1851.
Oil on canvas, 76.4 × 109.5 cm. Manchester City Art
Galleries
See fig. 33.

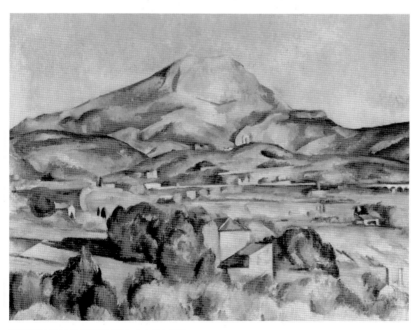

35 Paul Cézanne, *Mont Sainte-Victoire seen from Bellevue*,
c.1888–90. Oil on canvas, 73 × 92 cm. Barnes
Foundation, Merion, PA
See fig. 33.

12 | Roger Fry

Vision and Design, 1920

Roger Fry, *Vision and Design*, London, 1920.
Excerpt from 'Retrospect' in *Vision and Design*,
5th edn, London, 1957, pp. 284–302.

The work of re-reading and selecting from the mass of my writings as an art critic has inevitably brought me up against the question of its consistency and coherence. Although I do not think that I have republished here anything with which I entirely disagree, I cannot but recognize that in many of these essays the emphasis lies in a different place from where I should now put it. Fortunately I have never prided myself upon my unchanging constancy of attitude, but unless I flatter myself I think I can trace a certain trend of thought underlying very different expressions of opinion. Now since that trend seems to me to be symptomatic of modern aesthetic, and since it may perhaps explain much that seems paradoxical in the actual situation of art, it may be interesting to discuss its nature even at the cost of being autobiographical.

In my work as a critic of art I have never been a pure Impressionist, a mere recording instrument of certain sensations. I have always had some kind of aesthetic. A certain scientific curiosity and a desire for comprehension have impelled me at every stage to make generalizations, to attempt some kind of logical co-ordination of my impressions. But, on the other hand, I have never worked out for myself a complete system such as the metaphysicians deduce from *a priori* principles. I have never believed that I knew what was the ultimate nature of art. My aesthetic has been a purely practical one, a tentative expedient, an attempt to reduce to some kind of order my aesthetic impressions up to date. It has been held merely until such time as fresh experiences might confirm or modify it. Moreover, I have always looked on my system with a certain suspicion. I have recognized that if it ever formed too solid a crust it might stop the inlets of fresh experience, and I can count various occasions when my principles would have led me to condemn, and when my sensibility has played the part of Balaam with the effect of making temporary chaos of my system. That has, of course, always rearranged itself to take in the new experience, but with each such cataclysm it has suffered a loss of prestige. So that even in its latest form I do not put forward my system as more than a provisional induction from my own aesthetic experiences.

I have certainly tried to make my judgement as objective as possible, but the critic must work with the only instrument he possesses – namely, his own sensibility with all its personal equations. All that he can consciously endeavour is to

perfect that tool to its utmost by studying the traditional verdicts of men of aesthetic sensibility in the past, and by constant comparison of his own reactions with those of his contemporaries who are specially gifted in this way. When he has done all that he can in this direction – and I would allow him a slight bias in favour of agreement with tradition – he is bound to accept the verdict of his own feelings as honestly as he can. Even plain honesty in this matter is more difficult to attain than would be supposed by those who have never tried it. In so delicate a matter as the artistic judgement one is liable to many accidental disturbing influences, one can scarcely avoid temporary hypnotisms and hallucinations. One can only watch for and try to discount these, taking every opportunity to catch one's sensibility unawares before it can take cover behind prejudices and theories.

When the critic holds the result of his reaction to a work of art clearly in view he has next to translate it into words. Here, too, distortion is inevitable, and it is here that I have probably failed most of accuracy, for language in the hands of one who lacks the mastery of a poet has its own tricks, its perversities and habits. There are things which it shies at and goes round, there are places where it runs away and, leaving the reality which it professes to carry tumbled out at the tail of the cart, arrives in a great pother, but without the goods.

But in spite of all these limitations and the errors they entail it seems to me that the attempt to attain objective judgements has not altogether failed, and that I seem to myself to have been always groping my way towards some kind of a reasoned and practical aesthetic. Many minds have been engaged alongside of mine in the same pursuit. I think we may claim that partly as a result of our common efforts a rather more intelligent attitude exists in the educated public of today than obtained in the last century.

Art in England is sometimes insular, sometimes provincial. The Pre-Raphaelite movement was mainly an indigenous product. The dying echoes of this remarkable explosion reverberated through the years of my nonage, but when I first began to study art seriously the vital movement was a provincial one. After the usual twenty years of delay, provincial England had become aware of the Impressionist movement in France, and the younger painters of promise were working under the influence of Monet. Some of them even formulated theories of naturalism in its most literal and extreme form. But at the same time Whistler, whose Impressionism was of a very different stamp, had put forward the purely decorative idea of art, and had tried in his 'Ten o'clock', perhaps too cavalierly, to sweep away the web of ethical questions, distorted by aesthetic prejudices, which Ruskin's exuberant and ill-regulated mind had spun for the British public.

The Naturalists made no attempt to explain why the exact and literal imitation of nature should satisfy the human spirit, and the 'Decorators' failed to distinguish between agreeable sensations and imaginative significance.

After a brief period during which I was interested in the new possibilities opened up by the more scientific evaluation of colour which the Impressionists practised, I came to feel more and more the absence in their work of structural design. It was an innate desire for this aspect of art which drove me to the study of the Old Masters and, in particular, those of the Italian Renaissance, in the hope of discovering from them the secret of that architectonic idea which I missed so

badly in the work of my contemporaries. I think now that a certain amount of 'cussedness' led me to exaggerate what was none the less a genuine personal reaction. Finding myself out of touch with my generation I took a certain pleasure in emphasizing my isolation. I always recognized fully that the only vital art of the day was that of the Impressionists whose theories I disbelieved, and I was always able to admit the greatness of Degas and Renoir. But many of my judgements of modern art were too much affected by my attitude. I do not think I ever praised Mr Wilson Steer or Mr Walter Sickert as much as they deserved, and I looked with too great indulgence on some would-be imitators of the Old Masters. But my most serious lapse was the failure to discover the genius of Seurat, whose supreme merits as a designer I had every reason to acclaim. I cannot even now tell whether I ever saw his work in the exhibitions of the early nineties, but if I did his qualities were hidden from me by the now transparent veil of pointillism – a pseudo-scientific system of atmospheric colour notation in which I took no interest.

I think I can claim that my study of the Old Masters was never much tainted by archaeological curiosity. I tried to study them in the same spirit as I might study contemporary artists, and I always regretted that there was no modern art capable of satisfying my predilections. I say there was no modern art because none such was known to me, but all the time there was one who had already worked out the problem which seemed to me insoluble of how to use the modern vision with the constructive design of the older master. By some extraordinary ill luck I managed to miss seeing Cézanne's work till some considerable time after his death. I had heard of him vaguely from time to time as a kind of hidden oracle of ultra-impressionism, and, in consequence, I expected to find myself entirely unreceptive to his art. To my intense surprise I found myself deeply moved. I have discovered the article in which I recorded this encounter, and though the praise I gave would sound grudging and feeble today – for I was still obsessed by ideas about the content of a work of art – I am glad to see that I was so ready to scrap a long-cherished hypothesis in face of a new experience.

In the next few years I became increasingly interested in the art of Cézanne and of those like Gauguin and Van Gogh who at that time represented the first effects of his profound influence on modern art, and I gradually recognized that what I had hoped for as a possible event of some future century had already occurred, that art had begun to recover once more the language of design and to explore its so long neglected possibilities. Thus it happened that when at the end of 1911, by a curious series of chances, I was in a position to organize an exhibition at the Grafton Galleries, I seized the opportunity to bring before the English public a selection of works conforming to the new direction. For purposes of convenience it was necessary to give these artists a name, and I chose, as being the vaguest and most non-committal, the name of Post-Impressionist. This merely stated their position in time relatively to the Impressionist movement. In conformity with my own previous prejudices against Impressionism, I think I underlined too much their divorce from the parent stock. I see now more clearly their affiliation with it, but I was none the less right in recognizing their essential difference, a difference which the subsequent development of Cubism has rendered more evident. Of

late the thesis of their fundamental opposition has been again enforced in the writings of M. Lhote.

If I may judge by the discussions in the press to which this exhibition gave rise, the general public failed to see that my position with regard to this movement was capable of a logical explanation, as the result of a consistent sensibility. I tried in vain to explain what appeared to me so clear, that the modern movement was essentially a return to the ideas of formal design which had been almost lost sight of in the fervid pursuit of naturalistic representation. I found that the cultured public which had welcomed my expositions of the works of the Italian Renaissance now regarded me as either incredibly flippant or, for the more charitable explanation was usually adopted, slightly insane. In fact, I found among the cultured who had hitherto been my most eager listeners the most inveterate and exasperated enemies of the new movement. The accusation of anarchism was constantly made. From an aesthetic point of view this was, of course, the exact opposite of the truth, and I was for long puzzled to find the explanation of so paradoxical an opinion and so violent an enmity. I now see that my crime had been to strike at the vested emotional interests. These people felt instinctively that their special culture was one of their social assets. That to be able to speak glibly of Tang and Ming, of Amico di Sandro and Baldovinetti, gave them a social standing and a distinctive cachet. This showed me that we had all along been labouring under a mutual misunderstanding, i.e. that we had admired the Italian primitives for quite different reasons. It was felt that one could only appreciate Amico di Sandro when one had acquired a certain considerable mass of erudition and given a great deal of time and attention, but to admire a Matisse required only a certain sensibility. One could feel fairly sure that one's maid could not rival one in the former case, but might by a mere haphazard gift of Providence surpass one in the second. So that the accusation of revolutionary anarchism was due to a social rather than an aesthetic prejudice. In any case the cultured public was determined to look upon Cézanne as an incompetent bungler, and upon the whole movement as madly revolutionary. Nothing I could say would induce people to look calmly enough at these pictures to see how closely they followed tradition, or how great a familiarity with the Italian primitives was displayed in their work. Now that Matisse has become a safe investment for persons of taste, and that Picasso and Derain have delighted the miscellaneous audience of the London Music Halls with their designs for the Russian Ballet, it will be difficult for people to imagine the vehemence of the indignation which greeted the first sight of their works in England.

In contrast to its effect on the cultured public the Post-Impressionist exhibition aroused a keen interest among a few of the younger English artists and their friends. With them I began to discuss the problems of aesthetic that the contemplation of these works forced upon us.

But before explaining the effects of these discussions upon my aesthetic theory I must return to consider the generalizations which I had made from my aesthetic experiences up to this point.

In my youth all speculations on aesthetic had revolved with wearisome persistence around the question of the nature of beauty. Like our predecessors we sought for the criteria of the beautiful, whether in art or nature. And always this

search led to a tangle of contradictions or else to metaphysical ideas so vague as to be inapplicable to concrete cases.

It was Tolstoy's genius that delivered us from this impasse, and I think that one may date from the appearance of 'What is Art?' the beginning of fruitful specula-tion in aesthetic. It was not indeed Tolstoy's preposterous valuation of works of art that counted for us, but his luminous criticism of past aesthetic systems, above all, his suggestions that art had no special or necessary concern with what is beau-tiful in nature, that the fact that Greek sculpture had run prematurely to decay through an extreme and non-aesthetic admiration of beauty in the human figure afforded no reason why we should for ever remain victims of their error.

It became clear that we had confused two distinct uses of the word beautiful, that when we used beauty to describe a favourable aesthetic judgement on a work of art we meant something quite different from our praise of a woman, a sunset or a horse as beautiful. Tolstoy saw that the essence of art was that it was a means of communication between human beings. He conceived it to be *par excellence* the language of emotion. It was at this point that his moral bias led him to the strange conclusion that the value of a work of art corresponded to the moral value of the emotion expressed. Fortunately he showed by an application of his theory to actual works of art what absurdities it led to. What remained of immense importance was the idea that a work of art was not the record of beauty already existent elsewhere, but the expression of an emotion felt by the artist and conveyed to the spectator ...

It was, I think, the observation of ... cases of reaction to pure form that led Mr Clive Bell in his book, *Art*, to put forward the hypothesis that however much the emotions of life might appear to play a part in the work of art, the artist was really not concerned with them, but only with the expression of a special and unique kind of emotion, the aesthetic emotion. A work of art had the peculiar property of conveying the aesthetic emotion, and it did this in virtue of having 'significant form'. He also declared that representation of nature was entirely irrelevant to this and that a picture might be completely non-representative.

This last view seemed to me always to go too far since any, even the slightest suggestion, of the third dimension in a picture must be due to some element of representation. What I think has resulted from Mr Clive Bell's book, and the dis-cussions which it has aroused on this point is that the artist is free to choose any degree of representational accuracy which suits the expression of his feeling. That no single fact, or set of facts, about nature can be held to be obligatory for artistic form. Also one might add as an empirical observation that the greatest art seems to concern itself most with the universal aspects of natural form, to be the least pre-occupied with particulars. The greatest artists appear to be most sensitive to those qualities of natural objects which are the least obvious in ordinary life precisely because, being common to all visible objects, they do not serve as marks of dis-tinction and recognition.

With regard to the expression of emotion in works of art I think that Mr Bell's sharp challenge to the usually accepted view of art as expressing the emotions of life has been of great value. It has led to an attempt to isolate the purely aesthetic feeling from the whole complex of feelings which may and generally do accom-pany the aesthetic feeling when we regard a work of art.

Let us take as an example of what I mean Raphael's *Transfiguration*, which a hundred years ago was perhaps the most admired picture in the world, and twenty years ago was one of the most neglected [fig. 33]. It is at once apparent that this picture makes a very complex appeal to the mind and the feelings. To those who are familiar with the Gospel story of Christ it brings together in a single composition two different events which occurred simultaneously at different places, the Transfiguration of Christ and the unsuccessful attempt of the Disciples during His absence to heal the lunatic boy. This at once arouses a number of complex ideas about which the intellect and feelings may occupy themselves. Goethe's remark on the picture is instructive from this point of view. 'It is remarkable', he says, 'that any one has ever ventured to query the essential unity of such a composition. How can the upper part be separated from the lower? The two form one whole. Below the suffering and the needy, above the powerful and helpful – mutually dependent, mutually illustrative.'

It will be seen at once what an immense complex of feelings interpenetrating and mutually affecting one another such a work sets up in the mind of a Christian spectator, and all this merely by the content of the picture, its subject, the dramatic story it tells.

Now if our Christian spectator has also a knowledge of human nature he will be struck by the fact that these figures, especially in the lower group, are all extremely incongruous with any idea he is likely to have formed of the people who surrounded Christ in the Gospel narrative. And according to his prepossessions he is likely to be shocked or pleased to find instead of the poor and unsophisticated peasants and fisherfolk who followed Christ, a number of noble, dignified, and academic gentlemen in improbable garments and purely theatrical poses. Again the representation merely as representation, will set up a number of feelings and perhaps of critical thoughts dependent upon innumerable associated ideas in the spectator's mind.

Now all these reactions to the picture are open to anyone who has enough understanding of natural form to recognize it when represented adequately. There is no need for him to have any particular sensibility to form as such.

Let us now take for our spectator a person highly endowed with the special sensibility to form, who feels the intervals and relations of forms as a musical person feels the intervals and relations of tones, and let us suppose him either completely ignorant of, or indifferent to, the Gospel story. Such a spectator will be likely to be immensely excited by the extraordinary power of co-ordination of many complex masses in a single inevitable whole, by the delicate equilibrium of many directions of line. He will at once feel that the apparent division into two parts is only apparent, that they are co-ordinated by a quite peculiar power of grasping the possible correlations. He will almost certainly be immensely excited and moved, but his emotion will have nothing to do with the emotions which we have discussed hitherto, since in the case we have supposed our spectator to have no clue to them.

It is evident then that we have the possibility of infinitely diverse reactions to a work of art. We may imagine, for instance, that our pagan spectator, though entirely unaffected by the story, is yet conscious that the figures represent men,

and that their gestures are indicative of certain states of mind and, in consequence, we may suppose that according to an internal bias his emotion is either heightened or hindered by the recognition of their rhetorical insincerity. Or we may suppose him to be so absorbed in purely formal relations as to be indifferent even to this aspect of the design as representation. We may suppose him to be moved by the pure contemplation of the spatial relations of plastic volumes. It is when we have got to this point that we seem to have isolated this extremely elusive aesthetic quality which is the one constant quality of all works of art, and which seems to be independent of all the prepossessions and associations which the spectator brings with him from his past life.

A person so entirely preoccupied with the purely formal meaning of a work of art, so entirely blind to all the overtones and associations of a picture like the *Transfiguration* is extremely rare. Nearly everyone, even if highly sensitive to purely plastic and spatial appearances, will inevitably entertain some of those thoughts and feelings which are conveyed by implication and by reference back to life. The difficulty is that we frequently give wrong explanations of our feelings. I suspect, for instance, that Goethe was deeply moved by the marvellous discovery of design, whereby the upper and lower parts cohere in a single whole, but the explanation he gave of this feeling took the form of a moral and philosophical reflection.

It is evident also that owing to our difficulty in recognizing the nature of our own feelings we are liable to have our aesthetic reaction interfered with by our reaction to the dramatic overtones and implications. I have chosen this picture of the *Transfiguration* precisely because its history is a striking example of this fact. In Goethe's time rhetorical gesture was no bar to the appreciation of aesthetic unity. Later on in the nineteenth century, when the study of the Primitives had revealed to us the charm of dramatic sincerity and naturalness, these gesticulating figures appeared so false and unsympathetic that even people of aesthetic sensibility were unable to disregard them, and their dislike of the picture as illustration actually obliterated or prevented the purely aesthetic approval which they would probably otherwise have experienced. It seems to me that this attempt to isolate the elusive element of the pure aesthetic reaction from the compounds in which it occurs has been the most important advance of modern times in practical aesthetic.

The question which this simile suggests is full of problems; do these form chemical compounds, as it were, in the case of the normal aesthetically gifted spectator, or are they merely mixtures due to our confused recognition of what goes on in the complex of our emotions? The picture I have chosen is also valuable, just at the present time, from this point of view. Since it presents in vivid opposition for most of us a very strong positive (pleasurable) reaction on the purely aesthetic side, and a violently negative (painful) reaction in the realm of dramatic association.

But one could easily point to pictures where the two sets of emotions seem to run so parallel that the idea that they reinforce one another is inevitably aroused. We might take, for instance Giotto's *Pietà*. In my description ... the two currents of feeling ran so together in my own mind that I regarded them as being completely fused. My emotion about the dramatic idea seemed to heighten my emotion about the plastic design. But at present I should be inclined to say that

166

this fusion of two sets of emotion was only apparent and was due to my imperfect analysis of my own mental state.

Probably at this point we must hand over the question to the experimental psychologist. It is for him to discover whether this fusion is possible, whether, for example, such a thing as a song really exists, that is to say, a song in which neither the meaning of the words nor the meaning of the music predominates; in which music and words do not merely set up separate currents of feeling, which may agree in a general parallelism, but really fuse and become indivisible. I expect that the answer will be in the negative.

If on the other hand such a complete fusion of different kinds of emotion does take place, this would tend to substantiate the ordinary opinion that the aesthetic emotion has greater value in highly complicated compounds than in the pure state.

Supposing, then, that we are able to isolate in a work of art this purely aesthetic quality to which Mr Clive Bell gives the name of 'significant form'. Of what nature is it? And what is the value of this elusive and – taking the whole mass of mankind – rather uncommon aesthetic emotion which it causes? I put these questions without much hope of answering them, since it is of the greatest importance to recognize clearly what are the questions which remain to be solved.

I think we are all agreed that we mean by significant form something other then agreeable arrangements of form, harmonious patterns, and the like. We feel that a work which possesses it is the outcome of an endeavour to express an idea rather than to create a pleasing object. Personally, at least, I always feel that it implies the effort on the part of the artist to bend to our emotional understanding by means of his passionate conviction some intractable material which is alien to our spirit.

I seem unable at present to get beyond this vague adumbration of the nature of significant form. Flaubert's 'expression of the idea' seems to me to correspond exactly to what I mean, but, alas! he never explained, and probably could not, what he meant by the 'idea'.

As to the value of the aesthetic emotion – it is clearly infinitely removed from those ethical values to which Tolstoy would have confined it. It seems to be as remote from actual life and its practical utilities as the most useless mathematical theory. One can only say that those who experience it feel it to have a peculiar quality of 'reality' which makes it a matter of infinite importance in their lives. Any attempt I might make to explain this would probably land me in the depths of mysticism. On the edge of that gulf I stop.

Henri Focillon

The Life of Forms in Art, 1934

Henri Focillon (1881–1943) is the first representative in this collection of the French tradition in the history of art, a more 'archaeological one than the German, extending from nineteenth-century scholars such as Arcisse de Caumont (1802–73) and Eugène-Emanuel Viollet-le-Duc (1814–79) to Emile Mâle (1862–1954). Like Burckhardt, Riegl, Wölfflin and Frankl, Focillon spent his life in the scholarly world. After being professor of art history and director of museums at Lyons, in 1924 he followed Mâle as professor of art history at the Sorbonne and in 1937 he became professor of art history at the Collège de France, at which time he also began teaching in the United States. His scholarly influence was largely felt through his students, both directly and indirectly, and while he wrote on a wide variety of subjects including the prints of Piranesi, Dürer and others, his most influential publications were those on the Middle Ages. These include *The Art of the West* (1938), which provides a lucid framework for the study of the period throughout Western Europe, and *The Life of Forms in Art* (1934), from which the following excerpt is taken.[1] In this text Focillon attempts to analyse the life of 'forms by combining into the single concept of 'style the relatively rigid 'Hegelian systems of Riegl (text 9, 1901) and Wölfflin (text 10, 1915) with the more systematic and 'empirical approach of Burckhardt (text 6, 1872). Like Fry in his analysis of Raphael's *Transfiguration*, he argues that forms are fundamentally abstract in nature, even in the most representational works such as *The School of Athens*, where the human figures are described as forming garlands and interlace patterns.

He defines a style as the existence of coherence and harmony, so that what appear to be heterogeneous collections of monuments can be shown to be members of an identifiable group. A style has its formal elements and its system of relationships, like the vocabulary and syntax of a language. In some instances the whole of a style is encapsulated in one of its elements, as is the case with the rib vault in Gothic architecture.[2] He defines Gothic provocatively as guesswork and reasoning, empirical research and inner logic 'all at once', and a style which uses the logic of the eye, the logic of structure and the logic of intellect, at different times as well as simultaneously (fig. 36).

Similarly illuminating are his comments on the three stages of stylistic development. On the early stage he argues that 'experimental' is a better label than 'archaic' because it expresses vitality; on the middle stage, 'classic art, rather than being conformist is the result of one last experiment which retains its vitality; the imitation of classicism serves the needs of romanticism, and the representation of youthful forms is a likely indication of incipient decline; and concerning the late stage, the baroque is prone to a confusion between form and sign.

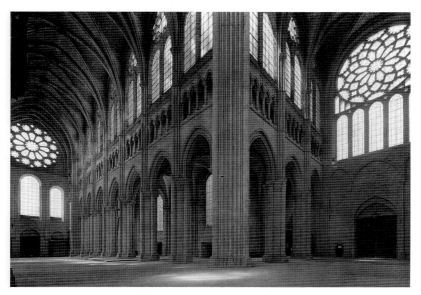

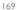

36 Interior of Chartres Cathedral, looking north-west, late twelfth century.

Focillon, like Frankl (text 11, 1914), defines the Gothic style with reference to a single feature which he considers fundamental, namely the rib vault. The diagonality of the vault characterizes every other part of the design, from the shapes of the piers to the spatial relationship between the crossing and the transept arms. This photograph was taken during the Second World War when the stained glass had been removed so that, in the words of Jean Bony, 'Chartres was once again reduced to pure architecture.' This claim raises the question of who was responsible for the construction and fitting out of the cathedral as a whole, the architect, the patron or someone else? (Jean Bony, 'The Resistance to Chartres', *Journal of the British Archaeological Association*, 20–1, 1958, pp. 35–6.)

1 Henri Focillon, *The Art of the West* (1938), translated by D. King, 2nd edn, 2 vols., London, 1969, including an intellectual biography of Focillon by Jean Bony. *The Life of Forms in Art* (1934), translated by C.B. Hogan and G. Kubler, New York, 1989.

2 For a full exposition of this view see Paul Frankl, *Gothic Architecture*, Harmondsworth, 1962, pp. 1–14.

13 | Henri Focillon

The Life of Forms in Art, 1934

Henri Focillon, *La Vie des formes*, Paris, 1934.
Excerpts from 'The World of Forms', in *The Life
of Forms in Art*, translated by C.B. Hogan and
G. Kubler, New York, 1989, pp. 44–63.

… It is … in those compositions by Raphael that are laden with whole garlands of
human bodies that we can best comprehend the genius for harmonic variations
that combines over and over again those shapes wherein the life of forms has
absolutely no aim other than itself and its own renewal. The mathematicians in
the *School of Athens*, the soldiers in the *Massacre of the Innocents*, the fishermen in the
Miracle of the Fishes, Imperia seated at the feet of Apollo or kneeling before Christ
– all these are the successive interlaces of a formal thought composed of and sup-
ported by the human body, and by means of which are contrived symmetries,
contrappostos and alternating rhythms. Here, the metamorphosis of shapes does
not alter the factors of life, but it does compose a new life – one that is no less
complex than that of the monsters of Asiatic mythology or of Romanesque sculp-
ture. But whereas these latter are fettered hand and foot by abstract armatures and
by monotonous calculations, the ornament of human form remains identical and
intact in its harmony and draws ceaseless new compulsions from that very
harmony. Form may, it is true, become formula and canon; in other words, it may
be abruptly frozen into a normative type. But form is primarily a mobile life in a
changing world. Its metamorphoses endlessly begin anew, and it is by the princi-
ple of *style* that they are above all co-ordinated and stabilized.

This term has two very different, indeed two opposite meanings. Style is an
absolute. *A* style is a variable. The word 'style' in its generic sense indicates a
special and superior quality in a work of art: the quality, the peculiarly eternal
value, that allows it to escape the bondage of time. Conceived as an absolute, style
is not only a model, but also something whose validity is changeless. It is like a
great summit that, rising between two slopes, sharply defines the expanse of
skyline. In utilizing style as an absolute, we give expression to a very fundamental
need: that of beholding ourselves in our widest possible intelligibility, in our most
stable, our most universal aspect, beyond the fluctuations of history, beyond local
and specific limitations. *A* style, on the other hand, is a development, a coherent
grouping of forms united by a reciprocal fitness, whose essential harmony is nev-
ertheless in many ways testing itself, building itself and annihilating itself. Pauses,
tensions, relaxations occur in the best defined of styles. This fact was established
long ago by the study of the monuments of architecture. The founders of

medieval archaeology in France, especially Arcisse de Caumont, taught us that Gothic art, for example, could not be regarded merely as a heterogeneous collection of monuments. By means of a strict analysis of forms, it was defined as a style, that is, as a closely related sequence and succession. A comparable analysis show that all the arts may be comprehended by this same token of a style – even to the very life of mankind, in so far as its individual life and its historical life are both forms.

What, then, constitutes a style? First, its formal elements, which have a certain index value and which make up its repertory, its vocabulary and, occasionally, the very instrument with which it wields its power; second, although less obviously, its system of relationships, its syntax. The affirmation of style is found in its measures. In such wise did the Greeks understand a style when they defined it by the relative proportions of its parts. Rather than the mere substitution of volutes for a molding on the capital, it is a measure that distinguishes the Ionic from the Doric order, and it is clear that the column of the temple of Nemea is an aberration, since it has Ionic measures, although its elements are Doric. The history of the Doric order, that is, its stylistic development, consists solely of variation on and studies of measure. But there are other arts whose component elements also possess a truly fundamental value. One of these is Gothic art. It might well be said that the rib vault contains Gothic art in its entirety, composes it and controls the derivation of all its parts, although we should not forget that in certain monuments the rib vault does appear without engendering a style, that is, a series of planned harmonies. The earliest Lombard rib vaults, for example, had no issue in Italy. The style of the rib vault developed in other countries, and in other countries its possibilities grew and became coherent.

This activity on the part of a style in the process of self-definition, that is, defining itself and then escaping from its own definition, is generally known as an 'evolution', this term being here understood in its broadest and most general sense. Biological science checked and modulated the concept of evolution with painstaking care; archaeology, on the other hand, took it simply as a convenient frame, a method of classification. I have elsewhere pointed out the dangers of 'evolution': its deceptive orderliness, its single-minded directness, its use, in those problematic cases in which there is discord between the future and the past, of expedient of 'transitions', its inability to make room for the revolutionary energy of inventors. Any interpretation of the movements of styles must take into account two essential facts. First, several styles may exist simultaneously within neighbouring districts and even within the same district; second, styles develop differently in accordance with whatever technical domain they may occupy. With these reservations established, the life of a style may be considered either as a dialectic or as an experimental process.

Nothing is more tempting – and in certain cases nothing is better warranted – than to show how forms comply with an internal, organizing logic. In the same way that sand spread out on the diaphragm of a violin would fall into different symmetrical figures in response to the strokes of a bow, so does a secret principle, stronger and more rigorous than any possible creative conceit, summon together forms that multiply by mitosis [a splitting of threads], by change of key or by

affinity. This is certainly the case in the mysterious domain of ornament, as well as in any art that borrows and subjects the pattern of the image to ornament. For, the essence of ornament is that it may be reduced to the purest forms of comprehensibility and that geometrical reasoning is infallibly applicable to the analysis of the relationship between its parts. This was the method pursued by Jurgis Baltrušaitis in his brilliant studies of the dialectic of ornament in Romanesque sculpture. In studies of this sort, it is by no means improper to equate style and stylistic analysis, in the sense of 'reconstructing' a logical process that already exists, with a force and power more than adequately evident, within the styles themselves. It is of course understood that the character of this process varies in quality and uniformity according to time and place. But it is still perfectly true that an ornamental style takes shape and exists as such only by virtue of the development of an internal logic, of a dialectic worth nothing except in relation to itself. Variations in ornament are not occasioned by the incrustation of alien elements or by a merely accidental choice, but by the play of hidden rules. This dialectic both accepts and demands new contributions, according to its own needs. Whatever has been contributed has already been demanded. The dialectic may, indeed, invent such contributions. A doctrine that still colours many of our studies in the history of art, that is, the doctrine that 'influences' may be interpreted in one heterogeneous mass and considered as resulting from impact and conflict, must therefore be qualified and tempered.

This interpretation of the life of styles is one that is admirably adapted to the subject of ornamental art. But is it adequate in all other cases? To architecture, and especially to Gothic architecture (when considered as the development of a theorem), it has been applied in speculations that were both absolute and, as regards ordinary historical activity, practical. Indeed, it is nowhere possible to behold more clearly than in Gothic architecture how, from a given form, there are derived to the very last detail the happy issues that affect the structure, the organization of masses, the relation of voids to solids, the treatment of light and even the decoration itself. No graph, apparent or real, could be more plainly indicated. It would be a mistake, however, not to recognize in this graph the action of an *experiment* at each of its crucial points. By experiment I mean an investigation that is supported by prior knowledge, based on a hypothesis, conducted with intelligent reason and carried out in the realm of technique. In this sense it may well be said that Gothic architecture is guesswork and reasoning, empirical research and inner logic all at once. The proof of its experimental character is the fact that, in spite of the rigorousness of its methods, some of its experiments remained almost wholly without results; in other words, much was wasted and much was barren. How little do we know of the innumerable mistakes that lurk in the shadow of success! Examples of such mistakes could perhaps be discovered in the history of the flying buttress, which was originally a concealed wall, with a cut-out passage, and later became an arch, awaiting its transformation into a rigid prop. Furthermore, the notion of logic in architecture is applicable to several different functions, which sometimes coincide and sometimes do not. The logic of the eye, with its need for balance and symmetry, is not necessarily in agreement with the logic of structure, which in turn is not the logic of pure

172

intellect. The divergence of these three kinds of logic is remarkable in certain states of the life of styles, among others in flamboyant art. But it is, nevertheless, admissible to suppose that the experiments of Gothic art, bound powerfully one to the other, and in their royal progress discarding all solutions that were either hazardous or unpromising, constitute by their very sequence and concatenation a kind of logic – an irresistible logic that eventually expresses itself in stone with a classic decisiveness.

If we turn from ornament and architecture to the other arts, and especially to painting, we see that the life of forms is manifested in these arts by a larger number of experiments, and that it is subjected to more frequent and more unexpected variations. For the measures are here more delicate and sensitive, and the material itself invites a degree of research and experiment that must be constantly proportionate to its manageability. Further the notion of style – a notion that is equally applicable to everything, including the art of living – is qualified by materials and techniques: it does not behave uniformly or synchronously in all realms. Then, too, each historical style exists under the aegis of one technique that overrides other techniques and that gives to the style its tonality. This principle, which may be called the law of technical primacy, was formulated by Louis Bréhier with respect to those barbarian arts that were dominated by ornamental abstraction rather than by anthropomorphic design and by architecture. But, on the other hand, it is architecture that receives the tonic of the Romanesque and the Gothic styles. And we know how painting, at the end of the Middle Ages, tends to encroach on, to redirect and finally to triumph over all the other arts. And yet, within one given style that is homogeneous and faithful to its technical primacy, the various arts live and move with perfect freedom. Each subordinate art seeks to come into agreement with the dominant art. This it attains through experiments, not the least interesting examples of which are the adaption of the human form to ornamental designs or the variations in monumental painting due to the influence of stained-glass windows. The reason for this is that each one of the arts is attempting to live for itself and to liberate itself, until the day comes when it may take its own turn as the dominant art.

Although the uses to which this law of technical primacy may be put are virtually inexhaustible, it is, perhaps, but one aspect of a more general law. Each style passes through several ages and several phases of being. This does not mean that the ages of style and the ages of mankind are the same thing. The life of forms is not the result of chance. Nor is it a great cyclorama neatly fitted into the theatre of history and called into being by historical necessities. No. Forms obey their own rules – rules that are inherent in the forms themselves, or better, in the regions of the mind where they are located and centred – and there is no reason why we should not undertake an investigation of how these great ensembles, united by close reasoning and by coherent experiment, behave throughout the phases that we call their life. The successive states through which they pass are more or less lengthy, more or less intense, according to the style itself: the experimental age, the classic age, the age of refinement, the baroque age. These distinctions are perhaps not wholly new, but it must be borne in mind that – as Waldemar Deonna has pointed out in a penetrating analysis of certain epochs in the history

of art – these ages or states present the same formal characteristics at every epoch and in every environment. This is so unmistakably the case that we need not be surprised in noting close similarities between Greek archaism and Gothic archaism, between Greek art of the fifth century BC and the sculptures of the first half of the thirteenth century AD, between the flamboyant, or baroque state of Gothic, and eighteenth-century Rococo art. The history of forms cannot be indicated by a single ascending line. One style comes to an end; another comes to life. It is only natural that mankind should revaluate these styles over and over again, and it is in the application to this task that I apprehend the constancy and the identity of the human spirit.

The experimental state is the one in which style is seeking to define itself. This is generally called archaism, in either the pejorative or the laudatory sense, according to whether we see in it a crude inarticulateness or an auspicious promise, dependent, obviously, on the historical moment that we ourselves occupy, If we follow the history of Romanesque sculpture during the eleventh century we become aware of the apparently unsystematic and 'crude' experiments whereby form seeks not only to exploit ornamental variations, but also to incorporate man himself into them, thus adapting him to certain architectural functions, even though in the eleventh century man, as man, had not yet become an object of study, and far less a universal measure. The plastic treatment of the human body was still concerned with the integrity of the masses and their density as blocks or as walls. The modelling, a mere gentle undulation, did not penetrate below the surface; the thin, shallow folds possessed no more than a calligraphic value. And such is the course followed by every archaism. Greek art begins with that same massive unity, that same plenitude and density. It dreams of monsters that it has not yet turned into men; it is indifferent to the musical quality of those human proportions whose various canons dominate its classic age; it seeks for variations only in a tectonic order that is conceived primarily in terms of bulk. In Romanesque archaism, as in Greek, experimentation proceeds with disconcerting speed. The sixth century BC, like the eleventh AD, suffices for the elaboration of a style; the first half of the fifth BC and the first of the twelfth AD, witness its flowerings. Gothic archaism is perhaps even more rapid. It multiplies structural experiments, creates types that would normally be considered as stopping points and continues to renew them until, with Chartres, its future has been, as it were, ordained. The sculpture of the same period presents a remarkable example of the constancy of these laws: it has no meaning if it be regarded as the ultimate expression of Romanesque art or as the 'transition' from Romanesque to Gothic. For an art of movement, this sculpture substitutes an art of frontality and immobility; for a grandiose arrangement of the tympani, the reiteration of the Christ enthroned within the tetramorph. Its manner of imitating Languedocian types shows it as retrograding from these latter, older models; it has entirely forgotten the rules of style that implement the Romanesque classicism, and whenever it seems to draw inspiration from that source, it does so by contradiction: form and iconography no longer agree. This sculpture of the second half of the twelfth century, contemporary with Romanesque baroque, undertakes its experiments in another direction, and for other ends. It is starting afresh.

It would be idle to attempt to enrich the long series of definitions that have been given for classicism. Simply by regarding it as a state, or as a moment, I have already qualified it. But it is never beside the point to remember that classicism consists of the greatest propriety of the parts one to the other. It is stability, security, following on experimental unrest. It confers, so to speak, a solidity on the unstable aspects of experimentation (because of which it is also, in a way, a renunciation). Thus it is that the endless life of styles coincides with style as a universal value, that is, as an order whose value never ceases, and which, far beyond the graph of time, establishes what I have called the expanse of skyline. But classicism is not the result of a conformist attitude. On the contrary, it has been created out of one final, ultimate experiment, the audacity and vitality of which it has never lost. How good it would be could we rejuvenate this venerable word – a word that has today lost all meaning through so much careless and indeed illegitimate usage! Classicism: a brief, perfectly balanced instant of complete possession of forms; not a slow and monotonous application of 'rules', but a pure, quick delight, like the *akme* of the Greeks, so delicate that the pointer of the scale scarcely trembles. I look at this scale not to see whether the pointer will presently dip down again, or even come to a moment of absolute rest. I look at it instead to see, within the miracle of that hesitant immobility, the slight, inappreciable tremor that indicates life. It is for this reason that the classic state differs radically from the academic state, which is merely a lifeless reflection, a kind of inert image. It is for this reason that the analogies or identities occasionally revealed by the various types of classicism in the treatment of forms are not necessarily the result of an influence or imitation. The wonderful statues of the *Visitation*, full, calm, monumental, on the north portal of Chartres, are much more 'classic' than the figures at Rheims whose draperies suggest a direct imitation of Roman models. Classicism is by no means the unique privilege of ancient art, which itself passed through different states and ceased being classic art when it became baroque art. If the sculptors of the first half of the thirteenth century had constantly drawn inspiration from that so-called Roman classicism of which France retained so many traces, they would have ceased being classic. A remarkable proof may be seen in a moment that deserves a careful analysis: the *Belle Croix* of Sens. The Virgin, as she stands beside her crucified son in all her simplicity and in all the absorption and chastity of her grief, still bears the traits of that first experimental age of the Gothic genius that recalls the dawn of the fifth century BC. But the figure of Saint John on the other side of the cross is, in the treatment of the draperies, plainly an imitation of some mediocre Gallo-Roman full-round work, and particularly in the lower part of the body it is entirely out of key with the purity of the group as a whole. The classic state of a style is not attained from without. The dogma of slavish imitation of the ancients can serve the objectives of any romanticism.

This is not the place to show how forms pass from the classic state to those experiments in refinement that, as regards architecture at least, enhance the elegance of structural solutions to what may seem a very bold paradox, and that reach that state of dry purity and of calculated interdependence of the parts so singularly well-expressed in the style known as *art rayonnant*. Nor to show how, in the

175

meanwhile, the image of man discards little by little its monumental character, loses contact with architecture and becomes elongated and enriched with new axial torsions and with more subtle modelling. The poetry of bare flesh as an artistic subject induces every sculptor to become, after a fashion, a painter, and arouses in him a taste for the warmth of reality. Flesh becomes flesh; it loses the quality, the look of stone. Ephebism in the representation of man is not the sign of the youth of an art; it is, on the contrary, perhaps the first gracious annunciation of decline. The svelte, alert figures of the *Resurrection* on the main portal of Rampillon, the statue of Adam from St-Denis (despite its restorations) and certain fragments from Notre Dame – all these shed over French art at the end of the thirteenth century and during the entire fourteenth century a truly Praxitelean light. Such comparisons are no longer, we feel, merely matters of taste on our part; they seem to be justified by an inner life that is incessantly active, incessantly effective in various periods and environments of human civilization. It might be perhaps permissible to explain in this way, and not simply by means of analogies of process, the characteristics held in common by quite different things. One might cite, for instance, the figures of women that were painted on the sides of Attic funerary *lekythoi* in the fourth century BC, and those whose sensitive, flexible likenesses the Japanese masters designed with their little brushes for the wood engravers at the end of the eighteenth century.

The baroque state likewise reveals identical traits existing as constants within the most diverse environments and periods of time. Baroque was not reserved exclusively for the Europe of the last three centuries any more than classicism was the unique privilege of Mediterranean culture. In the life of forms, baroque is indeed but a moment, but it is certainly the freest and the most emancipated one. Baroque forms have either abandoned or denatured that principle of intimate propriety, an essential aspect of which is a careful respect for the limits of the frame, especially in architecture. They live with passionate intensity a life that is entirely their own; they proliferate like some vegetable monstrosity. They break apart even as they grow; they tend to invade space in every direction, to perforate it, to become as one with all its possibilities. This mastery of space is pure delight to them. They are obsessed with the object of representation; they are urged towards it by a kind of maniacal 'similism'. But the experiments into which they are swept by some hidden force constantly overshoot the mark. These traits are remarkable, nay strikingly noticeable, in baroque ornamental art. Never has abstract form a more obvious – although not necessarily a more powerful – mimic value. And the confusion between form and sign never becomes more complete. Form no longer signifies itself alone; it signifies as well a wholly deliberate content, and form is tortured to fit a 'meaning'. It is here that the primacy of painting may be seen coming into play, or, better, it is here that all the arts pool their various resources, cross the frontiers that separate them and freely borrow visual effects one from the other. At the same time, by a curious inversion that is governed by a nostalgia arising from the very forms themselves, and interest in the past is awakened, and baroque art seeks models and examples and confirmations from the most remote regions of antiquity. But what baroque wants from history is the past life of baroque itself. Exactly as Euripides and Seneca, and not

176

Aeschylus, inspired the seventeenth-century French dramatists, so did the baroque of nineteenth-century romanticism particularly admire in medieval art the flamboyant style: that baroque form of Gothic. I do not mean that there are exact parallels between baroque art and romanticism at every point, and if in France these two 'states' of form appear separate and distinct, it is not simply because one followed the other, but because a historical phenomenon of rupture – a brief and violent interval of *artificial* classicism – divided them. French painters had to cross what I may call the gulf of David's art before they could rejoin the art of Titian, Tintoretto, Caravaggio, Rubens and later, under the Second Empire, of the great eighteenth-century masters.

We must never think of forms, in their different states, as simply suspended in some remote, abstract zone, above the earth and above man. They mingle with life, whence they come; they translate into space certain movements of the mind. But a definite style is not merely a state in the life of forms, not is it that life itself: it is a homogeneous, coherent, formal environment, in the midst of which man acts and breathes. It is, too, an environment that may move from place to place *en bloc*. We find Gothic art imported in such wise into northern Spain, into England, into Germany, where it lived on with varying degrees of energy and with a rhythm sufficiently rapid to permit an occasional incorporation of older forms that, although they had become localized, were never vitally essential to the environment. Occasionally, again, this rhythm may precipitate movements sooner than might be expected. Whether stable or nomadic, all formal environments give birth to their own various types of social structure: styles of life, vocabularies, states of awareness. Expressed in a more general way, the life of forms gives definition to what may be termed 'psychological landscapes', without which the essential genius of the environments would be opaque and exclusive for all those who share in them. Greece, for instance, exists as a geographical basis for certain ideas about man, but the landscape of Doric art, or rather, Doric art as a landscape, created a Greece without which the real Greece is merely a great, luminous desert. Again, the landscape of Gothic art, or rather, Gothic art as a landscape, created a France and a French humanity that no one could foresee: outlines of the horizon, silhouettes of cities – a poetry, in short, that arose from Gothic art, and not from geology or from Capetian institutions. But is not the essential attribute of any environment that of producing its own myths, of shaping the past according to its own needs?

Formal environment creates historical myths that are fashioned not only by the state of existing knowledge and by existing spiritual needs but also by the exigencies of form. Take, for example, the long succession of fables that, appearing, disappearing and reappearing, have come down to us from the remotest Mediterranean antiquity. According to whether these fables are embodied in Romanesque art or Gothic art, in humanist art or baroque art, in David's art or romantic art, they change shape, they fit themselves to different frames and different curves, and, in the minds of those who witness metamorphoses such as these, they evoke wholly different, if not indeed wholly opposite, images. These fables occur in the life of forms, not as an irreducible factor nor as a foreign body, but as a true substance, plastic and docile.

It may seem that I have laid down a far too unwieldy determinism in underlining with such insistence the various principles that rule the life of forms and that so react upon nature, man and history as to constitute an entire universe and humanity. It may seem that I am anxious to isolate works of art from human life, and condemn them to a blind automatism and to an exactly predicable sequence. This is by no means so. The state of a style or, if one prefers, a state in the life of forms, is simultaneously the guarantor and the promoter of *diversity*. Man's spirit is truly free in the impregnability of a high intellectual self-expression. The power of formal order alone authorizes the ease and spontaneity of creation. A large number of experiments and variations is likely to occur whenever the artist's expression is at all confined, whereas unlimited freedom inevitably leads to imitation. In case these principles should be disputed, two observations may be made that will shed light on the qualities of activity and of apparent uniqueness that coexist within the closely knit phenomena of forms.

First, forms are not their own pattern, their own mere naked representation. Their life develops in a space that is not the abstract frame of geometry; under the tools and at the hands of men it assumes substance in a given material. It is there and not elsewhere that forms exist, that is, in a highly concrete, but highly diversified world. An identical forms keeps its dimensions, but changes its quality according to the material, the tool and the hand. A text does not change because of the different papers on which it chances to be printed; the paper is but the support for the text. In a drawing, however, the paper is an element of life; it is the very heart of the design. A form without support is not form, and the support itself is form. It is essential, therefore, to bear in mind how immense is the variety of techniques in the genealogy of a work of art, and to show that the principle of all technique is not inertia, but activity.

And second, man himself, who is no less diversified, must be taken into consideration. The source of man's diversity does not lie in the accord or disaccord of race, environment or time, but in quite another region of life, which seems to comprise affinities and accords far more subtle than those that preside over the general historical groupings of mankind. There exists a kind of spiritual ethnography that cuts across the best-defined 'races.' It is composed of families of the mind – families whose unity is effected by secret ties and who are faithfully in communication with one another, beyond all restrictions of time or place. Perhaps each style, each state of a style, even each technique seeks out by preference a certain state of man's nature, a certain spiritual family. In any case, it is the relationship between these three values that clarifies a work of art not only as something that is unique, but also as something that is a living word in a universal language.

14 Alfred H. Barr

'The Development of Abstract Art', 1936

Alfred H. Barr (1902–79) is the first of the more recent writers represented in this volume who worked in the world of the art gallery rather than the university. After graduating from Harvard he joined the Museum of Modern Art in New York where he became director from 1929 to 1943, and continued to be associated with it until his death. He is one of the scholars most closely associated with the acceptance of modern art as part of the Western artistic tradition, especially in the United States, which of course had a central role to play in the future of the movement. It may be that the demands made by the mounting of exhibitions caused him to stress the discrete character of the movements which made up modern art, but, whatever the reason, Barr gave us the means of organizing this body of 'styles and the ways in which they reacted to one another in a form which is now a standard part of art-historical exposition: the chart.

The one published here, from 1936, illustrates his attitudes towards the subject. First is his belief that works of art can all be classified into one or other school or style. Second is the number and variety of such categories, the chart showing no fewer than 23 styles or the names of artists representing styles in the 45 years between 1890 and 1935. Third is Barr's belief that the character of each of these movements can be summed up in a single name and their origins in an arrow. This combination of large numbers of movements with the belief that they can be represented as a sequence is one of the defining characteristics of much art-historical writing in the twentieth century. Finally, there is the sense that abstraction is the dominant art form of modernism.

Alongside the claims of newness which this unprecedented variety suggested, Barr also wishes to present modern art as part of the great tradition, which he illustrates in another chart drawn to accompany an exhibition of fifteenth- to eighteenth-century Italian art held at the Museum of Modern Art in 1939.[1]

It may be relevant that in his youth Barr collected and classified butterflies, which suggests a parallel between practices in two different fields not unlike that between Morelli's involvement with anatomy and Conan Doyle's interest in ears.[2]

1 Reproduced in I. Sandler and A. Newman, eds., *Defining Modern Art*, New York, 1986, p. 177.
2 See the introduction to Morelli (text 8, 1890), note 3.

'The Development of Abstract
Art', 1936

Alfred H. Barr, Jr., 'The Development of Abstract
Art', chart prepared for the Museum of Modern
Art, New York, and used for the dust-jacket of
the exhibition catalogue, *Cubism and Abstract Art*,
Museum of Modern Art, New York, 1936.

180

15 Erwin Panofsky

'The History of Art as a Humanistic
Discipline', 1940

Erwin Panofsky (1892–1968) was one of the most prominent art historians of the twentieth
century. He has been called the last Hegelian and the model to which art historians of the later
twentieth century should return.[1] His writings are of fundamental importance and include studies
in such diverse areas as Gothic architecture, Netherlandish painting and the psychological and his-
torical significance of the study of human proportions. He also provided the classic definition of
*iconography and investigated the concept of renaissances, the importance of Neoplatonism in the
Renaissance and film as a medium, to mention only a selection.[2] After studying in Berlin and at the
University of Freiburg, where he worked under the historians of medieval art Adolf Goldschmidt
and Wilhelm Vöge, from 1921 he taught at Hamburg, working in conjunction with Aby Warburg
and the philosopher Ernst Cassirer. He was removed from office by the Nazis in 1933, and moved
to the United States where he taught at Princeton and in New York.

The text reprinted here consists primarily of definitions of humanism and of art history. Panofsky
defines *humanism as an attitude of belief in the dignity of man, insisting on the values of rationality
and freedom and acknowledging the limitations of fallibility and frailty, and resulting in the ideals of
responsibility and tolerance. He describes humanists as *cultural historians who reject authority
but respect tradition. They share many characteristics with scientists, in particular the fact that they
start with observation and move to analysis. They differ in that the scientist treats human records
as tools, whereas the humanist treats them as objects of interest in their own right; and while the
scientist can embark on an immediate analysis of the object, the humanist must first mentally
'reconstruct' it, on the basis of other objects and the supposed intention of its maker.

According to Panofsky, art historians are humanists whose primary material is the work of art,
and a work of art is any made object which has an aesthetic significance, whatever its chief
intended purpose. Like other humanists they have to reconstruct this significance in part on the
basis of intuition.

This definition of art history as a branch of humanism would probably have been accepted by
most art historians up to Panofsky's time. His description of *connoisseurs would probably have
met with Morelli's approval as well (text 8, 1890), that is that they differ from art historians in limit-
ing their contribution to identifying the date, provenance and authorship of a work of art, and eval-
uating its *quality and condition, like a diagnostician who is not interested in historical concepts.

Panofsky indicates the character of his approach by describing his archetypal art historian as reading 'old' books on mythology and religion. It is certainly true that anyone wanting to be described as a humanist in Panofsky's terms would need to be educated in its tradition from antiquity onwards, and that involves the study of ancient tomes, but it is significant that his description does not apply to all kinds of investigation, such as many twentieth-century subjects, including some of his own work. The same sort of assumption lies behind his description of the artist's task as being the representation of the visible world, in consequence restricting himself to the same antique and Renaissance tradition and excluding major non-representational aspects of other traditions such as those of Islam and modernism.

Panofsky acknowledges three problems which arise in defending the history of art as a rigorous discipline. They all concern the problem of where to start, that is, the need always to know something else before you can begin an investigation. The first problem is the fact that the understanding of one document requires an understanding of other documents, each of which presents the same difficulty; the second concerns aesthetically re-creating the work and rationally investigating it, which appear to be contradictory activities, given the instinctive and subjective judgements on which the re-creation must be based; and the third concerns rational investigation and the formation of a theory of art, where the theory is essential to the rational investigation and vice versa. He proposes as a solution to all three problems the concept of the organic situation, which he illustrates with the anatomical metaphor of legs and a body, both of which are useless when separate but which can walk in conjunction with one another.

This defence is arguably unsatisfactory for the second and third problems, since in the anatomical metaphor the two parts of the organism belong to the same category of things, parts of the human body, as with the two documents of the first problem. Intuition and rational investigation conversely do not, and it is indeed the extent of the difference between them which constitutes the problem. Panofsky is here attempting to resolve the dilemma faced by all historians, namely that, however difficult it is to construct, we must have a framework in order to understand the past as something more than the chaos of individual events, yet one cannot construct the framework without a knowledge of the events (see also *history and *periods).

Panofsky describes attempts to assess *quality in terms of the values of the time in which the object was made as being more objective than attempts which simply superimpose the values of one's own time on to another. This is clearly part of the discipline which art historians must impose on themselves, but it should not obscure the fact that, however much evidence there is for the values by which a past age judged its works of art, the raw material of the exercise (that is the human response which is being translated from the twentieth century to another more or less distant time) remains subjective.

Panofsky's description of *archaeological research as being 'blind and empty' when it is not allied with the aesthetic re-creation of the object also raises a number of difficulties. His criticism may be valid when one is dealing with a work of art from the point of view of an art historian, but what of an archaeologist who does not recognize the category of a work of art, and treats the object simply as a human artefact? Some might say that this archaeologist's method is the way in which all art should be approached as its results are more reliable, in the same way as behaviourist *psychologists defend their approach against what they see as the unprovable assertions of the Freudians.

Panofsky's attitude to archaeology provides an indication of what is perhaps his greatest weakness. He makes clear his acceptance of the need to test theories and objects against the political and social tendencies of a personality, period or country, but he seldom does so. He is largely silent on methods of production, the effect on the work of the techniques available, on the social function of the work and the audience's expectations, the part played by the unconscious and the irrational in the creation of objects, or on the relationship between art and "ideology (ideology in the Marxist sense of manipulation and power). His approach therefore has something of that of the armchair scholar who believes that wisdom comes from a well-stocked library, that ideas are all and that it is therefore unnecessary to conduct fieldwork.

Despite these comments Panofsky stands out among art historians for always making his theoretical position clear, whether he is writing about architecture, proportions or film, making his essays a good basis for discussion.

1 See Michael Podro, *The Critical Historians of Art*, New Haven and London, 1982, chapter IX, for the first description, and Clark, text 21, 1974, for the second.

2 See, for example, his *Gothic Architecture and Scholasticism*, Latrobe, PA, 1951; *Early Netherlandish Painting: its Origins and Character*, Cambridge, MA, 1953; 'The History of the Theory of Human Proportions as a Reflection of the History of Styles', in *Meaning in the Visual Arts*, Garden City, NY, 1955, pp. 55–107; *Studies in Iconology: Humanistic Themes in the Art of the Renaissance*, New York, 1939; *Renaissance and Renascences in Western Art*, Stockholm, 1960; *Perspective as Symbolic Form*, translated by C.S. Wood, New York, Cambridge, MA, and London, 1991; and 'Style and Medium in the Motion Pictures', *Critique*, 1 (3), 1947, reprinted in G. Mast and M. Cohen, eds., *Film Theory and Criticism*, Oxford, 1979, pp. 243–63.

15 | Erwin Panofsky

'The History of Art as a Humanistic
Discipline', 1940

Erwin Panofsky, 'The History of Art as
a Humanistic Discipline', in T. Greene, ed.,
The Meaning of the Humanities, Princeton, NJ,
1940, pp. 89–118; reprinted in Erwin Panofsky,
Meaning in the Visual Arts, Garden City, NY,
1955, pp. 1–25. Reprinted by permission of
Princeton University Press © 1966 Princeton
University Press.

1 Nine days before his death Immanuel Kant was visited by his physician. Old, ill and nearly blind, he rose from his chair and stood trembling with weakness and muttering unintelligible words. Finally his faithful companion realized that he would not sit down again until the visitor had taken a seat. This he did, and Kant then permitted himself to be helped to his chair and, after having regained some of his strength, said, 'Das Gefühl für Humanität hat mich noch nicht verlassen' – 'The sense of humanity has not yet left me'. The two men were moved almost to tears. For, though the word *Humanität* had come, in the eighteenth century, to mean little more than politeness and civility, it had, for Kant, a much deeper significance, which the circumstances of the moment served to emphasize: man's proud and tragic consciousness of self-approved and self-imposed principles, contrasting with his utter subjection to illness, decay and all that is implied in the word 'mortality.'

Historically the word *humanitas* has had two clearly distinguishable meanings, the first arising from a contrast between man and what is less than man; the second, between man and what is more. In the first case *humanitas* means a value, in the second a limitation.

The concept of *humanitas* as a value was formulated in the circle around the younger Scipio, with Cicero as its belated, yet most explicit spokesman. It meant the quality which distinguishes man, not only from animals, but also, and even more so, from him who belongs to the species *homo* without deserving the name of *homo humanus*; from the barbarian or vulgarian who lacks *pietas* and *paideia* [upbringing] that is, respect for moral values and that gracious blend of learning and urbanity which we can only circumscribe by the discredited word 'culture'.

In the Middle Ages this concept was displaced by the consideration of humanity as being opposed to divinity rather than to animality or barbarism. The qualities commonly associated with it were therefore those of frailty and transience: *humanitas fragilis, humanitas caduca*.

Thus the Renaissance conception of *humanitas* had a two-fold aspect from the outset. The new interest in the human being was based both on a revival of the classical antithesis between *humanitas* and *barbaritas*, or *feritas*, and on a survival of the medieval antithesis between *humanitas* and *divinitas*. When Marsilio Ficino

defines man as a 'rational soul participating in the intellect of God, but operating in a body,' he defines him as the one being that is both autonomous and finite. And Pico's famous 'speech,' 'On the Dignity of Man', is anything but a document of paganism. Pico says that God placed man in the centre of the universe so that he might be conscious of where he stands, and therefore free to decide 'where to turn'. He does not say that man *is* the centre of the universe, not even in the sense commonly attributed to the classical phrase, 'man the measure of all things'.

It is from this ambivalent conception of *humanitas* that humanism was born. It is not so much a movement as an attitude which can be defined as the conviction of the dignity of man, based on both the insistence on human values (rationality and freedom) and the acceptance of human limitations (fallibility and frailty); from this two postulates result – responsibility and tolerance.

Small wonder that this attitude has been attacked from two opposite camps whose common aversion to the ideas of responsibility and tolerance has recently aligned them in a united front. Entrenched in one of these camps are those who deny human values: the determinists, whether they believe in divine, physical or social predestination, the authoritarians, and those 'insectolatrists' who profess the all-importance of the hive, whether the hive be called group, class, nation or race. In the other camp are those who deny human limitations in favour of some sort of intellectual or political libertinism, such as aestheticists, vitalists, intuitionists and hero-worshippers. From the point of view of determinism, the humanist is either a lost soul or an ideologist. From the point of view of authoritarianism, he is either a heretic or a revolutionary (or a counterrevolutionary). From the point of view of 'insectolatry', he is a useless individualist. And from the point of view of libertinism he is a timid bourgeois.

Erasmus of Rotterdam, the humanist *par excellence*, is a typical case in point. The church suspected and ultimately rejected the writings of this man who had said: 'Perhaps the spirit of Christ is more largely diffused than we think, and there are many in the community of saints who are not in our calendar.' The adventurer Ulrich von Hutten despised his ironical skepticism and his unheroic love of tranquillity. And Luther, who insisted that 'no man has power to think anything good or evil, but everything occurs in him by absolute necessity,' was incensed by a belief which manifested itself in the famous phrase: 'What is the use of man as a totality [that is, of man endowed with both a body and a soul], if God would work in him as a sculptor works in clay, and might just as well work in stone?'

II The humanist, then, rejects authority. But he respects tradition. Not only does he respect it, he looks upon it as upon something real and objective which has to be studied and, if necessary, reinstated: '*nos vetera instauramus, nova non prodimus,*' ('we restore old things, we do not produce new ones') as Erasmus puts it.

The Middle Ages accepted and developed rather than studied and restored the heritage of the past. They copied classical works of art and used Aristotle and Ovid much as they copied and used the works of contemporaries. They made no attempt to interpret them from an archaeological, philological or 'critical,' in

short, from an historical, point of view. For, if human existence could be thought of as a means rather than an end, how much less could the records of human activity be considered as values in themselves.

In medieval scholasticism there is, therefore, no basic distinction between natural science and what we call the humanities, *studia humaniora*, to quote again an Erasmian phrase. The practice of both, so far as it was carried on at all, remained within the framework of what was called philosophy. From the humanistic point of view, however, it became reasonable, and even inevitable, to distinguish, within the realm of creation, between the sphere of *nature* and the sphere of *culture*, and to define the former with reference to the latter, i.e., nature as the whole world accessible to the senses, except for the *records left by man*.

Man is indeed the only animal to leave records behind him, for he is the only animal whose products 'recall to mind' an idea distinct from their material existence. Other animals use signs and contrive structures, but they use signs without 'perceiving the relation of signification,' and they contrive structures without perceiving the relation of construction.

To perceive the relation of signification is to separate the idea of the concept to be expressed from the means of expression. And to perceive the relation of construction is to separate the idea of the function to be fulfilled from the means of fulfilling it. A dog announces the approach of a stranger by a bark quite different from that by which he makes known his wish to go out. But he will not use this particular bark to convey the idea that a stranger *has* called during the absence of his master. Much less will an animal, even if it were physically able to do so, as apes indubitably are, ever attempt to represent anything in a picture. Beavers build dams. But they are unable, so far as we know, to separate the very complicated actions involved from a premeditated *plan* which might be laid down in a drawing instead of being materialized in logs and stones.

Man's signs and structures are records because, or rather in so far as they express ideas separated from, yet realized by, the processes of signalling and building. These records have therefore the quality of emerging from the stream of time, and it is precisely in this respect that they are studied by the humanist. He is, fundamentally, a historian.

The scientist, too, deals with human records, namely with the works of his predecessors. But he deals with them not as something to be investigated, but as something which helps him to investigate. In other words, he is interested in records not in so far as they emerge from the stream of time, but in so far as they are absorbed in it. If a modern scientist reads Newton or Leonardo da Vinci in the original, he does so not as a scientist, but as a man interested in the history of science and therefore of human civilization in general. In other words, he does it as a *humanist*, for whom the works of Newton or Leonardo da Vinci have an autonomous meaning and a lasting value. From the humanistic point of view, human records do not age.

Thus, while science endeavours to transform the chaotic variety of natural phenomena into what may be called a cosmos of nature, the humanities endeavour to transform the chaotic variety of human records into what may be called a cosmos of culture.

There are, in spite of all the differences in subject and procedure, some very striking analogies between the methodical problems to be coped with by the scientist, on the one hand, and by the humanist, on the other.

In both cases the process of investigation seems to begin with observation. But both the observer of a natural phenomenon and the examiner of a record are not only confined to the limits of their range of vision and to the available material; in directing their attention to *certain* objects they obey, knowingly or not, a principle of pre-selection dictated by a theory in the case of the scientist and by a general historical conception in the case of the humanist. It may be true that 'nothing is in the mind except what was in the senses'; but it is at least equally true that much is in the senses without ever penetrating into the mind. We are chiefly affected by that which we allow to affect us; and just as natural science involuntarily selects what it calls the phenomena, the humanities involuntarily select what they call the historical facts. Thus the humanities have gradually widened their cultural cosmos and in some measure have shifted the accents of their interests. Even he who instinctively sympathizes with the simple definition of the humanities as 'Latin and Greek' and considers this definition as essentially valid as long as we use such ideas and expressions as, for instance, 'idea' and 'expression' – even he has to admit that it has become a trifle narrow.

Furthermore, the world of the humanities is determined by a cultural theory of relativity, comparable to that of the physicists; and since the cosmos of culture is so much smaller then the cosmos of nature, cultural relativity prevails within terrestrial dimensions, and was observed at a much earlier date.

Every historical concept is obviously based on the categories of space and time. The records, and what they imply, have to be dated and located. But it turns out that these two acts are in reality two aspects of one. If I date a picture about 1400, this statement would be meaningless if I could not indicate *where* it could have been produced at that date; conversely, if I ascribe a picture to the Florentine school, I must be able to tell *when* it could have been produced in that school. The cosmos of culture, like the cosmos of nature, is a spatio-temporal structure. The year 1400 means something different in Venice from what it means in Florence, to say nothing of Augsburg, or Russia, or Constantinople. Two historical phenomena are simultaneous, or have a determinable temporal relation to each other, only in so far as they can be related within one 'frame of reference', in the absence of which the very concept of simultaneity would be as meaningless in history as it would in physics. If we knew by some concatenation of circumstances that a certain Negro sculpture had been executed in 1510, it would be meaningless to say that it was 'contemporaneous' with Michelangelo's Sistine ceiling.

Finally, the succession of steps by which the material is organized into a natural or cultural cosmos is analogous, and the same is true of the methodical problems implied by this process. The first step is, as has already been mentioned, the observation of natural phenomena and the examination of human records. Then the records have to be 'decoded' and interpreted, as must the 'messages from nature' received by the observer. Finally the results have to be classified and co-ordinated into a coherent system that 'makes sense'.

Now we have seen that even the selection of the material for observation and examination is predetermined, to some extent, by a theory, or by a general historical conception. This is even more evident in the procedure itself, as every step made towards the system that 'makes sense' presupposes not only the preceding but also the succeeding ones.

When the scientist observes a phenomenon he uses *instruments* which are themselves subject to the laws of nature which he wants to explore. When the humanist examines a record he uses *documents* which are themselves produced in the course of the process which he wants to investigate.

Let us suppose that I find in the archives of a small town in the Rhineland a contract dated 1471, and complemented by records of payments, by which the local painter 'Johannes *qui et* Frost' was commissioned to execute for the church of St James in that town an altarpiece with the Nativity in the centre and Saints Peter and Paul on the wings; and let us further suppose that I find in the Church of St James an altarpiece corresponding to this contract. That would be a case of documentation as good and simple as we could possibly hope to encounter, much better and simpler than if we had to deal with an 'indirect' source such as a letter, or a description in a chronicle, biography, diary, or poem. Yet several questions would present themselves.

The document may be an original, a copy or a forgery. If it is a copy, it may be a faulty one, and even if it is an original, some of the data may be wrong. The altarpiece in turn may be the one referred to in the contract; but it is equally possible that the original monument was destroyed during the iconoclastic riots of 1535 and was replaced by an altarpiece showing the same subjects, but executed around 1550 by a painter from Antwerp.

To arrive at any degree of certainty we would have to 'check' the document against other documents of similar date and provenance, and the altarpiece against other paintings executed in the Rhineland around 1470. But here two difficulties arise.

First 'checking' is obviously impossible without our knowing what to 'check'; we would have to single out certain features of criteria such as some forms of script, or some technical terms used in the contract, or some formal or iconographic peculiarities manifested in the altarpiece. But since we cannot analyse what we do not understand, our examination turns out to presuppose decoding and interpretation.

Secondly, the material against which we check our problematic case is in itself no better authenticated than the problematic case in hand. Taken individually, any other signed and dated monument is just as doubtful as the altarpiece ordered from 'Johannes *qui et* Frost' in 1471. (It is self-evident that a signature on a picture can be, and often is, just as unreliable as a document connected with a picture.) It is only on the basis of a whole group or class of data that we can decide whether our altarpiece was stylistically and iconographically 'possible' in the Rhineland around 1470. But classification obviously presupposes the idea of a whole to which the classes belong – in other words, the general historical conception which we try to build up from our individual cases.

However we may look at it, the beginning of our investigation always seems to

presuppose the end, and the documents which should explain the monuments are just as enigmatical as the monuments themselves. It is quite possible that a technical term in our contract is a *hapax legomenon* [unique occurrence] which can only be explained by this one altarpiece; and what an artist has said about his own works must always be interpreted in the light of the works themselves. We are apparently faced with a hopeless vicious circle. Actually it is what the philosophers call an 'organic situation'. Two legs without a body cannot walk, and a body without legs cannot walk either, yet a man can walk. It is true that the individual monuments and documents can only be examined, interpreted and classified in the light of a general historical concept, while at the same time this general historical concept can only be built up on individual monuments and documents; just as the understanding of natural phenomena and the use of scientific instruments depends on a general physical theory and vice versa. Yet this situation is by no means a permanent deadlock. Every discovery of an unknown historical fact, and every new interpretation of a known one, will either 'fit in' with the prevalent general conception, and thereby corroborate and enrich it, or else it will entail a subtle, or even a fundamental change in the prevalent general conception, and thereby throw new light on all that has been known before. In both cases the 'system that makes sense' operates as a consistent yet elastic organism, comparable to a living animal as opposed to its single limbs; and what is true of the relationship between monuments, documents and a general historical concept in the humanities is evidently equally true of the relationship between phenomena, instruments and theory in the natural sciences.

189

III I have referred to the altarpiece of 1471 as a 'monument' and to the contract as a 'document', that is to say, I have considered the altarpiece as the object of investigation, or 'primary material', and the contract as an instrument of investigation, or 'secondary material'. In doing this I have spoken as an art historian. For a palaeographer or a historian of law, the contract would be the 'monument', or 'primary material', and both may use pictures for documentation.

Unless a scholar is exclusively interested in what is called 'events' (in which case he would consider all the available records as 'secondary material' by means of which he might reconstruct the 'events'), everyone's 'monuments' are everyone else's 'documents,' and vice versa. In practical work we are even compelled actually to annex 'monuments' rightfully belonging to our colleagues. Many a work of art has been interpreted by a philologist or by a historian of medicine; and many a text has been interpreted, and could only have been interpreted, by a historian of art.

An art historian, then, is a humanist whose 'primary material' consists of those records which have come down to us in the form of works of art, but what is a work of art?

A work of art is not always created exclusively for the purpose of being enjoyed, or, to use a more scholarly expression, of being experienced aesthetically. Poussin's statement that 'la fin de l'art est la délectation' was quite a revolutionary one, for earlier writers had always insisted that art, however enjoyable,

was also, in some manner, useful. But a work of art always *has* aesthetic significance (not to be confused with aesthetic value): whether or not it serves some practical purpose, and whether it is good or bad, it demands to be experienced aesthetically.

It is possible to experience every object, natural or man-made, aesthetically. We do this, to express it as simply as possible, when we just look at it (or listen to it) without relating it, intellectually or emotionally, to anything outside of itself. When a man looks at a tree from the point of view of a carpenter, he will associate it with the various uses to which he might put the wood; and when he looks at it from the point of view of an ornithologist he will associate it with the birds that might nest in it. When a man at a horse race watches the animal on which he has put his money, he will associate its performance with his desire that it may win. Only he who simply and wholly abandons himself to the object of his perception will experience it aesthetically.

190

Now, when confronted with a natural object, it is an exclusively personal matter whether or not we choose to experience it aesthetically. A man-made object, however, either demands or does not demand to be so experienced, for it has what the scholastics call an 'intention'. Should I choose, as I might well do, to experience the redness of a traffic light aesthetically, instead of associating it with the idea of stepping on my brakes, I should act against the 'intention' of the traffic light.

Those man-made objects which do not demand to be experienced aesthetically, are commonly called 'practical', and may be divided into two classes: vehicles of communication, and tools or apparatuses. A vehicle of communication is 'intended' to transmit a concept. A tool or apparatus is 'intended' to fulfil a function (which function, in turn, may be the production or transmission of communications, as is the case with a typewriter or with the previously mentioned traffic light).

Most of the objects which do demand to be experienced aesthetically, that is to say, works of art, also belong in one of these two classes. A poem or a historical painting is, in a sense, a vehicle of communication; the Pantheon and the Milan candlesticks are, in a sense, apparatuses; and Michelangelo's tombs of Lorenzo and Giuliano de' Medici are, in a sense, both. But I have to say 'in a sense', because there is this difference: in the case of what might be called a 'mere vehicle of communication' and a 'mere apparatus', the intention is definitely fixed on the idea of the work, namely, on the meaning to be transmitted, or on the function to be fulfilled. In the case of a work of art, the interest in the idea is balanced, and may even be eclipsed, by an interest in form.

However, the element of 'form' is present in every object without exception, for every object consists of matter and form; and there is no way of determining with scientific precision to what extent, in a given case, this element of form bears the emphasis. Therefore one cannot, and should not, attempt to define the precise moment at which a vehicle of communication or an apparatus begins to be a work of art. If I write to a friend to ask him to dinner, my letter is primarily a communication. But the more I shift the emphasis to the form of my script, the more nearly does it become a work of calligraphy; and the more I emphasize the form of my

language (I could even go so far as to invite him by a sonnet), the more nearly does it become a work of literature or poetry.

Where the sphere of practical objects ends, and that of 'art' begins, depends, then, on the 'intention' of the creators. This 'intention' cannot be absolutely determined. In the first place, 'intentions' are, *per se*, incapable of being defined with scientific precision. In the second place, the 'intentions' of those who produce objects are conditioned by the standard of their period and environment. Classical taste demanded that private letters, legal speeches and the shields of heroes should be 'artistic' (with the possible result of what might be called fake beauty), while modern taste demands that architecture and ashtrays should be 'functional' (with the possible result of what might be called fake efficiency). Finally our estimate of those 'intentions' is inevitably influenced by our own attitude, which in turn depends on our individual experiences as well as on our historical situation. We have all seen with our own eyes the transference of spoons and fetishes of African tribes from the museums of ethnology into art exhibitions.

One thing, however, is certain: the more the proportion of emphasis on 'idea' and 'form' approaches a state of equilibrium, the more eloquently will the work reveal what is called 'content'. Content, as opposed to subject matter, may be described in the words of Peirce as that which a work betrays but does not parade. It is the basic attitude of a nation, a period, a class, a religious or philosophical persuasion – all this unconsciously qualified by one personality, and condensed into one work. It is obvious that such an involuntary revelation will be obscured in proportion as either one of the two elements, idea or form, is voluntarily emphasized or suppressed. A spinning machine is perhaps the most impressive manifestation of a functional idea, and an 'abstract' painting is perhaps the most expressive manifestation of pure form, but both have a minimum of content.

IV In defining a work of art as a 'man-made object demanding to be experienced aesthetically' we encounter for the first time a basic difference between the humanities and natural science. The scientist, dealing as he does with natural phenomena, can at once proceed to analyse them. The humanist, dealing as he does with human actions and creations has to engage in a mental process of a synthetic and subjective character: he has mentally to re-enact the action and to re-create the creations. It is in fact by this process that the real objects of the humanities come into being. For it is obvious that historians of philosophy or sculpture are concerned with books and statues not in so far as these books and sculptures exist materially, but in so far as they have a meaning. And it is equally obvious that this meaning can only be apprehended by re-producing, and thereby, quite literally, 'realizing', the thoughts that are expressed in the books and the artistic conceptions that manifest themselves in the statues.

Thus the art historian subjects his 'material' to a rational archaeological analysis at times as meticulously exact, comprehensive and involved as any physical or astronomical research. But he constitutes his 'material' by means of an intuitive aesthetic re-creation, including the perception and appraisal of 'quality', just as

any 'ordinary' person does when he or she looks at a picture or listens to a symphony.

How, then, is it possible to build up art history as a respectable scholarly discipline, if its very objects come into being by an irrational and subjective process?

This question cannot be answered, of course, by referring to the scientific methods which have been, or may be, introduced into art history. Devices such as chemical analysis of materials, X-rays, ultraviolet rays, infrared rays and macrophotography are very helpful, but their use has nothing to do with the basic methodical problem. A statement to the effect that the pigments used in an allegedly medieval miniature were not invented before the nineteenth century may settle an art-historical question, but it is not an art-historical statement. Based as it is on chemical analysis plus the history of chemistry, it refers to the miniature not *qua work* of art but *qua* physical object, and may just as well refer to a forged will. The use of X-rays, macrophotographs, etc., on the other hand, is methodically not different from the use of spectacles or of a magnifying glass. These devices enable the art historian to see more than he could see without them, but *what* he sees has to be interpreted 'stylistically', like that which he perceives with the naked eye.

The real answer lies in the fact that intuitive aesthetic re-creation and archaeological research are interconnected so as to form, again, what we have called an 'organic situation'. It is not true that the art historian first constitutes his object by means of re-creative synthesis and then begins his archaeological investigation – as though first buying a ticket and then boarding a train. In reality the two processes do not succeed each other, they interpenetrate; not only does the re-creative synthesis serve as a basis for the archaeological investigation, the archaeological investigation in turn serves as a basis for the re-creative process; both mutually qualify and rectify one another.

Anyone confronted with a work of art, whether aesthetically re-creating or rationally investigating it, is affected by its three constituents: materialized form, idea (that is, in the plastic arts, subject matter) and content. The pseudo-impressionistic theory according to which 'form and colour tell us of form and colour, that is all,' is simply not true. It is the unity of those three elements which is realized in the aesthetic experience, and all of them enter into what is called aesthetic enjoyment of art.

The re-creative experience of a work of art depends, therefore, not only on the natural sensitivity and the visual training of the spectator, but also on his cultural equipment. There is no such thing as an entirely 'naïve' beholder. The 'naïve' beholder of the Middle Ages had a good deal to learn, and something to forget, before he could appreciate classical statuary and architecture, and the 'naïve' beholder of the post-Renaissance period had a good deal to forget, and something to learn, before he could appreciate medieval, to say nothing of primitive, art. Thus the 'naïve' beholder not only enjoys but also, unconsciously, appraises and interprets the work of art; and no one can blame him if he does this without caring whether his appraisal and interpretation are right or wrong, and without realizing that his own cultural equipment, such as it is, actually contributes to the object of his experience.

The 'naïve' beholder differs from the art historian in that the latter is conscious of the situation. He knows that his cultural equipment, such as it is, would not be in harmony with that of people in another land and of a different period. He tries, therefore, to make adjustments by learning as much as he possibly can of the circumstances under which the objects of his studies were created. Not only will he collect and verify all the available factual information as to medium, condition, age, authorship, destination, etc., but he will also compare the work with others of its class, and will examine such writings as reflect the aesthetic standards of its country and age, in order to achieve a more 'objective' appraisal of its quality. He will read old books on theology or mythology in order to identify its subject matter, and he will further try to determine its historical *locus*, and to separate the individual contribution of its maker from that of forerunners and contemporaries. He will study the formal principles which control the rendering of the visible world, or, in architecture, the handling of what may be called the structural features, and thus build up a history of 'motifs'. He will observe the interplay between the influences of literary sources and the effect of self-dependent representational traditions, in order to establish a history of iconographic formulae or 'types'. And he will do his best to familiarize himself with the social, religious and philosophical attitudes of other periods and countries, in order to correct his own subjective feeling for content. But when he does all this, his aesthetic perception as such will change accordingly, and will more and more adapt itself to the original 'intention' of the works. Thus what the art historian, as opposed to the 'naïve' art lover, does, is not to erect a rational superstructure on an irrational foundation, but to develop his re-creative experiences so as to conform with the results of his archaeological research, while continually checking the results of his archaeological research against the evidence of his re-creative experiences.

193

Leonardo da Vinci has said: 'Two weaknesses leaning against one another add up to one strength.' The halves of an arch cannot even stand upright; the whole arch supports a weight. Similarly, archaeological research is blind and empty without aesthetic re-creation, and aesthetic re-creation is irrational and often misguided without archaeological research. But, 'leaning against one another', these two can support the 'system that makes sense', that is a historical synopsis.

As I have said before, no one can be blamed for enjoying works of art 'naïvely' – for appraising and interpreting them according to his lights and not caring any further. But the humanist will look with suspicion upon what might be called 'appreciationism'. He who teaches innocent people to understand art without bothering about classical languages, boresome historical methods and dusty old documents, deprives naïveté of its charm without correcting its errors.

'Appreciationism' is not to be confused with 'connoisseurship' and 'art theory'. The connoisseur is the collector, museum curator or expert who deliberately limits his contribution to scholarship to identifying works of art with respect to date, provenance and authorship, and to evaluating them with respect to quality and condition. The difference between him and the art historian is not so much a matter of principle as a matter of emphasis and explicitness, comparable to the difference between a diagnostician and a researcher in medicine. The connoisseur tends to emphasize the re-creative aspect of the complex process which I have

tried to describe, and considers the building up of a historical conception as sec-
ondary; the art historian in the narrower, or academic, sense is inclined to reverse
these accents. But the simple diagnosis 'cancer,' if correct, implies everything
which the researcher could tell us about cancer, and therefore claims to be
verifiable by subsequent scientific analysis; similarly the simple diagnosis
'Rembrandt around 1650,' if correct, implies everything which the historian of
art could tell us about the formal values of the picture, about the interpretation of
the subject, about the way it reflects the cultural attitude of seventeenth-century
Holland, and about the way it expresses Rembrandt's personality; and this diag-
nosis, too, claims to live up to the criticism of the art historian in the narrower
sense. The connoisseur might thus be defined as a laconic art historian, and the art
historian as a loquacious connoisseur. In point of fact the best representatives of
both types have enormously contributed to what they themselves do not consider
their proper business.

Art theory, on the other hand – as opposed to the philosophy of art or aesthet-
ics – is to art history as poetics and rhetoric are to the history of literature.

Because of the fact that the objects of art history come into being by a process of
re-creative aesthetic synthesis, the art historian finds himself in a peculiar difficulty
when trying to characterize what might be called the stylistic structure of the
works with which he is concerned. Since he has to describe these works, not as
physical bodies or as substitutes for physical bodies, but as objects of an inward
experience, it would be useless – even if it were possible – to express shapes,
colours, and features of construction in terms of geometrical formulae, wave
lengths and statical equations, or to describe the postures of a human figure by
way of anatomical analysis. On the other hand, since the inward experience of the
art historian is not a free and subjective one, but has been outlined for him by the
purposeful activities of an artist, he must not limit himself to describing his per-
sonal impressions of the work of art as a poet might describe his impressions of a
landscape or of the song of a nightingale.

The objects of art history, then, can only be characterized in a terminology
which is as re-constructive as the experience of the art historian is re-creative: it
must describe the stylistic peculiarities, neither as measurable or otherwise deter-
minable data, nor as stimuli of subjective reactions, but as that which bears witness
to artistic 'intentions'. Now 'intentions' can only be formulated in terms of alter-
natives: a situation has to be supposed in which the maker of the work had more
than one possibility of procedure, that is to say, in which he found himself con-
fronted with a problem of choice between various modes of emphasis. Thus it
appears that the terms used by the art historian interpret the stylistic peculiarities
of the works as specific solutions of generic 'artistic problems'. This is not only the
case with out modern terminology, but even with such expressions as *rilievo,*
sfumato, etc., found in sixteenth-century writing.

When we call a figure in an Italian Renaissance picture 'plastic', while describ-
ing a figure in a Chinese painting as 'having volume but no mass' (owing to the
absence of 'modeling'), we interpret these figures as two different solutions of a
problem which might be formulated as 'volumetric units (bodies) *vs.* illimited
expanse (space)'. When we distinguish between a use of line as 'contour' and, to

quote Balzac, a use of line as 'le moyen par lequel l'homme se rend compte de l'effet de la lumière sur les objets' [the means by which man takes account of the effect of light on objects], we refer to the same problem, while placing special emphasis upon another one: 'line *vs.* areas of colour'. Upon reflection it will turn out that there is a limited number of such primary problems, interrelated with each other, which on the one hand beget an infinity of secondary and tertiary ones, and on the other hand can be ultimately derived from one basic antithesis: differentiation *vs.* continuity.

To formulate and to systematize the 'artistic problems' – which are of course not limited to the sphere of purely formal values, but include the 'stylistic struc- ture' of subject matter and content as well – and thus to build up a system of '*Kunstwissenchafiliche Grundbegriffe*' [the principles of art-historical knowledge] is the objective of art theory and not of art history. But here we encounter, for the third time, what we have called an 'organic situation'. The art historian, as we have seen, cannot describe the objects of his re-creative experience without reconstructing artistic intentions in terms which imply generic theoretical con- cepts. In doing this, he will, consciously or unconsciously, contribute to the development of art theory, which, without historical exemplification, would remain a meagre scheme of abstract universals. The art theorist, on the other hand, whether he approaches the subject from the standpoint of Kant's *Critique*, of neo-scholastic epistemology, or of *Gestaltpsychologie*, cannot build up a system of generic concepts without referring to works of art which have come into being under specific historical conditions; but in doing this he will, consciously or unconsciously, contribute to the development of art history, which, without the- oretical orientation, would remain a congeries of unformulated particulars.

When we call the connoisseur a laconic art historian and the art historian a loquacious connoisseur, the relation between the art historian and the art theorist may be compared to that between two neighbours who have the right of shooting over the same district, while one of them owns the gun and the other all the ammunition. Both parties would be well advised if they realized this condition of their partnership. It has rightly been said that theory, if not received at the door of an empirical discipline, comes in through the chimney like a ghost and upsets the furniture. But it is no less true that history, if not received at the door of a theoret- ical discipline dealing with the same set of phenomena, creeps into the cellar like a horde of mice and undermines the groundwork.

Nikolaus Pevsner

An Outline of European Architecture,
1943

Nikolaus Pevsner (1902–83) is one of the few art historians to have become a household name. This is due to his initiation and, even more noteworthy, his completion of the Buildings of England series, one of the largest research and publication projects ever mounted in architectural history, and one which made the architecture of England accessible, county by county, on a previously unheard-of scale.[1] Similarly, with his championing of the modern movement (in part through his seminal study *Pioneers of Modern Design* of 1949)[2] and his equivalent stinging denunciations of the effect of Victorian values on British design (contrast figs. 37 and 38), he is one of the few scholars to have influenced the art of their own time.

He started his career in Germany, working at the universities of Dresden and Göttingen before coming to England in the 1930s where, after the war, he was made professor of art history at Birkbeck College in the University of London. In terms of his methods Pevsner was an eclectic. He was first and foremost an *empiricist, of such energy that he has been described as an academic locomotive and a discerning vacuum cleaner. As evidence for this one can again refer to the Buildings of England gazetteers, or to the opening paragraph of his book *Some Architectural Historians of the Nineteenth Century*, which plunges the reader straight into no fewer than nineteen facts in its nineteen lines, all annotated. Even the title illustrates the point: *some* architectural writers, that is not all, or even an identifiable group, just some, and certainly not a promise of a systematic treatment of the category of activity represented by architectural writing in the nineteenth century.[3]

He also wrote of art in its social context, defining it so as to include things like scissors and wallpaper as well as the more usual buildings and sculptures. One of the most germane of his characteristics from our point of view is that in all his extensive bibliography he seldom wrote about the methods he employed, which is the mark of the true empiricist, and it is significant for his eclecticism that when he did do so he described his method in terms which are unabashedly *Hegelian, as the text reprinted here illustrates.

Three points stand out in this text. The first concerns the primacy of architecture among the arts in terms of high aesthetic purpose. Using his now celebrated distinction between a bicycle shed and Lincoln cathedral, Pevsner nails the colours of high aesthetic purpose to the mast-head: *architecture means buildings designed to be aesthetically appealing (figs. 5, 31 and 36). He argues that

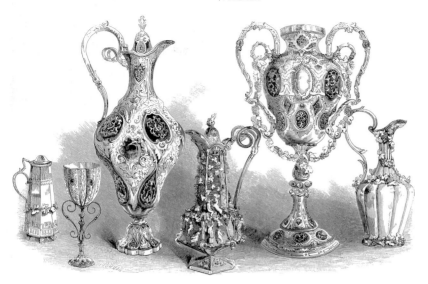

37 Chased, gilt and enamelled silver claret jugs, vase and goblet, 1851. From the Great Exhibition catalogue

Figs. 37 and 38 illustrate the contrast which Pevsner draws between unacceptable and acceptable industrial design, between indulgence in the peripheral and the superfluous, as in the silverware, and concentration on form and its function, as in the street lamps. This contrast is similar to that drawn by Fry between the paintings of Hunt and Cézanne (figs. 34 and 35). It is also of course a contrast between the nineteenth century and the modern.

architecture produces aesthetic sensations in three different ways, by planes, masses and volumes. The first and second of these are shared with painting and sculpture respectively, but the third is the architect's alone. Since the architect has to have the abilities of the painter and sculptor as well as his own, it therefore follows that architecture can claim pride of place among the arts.

The remorseless progress from premise to conclusion evident in this claim ignores the fact that the point is restricted entirely to the creation of abstract form. Architecture can equally be shown to be more restricted than painting and sculpture because buildings cannot be about anything, so that narrative and the exploration of individual psychology are closed to them.[4] In other words it could be argued that his assessment of architecture in this regard is lacking in a concern for human values.

Conversely, in the second argument concerning the primacy of architecture in terms of social function, Pevsner's addition of a social dimension to the tally in favour of architecture places humanity at the centre of the issue: the need for buildings to perform a social function restrains the art of architecture in a wholesome way, keeping it within an understandable human perspective. Easel painting on the other hand lacks contact with real life, and can lead to the artist adopting a 'take-it-or-leave-it' attitude towards society. Easel painting was the leading art of the nineteenth century, indicating the diseased state not only of the arts at the time but of Western civilization as a whole.

38 Peter Behrens, Street Lamps, 1907–8.
See fig. 37.

Pevsner takes it as a hopeful sign of the twentieth century that the fine arts are returning to an architectural character. In stating that even great easel paintings are achievements divorced from the common ground of life, he raises the issue of the status of art for art's sake, that is, in his terms, the artist's right to say 'take-it-or-leave-it'.

The third argument concerns architecture and the spirit of the age. At the end of the text Pevsner sets out the most Hegelian aspects of his views. Architecture is subject to 'evolution in the context of the spirit of the age. He underlines this by noting that change in architecture cannot be entirely due to changes in materials, purposes or social conditions, so that, for example, neither the Gothic nor the modern movement can be explained by a technical advance, but by the fact that a new spirit required it. He is here following Riegl against Semper (Riegl, text 9, 1901).

1 Nikolaus Pevsner, *The Buildings of England*, Harmondsworth, 1951ff, plus numerous revised editions by various authors, and parallel projects underway in Ireland, Scotland and Wales.
2 Nikolaus Pevsner, *Pioneers of Modern Design from William Morris to Walter Gropius* (1949), 2nd edn, Harmondsworth, 1975.
3 Nikolaus Pevsner, *Some Architectural Writers of the Nineteenth Century*, Oxford, 1972, p. 1.
4 See for example Leonardo's argument that painting is superior to sculpture, because it is 'the sole imitator of all visible works of nature …', quoted in E.G. Holt, *A Documentary History of Art, I: The Middle Ages and the Renaissance*, Garden City, NY, 1957, pp. 284 and 285–6.

16 | Nikolaus Pevsner

An Outline of European Architecture,
1943

Nikolaus Pevsner, Introduction to *An Outline*
of European Architecture, Harmondsworth, 1943;
reprinted, Harmondsworth, 1990, pp. 23–5.
Reprinted by permission of Penguin
Books Limited.

A bicycle shed is a building; Lincoln Cathedral is a piece of architecture. Nearly everything that encloses space on a scale sufficient for a human being to move in is a building; the term architecture applies only to buildings designed with a view to aesthetic appeal. Now aesthetic sensations may be caused by a building in three different ways. First, they may be produced by the treatment of walls, proportions of windows, the relation of wall-space to window-space, of one storey to another, or ornamentation such as the tracery of a fourteenth-century window, or the leaf and fruit garlands of a Wren porch. Secondly, the treatment of the exterior of a building as a whole is aesthetically significant, its contrasts of block against block, the effect of a pitched or flat roof or a dome, the rhythm of projections and recessions. Thirdly, there is the effect on our senses of the treatment of the interior, the sequence of rooms, the widening out of a nave at the crossing, the stately movement of a Baroque staircase. The first of these three ways is two dimensional; it is the painter's way. The second is three-dimensional, and as it treats the building as volume, as a plastic unit, it is the sculptor's way. The third is three-dimensional too, but it concerns space; it is the architect's own way more than the others. What distinguishes architecture from painting and sculpture is its spatial quality. In this, and only in this, no other artist can emulate the architect. Thus the history of architecture is primarily a history of man shaping space, and the historian must keep spatial problems always in the foreground. This is why no book on architecture, however popular its presentation may be, can be successful without ground plans.

But architecture, though primarily spatial, is not exclusively spatial. In every building, besides enclosing space, the architect models volume and plans surface, i.e. designs an exterior and sets out individual walls. That means that the good architect requires the sculptor's and the painter's modes of vision in addition to his own spatial imagination. Thus architecture is the most comprehensive of all visual arts and has a right to claim superiority over the others.

This aesthetic superiority is, moreover, supplemented by a social superiority. Neither sculpture nor painting, although both are rooted in elementary creative and imitative instincts, surround us to the same extend as architecture, act upon us so incessantly and so ubiquitously. We can avoid intercourse with what people

call the Fine Arts, but we cannot escape buildings and the subtle but penetrating effects of their character, noble or mean, restrained or ostentatious, genuine or meretricious. An age without painting is conceivable, though no believer in the life-enhancing function of art would want it. An age without easel-pictures can be conceived without any difficulty, and, thinking of the predominance of easel-pictures in the nineteenth century, might be regarded as a consummation devoutly to be wished. An age without architecture is impossible as long as human beings populate this world.

The very fact that in the nineteenth century easel-painting flourished at the expense of wall-painting and ultimately of architecture, proves into what a dis-eased state the arts (and Western civilization) had fallen. The very fact that the Fine Arts today seem to be recovering their architectural character makes one look into the future with some hope. For architecture did rule when Greek art and when medieval art grew and were at their best; Raphael still and Michelangelo conceived in items of balance between architecture and painting. Titian did not, Rembrandt did not, nor did Velázquez. Very high aesthetic achievements are possible in easel-paining, but they are achievements torn out of the common ground of life. The nineteenth century and, even more forcibly, some of the most recent tendencies in fine arts have shown up the dangers of the take-it-or-leave-it attitude of the independent, self-sufficient painter. Salvation can only come from architecture as the art most closely bound up with the neces-sities of life, with immediate use, and functional and structural fundamentals.

That does not, however, mean that architectural evolution is caused by func-tion and construction. A style in art belongs to the world of mind, not the world of matter. New purposes may result in new types of building, but the architect's job is to make such new types both aesthetically and functionally satisfactory – and not all ages have considered, as ours does, functional soundness indispensable for aesthetic enjoyment. The position is similar with regard to materials. New mate-rials may make new forms possible, and even call for new forms. Hence it is quite justifiable if so many works on architecture (especially in England) have empha-sized their importance. If in this book they have deliberately been kept in the background, the reason is that materials can become architecturally effective only when the architect instils into them an aesthetic meaning. Architecture is not the product of materials and purposes – nor by the way of social conditions – but of the changing spirits of changing ages. It is the spirit of an age that pervades its social life, its religion, its scholarship, and its arts. The Gothic style was not created because somebody invented rib-vaulting; the Modern Movement did not come into being because steel frame and reinforced concrete construction had been worked out – they were worked out because a new spirit required them.

Thus the following chapters will treat the history of European architecture as a history of expression, and primarily of spatial expression.

17 | **Arnold Hauser**

The Philosophy of Art History, 1959

Arnold Hauser (1892–1978), German art historian and Marxist theorist, made a great impact in the middle of the century with his seminal work *The Social History of Art* of 1951.[1] That his influence was short-lived is in part explained by his own analysis of the relationship between sociology and art history in the text reprinted here. Hauser begins by pointing out the insights which an awareness of broad social factors can provide, arguing, for example, that great art is usually in some way about life, that it is something which enables us to cope better with the chaotic nature of things, and that art as part of 'culture usually serves to protect society. It is in these areas, he argues, that the social history of art has a unique contribution to make.

By way of illustration Hauser raises the question of the contrast between Flemish and Dutch naturalism in the seventeenth century, exemplified by Rubens and Rembrandt respectively (figs. 39 and 40), which are fundamentally different despite being contemporary, geographically contiguous and based on common cultural traditions. The explanation which he offers lies in their different economic and social conditions, Flanders being a courtly-aristocratic society in which flamboyance and display were of central importance, and Holland a bourgeois and commercial one where the opposite was the case. This provides a clear connection between artistic form and social conditions.

He argues that sociology is also relevant because it is the central discipline of our time, in the same way as theology in the Middle Ages, philosophy in the seventeenth century, or economics in the eighteenth. This central position is due primarily to the formulation by 'Marx, Nietzsche and Freud of the view that our ideas, like everything else, are influenced by our background and our class interests, and that spiritual values are political weapons: everything expressed derives from a social interest and is therefore distorted by it (see also Sontag, text 18, 1964).

Hauser acknowledges three limitations of applying such an approach to works of art. The first concerns the nature of the work of art itself. One of the most important characteristics of a work of art is its status as an independent entity with an inner logic, which means that it is not susceptible to sociological analysis. Attempts to explain the work by tracing its sources or defining its context can blind us to its internal aspects and destroy our awareness of its aesthetic qualities. Even the function which a work is intended to perform can be irrelevant to its aesthetic structure. If the sociological approach is applied without bearing this warning in mind then the painting, building or

carving can easily be lost sight of and come to be considered as 'a record of something more important than the work itself'. The social history of art also tends to analyse the material into more or less simple constituent parts, an action which runs the risk of losing the characteristic complexity of a work of art. The direct study of the work of art is the area which Hauser assigns to the history of art, though he adds that art-historical methods can themselves be destructive of art's defining qualities.

Secondly, sociology does not explain 'quality: the same social conditions can produce valuable works and worthless works, and the elements which such works have in common are irrelevant from the artistic point of view.

The third and final limitation concerns the fact that sociology does not explain the connection (or lack of connection) between artistic quality and popularity. One might have expected the social history of art to have something to say about this aspect. It can, for example, establish the relative popularity of images by conducting a survey and applying the proper statistical techniques concerning margins of error, distribution among social classes, and so on, but this only relates to one half of the equation, and once again it is the matter of quality which renders it problematic.

The balance between the history of art, with its prime interest in the individual work, and the social history of art, with its interest in society as a whole, is expressed in what Hauser calls his leading principle: the behaviour of individuals is the product both of their inborn capacities and of the situation in which they find themselves.[2] His method might therefore have been expected to make its mark on the art-historical world, appealing to art historians seeking a greater social content for the discipline, while not alienating the majority for whom artistic values held central place. In fact, however, as noted at the start, this version of the social history of art was almost universally rejected, as much by radicals as traditionalists, with writers of every shade denying the applicability of the label to their own approach. There appear to have been two chief reasons for this. The first is Hauser's own criticism: he acknowledges, for instance, that the relationship between stylistic trends and social groups is much more flexible than he had realized when he wrote *The Social History of Art*. Thus terms such as 'courtly', 'bourgeois', 'liberal', etc., are too schematized and rigid to do justice to the complexity of the material, and each category contains such a variety of artistic views and aims that the label does not tell us much that is relevant.

The second reason concerns the fact that, despite his claim to be applying the methods of sociology to the material and problems of the history of art, for the most part Hauser, like other art historians, concentrated on 'high art' and ignored the question of how things are made. One can therefore argue that his work goes only a little way beyond that of Winckelmann and Burckhardt in setting works in context. (See also 'art history, 'cultural history and 'style.)

1 Arnold Hauser, *The Social History of Art*, London, 1951.
2 Arnold Hauser, *The Philosophy of Art History*, London, 1959, p. vi.

39 Rubens, *The Betrothal of St Catherine*, c.1628. Oil on canvas, 80.2 × 55.5 cm. Staatliche Museen zu Berlin, Preussischer Kulturbesitz Gemäldegalerie, Berlin
Hauser points out the sharp difference in style between the two examples of Flemish and Dutch naturalism in figs. 39 and 40, between the exuberant, open form of the Rubens sketch and the calm, contained form of the Rembrandt etching, despite the fact that they were pro-

duced by societies that were contemporary, contiguous and with a common cultural background. The differences in subject matter and technique are not sufficient to explain this, and Hauser proposes that the cause is sociological, namely that one society was courtly and aristocratic and the other was bourgeois; to which could be added the difference between the Catholic and Protestant religions.

204

40 Rembrandt, *Christ Preaching*, c.1652. Etching,
14.7 × 20 cm.
See fig. 39.

17 Arnold Hauser

The Philosophy of Art History, 1959

Arnold Hauser, 'The Scope and Limitations of a
Sociology of Art', in *The Philosophy of Art History*,
London, Routledge, 1959, pp. 3–17.

A work of art is a challenge; we do not explain it, we adjust ourselves to it. In interpreting it we draw upon our own aims and endeavours, inform it with a meaning that has its origin in our own ways of life and thought. In a word, any art that really affects us becomes to that extent modern art.

Works of art however are like unattainable heights. We do not go straight towards them, but circle round them. Each generation sees them from a different point of view and with a fresh eye; nor is it to be assumed that a later point of view is more apt than an earlier one. Each aspect comes into sight in its own time, which cannot be anticipated or prolonged; and yet its significance is not lost, for the meaning that a work assumes for a later generation is the result of the whole range of previous interpretations.

We are now living in the day of the sociological interpretation of cultural achievements. This day will not last for ever, and it will not have the last word. It opens up new aspects, achieves new and surprising insights; and yet this point of view evidently has its own limitations and inadequacies. At best perhaps, before its day is over, we may be able to anticipate some of the future criticisms and become aware of its insufficiencies without forgoing the insights that have been and may be gained within these limits.

There are still people who do not feel quite happy when spiritual phenomena, or, as they prefer to call them, the higher spiritual values, are in any way brought into connection with the struggle for existence, class conflict, competition, prestige, and the like. To deal with them fully would take us too far from our subject; here we can only remark that requiring the spiritual to be preserved from all contact with the material frequently turns out to be a way of defending a position of privilege.

Far more worthy of consideration are those who resist a sociological interpretation of spiritual achievements from a conviction that any significant structure, and above all a work of art, is an independent entity, a closed and complete system in itself, the elements of which are to be entirely explained in terms of interdependence, without any recourse to circumstances of its origin or to its influence. For a work of art undoubtedly has an inner logic of its own, and its particular quality is most clearly seen in the internal structural relations of the various levels of organization and the various motifs distinguishable in it. It is further indisputable that

consideration of genetic relationships, that is, of the stages by which the artist moved from one idea or motif to another, not merely introduces a different emphasis, but is also likely to blind us to internal connections and alter the values upon which the aesthetic effect of the work depends. The factors that are most important in the actual production of the work are not equally important in giving it artistic value and effectiveness. Again, the practical aims of the artist, that is, the extraneous purposes that the work of art may be intended to serve, are not always in accord with the inner aesthetic structure that the work reveals. But the exponents of the theory of 'art for art's sake' – and that is what is at issue here – are not content with asserting that a work of art is a microcosm and exerts a sovereign power over men; they maintain that any reference to actualities beyond the work must irretrievably destroy its aesthetic illusion. That may be correct, and yet this illusion is not all, to produce it is not the exclusive or the most important aim of artistic endeavour. Even if it be true that we have to loosen our hold upon reality to a certain extent in order to fall under the spell of art, it is no less true that all genuine art leads us by a detour, which may be longer or shorter, back to reality in the end. Great art gives us an interpretation of life which enables us to cope more successfully with the chaotic state of things and to wring from life a better, that is, a more convincing and more reliable, meaning.

The purely formal laws of art are not essentially different from the rules of a game. However complicated, subtle, and ingenious such rules may be, they have little significance in themselves, that is to say, apart from the purpose of winning the game. Considered as mere movements, the manœuvres of football players are unintelligible and, in the long run, boring. For a time one can find a certain pleasure in their speed and suppleness – but how meaningless are these qualities compared with those noted by the expert observer who understands the object of all this running, jumping, and pushing. If we do not know or even want to know the aims that the artist was pursuing through his work – his aims to inform, to convince, to influence people – then we do not get much further in understanding his art than the ignorant spectator who judges the football simply by the beauty of the players' movements. A work of art is a communication; although it is perfectly true that the successful transmission of this requires an outward form at once effective, attractive, faultless, it is no less true that this form is insignificant apart from the message it communicates.

The work of art has been compared to the opening of a window upon the world. Now, a window can claim the whole of our attention or none. One may, it is said, contemplate the view without concerning oneself in the very least with the quality, structure, or colour of the window-pane. By this analogy, the work of art can be described as a mere vehicle for experiences, a transparent window-pane, or a sort of eyeglasses not noticed by the wearer and employed simply as means to an end. But just as one can concentrate one's attention upon the window-pane and the structure of its glass without taking note of the view beyond, so, it is said, one can treat the work of art as an independent, 'opaque' formal structure, complete in itself and in isolation, as it were, from anything external to it. No doubt one can stare at the window-pane as long as one likes; still, a window is made to look out of.

Culture serves to protect society. Spiritual creations, traditions, conventions, and institutions are but ways and means of social organization. Religion, philosophy, science, and art all have their place in the struggle to preserve society. To confine oneself to art, it is first of all a tool of magic, a means of ensuring the livelihood of the primitive horde of hunters. Then it becomes an instrument of animistic religion, used to influence good and bad spirits in the interest of the community. Gradually this is transformed into a magnification of the almighty gods and their earthly representatives, by hymn and panegyric, through statues of gods and kings. Finally, in the form of more or less open propaganda, it is employed in the interests of a close group, a clique, a political party, a social class. Only here and there, in times of relative security or of social estrangement of the artists, it withdraws from the world and makes a show of indifference to practical aims, professing to exist for its own sake and for the sake of beauty. But even then it performs an important social function by providing men with a means of expressing their power and their 'conspicuous leisure'. Indeed, it achieves much more than that, promoting the interests of a certain social stratum by the mere portrayal and implicit acknowledgment of its moral and aesthetic standards of value. The artist, whose whole livelihood, with all his hopes and prospects, depends upon such a social group, becomes quite unintentionally and unconsciously the mouthpiece of his customers and patrons.

The discovery of the propaganda value of cultural creations, and of art in particular, was made early in human history and exploited to the full, whereas thousands of years passed before man was ready to acknowledge the ideological character of art in terms of an explicit theory, to express the idea that art pursues practical aims either consciously or unconsciously, is either open or veiled propaganda. The philosophers of the French, and even of the Greek enlightenment, discovered the relativity of cultural standards, and doubts regarding the objectivity and ideality of human valuations were expressed again and again in the course of the centuries; Marx, however, was the first to formulate explicitly the conception that spiritual values are political weapons. He taught that every spiritual creation, every scientific notion, every portrayal of reality derives from a certain particular aspect of truth, viewed from a perspective of social interest, and is accordingly restricted and distorted. But Marx neglected to note that we wage a continual war against such distorting tendencies in our thought, that in spite of the inevitable partialities of our mental outlook, we do possess the power of examining our own thought critically, and so correcting to a certain extent the one-sidedness and error of our views. Every honest attempt to discover the truth and depict things faithfully is a struggle against one's own subjectivity and partiality, one's individual and class interests; one can seek to become aware of these as a source of error, while realizing that they can never be finally excluded. Engels understood this process of pulling oneself out of the mud by one's own bootstraps when he spoke of the 'triumph of realism' in Balzac. But no doubt such correcting of our ideological falsification of the truth operates within the limits of what is thinkable and imaginable from our place in the world, not in a vacuum of abstract freedom. And the fact that there are such limits of objectivity is the ultimate and decisive

justification for a sociology of culture; they stop up the last loophole by which we might hope to escape from the influence of social causation.

Apart from its external limitations, the sociology of art also has internal limitations. All art is socially conditioned, but not everything in art is definable in sociological terms. Above all, artistic excellence is not so definable; it has no sociological equivalent. The same social conditions can give rise to valuable or to utterly valueless works, and such works have nothing in common but tendencies more or less irrelevant from the artistic point of view. All that sociology can do is to account in terms of its actual origin for the outlook on life manifested in a work of art, whereas for an appreciation of its quality everything depends upon the creative handling and the mutual relations of the elements expressing that outlook. Such elements may assume the most diverse aesthetic quality, and again the qualitative criteria may be the same in spite of great diversity of outlook. It is no more than an idle dream, a residue of the ideal of *kalokagathia* [nobility], to suppose that social justice and artistic worth in any way coincide, that one can draw any conclusions with regard to the aesthetic success or failure of a work from the social conditions under which it has been produced. The great alliance envisaged by nineteenth-century liberalism between political progress and genuine art, between democratic and artistic feeling, between the interests of humanity in general and universally valid rules of art was a fantasy without any basis in fact. Even the alleged connection between truth of art and truth in politics, the identification of naturalism with socialism, which was from the beginning a basic thesis of socialistic art theory and still is part of its creed, is very dubious. It might be very satisfying to know that social injustice and political oppression were punished with spiritual sterility, but this is not always the case. There have indeed been periods such as that of the Second Empire, in which the predominance of a not very sympathetic social type was characterized by bad taste and lack of originality in art; but along with that inferior art much valuable work was being produced as well. Along with Octave Feuillet there was Gustave Flaubert, along with the Bouguereaus and Baudrys, artists of the rank of Delacroix and Courbet. It may, however, be significant that from the social and political point of view Delacroix was no closer to Courbet than to Bouguereau, that the common artistic aims of these two artists did not rest upon any sort of political solidarity.

Still, on the whole one may say that in the Second Empire the *arriviste* bourgeoisie got the artists it deserved. But what is one to say about epochs such as those of the Ancient Orient or the Middle Ages, in which a most severe despotism or a most intolerant spiritual dictatorship, far from preventing the production of the greatest art, created conditions of life under which the artist did not seem to suffer in the least, certainly no more than he now fancies himself to suffer under the compulsions of even a very liberal form of government? Does not this show that the preconditions of quality in art lie beyond the alternatives of political freedom or unfreedom, and that such quality is not to be compassed by sociological methods?

And what of examples that seem to suggest a contrary view: Greek classical art, which had scarcely any connection with the common people and only the very slightest connection with democracy? Or the 'democracy' of the Italian

208

Renaissance, which was anything but a democracy in reality? Or cases from our own day which show the attitude of the masses to art?

It is reported that some time ago an English firm published a book of reproductions of paintings of the most various sorts – good and bad, examples of popular and of more refined taste, devotional pictures, illustrations of anecdotes, and genuine pictorial creations all jumbled up together. The purchasers of the book were requested to indicate the pictures they preferred. The result was that, although as book-buyers the persons questioned were more or less cultivated, and although eighty per cent of the reproductions fell within the category of 'good art', thus loading the scales in its favour, not one of the first six pictures getting the most votes belonged to this category.

If we took this kind of response to signify that the great public is definitely opposed to the better sort of art and prefers the worse, we could at any rate formulate a sociological law establishing a relation – though an inverse relation – between aesthetic quality and popularity; but there is no trace of any consistent attitude to aesthetic quality in this case. Undoubtedly there is always a certain tension between quality and popularity, at times – as now with modern art – an open conflict. Art that is worth anything is addressed to those who have attained a certain cultural level, not to the 'natural man' of Rousseau; understanding of it depends upon certain educational preconditions, and its popularity is inevitably limited. Uneducated people, on the other hand, do not positively favour bad art over good; they judge success by quite other than aesthetic criteria. They react, not to what is artistically good or bad, but to features that have a reassuring or a disturbing effect upon their course of life; they are ready to accept what is artistically valuable provided that it supplies vital value for them by portraying their wishes, their fantasies, their day- dreams, provided that it calms their anxieties and increases their sense of security. One must not, however, forget that the strange, the unaccustomed, the difficult has, merely as such, a disquieting effect upon an uneducated public.

Thus sociology fails to explain the connections between artistic quality and popularity; and to questions about the material conditions of the creation of works of art it gives answers that are not altogether satisfying. For sociology is subject to certain limitations common to all those disciplines, notably psychology, which employ the genetic method to deal with cultural forms, limitations arising out of that method. It is in fact likely to lose sight, from time to time, of the work of art as such and to consider it a record of something more important than the work itself. And just as the factors psychologically decisive in the creative process are not always identical with the artistically most important factors in the work, so also the sociologically most significant features of a work or of a school are not always the ones that are aesthetically relevant. From a sociological point of view a second-rate or third-rate artist may occupy a key position in a particular artistic movement. The social history of art does not replace or invalidate art history, or vice versa; each starts from a different set of facts and values. When the social history of art is judged by the standards of art history, the facts begin to seem distorted. To counter this impression, one may point out that even art history adopts standards different from those of simple art criticism, and again from those of

immediate aesthetic experience, that there is often a decided tension between historical and aesthetic values. The sociological view of art is to be rejected only if it claims to be the sole legitimate point of view, and if it confuses the sociological importance of a work with aesthetic value.

Apart from this shifting of emphasis, which, though it may confuse is easily compensated for, the sociology of art has in common with other disciplines employing the genetic method a further inadequacy in the eyes of the art-lover: it claims to derive special and unique characteristics of works of art from that which is of quite another order, from something general and artistically indifferent. The worst example of this sort of trespassing is seen in any attempt to show that artistic quality or artistic talent is dependent upon economic conditions. It would be too cheap a retort merely to assert that only a few dogmatic simpletons have proposed to derive spiritual forms directly from economic facts, that the formation of ideologies is a long, complicated, gradual process, far different from that envisaged by vulgar materialism. Complicated, full of interruptions and contradictions the way may be that leads from certain social conditions to the creation of spiritual values, as for instance from Dutch middle-class capitalism to the works of Rembrandt; still, in the end one has to decide whether or not such conditions are relevant. One can put off the decision, conceal one's position, talk of dualism and dialectic, reciprocity and mutual dependence of spirit and matter; but after all one is either an idealist or a realist, and has to face the question of whether genius falls from heaven or fashions itself here on earth.

However one may decide this ultimate question, the translation of economic conditions into ideologies remains a process that can never be completely clarified; at some point or other, it involves a gap or leap. But we should not suppose that only the transition from material conditions to the spiritual involves us in a leap of this sort; all transition from one spiritual form to another, change of style and fashion, collapse of an old tradition and rise of a new, influence of one artist on another, or even a single artist's turns of direction – all these changes are equally discontinuous and inexplicable. Seen from without, every change looks abrupt and remains, strictly speaking, unintelligible. Continuous gradual change is something of which we have only a subjective, inner experience; it cannot be reconstructed from objective data.

The leap from the material to the spiritual is immeasurable, and yet we make this leap within the sphere of social life, even within the sphere of economics. The most primitive economy is a humanly organized economy, not a natural condition; nature once left behind, we do not anywhere encounter the merely material; we may think we are talking about material conditions, but the leap into the realm of spiritual conceptions has already occurred. The distance between natural occurrences and the most primitive economy is thus in a way greater than that from primitive economy to the highest flights of the human spirit, although every stretch of the way is broken by abysses.

One of the most obvious shortcomings of the sociology of art, as of all genetic explanation of spiritual structures, derives from the endeavour to analyse into simple elements an object whose very nature consists in its complexity. No doubt scientific explanation involves simplification, analysis of the complex into such

components as occur in other complexes also. Outside the field of art this proce-
dure does not destroy anything really of the essence of the object, but when
applied to art, it eliminates the object as presented in its completeness, the only
way in which it can be properly presented. If one eliminates or purposely neglects
the complexity of the work of art, interweaving motifs, ambiguity of symbols,
polyphony of voices, mutual dependence of form and content, unanalysable
fluctuations of cadence and emphasis, then the best of what art offers us is gone.
Still, sociology is not alone in incurring this sort of loss, for all scientific treatment
of art has to pay for knowledge gained by destroying the immediate, ultimately
irretrievable, aesthetic experience. In even the most sensitive and understanding
historical analyses of art, that original direct experience has been lost. All this is, of
course, no excuse for the special shortcomings to which the sociologist is prone,
not does it liberate him from the duty of correcting the defects of his point of view
as best he may, or at least of being aware of them.

The work of art is not only a source of complex personal experience, but also
has another kind of complexity, being a nodal point of several different causal
lines. It is the outcome of at least three different types of conditions: psychologi-
cal, sociological and stylistic. As a psychological being, the individual retains not
merely the freedom of choosing among the various possibilities permitted by
social causation; he is also always creating for himself new possibilities in no way
prescribed by his society, even though they may be restricted by the social condi-
tions under which he lives. The creative individual invents new forms of expres-
sion, does not find them ready-made. What he takes for granted is of a negative
rather than positive character: it is the totality of what cannot be thought, felt,
expressed, or understood at that particular historical moment. Undoubtedly, such
'blind spots' of an epoch can be established only subsequently; our actual state of
affairs always has an anarchical look, as if the individual could do with it just what
he fancies. Subsequently one comes to see a social law that has moulded the indi-
vidual choices in accordance with a unitary trend. In a similar way a stylistic line
gradually comes to be recognized, along which particular modes of expression
which have seemed to be freely selected fall into place. Indeed, stylistic trends,
even more than sociological, have definitely the appearance of being objective
regularities that impose themselves upon the individual choices; viewed retro-
spectively, the individuals seem to be little more than carriers of these anonymous
stylistic trends.

But the history of style cannot do away with either psychological or sociologi-
cal causation. It will never be possible to explain by purely formal, stylistic consid-
erations why a line of artistic development breaks off at a certain point and gives
place to a completely different one instead of going on to further progress and
expansion – in short, why a change occurred just when it did. The 'climax' of a
line of development cannot be foretold on the basis of formal criteria; revolution
occurs when a certain style is no longer adapted to expressing the spirit of the
time, something that depends on psychological and sociological conditions.
Change of style, no doubt, occurs in a direction determined from within; but
there are always a number of possible directions, and in any case the 'maturity' of
choice is never fixed in advance or secure from the unforeseeable. Among the

211

circumstances governing the occurrence of the change, social conditions are probably pre-eminent; but it would be a mistake to suppose that social conditions produce the forms in terms by which the artistic revolution expresses itself; these forms are just as much the product of psychological and stylistic as of sociological factors. When one considers social causation, psychology appears as a sort of incipient, abortive sociology; when one regards the psychological motivation, sociology looks like a refusal to trace events to their ultimate origins in the make-up of the human soul. From the stylistic point of view, both psychology and sociology make the same mistake: they derive what is special to art from motives of a heterogeneous character, explain artistic forms in terms of something that has nothing to do with 'form'. Only in descriptive analysis is the uniqueness and complexity of the work of art preserved; it is inevitably destroyed by attempts at pragmatic explanation, whether genetic or teleological. In this respect psychology and art history are on the same footing as sociology.

212

The inadequacy, however, that we often find in the sociologist's view of art is not simply the result of the method of research which sociology shares with psychology and art history. It is also owing to the rather undeveloped language applied by the sociologist to the subtly differentiated world of art, a language vastly inferior to the far more refined and appropriate language of the psychologist and the art historian. The concepts with which the sociologist works are woefully inadequate for dealing with the wealth and subtlety of artistic production. Categories such as 'courtly', 'bourgeois', 'capitalistic', 'urban', 'conservative', and 'liberal' are too narrow and schematic and also too rigid to do justice to the special character of a work of art. Each category comprehends such a variety of artistic views and aims that it does not tell us much that is really relevant. What do we really know about the artistic problems with which Michelangelo had to wrestle, about the individuality of his means and methods, when we have noted merely that he was contemporary with the formulae of the Council of Trent, the new political realism, the birth of modern capitalism and absolutism? When we know all this, we perhaps understand better his restless spirit, the turn that his art took in the direction of mannerism, possibly even in some measure the astounding inarticulateness of his last works. His greatness and the incomparable quality of his aims are no more explained this way than Rembrandt's genius is to be explained by the economic and social conditions that were at once the foundation of his artistic career and his undoing. Here we come up against the definite limits of sociological enquiry.

But if there are such limits, do they really matter? If sociology is unable to penetrate to the ultimate secret of the art of a Rembrandt, are we to dispense entirely with what it can tell us? For example, are we to refuse to probe into the social preconditions of his art, and so of the stylistic peculiarities that distinguish it from the art of the contemporary Flemish painters, notably Rubens? That would be to ignore the only means of throwing light upon the otherwise unintelligible fact that two such different types of art as Flemish baroque and Dutch naturalism arose almost simultaneously, in direct geographical contact with one another, on the basis of similar cultural traditions and a long political experience in common, but under markedly different economic and social conditions. Certainly, we have

here no explanation of Rubens's greatness or the mystery of Rembrandt. But then, what genetic explanation of this stylistic difference is there other than the sociological one that Rubens produced his works in a courtly-aristocratic society, Rembrandt his in a bourgeois world, with its inclination to inwardness? That Rubens, unlike Rembrandt, went to Italy and absorbed the spirit of Italian baroque is rather a symptom than an explanation in itself. Mannerism was in fashion at the turn of the century in the northern provinces as in the southern, and at first Protestant tendencies were to be found in the South just as much as in the North. But in Flanders, in consequence of the Spanish rule, there was an ostentatious court, an aristocracy accustomed to appear in public, a magnificent Church – all things that did not exist in the sober, Protestant Holland that repelled the Spaniards. There, on the contrary, we find a bourgeois capitalism, liberal and without much feeling for prestige, and so ready to let its artists work according to their own fancies, and starve as they pleased. Rembrandt and Rubens are unique and incomparable; not so their styles and their fates. The various turns and changes that we detect in the course of their artistic development and the story of their lives are by no means without parallel, and do not incline us to attribute the difference of type in their art simply to individual disposition and personal genius.

213

Sociology possesses no philosopher's stone, does not work miracles or solve all problems. Still, it is more than just one departmental discipline among many. As was theology in the Middle Ages, philosophy in the seventeenth century, and economics in the eighteenth, it is a focal discipline in our day, one upon which the entire world-view of the age centres. To recognize the claims of sociology is to decide in favour of a rational ordering of life and for a struggle against prejudices. The idea upon which this cardinal position of sociology is founded is the discovery of the ideological character of thought, a discovery made in several different guises, during the past hundred years, in Nietzsche's and Freud's exposures of self-deception no less than in Marx's historical materialism. To get clear about oneself, to become conscious of the presuppositions of one's own character, thought, and will is the requirement upon which all these different thinkers insist. Sociology endeavours to probe into the preconditions of thought and will which derive from a man's social position. Objections made to such research are mostly due to the fact that correct estimation of these social connections is not a purely theoretical matter; men are inclined to admit them or deny them on ideological grounds. Many of those who will not hear of sociology exaggerate its deficiencies in order that they need not become conscious of their prejudices. Others resist sociological interpretation of everything in the spiritual realm, not wishing to give up the fiction of a timeless validity of thought and a meta-historical destiny for man. Those on the other hand who accept sociology as simply one means towards more perfect knowledge have no reason to minimize either its undeniable limitations or the extent of its unexplored possibilities.

Susan Sontag (1933–) is, along with Roger Fry, William Fagg and Olu Oguibe, one of the few twen-tieth-century authors in this collection who is not an art historian. She is also probably the best known of them all because of her status as an American author and essayist on a wide variety of subjects usually involving both cultural and political comment and literary or visual criticism. She is also an influential editor and film director. She has written books on subjects such as photography and the writings of the °poststructuralist Roland Barthes, and has also published numerous collec-tions of essays and reviews.¹ *Against Interpretation* is such a collection, containing work written between 1962 and 1965, which Sontag describes as texts about problems raised for her by works of art in different genres, in particular the theoretical assumptions underlying judgements made about them.

Sontag's text is not primarily about the history of the visual arts, but almost every one of the points she makes has a bearing on our subject. She argues that from Plato to our own day there seems to have been a belief in the Western world that art needs interpreting, with the result that the content of a work became divorced from its form, the first being essential and the second sub-sidiary. This is the case whether we are talking about art as a picture of the visible world (as in the Renaissance) or art as a statement made by the artist (as in much twentieth-century art), since in both it is still assumed that the work consists primarily of its content. As the Western world has become increasingly complex, so possible interpretations have burgeoned until actual experience of the work of art has almost become irrelevant. Today, she argues, we need interpretation so badly because we are contemptuous of appearances. There is a clear indication of this in the importance which we accord to the theories of Marx and Freud: both these authors tell us that events only give the appearance of being intelligible, and that they have no meaning without inter-pretation. These for Sontag are aggressive doctrines which impoverish their subjects.

Sontag's essay is therefore most directly relevant to the debate for and against the ideas of Hegel and Marx, and that of theory versus experience. (See for example the arguments of Burckhardt, text 6, 1872, and Gombrich, text 19, 1967, on the one hand, and of Clark, text 21, 1974 and Foucault, under °discourse analysis, on the other. See also °Hegelianism, °Marxism, °ideology, °psy-choanalysis, °history, °art history and °subjects/disciplines.) In considering Sontag's point one needs to bear in mind her observation that there is no such thing as an uninterpreted brute fact, so that interpretation in the strict sense is unavoidable. Sontag must therefore be seen as dealing with

certain kinds of interpretation, and with the fact that there are cultural contexts in which interpretation is a liberating act and others in which it is the reverse. The difficulty is in distinguishing which is which.

There is one respect in which the primarily literary character of the essay raises difficulties from an art-historical point of view. Sontag describes how, in the age of innocence before theory (presumably before the rise of philosophy in ancient Greece), one defined art as what it did. This, however, makes it necessary to define what one means by °art, because in defining it as what it does one turns a painting of a bison into the metaphorical equivalent of a spear, and it becomes difficult to see why it should be considered as art in the first place.

In response to the question 'What is the alternative to interpretation?', Sontag answers that the first thing is to pay more attention to form and to develop a descriptive vocabulary to go with it, in order to 'reveal the sensuous surface of art without mucking about in it'. (See also °avant-garde.)[2]

1 Susan Sontag, *On Photography*, Harmondsworth, 1979; and *A Barthes Reader*, London, 1982.
2 Compare Clement Greenberg, 'Towards a Newer Laocoön', *Partisan Review*, 7 (4), 1940, pp. 296–310; reprinted in Francis Frascina, ed., *Pollock and After: the Critical Debate*, London, 1985, pp. 35–46.

18 | Susan Sontag

'Against Interpretation', 1964

Susan Sontag, 'Against Interpretation', *Evergreen
Review*, 1964; reprinted in *Against Interpretation
and Other Essays*, London, 1987, pp. 3–14.
Reprinted by permission of Wylie, Aitken &
Stone Inc.; © 1961, 1962, 1963, 1964, 1965, 1966
by Susan Sontag.

The earliest *experience* of art must have been that it was incantatory, magical; art
was an instrument of ritual. (Cf. the paintings in the caves at Lascaux, Altamira,
Niaux, La Pasiega, etc.) The earliest *theory* of art, that of the Greek philosophers,
proposed that art was mimesis, imitation of reality.

It is at this point that the peculiar question of the *value* of art arose. For the
mimetic theory, by its very terms, challenges art to justify itself.

Plato, who proposed the theory, seems to have done so in order to rule that the
value of art is dubious. Since he considered ordinary material things as themselves
mimetic objects, imitations of transcendent forms or structures, even the best
painting of a bed would be only an 'imitation of an imitation'. For Plato, art is
neither particularly useful (the painting of a bed is no good to sleep on), nor, in the
strict sense, true. And Aristotle's arguments in defence of art do not really chal-
lenge Plato's view that all art is an elaborate *trompe l'œil*, and therefore a lie. But he
does dispute Plato's idea that art is useless. Lie or no, art has a certain value accord-
ing to Aristotle because it is a form of therapy. Art is useful, after all, Aristotle
counters, medicinally useful in that it arouses and purges dangerous emotions.

In Plato and Aristotle, the mimetic theory of art goes hand in hand with the
assumption that art is always figurative. But advocates of the mimetic theory need
not close their eyes to decorative and abstract art. The fallacy that art is necessarily
a 'realism' can be modified or scrapped without ever moving outside the prob-
lems delimited by the mimetic theory.

The fact is, all Western consciousness of and reflection upon art have remained
within the confines staked out by the Greek theory of art as mimesis or represen-
tation. It is through this theory that art as such – above and beyond given works of
art – becomes problematic, in need of defence. And it is the defence of art which
gives birth to the odd vision by which something we have learned to call 'form' is
separated off from something we have learned to call 'content', and to the well-
intentioned move which makes content essential and form accessory.

Even in modern times, when most artists and critics have discarded the theory
of art as representation of an outer reality in favour of the theory of art as subjec-
tive expression, the main feature of the mimetic theory persists. Whether we con-
ceive of the work of art on the model of a picture (art as a picture of reality) or on

the model of a statement (art as the statement of the artist), content still comes fist. The content may have changed. It may now be less figurative, less lucidly realistic. But it is still assumed that a work of art is its content. Or, as it's usually put today, that a work of art by definition says something. ('What X is saying is ...', 'What X is trying to say is...', 'What X said is ...' etc., etc.)

2 None of us can ever retrieve that innocence before all theory when art knew no need to justify itself, when one did not ask of a work of art what it *said* because one knew (or thought one knew) what it *did*. From now to the end of consciousness, we are stuck with the task of defending art. We can only quarrel with one or another means of defence. Indeed, we have an obligation to overthrow any means of defending and justifying art which becomes particularly obtuse or onerous or insensitive to contemporary needs and practice.

This is the case, today, with the very idea of content itself. Whatever it may have been in the past, the idea of content is today mainly a hindrance, a nuisance, a subtle or not so subtle philistinism.

Though the actual developments in many arts may seem to be leading us away from the idea that a work of art is primarily its content, the idea still exerts an extraordinary hegemony. I want to suggest that this is because the idea is now perpetuated in the guise of a certain way of encountering works of art thoroughly ingrained among most people who take any of the arts seriously. What the overemphasis on the idea of content entails is the perennial, never consummated project of *interpretation*. And conversely, it is the habit of approaching works of art in order to *interpret* them that sustains the fancy that there really is such a thing as the content of a work of art.

3 Of course, I don't mean interpretation in the broadest sense, the sense in which Nietzsche (rightly) says, 'There are no facts, only interpretations.' By interpretation, I mean here a conscious act of the mind which illustrates a certain code, certain 'rules' of interpretation.

Directed to art, interpretation means plucking a set of elements (the X, the Y, the Z, and so forth) from the whole work. The task of interpretation is virtually one of translation. The interpreter says Look, don't you see that X is really – or, really means – A? That Y is really B? That Z is really C?

What situation could prompt this curious project for transforming a text? History gives us the materials for an answer. Interpretation first appears in the culture of late classical antiquity, when the power and credibility of myth had been broken by the 'realistic' view of the world introduced by scientific enlightenment. Once the question that haunts post-mythic consciousness – that of the *seemliness* of religious symbols – had been asked, the ancient texts were, in their pristine form, no longer acceptable. Then interpretation was summoned, to reconcile the ancient texts to 'modern' demands. Thus the Stoics, to accord with their view that the gods had to be moral, allegorized away the rude features of Zeus and his boisterous clan in Homer's epics. What Homer really designated by the adultery of Zeus with Leto, they explained, was the union between power and wisdom. In the same vein, Philo of Alexandria interpreted the literal historical narratives of the Hebrew Bible as spiritual paradigms. The story of the exodus from Egypt, the wandering in the desert for forty years, and the entry into the

promised land, said Philo, was really an allegory of the individual soul's emancipation, tribulations, and final deliverance. Interpretation thus presupposes a discrepancy between the clear meaning of the text and the demands of (later) readers. It seeks to resolve that discrepancy. The situation is that for some reason a text has become unacceptable; yet it cannot be discarded.

Interpretation is a radical strategy for conserving an old text, which is thought too precious to repudiate, by revamping it. The interpreter, without actually erasing or rewriting the text, *is* altering it. But he can't admit to doing this. He claims to be only making it intelligible, by disclosing its true meaning. However far the interpreters alter the text (another notorious example is the Rabbinic and Christian 'spiritual' interpretations of the clearly erotic *Songs of Songs*), they must claim to be reading off a sense that is already there.

Interpretation in our own time, however, is even more complex. For the contemporary zeal for the project of interpretation is often prompted not by piety towards the troublesome text (which may conceal an aggression), but by an open aggressiveness, an overt contempt for appearances. The old style of interpretation was insistent, but respectful; it erected another meaning on top of the literal one. The modern style of interpretation excavates, and as it excavates, destroys; it digs 'behind' the text, to find a sub-text which is the true one. The most celebrated and influential modern doctrines, those of Marx and Freud, actually amount to elaborate systems of hermeneutics, aggressive and impious theories of interpretation. All observable phenomena are bracketed, in Freud's phrase, as *manifest content*. This manifest content must be probed and pushed aside to find the true meaning – the *latent content* – beneath. For Marx, social events like revolutions and wars; for Freud, the events of individual lives (like neurotic symptoms and slips of the tongue) as well as texts (like a dream or a work of art) – all are treated as occasions for interpretation. According to Marx and Freud, these events only *seem* to be intelligible. Actually, they have no meaning without interpretation. To understand *is* to interpret. And to interpret is to restate the phenomenon, in effect to find an equivalent for it.

Thus, interpretation is not (as most people assume) an absolute value, a gesture of mind situated in some timeless realm of capabilities. Interpretation must itself be evaluated, within a historical view of human consciousness. In some cultural contexts, interpretation is a liberating act. It is a means of revising, of transvaluing, of escaping the dead past. In other cultural contexts, it is reactionary, impertinent, cowardly, stifling.

4 Today is such a time, when the project of interpretation is largely reactionary, stifling. Like the fumes of the automobile and of heavy industry which befoul the urban atmosphere, the effusion of interpretations of art today poisons our sensibilities. In a culture whose already classical dilemma is the hypertrophy of the intellect at the expense of energy and sensual capability, interpretation is the revenge of the intellect upon art.

Even more. It is the revenge of the intellect upon the world. To interpret is to impoverish, to deplete the world – in order to set up a shadow world of 'meanings'. It is to turn the world into this world. ('This world'! As if there were any other.)

The world, our world, is depleted, impoverished enough. Away with all duplicates of it, until we again experience more immediately what we have.

5 In most modern instances, interpretation amounts to the philistine refusal to leave the work of art alone. Real art has the capacity to make us nervous. By reducing the work of art to its content and then interpreting *that*, one tames the work of art. Interpretation make art manageable, comfortable.

This philistinism of interpretation is more rife in literature than in any other art. For decades now, literary critics have understood it to be their task to translate the elements of the poem or play or novel or story into something else. Sometimes a writer will be so uneasy before the naked power of his art that he will install within the work itself – albeit with a little shyness, a touch of the good taste of irony – the clear and explicit interpretation of it. Thomas Mann is an example of such an overcooperative author. In the case of more stubborn authors, the critic is only too happy to perform the job.

The work of Kafka, for example, has been subjected to a mass ravishment by no less than three armies of interpreters. Those who read Kafka as a social allegory see case studies of the frustrations and insanity of modern bureaucracy and its ultimate issuance in the totalitarian state. Those who read Kafka as a psychoanalytic allegory see desperate revelations of Kafka's fear of his father, his castration anxieties, his sense of his own impotence, his thraldom to his dreams. Those who read Kafka as a religious allegory explain that K. in *The Castle* is trying to gain access to heaven, that Joseph K. in *The Trial* is being judged by the inexorable and mysterious justice of God. Another *œuvre* that has attracted interpreters like leeches is that of Samuel Beckett. Beckett's delicate dramas of the withdrawn consciousness – pared down to essentials, cut off and often represented as physically immobilized – are read as a statement about modern man's alienation from meaning or from God or as an allegory of psychopathology.

Proust, Joyce, Faulkner, Rilke, Lawrence, Gide: one could go on citing author after author; the list is endless of those around whom thick encrustations of interpretation have taken hold. But it should be noted that interpretation is not simply the compliment that mediocrity pays to genius. It is indeed, the modern way of understanding something, and is applied to works of every quality. Thus, in the notes that Elia Kazan published on his production of *A Streetcar Named Desire*, it becomes clear that, in order to direct the play, Kazan had to discover that Stanley Kowalski represented the sensual and vengeful barbarism that was engulfing our culture, while Blanche Du Bois was Western civilization, poetry, delicate apparel, dim lighting, refined feelings and all, though a little the worse for wear to be sure. Tennessee Williams's forceful psychological melodrama now became intelligible: it was *about* something, about the decline of Western civilization. Apparently, were it to go on being a play about a handsome brute named Stanley Kowalski and a faded mangy belle named Blanche Du Bois, it would not be manageable.

6 It doesn't matter whether artists intend, or don't intend, for their works to be interpreted. Perhaps Tennessee Williams thinks *Streetcar* is about what Kazan thinks it to be about. It may be that Cocteau in *The Blood of a Poet* and in *Orpheus* wanted the elaborate reading which have been given these films, in terms of

Freudian symbolism and social critique. But the merit of these works certainly lies elsewhere than in their 'meaning'. Indeed, it is precisely to the extent that Williams's plays and Cocteau's films do suggest these portentous meanings that they are defective, false, contrived, lacking in conviction.

From interviews, it appears that Resnais and Robbe-Grillet consciously designed *Last Year at Marienbad* to accommodate a multiplicity of equally plausible interpretations. But the temptation to interpret *Marienbad* should be resisted. What matters in *Marienbad* is the pure, untranslatable, sensuous immediacy of some of its images, and its rigorous if narrow solutions to certain problems of cinematic form.

Again, Ingmar Bergman may have meant the tank rumbling down the empty night street in *The Silence* as a phallic symbol. But if he did, it was a foolish thought. ('Never trust the teller, trust the tale,' said Lawrence.) Taken as a brute object, as an immediate sensory equivalent for the mysterious abrupt armoured happenings going on inside the hotel, that sequence with the tank is the most striking moment in the film. Those who reach for a Freudian interpretation of the tank are only expressing their lack of response to what is there on the screen.

It is always the case that interpretation of this type indicates a dissatisfaction (conscious or unconscious) with the work, a wish to replace it by something else.

Interpretation, based on the highly dubious theory that a work of art is composed of items of content, violates art. It makes art into an article for use, for arrangement into a mental scheme of categories.

7 Interpretation does not, of course, always prevail. In fact, a great deal of today's art may be understood as motivated by a flight from interpretation. To avoid interpretation, art may become parody. Or it may become abstract. Or it may become ('merely') decorative. Or it may become non-art.

The flight from interpretation seems particularly a feature of modern painting. Abstract painting is the attempt to have, in the ordinary sense, no content; since there is no content, there can be no interpretation. Pop Art works by the opposite means to the same result; using a content so blatant, so 'what it is', it, too, ends by being uninterpretable.

A great deal of modern poetry as well, starting from the great experiments of French poetry (including the movement that is misleadingly called Symbolism) to put silence into poems and to reinstate the magic of the word, has escaped from the rough grip of interpretation. The most recent revolution in contemporary taste in poetry – the revolution that has deposed Eliot and elevated Pound – represents a turning away from content in poetry in the old sense, an impatience with what made modern poetry prey to the zeal of interpreters.

I am speaking mainly of the situation in America, of course. Interpretation runs rampant here in those arts with a feeble and negligible avant-garde: fiction and the drama. Most American novelists and playwrights are really either journalists or gentlemen sociologists and psychologists. They are writing the literary equivalent of programme music, And so rudimentary, uninspired, and stagnant has been the sense of what might be done with *form* in fiction and drama that even when the content isn't simply information, news, it is still peculiarly visible, handier, more exposed. To the extent that novels and plays (in America), unlike poetry and

painting and music, don't reflect any interesting concern with changes in their form, these arts remain prone to assault by interpretation.

But programmatic avant-gardism – which has meant, mostly, experiments with form at the expense of content – is not the only defence against the infestation of art by interpretations. At least, I hope not. For this would be to commit art to being perpetually on the run. (It also perpetuates the very distinction between form and content which is, ultimately, an illusion.) Ideally, it is possible to elude the interpreters in another way, by making works of art whose surface is so unified and clean, whose momentum is so rapid, whose address is so direct that the work can be – just what it is. Is this possible now? It does happen in films, I believe. This is why cinema is the most alive, the most exciting, the most important of all art forms right now. Perhaps the way one tells how alive a particular art form is, is by the latitude it gives for making mistakes in it, and still being good. For example, a few of the films of Bergman – though crammed with lame messages about the modern spirit, thereby inviting interpretations – still triumph over the pretentious intentions of their director. In *Winter Light* and *The Silence*, the beauty and visual sophistication of the images subvert before our eyes the callow pseudo-intellectuality of the story and some of the dialogue. (The most remarkable instance of this sort of discrepancy is the work of D.W. Griffith.) In good films, there is always a directness that entirely frees us from the itch to interpret. Many old Hollywood films, like those of Cukor, Walsh, Hawks, and countless other directors, have this liberating anti-symbolic quality, no less than the best work of the new European directors, like Truffaut's *Shoot the Piano Player* and *Jules and Jim*, Godard's *Breathless* and *Vivre sa vie*, Antonioni's *L'Avventura*, and Olmi's *The Fiancés*.

221

The fact that films have not been overrun by interpreters is in part due simply to the newness of cinema as an art. It also owes to the happy accident that films for such a long time were just movies; in other words, that they were understood to be part of mass, as opposed to high, culture, and were left alone by most people with minds. Then, too, there is always something other than content in the cinema to grab hold of, for those who want to analyse. For the cinema, unlike the novel, possesses a vocabulary of forms – the explicit, complex and discussable technology of camera movements, cutting, and composition of the frame that goes into the making of a film.

8 What kind of criticism, of commentary on the arts, is desirable today? For I am not saying that works of art are ineffable, that they cannot be described or paraphrased. They can be. The question is how. What would criticism look like that would serve the work of art, not usurp its place?

What is needed, first, is more attention to form in art. If excessive stress on *content* provokes the arrogance of interpretation more extended and more thorough descriptions of *form* would silence. What is needed is vocabulary – a descriptive, rather than prescriptive, vocabulary – for forms. The best criticism, and it is uncommon, is of this sort that dissolves considerations of content into those of form. On film, drama, and painting respectively, I can think of Erwin Panofsky's essay, 'Style and Medium in the Motion Pictures', Northrop Frye's essay 'A Conspectus of Dramatic Genres', Pierre Francastel's essay 'The Destruction of a Plastic Space'. Roland Barthes's book *On Racine* and his two essays on Robbe-

Grillet are examples of formal analysis applied to the work of a single author. (The best essays in Erich Auerbach's *Mimesis* like 'The Scar of Odysseus', are also of this type.) An example of formal analysis applied simultaneously to genre and author is Walter Benjamin's essay, 'The Story Teller: Reflections on the Works of Nicolai Leskov'.

Equally valuable would be acts of criticism which would supply a really accurate, sharp, loving description of the appearance of a work of art. This seems even harder to do than formal analysis. Some of Manny Farber's film criticism, Dorothy Van Ghent's essay 'The Dickens World: A View from Todgers'', Randall Jarrell's essay on Walt Whitman are among the rare examples of what I mean. These are essays which reveal the sensuous surface of art without mucking about in it.

9 *Transparence* is the highest, most liberating value in art – and in criticism – today. Transparence means experiencing the luminousness of the thing in itself, of things being what they are. This is the greatness of, for example, the films of Bresson and Ozu and Renoir's *The Rules of the Game*.

Once upon a time (say, for Dante), it must have been a revolutionary and creative move to design works of art so that they might be experienced on several levels. Now it is not. It reinforces the principle of redundancy that is the principal affliction of modern life.

Once upon a time (a time when high art was scarce), it must have been a revolutionary and creative move to interpret works of art. Now it is not. What we decidedly do not need now is further to assimilate Art into Thought, or (worse yet) Art into Culture.

Interpretation takes the sensory experience of the work of art for granted, and proceeds from there. This cannot be taken for granted, now. Think of the sheer multiplication of works of art available to every one of us, superadded to the conflicting tastes and odours and sights of the urban environment that bombard our senses. Ours is a culture based on excess, on overproduction; the result is steady loss of sharpness in our sensory experience. All the conditions of modern life – its material plenitude, its sheer crowdedness – conjoin to dull our sensory faculties. And it is in the light of the condition of our senses, our capacities (rather than those of another age), that the task of the critic must be assessed.

What is important now is to recover our senses. We must learn to *see* more, to *hear* more, to *feel* more.

Our task is not to find the maximum amount of content in a work of art, much less to squeeze more content out of the work than is already there. Our task is to cut back content so that we can see the thing at all.

The aim of all commentary on art now should be to make works of art – and, by analogy, our own experience – more, rather than less, real to us. The function of criticism should be to show *how it is what it is*, even *that it is what it is*, rather than to show *what it means*.

10 In place of a hermeneutics we need an erotics of art.

19 E.H. Gombrich

'In Search of Cultural History', 1967

Ernst Gombrich (1909–) is probably the best-known art historian of his generation, outside as well as inside the subject. After studying art history in his native Vienna under Julius von Schlosser and developing his interests in the tradition of members of the Vienna School such as Franz Wickhoff, Alois Riegl and Max Dvořák, he left Austria for England in 1936 before the Nazi occupation to work in the Warburg Institute in London, where he held the post of director from 1959 to 1976.

His chief specialist contributions have been in the field of the history of Renaissance art, particularly in essays such as those collected in *Norm and Form* (1966) and *Symbolic Images* (1972), but he has also undertaken significant work on the bearing of psychology on the making and perceiving of images, as for instance in *Art and Illusion* (1960), *Meditations on a Hobby Horse* (1963), *The Image and the Eye* (1982) and *The Sense of Order* (1979), the last of which is arguably his most original book. *The Story of Art* (1950), an overview of the whole subject, is probably the world's most widely read book on the history of art. Gombrich's interests extend to the history of ideas (including that of the historiography of art) and to the history of literature. He has published an intellectual biography of Aby Warburg (1986) and various studies of the German classics, including Lessing, Schiller and Goethe. His own comments on his *œuvre* and philosophical outlook can be found in his conversations with Didier Eribon, published in England under the title *A Lifelong Interest* (1993).[1]

Gombrich has been identified as a pivotal figure in the world of contemporary art history, with many art historians defining their own philosophical positions in relation to his. Thus the volume of essays published to celebrate his eighty-fifth birthday contains contributions by many of the most prominent of today's art historians.[2] Others have taken him as the standard-bearer of outmoded traditional values and approaches in the subject, alleging his lack of interest in the social sciences, his acceptance of a 'canon of works decided on by previous generations of critics, and the central place which he accords to artistic 'intention. Yet his learning, interests and contributions are so varied that it is difficult to pigeon-hole him in this way. With regard to the canon, while it is true that his interests in Renaissance studies have concentrated on the works of great masters such as Leonardo and Raphael, in his work on vision as a whole any image is grist to his mill, from photographs and cartoons to newspaper illustrations and advertisements. He has consistently stressed the relevance of the changing functions of images in their social context and has proposed the metaphor of an 'ecology of art' to account for these interactions. He has also repeatedly concentrated on the importance of 'feedback' in the creative process. It is also noteworthy that, while

many in Britain consider him a traditional figure, in France he is ranked as a radical thinker alongside figures such as the deconstructionists.[3]

Gombrich has commented most extensively on three aspects of the history of art relevant to methods, namely naturalism, tradition, and *Hegelianism. Concerning the first of these, he has treated the representation of the natural world in art in the light of advances in the *psychology of perception. Thus, against the direct perception of aesthetic quality proposed by modernists like Fry (text 12, 1920), Gombrich argues that the artist always starts with a schema, with the assumption of an image, and proceeds by matching this against his motif in the visible world, which means following conventions. Art follows art, and the greatest influence on artists is earlier art. The central position of tradition in his thought is comprehensively illustrated by his humanist's credo which depends upon and celebrates the continuity of Western civilization from ancient Greece to the present day.[4]

The third aspect, *Hegelianism is best considered alongside the approach known as cultural history. Gombrich himself belongs to this tradition, which extends back via Aby Warburg to Jacob Burckhardt (text 6, 1872) in the nineteenth century and in some respects to Winckelmann (text 4, 1764) in the eighteenth.[5] He has both acknowledged the importance of the Hegelian model for cultural history and, following K. R. Popper, criticized its influence.

One of the clearest statements of this critique is provided by his lecture entitled 'In Search of Cultural History', from which the excerpt printed here is taken.[6] Sections I, II and III, setting out the character and historiography of Hegelianism, are not included in the excerpt. They can be summarized as follows. Gombrich begins section I by arguing that, as a result of the eighteenth-century belief in progress, the long-standing interest in differences between cultures changed into cultural *history*, which in turn was first made into a system by Hegel. Cultural history as understood since the middle of the nineteenth century is therefore based on Hegelianism, and shares in its weaknesses.

In section II he sets out Hegel's system. The history of the universe is the history of God creating Himself. In this optimistic system everything is right because it *is*, so that no value judgements can

be made between cultures. Each people (Greeks, Romans, Germans, etc.) has its own spirit which is a temporary form of the absolute spirit. This *Volksgeist* expresses concretely all aspects of the consciousness of a people. Gombrich represents this diagrammatically by a wheel with eight spokes labelled along the rim as religion, constitution, law and so on (see diagram). If one tries to explain any one of these areas by seeking its essence one arrives at the centre, which therefore explains them all. He likens Hegel's technique of arguing by allegorical interpretation to the exegetical reading of scripture, by means of which, for example, events in the New Testament are assumed to be prefigured by events in the Old. In section III Gombrich questions the view that Burckhardt rejected Hegelianism in favour of working with the facts, because the facts appear to have led him in any case to a Hegelian optimism and an acceptance of the 'spirit' of nations.

Sections IV to VIII, which are reprinted here, come close to offering a statement of Gombrich's basic position, his view of 'a true cultural history'. The arguments presented in these four sections can be distilled as follows. Gombrich acknowledges that 'there is something in the Hegelian intuition that nothing in life is ever isolated, that any event and any creation of a period is connected by a thousand threads with the culture in which it is embedded.' This, however, does not mean that everything is a symptom of something else, as there is no iron law of isomorphism, that is of equivalence between the forms of different aspects of a culture. On the contrary, the past is a complicated and messy business and human society is characterized by complexity and accident, so that its history has to be written with minute attention to innumerable details. Artistic innovations can become important for no other reason than, for example, that they produce a valued human response.

The empirical character of Gombrich's approach is evident in the distinction which he draws between periods and movements. A period is a Hegelian idea, a collective event in which individuals are subordinate to the whole (hence 'Gothic man' and 'Baroque psychology'). A movement, conversely, is started and maintained by people, whose interests and motives are as varied as those of any group of individuals. Thus, since there is no more a psychology of an age than there is a spirit of an age, it is possible for human beings of different ages to understand one another. There is consequently a point to studying the art of the past, as a means of understanding another aspect of the human condition. Cultural historians are of course confronted by the dilemma that 'no culture can be mapped out in its entirety, while no element of this culture can be understood in isolation': their response must be a compromise with what is unavoidable carried through with confidence, like the faith exemplified by Aby Warburg in the assembling of his library.

It goes without saying that Gombrich has retained his interest in the issues raised in this essay of 1967 and has returned to certain aspects in various of his subsequent publications.[7] He has consistently stressed the relevance of the changing functions of images in their social context and has proposed the metaphor of an 'ecology of art' to account for these interactions. He has also repeatedly concentrated on the importance of 'feedback' in the creative process.

1 *The Story of Art* (1950), 16th edn, London, 1995; *Art and Illusion: a Study in the Psychology of Pictorial Representation* (1960), 5th edn, reprinted, London, 1994; *Meditations on a Hobby Horse* (1963), 4th edn, reprinted, London, 1994; *Norm and Form* (1966), 4th edn, reprinted, London, 1993; 'The Ambivalence of the Classical Tradition: the Cultural Psychology of Aby Warburg' (1966), in *Tributes: Interpreters of our Cultural Tradition*, Oxford, 1984, pp. 116–37; *Symbolic Images: Studies in the Art of the Renaissance* (1972), 3rd edn, reprinted, London, 1993; '"The Father of Art History": a Reading of the *Lectures on Aesthetics* of G.W.F. Hegel (1770–1831)' (1977), in *Tributes: Interpreters of our Cultural Tradition*, Oxford, 1984, pp. 51–69; *The Sense of Order: a Study in the Psychology of Decorative Art* (1979), 2nd

edn, reprinted, London, 1994; *The Image and the Eye: further Studies in the Psychology of Pictorial Representation* (1982), reprinted, London, 1994; *Topics of our Time: Twentieth-century Issues in Learning and in Art* (1991), reprinted, London, 1994; *A Lifelong Interest: Conversations on Art and Science with Didier Eribon*, London, 1993.

2 John Onians, ed., *Sight and Insight: Essays on Art and Culture in Honour of E.H. Gombrich at 85*, London, 1994.

3 A.L. Rees and F. Borzello, eds., *The New Art History*, London, 1986, p. 9: 'Art history's next stage is anyone's guess, though experience suggests some sort of compromise can be expected. A possible direction is supplied by the exhaustive *The Classical Hollywood Cinema* (Bordwell, Staiger and Thompson, London, 1985) which unites *Screen*-style theory with traditional historical research. In the light of the influence film studies has had on art history, it is interesting to note that the authors include Gombrich among their intellectual mentors. Radical scholars abroad tend to value Gombrich's writings alongside those of, say, Jacques Derrida, an unimaginable comparison in this country where Gombrich is currently seen as tradition personified among radical art historians'; see also A.P. Johnson, review of Norman Bryson, *Tradition and Desire*, Cambridge, 1984, in *Ideas and Production*, 5, 1986, pp. 127–31; and W.J.T. Mitchell, *Iconology: Image, Text, Ideology*, Chicago, IL, 1986, pp. 75–94.

4 E.H. Gombrich, 'The Tradition of General Knowledge' (1961), in *Ideals and Idols: Essays on Values in History and in Art* (1979), reprinted, London, 1994, pp. 22–3. For comments on what Gombrich calls 'idols' see, for examples such as quantity, novelty and topicality, his 'Research in the Humanities: Ideals and Idols' (1973), and, for paradigms, 'A Plea for Pluralism' (1971), both in *Ideals and Idols*, op. cit., pp. 116–20, and 184–8.

5 E.H. Gombrich, *Tributes*, op. cit., pp. 121–3.

6 E.H. Gombrich, 'In Search of Cultural History' (1967), in *Ideals and Idols*, op. cit., pp. 41–59. The text published in 1979 is an expanded version of the original lecture, but the original text survives almost intact; the additional material consists chiefly of more quotations from the authors discussed in the lecture; the subheadings have also been added. The footnotes were added for publication and hence contain material published after 1967. See *Ideals and Idols*, op. cit., p. 24.

7 These include 'Art History and the Social Sciences' (1975), in *Ideals and Idols*, op. cit., pp. 131–66; 'Relativism in the Humanities: the Debate about Human Nature' (1985), in *Topics of our Time*, op. cit., pp. 36–55; his Reynolds Lecture at the Royal Academy of Arts, London, entitled 'Styles of Art and Styles of Life' (1991); and his extensive review of the important book by Francis Haskell, *History and its Images* in the *New York Review of Books*, September 1993.

19 | E. H. Gombrich

'In Search of Cultural History', 1967

Excerpt from E.H. Gombrich, 'In Search
of Cultural History', the Philip Maurice Deneke
Lecture delivered at Lady Margaret Hall, Oxford,
19 November 1967; reprinted in *Ideals and Idols:
Essays on Values in History and in Art*, Oxford,
1979; reprinted, London, 1994, pp. 42–59.

…Not that Hegelian metaphysics were accepted in all their abstruse ramifications
by any [of the cultural historians of the nineteenth century]. The point is rather
that all of them felt, consciously or unconsciously, that if they let go of the
magnet that created the pattern, the atoms of past cultures would again fall back
into random dust-heaps.

In this respect the cultural historian was much worse off than any other histo-
rian. His colleagues working on political or economic history had at least a crite-
rion of relevance in their restricted subject matter. They could trace the history
of the reform of Parliament, of Anglo-Irish relations, without explicit reference
to an all-embracing philosophy of history.

But the history of culture as such, the history of all the aspects of life as it was
lived in the past, could never be undertaken without some ordering principle,
some centre from which the panorama can be surveyed, some hub on which the
wheel of Hegel's diagram can be pivoted. Thus the subsequent history of histori-
ography of culture can perhaps best be interpreted as a succession of attempts to
salvage the Hegelian assumption without accepting Hegelian metaphysics. This
was precisely what Marxism claimed it was doing. The Hegelian diagram was
more or less maintained, but the centre was occupied not by the spirit but by the
changing conditions of production. What we see in the periphery of the diagram
represents the superstructure in which the material conditions manifest them-
selves. Thus the task of the cultural historian remains very much the same. He
must be able to show in every detail of the period how it reflects its essential eco-
nomic character.[1]

Lamprecht, whom I mentioned before as one of Warburg's masters, took the
opposite line. He looked for the essence not in the material conditions but in the
mentality of an age.[2] He tried, in other words, to translate Hegel's *Geist* into psy-
chological terms …

In my own field, the History of Art, it was Alois Riegl who, at the turn of the
century, worked out his own translation of the Hegelian system into psychologi-
cal terms.[3] Like Hegel he saw the evolution of the arts both as an autonomous

dialectical process and as wheels revolving within the larger wheel of successive 'world-views'. In art the process went spiralling twice: from a tactile mode of apprehension of solid matter to an 'optic' mode, first in the case of isolated objects and then in that of their spatial setting. As in Hegel, also, this process with its inevitable stages puts the idea of 'decline' out of court. By classical standards of tactile clarity the sculpture of the Arch of Constantine [fig. 5] may represent a decline, but without this process of dissolution neither Raphael nor Rembrandt could have come into being.

Moreover, this relentless development runs parallel with changes in the 'world-views' of mankind. Like Hegel, Riegl thought that Egyptian art and Egyptian *Weltanschauung* were both on the opposite pole from 'spiritualism'. He postulates for Egypt a 'materialistic monism' which sees in the soul nothing but refined matter. Greek art and thought are both dualistic while late antiquity returns to monism, but at the opposite end of the scale, where (predictably) the body is conceived of as a cruder soul. 'Anyone who would see in the turn of late antiquity towards irrationalism and magic superstitions a decline, arrogates for himself the right to prescribe to the spirit of mankind the way it should have taken to effect the transition from ancient to modern conceptions.'[4] For Riegl was convinced that this late antique belief in spirits and in magic was a necessary stage without which the mind of man could never have understood electricity. And he proved to his own satisfaction (and to that of many others) that this momentous process was as clearly manifested in the ornamentation of late Roman fibulae as it was in the philosophy of Plotinus.

It was this claim to read the 'signs of the time' and to penetrate into the secrets of the historical process which certainly gave new impetus to art historical studies. Max Dvořák, in his later years, represented this trend so perfectly that the editors of his collected papers rightly chose as title *Kunstgeschichte als Geistesgeschichte*[5] ('Art History as a History of the Spirit'), a formulation which provoked Max J. Friedländer to the quip, 'We apparently are merely studying the History of the Flesh' ('Wir betreiben offenbar nur Körpergeschichte'). The great Erwin Panofsky, like Dilthey, presents a more critical and sophisticated development of this programme, but those who have studied his works know that he too never renounced the desire to demonstrate the organic unity of all aspects of a period.[6] His *Gothic Architecture and Scholasticism*[7] shows him grappling with the attempt to 'rescue' the traditional connection between these two aspects of medieval culture by postulating a 'mental habit' acquired in the schools of the scholastics and carried over into architectural practice. In his *Renaissance and Renascences in Western Art*[8] he explicitly defended the notion of cultures having an essence against the criticism of George Boas.

But perhaps the most original rescue attempt of this kind was made by the greatest cultural historian after Burckhardt, his admirer, critic and successor, Johan Huizinga.[9]

It will be remembered that Burckhardt had advised his friend to ask himself: 'How does the spirit of the fifteenth century express itself in painting?'

The average art historian who practised *Geistesgeschichte* would have started from the impression Van Eyck's paintings made on him and proceeded to select

other testimonies of the time that appeared to tally with this impression. What is so fascinating in Huizinga is that he took the opposite line. He simply knew too many facts about the age of Van Eyck to find it easy to square his impression of his pictures with the voice of the documents. He felt he had rather to reinterpret the style of the painter to make it fit with what he knew of the culture. He did this in his captivating book, *The Waning of the Middle Ages*,[10] literally the autumn of the Middle Ages, which is Hegelian even in the assumption of its title, that here medieval culture had come to its autumnal close, complex, sophisticated and ripe for the sickle. Thus Van Eyck's realism could no longer be seen as a harbinger of a new age; his jewel-like richness and his accumulation of detail were rather an expression of the same late-Gothic spirit that was also manifested, much less appealingly, in the prolix writings of the period which nobody but specialists read any more.

The wheel had come full circle. The interpretation of artistic realism as an expression of a new spirit, which is to be found in Hegel and which had become the starting point for Burckhardt's reading of the Renaissance, was effectively questioned by Huizinga, who subsequently devoted one of his most searching essays to this traditional equation of Renaissance and Realism.[11] But as far as I can see, he challenged this particular interpretation rather than the methodological assumption according to which the art of an age must be shown to express the same spirit as its literature and life.

Critical as he was of all attempts to establish laws of history, he still ended his wonderful paper on 'The Task of Cultural History'[12] with a demand for a 'morphology of culture' that implied, if I understand it correctly, a holistic approach in terms of changing cultural styles.

Now I would not deny for a moment that a great historian such as Huizinga can teach the student of artistic developments a lot about the conditions under which a particular style like that of Van Eyck took shape. For obviously there is something in the Hegelian intuition that nothing in life is ever isolated, that any event and any creation of a period is connected by a thousand threads with the culture in which it is embedded. Who would not therefore be curious to learn about the life of the patrons who commissioned Van Eyck's paintings, about the purpose these paintings served, about the symbolism of his religious paintings, or about the original context of his secular paintings which we only know through copies and reports?

Clearly neither the *Adoration of the Lamb* nor even the lost *Hunt of the Otter* can be understood in isolation without references to religious traditions in the first case and to courtly pastimes in the second.

But is the acknowledgement of this link tantamount to a concession that the Hegelian approach is right after all? I do not think so. It is one thing to see the interconnectedness of things, another to postulate that all aspects of a culture can be traced back to one key cause of which they are the manifestations.[13]

If Van Eyck's patrons had all been Buddhists he would neither have painted the *Adoration of the Lamb* nor, for that matter, the *Hunting of the Otter*, but though the fact that he did is therefore trivially connected with the civilization in which he worked, there is no need to place these works on the periphery of the

Hegelian wheel and look for the governing cause that explains both otter hunting and piety in the particular form they took in the early decades of the fifteenth century, and which is also expressed in Van Eyck's new technique.

If there is one fact in the history of art I do not find very surprising it is the success and acclaim of this novel style. Surely this has less to do with the *Weltanschauung* of the period than with the beauty and sparkle of Van Eyck's paintings.

I believe it is one of the undesirable consequences of the Hegelian habit of exegetics that such a remark sounds naïve and even paradoxical. For the habit demands that everything must be treated not only as connected with everything else, but as a symptom of something else. Just as Hegel treated the invention of gunpowder as a necessary expression of the advancing spirit, so the sophisticated historian should treat the invention of oil painting (or what was described as such) as a portent of the times. Why should we not find a simpler explanation in the fact that those who had gunpowder could defeat those who fought with bows and arrows or that those who adopted the Van Eyck technique could render light and sparkle better than those who painted in tempera?[14] Of course no such answer is ever final. You are entitled to ask why people wanted to defeat their enemies, and though the question may once have sounded naive we now know that strong influences can oppose the adoption of a better weapon. We also know that the achievement of life-like illusion cannot always be taken for granted as an aim of painting. It was an aim rejected by Judaism, by Islam, by the Byzantine Church and by our own civilization, in each case for different reasons. I believe indeed that methodologically it is always fruitful to ask for the reasons which made a culture or a society reject a tool or invention which seemed to offer tangible advantages in one particular direction. It is in trying to answer this question that we will discover the reality of that closely knit fabric which we call a culture.[15]

But I see no reason why the study of these connections should lead us back to the Hegelian postulates of the *Zeitgeist* and *Volksgeist*. On the contrary, I have always believed that it is the exegetic habit of mind leading to these mental short-circuits which prevents the posing of the very problem Hegelianism set out to solve.[16]

V: SYMPTOMS AND SYNDROMES

One may be interested in the manifold interactions between the various spheres of a culture and yet reject what I have called the 'exegetic method', the method, that is, that bases its interpretations on the detection of that kind of 'likeness' that leads the interpreter of the scriptures to link the passage of the Jews through the Red Sea with the Baptism of Christ. Hegel, it will be remembered, saw in the Egyptian sphinx an essential likeness with the position of Egyptian culture in which the Spirit began to emerge from animal nature, and carried the same metaphor through in his discussion of Egyptian religion and Egyptian hiero-glyphics. The assumption is always that some essential structural similarity

must be detected which permits the interpreter to subsume the various aspects of a culture under one formula.[17] The art of Van Eyck in Huizinga's persuasive morphology is not only to be connected with the theology and the literature of the time but it must be shown to share some of their fundamental characteristics. To criticize this assumption is not to deny the great ingenuity and learning expended by some cultural historians on the search for suggestive and memorable metaphorical descriptions. Nor is it to deny that such structural likenesses between various aspects of a period may be found to be interesting, as A.O. Lovejoy tried to demonstrate for eighteenth-century Deism and Classicism.[18] But here as always a priori assumptions of such similarity can only spoil the interest of the search. Not only is there no iron law of such isomorphism, I even doubt whether we improve matters by replacing this kind of determinism with a probabilistic approach as has been proposed by W.T. Jones in his book on *The Romantic Movement*.[19] The subtitle of this interesting book demands attention by promising a 'New Method in Cultural Anthropology and History of Ideas'; it consists in drawing up such polarities as that between static and dynamic, or order and disorder, and examining certain periods for their bias towards one or the other end of these scales, a bias which would be expected to show up statistically at the periphery of the Hegelian wheel in art, science and political thought, though some of these spheres might be more recalcitrant to their expression than others. In the contrast between 'soft focus' and 'hard focus' the Romantic, he finds, will be likely to lean towards the first in metaphysics, in poetical imagery and in paintings, a bias that must be symptomatic of Romantic mentality.

Such expectations, no doubt, accord well with commonsense psychology; but in fact no statistics are needed to show in this case that what looks plausible in this new method of salvaging Hegel still comes into conflict with historical fact. It so happens that it was Romanticism which discovered the taste for the so-called 'primitives' in painting, which meant, at that time, the hard-edged, sharp-focused style of Van Eyck or of the early Italians. If the first Romantic painters of Germany had one pet aversion it was the soft-focused bravura of their Baroque predecessors. Whatever their bias in metaphysics may have been, they saw in the smudged outline a symptom of artistic dishonesty and moral corruption. Their bias in the syndrome – to retain this useful term – was based on very different alternatives, alternatives peculiar to the problems of painting. Paradoxically, perhaps, they identified the hard and naïve with the otherworldly and the chaste. It was soft-focused naturalism that was symptomatic of the fall from grace ...

VI: MOVEMENTS AND PERIODS

The distinction at which I am aiming here is that between movements and periods. Hegel saw all periods as movements since they were embodiments of the moving spirit. This spirit, as Hegel taught, manifested itself in a collective, the supra-individual entities of nations or periods. Since the individual, in his view,

could only be thought of as part of such a collective it was quite consistent for Hegelians to assume that 'man' underwent profound changes in the course of history. Nobody went further in this belief than Oswald Spengler, who assigned different psyches to his different culture cycles. It was an illusion due to sentimentalizing humanitarians to believe that these different species of man could ever understand each other.

The same extremism was of course reflected in the claims of the totalitarian philosophies which stemmed from Hegel to create a new 'man', be it of a Soviet or of a National Socialist variety. Even art historians of a less uncompromising bent took to speaking of 'Gothic man' or 'Baroque psychology', assuming a radical change in the mental make-up to have happened when building firms discarded one pattern book in favour of another. In fact the study of styles so much fostered a belief in collective psychology that I remember a discussion shortly after the war with German students who appeared to believe that in the Gothic age Gothic cathedrals sprang up spontaneously all over Europe without any contact between the building sites.

It is this belief in the existence of an independent supra-individual collective spirit which seems to me to have blocked the emergence of a true cultural history. I am reminded of certain recent developments in natural history which may serve as illustrations. The behaviour of insect colonies appeared to be so much governed by the needs of the collective that the temptation was great to postulate a super-mind. How else, argued Marais in his book *The Soul of the White Ant*,[20] could the individuals of the hive immediately respond to the death of the queen? The message of this event must reach them through some kind of telepathic process. We now know that this is not so. The message is chemical; the queen's substance picked up from her body circulates in the hive through mutual licking rather than through a mysterious mental fluid.[21] Other discoveries about the communication of insects have increased our awareness of the relation between the individual and the hive. We have made progress.

I hope and believe cultural history will make progress if it also fixes its attention firmly on the individual human being. Movements, as distinct from periods, are started by people. Some of them are abortive, others catch on. Each movement in its turn has a core of dedicated souls, a crowd of hangers-on, not to forget a lunatic fringe. There is a whole spectrum of attitudes and degrees of conversion. Even within the individual there may be various levels of conviction, various conscious and unconscious fluctuations in loyalty. What seemed acceptable during the mass rally or revivalist meeting may look pretty crazy on the way home. But movements would not be movements if they did not have their badges, their outward signs, their style of behaviour, style of speech and of dress. Who can probe the motives which prompt individuals to adopt some of these, and who would venture in every case to pronounce on the completeness of the conversion this adoption may express? Knowing these limitations, the cultural historian will be a little wary of the claims of cultural psychology. He will not deny that the success of certain styles may be symptomatic of changing attitudes, but he will resist the temptation to use changing styles and changing fashions as indicators of profound psychological changes. The fact that we cannot assume

such automatic connections makes it more interesting to find out if and when they may have existed.

The Renaissance, for instance, certainly had all the characteristics of a move-ment.[22] It gradually captured the most articulate sections of society and influenced their attitude in various but uneven ways. Late Gothic or Mannerism were not, as far as I can see, the badge of any movement, though of course there were movements in these periods which may or may not have been correlated with styles or fashions in other cultural areas. The great issues of the day, notably the religious movements, are not necessarily reflected in distinctive styles. Thus both Mannerism and the Baroque have been claimed to express the spirit of the Counter-Reformation but neither claim is easy to substantiate. Even the exis-tence of a peculiar Jesuit style with propagandist intentions has been disproved by the more detailed analysis of Francis Haskell.[23]

We need more analyses of this kind, based on patient documentary research, but I venture to suggest that the cultural historian will want to supplement the analysis of stylistic origins by an analysis of stylistic associations and responses. Whatever certain Baroque devices may have meant to their creators, they evoked Popish associations in the minds of Protestant travellers. When and where did these associations become conscious? How far could fashion and the desire for French elegance override these considerations in a Protestant commu-nity? I know that it is not always easy to answer these questions, but I feel strongly that it is this type of detailed questioning that should replace the general-izations of *Geistesgeschichte*.

233

VII: TOPICS AND TECHNIQUES

… Having criticized a Hegel, a Burckhardt, or a Lamprecht for their excess of self-confidence in trying to solve the riddles of past cultures, I am bound to admit in the end that without confidence our efforts must die of inanition. A scholar such as Warburg would not have founded his Library without a burning faith in the potentialities of *Kulturwissenschaft*. The evolutionist psy-chology that inspired his faith is no longer ours, but the questions it prompted him to ask still proved fruitful to cultural history. In proposing as the principal theme of his Institute 'das Nachleben der Antike' – literally the after-life of ancient civilization – he at least made sure that the historian of art, of literature or of science discovered the need for additional techniques to hack a fresh path into the forest in pursuit of that protean problem. Warburg's library was formed precisely to facilitate the acquisition of such tools. It was to encourage trespass-ing, not amateurishness.

Warburg's problem arose in a situation when the relevance of the classical tradition for the cultural life of the day was increasingly questioned by national-ists and by modernists. He was not out to defend it so much as to explain and assess the reasons for its long 'after-life'. The continued value of that ques-tion for the present generation lies in the need to learn more about a once vital tradition which is in danger of being forgotten. But I would not claim

that it provides the one privileged entry into the tangled web of Western civilization.

Both the dilemmas and the advantages of cultural history stem from the fact that there can be no privileged entry. It seems to me quite natural that the present generation of students is particularly interested in the social foundations of culture; having myself been born in the reign of his Apostolic Majesty the Emperor Francis Joseph, who had come to the throne in 1848, I certainly can appreciate the rapidity of social change that prompts fresh questionings about the past. That all-pervasive idea of rank and hierarchy that coloured man's reaction to art, religion and even to nature, has become perplexing to the young. It will be the task of the cultural historian to trace and to explain it wherever it is needed for our understanding of the literature, the philosophy or the linguistic conventions of bygone cultures.

Perhaps this example also illustrates the difference between the social and the cultural historian. The first is interested in social change as such. He will use the tools of demography and statistics to map out the transformations in the organization of society. The latter will be grateful for all the information he can glean from such research, but the direction of his interest will still be in the way these changes interacted with other aspects of culture. He will be less interested, for example, in the economic and social causes of urban development than in the changing connotations of words such as 'urbane' or 'suburbia' or, conversely, in the significance of the 'rustic' order in architecture.

The study of such derivations, metaphors and symbols in language, literature and art provides no doubt convenient points of entry into the study of cultural interactions.[24] But I do not think more should be claimed for this approach than it is likely to yield. By itself it cannot offer an escape from the basic dilemma caused by the breakdown of the Hegelian tradition, which stems from the chastening insight that no culture can be mapped out in its entirety, while no element of this culture can be understood in isolation. It appears as if the cultural historian were thus still left without a viable programme, grubbing among the random curiosities of antiquarian lore.

I realize that this perplexity looks pretty formidable in the abstract, but I believe it is much less discouraging in practice. What Popper has stressed for the scientist also applies to the scholar.[25] No cultural historian ever starts from scratch. The traditions of his own culture, the bias of his teacher, the questions of the moment can all stimulate his curiosity and direct his questionings. He may want to continue some existing lines of research or to challenge their result; he may be captivated by Burckhardt's picture of the Renaissance, for instance, and fill in some of the gaps left in that immensely suggestive account, or he may have come to distrust its theoretical scaffolding and therefore feel prompted to ask how far and by whom certain Neo-Platonic tenets were accepted as an alternative to the Christian dogma.

Whether we know it or not, we always approach the past with some preconceived ideas, with a rudimentary theory we wish to test. In this as in many other respects the cultural historian does not differ all that much from his predecessor, the traveller to foreign lands. Not the professional traveller who is only interested

in one particular errand, be it the exploration of a country's kinship system or its hydroelectric schemes, but the broad-minded traveller who wants to understand the culture of the country in which he finds himself.

In trying to widen his understanding the traveller will always be well advised to treat inherited clichés about national characters or social types with a healthy suspicion, just as the cultural historian will distrust the second-hand stereotypes of the 'spirit of the age'. But neither need we ever forget that our reactions and observations will always be dependent on the initial assumptions with which we approach a foreign civilization. The questions we may wish to ask are therefore in no way random; they are related to a whole body of beliefs we wish to reinforce or to challenge. But for the cultural historian no less than for the traveller the formulation of the question will usually be precipitated by an individual encounter, a striking instance, be it a work of art or a puzzling custom, a strange craft, or a conversation in a minicab …

235

1 See my review of Arnold Hauser in 'The Social History of Art' (1953), in *Meditations on a Hobby Horse* (1963), 4th edn, reprinted, London, 1994; and 'Style', *International Encyclopedia of the Social Sciences*, New York, 1968.
2 See Karl J. Weintraub, *Visions of Culture*, Chicago and London, 1966.
3 Alois Riegl, *Die Spätrömische Kunstindustrie* (1901), Vienna, 1927.
4 Ibid., p. 404.
5 Max Dvořák, *Kunstgeschichte als Geistesgeschichte*, Munich, 1924.
6 Erwin Panofsky, *Aufsätze zu Grundfragen der Kunstwissenschaft*, Berlin, 1964. See now my *The Sense of Order: a Study in the Psychology of Decorative Art* (1979), 2nd edn, reprinted, London, 1994, chapter 8.
7 Erwin Panofsky, *Gothic Architecture and Scholasticism*, Latrobe, PA, 1951.
8 Erwin Panofsky, *Renaissance and Renascences in Western Art*, Stockholm, 1960, p. 3.
9 R.L. Colie, 'Johan Huizinga and the Task of Cultural History', *American Historical Review*, LXIX, 1964, pp. 607–30; Karl J. Weintraub, op. cit. See now also my 'Huizinga's *Homo Ludens*', *Bijdragen en Mededelingen Betreffende de Geschiedenis der Nederlanden* 88/2, 1973, pp. 275–96; and in *Tributes: Interpreters of our Cultural Tradition*, Oxford, 1984, pp. 139–63.
10 Johan Huizinga, *The Waning of the Middle Ages* (1919), London, 1924. Huizinga later regretted the choice of title for this reason, as I mentioned in 'Huizinga's *Homo Ludens*', op. cit.
11 Johan Huizinga, 'Renaissance and Realism' (1926), *Men and Ideas*, New York, 1959.
12 Johan Huizinga, 'The Task of Cultural History (1929), *Men and Ideas*, New York, 1959.
13 Morse Peckham, *Man's Rush for Chaos*, New York, 1966; Edgar Wind, 'Kritik der Geistes geschichte, Das Symbol als Genenstand kulturwissenschaftlicher Forschung', *Kulturwissenschaftliche Bibliographie zum Nachleben der Antike*, Einleitung, ed. Bibliothek Warburg 1, Leipzig, Berlin, 1934.
14 See my *Art and Illusion: a Study in the Psychology of Pictorial Representation* (1960), 5th edn, reprinted, London, 1994; and 'From the Revival of Letters to the Reform of the Arts: Nicolò Niccoli and Filippo Brunelleschi', in *The Heritage of Apelles: Studies in the Art of the Renaissance* (1976), reprinted, London, 1993, pp. 93–111.
15 See my 'The Logic of Vanity Fair, Alternatives to Historicism in the Study of Fashions, Style and Taste', in *Ideals and Idols: Essays on Values in History and in Art* (1979), reprinted, London, 1994.
16 See my 'Art and Scholarship' (1957), in *Meditations on a Hobby Horse*, op. cit.; and *Art and Illusion*, op. cit.
17 See Morse Peckham, op. cit.
18 A. O. Lovejoy, 'The Parallel between Deism and Classicism', *Essays in the History of Ideas*, Baltimore, 1948.

19 W. T. Jones, *The Romantic Syndrome,* The Hague, 1961.
20 Eugene Marais, *The Soul of the White Ant* (1934), London, 1937.
21 Colin G. Butler, *The World of the Honey-bee*, London, 1954.
22 See now my 'The Renaissance – Period or Movement?', in *Background to the English Renaissance: Introductory Lectures*, J. B. Trapp, ed., London, 1974, pp. 9–30.
23 Francis Haskell, *Patrons and Painters*, London, 1963.
24 Edgar Wind, op. cit.
25 K. R. Popper, 'Truth, Rationality and the Growth of Scientific Knowledge (1960), *Conjectures and Refutations*, London, 1963.

236

William Fagg

'In Search of Meaning in African Art', 1973

William Fagg (1914–92) was a leading anthropologist and keeper of the department of Ethnology at the Museum of Mankind in London. He made an important contribution to the study of African culture through his analyses of artefacts, as indicated by his publications on subjects such as wooden tribal figure sculpture, Nigerian beadwork, and the essay reprinted here.[1]

As °anthropologists normally avoid traditional art-historical methods, Fagg's use of them as valuable tools for the conduct of his research stands out as of particular interest in a study of methods such as this.

The first of the three methods which he discusses concerns °stylistic analysis. After acknowledging the ever-present need for the recording of more data, Fagg describes the really important task as being to achieve a full understanding and appreciation of works of art in the tribal society being studied. He underlines the importance of seeing them as works of art, and distinguishes them from mere artefacts acting as 'counters in a system of social structures'. As Fagg mentions, the concept of 'works of art' needs further examination, as it is very unlikely that the category would carry the same implications in Ibo society, for example, as it does in ours (see also °art). Thus, despite the fact that anthropologists and °archaeologists are specifically trained not to make them, value judgements are essential if one is going to establish a corpus of original works to be studied, that is, by excluding fakes and the objects of the tourist trade. In order to identify these fakes the student must practice °connoisseurship, not of the dilettantist kind, but one 'having regard both to universal values in art and to the specific tribal values'. This in turn requires stylistic analysis, in order, for example, to identify the exaggerations often included in fakes to make them more convincing, which Fagg usefully refers to as 'signs of stylistic feedback'.

The second method is also an aspect of connoisseurship, namely the distinguishing of works of high °quality from those which are poor. Since art is a form of communication it follows that the greatest art will communicate the most, especially in those ineffable areas which cannot be communicated by means of speech. Art in the service of spiritual feelings in particular falls into this category. Thus the most important truths about a society will only be accessible through its greatest works, whereas the poor works will be 'naïve and uncommunicative'. This does not mean that bad work should not be studied: at the very least it provides a framework for identifying the work of the master artists. Fagg illustrates the point about quality by means of a comparison between two

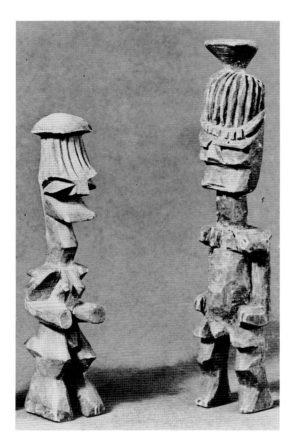

41 Wooden figures from western Iboland, before 1916. Fagg uses these two carvings to argue for the use of connoisseurship in the study of art in a context without documentary evidence. The techniques of the connoisseur are needed in order to separate the fake from the genuine and to assess the quality of the piece and thereby establish what it can contribute to an understanding of the society in which it was produced. Fagg argues that the carving on the left is of high quality and that on the right is mediocre. He recommends imagining them enlarged from their six or seven inches to as many feet, in order to bring out the power and conviction of the piece on the left, which demonstrates 'art in the service of spiritual feelings', as opposed to the 'naïve and uncommunicative' character of the other figure.

small wooden carvings from western Iboland (fig. 41). He does so in part by asking the viewer to judge the effect of making each object up to twelve times as large as it appears on the page, because monumental scale can show up weaknesses in form. Panofsky (text 15, 1940) covers similar ground in discussing the relationship between universal values and those of a specific social context.

The third method concerns *iconography. The levels of meaning which Fagg sets out (namely overt content – that is, subject matter – 'real' content, and style) are also similar to those proposed by Panofsky, with Fagg's overt content and real content resembling Panofsky's pre-iconographic and iconological levels. His inclusion of style in the context of meaning is also a reminder of the important part which *form plays in the way in which a work of art is read by the viewer. (See also Baldwin, Harrison and Ramsden, text 23, 1981.)

1 William Fagg, *The Tribal Image: Wooden Figure Sculpture of the World*, London, 1970; contributions to *Yoruba Beadwork: Art of Nigeria*, B. Holcombe, ed., London, 1981; and 'In Search of Meaning in African Art', in Anthony Forge, ed., *Primitive Art and Society*, Oxford, 1973, pp. 151–68.

20 | William Fagg

'In Search of Meaning in African Art',
1973

Excerpt from William Fagg, 'In Search of
Meaning in African Art', in Anthony Forge, ed.,
Primitive Art and Society, Oxford, 1973,
pp. 151–68. Reprinted by permission of
Oxford University Press © The Wenner-Gren
Foundation for Anthropological Research Inc.
1973.

… [In the study of African art] even at [the] descriptive level, there is need – and urgent need – for vastly more recording of data than has yet been done. The compilation of such data is well within the competence of ethnologists (in the sense of specialists in material culture), even if they will need a lot of help from others if they are to do the job in time. But I do not wish to concern myself here with this necessary accumulation of concrete facts so much as with the ends towards which it is a means – the study, understanding, and full appreciation of works of art and of their real place *as works of art* in the life of men, as distinct from their more superficial function (to which their status as art is irrelevant) as counters in a system of social structure.

The study of tribal art beyond taxonomy may not be quite a virgin field, but the attempts (including my own) which have been made to enter upon it from various directions have so far been amateurish. This need not surprise us, since there are no professionals to do it. Not only are we anthropologists (and archaeologists) not trained to be competent in this field; we are specifically trained to be incompetent in it. I mean of course that we are taught to exclude all value judgements from our methodology; the prohibition being enforced by precept when necessary, but much more by a strongly adverse climate of opinion. And this climate must clearly exert a strong pre-selective effect upon entrants to anthropology. I do not suggest that this situation is due to any particular school or branch of anthropology; it would appear to be almost universal in anthropological and archaeological worlds, and in general among most scientific or semi-scientific disciplines.

'Value judgements' is a term used, generally with somewhat pejorative intent, to refer to the operation of man's subjective judgement, or intuition, as distinct from his intellectual judgement. These, the two great complementary faculties of the human mind, are found in creative balance in the greatest periods of art – and perhaps also of science, since it is by intuitive leaps that scientific advances tend to be made. Thus science draws on the intuition as well as the intellect, and art on the intellect as well as on the intuition.

The indispensability of the subjective judgement – duly guided, complemented, and above all recognized by the intellect – in the study of tribal arts is

perhaps most easily demonstrated in terms of the actual objects with which the student must work. In working on the art of a given tribe he is typically confronted with a large though scattered corpus of works attributable to the tribe, and of this, one large segment is (if he is lucky) to be found still *in situ* in the tribal dwellings and shrines, while the remainder are scattered among the museums, private collections, and dealers' stocks of the rest of the world, having been collected at various times mainly during the present century. In the country of origin, wherein lies his best hope of documenting works to the standard required for his purpose, he may find surviving examples of the work of about three generations of artists, and in so far as he can identify and document these, they will serve as a control in all his other studies of the art. However, these undoubtedly genuine and traditional works will vary considerably in quality, as they have always done, though the predominant trend in this century will usually have been one of progressive degeneration; our student, as we shall see, will need to be able to distinguish fine works from mediocre and poor ones. But in addition he is likely nowadays to find two other classes of work in the country, often in great profusion: one is the tourist art, developed increasingly in the course of this century for the unsophisticated foreign traveller, most of it not made by traditionally trained artists and only occasionally showing much resemblance to the tribal art; the other, of more recent origin (though appearing older), consists of forged antiquities made largely to external order for the international art market, and commonly by traditional artists working for local entrepreneurs after their tribal commissions have more or less come to an end. Since such forgeries often exhibit uncanonical exaggerations and elaborations introduced for greater saleability, our student may have to look out for signs of stylistic feedback occurring in recent work found in traditional use, as has happened among the Siena. As for collections in the rest of the world, they include an additional large category of misleading objects, namely fakes made in Europe on a large scale before the Second World War, though that industry may be said to have entered a decline when it became possible to procure them, with a greater show of authenticity, from the countries of origin. And in general it may be said that the great majority of genuine examples have passed through the hands of dealers and are therefore devoid of documentation.

The mere enumeration of these categories of works which our student must examine or exclude is enough to make it clear that connoisseurship in the chosen field is a prerequisite of successful research in tribal art — a connoisseurship not dilettantist like some in the European past but having regard both to universal values in art and to the specific tribal values. It is obvious that research based in part on unrecognized fakes is vitiated at source, and will be at least partially discredited by discovery of this fact. But such expertise is not, it seems, within reach of all: just as some people are said to be 'tone-deaf', so some appear to be 'art-blind' because they lack (whether the lack be biological or cultural) the faculty of intuitive appreciation. For it is not sufficient (though it is useful) to learn a series of specific formal criteria to distinguish fakes from genuine pieces; what is required is instantaneous intuitive recognition (to be followed up as necessary by analytical methods) of the qualities, including the authenticity, of the work. (He who

appraises only by the letter and not by the spirit will be not only painfully slow in rejecting the irrelevant but also wide open to deception, since it is precisely the letter which the studious forger can successfully reproduce, whereas the spirit requires a creative artist.) Nor can the student sidestep the requirement of connoisseurship by confining his attention to works which he can find actually in traditional use by his tribe, unless the tribe is one of the very few remaining in which an adequate range of its most characteristic work still exists *in situ*.

But the elimination of fakes and other dubious pieces is of course only the preliminary qualifying test of connoisseurship, though even this calls for a fair amount of experience in the field and the museum. We can all agree that fakes should be eliminated from our universe of discourse, and I have introduced them only to show that even at this lowly level the student's subjective judgement is needed and should be used. The next, and doubtless more controversial, step in the argument is the proposition that intuitive discrimination in point of quality among the available genuine works in the tribal tradition is equally indispensable if they are to yield their full value as anthropological data; and specifically that the finest works are of much the greatest value in any attempt to interpret the art of the tribe. The range of quality will normally be very wide, from a few works of top quality through a mass of competent work to those which, while technically complying with ritual prescription, can only be described as bad art. This variation of quality will be especially great among the peoples most prolific in sculpture, such as the Yoruba, since the number of carvers who could make a living at it greatly exceeded the number who had a special aptitude for it; a carver's son, himself innocent of natural genius or talent, would almost inevitably be taught the craft in order to help meet the demand, whereas unrelated apprentices of the master, prompted by a real vocation, would be more likely to produce creative work. There may well be a million or more Yoruba sculptures extant, and of these a fairly small proportion are works of real genius, fit to stand with the greatest works of African art, whereas a far larger number, perhaps the majority, are by comparison naïve and uncommunicative, conveying nothing beyond their overt subject matter. I do not claim that the student's exercise of his subjective judgement is necessarily to be accepted as a mystery, beyond reach of analysis and study. But if we discern in it more than one process, we must not suppose that they are really discrete in practice; our analysis is purely expository, and does not detract from the instantaneity of the flash of insight. I think then, that when a student has become proficient in the *métier*, his judgement may be seen as falling into two main parts (though which, if either, should be placed first I do not know). Let us suppose him confronted by a masterpiece for the first time. He will at once see that the artist has *succeeded*, that he has solved his problems and done what he has set out to do. (Even when a great artist is engaged on some transcendental religious work, the communication between brain and hands must surely be concerned above all with concrete and material problems of form.) And he will see also that those problems are problems of *sculpture*. The first criterion is incomplete without the second because it is possible to be completely successful in a misguided enterprise, as when a skilled carver for the tourist trade produces a photographic (one might almost say pantographic) likeness of his subject. Even in

241

naturalistic art the true sculptor is likely to be thinking in terms of stylization, of introducing regularities by heightening emphasis on one feature, reducing it on a second, perhaps suppressing a third altogether.

Visual art, like music, is a form of communication and is concerned especially with communicating the ineffable, that is truths, values, feelings, etc., for which the normal channels of communication such as speech are unavailable or inadequate. Art in Africa, as in medieval Europe, was primarily inspired by religion, and its prime purpose may similarly be assumed to have been to evoke, and associate with worship, the deeper levels of spiritual feeling. We may reasonably regard the different methods of communication open to man – through which alone he can be known, studied, and understood – as a continuum or spectrum, encompassing the spoken and the written word, the drama, music and the dance, and the visual arts. There should not be a pale beyond which some part of this continuum is considered inaccessible to 'the study of man' – especially if it is the part through which man can express himself most freely, most directly, and most profoundly. These means of communication – poetry, music dance, art – must be penetrated chiefly by the divination of the subjective judgement, which cannot for example give equal weight to Robert Burns and the Great McGonagall. And this faculty of qualitative discrimination between banality and genius in the interpretation of the nature of things becomes pre-eminently indispensable in the arts which are beyond words, such as sculpture, and which must be 'read' directly, without the intervention of words. For the mediocre artist simply does not have the creative ability to conceptualize through form the most important truths of art which are also (I divine) the most important truths about his society. The student cannot 'read' what is not there, and in the case of poor work the sculptural forms will be so vague and 'blind' as to be unreadable. I am not here despising the study of mediocre or even bad art, from which a great deal can be learnt, but I do suggest that one of the main uses of such art is to provide a frame of reference within which can be identified and evaluated the work of the master artists who alone have the power to embody the quintessential values of the community.

Everyone who is familiar with tribal art will be able to think of countless examples to support the foregoing paragraphs, works which manifestly do or do not communicate, which do or do not realize the artistic and religious possibilities of the type. What I think a particularly telling illustration is afforded by a pair of small wooden standing figures collected by P.A. Talbot before the First World War in western Iboland. Although he failed to document them, it is perfectly clear that they come from the same place (probably a village in the Owerri district) and had the same ritual purpose: they differ only in that one is by a poor carver, who has managed little more than the minimum called for by ritual prescription or convention, while the other is by an artist of genius who has achieved a small masterpiece of Ibo art (fig. 41b). If we imagine them enlarged, the former would seem more and more painfully banal, the latter would increase in power and effect, its forms so bold and sure that even a twelvefold enlargement to a height of six feet would show no weakness. And above all, the sculptural forms of the second are clearly significant.

Philistines (of whom there are a number in anthropology and other social sciences) often naïvely argue, bowing to the prohibition on value judgements, that is useless to try to apply artistic criteria to the arts of the tribal peoples because these peoples simply do not have the concept of art. In fact, of course, what they do not have is the *literary* concept of art which has dominated Western art in the last two centuries and is associated with the rise of aesthetics (which etymologically *ought* to be about feeling) – a concept which is at war with the very nature of visual art. The philistine case is, paradoxically, destroyed precisely by the fact that the tribal peoples express their concept of art not in language but in art itself (a super-language). Even the Greeks, for all their preoccupation with verbal analysis, seem to have apprehended this, having no separate word for art in our sense but making do with the word for skill of all kinds (*technē*).

We should here say a word on the much belaboured question of whether there are universal values in art. All those who are able and willing to use an informed subjective judgement on the problem *know* that universal values exist. Those who restrict themselves to the objective judgement, on the other hand, are almost necessarily in doubt on such matters. Even they, however, may be influenced by such statistical experiments as that on Bakwele masks reported by Child and Siroto (1965): a comprehensive collection of photographs for these masks was first placed in order of merit by a group of art pundits at Yale and then submitted to various Bakwele groups – who achieved a remarkable degree of concordance with the Yale men. Where discrepancies appeared, reasonable ethnographical or technical explanations seemed to be available. For while these universal values may be said to have absolute validity, they are veiled for most people by their cultural preconceptions. The Western art world may now, as a result of the influence of Malraux and others, be said to be completely eclectic and 'open' in the sense that none of the world's arts are barred from our universe of art; at the other extreme are the tribal peoples of Africa and elsewhere, whose art forms are so closely tied to the religious beliefs peculiar to them as to be of little interest or meaning for their neighbours, except where the relationship between any two or more tribes is itself undergoing a change. Thus cultural ethnocentrism operates as a barrier between African tribes to the appreciation of universals, while the traffic in them between the tribes and the western world is one-way: that is, the enlightened and omnicompetent art-loving Westerner can in theory appreciate the universals in the art of each tribe, which presents so to speak a window in his direction but, more or less, a blank wall to other tribes.

In this paper we are concerned especially with the problem of meaning in African art. It will clarify thought if we observe the distinction between (1) subject matter, or overt content, (2) subject, or real content or meaning, and (3) style. The first and last of these are often confounded (as when, for example, the Yoruba convention of the mouth as two parallel bars is regarded as an element of style rather than of subject matter – though it is of course a useful concomitant of style and is quite properly used to identify Yoruba works.) But it is the second that is our quarry, and this is, at least for the ordinary man who is not an artist, something far more fugitive and volatile. It tends to be expressed through a subtle synthesis (as is the nature of art), which if subjected to objective-analytical study,

simply disappears. The ethnographer who does not wish this to happen must equip himself with other, more subjective tools – which he should not hesitate to regard as a necessary part of ethnography.

We should not allow our attitudes towards tribal art to be too much coloured by one of the major wrong turnings taken by revolutionary modern art and its expositors from quite early in the century – the 'liberation' of artistic form from content or subject. (We may note in passing that this left form and style very much at the mercy of fashion, which is no doubt how they became commercially manipulable.) The point is that if the ethnographer is going to seek help, as he must, from artists, there will be little profit in approaching those artists who are still floundering down this cul-de-sac. For our great need is to study form not only in itself but as an expression of subject. (All the anthropological-sociological studies so far undertaken of 'art in society' seem to have been really concerned more with 'society around art', since they stop short of entering the field of art itself – although some few of them, such as those of Edmund Leach, are written with considerable understanding of art and sometimes even succeed in the limited objective of capturing certain small areas for sociological explanation which had previously been assumed to be within the province of art.)

The study of meaning in African (and, more generally, in tribal) art is at a rudimentary, not to say primitive, stage. Collectors have generally been content at most to record the overt content (such as 'figure of a woman with two children', or if they do more ('the earth goddess') are often merely reproducing European conjectures. These, however, are still within the realm of subject matter, whereas meaning or real subject is to be looked for within the realm of ideas, which are the province of philosophy ...

21 T.J. Clark

'The Conditions of Artistic Creation', 1974

Timothy J. Clark (1943–) can be credited with succeeding where Arnold Hauser failed (text 17, 1959), that is, in making the social context and conditions of production central aspects of the study of works of art, as in his most influential books on Courbet and Manet – *Image of the People: Gustave Courbet and the 1848 Revolution* (1973) and *The Painting of Modern Life: the Art of Manet and his Followers* (1985) as well as in articles such as that on Manet's *Olympia* (1980).[1] He is a graduate of the Courtauld Institute of Art in the University of London, and has held the professorship of Fine Art at the University of Leeds (1976–80), where his influence is still discernible, and a professorship at Harvard and then one at the University of California at Berkeley.

In the article reprinted here, which originally appeared in the *Times Literary Supplement*, Clark gives an overview of the history of art history in the twentieth century by dividing it into three periods, contrasting a golden age in the early decades with a more cautious and unadventurous period in the middle of the century, and concluding with a statement of how he hopes it will develop in the future. He defines the golden age by recalling that, in the 1920s, the Hungarian *Marxist philosopher and critic Georg Lukács (1885–1971) chose two art historians out of three scholars in his selection of the truly important historians of the recent past (Riegl and Dvořák, along with the historian Wilhelm Dilthey). For Clark, the scholars of this period were great because they asked important questions, especially about the way in which art was produced by the artist and received by the audience. He singles out for praise Panofsky's work on perspective as symbolic form, which uses the subject to clarify and explain the ways in which people think about everything, not just visual representation. Behind this generation he sees the uncompromising work of *Hegel.

In the second period, that of the post-war generation, art historians, in Clark's view, stopped asking the important questions which had been posed by the previous generation and substituted 'methods' such as formal analysis; they used *iconography, not in order to understand the connection between an artist and a context, but as 'desultory theme-chasing'; they stopped producing provocative studies like that of Panofsky on perspective and descended into a 'dreary professional literature'; and they rejected the Hegelian structures on which the golden age was based. Instead the subject became the servant of the art market or the provider of second-hand notions of taste and the good life.

Turning thirdly to the future, Clark proposes that, in order to re-establish the previous stature of the history of art, we should excavate what was worthwhile in the heroic period and disinter the legacy

of Hegel. We need to substitute for the current notion of artistic creation one of artistic production and to establish a hierarchy of importance among the resources available to the artist, namely between technical means, pictorial tradition, and ideas. We need facts about patronage, art dealing and the status of the artist, and questions on the relationship between art and 'ideology. Ideology should in fact be central to our interests: we should study the way in which social classes use works of art to maintain their position; style should be analysed as if it were an expression of an ideology in visible form; we should explore the extent to which the conditions and relations of artistic production explain that relationship, and how it was received and perceived by patrons and audiences. Such an investigation could result in telling us how ideologies *work*. This should be the scope of the ambitions of the history of art.

Clark's essay can in part be assessed by posing the following four questions. First, how accurate are his accounts of the state of the history of art in the golden age and the post-war period? Clark's assessment of the status and worth of the art historians of the golden age would probably find wide agreement and is certainly supported by the evidence presented elsewhere in this book. It is more difficult to be certain about what he says of the post-war generation, where he mentions no names. It is easier to be specific about those one is praising than those one is criticizing, but even with this proviso his silence over Gombrich in particular is significant, not only because of his prominence but also because there is a good case for arguing that, whatever their differences, Panofsky and Gombrich have more in common than any other two eminent art historians working in the twentieth century.

It is also relevant that one can cite specific instances from the writings of members of this generation which provide a social context for artistic production. Gombrich begins a discussion of iconology with an analysis of the circumstances surrounding the designing of the statue of Eros at Piccadilly Circus, and how these may have affected its meaning. Similarly Andrew Martindale's book on the rise of the artist deals with most of those questions of production and social status which Clark seeks, his account revealing a great deal about the range of work in which artists were involved, as well as about the attitudes of a society towards humour and the psychology of status.[2]

Despite this sort of contrary evidence Clark's generalization makes a point, since many, if not most, studies of artists presented their subject without asking any questions about their social context or the conditions which might have contributed to the formation of the objects which they produced.

The character of the texts of the golden age themselves raises another question. Clark notes that few of the important publications of the period had by 1974 been translated into English, and blames this on 'snobbery and lassitude ... and fear'. Perhaps these are the causes, but Dilthey's *magnum opus, Introduction to the Human Sciences*, for example, presents such a dense skein of words and ideas one need not be surprised that its translation waited for over a century.[3] Even the scholars of the golden age themselves could be defeated by such texts, as with Frankl's *The System of Art-historical Knowledge*, a thousand-page study of the theory of the development of architectural form which sank like a stone even in Germany because of its length and impenetrable language.[4]

Secondly, what are the contexts of the criticisms voiced in the article? The first is the ferment of the late 1960s and early 1970s in the university world, with its student activism and a new openness to continental ideas (see, for example, 'poststructuralism and 'discourse analysis). There is also the

246

more personal context of the area of the history of art on which Clark was most actively engaged at the time. Many of the criticisms which Clark voices are specifically applicable to the art history of the modern period, and may appear less justified when applied to other periods, where (as the writings of Gombrich and Martindale to some extent illustrate[5]) Clark's important questions were more frequently confronted. Finally there is the most important context of all, the place of publication and the presumed readership of the article. This is an occasional piece directed at an audience wider than the art-historical world, written to make a specific point, which may explain not only its power, but also its omissions and lack of qualification.

Thirdly, how justifiable is the uncompromising demand for the exclusive use of his own approach? Clark argues that art-historical investigation should begin with society, and that this social historical method should be used to the exclusion of all others. The crux of the matter lies in whether investigators choose, broadly speaking, to start with the object and work towards the idea, or the other way round, and that choice rests in part with what impels them to undertake an investigation in the first place; the degree of their success should be the basis for judgement. The result may be a highly productive social history of art which starts with the object. (See also 'art history, 'theory and 'subjects/disciplines.)

247

Finally, how radical is Clark's proposal for the future? His article is a call for a complete change in the direction and character of the subject, an intervention intended to lead not to the diversification of the subject but to a renewed concentration under the umbrella of the social history of art where the big questions can be asked. Clark's approach belongs to a strong intellectual tradition: he identifies his ideal history of art as one which has its roots in older art-historical traditions and he sets Panofsky up as a sort of ideal art historian. He rejects trendiness by distancing himself from those who want to study the history of art in terms of what he calls sub-Freudian, filmic, feminist, or radical modes of enquiry, all of which he sees as 'hot-foot in pursuit of the New'. While 'Marxist analysis plays an important part in his argument, he stresses that there are no simple answers, such as those offered by Marxists who have sought to identify specific artists as representatives of the consciousness of specific classes.

While the revolutionary character of Clark's article is therefore somewhat ambivalent, many scholars nevertheless saw it as marking the start of what has come to be called the new art history. It can therefore be used to define a significant break in the development of the subject. (See also 'art and 'style.)

1 T.J. Clark, *Image of the People: Gustave Courbet and the 1848 Revolution*, London, 1973; *The Painting of Modern Life: the Art of Manet and his Followers*, London, 1985; and 'Preliminaries to a Possible Treatment of *Olympia* in 1865', *Screen*, 21, 1980, pp. 18–41.

2 E. H. Gombrich, *Symbolic Images: Studies in the Art of the Renaissance* (1972), 3rd edn, reprinted, London, 1993, pp. 1–5; Andrew Martindale, *The Rise of the Artist in the Middle Ages and the Renaissance*, London, 1972, pp. 50–2. Martindale cites, for example, the duties of the resident artist of the castle of Hesdin in the early fifteenth century, which included maintaining the amusement machines which covered unsuspecting onlookers with jets of water or bags of flour or soot, or dumped them through a trap-door in the floor into a sackful of feathers.

3 Wilhelm Dilthey, *Introduction to the Human Sciences: an Attempt to Lay a Foundation for the Study of Society and History* (1883), translated by Ramon J. Betanzos, London, 1989. Michael Podro's *The Critical Historians of Art*, New Haven and London, 1982, provides an account of the historians of the golden age and their forerunners which may have supplied a part of what Clark was looking for.

4 Paul Frankl, *Das System der Kunstwissenschaft*, Leipzig, 1938. See James Ackerman, foreword to Paul Frankl, *Principles of Architectural History: the Four Phases of Architectural Style, 1420–1900*, translated by J. F. O'Gorman, Cambridge, MA, 1968, p. vi.

5 See note 2.

21 | T.J. Clark

'The Conditions of Artistic
Creation', 1974

T. J. Clark, 'The Conditions of Artistic Creation',
Times Literary Supplement, 24 May 1974, pp. 561–2.

I could begin by saying that art history is in crisis, but that would have too strident
a ring. Out of breath, in a state of genteel dissolution – those might be more
appropriate verdicts. And in any case, in whatever form it was proposed, it would
be such an ordinary diagnosis – stock accusation, stock deprecatory smile – that
perhaps the first question to ask is this: why should art history's problems matter?
On what grounds could I ask anyone else to take them seriously?

To answer that question I have to remind you, remind myself, of what art
history once was. There's a passage from Lukács's great essay of 1922, *Reification
and the Consciousness of the Proletariat*, which sticks in my mind, and will do to
conjure up an alien time:

> '*And yet, as the really important historians of the nineteenth century such as Riegl,
> Dilthey and Dvořák could not fail to notice, the essence of history lies precisely in the
> changes undergone by those structural forms which are the focal points of man's interac-
> tion with environment at any given moment and which determine the objective nature of
> both his inner and outer life. But this only becomes objectively possible (and hence can
> only be adequately comprehended) when the individuality, the uniqueness of an epoch or
> a historical figure, etc., is grounded in the character of these structural forms, when it is
> discovered and exhibited in them and through them.*'

That passage is haunting for several reasons. First of all it proposes a difficult and
fertile thesis about history – it comes, of course, in the middle of an argument, and
I don't present it for use on its own – that art historians might care to contemplate
again. But let's leave that aside for the moment. Let's simply look at that curious
phrase, 'the really important historians of the nineteenth century', and the way
the examples that come to mind include two art historians out of three names
cited! What an age was this when Riegl and Dvořák were the real historians, wor-
rying away at the fundamental questions – the conditions of consciousness, the
nature of 'representation'? And Lukács could have looked around him in 1922
and pointed to the debate *going on*, unresolved, sharpened, often bitter.

The roll-call of names – Warburg, Wölfflin, Panofsky, Saxl, Schlosser – is not
what matters exactly. It is more the sense we have, reading the best art history of

this period, of an agreement between protagonists as to what the important, unavoidable questions are. It is the way in which the most detailed research, the most arcane discoveries, lead back time and again towards the terrain of disagreement about the whole nature of artistic production. What are the conditions of artistic creation? (Is that word 'creation' allowable anyway? Should we substitute for it the notions of production or signification?) What are the artist's *resources*, and what do we mean when we talk of an artist's materials – is it a matter, primarily, of technical resources, or pictorial tradition, or a repertory of ideas and the means to give them form? Clearly – convenient answer, which has become the common wisdom now – it is all three: but is there a hierarchy among them, do some 'materials' determine the use of others? Is that hierarchy fixed?

It seems to me that these questions have been scrapped by art history now. And perhaps we ought to ask what made it possible to pose them at all, to ask them of dense, particular evidence. And why did the problems die? Why are we left with caricatures of certain proposals in an ongoing debate, arguments that have been miraculously turned into 'methods' – formal analysis, 'iconography'? We won't answer those questions by sanctifying the past, and that is the last thing I want to do. Heaven knows, one is tired of the old stories of the great generation – beautiful Wölfflin, Riegl and his carpets, etc. I don't want to add to that abstraction, and one thing we badly need is an archaeology of the subject in its heroic period: a critical history, uncovering assumptions and allegiances. But nevertheless, we need to rediscover the kind of thinking that sustained art history at that time.

In part it really is just this: a mode of argument, a habit of mind. Take this example from Panofsky's marvellous *Perspective as Symbolic Form*, published in 1925. He is talking here about the ambiguity of perspective, the way it makes the visual world objective, measurable, and yet makes it dependent on the most subjective point of reference, the single all-seeing eye:

> '*It mathematizes … visual space, but it is still visual space that it mathematizes; it is an ordering, but an ordering of visual appearance. And in the end it is hardly more than a question of emphasis whether the charge against perspective is that it condemns "true being" to the* appearance *of things seen or that it binds the free and, as it were, spiritual intuition of form to the appearance of* things seen. *Through this location of the artist's subject in the sphere of the phenomenal, the perspective view closes to religious art the territory of magic within which the work of art is itself the wonder worker … but it opens to religious art … the territory of the vision, within which the wonderful becomes an immediate experience of the spectator …*'

That is dialectical thinking, with all the strength of dialectic – its power to open up a field of enquiry, to enable certain questions to be asked. And Panofsky's essay is full – inconveniently full – of the same mode of discourse: whether he is arguing that the Middle Ages' negation of spatial illusion is 'the condition for the truly modern view of space', or wondering why it is that innovation is so often bound up with a renunciation of previous achievements, with primitivism, setbacks, reversals, 'so that we see Donatello emerging not from the faded classicism of the followers of Arnolfo but from a definite tendency towards Gothic revival'.

In the best art-historical circles now, this mode of thinking is scorned – a Hegelian habit, juvenile exercises that Panofsky grew out of. On the contrary, I believe they are what kept his thinking alive; and the absence of them – in the dreary professional literature of perspective that follows – is what produces loss of problems, loss of the problems' dimensions. It is odd how reactionaries of Right and Left present as their clinching case, these days, the same caricature of Hegel – a cardboard idealist Hegel, a Christian Hegel, Hegel without 'the love and labour of the particular'. In art history – and, I believe, elsewhere – it is precisely the Hegelian legacy that we need to appropriate: to use, criticize, reformulate. To do any of those things, we shall need to disinter it. We shall need, apart form anything else, a massive work of translation. What kind of situation is it where my working copy of Riegl's *Spätrömische Kunstindustrie* [text 9, 1901] is a miserable abridged Italian version? Why are Dvořák, Warburg, even Burckhardt in the role of art historian, still locked inside their mother tongue? Because of snobbery and lassitude, I suspect; and an understandable *fear* of the texts in question.

Up to now I have been talking, deliberately, about the past. But the question is, of course, how did the past disappear? How was it that those questions, that paradigm, got lost?

There are many answers, and some of them I shall avoid, with a kind of fastidiousness. I don't propose to discuss the way in which art history became manservant of the art market, checking dates for the dealers, providing pedigrees for rich collectors – though I'm surrounded by evidence of the stupidity, and straightforward corruption, that resulted. Kurt Forster has written elsewhere of the way in which art history became the vehicle for reach-me-down notions of taste, order and the good life, 'compensatory history' for the *Bildungsburgertum* [cultured society]. (I relished the moment, some years ago now, when a vice-chancellor's wife was pictured sitting on a camp-stool on the steps of an occupied university building, with a copy of a well-known art history book displayed on her lap: it was part of her protest, she told an enthusiastic local press, 'against militantism and in favour of civilization'.)

These are, so to say, external problems – crucial, but unsavoury. And it seems as if art history hardly needed prodding, as if it was ready to fall apart at the seams. Iconography is the notorious example: in a generation it has declined from a polemic about tradition and its forms, an argument over the conditions in which an artist encountered an ideology, into desultory theme-chasing – 100 pictures of the Noble Savage, with fifty early blast furnaces thrown in. And that is only the most obvious case of a general decomposition.

Why? Because, as I have hinted already, the terms in which the paradigm problems were posed were incapable of renovation. We have to discover ways of putting the questions in a quite different form, and that is where the social history of art – my brief, my 'speciality' – comes in. It ought to be clear by now that I'm not interested in the social history of art as part of a cheerful diversification of the subject, taking its place alongside the other varieties – formalist, 'modernist', sub-Freudian, filmic, feminist, 'radical', all of them hot-foot in pursuit of the New. For diversification, read disintegration. And what we need is the opposite: concentration, the possibility of argument instead of this deadly coexistence, a means

of access to the old debates. That is what the social history of art has to offer: it is the place where the questions have to be asked, and where they cannot be asked in the old way.

That can look deceptively simple: it cannot be done merely by shifting one's ground. True enough, the old questions of art history were structured around certain beliefs, certain unquestioned presuppositions: the notion of the Artist, of the artist as 'creator' of the work, the notion of a pre-existent feeling – for form, for space, of the world as God's or the gods' creation – which the work was there to 'express'. These beliefs eroded the subject; they turned questions into answers; they ruled out of court, for instance, any history of the conditions of artistic production. (The great paragraph in *The German Ideology* on Raphael and the division of labour – which adumbrates a whole history of art as work – was ignored by Marxist and anti-Marxist alike.) And needless to say the beliefs – the sheer vulgar metaphysic – are all that present-day art history is left with; the actual work that Riegl or Panofsky did, against the grain of the concepts they used, has been put aside.

To escape from this situation, it seems to me we need a work of theory and practice. We need *facts* – about patronage, about art dealing, about the status of the artist, the structure of artistic production – but we need to know what questions to ask of the material. We need to import a new set of concepts, and keep them in being – build them into the method of work. Let me indicate, briefly, the kind of questions I mean.

The first kind of question has to do with the relation between the work of art and its ideology. I mean by ideologies (the concept seems to me to be indelibly plural, though all ideologies feed off each other and share the same function) those bodies of beliefs, images, values and techniques of representation by which social classes, in conflict with each other, attempt to 'naturalize' their particular histories. All ideologies claim for a quite specific, and disputable, relation to the means of production a quality of inevitability, a seat in human nature. They take as their material the real constraints and contradictions of a given historical situation – they are bound to, otherwise what content would they have, what would they be for? – but they generalize the repressions, imagine the contradictions solved.

The work of art stands in a quite specific relation to these ideological materials. Ideology is what the picture is, and what the picture is not. (We might say that 'style' is the form of ideology: and that indicates the necessity and the limitations of a history of styles.) Ideology is the dream-content, without the dream work. And even though the work itself – the means and materials of artistic production – is determinate, fixed within ideological bounds, permeated by ideological assumptions; even so, the fact that work is done is crucial. Because the work takes a certain set of technical procedures and traditional forms, and makes them the tools with which to alter ideology – to transcribe it, to represent it. This can be anodyne, illustration: we are surrounded by duplicates of ideology: but the process of work creates the space in which, at certain moments, an ideology can be appraised. The business of 'fitting' ideological materials most tightly, most completely into the forms and codes which are appropriate to the technical

251

materials at hand *is also* a process of revealing the constituents – the historical, sep-arable constituents, normally hidden beneath the veil of naturalness – of these ide-ological materials. It is a means of testing them, of examining their grounds.

Take Vermeer, for me a kind of touchstone – of quality, clearly, but also of the elusiveness of this process at its most intense. It seems to me that Vermeer's work exploits the fact that any ideology is by its nature incoherent: its parts do not fit; its expanding generalizations cannot quite coexist with any *one* image, with any pre-cision (and the precision itself is always partial, always made out of ideology) in the materials you work with. What we attend to in Vermeer is the subtle – infinitely subtle – lack of sychronization between two different interiors, which ideology wants us to believe are consonant: between the space and furnishing of those ascetic, gaudy rooms and the space and furnishing of a particular gaze, a par-ticular inner life.

Or again, what holds us is our sense, on the one hand, that vision in these pic-tures is unproblematic, under control (with the help, naturally, of the latest mechanical aids); on the other, as we look further, that the visible is a tissue of improbabilities, strangeness, losses of focus, looming nearness, unreadable shifts in space. Light itself is offered to us here, as nowhere else, as something neutral and ineffable; and yet even light is *allowed* into these rooms, even its clarity is pre-sented to us as the technical achievement it was – the unflawed glass, the unclut-tered decor.

This is the beginning of an account: I'm well aware of its deficiencies. But I offer it as an example of the kind of relationship we are dealing with – just how problematic, and yet how capable of point-by-point description, the contact of work and ideology might be.

I have hardly space to indicate the other kind of question which belongs to the social history of art. It is this: what exactly were the conditions and relations of artistic production in a specific case? Just *why* are these particular ideological materials used, and not others? Just what determined this particular encounter of work and ideology. When I called these another kind of question from the first, I didn't mean to imply any rigid distinction. On the contrary, you cannot pull them apart from the others I have described: I would go so far as to say, in the face of derision from the semiologists, that one question cannot be asked at all without the other. I do not believe, for instance, that we can even *identify* the work's ide-ology without asking questions of this kind.

Where do they lead us? Towards a description, a close description of the class identity of the worker in question, and the ways in which this identity made certain ideological materials available and disguised others, made certain materials workable and others completely intractable, so that they stick out like sore thumbs, unassimilated. Towards an account of how the work took on its public form – what its patrons wanted, what its audience perceived. To find that out, we have to look for the wordless appropriation of the work which sometimes leaves its traces in the margins of the critics' discourse, in the dealers' records, in the casual transmutation of a title as the picture passes from hand to hand.

All of these questions lead back to the territory beyond ideology: they indicate the materials out of which ideology is made, and unmade; they remind us that the

idea of a specific ideological 'instance' is nonsense – it is of the essence of ideology to be unstable, protean, omnipresent but nowhere, using everything and altering nothing, alternately a content and a form. For the same kind of reasons, though, this would have to be a separate argument. I believe that access to ideology is always incomplete – and it is the lack of finish that counts, in our explanation of an artist's production. The notion of the 'representative' artist, who gives us a complete depiction of the 'possible consciousness' of a class – a notion dear to a certain brand of Marxist history – seems to me a figment. (It's their constant awareness of these facts that makes Walter Benjamin's work on Baudelaire or Sartre's *Conscience de classe chez Flaubert* so much more useful than most of their 'scientific' opponents.)

What we are considering at this point is the conditions in which a certain 'sub-jectivity' – utterly false, utterly undeniable – was constituted and given form. No topic, of course, is more open to an ideological treatment; it is here that the old concepts come crowding back, insistent, ingratiating, promising keys to the mystery. And yet, if it could be done properly, no enquiry could tell us more about how ideologies *work*.

That, after all, is the scope of of art history's ambitions. Or it was, and it ought to be.

253

22 John Onians

'Art History, *Kunstgeschichte* and
Historia', 1978

John Onians (1942–) is best known among contemporaries for the breadth of his learning and his willingness to propose unexpected hypotheses. A graduate of Cambridge and the Courtauld and Warburg Institutes of the University of London, he has taught at the University of East Anglia since 1971, where he currently holds a professorship and the directorship of the European Art Research Programme and where he was in part instrumental in turning the department into the School of World Art Studies. His publications, in particular those on art and thought in the Hellenistic world and the meaning of different types of columns from antiquity to the Renaissance, underline his commitment to the history of art as a history of ideas.¹ He was founder editor of *Art History*, the journal of the Association of Art Historians, which was launched in 1978 and which became in many ways a flagship of the *new art history in Britain. The text reprinted here is his editorial for the second issue of the journal, in which he reflects on the choice of the title.

He begins by describing the difference between the English-speaking and German-speaking approaches to the subject, labelling them respectively the 'history of art' and 'art history'. The first is the tradition of *antiquarianism, *connoisseurship and a commonsense vocabulary, the second that of intellectual constructions and the social sciences. The history of art as taught at British universities since the Second World War has been very much a mixture of the two.

His proposal for renovating this combined tradition, or at least for establishing the character of the new journal, is to argue that in using the term 'art history' we should be aware that the potency which the two terms 'art' and 'history' have separately is lost when they are used together. Onians also champions the Greek meaning of history as enquiry rather than recording. In doing so he makes the same choice as he did in selecting 'art history' as the title, namely placing himself against *empiricism and the collecting of facts (which he says can be performed by children), and coming down firmly on the side of those for whom history is about ideas. The invitation to make this choice between enquiry and recording recalls the damaging consequences which can result when ideas and facts are pursued in isolation, and conversely the enrichment which can ensue when they successfully constitute a joint project. (See also *subjects/disciplines.)

Onian's paper raises a number of issues. Thus, for instance, his point about the terms 'art' and 'history' being more powerful than 'art history' is underlined if one considers the power of the names of the independent disciplines of *archaeology and *architecture, whose richness is

illustrated by the ease with which they can be used as metaphors: archaeology as a description of how one gets at the past or analyses an institution in particularly revealing ways; architecture for the structure of anything from an idea to an administration, and most memorably, and often in the plural, for new forms of relationship between the hardware and software of computers. It may even be that this kind of power cannot adhere to labels consisting of more than one word.

If there is a power in the name of the discipline then, as Onians says, it resides in the very different character of the two concepts which are juxtaposed. This is something which characterizes the subject, namely the fact that it attempts to study a creative process with the tools of a subject which is primarily retrospective and analytical in character and which has an ideal of objectivity. Because art historians as academics are more interested in analysis than in the kind of creativity associated with artists, they tend to concentrate on the ideas in a work of art. While this may be appropriate for literature, where the medium, writing, is the same as that of the criticism, it ought not to be so for the visual arts, where the form in which the ideas are expressed is inseparable from them.

255

This raises the question of whether art historians are historians specializing in art (as others specialize in war, constitutions or social conditions), or students of art attempting to understand the past of their subject. The answer to this question is fairly straightforward as far as academics are concerned, namely that we are historians specializing in understanding art however that is defined, but the issue is less clear-cut where many students are concerned, as anyone will realize who has been involved with classes aimed at both art history and practical students: the two groups can have very different ideas of what they hope to get out of the teaching. Even these circumstances do, however, provide the same answer, since those who attempt to approach things the other way round (that is as art students attempting to understand the past of their subject) are involving themselves in a different activity, such as that of the critic. Critics, like connoisseurs, need have no interest in the context of the work under review, as they have the right to treat any work as contemporary and a direct communication with the viewer or reader, like the poem considered as a 'verbal icon', that is, a composition considered independent of its historical context. In making absolute judgements of *quality the art historian is acting as a critic; in setting the object in context the critic is acting like a historian.

I John Onians, *Hellenistic Art and Thought*, London, 1979; *Bearers of Meaning: the Classical Orders in Antiquity, the Middle Ages, and the Renaissance*, Princeton, NJ, 1988.

22 John Onians

'Art History, *Kunstgeschichte* and *Historia*', 1978

John Onians, 'Art History, *Kunstgeschichte* and *Historia*', *Art History*, 1, no. 2, June 1978, pp. 131–3.

The title *Art History* was not chosen for the journal without some private doubts about its suitability, and it might not be inappropriate to voice one of them now. The essential point is that art history is not a natural English expression, as, for example, is the history of art. As a juxtaposition of two unmodified abstract nouns it betrays its German origin as a simple translation of *Kunstgeschichte*. This is, of course, in itself no objection to its use, since one advantage of English is its capacity to absorb with equal ease translated phrases from both Germanic and Latin languages. The problem is that in this case the expression is a constant reminder that not only the term, but the subject it refers to, with all its apparatus of methods, values and goals, is also an importation from the German-speaking world; and one which has been adopted with surprisingly little modification by English speakers.

Some people may well argue that such an English development of the subject is unnecessary since it has achieved such a fruitful maturity already elsewhere. But the objection to this is the same as that to the maintenance of the purity of any established cultural tradition, that without internal innovation and the introduction of new elements from outside it would soon lose the flexibility and variety necessary to maintain its vitality. An English-speaking contribution can only enrich the subject, just as could a similar contribution from some other group such as Chinese or Africans.

Others may rightly claim that the English-speaking world already has contributed significantly to the development of aspects of the subject; such as the antiquarian approach, connoisseurship and the application of a commonsense vocabulary to describe the response to art. It is, however, unfortunately true that although these features have been characteristic of an English-speaking approach they have actually suffered with the rise of art history as an academic subject, since the whole centre of gravity of the study of art and its history has, in England at least, over the last forty years shifted from the galleries of Bond Street, the libraries of Burlington House and the drawing rooms of Bloomsbury to the seminar rooms of universities; the staff of the new courses were often either German speakers themselves, or trained by them, and the books on which they relied often either German, or selected and commissioned by editors and publishers of Central European origin working in this country, so that academic art historians in Britain

often felt that they were establishing themselves in some sort of opposition to the national tradition, however much they continued to acknowledge it. The one context in which the two traditions might have come together to produce a richer unity, the universities of Oxford and Cambridge, showed a relative indifference to the new discipline. The situation in the United States may not be as artificial in some ways, since any separate tradition is liable to lose its isolation in the 'melting pot', but there too the welcome influx of German-speaking scholars brought about by the tragic situation in Europe ensured that *Kunstgeschichte*, though admittedly in a more broadly based form, should become the dominant manifestation of the subject.

One doubt about *Art History* is, thus, that by its jarring lack of correspondence to normal English linguistic usage it draws attention to our fundamental dependence on the cultural tradition of Switzerland, Austria and Germany and it may well be thought inauspicious, in a journal which might, however modestly, mark a new stage in the subject's development in the English-speaking world, to pin such a debt to its masthead. The debt should be acknowledged and we are happy to do so, but it is what we do with the basis which we have been given that will provide the measure of our own contribution. So perhaps our un-English title will serve as some sort of challenge to our self-consciousness and self-confidence to remind us that not all we write should be as derivative as the name of our subject.

This little excursion into philology produces a conclusion which is perhaps unnecessarily negative, since it draws attention to frontiers which some may feel to be unreal. Yet, at the risk of heaping up more pedantry, I would suggest that a further look at the words 'art history' may produce results which are positive and liberating as well. What do we in fact refer to when we use them? At one level a simple answer, and one which fits with a fashionably phenomenological approach, is to say, in England 'what is done and taught at the Courtauld Institute', and elsewhere in the English-speaking world one might replace that institution with the names of half a dozen others. But there is clearly little challenge in defining one's task in terms of something which is already being done and one should beware of doing so. It is more rewarding to consider not just what it is but what it might be, and here philology may help rather than hinder us. For if when we thought of 'art' we were also conscious of all the changing usages of the word over the last two thousand years our subject would certainly take on new dimensions; and if, when we used the word 'history', we also thought of all the different approaches that word and its cognates in other languages have covered since the Greeks, our methods and goals could only be enlarged. Somehow both words, 'art' and 'history' have a magnificence and potency about them when thought of separately which they sadly lose as soon as they are coupled in the bed of 'art history'; which certainly suggests that we are not living them both to the full.

I have no intention here of reviewing all the uses of either word, but it does seem worthwhile to point to the disparity between the conventional modern notion of history as 'the narration of past events' and the original meaning of the Greek *historia* with its emphasis on an 'enquiry' rather than 'record' and its inclusion of 'present as well as past events'. I can't help thinking that if we too thought

257

of what we were doing as 'enquiry', as well as 'record', we would expect more of our intellects and imaginations and as a result our activity would generate a greater interest on the part of others. For a start, if we think we are just establishing facts, nobody has to think very hard about what they are doing, since most people agree more or less on what constitutes a fact; you could tell children to go and collect them. An enquiry on the other hand raises all sorts of issues: into what, why, with what goal, using what assumptions, etc.? The role of an 'enquirer into what is happening and what happened' which we take on as 'historians' should demand more of us, whether we identify ourselves with Thucydides writing the history of the Peloponnesian war while it was going on, with Herodotus who called the enquiries he made on his travels *historiai*, or with the judges of the Homeric epics, the original *histores*. There is no reason but recent professional convention that the art historian should shrink from the roles more usually adopted by the journalist and the critic. Besides which it is not necessary to take the word 'art' very far back to find it covering not only the fine arts but also those products of technology and design whose inclusion in our province today provokes so much argument.

23 Michael Baldwin, Charles Harrison and Mel Ramsden

'Art History, Art Criticism and Explanation', 1981

Charles Harrison (1942–), professor of the history and theory of art at the Open University, has had a major impact on our understanding of modernism in the visual arts, especially through his collaborative work with Fred Orton, his work on the Open University course on modern art and modernism, and, with Paul Wood, his comprehensive collection of texts and documents on theories and ideas in modern art. He has also involved himself with the making of art, chiefly through the group Art & Language, which was formed in 1968, with the first issue of its journal, *Art-Language*, appearing in 1969. In this context he has collaborated with Michael Baldwin (1945–) and Mel Ramsden (1944–), artists who have worked and exhibited together and with others in Art & Language.[1]

The article reprinted here is a published version of a paper delivered by Harrison to the annual conference of the Association of Art Historians which was derived from conversations and other published material produced within Art & Language. The three authors attempt to demystify the status and meaning of works of art, history and criticism, particularly those examining the modernist tradition. Because of the more than usually dense character of the text the commentary begins with a full summary, using the authors' headings.

Baldwin, Harrison and Ramsden argue that the standard questions which historians of art ask of a work of art are 'What is it?', 'What is it of?' and 'What is its meaning?' These are commonly separated from the question 'To whom is it addressed?', but should perhaps not be.

OF The most substantial of these questions is 'What is it of?', since this includes the question 'What caused it to be the way it is?', which is the issue specifically avoided by modernists such as Clive Bell and Clement Greenberg, who treat aesthetic experience as something natural rather than as something culturally determined, that is as something dependent on knowledge and reflection. To the question 'What was the artist's motive?', modernists such as these will thus not accept the answer 'They did it for the money.' But since artists, like everyone else, have to work to live, this should be taken into account in assessing their reasons for making things. Some art historians who are not modernists, such as Gombrich, do confront the question of causes, but they allow others, chiefly critics and *connoisseurs, to determine which objects they study.

EXPRESSION The authors also reject the more recent idea that what a work of art is about is the

result of a joint venture between author and spectator. They do so by asking how the spectators know that what they feel has been caused by the picture.

THE TROBRIAND ISLAND PROBLEM This section attempts to clarify the modernist position by seeing it as an example of that form of anthropology which presupposes the total immersion of the investigator in the culture to be studied. Baldwin, Harrison and Ramsden criticize this approach on five grounds: (i) as resulting in a form of voluntary myopia; (ii) for stressing the positive statements which a culture makes about itself and hence for ignoring its silences or assumptions; (iii) for reading meanings into events and objects rather than attempting to derive meanings from them; (iv) for describing causes as natural when they are cultural; and (v) for taking the coherence of an account of something as evidence for coherence in the thing itself, thus excluding the apparently extraneous and trivial from the list of possible causes (such as 'worrying about the bank-rate while you write your tragic poem').

260

MODERNISM This section offers an account of the origins and hence the causes of modernism. It is seen initially to have been a mechanism used by the rising bourgeoisie in mid-nineteenth-century France to distinguish themselves from the working class, and to have been transformed in twentieth-century America into something less class-based and with a function more like that of a religion.

EXPLANATION Art history must reject the method of total immersion and instead attempt to *explain* the work of art. To do this it needs to fulfil the following three requirements: the category to which the object of study belongs must be rigorously defined and the definition adhered to; analysis of what pictures are of must be derived from knowledge and not from statements with a purely personal basis, no matter how convinced they may be; and the practices of the enquiry should themselves be open to scrutiny.

SECOND-ORDER DISCOURSE In order to conduct the enquiry demanded in the previous section, and in order to choose between varying ways of questioning the object, it is necessary to open a second-order discourse, that is a second conversation within which the first may be critically examined and its terms of reference explained. This discourse must avoid the two extremes of a materialist determinism on the one hand and an assumption of the complete autonomy of art on the other, and instead explore the middle area of ideas and beliefs *about* art and how these have affected meanings *in* art. This is the kind of anthropology we should be using, one which encloses the first-order discourse of the immersion method in another which can describe and explain not only what the 'immersed' anthropologist[2] sees, but also what the outsider sees, from outside the Islands and from outside Art.

In this text the authors define and confront the major questions of art history, looking especially at the causes of works of art and how we assess what we accept as spectators, while also examining the relevance of various anthropological approaches. Turning now from summary to comments, these concern applicability, and a third anthropological method.

APPLICABILITY The authors make it clear that their argument begins with the character of modernism, so that it may not be applicable to other periods. Thus while the answer 'He did it for the money' may have been unacceptable to a certain kind of modernist, it is a routine response in the

study of most pre-modern periods. Equally it is uncertain how much sense it would make to explain the origins of Mannerism, for example, by shifts in class power.

The concentration of the article on modernism is also evident in the way the authors take the date of an object as being a question to which there is likely to be a factual answer. In the nineteenth and twentieth centuries there is indeed a good chance that most objects of any note will be documented to a particular year, if not month or even day. For pre-modern periods, however, the establishing of a date is almost always inextricably involved with questions such as 'What is it of?' and 'What is its meaning?' That is, in order to argue for a date you have to understand the culture which produced the object, and vice versa. Panofsky presents a classic example of this sort of exercise (see *iconography).

A THIRD ANTHROPOLOGICAL METHOD Both of the anthropological approaches outlined in the article begin from outside the *culture being studied, with one type of anthropologist attempting to understand it by immersion, the other type of anthropologist by containing it in the intellectual structure of a second-order discourse. To these can be added a third possibility, namely where the anthropologist *is* a Trobriand Islander and neither an interloper nor an external observer (this is implicit in Harrison's argument, but needs extracting).

This third model is in fact that followed by most students in Western Europe and North America embarking on the study of the history of art. That is, they want to know about what they think of as their own culture. This of course raises as many problems as the 'total immersion' approach, in particular the problem of studying something of which one is oneself a part (which is the reason why anthropologists started in the nineteenth century by looking at societies outside their own). This inside/outside problem acknowledges that one has to adopt a position outside something in order to study it at all, but it has become a pressing issue because so much contemporary art history deals primarily with the art (and art history) of its own time, as is the case, indeed, with the article under discussion.

Finally, another major problem with anthropological approaches has been the silence of those who adopt them on judgements of *quality. When discussing this problem in another article Harrison suggests that avoiding such judgements would be to suffer the fate of being like a social anthropologist.[3] One exception to this rule is William Fagg's application of art-historical methods to a typical example of anthropological study (text 20, 1973) and it is true that since the early 1980s anthropologists have addressed questions of quality, along with those of writing and intention in general. (See also *intention, *reception theory, and, the *death of the author.)

1 Charles Harrison and Fred Orton, *Modernism, Criticism, Realism*, London and New York, 1984; The Open University: *A316: Modern Art and Modernism: Manet to Pollock*, Milton Keynes, 1983; Charles Harrison and Paul Wood, *Art in Theory 1900–90: an Anthology of Changing Ideas*, Oxford, 1992; and Charles Harrison, *Essays on Art & Language*, Oxford, 1991.

2 Alasdair MacIntyre, 'The Idea of a Social Science', in *Against the Self-Images of the Age: Essays in Ideology and Philosophy*, London, 1971, pp. 211–29. Harrison follows MacIntyre in referring to this 'immersion' method as Winchian, after Peter Winch's *The Idea of a Social Science and its Relation to Philosophy* (1958), 6th impression, London, 1970, but as there is some uncertainty about the extent to which Winch accepted this description, the term 'Winchian has been avoided in this introduction.

3 Charles Harrison, 'Taste and Tendency', in A.L. Rees and F. Borzello, eds., *The New Art History*, London, 1986, p. 81.

23 | Michael Baldwin, Charles Harrison and Mel Ramsden

'Art History, Art Criticism and Explanation', 1981

Excerpts from Michael Baldwin, Charles Harrison and Mel Ramsden, 'Art History, Art Criticism and Explanation', *Art History*, 4, no. 4, December 1981, pp. 432–56

The aim of this paper is to show that the practice, history and criticism of art must be open to conversation, that it must have some discursive, rather than merely liturgical, aspect in relation to others, and that it must be adequate in respect of the mind-independent world, if it is to have a history rather than to exist as mere anecdote or as a function of historicism. It also needs to be shown why it should be important to make this point; that is to say a characterization of normal art discourse as dogmatic, self-certifying and comparatively empty of real explanatory content needs to be given and defended.

There may be those whose sense that they are neither critics nor Modernists will seem to offer some reassurance in the face of such a characterization. And it is indeed the case that the historian of Renaissance art, for instance, can nowadays at least find a few decent books to read. But how art is *in general* interpreted is an aspect of how it is generally seen as produced, and the prevailing modern models of interpretation and explanation, by which the conditions of production of art are obscured and mystified, are by now sufficiently well entrenched to afflict most discussion of most art.

The proper concerns of the majority of discourse about art might be characterized in terms of fuzzy families of questions. Apart from those which might reasonably be satisfied by factual-type answers, like date, dimensions, location and so on, the substantial questions will be related to one or more of the following: What is it? To whom is or was it addressed? What does it look like? What is it *of*? or What does it represent or signify? What does it express? or What is its meaning? and Is it any good?

It is a convention of our empiricist world that history or historians eschew the transient matter of value, which is seen as the critic's concern. It might be thought that a historian with explanatory-type pretensions or aims must eschew the matter of value *a fortiori*. This is not the case. A concentration on the last of the above list of questions serves only speciously as a line of demarcation distinguishing critics from historians. This paper is not concerned with the fugitive professional distinctions between critics and historians of art, but rather with those concerns and activities they have in common. The principal unifying practices have normally been those of interpretation and explanation, and it is on these that we should

therefore concentrate. It should become clear why the issue of judgements of 'quality' – which may be taken as an artistic term for value – seems to be subsidiary in the face of a concern with explanation. Suffice it to say, for the moment, that explanatory-type discourse has itself to be considered as value-impregnating.

In normal art-historical discourse the interpretation of a work of art – the recovery of its meaning – has been thought to hinge upon questions, of 'What is it *of?*' or 'What does it represent or signify?', and 'What does it express or mean?' These questions are plainly connected or homologous or identical. They have generally been seen as distinct from the question, 'To whom is it or was it addressed?' This may turn out to have been a mistake.

OF.

If anyone is still labouring under the delusion that what a picture looks like is nec- 263
essarily what it is of, they are referred to Nelson Goodman's *Languages of Art*, where the confusion between the two is decisively sorted out. Briefly, a portrait which happens to look like Arthur Scargill may not be of Arthur Scargill, and given the information that it is actually *of* Keith Joseph, we are plainly better occupied in searching it for the *nature* of its resemblance to Keith Joseph, or even for reasons for its apparent unlikeness to him, than in complaining that it looks like Arthur Scargill. Of course, given the right circumstances it could be *of* Arthur Scargill as well. For instance, a satirical purpose might render an apparent likeness to Arthur Scargill highly significant in a portrait of Keith Joseph.

The acknowledgement of such a possibility is not unduly complicated. Indeed, it could be said that the very point about the activity of representation is that it makes possible just such manipulation of referents. We have grown accustomed to blue nudes, soft watches and mustachioed Mona Lisas, but it has *always* been important to the construction of pictures that the mapping-on of characteristics and aspects is a normal, indeed virtually indispensable function of the inculcation of meaning.

Given this acknowledgement, likeness can be seen as a distracting vagary. The question of what a picture is *of* is far more substantial; that is to say it demands that we enquire into the *causes* of its specific appearance, those features of the world, things, people, events, ideas, practices or other works of art, to which the picture is causally connected. A portrait is of Keith Joseph by virtue of his having featured somehow in the chain of causes leading to its production, and *not*, *prima facie*, because it happens to look like him …

What, then, is to *count* as a cause? What do we need to take into consideration in explaining the specific appearance and tendency of a work of art, and in recovering its meaning? According to Clive Bell – writing in 1914, but still echoing through the dingy corridors of myriad art schools and art departments – 'To appreciate a work of art we need bring with us nothing from life, no knowledge of its ideas and affairs, no familiarity with its emotions … nothing but a sense of form and colour and a knowledge of three-dimensional space.' This is virtually to say that we do not need to see the work of art as caused or produced at all. Or are appreciation and understanding not connected?

Clement Greenberg has offered a more sophisticated version of this.

> 'Aesthetic judgements are given and contained in the immediate experience of art. They coincide with it; they are not arrived at afterwards through reflection and thought …' And later in the same article: 'I … used to indulge in … talk about "content" myself. If I do not do so any longer it is because it came to me, dismayingly, some years ago that I could always assert the opposite of whatever it was I did say about "content" and not get found out; that I could say almost anything I pleased about "content" and sound plausible.'

Greenberg is always harder to pin down, and easier to underestimate than many of his less intelligent critics seem to suppose. The word 'content' in this passage is carefully scare-quoted. But given the point that what works of art are *of* is causally determined, his implications have to be denied. What he is saying is not that questions about the causes of meanings in pictures are impossible or necessarily irrelevant, but rather that they are undecidable, and that such enquiry is therefore fruitless in accounting for aesthetic experience, which itself is somehow naturally 'given'. (Given to whom? we might ask.) The argument against this position is an argument against the means of identification of aesthetic experience as a separate and ineffable category somehow distinct from other types of cognitive and non-cognitive activity. If any are in doubt as to the validity of this counter-argument, they are again referred to Nelson Goodman, specifically to his article on 'Art as Inquiry'. Briefly, it can be stated that 'aesthetic experience' – *whatever* it can be taken to mean – *has* to be seen as a cultural category and not as a natural category. This entails that it *cannot* be independent of knowledge, reflection, thought or interest.

What is at issue is just where the range of possible causes is closed off in the enquiring practices of art criticism and art history. That [E.H. Gombrich's] *The Story of Art* can be considered as a feasible project, for instance, presupposes that some closures operate to circumscribe enquiry and explanation. It presupposes Art as a distinct category with a story properly its own. The achievements of the author of *Art and Illusion* are indeed indispensable, but it has to be said that, along with the great majority of even sophisticated Western aestheticians, Gombrich has mostly kept his hands clean of the nasty social sciences by making the assumption that what comes up for the count *as* art is what has stood the test of time. That is to say that he had tended – at least until recently – to accept the operations of the connoisseur and the critic as prior to those of the historian in deciding what is to count as a subject.

There is indeed some satisfaction to be drawn from the prospect of the former Director of the Warburg Institute enthroned on the beach of art history in a noble attempt to repel the flowing tides of social science and epistemological relativism. But in evading any consideration of the possibility of false consciousness Gombrich was bound to ignore the extent to which specific interests might at some point have determined the nature of his subject matter; unless, that is, the operations of the connoisseur and the critic are to be seen as interest-free, or as only determined by properly cognitive interests any by the pursuit of empirically

264

adequate knowledge. For the underlying assumption of *The Story of Art* – of almost *any* presently conceivable Story of Art – is that what the critic and connoisseur have been in a position to single out is what a work of art ontologically *is*, and what it is *of*; that its meaning has somehow been fixed by their operations into a coherent tableau; or at least that enquiry into what the work of art is *of*, and thus into the conditions of its production, takes place in terms of the interpretations which have initially been fixed by the critic and connoisseur in their roles as transcendental consumers. They have been allowed to decide not just *what* will stand the test of time, but what that residue is to be seen *as*. This is to say that they transmit a culture – a set of interpretations and meaning and meaning horizons – not just a set of 'neutral' objects on which open enquiry is then somehow possible.

The danger is that the art historian will then search for just those causes which will ratify his subject matter *as* his subject matter and as an aspect of *his* culture. Or, to put it another way, that enquiry into conditions of production – even where it appears to be conducted in a spirit of historical materialism – will in fact be limited by presuppositions about what have counted and will count as the conditions of interpretation or as 'meaning'. To do this is to put the cart of 'meaning' and understanding before the horse of reference and explanation.

Within a framework thus determined by the connoisseur – the paradigm sensitive contemplating observer – statements such as 'He did it for the money' are accorded the perlocutionary status of fouls and the cognitive status of noises off, and are ruled out as types of explanation of how proper works of art are caused, and thus, in part, of what they are *of*. Whatever such rude statements are taken to refer to is *not* what the sensitive observer takes the work of art to be and to mean. He needs to be able to see it *as* so-and-so, and as caused by so-and-so, in order that others of his beliefs and assumptions should remain tenable. Only in the case of works already put beyond the Pale, already put outside the limits of the sensitive observer's world, are such vulgar explanations as 'He did it for the money' allowed as confirmations of derogatory assessments.

For the self-employed speculator or the tenured academic – motivated, no doubt, by the great concerns of civilization and a desire for the advancement of culture – 'He did it for the money' may indeed seem a simple-minded and vulgar statement. But isn't it possible that the same statement is a far more complex expression for the wage-earner who would willingly acknowledge that his *own* life is structurally determined by just such a necessity? To be able to see the production of the work of art as determined in ways commensurate with one's own social existence and self-consciousness and needs, is, after all, a prerequisite for the recovery of some meaning. According to one of the most important, and surely most secure, theses of Marx, the production of the means to satisfy basic needs is the primary historical act of human existence. From a historical materialist point of view, whatever art means it *cannot* be constituted in such a way as to rule out 'He did it for the money' as a form of explanation, since, in the historical materialist picture of the modern world, *no* form of production is so constituted.

Of course, to make this point hold, we have to be able to see the artist as a type of producer. We assert, dogmatically, that artists are producers; and it should

265

follow as a consequence that the operations of the critic and connoisseur, of what-ever persuasion, cannot defensibly be taken as prior to those of the historian in the production of explanations.

So much, for the moment, for the question of what pictures are *of*.

EXPRESSION.

We return to the second question which must feature in interpretation and expla-nation of the work of art, namely 'What does it express?'...

Of claims as to what pictures express, a similar argument may be used as that which addresses the question of what is entailed by claims about what they are *of*. The point at issue is just how, or by whom, the expressive referents of works of art are fixed. According to the prevailing Modernist view – from the ubiquitous Roger Fry on down to the egregious Peter Fuller – the work of art carries its immanent expressive meaning to the sensitive observer across cultures and down the ages; in the one case by virtue of its 'formal strength' and 'purity' (whatever these may mean), in the other by virtue of its rootedness in those 'relative con-stants', the great themes of the psycho-biological human condition...

The Modernist thesis is that 'although the past did appreciate [the old Masters]... justly, it often gave wrong or irrelevant reasons for doing so.' Michael Baxandall has made the point that the gown which is cast off in Sassetta's panel of St Francis renouncing his heritage is 'an ultramarine gown'; that is to say, that to a contemporary spectator — and more specifically to the friars of Sansepolcro who had had to fork out for the lapis lazuli — the specific pigment used for this part of the picture would have served to make it symbolically and literally clear that something materially costly was being cast aside. To Roger Fry and his epigones, for whom form and colour are above all to be perceived as autonomous expres-sive resources, such types of meaning, in so far as they are aware of them at all, are ruled out as 'unaesthetic' and 'unartistic'. The conditions of production which served to secure meaning for the fifteenth-century spectator are thus idealized away in the conditions of interpretation of the Modernist explainer, confident as he is that what speaks to him is what matters historically.

This is the climate in which we live. The expressive referents of pictures are most commonly fixed for us by those whose authority derives not so much from real research, as from a self-certifying confidence in their own sensitivity, or, as the tedious tribe of art-school teachers would have it, in their possession of that fictional category, 'visual awareness'. Such sensitivity and such awareness are developed with practice apparently, where they are not God-given, as necessary professional qualifications of those concerned with art. So far as the aspiring critic or art historian is concerned, the requirement is to 'practise looking'. You have to 'really look at the picture'.

Yes indeed. But given differences in culture, in psychology, in interests, etc., there is no guarantee that any two observers, however conscientious and pro-longed their scrutiny, will be in agreement as to what they see, let alone what they see it *as* and as representing ...

266

That supposedly basic teaching routine, the compare-and-contrast exercise, founders in this quagmire. The very combination of any two elements, any two pictures, presupposes a set of assumptions about how they are to be connected. The successful student is the one whose 'correct' observations demonstrate a potential professionalism, a willingness to be institutionalized by the assumptions of his mentors. Yet what is given in the setting of such exercises, and what is enquired about and stated in their performance, goes all too rarely to those aspects of the pictures conjoined which have actually determined their production, and which might therefore be considered as *sine qua non* in any discussion of representation, expression and significance. Once again, those assumptions about meaning which determine the grounds for comparison misdirect or circumscribe enquiry into the conditions of production.

As regards normal claims about what pictures express, the essence of the problem is this: first, it is assumed that what a picture expresses is somehow to be decided by the ideal sensitive observer in terms of its 'visual appearance', and in isolation from any information about how it was produced; second – and this is practically entailed by the first point – that the sensitive observer's statement about what he observes and 'feels' is identical with what the picture expresses. To put it simply, the statement, 'This is what I *feel*', is seen as equivalent to the statement, 'This is what the picture *expresses*.'

There are a number of possible meanings of statements like 'This picture p expresses sadness.' What is meant by this statement is often 'This picture p makes me feel sadness', sometimes 'This picture is thought by me (and etc.) to express sadness', sometimes in the sense that 'What is depicted (e.g. a person) is sad', sometimes that 'This picture has the expressive effect of sadness', etc., etc. These various possibilities imply various conceptions as to the sort of symbol p is, as to the dependence or independence of expression with respect to the onlooker, and so on.

Let us consider first the critical circumstances in which 'p expresses s' is taken to mean 'p expresses s irrespective of (or possibly in respect of) any (or some) cognitive or emotive state s caused by the symbol p in the critic'. In practice, what often happens is that critics establish expressive meanings by virtue of their own stipulative power. They constitute the possibilities of the 'fixing of reference', so to speak. What occurs in this mechanism is the conventionalization of, or near conventionalization of, expressive symbols. The force of the idea of expression gets lost. (This is not to say, however, that expressive symbols are never deposited in a culture as conventions. And obviously expressive things are symbolic. They form part of, or are, a system of signification.)

What is lost or obscured is the indexicality of expressive symbols. Or rather, the fact that at some point the *claim* that p expresses s entails the indexicality of p – its causal character. There is a tendency in criticism to make an abstraction of the expressive relation. The constitutiveness of the critic's account renders it incorrigible.

Another way that expression claims are grounded is in terms of 'p makes me feel sad'. This faces worse difficulties in respect of the above analysis, *mutatis mutandis*.

In view of the foregoing it should be clear that the two statements 'This is what I feel' and 'This is what the picture expresses' are *not* equivalent; or at the very least that we have no grounds, *a priori*, for assuming that they are or that any natural mechanism connects them. Nor is this problem solved by modern cinéaste semiologists like Christian Metz with the idea that the work of art is ontologically a kind of 'text' somehow 'co-produced' by author and spectator, since this tells us nothing about how the resulting 'reading' is to be evaluated as a naturalistic explanatory claim. As regards the observer, how does he *know* that what he feels has been caused by the picture, rather than by a headache, by the rise in the bank-rate, by something he read about the picture or by something he read about the artist, or by assumptions about art or aesthetic experience in general? Is aesthetic experience so unlike all other forms of experience that it is incapable of admixture with them or of being multiply caused and determined, and therefore of being itself explained? And as regards the picture, unless what we mean by 'a picture' is some bundle of indices to our own psychological properties, the meaning it has – what it expresses – is what there was cause for, independently of our minds and interests. We may represent it to ourselves, but this does not mean that we make or reproduce it. For representation is an activity directed by our own aims and interests.

If a meaning has been deposited in a work of art, then art history must ask *how* that meaning was possible and how it was possibly produced. It is not enough just to 'uncover' it. What a work of art means is determined by what it is *possible* that it means, and to enquire into the determination on meaning and expression is therefore to enquire into real and possible causes – to do some historical work. A claim about what a work of art expresses can only be defended to the extent that statements about its history can be defended. Claims about what a picture expresses are no more than autobiographical statements unless they are claims about how that picture was produced. The world of art is infested with people all too eager to volunteer autobiographical statements as if these counted as real explanations …

THE TROBRIAND ISLAND PROBLEM.

Our aim up to this point has been to show that both enquiries into what works of art are *of*, or what they represent or signify, and enquiries into what they express or mean are properly enquiries into causes, and that explanations of representation and expression are properly claims about how works of art have been or are caused and produced. What follows is a characterization of a type of study in which interests in cause are inhibited by an interest in 'understanding'.

Our metaphor is borrowed from the field of Social Anthropology. It was suggested by Alasdair MacIntyre's essay on 'The Idea of a Social Science', which in turn was largely written as a review of Peter Winch's book by the same name.

Imagine an anthropologist – a structuralist if you like – studying a community of Trobriand Islanders. According to Winch's view of the aims and practices of social science, the anthropologist studies this community by joining it. It is only

by doing so, he asserts, by learning its language, internalizing its customs and rules, living its life, that he can explain it. His aim is to represent the world of the Trobriand Islander by being one himself. The Islander's behaviour is shown to be motivated by what the Islander himself believes. To quote MacIntyre, 'Their rules, not his, define the objects of [the anthropologist's] study.' Enquiry into the independent causes and mechanisms of the Islanders' behaviour is not this anthropologist's aim; indeed, the very process of going native prohibits such enquiry, since the consequent forms of self-consciousness are ruled out for the members of the community itself, by definition. To understand the causes of belief in the supernatural, for instance, is to suspend such belief and thus to rule oneself out of the congregation.

The social anthropologist of a Winchian persuasion is accustomed to defend his interpretation in terms of the amount of time he has spent among the natives, observing their rules and handling their artefacts, and in terms of the coherence of the picture which he can reconstitute by virtue of having learned their language. If you wish to criticize his work, he will tell you, you must first go where he has been and spend longer and become a more complete Trobriand Islander than he. To fail to do this is to be disqualified from any status as a considerable critic of his work.

What if such a characterization were applied to the community of art, art history and art criticism? Suppose that this community were to be seen as a kind of Trobriand Island, composed of natives and anthropologists, with the latter doing their best to turn themselves into the former? What might we then expect, and how might we tell anthropologists and natives apart? We offer five potential symptoms in search of a diagnosis.

First: There will be an attempt to identify the anthropologist's interpretations with the *explicit* meanings expressed by the natives. Indeed the anthropologist's professional self-image depends on just such an identification. The danger is that the observable effects in the Islander's behaviour will be confused with the causes of that behaviour. 'Why does he carry a stone in a forked stick?' 'Because it's his soul.' To the Winchian anthropologist the statement that souls are not such as to be carried in forked sticks is neither here nor there. The islander's statement of his reasons has to be taken as constitutive, and other explanations for his actions are likely to be ruled out as fouls. Agents' conceptions and reasons are seen as adequate in explanation precisely because they are constitutive of the anthropologist's view.

'Why did Kandinsky paint pictures that looked like nothing on earth?' 'Because he wished to make art more spiritual' or 'Because he was prompted by inner necessity', or 'Because by achieving autonomy for the expressive resources of painting he would produce a greater concentration on visual experience'. These are all equivalents to the anthropologist's reproduction of the Trobriand Islander's reasons for carrying a stone in a forked stick. They are not causal explanations. If we ask, 'How could Kandinsky have entertained such reasons; how could he have held such plainly irrational beliefs?' the answer is all too often, like the Winchian anthropologist's, that it is beyond the art historian's brief to account for beliefs. He merely represents them as aspects of the structure of the art-historical

tableau; and it is the structure he's interested in, not what it holds up or is held up by. The activities whereby members of the art world produce and manage 'settings' for themselves within that world are identical with their procedures for making those activities accountable. Such practices may be widespread, but their effect is to facilitate mystification.

Second: We can expect that the anthropologist's or art historian's constitution of meaning within the community will be derived from what he can read out of its language. The limits of the language are taken to be the limits of the world. Terms and categories derived from the conversational circumstances of the artist's practice – 'form', 'tone', 'pushing the paint about', 'exploring the unconscious', 'unmasking the codes of bourgeois society' or whatever – will be taken as signifiers of meaning in explanation of that practice. Behaviour will again be seen as governed by what has been articulated about it. Such a procedure faces the dangers which C.B. MacPherson has pointed out for the study of seventeenth-century political theory. If you want to make sense of what the Levellers said and wrote, you must identify those assumptions which were *unspoken* precisely because they were universally shared among the community addressed. If you take 'franchise of the freeborn' according to your own usage, you may idealize those Levellers who upheld the political aim of 'franchise of the freeborn' as proponents of a revolution in favour of the working class. But given the information that 'the freeborn' was actually used in the seventeenth century as a category excluding servants and other employees, and that its real causal referents were thus different from yours, you will be drawn rather to the conclusion that an essentially bourgeois revolution was what was to be effected – and you will be talking about a very different type of historical change and about different ideological determinations and consequences. In the seventeenth century there was no geographically stable working class identifiable as such in Marxist terms, and a proletarian revolution was not historically conceivable at the time.

Similarly, if you accept the usage of the English art world in the later 1950s at its own valuation, you may come to the conclusion that Pop Art represents a democratizing tendency in favour of popular culture. Whereas in fact the confusion of 'popular culture' with 'mass culture' by the bright young things of the ICA and the Royal College of Art is far more accurately interpreted as signifying an inclination to sidle up to the world of advertising and 'the media'. It signified a concern, that is to say, with conditions of distribution and consumption, not a concern with conditions of production. And art, as defined by such a concern, is not a *possibly* popular activity. (We are of course making a point about the similar logical form of two errors in historical explanation and not suggesting a comparison of the achievements of Richard Hamilton and Peter Blake with those of Richard Overton and John Lilburne.)

Third: We will expect historical enquiry to be determined by the search for constitutive meanings – for those types of conclusion which support the anthropologist-cum-historian's coherent and self-certifying tableau – rather than by the search for mechanisms of production of both meanings *and* interpretations. Just as the anthropologist's capacity to 'understand' becomes the determinant of meaning, so the critic's capacity to 'feel' becomes the determinant of

meaning. This serves to mask the requirement that recognition of mechanisms of production – causes – should determine what it is the critic or historian must strive to come to terms with and to explain. We have already suggested how the art historian's compare-and-contrast exercise is determined by just such an inclination to read an acceptable meaning *into* the pictures presented, rather than read *from* them whatever can be learned from the consideration of how they were produced.

Fourth: because the Winchian-anthropologist-cum historian's aim is to internalize an attitude towards nature rather than to explain the mechanisms of production of a culture, we will expect cultural categories to be represented as if they were natural categories. The identification of certain 'eternal verities' – birth and death and hunger and reverence for the elements, etc. – will be seen as unquestionable criteria of the constitutiveness and coherence of his account. Enter the quivering romantic humanist art critic, or his more fashionable twin, the Freudian-cum-Marxist self-promoter, the self-appointed guardian and explainer of the transcendental tear-jerking communicativeness of Great Art ...

271

Fifth, and perhaps most important of all: The anthropologizing art historian's own findings will be seen by him as validated by the coherence, the structural elegance or adequacy of his own account; and the coherence of his account, in turn, will be seen as demonstrating the coherence and rationality of the community under study. That he can successfully fix its 'meanings' within a structure of meaning – a language – is to be taken as demonstrating that that is what the community's meanings *are*, and that these are unquestionable and adequately explained. What Roy Bhaskhar, discussing scientific projects, has called 'non-cognitive conditions' – the operations of those interests, aims and influences which are not epistemologically significant to the ratification of the enterprise (like worrying about the bank-rate while you write your tragic poem, or having an eye on the market while you paint your hyper-realist picture) – are ruled out of consideration, *both* in the anthropologist-historian's enquiry into the meaning of behaviour within the community *and* in his justification of his own account. To consider such factors as significant in explanation would, after all, be to step outside the conceptual framework of the study itself and to commit a foul. In the world of the Winchian anthropologist, what are given as reasons *must* be taken as adequate causal explanations in themselves.

So, if a group of artists can be gathered under the curatorial category of 'A New Spirit in Painting', it follows that there must be such a spirit, as a natural and ineffable feature of the world. Never mind the sheer irrationality and the provincial bathos of concatenating Alan Charlton or Georg Basilitz with Pablo Picasso; forget the manifest machinations of dealers, the massive financial support provided by the West German government, and the gouging careerism of the curators; just look at the pictures and feel a reawakened humanism. No vulgar considerations can have any bearing – any causal significance in relation to what these pictures mean and express. To claim that such considerations *must* have causal and explanatory significance would be to commit a social solecism, to risk being accused of lacking 'love for art' and lacking 'objectivity' (which are taken as synonymous), and thus to invite ostracism from the Islands of the Sensitive.

MODERNISM.

If you can specify a set of characteristic symptoms, and if these are then shown by observation to be present, it seems reasonable to proceed to a diagnosis of infection. We have offered a hypothesis: What if the modern community of art and art discourse *were* a kind of Trobriand Island, full of natives and Winchian would-be joiners? Certain consequences would be observable; and we are suggesting that just such consequences *are* to be observed as normal and normative aspects of art discourse. The hypothesis therefore seems to be valid. We are, it seems, marooned on a Trobriand Island.

This metaphor may be used as a means of identifying the ideological character and practices of Modernism – not Modernism seen simply as an art-historical period, or a mere art-critical stance, but as a historical ideology, or a part of one, a type of culture, by which the activities of all of us are affected to varying degrees, and in which we are all therefore variously implicated. The very fact that an analogy can be sustained with an account of concepts of meaning in the Social Sciences suggests that we are dealing with a characterization of intellectual practice which goes well beyond the art-world in its scope.

It is hard to imagine how those who teach or have taught in colleges or departments of art could have failed to observe examples of those practices we have described. If any have failed to observe such examples, they should at least consider the possibility that their own activities may be open to a radical redescription by those who have managed to avoid going native. They are open, that is to say, to the charge of false consciousness.

There is much talk of the liberating effects of art. The possibility of true liberation, we would assert, entails the ability to distinguish the real from the ideological. To see a system of beliefs as ideological is to see it as grounded in the existence of a particular contingent form of class society, and as serving the interests of a system of false consciousness intrinsic to it. It is to see these beliefs as part of culture, part of history, and therefore themselves open to causal explanation.

So where do the causes of Modernism lie? The question is plainly ambitious and deeply complex, and it lies well outside the possible range of this paper. It is assuredly not to be answered by some crude Marxist formula concerning the Determination of the Superstructure by the Base, or the Logic of Bourgeois Domination under Modern Capitalism, though it is certainly true that ideologies do have material and other causes and that the function of a dominant ideology *is* to dominate.

In so far, however, as *some* guide to the mechanisms of production of an ideology are to be found in the interests it seems to satisfy, we offer a tentative suggestion for a research project in social history. Those ideas and attitudes characteristic of Modernism appear to surface during the nineteenth century and to become clearly identifiable in its latter half, at a time when the hereditary upper bourgeoisie appeared militantly concerned to distinguish themselves from the rising petty bourgeoisie and the nouveau riche – to make it clear, in a world in which the distinctions between aristocracy and working class were well rehearsed, that more than one class was sandwiched between them. This literate, educated

and comparatively leisured class seems to have been concerned to establish its place in history as the proper guardian of knowledge, civilization, sensitivity and the eternal verities. The concepts of change and renewal and novelty were admitted by this class, and served to distinguish its view of history from that of the aristocracy; on the other hand it did not envisage itself as subject to *transformation* by such changes, and this served to distinguish its self-image from that of the working class.

As the focus and symbol of its own historic capacity for the articulation of meaning, art was idealized as the proper subject of this class. The artist, in so far as he could be securely identified at all, was projected as the ideal 'creator', the ideal worker, but never as a *producer* in any sense compatible with historical materialism, determined as other producers are determined. His artefacts were not sorted out as types of production, but as bundles of those properties which were negotiable within the conversation of the bourgeoisie. As such, though their incidental characteristics were seen as changing in response to a 'changing world' (i.e. to fashion), the fundamental expressive values of works of art were seen as transcendental, ahistorical and immaculate in the sense of being uncaused. It follows that such remarks as we have caricatured in the form 'He did it for the money' had always to be ruled out as a condition for the recovery of any meaning in proper art.

This may well seem an over-simple and over-tidy hypothesis, and it is certainly true that it is easiest to exemplify from those writers on art who are most easily criticized. But it is also the case that these have been among the most influential. Clive Bell is a prime example, and the one whose class–character was most clearly stamped on his writing. Here he is in characteristic vein:

> '*The artist and the saint do what they have to do, not to make a living, but in obedience to some mysterious necessity. They do not produce to live – they live to produce. There is no place for them in a social system based on the theory that what men desire is prolonged and pleasant existence. You cannot fit them into the machine, you must make them extraneous to it. You must make pariahs of them, since they are not a part of society but the salt of the earth.*'

Whatever else it may or may not imply, such a characterization of the artist is plainly not compatible with the historical materialist conception of man as in the last instance characterized by basic needs which must be satisfied by production of the means of subsistence. In this ideal projection of art, the intellectual abilities, the needs, desires, pleasures, aspirations and self-images of the literate hereditary bourgeoisie achieved their perfect realization.

The ideology of which Modernism is a part may to a certain extent have moved beyond this class, which itself has been subject to some historical change, and its entrenchment in America is perhaps subject to a slightly different class analysis. Certainly the ideology of Modernism cannot now be wholly incorporated in or dismissed as 'bourgeois ideology'. It is hard indeed to characterize it as a class-based ideology at all. It has perhaps achieved the status of something like a religion: a set of widespread and institutionalizing protocols and beliefs regarding what is neither real nor true. But this does not invalidate the initial identification

273

we have proposed, and it might be said that the stamp of the concept of a 'knowledge class' was successfully carried in Modernism's migration across the Atlantic, where it now serves the interest of SoHo and Park Avenue alike. After all, if 'knowledge' is not knowledge of what's real, then anyone can lay claim to it, and conversion comes easy.

It probably was true at the time of the entrenchment of the ideology of Modernism that the hereditary bourgeoisie held the central position in the advancement of knowledge. What is at issue now is whether it still does; or rather, since *de facto* membership of the congregation is now open to all those able and willing to demonstrate a measure of education, intelligence and sensitivity, just what is joined in joining it and what price is paid. The suggestion offered here is that the conditions of entry are those which the Winchian anthropologist imposes upon himself on joining the Trobriand Islanders: that one leave behind those concepts and modes of enquiry and explanation which are not available to the members of the congregation themselves, and thus not constitutive of their meanings, their beliefs, their picture of the world.

There are of course those in the field of aesthetics and art history who have managed to keep at least a foot outside the Island. They are not generally to be found among the volunteers of left-wing commitments. Nor are they often people who are *just* aestheticians or art historians. They are typically scholars who at one time or another have been exposed to the methodological and epistemological constraints which govern theory-formation and practice in the natural sciences, where the problems of distinction between the ideological and the real are seen as more central and are very much better rehearsed ... Normal art criticism, however, now seems virtually irredeemable in its entirety.

There has been much talk of late of 'Post-Modernism' and 'Anti-Modernism' and so on. Some of this talk has appeared to express a well-intentioned and leftish awareness of, and dissociation from, the Hegemony of Bourgeois Idealism, etc., etc. But in practice these vaunted alternatives have been all too easily incorporated as favourable mutations within just that ideology they purport to supplant, but which they have failed adequately to characterize and to redescribe. 'Alternative art history' – Pissarro instead of Monet, Tatlin instead of Malevich, Grosz instead of Klee, Hockney instead of Hoyland, or whoever – merely increases the range of consumer durables for normative exercises in art appreciation. 'The line of Daumier, Courbet, the early Van Gogh, Meunier and Dalou is that of the real art of the growing proletariat, while that of the bourgeoisie continues towards the abstraction of the twentieth century.' Anthony Blunt wrote that in 1937, and look what happened. A true alternative will at least initially survey the same subject matter, the same artists. There is no real future or interest in trying to reverse the relative ranking of good and indifferent art if you can't redirect the categories according to which art is singled out in the first place, and to try to do so is to miss the substantive point. Nor should the leftish posturing of John Berger and his ilk – all palpitating self-exposure and no logic – be taken as any kind of substitute for explanation or critique.

Nor does the ahistorical semiologist's vaunted 'unmasking of codes' do much to effect real changes in understanding or provide grounds for explanation which

are better than self-certifying. For all its apparent elegance, the so-called 'science of signs' will never wake up among the real sciences. Committed as the semiologist is to the position that the limits of a dubiously metaphorized language are the limits of a world, he can do little but proliferate translation problems, alternative readings of 'pictures-as-texts'. The new, fashionable global form of semiology, *the nouveau mélange* of psychoanalysis, Marxism and linguistics, seems stuck with this mistake – seems indeed ambitious to extend its currency. With some assistance from semiology we achieve, perhaps, a measure of methodological sophistication and a capacity to add some detail to our compacted structure of meaning, but we're still back on the Trobriand Island, joining away like the rest. And controversy in normal art history remains a matter of competing interpretations, which reduce to the status of translation problems.

No, if there is to be a real alternative to the Modernist Trobriand Island, it will have to be through the characterization of art-historical practice in terms of different forms of enquiry. The only means to break out of the charmed circle of self-authenticating explanation is through enquiry into causes and conditions of production – an enquiry which is at least initially free of those presuppositions about what meaning in art is and who it is for which have for so long been allowed to restrict the range of causes which come up for consideration. Such freedom might seem difficult to achieve, but it may be worth considering the resource provided by those who already have it; those, that is to say, for whom art is indeed meaningless, unless 'He did it for the money' (etc.) be allowed as a condition for the recovery of meaning. And if we can't ask the right questions we should not be surprised if people get tired of the answers.

EXPLANATION: A HYPOTHESIS AND THREE PRESCRIPTIONS.

We offer the following hypothesis: Art history has to be explanatory, because artists are producers; that is to say, if art history is *not* truly explanatory – if the circle of 'understanding' is not broken by identification of those types of causal explanation from which our anthropologist abstains – then the status of the artist as a producer will remain masked and his works will continue to generate mere problems of translation and discrimination for those equipped to argue about what place works of art are to have in the decoration and justification of their own lives.

So, for art history to lay claim to a real explanatory function, what criteria must be fulfilled? Our first two answers to this question are by way of recapitulation.

First: Those objects – works of art – which are taken to initiate art-historical enquiry must be described in a logically scrupulous ontology, and *not* according to the entrenched themes and topics of an ideology for which the habits of art appreciation may stand as pathetic symptoms. But logic will not solve all the problems. It may eliminate many embarrassing errors, but it cannot redirect enquiry in favour of different interests. Causal theories of meaning and reference remain relatively exotic in logic. So:

Second: It must be recognized in theory and in practice that interpretations of what pictures are *of*, of what they represent, and claims about what they express

and mean are to be derived from knowledge – or at least practically grounded speculation – about how they are caused and produced, and not from the autobiographical pronouncements of mandarins or would-be mandarins. We must therefore be willing to scrutinize any statement about what works of art mean for the residue of hidden or inexplicit claims and assumptions about the mechanisms of their production.

Our third prescription addresses the issue of what is required if the first two are to be given some practical effect.

Third: What is needed is that the enquiring practices of art history and art criticism should themselves be open to accountability as to their causes and determinations. Just as claims about the meaning of works of art must be scrutinized for hidden assumptions about the mechanisms of production of those works, so the art historian's own means of interpretation and explanations must be open to scrutiny as to how those interpretations and explanations have themselves been caused and determined. In 'Art as Inquiry', Goodman dismisses the idea of aesthetic contemplation out of hand. As an analytical philosopher supposing his hands to be clean of the social sciences he can afford to be coolly dismissive of what appears to him as a clearly absurd approach to art and aesthetic experience. But for those of us who have lived and worked in the atmosphere of Modernism, the determining agency of Modernist ideas has to be acknowledged. For us, the possibility of liberation resides only distantly in the view of a different conceptual framework. First, we have to come to an understanding of the causal determinations upon our own present modes of enquiry, interpretation and explanation. As art historians we have to scrutinize our own practices for those constitutive assumptions which are not subject to criteria of empirical adequacy or to rational defence before rational minds. We too, it may have to be acknowledged, do it for the money, to further our self-images, because we are idle, because it's better than working for a living. And these factors may have to be acknowledged as causal determinations of the *meaning* of what we say and write. The best defence against the accusation that the meaning of our activity is *exhausted* by such accounts is that our interpretations should be open to correction according to causal as well as hermeneutical criteria, and that they should therefore be explanatory. If an interpretation is *not* genuinely explanatory, then nothing counts against it.

To accept the possibility of correction is, of course to accept a degree of professional risk. Such requirements are criteria of good practice in science (at least as idealized by Popper), but are not customarily made of art-historical explanation. The point about science is that non-cognitive causes do not necessarily impugn its normative power or vitiate the informative content of explanation. That is to say, scientific experiments or theories can be so framed and scrutinized as to enable considerations of the scientist's gouging careerism, or his anxiety about the bank-rate or whatever, to be set aside in evaluation of their informative content and their truth. But it remains to be demonstrated how the same statement could be defended in respect of art-historical enquiry, let alone of art criticism …

But normal art history is characterized by its essential conformism, by habits of playing safe, by fear of speculation, by lack of intellectual and methodological

276

rigour, and by those dogmatic effects which suggest that there must have been dogmatic aims. There is some apparent justification for this in the timorousness of the majority of contemporary art, with its pathetically contained or bathetically aggrandized ambitions, and its trivial confusions and mysteries. But are art students, for example, therefore to be abandoned, to be deprived of proper teaching even in that small percentage of the timetable given over to art history and so-called complementary studies? The concept of complementarity entails a defensible base. So how do teachers of complementary studies earn their salaries? The question is at least worth asking. For to ask what kind or art we have or could have is to ask, 'What must the world be like, or have been like for such a thing to be produced? And answer to such questions have a clearly prescriptive aspect in relation to the practices, interests and aims of art history and criticism.

Certainly what art historians do is irretrievably a part of culture and not a part of that part of culture which is science. But that is no excuse for exploiting the ease with which they can get away with empty and uninformative pronouncements, nor, unless they are indeed Winchian anthropologists, are they excused the requirement of asking 'What *kind* of culture? What are its aims and interests? What ends, for instance, are served by the mystification of meaning and the idealization of practice?'

In his introduction to the Arts Council's valediction of Roger Fry some fifteen years ago, Quentin Bell ended with the following quotation:

> '*And finally the lecturer, after looking long through his spectacles, came to a pause. He was pointing to a late work by Cézanne, and he was baffled. He shook his head; his stick rested on the floor. It went, he said, far beyond any analysis of which he was capable. And so instead of saying "Next slide", he bowed, and the audience emptied itself into Langham Place. For two hours they had been looking at pictures. But they had seen one of which the lecturer himself was unconscious – the outline of the man against the screen an ascetic figure in evening dress who paused and pondered, and then raised his stick and pointed. That was a picture that would remain in memory together with the rest, a rough sketch that would serve many of his audience in years to come as the portrait of a great critic, a man of profound sensibility but of exacting honesty, who, when reason could penetrate no further, broke off; but was convinced, and convinced others, that what he saw was there.*'

It is an ironic, if symptomatic, achievement of Modernist criticism that 'going beyond analysis' has become fixed as one of the principal expressive referents in terms of which value is actually established for works of art. The fundamental criterion of value, that is to say, is proposed as ineffable and irrational. The point is not that there *are* no mysteries. No doubt there are some, though we should bear in mind that the mysteries of one generation are often explained in the knowledge of another. The point is rather that a tendency to value the acceptance of mystery as a humanizing characteristic in the professions of art and art history tends to encourage idleness at best and evasiveness at worst in the face of that which may indeed be open to rational enquiry and to explanation – albeit, perhaps, by others less sensitive than those who normally write about art ...

THE NEED FOR A SECOND-ORDER DISCOURSE.

We return to the issue of what is to come up for the count in and as explanation, the question of which bits of information belong together in the attempt to recover meaning from art. According to what assumptions about the possibility of meaning in art is 'He did it for the money' ruled out as a determinant? We offer one further hypothesis: The meanings we can make are causally determined by the world in which those meanings have their effects. Within cultural discourse, as opposed to natural-scientific discourse, to explain the non cognitive conditions of production of an interpretation is to impugn its normative power. Cultural discourse is a moment in its own making. Scientific theory is not. In experimental science, the experimenter devises experiments to find out what he did not produce. The islanders of art's institutions proceed in terms of what they must themselves have produced as if they had had no hand in its production. Knowledge is handed down to the onlookers.

278

Imagine a conversation between three art historians concerned to explain the work of Degas to students. The first says, 'In order to understand Degas you have to really look at the pictures.' The second says, 'In order to understand Degas you have to read nineteenth-century French novels.' The third says, 'In order to understand Degas you have to know how much he paid his models.' Under present conditions the ensuing argument is all too likely to reduce to the equivalent of a squabble over translation problems, alternative readings of the 'text' as it were, decidable for each participant only in terms of his own interpretations and interests and preferences. Yet each of these statements serves as a paradigm of how the work is to be approached; not just of how it is to be characterized as a piece of production, but also of how that characterization itself relates to some view of the world within which the historian produces his *own* work.

For such squabbles to be transformed into substantial and decidable arguments, we need a form of second-order discourse, a conversation within which to include, to discuss and to explain the content of the first. And to be able to explain this first-order discourse we shall, once again, have to enquire into the mechanisms of production, the causes, of what is said within it. Art is produced from all kind of causes, but so are art history and art criticism. The relationship between the two sets of causes is not generally very well thought about. It should be made clear, incidentally, that we are not proposing a crude determinism – suggesting, for instance, that all ideas and beliefs are open to exhaustive causal explanation by reference to 'the material conditions of life'. Ideas may not move mountains, as the proponents of a 'universal' abstract art seemed to have believed they could in the 1920s and 1930s, but ideas can certainly be determinants of modes of production, activities, the consequences of which are that mountains do get moved. What we have to offer is not a form of economic reductionism. It does not go to a rigid materialist inversion of Hegel. It does not go to the overthrowing of all claims for the autonomy of art. It goes rather to the matter of the fraudulence of the discursive or analytical closures performed in art [discourse], and to its hermeneutical circularity, which are the principal symbols of its ideological purpose.

Particular modes of interpretation are plainly to be acknowledged among the determinants on production of works of art. Criticism plainly influences art. Our second-order discourse might help us to discover how and why this is so. Within such a discourse, that is to say, it might be possible to decide the extent to which historical, cultural and ideological accretions – ideas and beliefs *about* art – have been the causes of particular identifications of meanings in art; to distinguish, that is to say, between the mechanisms of production of particular interpretations and explanations, and the mechanisms of production of meaning in the works of art themselves. It is perhaps partly because we don't have such a second-order discourse – or because in so far as we do have one it merely reflects and ratifies the first without explaining it – that normal argument in art criticism and art history is so readily reduced to *ad hominem* slanging; to a confusion, that is to say, of redescriptions of someone's ideology with redescriptions of some work of art's ontology.

To return for the last time to our analogy of the Trobriand Island; the function of a second-order discourse in respect of the anthropologist's deliberations will be twofold: it must be capable of describing what he describes and explaining what he explains; and it must *include that function* within an explanation of the determinants on the anthropologist's own deliberations. A second-order discourse – a real alternative practice – will therefore ideally both have to show how the artist's behaviour is open to causal explanation rather than to mere structuring and ratification in terms of some art-historical tableau, *and* it will have to provide an account of the art historian's own interpretations and explanations which goes outside the Island itself, outside Art, and outside the art historian's own professional vocabulary, for its terms and concepts and notions of cause. If the limits of the art-world's own vocabulary are to be taken as the limits of art-historical explanation, then art history itself will be open to critical redescription and encapsulation by those who are not of its congregation.

There is no other way to avoid such encapsulation than to do some work. After all, to realize that there are things you can't talk about, possible truths beyond the limits of your language, is surely to recognize the need to learn. The demand that is made of the critic's or historian's thought is a demand 'to reflect on his position in the process of production'.

It should be made clear that the second-order discourse can be no more free from aims and interests than the first. How it is framed will depend on where one stands in relation to social theory and other comparable commitments. Recognition of the essentially bourgeois roots of the modern ideology of art does invite redescription from a historical materialist standpoint. The latter is not as the French might have it, the 'logical opposite' of bourgeois ideology; it is its *historical opponent*. Tim Clark gets half-way there in his recent article on Manet's *Olympia*, in talking of the critical and explanatory potential of the 'meaning of the dominated' – of what is recovered or recoverable as meaning by those who are not generally in control of the manipulation of symbols in culture. But the point is that within a world constituted by bourgeois understanding, the dominated *have* no 'meanings' that are not either noises-off or pale imitations of the meanings of the dominating. Only by the operation of a second-order discourse in which their

279

own interests and intuitions are expressed, can the dominated change the rules, so that, for instance, 'He did it for the money' ceases to be a perlocutionary noise-off and becomes instead an acceptable explanation, a critical condition of the possibility of recovery of meaning. Only within such a second-order discourse can the roles be reversed, and the redescribed meanings of those formerly dominating become a subset of the meanings of those formerly dominated.

Our conviction that such a reversal is *what is required* is not an attempt to bend theory into conformity with some Marxist faith – some vulgar economic reductionism. Nor is it the result of any illusion that the middle-class artist or art critic or art historian is in a position to volunteer self-identification with the interests of the working class without a methodological hiatus. It is rather a somewhat reluctant recognition of the fact that in face of the manifest problems and deficiencies of normal art history *no other characterization of practice seems at present likely offer a defensible project of work.* Only a redescription of culture and art within which historical materialist and causal forms of explanation can be seen as critically efficient will serve to bring the right skills and competences into operation. And it should be clear that what is at stake here is not just the deployment of skills relevant to the practice of art criticism or art history, but also of those required in the production of art itself.

The purport of this paper is methodologically prescriptive, but does not attempt to be prescriptive in respect of the metaphysical relations between persons and objects. We are not searching for and would not expect to find cognitive foundations for knowledge of art. There are no such foundations for any knowledge. Our aim is rather to seek some points of reference for thinking about a discourse which is not always quite thinkable, but which is at least not characterized by the fraudulence of its emancipatory claims. Whether such a discourse can be envisaged as art discourse or not is at present an *administrative* issue.

24 Svetlana Alpers

'Interpretation without
Representation, or, The Viewing
of *Las Meninas*', 1983

Svetlana Alpers, professor of the history of art at the University of California at Berkeley, has con-
tributed extensively to our understanding of Dutch art in the seventeenth century and its
European context. Her editorship of the journal *Representations*, her essay on description in Vasari
(1960), her book *Art as Describing* (1983), and the article reprinted here, 'Interpretation without
Representation' (1983), indicate her involvement with problems associated with the viewing of
works of art.[1]

In this essay Alpers proposes that it was Velázquez's ambition in painting *Las Meninas* (1656) to
embrace two conflicting modes of representation in a single painting (fig. 42). These modes are:
the window onto the world, with the artist and the viewer together on the same side of the
surface which constitutes the image, and the artist saying 'I see the world', as in Dürer's woodcut of
a draughtsman drawing a nude (fig. 43); and the *camera obscura*, in which the world is 'being seen',
as it projects itself onto the surface and is not seen through a window (fig. 44). This type also exists
in paintings, as in Vermeer's *View of Delft*, in which no account is taken of the viewer's location (fig.
45). In *Las Meninas* the two modes are combined: in the first, the window onto the world, the
artist stands before the picture with the viewer; in the second, the descriptive mode, he is
accounted for within the picture.

Alpers argues that this conclusion could not be arrived at by the current standard methods of the
history of art for the following reasons. It is characteristic of art-historical practice to seek meaning
in the notion of plot rather than in the notion of pictorial representation. Thus *Las Meninas* has
been explained by traditional art historians as being like a little play in which the Infanta calls in to
see the painter, and they in turn are joined by the King and Queen, with the implication that
Velázquez is here laying claim to noble status both for himself and for the art of painting. It is this
tendency to relegate the visual evidence to a position of secondary importance which made the
solution now proposed by Alpers unthinkable within the established approaches. The main thrust
of her article is the need to remember the importance of what is actually before our eyes (see also
Sontag, text 18, 1964), though many students of twentieth-century painting might be surprised to
read that they stressed plot above pictorial qualities, when they have been so roundly criticized by
social historians for following Clement Greenberg (1909–94) and others in not looking beyond
the surface of the picture to its narrative meaning. Alpers suggests three causes of this dependence
on texts and fear of representation: iconography, naturalistic standards and the social history of art.

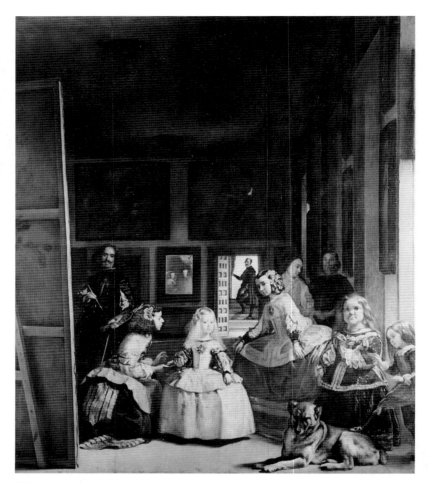

282

42 Diego Velázquez, *Las Meninas*, 1656. Oil on canvas,
3.18 x 2.76 m. Museo Nacional del Prado, Madrid
Alpers proposes that in *Las Meninas* Velázquez has
combined two normally distinct ways in which the spec-
tator relates to an image. One is the window onto the
world, with the spectator in the same position as the
artist, seeing the world through the same eyes, as in
Dürer's woodcut of a draftsman drawing a nude (fig.
43). The other is the world projecting itself onto the
support without the intervention of the artist, as with
a *camera obscura* (fig. 44) and as in Vermeer's *View of
Delft* (fig. 45).

43 Albrecht Dürer, *Draftsman Drawing a Nude*, 1525.
Woodcut, 8 × 22 cm. From *Manual of Measurement*
See fig. 42.

283

Panofsky's *iconographic method forces the art historian to look for the meaning of visual objects in literary texts. It also relegates the painting itself to a position of secondary importance, because of the way in which he presents his method: he draws no distinction between the man with the hat and the picture of the man with the hat. In other words Panofsky should not have described the man as if he were present in the picture, because he is rather being *re*-presented there.

This in turn raises the question of *how* the man in the hat is represented. Gombrich argues that perfect representation of the visual world makes the picture disappear. This, however, leads to the conclusion that meaning must lie elsewhere than in the picture, either beyond or behind its surface, so that once again the art historian is steered away from the representation itself.

The social history of art has encouraged a search for clues in *Las Meninas* to the social status of the artist, which again takes attention away from the painting itself.

Finally, Alpers also describes how Michel Foucault, approaching the painting from outside the discipline and without these encumbrances, found the representation of the painting *in* the painting and evoked 'the theme of reciprocity between an absent viewer (before the painting) and the world in view'.

Alpers's observations point to the conclusion that the strengths of one generation can become the shackles of the next. Panofsky's very brilliance created an *iconographic straitjacket for his followers, Gombrich's success with the analysis of illusion produced a situation which could mislead when applied to the study of painting in itself, and the social history of art also reduced the breadth of focus in its own way.

1 Svetlana Alpers, 'Ekphrasis and Aesthetic Attitudes in Vasari's *Lives*', *Journal of the Warburg and Courtauld Institutes*, 23, 1960, pp. 190–215; *Art as Describing: Dutch Art in the Seventeenth Century*, London and Chicago, 1983; 'Interpretation without Representation, or The Viewing of *Las Meninas*', *Representations*, 1, no. 1, February 1983, pp. 31–42.

44 Johan van Beverwyck, *Demonstration of the Working of the Eye in a* Camera Obscura, 1664. From *Schat der Ongesontheyt*. See fig. 42.

45 Jan Vermeer, *View of Delft*, c.1660. Oil on canvas, 98 × 117 cm. Mauritshuis, The Hague. See fig. 42.

24 | Svetlana Alpers

'Interpretation without Representation, or, The Viewing of *Las Meninas*', 1983

Excerpts from Svetlana Alpers, 'Interpretation without Representation, or, The Viewing of *Las Meninas*', *Representations*, 1, no. 1, February 1983, pp. 31–42

Along with Vermeer's *Art of Painting* and Courbet's *Studio*, Velázquez's *Las Meninas* [fig. 42] is surely one of the greatest representations of pictorial representation in all of Western painting. Why has this work eluded full and satisfactory discussion by art historians? Why should it be that the major study, the most serious and sustained piece of writing on this work in our time, is by Michel Foucault? There is, I shall argue, a structural explanation built into the interpretative procedures of the discipline itself that has made a picture such as *Las Meninas* literally unthinkable under the rubric of art history. Before considering the work, as I propose to do, in representational terms, let us consider why this should be so.

Historically, we can trace two lines of argument about *Las Meninas*: the first, most elegantly encapsulated in Théophile Gautier's 'Où est donc le tableau?' has been concerned with the extraordinarily real presence of the painted world. The frame appears to intersect a room whose ceiling, floor, and window bays extend, so it is suggested, to include the viewer. The light and shadow–filled space is not only intended for the viewer's eyes – as in the case of its much smaller predecessor hung at the Spanish court, Van Eyck's *Arnolfini Wedding*. Given the great size of the canvas, it is intended also for the viewer's body. The size of the figures is a match for our own. This appeal at once to eye and to body is a remarkable pictorial performance which contradictorily presents powerful human figures by means of illusionary surfaces. In the nineteenth century it was a commonplace for travellers to Madrid to refer to it in what we can call photographic terms. Continuing a tradition started in the eighteenth century about such works as Vermeer's *View of Delft* [fig. 45], it was compared to nature seen in a *camera obscura*, and Stirling-Maxwell, an early writer, noted that *Las Meninas* anticipated Daguerre. The pictorial quality of presence is sustained in the apparently casual deportment of the figures that is distinguished, as so often in the works of Velázquez, by a particular feature: the fact that we are looked at by those at whom we are looking. To twentieth-century eyes at least, this gives it the appearance of a snapshot being taken. In the foreground, the little princess turns to us from her entourage, as does one of her maids, and a dwarf, and of course Velázquez himself who has stepped back from his canvas for this very purpose.

The gaze out of the canvas is a consistent feature in Velázquez's works. In their separate portraits, royalty and dwarf alike meet our eyes, but most astounding are the minor figures in the larger scenes: two of the peasants celebrating Bacchus in an early work, for example, or the memorable soldier to the left and the officers to the right of *The Surrender of Breda*, or the woman situated at the margin between the two spaces of *The Spinners*. I refer to this phenomenon as a gaze, to distinguish it from a glance. It does not initiate or attend to some occurrence; empty of expression, it is not, in short, narrative in nature. The gaze, rather, signals from within the picture that the viewer outside the picture is seen and in turn it acknowledges the state of being seen. Though not invented for the occasion of *Las Meninas*, the device is heightened here because it is thematized by the situation, or possibly the situations at hand.

Just what the situation is – hence what the subject of the work is – has been the concern of the second line of argument about *Las Meninas*. The problem is not one of identification – an early commentator identified each participant in the scene (even including the figure pausing in the light of the distant doorway whose role of marshal in the queen's entourage significantly matches Velázquez's role in service to the king). However the presence of the king and queen marked by their reflection in the prominent mirror at the centre of the far wall, and the large picture seen from the back on its stretcher, which intrudes at the left, raise problems. Where are the king and queen or what is the source of their reflections, and what is the subject being painted on the unseen canvas? The impulse in recent studies has been to answer these questions by attempting to supply the plot – a little playlet as one scholar calls it – of which this picture is a scene. The little Infanta, so this account goes, has dropped in to see Velázquez at work, stops to ask her maid of honour for a drink of water and looks up when surprised by the unexpected entrance of her parents, the king and queen.

It is characteristic of art-historical practice that it is the question of plot to which the notion of the meaning of the work is appended, rather than to the question of the nature of the pictorial representation. Though scholars differ about the specifics of the plot – are the royal pair posing for their portraits when the princess arrives, or is it rather the princess and her retinue who pose as the king and queen arrive? – they are agreed that it is the presence of the king and queen with the painter that is emplotted here. And it is on this basis that the meaning of *Las Meninas* is today interpreted as a claim for the nobility of painting as a liberal art and as a personal claim for nobility on the part of Velázquez himself. In short, *Las Meninas* is now understood as a visual statement of the social rank desired by the painter.

To back up this point, detailed documentation has been collected to show that all Spanish painters worked under financial and social pressures due to their low professional status as craftsmen, and that some struggled to bring about change. Of course any pictorial performance of the brilliance and accomplishment of *Las Meninas* might be said to make high claims for art, but the nature of Velázquez's claims are problematic in the sense that he does not distinguish the liberal aspect of art from its craft. From his self-conscious avowal of paint as both the creator of illusion and as material pigment in his early *Waterseller*, to his devoted foregrounding

of women preparing thread for the weaving of tapestries in the work known as *The Spinners*, Velázquez's embraced the very craftsmanship that this modern interpretation would have him reject. In *Las Meninas*, the casual yet striking juxtaposition of Velázquez's palette with the adjacent head of a maid of honour – beribboned head matched to palette in both brushstroke and hue – makes the claim for craft once more.

In order to reduce *Las Meninas* to its current meaning two moves are necessary: first, against the evidence of the picture it is argued that artist and king are represented together and their proximity is seen as the central feature of the work; second, art historians separate what they claim to be the seventeenth-century meaning of the work from its *appearance*, which is put in its place as merely the concern of modern viewers.

It is this insistence on the separation of questions of meaning from questions of representation that makes *Las Meninas* unthinkable within the established rubric of art history. The problem is endemic to the field. Before suggesting why this should be so, let me give one further example: the recent discovery of what should perhaps be called paintings without meaning. I am not referring to the response to a dada-ist manœuvre, but rather to the attempted interpretation of 'normal' Dutch paintings such as Fabritius's haunting *Sentry*. The soldier seated with his expectant dog beneath an improbable column, loading his gun under the aspect of sleep, and assimilated to a complex assemblage of truncated or only partly visible structures is puzzling, but surely not meaningless. Since, however, research has turned up no text or moral message which informs the painting, a scholar has felt justified in concluding that what we have before us is just realism. There is a clear and present danger for art historians who fail to find the kinds of messages – be they moral, social, or professional – currently considered to be the meanings of works by artists such as Velázquez, Vermeer, or Bruegel. The danger is that these works also will have to be admitted to be meaningless. What is missing is a notion of representation or a concern with what it is to picture something. And it is therefore not surprising that in recent times it is students of texts who have most successfully turned their attention to the works of artists such as these – artists whose works are self-conscious and rich in those representational concerns to which literary studies have been more attuned.

Why should art history find itself in this fix? The answer lies, paradoxically, in a great strength of the discipline particularly as it has been viewed and used by literary scholarship. The cornerstone of the art-historical notion of meaning is iconography – so named by Panofsky who was its founding father in our time. Its great achievement was to demonstrate that representational pictures are not intended solely for perception, but can be read as having a secondary or deeper level of meaning. What then do we make of the pictorial surface itself? In his seminal essay on iconography and iconology, Panofsky clearly evades this question. He introduces his subject with the simple example of meeting a friend on the street who lifts his hat in greeting. The blur of shapes and colours identified as a man and the sense that he is in a certain humour are called by Panofsky the primary or natural meanings, but the understanding that to raise the hat is a greeting is a secondary or conventional meaning. So far we have been dealing only

287

with life. Panofsky's strategy is then to simply recommend transferring the results of this analysis from everyday life to a work of art. So now we have a *picture* of a man lifting his hat. What Panofsky chooses to ignore is that the man is not present but is *re*-presented in the picture. In what manner, under what conditions is the man represented in paint on the surface of a canvas?

Art historians answer this question in stylistic terms. Gombrich, quite consciously taking up where Panofsky left off, made it his major task to define style. Encapsulated in the brilliant phrase 'making comes before matching', the ruling insight of Gombrich's *Art and Illusion* has provided a generation of literary critics with the touchstone for their analyses of literary convention. But they have ignored the fact that in the process of replacing an expressive notion of style with a representational one, Gombrich effectively eliminates just what he sets out to define. Despite his emphasis on 'making' or convention, he is far from the structuralist that he is sometimes taken to be. Gombrich treats representation as a matter of skill – skill in rendering and skill in perception. Pictorial conventions in Western art, he argues, serve the perfection of naturalistic representation which Gombrich significantly chooses to call 'illusions'. Basing himself on the irrefutable evidence offered by the study of perception, Gombrich concludes by defining a perfect representation as indistinguishable to our eyes from nature. Like the current commentators on *Las Meninas*, Gombrich effectively credits the perfect representation with making pictures disappear: the question of representation retreats before the perfect illusion Velázquez produces of the painter, the princess, and her entourage. Any meaning must clearly lie elsewhere – beyond or beneath the surface of the picture.

It is here that the strength of Foucault's commentary on *Las Meninas* lies. Beginning, as he does, with a determinate and determining notion of classical representation, he finds in this painting *its* representation. Foucault's exposition of this point proceeds through a careful viewing of the work which is impressive for its attentiveness. His interest in representation gives him the motive for looking which is lost to those who seek meaning in signs of a claim to social status. Foucault finely evokes the theme of reciprocity between an absent viewer (before the painting) and the world in view. He argues that the absence of a subject-viewer is essential to classical representation. This seems to me wrong. For the reciprocity between absent viewer and world in view is produced not by the *absence* of a conscious human subject, as Foucault argues, but rather by Velázquez's ambition to embrace two conflicting modes of representation, each of which constitutes the relationship between the viewer and the picturing of the world differently. It is the tension between these two – as between the opposing poles of two magnets that one might attempt to bring together with one's hands – that informs this picture.

Imagine two different kinds of pictures – the first is conceived to be like a window on the perceived world. The artist positions himself on the viewer's side of the picture surface and looks through the frame to the world, which he then reconstructs on the surface of the picture by means of the geometric convention of linear perspective. We can represent this with Dürer's rendering of a draughtsman at work [fig. 43]. The relationship of the male artist to the

female observed, who offers her naked body to him to capture in his drawing, is part and parcel of the commanding attitude towards the world assumed by this mode of representation.

The second mode is not a window but rather a surface onto which an image of the world casts itself, just as light focused through a lens forms a picture on the retina of the eye. In place of an artist who frames the world to picture it, the world produces its own image without a necessary frame. This replicative image is just there for the looking, without the intervention of a human maker. The world so seen is conceived of as existing prior to the artist-viewer. And in contrast to Dürer's artist, let us take two men observing the image made by a *camera obscura* [fig. 44]. (Appropriately, this is how the working of the eye was illustrated in a Dutch medical handbook of the time.) The men are in a dark room which is equipped with a light-hole fitted with a lens. They hold out a surface on which is cast the image of the landscape outside. Rather than man possessing through his art the woman he observes, two men attend to the image of the prior world. The artist of the first kind claims that 'I see the world' while that of the second shows rather that the world is 'being seen'.

I am not just imagining two kinds of pictures, but describing two modes of representation that are central in Western art. As an example of the first, Albertian model we might keep in our mind's eye a work such as Titian's *Venus of Urbino*. The artist is a viewer who is actively looking out at objects – preferably human figures – in space, figures whose appearance, considered as a matter of size, is a function of their distance from the viewer. For the second, which I call the northern or descriptive mode, think of Vermeer's *View of Delft* [fig. 45]. A fragment of a larger world is compressed into a piece of canvas, impressing its surface with colour and light without taking the position of a viewer external to it into account. No scale or human measure is assumed. In Velázquez's *Las Meninas* we find the two as it were compounded in a dazzling, but fundamentally unresolvable way. While in the Albertian picture the artist presumes himself to stand with the viewer *before* the pictured world in both a physical and epistemological sense, in the descriptive mode he is accounted for, if at all, *within* that world. A pictorial device signalling this is the artist mirrored in the work (as in Van Eyck's *Arnolfini*) or a figure situated as a looker within, rather like a surveyor situated within the very world he maps. In Dutch paintings of this type the looker within the picture does not look out. That would indeed be a contradiction since a picture of this sort does not assume the existence of viewers prior to and external to it, as does the Albertian mode.

In *Las Meninas* the looker within the picture – the one whose view it is – not only looks out, but is suitably none other than the artist himself. What is extraordinary about this picture as a representation is that we must take it at once as a replication of the world *and* as a reconstruction of the world that we view through the window frame. The world seen has priority, but so also do we, the viewers on this side of the picture surface. Let me explain. Paradoxically, the world seen that is prior to us is precisely what, by looking out (and here the artist is joined by the princess and part of her retinue), confirms or acknowledges us. But if *we* had not arrived to stand before this world to look at it, the priority of the world seen

would not have been defined in the first place. Indeed, to come full circle, the world seen is before us because we (along with the king and queen as noted in the distant mirror) are what commanded its presence.

Las Meninas is produced not out of a single, classical notion of representation as Foucault suggests, but rather out of specific pictorial traditions of representation. It confounds a stable reading, not because of the absence of the viewer-subject, but because the painting holds in suspension two contradictory (and to Velázquez's sense of things, inseparable) modes of picturing the relationship of viewer, and picture, to world. One assumes the priority of a viewer before the picture who is the measure of the world and the other assumes that the world is prior to any human presence and is thus essentially immeasurable ...

It has been my intention in this brief section to begin to suggest ways in which pictorial representation, an aesthetic order, engages also a social one. It seems to me, however, to be a mistake to conclude, as has been done on occasion, that Velázquez paints the bankruptcy (as it undoubtedly then was) of the Spanish court and the failure of the royal one. What is remarkable — in the sense of needing to be remarked — about this art is something that Velázquez shares with a number of seventeenth-century artists. It is that his understanding of the complex conditions of representation — both aesthetic and social — did not undermine his trust in it. As *Las Meninas* shows, Velázquez sees himself as part of the very court he sees through.

25　Hans Belting

The End of the History of Art?, 1984

Hans Belting, professor of art and media theory at the Hochschule für Gestaltung in Karlsruhe, is best known for his substantial contributions to the history of medieval art, but he has also published on artists as diverse as Giovanni Bellini and Max Beckmann. In his work he has attempted to come to terms with the challenges of the *new art history, as demonstrated in his book on the relationship between image and recipient.[1] *The End of the History of Art?* is a similar attempt at bridge-building. It contains one essay on the relationship between contemporary art and contemporary art history, and another on the legacy of Vasari. The text reprinted here is the preface to the book. Belting characterizes the shortcomings of the old art history and the possibilities of the (or a) new one. He argues that art historians have lost faith in a rational process of art history, that is in the concept of a universal history of art as initiated by Vasari, which considered art as something autonomous, which recognized only artists and sometimes patrons as representatives of a wider world, and which restricted itself largely to discussing questions of style. Its tools, such as those of the *connoisseur and the collector of facts, are increasingly valueless, especially when applied to periods where the historical record is very well provided with documentation as to what was being made, where, and by whom. If, however, that kind of art history is at an end, a new one is being established, asking new questions and requiring new tools for looking at art in its social context.

For Belting the beginnings of this change from one art history to another can be traced back to the roots of modernism itself, when the avant-garde repudiated tradition and forced the need for two different histories of art, one for the pre-modern and the other for the modern period. From our current perspective it may be possible to bring these two conceptions of art history together, by challenging the boundaries between art and the culture which produces it. He believes that contemporary artists are already mounting this new challenge, as they place themselves outside an autonomous aesthetic context and immerse themselves in an anthropological awareness of their culture in particular and all cultures in general, by using all visual and linguistic media. This means that the old antagonism between art and life has been defused.

Finally, Belting urges art historians to pay more attention to the art of their own time, because it is changing so rapidly and because its role is so uncertain. Such a study could be very fruitful because we are living in a time when the single direction of the history of art has come to an end, and we are inhabiting a kind of 'momentary respite'. This respite enables us to re-examine the justifications

which have been made for art in all ages. Art historians are now concentrating on the three prob-
lems of what constitutes an image, what constitutes truth and what is the difference between
modernism and what has succeeded it.

Belting's assessment of the central position of modernism, as the cause of the split in art history
and the possible means of healing it, is similar to that of Clark (text 21, 1974) and Baldwin,
Harrison and Ramsden (text 23, 1981; see also *avant-garde). The idea that the removal of the
split can be assisted by the involvement of art historians in contemporary art is supported by the
interest which postmodern art shows in historicity. A new art history could therefore develop in
which there was little distinction between art and the study of its history, as art history was in
Vasari's day, and which itself formed the basis of an enduring tradition.[2]

In placing at the head of his list of priorities the need to understand the art of our own time Belting
is asking the art historian to act in part as an art critic, that is to assess the value of art objects before
they have acquired any historical distance. This involves the special challenge that, because of the
myopia which accompanies the personal experience of history, the tools of the historian (whether
old or new) may not be the right ones for dealing with contemporary phenomena. Because ideas
form the currency with which art historians work, they sometimes assume that they are more
important than execution and that they are what constitutes a work of art. Wölfflin observed that
art historians are very wary of making judgements of *quality, whereas for artists quality is every-
thing, and they scorn art historians who avoid the issue.[3] (Wölfflin, text 10, 1915; see also Onians,
text 22, 1978.)

Belting may be being over-optimistic about the opportunities facing our own age in his argument
that the old divide between art and life has been reduced in the postmodern period. Such a divide
may indeed have been bridged, but only for a small part of society. If anything the 'heroic' principles
of the age of modernism have for many people a clarity which they could support or oppose, but
which they at least thought they understood, by contrast to the self reference and irony which
characterize postmodernism. Similarly with Belting's belief that we are well placed to achieve a
reconciliation of aspects of our culture because of the confused state in which we find ourselves: I
hope he is right, but reconciliation may be the last thing to emerge from such a state of confusion.[4]
(See *anthropology, *art, and *art history.)

292

1 Hans Belting, Cyril Mango and Doula Mouriki, *The Mosaics and Frescoes of St Mary Pammakaristos (Fethiye Camii) at
Istanbul*, Washington DC, 1978; *The Image and its Public in the Middle Ages: Form and Function of Early Paintings of the
Passion*, translated by M. Bartusis and R. Meyer, New Rochelle, 1990; and *Likeness and Presence: A History of the Image
before the Era of Art*, Chicago, 1993.

2 The extent to which art historians are more fully involved with contemporary art than they were a hundred or even
thirty years ago is evident from publications such as Francis Frascina, *Pollock and After: the Critical Debate*, London,
1985.

3 For an articulate artist speaking about the effects of theory on the making of art, see Terry Atkinson, 'Phantoms in the
Studio', *Oxford Art Journal*, 13, 1990, pp. 49–62.

4 For other articles on apocalyptic themes see Victor Burgin's article of the same name in *The End of Art Theory: Criticism
and Postmodernity*, Basingstoke and London, 1986, pp. 140–204, and Michael Rosenthal, 'The Death of British Art
History', *Art Monthly*, 125, April 1989, pp. 3–8.

25 | Hans Belting

The End of the History of Art?, 1984[1]

Hans Belting, *Das Ende der Kunstgeschichte*, Munich, 1984. Preface to *The End of the History of Art?*, translated by C.S. Wood, Chicago, University of Chicago Press, 1987, pp. ix–xii.

We have heard before of the end of the history of art: the end both of art itself and of the scholarly study of art. Yet every time that apparently inevitable end was lamented, things nevertheless carried on, and usually in an entirely new direction. Art is produced today in undiminished volume; the academic discipline, too, survives, although with less vitality and more self-doubt than ever. What does stand seriously in question is that conception of a universal and unified 'history of art' which has so long served, in different ways, both artist and art historian. Artists today often decline to participate in an ongoing *history* of art at all. In so doing they detach themselves from a tradition of thought which was after all initiated *by* an artist, Giorgio Vasari, and in many ways *for* artists, a tradition which provided artists with a common programme. Art historians appeared on the scene only much later. Today they either accept a model of history which they did not themselves devise, or shun the task of establishing a new model because they cannot. Both the artist and the art historian have lost faith in a rational, teleological process of artistic history, a process to be carried out by the one and described by the other.

The perplexity arising from this situation is not necessarily to be regretted, for it can incite the artist towards new objectives and the art historian towards new questions. What seemed for so long self-evident – the commitment to the concept of all-embracing, universal 'history' of art – suddenly strikes us as peculiar. But to reflect on the demise of a history of art is surely not to prophesy the end of the discipline of art history. Our theme is rather the emancipation from received models of the historical presentation of art, an emancipation often achieved in practice but seldom reflected upon. These models were for the most part varieties of stylistic history. They presented art as an autonomous system, to be evaluated by internal criteria. Human beings appeared in these histories only as artists or, if need be, as patrons.

The old art history sustained its first crisis at the hands of the avant-garde, which declared itself hostile to tradition and erected its own historical model. Afterwards two versions of the history of art coexisted, models which in their notions of 'progress' superficially resembled one another, but which in their actual accounts remained quite independent. Both versions preserved a faith in

293

the existence of 'art'. But that art no longer presented a single face: it had to be defined separately for the modern and premodern periods. Thus the historical account broke down precisely at that point where it might have engendered an alliance. This failure only revealed the extent to which both versions of the development of art had survived on the self-understanding of artists and on the arguments of critics – even as the academic discipline was desperately seeking scientific methods of its own.

The resulting confusion can generate productive energies only if its sources can be understood. For we have arrived at a point where questions about the meaning and function of art can only be discussed profitably within a larger context of past and present experience of art. Today artists include both older and modern art in the same retrospective survey, accepting both as historical phenomena, as a single problematic legacy to be confronted or consciously rejected. Likewise, the boundaries between art and the culture and people that produced it are being challenged. The interpretative tools of the old art history were refined to such an extreme that they threatened to become ends in themselves, and in those fields where the inventory of historical material was more or less complete they came to be of no practical use at all. Crossing the boundaries between art and its social or cultural 'background' demands different tools and different goals of interpretation. Only an attitude of experimentation promises new answers. The connoisseur, although he retains his right to existence, can as little provide these answers as the positivist who trusts only in strictly factual information, or the specialist who jealously defends his field against dilettantes.

Today the artist joins the historian in rethinking the function of art and challenging its traditional claim to aesthetic autonomy. The dutiful artist used to study masterpieces in the Louvre; today he confronts the entire history of mankind in the British Museum, acknowledging the historicity of past cultures and in the process becoming aware of his own historicity. Anthropological interests prevail over exclusively aesthetic interests. The old antagonism between art and life has been defused, precisely because art has lost its secure frontiers against other media, visual and linguistic, and is instead understood as one of various systems of explaining and representing the world. All this opens up new possibilities but also new problems for a discipline which has always had to legitimize the isolation of its object – art – from other domains of knowledge and interpretation.

This is not to suggest that art historians are to abandon the work of art as their primary object of enquiry, nor are they to borrow from social history or other disciplines what they ought to find out for themselves. Both the role of art in human society and the nature of the individual work of art – its status as an image or its 'figurality' – are permanently changing: they are more than ever deserving of scholarly attention. The role of art in our own society, at least in its traditional manifestations, is as uncertain as its further course is unpredictable. We no longer march forward along the narrow path of a unidirectional history of art, but instead have been granted a kind of momentary respite, in order to re-examine the various statuses and justifications of art, both in past centuries and in the era of modernism. Artists today are rethinking their own tasks, the surviving possibilities of such media as painting and sculpture, in light of the historical legacy of art. Art

historians are testing different models of telling the history of art, not the history of an unchallenged evolution but the history of ever new solutions for the ever new problem of what makes an 'image' and what make it a convincing vision of 'truth' at a given moment. Finally, the problem of the status of modern over against contemporary art demands the general attention of the discipline – whether one believes in postmodernism or not.

The present situations of art history as a discipline and of the experience of art as a general phenomenon allow for no easy answers. Initiating a fresh discussion of problems common to all art historians seems more urgent than offering a programme of action. Indeed, I am avoiding nothing so much as a new or other 'system' of art history. On the contrary, I am convinced that today only provisional or even fragmentary assertions are possible. Moreover, I often judge from within a German background, which may seem a disadvantage for English readers, but may also confirm that even in a world of disappearing boundaries, individual positions are still rooted in and limited by particular cultural traditions. This applies even more to personal convictions about art itself, which, however, are not my topic here ...

1 *The End of the History of Art?* has been revised and expanded as *Das Ende der Kunstgeschichte. Eine Revision nach zehn Jahren*, Munich, 1994. It includes a section on present-day art institutions and also takes account of the changing notion of art history in a world of new media, with a chapter devoted to Peter Greenaway and the cinema.

Griselda Pollock (1949–) is one of the best-known writers on ʾfeminism and ʾart history. She has explored the relationship between the two largely in the context of nineteenth- and twentieth-century painting, in books such as *Mary Cassatt* (1980), *Old Mistresses: Women, Art and Ideology*, with Rozsika Parker (1981), and *Dealing with Degas: Representations of Women and the Politics of Vision*, with Richard Kendall (1992).[1] She is professor of the Social and Critical Histories of Art at the University of Leeds, but has on occasions questioned whether she views the discipline from within or without, as is indicated by the title of the text reprinted here. This is the first chapter of *Vision and Difference*, and is intended to serve as an outline of Pollock's main ideas on the relationship between feminism and art history, and as an introduction to the rest of the essays in the book.[2]

To summarize Pollock's argument, adding women to the history of art challenges the discipline politically because their exclusion from it is the result of structural sexism, which operates alongside class and race to maintain the status quo. Once feminists had established that there had been women artists, it became clear that there was no point in then looking for 'great' women artists – for female Michelangelos – because the criteria for greatness have been laid down by men.

Feminist art historians need therefore to reveal the biases of the history of art not merely concerning women artists, but in the discipline as a whole. Specifically, they need to produce a change in thinking, a paradigm shift, criticize and reject the view (which underpins the art history of modernism in particular) that creativity exists in an aesthetic realm separate from any social context. Artistic creation must be seen as artistic production, using Marx's model of the totality of social forces. Marx rejected the model of the individual artist creating images which the art world then accepts or rejects, and substituted one in which the arts are the result of the social relations which form their productive conditions; that is, he moved the stress from the consumption of the object to its social production. Art must be seen in the context of the whole of society.

Pollock continues with the observation that there are close parallels to this approach in other fields, including the social history of art, literary studies and film theory. Images and texts are not mirrors of the world, but things which have been coded by various conventions. They are also a means of setting out social processes, that is, they are formed as much by the rules of one particular mode of representation as by their ostensible subject. This point can be clarified by the concept of ideology, which Pollock defines as a hierarchy of meanings and a means of using them in power

relations in society. Culture is what both makes us part of an ideology and helps us to understand our place in it.

In Pollock's view, understanding the role which both the making and the study of art play, as outlined in the other chapters of *Vision and Difference*, requires two things. The first is the establishment of the place of art in the struggles between classes, races and genders, and the second is the specific process of analysing what is being produced, and how and for whom in any individual case. The means for doing this are provided by the study of sign systems and psychoanalysis, in short by the study of cultural practices, which are our chief means as human beings of understanding the world and surviving in it.

Contributions have also been made by women's studies, especially in confronting the political effects of the existence of boundaries between disciplines, and in breaking them down. We need to question whether such pairs of apparent opposites as man/woman, individual/family do not mean very different things in different circumstances, so that in talking of two women, one in seventeenth-century England and one in twentieth-century India, we do not assume that the two different sets of circumstances contain the same concept of woman. In short we need to establish the extent to which sexual differences are produced by social forms. For example, a visitor to the Royal Academy in London in the middle of the nineteenth century, seeing a painting of a woman choosing a sexual partner to whom she is not married would have classified her as a fallen woman, a disordering force, an animalized creature characteristic of the working classes and primitive peoples. One must ask whether the response would have been different if the viewer were a man rather than a woman, or if the artist had been a woman instead of a man. This in turn raises the question of the extent to which it was possible for a woman to paint seriously in the middle of the nineteenth century, especially if she intended to earn money from doing so, a question which cannot be discussed outside a consideration of the position of women in British society as a whole at the time.

Pollock argues that this sort of approach can radically transform existing accounts of the subject in question, so that a study of women Impressionists involving all these aspects will also challenge masculine assumptions behind conventional accounts of late nineteenth-century painting. The aim is to show that feminist intervention goes beyond a local concern with 'the woman question' and makes gender central to the terms of historical analysis.

Another area in which feminist approaches have a particular contribution to make is in that of genius, which in traditional art history is an exclusively male preserve. Indeed, it remains so even in the writings of scholars otherwise closely allied in their methods and aims to the feminists, including Marxists such as Clark (text 21, 1974), the art historian Harrison and the artists Baldwin and Ramsden (text 23, 1981) and the French Marxist theorist Louis Althusser. An analysis of the treatment of the history of Elizabeth Siddal in histories of Pre-Raphaelitism illustrates this: in most texts Siddal appears only as the inspiration of the 'fascinating Victorian genius' Rossetti. Her history must therefore be rewritten in terms of the social conditions of working women, of milliners, models and teachers in the London of the time.

Feminist approaches can also be applied to the psychoanalytical analysis of texts. Rossetti again provides a useful example, with excerpts from his writings involving descriptions of women. Freudianism is considered an acceptable tool in this sphere if it is seen not as a prescription for a

patriarchal society but as a description of one. Just as Marxist theory explains the historical and economic situation, so can psychoanalysis provide an understanding of ideology and sexuality. Thus while the distinctions drawn in the nineteenth century between men and women are fundamental, they appear quite abstract when compared with the very specific distinctions maintained between classes (contrast, for example, ladies and women, with gentlemen and working-class men). All of these considerations and methods can be brought to bear on the texts selected from Rossetti to reveal the sexual ideology which conditions them. Psychoanalysis underlines the importance of the visual in the construction of sexual difference. Woman is a visual sign, so that feminist analyses focus on pleasure, as Marxist ones focus on ideology. The works of Rossetti dramatize the excessive representation of women at this period. This analysis of visual codes and their institutional support stands in sharp contrast to traditional art-historical discussions of styles or movements such as Pre-Raphaelitism, Impressionism, and so on.

298

The women's movement uses psychoanalytical analysis to break down the barriers between art making, art history and art criticism. The political point of feminist art history must be to change the present by means of the way in which we describe the past, which means that we cannot ignore living artists. Just as feminist art history confronts modernist art history, so feminist art practice confronts modernist art practice. Feminist art groups have helped attack the autonomous and apolitical position of modernism, which is still powerful in art education despite the belief that we live in a postmodern age. Their purpose is not merely to make a place for women artists in the contemporary art world, but to attack contemporary visual systems which have such a great effect on the social conditioning of sexual difference. These women artists are discovering means of addressing women in ways not conditioned by masculine desire, fantasy and hatred. Feminist artists therefore contribute to feminist art history and vice versa.

Pollock sums up her book as a contribution to the feminist intervention in the history of art. This intervention is practical, and is conditioned by the class, race and gender of those who produce it. Alliances with those criticizing modernism have helped shape feminist approaches while also revealing the institutional reasons for blindness on the part of some of these allies towards issues of gender and, in their ethnocentricity, of race. This suggests an agenda for future work focusing on the fact that our societies are not only middle-class but also imperialist and colonizing.

Pollock describes the community from which her book emerges and to which it is addressed as consisting of feminists across the world, as part of the intellectual contribution to the political struggle. The aim of feminism for Pollock is revolution, in the spheres of both theory and practice, which are indispensable to each other. What has art history to do with the struggle for the liberation of women? Art history is now closely related to big business and major exhibitions are sponsored by multinational companies. When one asks what they hope to get in return for their support, the answer, at least for an exhibition like that on the Pre-Raphaelites in 1984, is in part the following: they want an assertion of the values and meanings by which women are oppressed, in which creativity is male, women provide the beautiful images for the male gaze, are denied the role of producers of culture, and are treated as signs within a narrative which is about masculinity.

There is now in Pollock's view a complete breakdown in communication between traditional art historians and those who are contesting the old model. The new model will rewrite all of cultural history. Feminist contributions to this rewriting are not part of a fledgling discipline like a 'new art

history' aiming to make improvements or season the old with current intellectual fashions; they are part of a functioning women's movement set on changing the world.

Turning from summary to comment, this text can be described as a statement of commitment to action in support of the women's movement. Pollock expressly places herself outside art history and as intervening in it, so that another author commenting from within the discipline unavoidably sets her arguments in a different context. Thus, if I claim the introduction of women's art and the new ways of examining it as pure gain for the history of art, I am likely to be acting counter to Pollock's intentions.

This is the most polemical of the texts published here. Its mode of characterization can be illustrated by two of Pollock's comments on the pervasiveness of the exclusion of women from the category of genius. In the first, Pollock ascribes to modernist art history the view that women cannot be great artists because they lack the phallus, which is what constitutes the nugget of genius. A number of artists can readily be described as painting with their penis, such as Picasso and Alan Jones (though the second denies it),[3] and some art historians have followed this lead in discussing their work. However, Pollock's description is not recognizable as a characterization of the literature on modern artists as a whole.

In the second, Pollock implies (by the insertion of the word sic) that authorship is presumed by writers in general to be exclusively male ('the notion of a beautiful object or fine book expressing the genius of the author/artist and through him (sic) the highest aspirations of human culture ...'). While it is undeniably the case that the contribution of women artists to the visual arts has not been acknowledged, in literature there is in the late twentieth century little if any indication of an analogous exclusion of women from the °canon of great writers.

The other issues that Pollock raises are discussed in the relevant entries in the glossary, in connection with the following questions. To what extent is it possible to conduct a political campaign by scholarly means (see °politics)? What advantage is gained from requiring that a subject is approached in only one way (see °theory)? What are the gains and losses of using a language only easily accessible to a particular group (see °vocabulary)? (See also °feminism, °ideology, °semiotics, °psychoanalysis, °art and °art history.)

In conclusion it is worth noting that Pollock is as critical of the art-historical profession as Morelli was a century ago, except that she makes her criticisms from a diametrically opposite direction. Morelli castigated art historians for relying on reading and for thinking about their subject without the experience of the individual work of art, that is, for spending more time in the library than the gallery (text 8, 1890). Pollock criticizes them for being too wedded to the individual work of art and the individual artist and for being unwilling to take up the challenge of theory and sociology, that is for spending more time in the gallery than the library.

1 Griselda Pollock, *Mary Cassatt*, London, 1980; Griselda Pollock and Rozsika Parker, *Old Mistresses: Women, Art and Ideology* (1981), reprinted, London, 1987; and Griselda Pollock and Richard Kendall, eds., *Dealing with Degas: Representations of Women and the Politics of Vision*, London, 1992.

2 Griselda Pollock, *Vision and Difference: Femininity, Feminism and the Histories of Art*, London, 1988, pp. 1–17.

3 On this issue see also Lisa Tickner, 'The Body Politic: Female Sexuality and Women Artists since 1970', *Art History*, 1, 1978, pp. 236–51, especially p. 242.

'Feminist Interventions in the
Histories of Art', 1988

Griselda Pollock, 'Feminist Interventions in the
Histories of Art: an Introduction', in *Vision and
Difference: Femininity, Feminism and the Histories
of Art*, London, 1988, pp. 1–17.

Is adding women to art history the same as producing feminist art history? Demanding that women be considered not only changes what is studied and what becomes relevant to investigate but it challenges the existing disciplines politically. Women have not been omitted through forgetfulness or mere prejudice. The structural sexism of most academic disciplines contributes actively to the production and perpetuation of a gender hierarchy. What we learn about the world and its peoples is ideologically patterned in conformity with the social order within which it is produced. Women's studies are not just about women – but about the social systems and ideological schemata which sustain the domination of men over women within the other mutually inflecting regimes of power in the world, namely those of class and those of race.

Feminist art history, however, began inside art history. The first question was 'Have there been women artists?' We initially thought about women artists in terms of art history's typical procedures and protocols – studies of artists (the monograph), collections of works to make an *œuvre* (*catalogues raisonnés*), questions of style and iconography, membership of movements and artists' groups, and of course the question of quality. It soon became clear that this would be a straitjacket in which our studies of women artists would reproduce and secure the normative status of men artists and men's art whose superiority was unquestioned in its disguise as Art and the Artist. As early as 1971 Linda Nochlin warned us against getting into a no-win game trying to name female Michelangelos. The criteria of greatness were already male-defined. The question 'Why have there been no great women artists?' simply would not be answered to anything but women's disadvantage if we remained tied to the categories of art history. These specified in advance the kind of answers such a question would merit. Women were not historically significant artists (they could never deny their existence once we began to unearth the evidence again) because they did not have the innate nugget of genius (the phallus) which is the natural property of men. So she wrote:

'*A feminist critique of the discipline is needed which can pierce cultural-ideological limitations, to reveal biases and inadequacies* not merely in regard to the question of women artists, but in the formulation of the crucial questions of the discipline

as a whole. *Thus the so-called woman question, far from being a peripheral sub-issue, can become a catalyst, a potent intellectual instrument, probing the most basic and 'natural' assumptions, providing a paradigm for other kinds of internal questioning, and providing links with paradigms established by radical approaches in other fields.'*

In effect, Linda Nochlin called for a paradigm shift. The notion of a paradigm has become quite popular among social historians of art who borrow from Thomas Kuhn's *Structure of Scientific Revolutions* in order to articulate the crisis in art history which overturned its existing certainties and conventions in the early 1970s. A paradigm defines the objectives shared within a scientific community, what it aims to research and explain, its procedures and its boundaries. It is the disciplinary matrix. A paradigm shift occurs when the dominant mode of investigation and explanation is found to be unable satisfactorily to explain the phenomenon which it is that science's or discipline's job to analyse. In dealing with the study of the history of nineteenth- and twentieth-century art the dominant paradigm has been identified as modernist art history. (This is discussed at the beginning of Essay 2). It is not so much that it is defective but that it can be shown to work ideologically to constrain what can and cannot be discussed in relation to the creation and reception of art. Indeed modernist art history shares with other established modes of art history certain key conceptions about creativity and the suprasocial qualities of the aesthetic realm. Indicative of the potency of the ideology is the fact that when, in 1974, the social historian of art T.J. Clark, in an article in the *Times Literary Supplement*, threw down the gauntlet from a Marxist position he still entitled the essay 'The Conditions of Artistic *Creation*' [text 21, 1974].

Within a few years the term production would have been inevitable and consumption has come to replace reception. This reflects the dissemination from the social history of art of categories of analysis derived from Karl Marx's methodological exerque *Grundrisse* ('Foundations'). The introduction to this text which became known only in the mid-1950s has been a central resource for rethinking a social analysis of culture. In the opening section Marx tries to think about how he can conceptualize the totality of social forces each of which has its own distinctive conditions of existence and effects yet none the less relies on others in the whole. His objective is political economy and so he analyses the relations between production, consumption, distribution and exchange, breaking down the separateness of each activity so that he can comprehend each as a distinct moment within a differentiated and structured totality. Each is mediated by the other moments, and cannot exist or complete its purpose without the others, in a system in which production has priority as it sets all in motion. Yet each also has its own specificity, its own distinctiveness within this non-organic totality. Marx gives the example of art in order to explain how the production of an object generates and conditions its consumption and vice versa.

'*Production not only supplies a material for a need, but also supplies a need for the material. As soon as consumption emerges from its initial natural state of crudity and immediacy ... it becomes itself mediated as a drive by the object. The need which consumption feels for the object is created by the perception of it. The object of art – like every other*

301

product – creates a public which is sensitive to art and enjoys beauty. Production not only creates an object for the subject, but also a subject for the object. Thus production produces consumption, (1) by creating the material for it; (2) by determining the manner of consumption; (3) by creating the products initially posited as objects in the form of a need felt by the consumer. It thus produces the object of consumption, the manner of consumption and the motive of consumption. Consumption likewise produces the producer's inclination by beckoning to him as an aim-determining need.'

This formulation banishes the typical art-historical narrative of a gifted individual creating out of his (*sic*) personal necessity a discrete work of art which then goes out from its private place of creation into a world where it will be admired and cherished by art lovers expressing a human capacity for valuing beautiful objects. The discipline of art history like literary criticism works to naturalize these assumptions. What we are taught is how to appreciate the greatness of the artist and the quality of art objects.

This ideology is contested by the argument that we should be studying the totality of social relations which form the conditions of the production and consumption of objects designated in that process as art. Writing of the shift in the related discipline of literary criticism, Raymond Williams has observed: 'What seems to me very striking is that nearly all forms of contemporary critical theory are theories of *consumption*. That is to say, that they are concerned with understanding an object in such a way that it can be profitably and correctly consumed.'

The alternative approach is not to treat the work of art as object but to consider art as practice. Williams advocates analysing first the nature and then the conditions of a practice. Thus we will address the general conditions of social production and consumption prevailing in a particular society which ultimately determine the conditions of a specific form of social activity and production, cultural practice. But then since all the component activities of social formation are practices we can move with considerable sophistication from the crude Marxist formulation of all cultural practices being dependent upon and reducible to economic practices (the famous base–superstructure idea) towards a conception of a complex social totality with many interrelating practices constitutive of, and ultimately determined within, the matrix of that social formation which Marx formulated as the mode of production. Raymond Williams in another essay made the case:

'The fatally wrong approach, to any such study, is from the assumption of separate orders, as when we ordinarily assume that political institutions and conventions are of a different and separate order from artistic institutions and conventions. Politics and art, together with science, religion, family life and the other categories we speak of as absolutes, belong in a whole world of active and interactive relationships … If we begin from the whole texture, we can go on to study particular activities, and their bearings on other kinds. Yet we begin, normally, from the categories themselves, and this has led again and again to a very damaging suppression of relationships.'

Williams is formulating here one of the major arguments about method propounded by Marx in *Grundrisse* where Marx asked himself where to begin his

analyses. It is easy to start with what seems a self-evident category, such as popula-
tion in Marx's case, or art in ours. But the category does not make sense without
understanding of its components. So what method should be followed?

> '*Thus, if I were to begin with the population, this would be a chaotic conception of the
> whole, and I would then, by means of further determination move analytically towards
> ever more simple concepts, from the imaginary concrete to ever thinner abstractions until I
> had arrived at the simplest determinations. From there the journey would have to be
> retraced until I had finally arrived at the population again, but this time not as a chaotic
> conception of a whole but as a rich totality of many determinations and relations.*'

If we were to take art as our starting-point, it would be a chaotic conception, an
unwieldy blanket term for a diversified range of complex social, economic, and
ideological practices and factors. Thus we might break it down to production,
criticism, patronage, stylistic influences, iconographic sources, exhibitions, trade,
training, publishing, sign systems, publics, etc. There are many art history books
which leave the issue in that fragmented way and put it together as a whole only
by compiling chapters which deal with these components separately. But this is to
leave the issue at the analytical level of the thin abstractions, i.e. elements
abstracted from their concrete interactions. So we retrace the steps attempting to
see art as a *social practice*, as a totality of many relations and determinations, i.e.
pressures and limits.

Shifting the paradigm of art history involves therefore much more than
adding new materials – women and their history – to existing categories and
methods. It has led to wholly new ways of conceptualizing what it is we study
and how we do it. One of the related disciplines in which radical new
approaches were on offer was the social history of art. The theoretical and
methodological debates of Marxist historiography are extremely pertinent and
necessary for producing a feminist paradigm for the study of what it is proper
to rename as cultural production … While it is important to challenge the pater-
nal authority of Marxism under whose rubric sexual divisions are virtually
natural and inevitable and fall beneath its theoretical view, it is equally important
to take advantage of the theoretical and historiographical revolution which the
Marxist tradition represents. A feminist historical materialism does not merely
substitute gender for class but deciphers the intricate interdependence of class
and gender, as well as race, in all forms of historical practice. None the less
there is a strategic priority in insisting upon recognition of gender power and of
sexuality as historical forces of significance as great as any of the other matrices
privileged in Marxism or other forms of social history or cultural analysis. In
Essay 3 a feminist analysis of the founding conditions of modernism in the gen-
dered and eroticized terrain of the modern city directly challenges an authorita-
tive social historical account which categorically refuses feminism as a necessary
corollary. The intention is to displace the limiting effects of such partial re-
readings and to reveal how feminist materialist analysis handles not only the
specific issues of women in cultural history but the central and commonly
agreed problems.

303

There were, however, other new models developing in corresponding disciplines such as literary studies and film theory, to name but the most influential. Initially the immediate concern was to develop new ways of analysing texts. The notion of a beautiful object or fine book expressing the genius of the author/artist and through him (*sic*) the highest aspirations of human culture was displaced by a stress on the productive activity of texts – scenes of work, writing or sign making, and of reading, viewing. How is the historical and social at work in the production and consumption of texts? What are texts doing socially?

Cultural practices were defined as signifying systems, as practices of *representation*, sites not for the production of beautiful things evoking beautiful feelings. They produce meanings and positions from which those meanings are consumed. Representation needs to be defined in several ways. As Representation the term stresses that images and texts are no mirrors of the world, merely reflecting their sources. Representation stresses something refashioned, coded in rhetorical, textual or pictorial terms, quite distinct from its social existence. Representation can also be understood as 'articulating' in a visible or socially palpable form social processes which determine the representation but then are actually affected and altered by the forms, practices and effects of representation. In the first sense representation of trees, persons, places is understood to be ordered according to the conventions and codes of practices of representation, painting, photography, literature and so forth. In the second sense, which involves the first inevitably, representation articulates – puts into words, visualizes, puts together – social practices and forces which are not, like trees, there to be seen but which we theoretically know condition our existence. In one of the classic texts enunciating this phenomenon, *The Eighteenth Brumaire of Louis Napoleon* (1852), Karl Marx repeatedly relies on the metaphor of the stage to explain the manner in which the fundamental and economic transformations of French society were played out in the political arena 1848–51, a political level which functioned as a representation but then actively effected the conditions of economic and social development in France subsequently. Cultural practice as a site of such representation has been analysed in terms derived from Marx's initial insights about the relation between the political and economic levels. Finally, representation involves a third inflection, for it signifies something represented to, addressed to a reader/viewer/consumer.

Theories of representation have been elaborated in relation to Marxist debates about ideology. Ideology does not merely refer to a collection of ideas or beliefs. It is defined as a systematic ordering of a hierarchy of meanings and a setting in place of positions for the assimilation of those meanings. It refers to material practices embodied in concrete social institutions by which the social systems, their conflicts and contradictions are negotiated in terms of the struggles within social formations between the dominant and the dominated, the exploiting and the exploited. In ideology cultural practices are at once the means by which we make sense of the social process in which we are caught up and indeed produced. But it is a site of struggle and confusion for the character if the knowledges are ideological, partial, conditioned by social place and power.

Understanding of what specific artistic practices are doing, their meanings and social effects, demands therefore a dual approach. First the practice must be

located as part of the social struggles between classes, races and genders, articulating with other sites of representation. But second we must analyse what any specific practice is doing, what meaning is being produced, and how and for whom. Semiotic analysis has provided necessary tools for systematic description of how images or languages or other sign systems (fashion, eating, travel, etc.) produce meanings and positions for the consumption of meanings. Mere formal analysis of sign systems, however, can easily lose contact with the sociality of a practice. Semiotic analysis, approached through developments in theories of ideology and informed by analyses of the production and sexing of subjectivities in psychoanalysis, provided new ways to understand the role of cultural activities in the making of meanings, but more importantly in the making of social subjects. The impact of these procedures on the study of cultural practices entirely displaces pure stylistic or iconographic treatments of isolated groups of objects. Cultural practices do a job which has a major social significance in the articulation of meanings about the world, in the negotiation of social conflicts, in the production of social subjects.

305

As critical as these 'radical approaches in other fields' was the massive expansion of feminist studies attendant on the resurgence of the women's movement in the late 1960s. Women's studies emerged in almost all academic disciplines challenging the 'politics of knowledge'. But what is the object of women's studies? Writing women back does indeed cause the disciplines to be reformulated but it can leave the disciplinary boundaries intact. The very divisions of knowledge into segregated compartments have political effects. Social and feminist studies in cultural practices in the visual arts are commonly ejected from art history by being labelled a sociological approach, as if reference to social conditions and ideological determinations are introducing foreign concerns into the discrete realm of art. But if we aim to erode the false divisions what is the unifying framework for the analysis of women?

In their introduction to the anthology *Women and Society*, the collective responsible for the 'Women in Society' course at Cambridge University in the 1970s questioned the possibility of even taking the term women for granted:

'*At first sight, it might seem as if concepts like male/female, man/woman, individual/family are so self evident that they need no "decoding", but can simply be traced through various historical or social changes. These changes would, for example, give a seventeenth-century English woman a different social identity from a low-caste Indian woman today, or would ascribe different functions to the family in industrial and pre-industrial societies. But the problem with both these examples is that they leave the alleged subject of these changes (woman, the family) with an apparently coherent identity which is shuffled from century to century or from society to society as if it was something that already existed independent of particular circumstances. One purpose of this book, and of our course as it has gradually evolved, is to question that coherency: to show that it is constructed out of social givens which can themselves be subjected to similar questioning. This book, therefore, concentrates on themes that return to the social rather than to the individual sphere,* emphasizing the social construction of sexual difference' [Pollock's emphasis].

At a conference the artist Mary Kelly was asked to talk to the question 'What is feminist art?' She redirected the question to ask 'What is the problematic for feminist artistic practice?' where problematic refers to the theoretical and methodological field from which statements are made and knowledge produced. The problematic for feminist analyses of visual culture as part of a broader feminist enterprise could be defined in terms offered above, the social construction of sexual difference. But it would need to be complemented by analysis of the psychic construction of sexual difference which is the site for the inscription into individuals, through familial social relations, of the socially determined distinction which privileges sex as a criterion of power.

We do need to point out the discrimination against women and redress their omission. But this can easily become a negative enterprise with limited objectives, namely correction and improvement. In art history we have documented women's artistic activity and repeatedly exposed the prejudice which refused to acknowledge women's participation in culture. But has it had any real effect? Courses on women and art are occasionally allowed in marginal spaces which do not replace the dominant paradigm. But even then there is cause for alarm. For instance in my institution on a four-year degree scheme students are exposed to feminist critiques of art history and a course on contemporary feminist artists for a period of twenty weeks, one two-term course. None the less the question was raised by an external assessor as to whether there was not too much feminism in this course. Indeed we should be deeply concerned about bias but no one seems unduly concerned about the massive masculinism of all the rest of our courses. The anxiety reflects something greater at stake than talking about women. Feminist interventions demand recognition of gender power relations, making visible the mechanisms of male power, the social construction of sexual difference and the role of cultural representations in that construction.

So long as we discuss women, the family, crafts or whatever else we have done as feminists we endorse the social givenness of woman, the family, the separate sphere. Once we insist that sexual difference is *produced* through an interconnecting series of social practices and institutions of which families, education, art studies, galleries and magazines are part, then the hierarchies which sustain masculine dominance come under scrutiny and stress, then what we are studying in analysing the visual arts is one instance of this production of difference which must of necessity be considered in a double frame: (a) the specificity of its effects as a particular practice with its own materials, resources, conditions, constituencies, modes of training, competence, expertise, forms of consumption and related discourses, as well as its own codes and rhetorics; (b) the interdependence for its intelligibility and meaning with a range of other discourses and social practices. For example the visitor to the Royal Academy in London in the mid-nineteenth century carried with her a load of ideological baggage composed of the illustrated papers, novels, periodical magazines, books on child care, sermons, etiquette manuals, medical conversations, etc., addressed to and consumed in distinctive ways by women of the bourgeoisie hailed through these representations as ladies. They are not all saying the same thing – the crude dominant ideology thesis. Each distinctively articulates the pressing questions about definitions of masculinity and

femininity in terms of an imperialist capitalist system, in ways determined by its institutional site, producers and publics. But in the interconnections, repetitions and resemblances a prevailing regime of truth is generated providing a large framework of intelligibility within which certain kinds of understanding are preferred and others rendered unthinkable. Thus a painting of a woman having chosen a sexual partner outside marriage will be read as a fallen woman, a disordering force in the social fabric, an embodiment of mayhem, a contaminating threat to the purity of a lady's womanhood, an animalized and coarsened creature closer to the physicality of the working-class populations and to the sexual promiscuity of 'primitive' peoples, etc., etc.

But will it be read differently if the viewer is a woman or a man? Will the representation be different if the producer is a woman or a man? This is a question I address in Essay 3. One of the primary responsibilities of a feminist intervention must be the study of women as producers. But we have problematized the category women to make its historical construction the very object of our analysis. Thus we proceed not from the assumption of a given essence of woman outside of, or partially immune to, social conditions but we have to analyse the dialectical relation between being a person positioned as in the feminine within historically varying social orders and the historically specific ways in which we always exceed our placements. To be a producer of art in bourgeois society in late nineteenth-century Paris was in some sense a transgression of the definition of the feminine, itself a class-loaded term. Women were meant to be mothers and domestic angels who did not work and certainly did not earn money. Yet the same social system which produced this ideology of domesticity embraced and made vivid by millions of women, also generated the feminist revolt with a different set of definitions of women's possibilities and ambitions. These were, however, argued for and lived out within the boundaries established by the dominant ideologies of femininity. In that subtle negotiation of what is thinkable or beyond the limits, the dominant definitions and the social practices through which they are produced and articulated are modified – sometimes radically – as at moments of maximum collective political struggle by women or less overtly as part of the constant negotiations of contradictions to which all social systems are subject. In those spaces where difference is most insistently produced, as I define the eroticized territories of the modern city in Essay 3, it is possible to outline in larger characters the differential conditions of women's artistic practice in such a way that its delineation radically transforms the existing accounts of the phenomenon. In Essay 3 on 'Modernity and the Spaces of Femininity' my argument is addressed to feminists engaged in the study of the women Impressionists, but equally it is a critique of both modernist and social art historians' versions of 'the painting of modern life' which exclusively consider the inescapable issues of sexuality from a masculinist viewpoint. My aim is precisely to show how a feminist intervention exceeds a local concern with 'the woman question' and makes gender central to our terms of historical analysis (always in conjunction with the other structurations such as class and race which are mutually inflecting).

A particularly fruitful resource for contemporary cultural studies has been 'discourse analysis', particularly modelled on the writings of the French historian

307

Michel Foucault. Foucault provided an anatomy of what he called the human sciences. Those bodies of knowledge and ways of writing which took as their object – and in fact produced as a category for analysis – Man. He introduced the notion of discursive formation to deal with the systematic interconnections between an array of related statements which define a field of knowledge, its possibilities and its occlusions. Thus on the agenda for analysis is not just the history of art, i.e. the art of the past, but also art history, the discursive formation which invented that entity to study it. Of course there has been art before art history catalogued it. But art history as an organized discipline defined what it is and how it can be spoken of. In writing *Old Mistresses: Women, Art and Ideology* (1981) Rozsika Parker and I formulated the issue thus: 'To discover the history of women and art is in part to account for the way art history is written. To expose its underlying values, its assumptions, its silences and its prejudices is also to understand that the way women artists are recorded is crucial to the definition of art and artist in our society.'

308

Art history itself is to be understood as a series of representational practices which actively produce definitions of sexual difference and contribute to the present configuration of sexual politics and power relations. Art history is not just indifferent to women; it is a masculinist discourse, party to the social construction of sexual difference. As an ideological discourse it is composed of procedures and techniques by which a specific representation of art is manufactured. That representation is secured around the primary figure of the artist as individual creator. No doubt theories of the social production of art combined with the structuralist assassination of the author would also lead to a denunciation of the archaic individualism at the heart of art-historical discourse. But it is only feminists who have nothing to lose with the desecration of Genius. The individualism of which the artist is a prime symbol is gender exclusive. The artist is one major articulation of the contradictory nature of bourgeois ideals of masculinity. The figure remains firmly entrenched in Marxist art history, witness the work of T.J. Clark, the Modern Art and Modernism course at the Open University, and even Louis Althusser on Cremonini. It has become imperative to deconstruct the ideological manufacture of this privileged masculine individual in art-historical discourse. In Essay 4 Deborah Cherry and I analyse the reciprocal positioning of masculine creator and passive feminine object in the art-historical texts which form the continuing basis for studies of Pre-Raphaelitism. The point of departure was an attempt to write Elizabeth Siddall and other women artists of the group back into art history. But they are already there, doing a specific job in their appointed guise. Any work on historical producers such as Elizabeth Siddall required at once a double focus. Initially it needed a critical deconstruction of the texts in which she is figured as the beloved inspiration and beautiful model of the fascinating Victorian genius Rossetti. Furthermore it involved a realization that her history lay right outside the discursive field of art history in feminist historical research which would not focus on individuals but on the social conditions of working women in London as milliners, models, in educational establishments, etc. In conjunction with an analysis derived from the model of Foucault's work we deployed the notion of woman as sign developed in an article by Elizabeth Cowie in 1978. Cowie combined models from structural anthropology's analysis of the

exchange of women as a system of communication with semiotic theory about signifying systems. Cowie's essay still provides one of the path-breaking theorizations of the social production of sexual difference.

Complementing the task of deconstruction is feminist rewriting of the history of art in terms which firmly locate gender relations as a determining factor in cultural production and in signification. This involves feminist readings, a term borrowed from literary and film theory. Feminist readings involve texts often produced by men and with no conscious feminist concern or design which are susceptible to new understanding through feminist perceptions. In Essay 6 I offer psychoanalytically derived readings of representations of woman in selected texts by the Victorian painter D.G. Rossetti. Psychoanalysis has been a major force in European and British feminist studies despite widespread feminist suspicion of the sexist applications of Freudian theory in this century. As Juliet Mitchell commented in her important book challenging feminist critique, *Psychoanalysis and Feminism*, Freudian theory offers not a prescription for a patriarchal society but a description of one which we can use to understand its functionings. In her introduction she referred to the Parisian feminist group Psychoanalyse et Politique and explained their interest in psychoanalysis:

> '*Influenced, but critically, by the particular interpretation of Freud offered by Jacques Lacan, Psychoanalyse et Politique would use psychoanalysis for an understanding of the operations of the unconscious. Their concern is to analyse how men and women live as* men and women *within the material conditions of their existence – both general and specific. They argue that psychoanalysis gives us the concepts with which we can comprehend how ideology functions; closely connected with this, it further offers analysis of the place and meaning of sexuality and gender differences within society. So where Marxist theory explains the historical and economic situation, psychoanalysis, in conjunction with notions of ideology already gained in dialectical materialism, is the way of understanding ideology and sexuality.*'

Foucault has provided a social account of the discursive construction of sexuality *and* he argued that in some critical sense 'sexuality' is fundamentally bourgeois in origin. 'It was in the great middle classes that sexuality, albeit in a morally restricted and sharply defined form, first became of major ideological significance.' Foucault identifies psychoanalysis as itself a product of the will to know, the construction and subjection of the sexualized body of the bourgeoisie. The deployment of psychoanalytical theory by contemporary feminists is not a flight from historical analysis into some universalistic theory. Rooted historically as the mode of analysis (and a technique for relieving the extreme effects) of the social relations, practices and institutions which produced and regulated bourgeois sexuality, psychoanalysis makes its revelation of the making of sexual difference. Foucault speaks of class sexualities but these fundamentally involved gendered sexualities. The making of masculine and feminine subjects crucially involved the manufacture and regulation of sexualities, radically different and hardly complementary let alone compatible, between those designated men and women. But these terms were ideological abstractions compared to the careful distinctions

309

maintained between ladies and women in class terms, and gentlemen and working-class men. The social definitions of class and of gender were intimately connected. But the issue of sexuality and its constant anxieties pressed with major ideological significance on the bourgeoisie. The case of Rossetti is studied not for an interest in this artist's particularity but in the generality of the sexual formation which provides the conditions of existence of these texts. To use Jacqueline Rose's phrase, we are dealing with bourgeois 'sexuality in the field of vision'.

For through psychoanalytical theory we can recognize the specificity of visual performance and address. The construction of sexuality and its underpinning sexual difference is profoundly implicated in looking and the 'scopic field'. Visual representation is a privileged site (forgive the Freudian pun). Works by Rossetti are studied not as a secondary version of some founding social moment, but as part of a continuum of representations from and to the unconscious, as well as at the manifest level through which masculine sexuality and sexual positionality was problematically negotiated by the mid-nineteenth-century metropolitan bourgeoisie. Woman is the visual sign, but not a straightforward signifier. If Marxist cultural studies rightly privilege ideology, feminist analyses focus on pleasure, on the mechanisms and managements of sexualized pleasures which the major ideological apparatuses organize, none more potently than those involved with visual representation. The works by Rossetti dramatize precisely the drives and impediments which overdetermine the excessive representation of woman at this period. The term 'regime of representation' is coined to describe the formation of visual codes and their institutional circulation as a decisive move against art history's patterns of periodization by style and movement, e.g. Pre-Raphaelitism, Impressionism, Symbolism, and so forth. In place of superficial stylistic differences, structural similarities are foregrounded.

In the final essay I consider the works of a group of feminist art producers in Britain in the 1970s and 1980s for whom psychoanalytical analyses of the visual pleasures is a major resource for their production of feminist interventions in artistic practice. There are significant continuities between feminist art practice and feminist art history, for those dividing walls which normally segregate artmaking from art criticism and art history are eroded by the larger community to which we belong as feminists, the women's movement. We are our own conversational community developing our paradigms of practice in constant interaction and supportive commentary. The political point of feminist art history must be to change the present by means of how we re-represent the past. That means we must refuse the art historian's permitted ignorance of living artists and contribute to the present-day struggles of living producers.

There are other links which make it relevant to conclude this book with an essay on contemporary feminist art. If modernist art history supplies the paradigm which feminist art history of the modern period must contest, modernist criticism and modernist practice are the targets of contemporary practice. Modernist thought has been defined as functioning on three basic tenets: the specificity of aesthetic experience; the self-sufficiency of the visual; the teleological evolution of art autonomous from any other social causation or pressure. Modernist protocols prescribe what is validated as 'modern art', i.e. what is relevant, progressing,

and in the lead. Art which engages with the social world is political, sociological, narrative, demeaning the proper concerns of the artist with the nature of the medium or with human experience embodied in painted or hewn gestures. Feminist artistic practices and texts have intervened in alliance with other radical groups to disrupt the hegemony of modernist theories and practices even now still active in art education in so-called postmodernist culture. They have done this not merely to make a place for women artists within the art world's parameters. The point is to mount a sustained and far-reaching political critique of contemporary representational systems which have an overdetermined effect in the social production of sexual difference and its related gender hierarchy.

Equally importantly they are discovering ways to address women as subjects not masquerading as the feminine objects of masculine desire, fantasy and hatred. The dominative pleasures of the patriarchal visual field are deciphered and disrupted and, in the gaps between, new pleasures are being forged from political understandings of the conditions of our existence and psychological making. Questions about how women can speak/represent within a culture which defines the feminine as silenced other are posed at the end of the third essay, about Mary Cassatt and Berthe Morisot, using a quotation from an article by Mary Kelly whose work is the major focus of Essay 7. This connection not only indicates the contribution of feminist practitioners in art to the development of feminist art history but expresses my concern to do immediately for living women artists what we can only do belatedly for those in the past – write them into history.

The essays collected here represent a contribution to a diversified and heterogeneous range of practices which constitute the feminist intervention in art's history. This is not an abstraction but a historical practice conditioned by the institutions in which it is produced, the class, race and gender position of its producers. No doubt the focus of my concerns is conditioned by the conversational community within which I work and to which I have access through the magazines, conferences, exhibitions and educational institutions which form the social organization of radical intellectual production in Britain. This community is a mixed one in which alliances are forged under the umbrella of common purposes contesting the hegemony of the dominant paradigms. This fact has both advantages and disadvantages. For instance, collaborative work on analyses of the institutions and practices of modernism and modernist art history and blindness towards gender issues evident in these enterprises has shaped my understanding of the objectives and political necessities of feminist interventions while giving me invaluable understanding of the dominant paradigms and their social bases which are indispensable to current feminist work. Moreover this work was not only Eurocentric but ethnocentric. The position of Black artists, men and women, past and present, in all the cultural and class diversity of their communities and countries needs to be analysed and documented. Race must equally be acknowledged as a central focus of all our analyses of societies which were and are not only bourgeois but imperialist, colonizing nations. This remains a shadowy concern within this body of writings. But confronted by those involved in struggles around this issue, we must undergo self-criticism and change our practices.

The major community from which this book emerges and to which it is

addressed is a dispersed one, composed of feminists working the world over researching, writing, talking with and for each other, in the construction of a radically new understanding of our world in all its horror and hope. The women who have inspired and supported me cannot be listed in their entirety. They are acknowledged throughout the texts which follow. This community is an academic one, benefiting from the privileged access to money and time to study and write. However compromised our activities sometimes seem within the bastions of power and privilege, and no doubt we are compromised and blinkered as a result, there remains a necessity for intellectual production in any political struggle. Some comfort can be gleaned from Christine Delphy's clear vision of feminist theory as a complement to the social movement of women:

312

> '*Materialist feminism is therefore an intellectual procedure whose advent is crucial for social movements and the feminist struggle and for knowledge. For the former it corresponds to the passage from utopian to scientific socialism and it will have the same implications for the development of feminist struggle. That procedure could not limit itself to women's oppression. It will not leave untouched any part of reality, any domain of knowledge, any aspect of the world. In the same way as feminism-as-a-movement aims at the revolution of social reality, so feminism-as-a-theory (and each is indispensable to each other) aims at a revolution in knowledge.*'

Feminism-as-a-theory represents a diversified field of theorizations of at times considerable complexity. Their production and articulation is, however, qualified at all times by the political responsibility of working for the liberation of women.

What has art history to do with this struggle? A remote and limited discipline for the preservation of and research into objects and cultures of limited if not esoteric interest, art history might seem simply irrelevant. But art has become a growing part of big business, a major component of the leisure industry, a site of corporate investment. Take for instance the exhibition at the Tate Gallery in 1984, *The Pre-Raphaelites*, sponsored by a multinational whose interests involved not only mineral, banking and property concerns, but publishing houses, zoos and waxworks, as well as newspapers and magazines. What were they supporting – an exhibition which presented to the public men looking at beautiful women as the natural order of making beautiful things? Reviewing the exhibition Deborah Cherry and I concluded:

> '*High Culture plays a specifiable part in the reproduction of women's oppression, in the circulation of relative values and meanings for the ideological constructs of masculinity and femininity. Representing creativity as masculine and Woman as the beautiful image for the desiring masculine gaze, High Culture systematically denies knowledge of women as producers of culture and meanings. Indeed High Culture is decisively positioned against feminism. Not only does it exclude the knowledge of women artists produced within feminism, but it works in a phallocentric signifying system in which woman is a sign within discourses on masculinity. The knowledges and significations produced by such events as* The Pre-Raphaelites *are intimately connected with the workings of patriarchal power in our society.*'

There are many who see art history as a defunct and irrelevant disciplinary boundary. The study of cultural production has bled so widely and changed so radically from an object to a discourse and practice orientation that there is a complete communication breakdown between art historians working still within the normative discipline and those who are contesting the paradigm. We are witnessing a paradigm shift which will rewrite all cultural history. For these reasons I suggest that we no longer think of a feminist art history but a feminist intervention in the histories of art. Where we are coming from is not some other fledgling discipline or interdisciplinary formation. It is from the women's movement made real and concrete in all the variety of practices in which women are actively engaged to change the world. This is no 'new art history' aiming to make improvements, bring it up to date, season the old with current intellectual fashions or theory soup. The feminist problematic in this particular field of the social is shaped by the terrain – visual representations and their practices – on which we struggle. But it is ultimately defined within that collective critique of social, economic and ideological power which is the women's movement.

313

Olu Oguibe (1964–) is an assistant professor in the history of art and architecture department at the University of Illinois at Chicago, and the editor of the *Journal of Contemporary African Art* in New York. The text reprinted here, 'In the "Heart of Darkness"', was published as an editorial in *Third Text*, the successor to *Black Phoenix*, founded in the 1970s to promote the exploration of Third World perspectives on contemporary art and culture. The essay is divided into seven parts, which can be outlined as follows.

Oguibe argues that Western writers assume that history is synonymous with the history of the West, an attitude which is most clearly revealed when they use concepts such as Post-History and the End of History based solely on the experience of the West, thereby implicitly consigning humanity outside their own group to a position of inconsequence.

Western writers also assume that modernity is uniquely bound up with the culture of the West, and that non-Western cultures are to be equated with primitivism. The problem for historians who wish to attack these assumptions is that by doing so they acknowledge the centrality of Western culture, so instead they should replace the single centre with a multiplicity of centres, and modernism with a multiplicity of modernisms.

The concept of Africanity has been grossly misused by Western scholars, from the old colonial image to the new one of dependency formed in conjunction with bodies such as the aid agencies. In seeking to counter these ideas we should reject the idea that all historical writing is distortion, because if it is then there is no point in trying to correct it. Instead it is possible to argue that the concept of Africanity could be beneficial to Africa's construction of its own cultural identity, just as the idea of Europe is to the construction of a European identity. There are no grounds for the view, proclaimed by some African scholars, that an African identity is of great antiquity, just as there are no grounds for claiming a European collective identity before Napoleon.

A construction such as 'sub-Saharan Africa' is not only flawed in factual terms, it is also malign, in that it is intended to define African culture as more primitive, more Other, than Arab culture. The further removal from the concept of Africa of groups like the whites in South Africa or the Asians in Uganda has the same aim. Thus the Panafricanist movement is not allowed the same freedom as

those constructing a new concept of Europe: the core 'meaning' of Europe can be expanded geo-graphically while that of Africa is contracted.

How should the African cultural historian define the start of 'modern' art in Africa, and from what date? Does one restrict the answer to the art of black Africans living in Africa, or does one include any group inside Africa whatever their origins, and even the black diaspora outside Africa?

The concepts of an 'authentic' African culture and a 'transition' from it to modernity are false. They can be undermined by asking why such anthropological constructions as 'transitional' or 'township' art are never applied to Europe or the West, or why the importation of outsider culture into European art has been considered the most significant revolution of its time, while the same in reverse in Africa is bemoaned as corrosive and destructive. The answer is of course because of the assumption of the centrality of the West.

To understand the culture of Africa today one has to begin by rejecting the outsider's exoticization of Africa. At the same time we must acknowledge the truth that the concept of the Other is part of all societies, an Other which is seen as the 'Heart of Darkness'. The only proper response to this cultural fact is one of modesty, and an acknowledgement of ignorance about the other society. The West may require a 'Heart of Darkness' in Africa in order to measure its own progress, but its scholars should remember the existence of the converse, that the West itself appears to others to have a heart of darkness, and that there is, of course, much light at each of these hearts.

Oguibe's text is the only one in this collection whose author starts from a position outside the Western tradition. Because of this it provides valuable perspectives even (and in some ways espe-cially) for those who do not identify themselves with African culture. Three points in particular appear to call for further comment in relation to the theme of this book.

The first and most important, as signalled by Oguibe's title, concerns the observation that all soci-eties have a view of themselves as the centre and another society as a contrast. In attempting to break through assumptions about one's own society one can, as Oguibe says, exchange the single centre for a multiplicity of centres. Such a strategy recommends itself provided it is acknowledged that the concept of the centre is based on perceived differences in quality, and that such differ-ences can follow power and need not be as 'natural' as they may appear (as, for example, with the shift of artistic dominance from Florence in the fifteenth century to Rome in the sixteenth, or that from Paris before the Second World War to New York after it).

The second point concerns Oguibe's wish to undermine the concept of a transition from primi-tivism to modernism in Africa. This has a clear and easily justifiable political purpose. It does, however, need to accommodate the fact that transition is often an accurate representation of a state of affairs. How else is one to describe, for example, the fact that folk tales and related mater-ial culture are often available in one generation but, in the face of a process of modernization, have been irretrievably lost by the next, whether in Sri Lanka or the Western Isles of Scotland?

Thirdly, the powerful contrast which Oguibe draws between the positive assessment of African influence on early twentieth-century European art and the negative response to the Western sources of modernist forms in Africa, needs to be seen in the light of the very different

315

circumstances involved: on the one hand are artists such as Picasso and Braque choosing to use pieces of African sculpture as the bases for their experiments while under no social pressure to do so, and on the other a culture under relentless pressure to accept the values and commodities of the West because of its cultural and economic status.

The central point of Oguibe's text is the need to examine our own culture from the outside, and the fact that scholars in the West have not been very successful at this. The use which westerners make of the label 'the West' might suggest an awareness of relativities in at least not defining the West as the centre, but examination of the usage indicates that we are not dealing with a concept which puts us to one side of some imagined centre outside the West, but rather with one which forms part of a dichotomy between West and East, between ourselves and the Other. In considering Oguibe's argument it is more productive for us to recall what must have been one of the most significant moments in the history of Western thought concerning this question of awareness, namely when William Jones, Judge of the Supreme Court in Calcutta in the 1780s, systemized the growing realization that Sanskrit belonged to the same family of languages as Greek. In so doing he raised a massive query over the Western definition of India as the Other, and in the process at least opened up an opportunity for us to see ourselves from a distance.

316

(On distinguishing between and within cultures see *geography, and on the problem of analysing something of which one is oneself a part, see Baldwin, Harrison and Ramsden, text 23, 1981, and *anthropology.)[1]

1 For more on the issues raised by Oguibe's text as a whole see the classic study by Edward Said, *Orientalism*, London, 1978, especially pp. 10–11 on politics and research and pp. 49–72; and Kenneth Coutts-Smith, 'Some General Observations on the Problem of Cultural Colonialism' (1976), in Susan Hiller, ed., *The Myth of Primitivism: Perspectives on Art*, London and New York, 1991, pp. 14–31. This collection also contains other relevant papers, such as that by Annie Coombes. On the same theme in literature, see Salman Rushdie, 'Commonwealth Literature Does Not Exist', 1983, in *Imaginary Homelands: Essays and Criticism 1981–1991*, London, 1992, pp.61–70.

27 | Olu Oguibe

'In the "Heart of Darkness"', 1993

Olu Oguibe, 'In the "Heart of Darkness"',
Third Text, 23, 1993, pp. 3–8.

Prehistory. History. Post-history. It is evidence of the arrogance of occidental culture and discourse that even the concept of history should be turned into a colony whose borders, validities, structures and configurations, even life tenure are solely and entirely decided by the West. This way history is constructed as a validating privilege which it is the West's to grant, like United Nations recognition, to sections, nations, moments, discourses, cultures, phenomena, realities, peoples. In the past fifty years, as occidental individualism grew with industrial hyperreality, it has indeed become more and more the privilege of individual discourses and schools of thought to grant, deny, concede, and retract the right to history. Time and history, we are instructed, are no longer given. Indeed history is to be distinguished from History, and the latter reserved for free-market civilization, which, depending on the school of thought, would either die or triumph with it. Though they both share a belief in consolidating systematization as a condition of historicism, Francis Fukuyama in the 1980s, and Arnold Gehlen in the immediate post-Nazi period differ on the specificities of the question. While on the one hand Fukuyama believes that the triumph of free market systematization over regulated economies marks the end of History, Gehlen and the subsequent school of post-Nazi pessimism posited that the triumph of liberal democracy over fascism marked the end of History and the beginning of *Post-histoire*.

In both cases what comes out very clearly, despite the fundamental differences which define and preoccupy the discourse on the fate of History, is the consignment of the rest of humanity outside the Old and New West into inconsequence. For Gehlen, who had a better and stronger sense of history as well as intellectual integrity than Fukuyama can claim, the entirety of humanity was victim to a universal syncretism which subverts the essence of history. For Fukuyama this universality is to be taken for granted, although the majority of humanity is indeed, factually and historically speaking, hardly strictly subject to liberal democracy. Humanity is synonymous with the Group of Seven and Eastern Europe. Under Reaganism–Thatcherism even the spatial definition of history severely retracts to the Pre-Columbian.

The contest for History is central to the struggle for a redefinition and eventual

decimation of centrism and its engendering discourse. Without restituting History to other than just the Occident, or more accurately, recognizing the universality of the concept of History while perhaps leaving its specific configurations to individual cultures, it is untenable and unrealistic to place such other temporal and ideological concepts as Modernism, Modernity, Contemporaneity, Development, in the arena. If Time is a colony, then nothing is free.

II Premodernism. Modernism. Postmodernism. For the West erase Premodernism. For the rest replace with Primitivism. It is tempting to dwell on the denial of modernity to Africa or cultures other than the West. The underlying necessity to consign the rest of humanity to antiquity and atrophy so as to cast the West in the light of progress and civilization has been sufficiently explored by scholars. If not for the continuing and pervading powers and implications of what Edward Said has described as structures of reference, it would be improper to spend time on the question. It is important to understand that while counter-centrist discourse has a responsibility to explore and expose these structures, there is an element of concessionism in tethering all discourse to the role and place of the outside. To counter perpetually a centre is to recognize it. In other words discourse – our discourse – should begin to move in the direction of dismissing, at least in discursive terms, the concept of a centre, not by moving it, as Ngugi has suggested, but in superseding it. It is in this context that any meaningful discussion of modernity and 'modernism' in Africa must be conducted, not in relation to the idea of an existing centre or a 'Modernism' against which we must all read our bearings, but in recognition of the multiplicity and culture-specificity of modernisms and the plurality of centres. The history of development in African societies has metamorphosed quite considerably over the centuries, varying from the accounts of Arab scholars and adventurers as well as internal records of royalties and kingdoms, to the subversive colonialist narratives and anthropological mega-narratives. Recent times have witnessed revisions in earlier texts, and a growing willingness to admit the shortcomings of outsider narratives. Countering discourses have replaced history, with all its inconsistencies and vulnerabilities, in the hands of each owning society, and shown how carefully we must tread.

III It is equally in the above light that the concept of an African culture, or an Africanity, which is quite often taken for granted, is problematic. It seems to me that we cannot discuss an African modernity or 'modernism' without agreeing first on either the fictiveness of 'Africanity' or the imperative of a plurality of 'modernisms' in Africa.

Of course one may well be wrong here. Yet it is to be recognized that, like Europe, the specificities of which are still in the making and the collective history of which does not date earlier than Napoleon – the idea of Rome and Greece is dishonest – Africa is a historical construct rather than a definitive. Many have argued, prominent among them the Afrocentrist school, the antiquity of a Black or African identity, an argument which falls flat upon examination. On the other

hand, history reveals the necessity for such unifying narratives in the manufacture of cultures of affirmation and resistance. The danger in not recognizing the essential fictiveness of such constructs, however, is that a certain fundamentalism, a mega-nationalism, emerges – all the more dangerous for its vagueness – which excises, elides, confiscates, imposes and distorts. Some will argue that history, after all, is perception, in other words, distortion. But if we were to accept this wholesale and without question, we would have no business trying to 'correct' history, unless, also, to correct is merely to reconfigure, to counter-distort.

We already recognize the dangerous potential of such fictions in the hands of the invading outsider. The spate of pseudo-scholarly interest in 'African' life, culture and art during and immediately after colonialism illustrates this. While in the beginning the totalizing construct was employed to underline the peculiarity of the 'savage' mind and thus justify outsider intervention, it has continued to be in use in justifying the changing face of that mission. From redeeming Christianity to salvage anthropology, it has remained essential to maintain this invention. Indeed, the need seems greater now than ever before as the collapse of colonialism and the rise of contesting discourses place anthropology, the handmaid of Empire, in danger. Anthropology's crisis of relevance, coupled with characteristic Western career opportunism, has necessitated the gradual reinvention of a singular and unique Africanity worthy of the Outside Gaze. The new manufacture finds ready clients in scholars, policy makers, non-governmental and aid organizations seeking objects of charity. Unless there is a singular Africanity, distinct and doomed, how else do we justify the pity which must put us ahead and on top? If the Other has no form, the One ceases to exist. It is for this reason that recent Outsider texts on African culture remain only extensions and mild revisions of existing fictions. To undermine the idea of The African is to exterminate a whole discursive and referential system and endanger whole agendas.

IV The history, or histories, of what we severally refer to as 'modern' or 'contemporary' 'African' art illustrates the above problems and dangers. From the point when it became acceptable to speak of a 'history of contemporary African' art, attempts at this history have run into often unacknowledged tight corners by ducking into the safety of earlier fictions of 'Africa'. The most obvious manifestation of this is in the seeming racio-geographical delineation of the 'African', which, we are often told, basically refers to sub-Saharan Africa. The obvious intent of this definition, of course, is to distinguish the African from the Arab, although the spatial boundaries specified by the register, sub-Saharan, effectively ridicule this intent. A less apparent intent, and indeed a more important one, is to place the Arab a notch above the 'African' on the scale of cultural evolution.

It is sufficient not to question this intent here, but to point out that the signifying register proves grossly inadequate. Not only does it wholly ignore the impossibility of hard edges between cultures and societies in the region it describes, and the long history of Arab-Negro interaction, together with all the subtleties and undecidables of racial translations, indeed the impurity of designates, it equally ignores internal disparities within the so-called 'African' cultures. To play on the

319

surface, it is never quite clear where East Africa fits on this cultural map of Africa, given not only the territorial problems of locating Somalia below the Sahara, but also of eliding Zanzibar's long history of Arabization. In a significant sense, then, the construction of a 'sub-Saharan' Africa not only ignores geographical inconsistencies but equally ignores accepted discursive positions in the West which not only recognize the triumph of History as the Impure but underlie the construction of Europe.

We see double standards. But that is hardly the most important point. We also find that essential tendency to ignore indigenous historical perceptions and constructs. The Outsider, whether occidental scholarship or Diasporic Negro discourse, quickly established delineations without acknowledging the possibility that these may not be shared by those whose histories are at the centre of discourse.

On the other hand, what we see are not double standards at all but a consistent referent. For, when we examine the continual construction of Europe such discrepancies are equally apparent. The most interesting examples are the ready admission of Israel into Europe and the struggle to exclude Turkey. In other words, in the end, the use of the designate, 'sub-Saharan' in the definition of the 'African' is only a cheap ruse masking other, less innocent referents. The bottom is not only race, but history as well. History as vassal.

Needless to say, white people in South Africa, Asians in Uganda, as well as other diasporic populations and communities, fall outside of this definition. Cultural Africa, therefore, is no longer contained by that lame composite, sub-Saharan, which now needs a further qualifier: 'excluding white [South] Africans'. But then, how would the Outside justify the condescension toward Africans, or its employment of The African in the satisfaction of its need for the exotic, if Arabs, with their 'long history' of civilization, or white [South] Africans were to be part of that construct?

On the political front, however, arguments have been stronger on the side of an all-embracing Africanity which supersedes disparities and differences and aspires towards the construction, not invention, of a new and credible Africanity. This is the position of Nkrumah's Pan-Africanism, and remains the ground argument of the Pan-African movement. Culturally, the argument is not only to recognize a plurality of Africanities but also aspire towards the active formulation of a singular African 'identity', somewhat along the lines of Pan-Europeanism and the construction of the West. For Outsider cultural historians and culture brokers, however, such strategies must be reserved for Europe.

V For the African cultural historian, the problems here are plenty. For instance, based on the above construction of Africa, it is increasingly fashionable to begin the history of 'modern' or so-called contemporary art in Africa from the turn of the last century, that is, from the Nigerian painter Aina Onabolu. On the other hand, earlier practitioners of 'modern' art exist in the Maghreb and Egypt, and strains of 'modernism' are discernible in the art of white South Africans from earlier than Onabolu. Also, if 'African' is a race-specific qualification, it would be

320

proper to remember that artists of Negro descent were practising in the contemporary styles of their time in Europe and America much earlier than the turn of the century. Where then does one locate the break with the past which the idea of a 'modernism' insinuates? In discussing 'modern' African art, does one continue to exclude half the continent? Is it realistic, otherwise, to discuss a modern culture that defies existing invented boundaries? Are there grounds in the present, which did not exist in the past, to justify a unifying discourse, or is it safer to pursue a plurality of discourses? Along what specific lines must such discourses run? Or shall we merely conclude, like Anthony Appiah, on the fictiveness of a singular cultural identity?

VI Several other problems and questions hinge on the above. If, after all, we reject the 'sub-Saharan' qualifier, we effectively subvert a host of other qualifiers and paradigmatic premises. The 'peculiarities' and particularities attributed to 'sub-Saharan' art which in turn sustain temporal and formalistic categorizations become untenable. Such conveniences of Outsider scholarship as the 'problems of transition' from the 'traditional' or the 'African' to the modern, or the question of Africa's 'identity crisis' and concern over the endangerment of 'authentic' African culture, all prove very problematic indeed. If Africa is not some easily definable species or category that yields to anthropology's classifications and labels, neither are its cultural manifestations.

321

'Transition' from 'antiquity' to the modern ceases to amaze and exoticize or evoke voyeuristic admiration or pity because antiquity ceases to exist. The supposed distress of Africans caught in a no-man's land between Europe and their 'authentic' selves becomes a lot more difficult to locate or explicate. Ethnographic categories usually applied with ease to sequester 'African' culture into temporal boxes are no longer easy to administer. What, for instance, would we qualify as 'transitional' art in Egypt that we cannot locate in Spain? What is client-driven art within the minority community of South Africa? How easily would we lament the 'corrosive influences' of Europe on the Somali of the Northern coast?

That is to pull one leg from the stool. In strict discursive terms, of course, none of the categories, delineations and constructs mentioned above has any relevance even within the context of a delimited 'Africa', especially since none of them is ever applied in the description and study of Europe or the West. African scholars could have bought into any of them, and indeed still do, but that is hardly the issue. The point, instead, is that such constructs as sequester specific societies and cultures and not others emanate from less innocent structures of reference the briefs of which are to create foils and negations of the Occident. So we can speak about 'transitional' art in Africa, and never in Europe. We may speak of 'Township' art in Africa, or at times of 'popular art', and these would connote different forms and manifestations from those in Europe. We may qualify nearly a century of artforms in Africa as 'contemporary' while applying the same term to only a strain of current art and discourse in Europe. We may take modernism in Europe for granted and have great difficulty in finding the same in Africa. The assimilation of Outsider culture into European art is considered the most

significant revolution of its time while the same is bemoaned in Africa as a sign of the disintegration and corrosion of the native by civilization. Or, on the other hand, Africans are to be patted on the head for making a 'successful transition' into modernity. Why, whoever thought they could emerge unscathed!

To discuss the 'problems' of modernity and modernism in Africa is simply to buy into the existing structures of reference which not only peculiarize modernity in Africa but also forbode crisis. What needs to be done is to reject that peculiarization and all those structures and ideational constructs that underlie it.

VII To reject the exoticization of Africa is to destroy an entire world-view carefully and painstakingly fabricated over several centuries. This is the imperative for any meaningful appreciation of culture in Africa today, and it would be unrealistic to expect it easily from those who invented the old Africa for their convenience. It dismisses an existing discourse and signifies a reclaiming process which leaves history and the discursive territory to those who have the privileged knowledge and understanding of their societies to formulate an own discourse. This is not to suggest an exclusionist politic, but to reassert what is taken for granted by the West and terminate the ridiculous notion of the 'intimate outsider' speaking for the native. It recognizes that there is always an ongoing discourse and the contemplation of life and its socio-cultural manifestations is not dependent on self-appointed outsiders.

Otherization is unavoidable, and for every One, the Other is the Heart of Darkness. The West is as much the Heart of Darkness to the Rest as the latter is to the West. Invention and contemplation of the Other is a continuous process evident in all cultures and societies. But in contemplating the Other, it is necessary to exhibit modesty and admit relative handicap since the peripheral location of the contemplator precludes a complete understanding. This ineluctability is the Darkness.

Modernity as a concept is not unique. Every new epoch is modern till it is superseded by another, and this is common to all societies. Modernity equally involves, quite inescapably, the appropriation and assimilation of novel elements. Often these are from the outside. In the past millennium the West has salvaged and scrounged from cultures far removed from the boundaries which it so desperately seeks to simulate. The notion of tradition, also, is not peculiar to any society or people, nor is the contest between the past and the present. To configure these as peculiar and curious is to be simple-minded. It is interesting, necessary even, to study and understand the details of each society's modernity, yet any such study must be free from the veils of Darkness to claim prime legitimacy. To valorize one's modernity while denying the imperative of transition in an Other is to denigrate and disparage.

The West may require an originary backwoods, the 'Heart of Darkness' against which to gauge its progress. Contemporary discourse hardly proves to the contrary. However, such darkness is only a simulacrum, only a vision through our own dark glasses. In reality, there is always a lot of light in the 'Heart of Darkness'.

322

Glossary of Concepts

This part of the book discusses, in alphabetical order, the main concepts involved in the study of art history, including a number which are not raised in the texts but which should form part of an exploration of methodology.

ANALYSIS/SYNTHESIS An analytical approach to the study of a material object involves break-ing it down, actually or metaphorically, into its constituent parts in order to establish the manner and the sequence in which they were put together, how they relate to one another, and what they might signify. The emphasis is on the part rather than the whole, to the extent that in some instances it is assumed that the whole does not exist. Analysis is one of the most powerful tools available to historians, and perhaps especially to those who deal with material evidence. This can be graphically illustrated by the example of a structure which has been subjected to extensive alteration, in which the variations in materials and in the ways in which the forms have been designed, prepared and put in place can establish the order of construction and hence a relative chronology for the building history (see, for example, fig. 46).

A synthetic approach is the opposite to this in that the investigator, while examining the parts, does so assuming the unity of the object, at least in the first instance. The difference between the two approaches can be illustrated by responses to the presence of a single different element in an otherwise uniform row of elements, as for instance in the piers of the nave of a church. An investi-gator applying the analytical method would assume that the odd feature represents a disruption such as a change of plan following on a break in building, while an investigator following the synthetic approach would assume that the odd feature formed part of an intended sequence, either to vary the rhythm for purely aesthetic reasons or to mark a threshold for symbolic or liturgical purposes.

Used together, analysis and synthesis provide checks against their respective characteristics and biases, that is, against the assumption on the one hand that no two parts of an object bear any intended relationship to one another until one is established, and on the other that every part of an object has the form, position and role intended for it until that is disproved.

ANTHROPOLOGY Anthropology entails two quite separate disciplines: the physical, which attempts through the study of fossils and anatomy to relate the human species to its place in the natural environment, and the social or cultural, which concerns itself with human organization and relationships and their relevant artefacts.

Social anthropologists work as far as possible from direct observation of people, although rather than being concerned solely with the present they are implicitly concerned with exploring and interpreting the links between past and present. Their area of interest therefore overlaps extensively with the history of art, since the things which people make and which can be visually analysed form one of the chief sources of information about a °culture, which has to be understood historically.

Social anthropologists relate activities such as making to the rest of society, while many art historians concentrate on the work of art to the exclusion of its context. Conversely anthropologists have avoided making value judgements, which at some level are unavoidable in the study of *cultural history (see *quality). Until quite recently social anthropologists have tended to study 'other' cultures, whereas art historians have investigated the art of what they have seen as their own culture. The anthropologists' traditional caution in avoiding their own culture has been due largely to a recognition of the difficulty of studying any cultural situation from inside itself. Their increasing engagement with their own or more similar cultures arises from their greater sensitivity to issues involved in representing 'others' as different.[1]

(For more on the inside/outside difficulty see the section on the Trobriand Island problem in Baldwin, Harrison and Ramsden, text 23, 1981; for an anthropologist using art-historical techniques see Fagg, text 20, 1973; and for the problem of the 'other' see Oguibe, text 27, 1993. See also Riegl, text 9, 1901, and Alpers, text 24, 1983.)

324

[1] Examinations of the relationship between anthropology and the study of art include R. Layton, *The Anthropology of Art*, London, 1981, and M. Greenhalgh and J.V.S. Megaw, eds., *Art in Society: Studies in Style, Culture and Aesthetics*, London, 1978, which deals primarily with the art of non-Western peoples, but contains a chapter by Josef Herman on 'The Modern Artist in Modern Society'. See also J. Coote and A. Shelton, eds., *Anthropology, Art and Aesthetics*, Oxford, 1992. Contributions to the history of art of an anthropological type include those of Aby Warburg, Meyer Schapiro and George Kubler. See E.H. Gombrich, 'The Ambivalence of the Classical Tradition: the Cultural Psychology of Aby Warburg' (1966), in *Tributes: Interpreters of our Cultural Tradition*, Oxford, 1984, pp. 116–37; Meyer Schapiro, 'Style' (1953), in *Anthropology Today: Selections*, S. Tax, ed., Chicago, IL, 1962, pp. 278–303; George Kubler, *The Shape of Time: Remarks on the History of Things*, 2nd edn, New Haven and London, 1973.

ANTIQUARIANISM The label 'antiquarian' has come to describe those primarily involved in collecting facts relevant to particular interests, without establishing a framework linking together those interests. Antiquaries are like archaeologists in that they concentrate on the material evidence and use inductive and empirical methods, and like social historians in that they are interested in all aspects of the past, but unlike either archaeologists or social historians they are not interested in the relationship between objects and history. The attitudes which most Greek and Roman writers had to the arts can be fairly described as antiquarian in this sense, as can the approaches of English scholars such as John Leland in the sixteenth century and William Dugdale in the seventeenth, or Bernard de Montfaucon, the historian of the material remains of the French monarchy, in the eighteenth. By the nineteenth century, however, antiquaries espoused *empiricism as a method and combined it with *archaeology to produce detailed studies, such as those of Robert Willis, of ancient and medieval buildings.[1] (See also *typology.)

[1] J.J. Pollitt, *The Art of Ancient Greece: Sources and Documents*, Cambridge, 1990, and *The Art of Rome, 753 BC–337 AD, Sources and Documents*, Englewood Cliffs, 1966; John Leland, *Itinerary* (c.1540s), J. Chander, ed., Stroud, 1993; William Dugdale, *Monasticon Anglicanum*, London, 1655; Bernard de Montfaucon, *Les Monuments de la monarchie française*, Paris, 1729–33; R. Willis, *Architectural History of Some English Cathedrals: Collected Papers 1842–63*, 2 vols., Chicheley, 1972–3. For a classic twentieth-century example of the genre, see L. F. Salzman, *Building in England Down to 1540*, Oxford, 1976.

ARCHAEOLOGY Archaeology can be defined as the study of the past through the surviving material evidence, and in particular through the techniques of excavation and recording and dating that evidence (such as stratigraphy, statistics, dendrochronology and radio-carbon testing). Archaeological research is therefore usually identified as primarily inductive in character, starting from an analysis and quantification of the material evidence and proceeding to the formulation of theories.

46 St Paul's Church, Jarrow, County Durham, seventh century and later. From Harold and Joan Taylor, *Anglo-Saxon Architecture*, Cambridge, 1965, vol. i, under Jarrow. The caption in Taylor and Taylor identifies the different parts of the wall and indicates how they relate to one another, as a means of establishing the order in which the various elements were built.

Because of its concentration on material evidence, archaeology has traditionally been distinguished from the discipline of history which explores the past through the medium of written documents. This division of labour has led to archaeology being identified with the study of prehistory and the early historical periods, but just as historians have made increasing use of material evidence so archaeologists have turned their attention to later periods and even to the very recent past, as is evident from the growth of industrial archaeology.

Because of the central role played by excavation in the discipline, the investigation of objects usually involves their physical analysis and even, in the case of sites and samples, their destruction. Minute analysis of the visual evidence without such physical involvement is, however, also a part of the archaeological method, and very similar to one of the main methods used by art historians. This method is discussed in detail by Panofsky (text 15, 1940), while architectural historians use this technique when, for example, they wish to establish the order in which the different parts of a wall were built (fig. 46).

Art historians differ from archaeologists chiefly in two respects, firstly in not, on the whole, having to excavate any of the material which they wish to investigate and hence in not being as closely involved with the technical and scientific aspects of their subject; and secondly in making judgements about the aesthetic quality of the objects in question (see Fagg, text 20, 1973, who comments that archaeologists are explicitly trained *not* to make such judgements). As with many subjects, however, these differences are less clearly drawn than they once were, with, for instance, the 'new' archaeology, like the 'new' art history, starting not from an inductive but from the opposite, theory-driven, deductive premise (see also ˚subjects/disciplines). The links between the subjects can also be expressed in historiographical terms, in that Giovanni Bellori (text 3, 1672) has been called the father of archaeological art history, and Johann Winckelmann (text 4, 1764), both the father of art history and the father of archaeology. (See also ˚history, ˚empiricism and ˚typology, as well as ˚design history in connection with industrial archaeology.)

ARCHITECTURE 'Architecture' as an overall label includes all forms of human construction, but it is also used in opposition to 'building' to distinguish constructions designed to impress from those without such pretensions. In this narrow sense it has traditionally been classed with painting and

sculpture as one of the fine arts, and indeed identified as the mistress of those arts. In the course of the twentieth century it has been increasingly distinguished from painting and sculpture, as is evident, for example, in the frequent use of the phrase 'art and architecture' in the titles of books on the history of art. The explanation for this change appears to lie chiefly in the character of the training of artists and architects. While an art school grants degrees in fine art to students specializing in painting, sculpture, tapestry, stained glass, and similar subjects, architecture is taught in a separate department under different rules. In particular, architecture courses are validated by a professional body while those in fine art are not.

Architecture bridges the gap between the fine arts and the crafts because on the one hand it has been historically associated with painting and sculpture and because on the other, like the crafts, it meets practical needs. (See Morris, text 7, 1888, Pevsner, text 16, 1943 and ˚art.)

ART The word 'art' has a wide variety of meanings. Restricting ourselves to the visual arts, art can be defined as 'fine', 'practical' and 'comprehensive'. In its narrowest sense (which is also the most widely used) Art with a capital A refers to a body of work considered to be inspired and of great importance to our well-being (as in the fine arts, work of art, the art of Michelangelo, art for art's sake, and art gallery). The core of the fine arts consists of painting, drawing and sculpture, or what is taught in art schools as part of a fine art degree. The fine arts can also include tapestry, ceramics, stained glass and similar categories of objects which are often considered more functional and hence more related to the crafts, and of course ˚architecture, which is a special case. There is a traditional hierarchical distinction between fine art and craft, which has often been applied to the detriment of the latter (see Riegl, text 9, 1901, and ˚feminism).

In the second, practical sense, art is about making anything from prints and pictures to films and plays, and relates in particular to the skill involved in the making (as in 'the art of the silversmith'). Defined in this way, there is no distinction between art and craft.

In the third, comprehensive sense, the visual arts can be described as consisting of those made objects which are presumed to have a visual content or to which we react aesthetically. Although this definition begs the meaning of the words 'content' and 'aesthetically', it places almost no restriction on the visual material which can be described as art. This very broad definition is advisable for the art historian because what we call art today is not or was not necessarily considered in the same way in other cultures and at other times. In fact one can go further and say that what is called art in the late twentieth century (which might be characterized as a branch of philosophy practised with materials and objects) represents a minority view among human cultures. Thus while a fifteenth-century Italian altarpiece, for example, may in part have been valued for similar reasons as it would be if displayed in a gallery today, it was also in large measure a practical object performing a social function. (See also Belting, text 25, 1984.)[1]

1 See Richard Wollheim, *Art and its Objects* (1968), 2nd edn, reprinted, Cambridge, 1992, for a comprehensive discussion of the philosophical problems associated with the concept of art. The following subjects are of particular relevance in the present context. The arabic numerals indicate the relevant section of Wollheim's original essay of 1968, and the roman numerals the relevant essay from those added in the second edition: aesthetics (41–4, 64, III, VI); art (1–3, 4–31, 40–4, I); architecture (II); art's historicity (60–1, III); craft (22); criticism (III); empiricism (62); expression (15–19, 25–31); forgery (III); intention (32–4); interpretation (37); language (45–59); Marxism (62–4); meaning (58); psychoanalysis (53); psychology (54–5, V); quality (VI); representation (11–14, V); signs (29, 35–6, 52, 56, VI); social determination (62–4); spectator (51–3); style (31–2); unity (59).

ART HISTORY Art history can be defined as the historical study of those made objects which are presumed to have a visual content, and the task of the art historian as explaining why such objects

look the way they do. The objects in question can range in time from the Palaeolithic era to the present day and in type from Michelangelo's Sistine ceiling and Picasso's *Guernica* to antiques and kitsch and performance art and film. These objects can be treated as, among other things, conveyers of aesthetic and intellectual pleasure, as abstract form, as social products, and as expressions of cultures and ideologies. (See also *art*.)

Setting aside the methods of the chemist and the physicist, at least four separate but overlapping approaches to the subject can be identified:

(i) Investigation of available written documents, to provide information on the authenticity, date, technique, provenance, affiliation and purpose of the object in question.

(ii) Investigation of the object, using visual techniques such as *stylistic analysis, again to assess the authenticity, date, technique, provenance, affiliation and purpose of the object, and in addition to assess its *quality and the visual types and pictorial traditions to which it belongs. (See also *connoisseurship.)

(iii) Investigation of the social context to which the object belongs, including an examination of the conditions of its production and reception. (See also *intention and *reception theory).

(iv) Construction or selection of systems to relate the object to types of large-scale historical development, including an assessment of the relevance of ideologies and theories of art. (See also *cultural history, *ideology, *Hegelianism and *subjects/disciplines.)

While the examination of available documentary evidence is something which all art-historical projects must involve, the second approach based on connoisseurship can be somewhat crudely identified with the more traditional wing of the subject and the third and fourth approaches with those of the social and 'new' histories of art, with cultural history to some extent straddling the divide between the two. In Vasari (1568), Van Mander (1604), Morelli (1890), Fry (1920) and Fagg (1973) connoisseurship is presented as central; Morelli actively ignores the documentary evidence available while Fagg, studying tribal art, has none to work with. Conversely Winckelmann (1764), Pevsner (1943) and Hauser (1959) stress the importance of the social context and Frankl (1914), Focillon (1934), Onians (1978), Belting (1984), Pollock (1988), and Oguibe (1993) emphasize the theoretical context. Burckhardt (1872), Riegl (1901), Wölfflin (1915), Panofsky (1940), Gombrich (1967) and Alpers (1983) stress the second and fourth methods, and Clark (1974) and Baldwin, Harrison and Ramsden (1981) the third and fourth. This is not, of course, to imply that these authors restrict themselves to the methods cited, still less that this is true of their work as a whole, only that these elements are prominent in the texts in question.[1]

While each of these four categories has been presented at one time or another as the only allowable method, the conclusion appears to be unavoidable that, while one or other will serve our purposes better for any particular task, we should always be aware of the importance of the other three, and of the ways in which they can all be misused. In combination they provide a set of methods which is broadly based, and a reminder that, among other things, the social and theoretical explanation of a work of art is crucial, and that the work itself remains an achievement which needs explaining in its own right.[2]

327

1 Eugene Kleinbauer's *Modern Perspectives in Western Art History: an Anthology of Twentieth-century Writings on the Visual Arts*, New York, 1971, provides something of a benchmark for the wide range of traditional art-historical methods in use before the appearance of the 'new' art histories in the early 1970s. Mark Roskill's *What is Art History?*, London, 1974 is often cited by those who wish to distance themselves from the traditional approaches as representative in this regard, but Roskill's range of methods differs only marginally from that of Vasari four centuries earlier and contains little of the variety of method evident among those of his contemporaries who might class themselves as traditionalists.

On the social history of art see, for example, T.J. Clark, *Image of the People: Gustave Courbet and the 1848 Revolution*, London, 1973, especially pp. 9–20. The introduction to A.L. Rees and F. Borzello, eds., *The New Art History*, London,

1986, provides a good brief account of the new art history. For the first use of the phrase 'the new art history' see Svetlana Alpers, 'Is Art History?', *Daedalus*, 106, part 3, 1977, p. 1. The journal *Block*, published by Middlesex Polytechnic from 1979 to 1989, has been highly influential in the introduction of new ways of studying theory, analysis and criticism of art, design and the mass media. The tasks defined by Norman Bryson as 'archival' and 'hermeneutic' in his introduction to *Calligram: Essays in New Art History from France*, Cambridge, 1988, pp. xiii–xxix, bear some resemblance to the division between the more traditional and the more radical approaches suggested here.

2 Publications which give some indication of the range and character of this kind of art history include the following, in order of publication: Meyer Schapiro, 'Style' (1953), in *Anthropology Today: Selections*, S. Tax, ed., Chicago, IL, 1962, pp. 278–303; George Kubler, *The Shape of Time: Remarks on the History of Things* (1962), reprinted, New Haven, CT, 1973); Peter Kidson, *The Medieval World*, London, 1967; Michael Baxandall, *Painting and Experience in Fifteenth-century Florence: a Primer in the Social History of Style* (1972), 2nd edn, London, 1988; Clark, op. cit., 1973, pp. 9–20; Janet Wolff, *The Social Production of Art*, London, 1981; Hugh Honour and John Fleming, *A World History of Art*, London, 1982; Robin Cormack, '"New Art History" vs. "Old History": Writing in Art History', *Byzantine and Modern Greek Studies*, 10, 1986, 223–31; Jonathan Harris, 'Art, Histories and Politics: the New Deal Art Projects and American Modernism', *Ideas and Production*, 5, 1986, pp. 104–19; Laura Mulvey, *Visual and Other Pleasures*, London, 1989; Martin Kemp, *The Science of Art: Optical Themes in Western Art from Brunelleschi to Seurat*, New Haven and London, 1990; Marcia Pointon, *Naked Authority: the Body in Western Painting 1830–1908*, Cambridge, 1990; David Freedberg and J. de Vries, eds., *Art in History, History in Art: Studies in Seventeenth-century Dutch Culture*, Santa Monica, CA, 1991; John House, 'Renoir's "Baigneuses" of 1887 and the Politics of Escapism', *Burlington Magazine*, 134, 1992, pp. 578–93; Mary Beard, 'Souvenirs of Culture: Deciphering (in) the Museum', *Art History*, 15, 1992, pp. 505–32; Francis Haskell, *History and its Images*, New Haven and London, 1992; John Gage, *Colour and Culture: Practice and Meaning from Antiquity to Abstraction*, London, 1993; Linda Seidel, *Jan van Eyck's Arnolfini Portrait: Stories of an Icon*, Cambridge, 1993.

AVANT-GARDE The term avant-garde describes those groups of artists who, since the middle of the nineteenth century, have defined themselves as ahead of their time or in the vanguard of artistic and, usually, political change. It has been widely used by art historians for the same purpose.

Being ahead of one's time has been defined in a great variety of ways. Clement Greenberg has provided one contentious version of the idea which can serve as an example of the range of its applicability. He argues that in the seventeenth and eighteenth centuries painters and sculptors had such a highly developed ability to produce illusions that, because they were not primarily thinking about the objects which they were making, the painters and sculptors became subservient to literature. In the nineteenth century a change in awareness appeared to offer an escape from this subservience, but the content of the painting or sculpture merely changed from literary subject matter to the artist's feelings; the medium of painting or sculpture itself remained of no importance. When by the middle of the nineteenth century artistic movements with their roots in bourgeois society had failed to achieve the liberation of the visual arts from literature and the artist's feelings, the only direction in which artists could turn was against bourgeois values and capitalism. Thus for Greenberg the avant-garde defines art as being responsible only to the values of art, which meant that artists had to escape from subject matter and ideas, which in turn meant a new stress on form. In their different ways Courbet, Manet and the Impressionists provided the means of this escape.[1] (See also Sontag, text 18, 1964, Baldwin, Harrison and Ramsden, text 23, 1981, and Belting, text 25, 1984.)

1 Clement Greenberg, 'Towards a Newer Laocoön', *Partisan Review*, 7 (4), 1940, pp. 296–310; reprinted in Francis Frascina, *Pollock and After: the Critical Debate*, London, 1985, pp. 35–46. See also Clement Greenberg, 'Avant-garde and Kitsch', *Partisan Review*, 6 (5), 1939, pp. 34–49; reprinted in Frascina, op. cit., pp. 21–33.

BEAUTY The concept of beauty has probably had more written about it than any other aspect of the visual arts. In the sixteenth, seventeenth and eighteenth centuries the term was used to describe characteristics in nature which singled out the parts of some individuals (whether plants, animals or humans) as more striking and perfect than those of others. Since no individuals are perfect in every aspect of their form, it was open to the artist to select the most beautiful parts

from a number of individuals and combine them in a single one, thus producing an image of ideal as opposed to natural beauty. Because of this art was considered to be superior to nature. (See Vasari, text 1, 1568, Bellori, text 3, 1672 and Winckelmann, text 4, 1764.) The beauty being sought in nature could be defined in terms of characteristics such as order, proportion, harmony and grace, so that the concept could also be applied to architecture.

As the subject matter of painting and sculpture broadened so too did the area of applicability of beauty, into landscape and the sublime, everyday life, still life and, in the early twentieth century, abstraction. In the late twentieth century the concept is not often appealed to by artists, and art historians refer to it less and less, choosing instead to discuss the issues raised by it in terms of *quality.

BIOGRAPHY In order to study the past the historian must select a part of it for special attention, and the life of any individual who has affected significant numbers of people (such as, for example, that of Marx or Michelangelo) has been seen as a good starting point for an investigation. However, the biographical format has been criticized on the grounds that in giving so much prominence to the individual subject it often ignores the context. The biography has proved particularly popular among art historians, from Vasari, whose history of art is formed by the idea of the life of the artist, via numerous emulators such as Filippo Baldinucci and Joachim von Sandrart in the seventeenth century and Horace Walpole in the eighteenth, to the late twentieth century, when biographies (and *catalogues raisonnés* as a closely related type) have been published on artists as diverse as Delacroix, Morisot, Hockney and the Carracci.[1]

1 Filippo Baldinucci, *Notizie de' professori del disegno da Cimabue in quà*, 1681–1728, and *The Life of Bernini* (1682), translated by Catherine Enggass, London, 1966; Joachim von Sandrart, *Teutsche Akademie*, Nuremberg, 1675–9; Horace Walpole, *Anecdotes of Painting in England*, 1762–71; Lee Johnson, *The Paintings of Eugène Delacroix: a Critical Catalogue, 1816–31*, vol. 1, Oxford, 1981; David Solkin, *Richard Wilson and the Landscape of Reaction*, Tate Gallery, London, 1982; Kathleen Adler and Tamar Garb, *Berthe Morisot*, Oxford, 1987; Peter Webb, *Portrait of David Hockney*, London, 1988; C. Goldstein, *Visual Fact over Verbal Fiction: a Study of the Carracci and the Criticism, Theory, and Practice of Art in Renaissance and Baroque Italy*, Cambridge, 1988.

CANON A canon can be defined as a body of work agreed to represent the greatest examples of a genre, and which hence provides a standard against which new work can be judged. Shakespeare and Michelangelo are the most prominent canonical figures in twentieth-century assessments of English literature and Italian art respectively. There are numerous reasons why some works form part of a canon and others do not, and why individuals' reputations rise and fall over time. Some scholars argue that the bases for making such judgements are objective and others that canons are nothing more than constructions formed to support the interests of power elites (see *quality). There are low as well as high, or radical as well as traditional, canons. Terry Eagleton, for example, after rejecting the canon of English literature as an ideological construction, sets out what he thinks are the major literary movements of current cultural relevance as those of the newly independent countries, the women's movement, critical reaction against mainstream ideology, and working-class writing.[1] Thus the important point is the need to be aware of the artificiality of the canon and the criteria used to construct it.

1 Terry Eagleton, *Literary Theory: an Introduction*, Oxford, 1983, pp. 215–16.

CLASSIC In its current most widely used sense classic describes something which is the best of its kind and which has been recognized as such over a period of time. In older usage the word is

Wiveton
6 inches

nave
base
course

north porch
base course

arcade
pier

arcade
base

north door
cap & base

north porch
cap & base

north porch
jamb & arch

north door
jamb & arch

south
door
jamb & arch

47 Arch mouldings from St Mary's Church, Wiveton, Norfolk, fifteenth century. From Richard Fawcett, 'St Mary at Wiveton in Norfolk and a Group of Churches Attributed to its Mason', *Antiquaries Journal*, 62, 1982, pp. 35–56, fig. 2

Just as Morelli attributed paintings to particular artists by classifying the ways in which details such as ear lobes were represented, so architectural historians have grouped the profiles of mouldings in Gothic buildings on the basis of characteristic forms in the complex curves of these features. In some cases the sequences are so unusual that a workshop can be identified and sometimes even what appears to be the hand of an individual mason.

330

closely associated with the term classical and with the balanced character of what have become the best-known types of representation of the arts of antiquity, and hence as the opposite pole to the concept of the romantic. It has overtones of calm, balance and superiority.

In specifically art-historical usage it describes the middle of the three phases early, classic and late (or baroque) into which Wölfflin divided a *cycle of stylistic development (fig. 49). Since these three phases are supposed to be of equal status it is confusing that 'classic' retains the overtones of superiority connected both with the classical world and with its current meaning of the best of its kind.

CONNOISSEURSHIP Connoisseurship involves the acquisition of an extensive first-hand experience of works of art with the aim, first, of attributing works to artists and schools, identifying *styles and establishing *sources and influences, and second, of judging their *quality and hence their place in a *canon. These are the essentials of the approach employed by Vasari in the sixteenth century and in part by Winckelmann in the eighteenth, while Morelli in the nineteenth concentrated the approach into the form of a narrow but powerful *empirical technique which he considered much more reliable than the written evidence.[1] Bernard Berenson (1865–1959), the best-known exponent of connoisseurship in the twentieth century, continued this tradition in arguing that the practical contribution of connoisseurship lies in making correct attributions, such as those of Morelli to the *œuvre* of Giorgione, and in establishing the order in which works were produced.[2]

Morellian technique still forms the basis of the *catalogue raisonné*. It is also prominent in more specialized contexts, as in attempts to attribute medieval buildings to specific architects, where 'it is in the mouldings and the smaller tricks of detail that evidence of identity must be sought', and similarly in the case of medieval manuscripts, where the 'less important decorations are ... precisely the elements of the book which ... are most useful in individualizing a manuscript', that is identifying the hands of those who produced it (fig. 47).[3] Finally, in the absence of *documentary

evidence, as in the study of tribal art, the connoisseur can provide the indispensable service of authentication, that is, of separating the original from the copy and the fake (see Fagg, text 20, 1973). (See also *empiricism and Panofsky, text 15, 1940.)

1 Winckelmann, text 4, 1764, and 'Instructions for the Connoisseur', in *Reflections on the Painting and Sculpture of the Greeks* (1755), translated by Henry Fuseli, London, 1765, p. 259; Morelli, text 8, 1890; see also, for example, J.A. Crowe and G.B. Cavalcaselle, *A History of Italian Painting* (1864), 2nd edn, London, 1903.

2 Bernard Berenson, *Aesthetics and History*, London, 1950, p. 179 and pp. 200–34.

3 J. Harvey, *English Medieval Architects*, London, 1954, p. xli. L. Delaissé, 'Towards a History of the Medieval Book', *Codicologica*, 1, 1976, p. 79.

CRAFT see ART, AND ARCHITECTURE

CULTURAL HISTORY Cultural history is a term of wide applicability used to describe the work of scholars such as social *anthropologists who are primarily studying the form and character of *culture in the broad sense. The label is also accepted shorthand for what is strictly speaking the cultural history of art. Cultural historians whose main interest is in the visual arts attempt to set the object studied into the context of the culture which produced it. They will examine all aspects of the culture in question and analyse what conditions the production of the object (such as climate, mores, etc), even if they keep the high culture of the community at the centre of their interests. Their approach includes aspects of both Hegelianism and empiricism, in terms of their acknowledgement of the interconnectedness of things (while denying the existence of a ruling principle) and their stress on the innumerable individual details of which the past consists (while recognizing that nothing can be understood in isolation). They therefore also have much in common with *humanists.

331

Cultural historians have shown an interest in virtually all cultures but have concentrated on Western art as part of the intellectual history of a civilization, stressing those elements which indicate continuity. Those of the second half of the twentieth century, such as Gombrich (see for example text 19, 1967), can claim a lineage extending back via Warburg to Burckhardt in the nineteenth century and even to Winckelmann in the eighteenth, with the change which he made from *biography to history. The arrangement of the library of the Warburg Institute in London illustrates the integrated nature of Warburg's historical perspective in graphic, indeed (given the distribution of material throughout its floors) in architectural, terms. He arranged it to provide what he called 'orientation', leading from astrology to astronomy, from alchemy to chemistry, from number magic to mathematics, from liver auguries to anatomy, from ritual action to mental orientation, linguistic expression and visual images, with everything leading back to the question of the origins of human culture.[1]

1 E.H. Gombrich, 'In Search of Cultural History' (1967), in *Ideals and Idols: Essays on Values in History and in Art* (1979), reprinted, London, 1994, pp. 20 and 53; and 'The Ambivalence of the Classical Tradition: the Cultural Psychology of Aby Warburg' (1966), in *Tributes: Interpreters of our Cultural Tradition*, Oxford, 1984, pp. 123–4 and 133. See also Michael Podro, *The Critical Historians of Art*, New Haven and London, 1982, *passim*.

CULTURE Culture in the broad sense refers to all aspects of the way in which a society relates to and makes sense of the world. In this respect it is that part of human experience which is distinguishable from nature, although the boundary between the two may be unclear. This is how the term is understood and used by anthropologists and social historians. Actions are frequently categorized as being determined either by culture or by nature. It is possible to argue that all human action is culturally determined, and that it is in the interests of those in positions of power to describe as natural as many aspects of behaviour as possible (see *ideology).[1] Such deterministic

48 *Kouros of Tenea*, c.575–50 BC. Marble, h. 1.35 m. Staatliche Antikensammlungen und Glyptothek, Munich Figs. 48, 49 and 50 illustrate the archaic, classical and baroque stages of a cycle identified in Greek sculpture. In the sixth-century *kouros* the carving closely echoes the planes of the block of stone from which one can imagine it was carved, the weight is evenly distributed between the feet, the legs and arms are rigid, and the gaze unswerving with the eyes staring straight ahead. The fifth-century bronze figure, standing in a contrapposto pose, is more relaxed and humanized than the earlier *kouros*. The figure is modelled in many planes and the eyes look away from the axis of the body (the demands of the style appear to remain the same whether a figure is made in bronze or in stone). The *Nike of Samothrace* of the second century is even more developed in terms of movement. This figure has a different function from the other two, and is draped, but the stylistic differences are representative of the general changes none the less. There is a close parallel between these three stages and those of Vasari's Renaissance cycle, as illustrated by the paintings of Giotto, Masaccio and Michelangelo (figs. 1, 2 and 3), and, moving the frame on by a century, those of Wölfflin's Renaissance and Baroque cycle, as illustrated by the paintings of Masaccio, Michelangelo and Rubens (figs. 2, 3 and 39).

theories and explanations are, however, now widely discredited in anthropology and the other social sciences generally.

The concept of culture has been attached to different aspects of society, of which the commonest is the geographical or national type, as in 'Western', 'African' or 'French' culture. Material culture, the field of ethnology, refers to the artefacts of a society as opposed to less concrete manifestations such as speech or kinship patterns. Visual culture incorporates a broader area as it can include behaviour, drama, and so on in addition to objects, while labels such as ''postmodernist' culture can be used to refer to the character of a period or a social state or condition. 'Popular' culture can be contrasted with 'high' culture and, more complicatedly, with 'mass' culture.[2]

Culture, more narrowly understood, refers to the literature, philosophy, art, knowledge (and sometimes science) and other accomplishments of an elite, that is 'high culture' (see Fry, text 12, 1920).

T.S. Eliot, in writing about culture, provides a revealing example of the division between these two definitions. When specifically defining it he describes culture in the broad sense as the product of the whole community, including everything from boiled cabbage to Gothic Revival churches, but when using the concept in practice he implicitly defines it as high culture, that of the dominant classes who constitute 'the primary consumers of the works of art produced by its minority members'.[3]

1 See the entry on culture in Raymond Williams, *Keywords: a Vocabulary of Culture and Society* (1968), 2nd edn, London, 1983.

2 See Panofsky, text 15, 1940, Sontag, text 18, 1964, Gombrich, text 19, 1967, Baldwin, Harrison and Ramsden, text 23, 1981 (especially for popular versus mass culture), Pollock, text 26, 1988, and Oguibe, text 27, 1993, as well as 'cultural history and 'Marxism.

3 T.S. Eliot, *Notes Towards a Definition of Culture*, London, 1948, pp. 31 and 42.

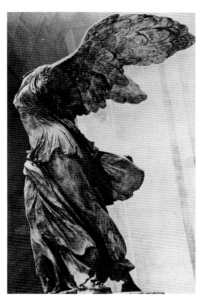

49 Hero or athlete, fifth century BC. Bronze, h. 2.05 m. Museo Nazionale, Reggio Calabria. See fig. 48.

50 *Nike of Samothrace*, c.180 BC. Marble, h. 2.45 m. Musée du Louvre, Paris See fig. 48.

CYCLES A cycle is one sequence of a recurrent sequence of phases, as in the life cycle of a butterfly or the rotation of a wheel. Two models of cycles have been widely used by art historians, namely the qualitative and the descriptive.

The phases of the *qualitative* model have been most commonly described by the biological metaphors of growth, maturity and decay, implying beginning, peak and decline. Vasari applied these three phases to antiquity, while for the Renaissance he substituted childhood, youth and maturity, thereby avoiding the problem of proposing a decline in his own time.

The phases of the *descriptive* model have been labelled early, °classic and baroque, early, high and late, or early, middle and late (figs. 48, 49 and 50). Although these names are intended to carry no judgements of relative °quality, the terms 'classic' and 'high' have clear overtones of superiority. This model was applied in detail to the art of the Renaissance by Wölfflin. The early phase is also referred to as the 'primitive' or the 'archaic' (see Focillon, text 13, 1934).

Cycles have been used in longer and shorter versions. Wölfflin and others saw two long cycles covering the whole of Western history, the first from the earliest beginnings to a decline in late antiquity, and the second from the start of the Renaissance to around 1900. The short cycles are more easily identifiable kernels of about two centuries in length, c.550 to c.350 BC in ancient Greece, and c.1400 to c.1600 in Renaissance Italy. The apparent coherence of these two shorter cycles may be partly explicable by the likelihood that the latest artists in each sequence (of which Vasari himself is an example) were aware of their relationship to the earliest. Some form of internal dynamic force independent of the knowledge of the participating artists has however been seen as a common feature of the model, because similar sorts of phases occur in the same order in architectural styles such as the Gothic, in which assumptions about the artists' knowledge of their predecessors cannot be made. See for example the early, middle and late Gothic façades of

Chartres Cathedral, c.1140 (fig. 31), Strasbourg Cathedral, c.1300 (fig. 13), and St-Maclou at Rouen, c.1500 (fig. 32). (See also *teleology).

One of the problems with cycles is that they only work in hindsight, so that, to their contemporaries, innovators must often have appeared as if they belonged to what turned out to be the 'wrong' group (see Wölfflin, text 10, 1915). Another difficulty is the extent to which cycles are explained by the influence of external events. Thus the apparent self-confidence of the style of the Baroque age is sometimes attributed at least in part to the Counter-Reformation. Yet there is no equivalent to the Counter-Reformation in the Hellenistic age, when a similar late or baroque phase can none the less be identified.

DEATH OF THE AUTHOR see POSTSTRUCTURALISM

DECONSTRUCTION see POSTSTRUCTURALISM

334

DESIGN HISTORY Design history can be defined as the study of industrially produced objects or the conditions of manufacture of any object, concentrating on the visual aspects of the subject and using the tools and methods of the history of art. Design historians consequently have a broad interest in material culture, craft and the applied arts, which relates them to *archaeologists and *architectural historians on the one hand and, through their interest in function, to sociologists on the other. In these terms a washing machine and the ceiling of the Sistine Chapel can be considered as members of the same class of objects. Thus far attention has on the whole been concentrated on objects produced since the Industrial Revolution, but the sphere of interest is now expanding to include all aspects of design regardless of date.[1]

1 See the *Journal of Design History*, as well as, for example, Adrian Forty, *Objects of Desire: Design and Society 1750–1980*, London, 1986; John A. Walker, *Design History and the History of Design*, London, 1989; and Anne Massey, *Interior Design of the Twentieth Century*, London, 1990.

DISCOURSE ANALYSIS The aims of Michel Foucault (1926–84) were extremely wide-ranging in that he set out to classify all the techniques of interpretation and all the formal power relationships of Western culture. The concept which he used in pursuit of these aims is that of the discourse. A discourse for Foucault is a way in which knowledge is articulated in society, by, for example, the various institutional forms which it takes. Knowledge produces and transmits power and includes social practices, ways of producing meaning, and all types of control. Things have no meaning outside their discourse, and each discourse is part of a wider network of discourses. Discourses extend in character from the very largest, such as *humanism, to the smallest, such as the physical layout of a church or prison. The law and medicine are examples of particularly powerful institutional discourses. Discourses can themselves be used to subvert discourses, exploiting conflicts within social institutions; they are 'tactical elements or blocks operating in the fields of force relations', force relations being the social institutions. For each practical discourse/discursive practice Foucault describes the rules of accumulation, exclusion, reactivism, derivation and succession.[1]

While Foucault shares a number of his ideas with the *poststructuralists, he differs from them in two respects, first in retaining the idea of the author, even if only as 'a strong moment of individuation in the history of ideas' and as 'a founder of discursivity'; and secondly in using periods, as he refers to the classical and bourgeois ages and takes the French Revolution as the turning point in recent history – the start of the modern era.[2]

In the area of techniques of interpretation he defined the difference between an old history and

a new. The old history was one of continuities, totalities, constants, quantities, accumulations, bureaucratic controls, the progress of conscious thought, linear successions, causal links, foundations, tradition, influence, development, evolution, fields, periods and the spirit of the age. These added up to a refresher course in the collective memory based on the sovereignty of the subject and hence were dependent on a humanist view of the world.

The new history he defined by contrast as one of discontinuities, difference, shifts, thresholds, ruptures, breaks, mutations, transformations, series of series, differentiated autonomies, the exploring of labyrinths and deformed itineraries. Its subject includes everything, but it cannot produce a total history. Power for Foucault is always malign, polymorphous and concealed, and it is the thinker's task to subvert it.

By using these methods Foucault divides up the past in a number of provocatively different and revealing ways. His image of history and the concept of discourse can be used as instruments in the understanding of how social institutions 'really' work, from hospitals and art galleries to universities and clubs. For art historians in particular the litany of terms which he offers in describing the old history (linear successions, causal links, foundations, tradition, influence, development, evolution, fields, periods and the spirit of the age) sounds like a roll-call of fundamental concepts, assumptions and methods, and therefore presents a basis for reassessment. His approach is also more accessible to art historians than those of other poststructuralists such as Derrida and Barthes, in that in some form he retains both the author and the period. This retention can probably be ascribed to the fact that he is dealing with history, which is arguably more resistant to a writer's will than literature.[3]

1 Michel Foucault, *The Order of Things: an Archaeology of the Human Sciences*, London, 1970 and *The Archaeology of Knowledge*, London, 1972.

2 Michel Foucault, 'What is an Author', *Partisan Review*, 42 (4), 1975, pp.603–14; reprinted in Josué V. Harari, ed., *Textual Strategies: Perspectives in Poststructuralist Criticism*, London, 1980, pp. 141–60.

3 For examples of applications of discourse analysis to art-historical material see Michael Clanchy, 'England in the Thirteenth Century: Power and Knowledge', in *England in the Thirteenth Century* (Proceedings of the 1984 Harlaxton Symposium), W.M. Ormrod, ed., Harlaxton, 1985, pp. 1–14; and Nicholas Green, *The Spectacle of Nature: Landscape and Bourgeois Culture in Mid-Nineteenth-century France*, Manchester, 1990. Alpers (text 24, 1983) discusses Foucault's analysis of Velázquez's *Las Meninas*.

EMPIRICISM Empiricism is the view that all knowledge derives from experiment. It is also used as a synonym for scientific method, which moves from observation to experiment, that is induction, starting with the facts, as opposed to deduction, starting with an idea or principle. These concepts are closely related to the wider philosophical concept of positivism in which it is held that the sciences are the only source of knowledge and that metaphysics and theology are to be avoided. In the history of art empiricism encourages °connoisseurship and a stress on the study of individual works of art, in particular the examining of °style in the manner of a chemical analysis. Its greatest monuments are highly detailed reappraisals of single paintings as in the work of Morelli (text 8, 1890), the establishing of a framework for a whole family of objects as in George Zarnecki's work on English Romanesque sculpture, and the epic collections of data of societies in the process of losing their traditional material culture, as for example in Ananda Coomaraswamy's work on Sri Lanka.[1] (See also °antiquarianism.)

Empiricism constituted the prevailing approach in the nineteenth century for a large school of historians and also for those art historians who practised connoisseurship,[2] while in the early twentieth century the almost diametrically opposed doctrine of °Hegelian metaphysics became the pervading approach. From the 1930s onwards empiricism once again characterized the discipline, until the 1970s when an interest in systems was revived (see °art history).

51 The Typology of the Hammer. From G. Barsalla, *The Evolution of Technology*, Cambridge, 1988, fig. 1.4. The caption to Barsalla's diagram begins: 'The evolutionary history of the hammer, from the first crudely shaped pounding stone (1) to James Nasmyth's gigantic steam hammer of 1842 (14)…'

This figure illustrates the extent to which it is productive to apply evolutionary metaphors to human artefacts and the point at which it ceases to be useful to do so. While all of the examples apart from the last bear some resemblance to the sequences of anatomical parts proposed in evolutionary theory, the last, a punch hammer, stands out as having nothing to do with such a sequence and represents a jump which is not explained.

One of the temptations of the empirical method is to erect massive defences of individual details in order to forestall premature theorizing and even to establish the irrelevance of larger theoretical frameworks. But while no historical study of any worth can be conducted without attention to the relevant facts, empiricism needs to be treated as one method among many, and in particular as something in a constant relationship with *theory (as it is, for example, by Burckhardt, text 6, 1872, Gombrich, text 19, 1967, and T.J. Clark.[3] On the interrelatedness of theory and empirical fact see also *theory and *archaeology, and Panofsky, text 15, 1940.)

1 George Zarnecki, *English Romanesque Sculpture*, London, 1953, and George Zarnecki, Richard Gem and Christopher Brooke, et al., *English Romanesque Art 1066–1200*, exhibition catalogue, Hayward Gallery, London, 1984; Ananda Coomaraswamy, *Medieval Sinhalese Art*, 2nd edn, New York, 1956.
2 For a critique of the work of one of the best-known of these empiricist historians, Leopold von Ranke, see R. Jauss, 'History of Art and Pragmatic Theory' (1970), in *Towards an Aesthetic of Reception*, translated by T. Bahti, Brighton, 1982, pp. 51–7.
3 T.J. Clark, *Image of the People: Gustave Courbet and the 1848 Revolution*, London, 1973, Introduction.

EVOLUTION The word evolution in its specialized sense is used to describe the neo-Darwinian theory that explains the origin of species by a combination of natural selection and chance mutation. In its very different everyday sense the term is used to describe change which is gradual rather than revolutionary, which moves from simple to complex or from lower to higher, and which does so towards a discernible goal, involving the idea of *progress.

Art historians have used the concept extensively in describing and explaining stylistic change (in relation, for example, to the *cycle), but they have done so on the whole in the everyday sense and on the basis of inappropriate parallels between natural forms and cultural ones. Thus one writer

has described an architectural style as 'a complete organism obedient to the same laws as creatures of the flesh…'[1]

Some writers have reacted more cautiously to the use of such metaphors. Riegl, for example, attacked the application of evolutionism to the history of art, especially Semper's view that form was determined entirely by material conditions.[2] Similarly Focillon expressed the view that art historians too easily applied a scientific model to a completely different set of circumstances, the sense of overriding orderliness, the single-minded directness, and especially the inability to make room for 'the revolutionary energy of inventors' being in his view inappropriate in the study of history (text 13, 1934). It does not matter that biological evolution is the very antithesis of orderly, since Focillon's criticism is of the idea as it has been applied.

Another indication of the caution needed in using evolutionary metaphors is provided by the simplified character of most diagrams setting out the variations in shape of a type of object over time. Fig. 51, for example, sets out a history or 'typology of the hammer as a sequence of examples. All but one of these are closely enough related to one another to justify seeing them as steps in a process which might have something in common with evolution. The last item in the sequence, however, is a punch hammer, the form of which has very little beyond its purpose in common with all the previous manual types.[3] It represents, in fact, the sort of step which is common in cultural change but without parallel in biological evolution, even with the most violent mutation. This example suggests that the notion of evolution has become so much a part of our mental furniture that we assume its relevance even when there is no reason to do so. This is of course a good reason for avoiding it.[4]

337

1 Pierre Heliot, *Du carolingien au gothique: l'évolution de la plastique murale dans l'architecture religieuse du nord-ouest de l'Europe (IXe–XIIIe siècle)*, Paris, 1966, p. 99.

2 See Alois Riegl, text 9, 1901; and *Stilfragen*, 1893, pp. vi and 12.

3 G. Basalla, *The Evolution of Technology*, History of Science Series, Cambridge, 1988, p. 20, fig. 1.4.

4 An indication of changes in the presentation of evolutionary theory itself, in ways which may be of use to art historians, is provided by the description of new and old models of the development of early life forms in Stephen Jay Gould, *Wonderful Life: the Burgess Shale and the Nature of History*, London, 1990, pp. 215–16, and figs. 3.71 and 3.72.

FEMINISM Since the early 1970s feminists have interacted with the history of art in a large number of ways. Most straightforwardly they have added to the corpus of known artists by conducting research into work that has been ignored by previous art historians.[1] They have also examined and assessed the effects of the division between the arts and the crafts on the reputations of artists. Because women were generally restricted to making artefacts such as quilts and clothing which were classified as crafts, art historians considered that what they made was marginal to the discipline and their makers therefore not eligible for inclusion in the 'canon of great artists (Riegl is exceptional before the mid-twentieth century in taking the fine arts and the crafts together as evidence for the history of a society).

They have also examined the relationship between women artists and women art historians and the 'ideology of their respective societies. This politicization of the subject was effected by scholars such as Linda Nochlin, Lisa Tickner, Rozsika Parker, Griselda Pollock and Lynda Nead, who have paid particular attention to those aspects of contemporary society which manifest its patriarchal character.[2] The contrasting of versions of subjects such as *Susanna and the Elders* by women and men artists has proved particularly fruitful in this regard (as in figs. 52 and 53).[3] Closely related to this approach is the significance of the notion of the 'male gaze', both for the ways in which images are made and they and the world in general are viewed and reconstructed (see, for example, fig. 54).

52 Jacopo Tintoretto, *Susanna and the Elders*, c.1550–70. Oil on canvas, 1.47 × 1.94 m. Kunsthistorisches Museum, Vienna
The paintings by Tintoretto and Gentilleschi (fig. 53) illustrate two versions of the same subject by a male and a female artist respectively. Tintoretto has portrayed Susanna as an attractive woman unaware that she is being watched, putting the imagined male viewer in the position of the Elders. Gentilleschi, in contrast, depicts a figure who is not so obviously attractive, at least to male eyes, and chooses a different moment in the story, when Susanna is being physically molested – an image that a woman might identify with more easily than a man.

338

53 Artemisia Gentilleschi, *Susanna and the Elders*, 1610. Oil on canvas, 1.7 × 1.19 m. Private collection. See fig. 52.

54 Sylvia Sleigh, *Philip Golub Reclining*, 1971. Oil on canvas, 42 × 60 cm. Lerner Misrachi Gallery, New York
This illustration calls attention to the character of the male gaze by depicting a man in the same pose as Velázquez's *Rokeby Venus*. It is illustrated alongside the *Rokeby Venus* in Rozsika Parker and Griselda Pollock, *Old Mistresses: Woman, Art and Ideology*.

In addition to these approaches with their roots in the history of art, feminists have also studied imagery using a variety of methods such as *psychoanalysis, *semiotics and *structuralism. Concerning psychoanalysis, for example, many feminists are cautious of accepting Freud's version because it appears to presuppose a patriarchally structured world and a form of sexual identification in which differences between male and female are natural and biologically determined. Some scholars such as Julia Kristeva have consequently turned to the psychoanalytical approaches of *poststructuralism, as for example in the work of Jacques Lacan which denies a fixed form to human nature, and they have used such methods to question the identity associated with being male or female. They argue that the subjective experience of gender can be shown to be socially and culturally constituted by anything from the most powerful element, such as schooling, to the apparently most trivial, such as the composition of family snapshots. They would deny that any human responses or characteristics are either biologically or psycho-sexually based. Thus in these terms neither the desire for motherhood nor hysteria are the result of inherent physiological factors. The questioning of gender differences represented by homosexuality has also played a part in this reassessment. From this basis and using the critical techniques of *deconstruction feminists have called attention to those aspects of society which they consider most fully identify it as patriarchal in character. The aims of many feminist poststructuralists are political and utopian, involving the construction of a society in which gender, race and class have ceased to determine inequalities in power relations.[4] (See Pollock, text 26, 1988.)

339

1 Linda Nochlin, 'Why Have There Been No Great Women Artists?' (1971), in Thomas B. Hess and Elizabeth C. Baker, eds., Art and Sexual Politics, New York, 1973, pp. 1–43.

2 Lisa Tickner, 'The Body Politic: Female Sexuality and Women Artists since 1970', Art History, 1, 1978, pp. 236–51; Rozsika Parker and Griselda Pollock, Old Mistresses: Women, Art and Ideology (1981), reprinted, London 1987; Lynda Nead, 'Feminism, Art History and Cultural Politics', in A.L. Rees and F. Borzello, eds., The New Art History, London, 1986, pp. 120–4.

3 See, for example, Norma Broude and Mary Garrard, Feminism and Art History: Questioning the Litany, New York, 1982, especially Mary Garrard, 'Artemisia and Susanna', pp. 146–71; and Linda Nochlin, Women, Art and Power, London, 1989.

4 Chris Weedon, Feminist Practice and Poststructuralist Theory (1987), reprinted, Oxford, 1989, pp. 148ff. Julia Kristeva, Revolution in Poetic Language (1974), abridged version translated by M. Waller, New York, 1984, especially part 1, 'The Semiotic and the Symbolic', and chapters 2 and 6. For an attempt to link contemporary feminist theory with the tradition of scholarship associated with Aby Warburg, see Margaret Iversen, 'Retrieving Warburg's Tradition', Art History, 16, 1993, pp. 541–53.

FORMS In art-historical usage the term 'form' is broadly synonymous with shape. Art historians use the analysis of forms primarily as a means of establishing the character of an object, and placing it in a chronological or *typological sequence. Forms in works of art are usually analysed using concepts of *style, and are themselves used in turn to define those concepts, as with the well-known pairs of types of forms devised by Wölfflin (text 10, 1915). The forms which make up a work can be read on an abstract level, even when they are part of a representation of the visible world.

Forms have an identifiable tendency to alter in particular sequential ways from one work to another over a period of time. They alter, among other reasons, because artists and patrons, at least in some cultures, frequently want new forms to differ from old ones. They also continue to relate to their predecessors because art forms owe more to earlier art forms than, for example, to artists' perceptions of nature.

Some writers have described such changes as representing a life within the forms themselves, as for example with the phenomenon of individual forms appearing to change as they age, as it were before our very eyes. This effect is noticeable when, for example, new models of cars or clothes gradually lose their power to attract attention and at some point are deemed to be out of date. (See also Focillon, text 13, 1934 and *evolution).

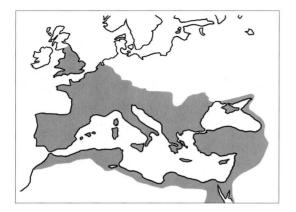

55 The Roman Empire at its greatest extent, second century AD.

This map illustrates the value of thinking about the Roman Empire not so much as a group of provinces but rather as the Mediterranean Sea and the land which happens to border it, thus underlining the central role of the sea in the economic structure of the Empire.

▓▓ The Roman Empire, second century AD.

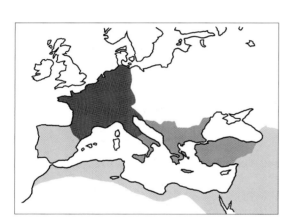

56 The Mediterranean, c. 800 AD, showing the boundaries of the Eastern Roman Empire, the Carolingian Empire, and the western parts of the Islamic Empire. The expansion of Islam after its foundation in the seventh century split the economic system of the Mediterranean in two, causing the eastern half of the Roman Empire to shrink and forcing the Germanic tribes ruling the still functioning skeleton of the western half to retreat and establish a new centre of gravity in Northern Europe between the Rhine and the Seine. This formed the basis of the Carolingian Empire and subsequently laid the foundations for the concept of Europe as a cultural entity.

▓▓ Eastern Roman Empire
▓▓ Frankish Kingdom/Carolingian Empire
▓▓ Islamic Empire

57 Broken line: Diocletian's boundary between the eastern and western halves of the Roman Empire, c. 300 AD. Solid line: the boundary between the Latin and Orthodox churches, c. 1300.

This map illustrates the extent of the influence of the fourth-century division of the Roman Empire into eastern and western or broadly Greek- and Latin-speaking halves. This is what lies behind the enmity between, for example, the Serbs and the Croats, despite the fact that they belong to the same group of South Slavonic peoples and that they only arrived in the Balkans in the seventh century, four centuries after the division was introduced.

―――― Boundary between the Latin and Orthodox Churches, c. 1300

- - - - Diocletian's boundary between the eastern and western parts of the Roman Empire, c. 300 AD

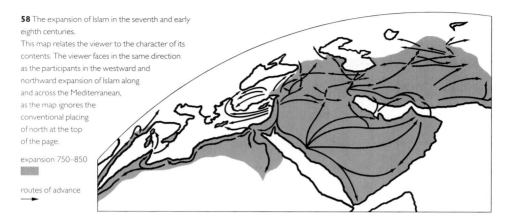

58 The expansion of Islam in the seventh and early eighth centuries.
This map relates the viewer to the character of its contents. The viewer faces in the same direction as the participants in the westward and northward expansion of Islam along and across the Mediterranean, as the map ignores the conventional placing of north at the top of the page.

expansion 750–850

routes of advance

341

GEOGRAPHY The discipline of geography shares with the history of art an interest in the interrelationship between objects and human activity, in which questions are asked of the object such as where was it made, and what was it made for? Geography can illuminate art history both practically, by providing particular kinds of physical information, and metaphorically, by offering different ways of thinking about things. Thus the map is both a real object containing information and one of the commonest images of the organizing of knowledge. Historical geography, for example, raises key questions such as what represents the physical centre of gravity of a culture and what its periphery (taking culture to mean anything from an empire to an artists' collective), what constitutes a nation, or why empires take the shapes they do. Maps can provide hypotheses as the basis for answers, as in the following two examples.

If the Roman Empire is defined not in terms of its provinces but as the Mediterranean Sea plus the land that borders it, then the relationships, cultural as well as economic, between its various parts appear in a very different light (fig. 55). The idea that it was the sea that formed the matrix provides the basis for the theory that the Western Empire did not collapse with the ending of a dynasty and the removal of formal structures of power in the fifth century, but only when the economic unity of the Mediterranean was disrupted by the Muslim invasions of North Africa and Spain in the seventh and eighth centuries. This in turn created a new centre of gravity of power between the Rhine and the Seine which led to the idea of a specifically European, as opposed to a Roman or Mediterranean, culture (fig. 56).

The second example concerns the proposition that administrative divisions of the Roman Empire offer similarly powerful explanations of subsequent events. The enmity between the Serbs and the Croats, for example, seems inexplicable given the fact that both groups identify themselves as south Slavs and speak the same Slavonic language. The boundary between them, however, is broadly that between the Latin- and Greek-speaking parts of the Mediterranean world. This boundary, which was established centuries before the arrival of the Slavs in the Balkans, was formalized in the late third century by Diocletian when he divided the Empire into eastern and western halves. With the legalization of Christianity in 312 the same boundary became that between the Latin and Orthodox Churches. It survived the arrival of the Slavs in the seventh century and led to their separate identification as Croats and Serbs on either side of the line, and subsequently provided the basis for the boundary between the Turkish Empire and Christian Europe, with Turkish rule being responsible for the subsequent presence of a Muslim population in the area (fig. 57).

The differences which have followed from Diocletian's administrative arrangements are primarily the use of the Roman and Cyrillic alphabets and adherence to the Latin and Orthodox rites in the West and East respectively. The second of these differences has the consequence that the church architecture of the two groups is as easily distinguishable as their newspapers, with longitudinal buildings for the Croats and centralized ones for the Serbs. A survey of the churches of the region would thus enable one to draw an accurate boundary between the groups, including the fluctuations of that boundary over the centuries.

The potential of this way of thinking about history is well illustrated by the technique used in the *Times Atlas of World History*, which contains many maps drawn as if on the surface of the globe and seen from a satellite located over the point from which an invading force or cultural movement originated, pointing the viewer in the same direction as the participants and ignoring the conventional placing of north at the top of the page (fig. 58).

HEGELIANISM The main tenets of Hegel's philosophy are that ideas underlie all forms of reality, that all events must be perceived in terms of steadily evolving principles, and that the entire historical process is a rational and necessary development leading to the emergence of a self-knowing, divine spirit, hence the labels 'idealist' and 'metaphysical' usually applied to the theory. Hegel called the spirit the inner nature and fate of the world, the inner architect of history and the eternal and absolute Idea. It expresses itself as the spirit of the nation (the *Volksgeist*) and of the age or 'period (the *Zeitgeist*), which two together constitute the pageant of history unfolding and moving forward in continuous development.

Since, from this viewpoint, art develops according to an intrinsic logic which is intelligible to the historian, the history of art can be seen as one of the most important ways of understanding the processes of world history. The development of the spirit takes place in three identifiable periods, the symbolic, the classical and the romantic, that is Oriental or Early art, the art of Graeco-Roman antiquity and finally the period of Christian and Germanic romanticism, which is Hegel's own age. While the Graeco-Roman period is the centrepiece and while Hegel uses Greek art to demonstrate what he means by beauty, this sequence of periods does not follow the rise and fall of the biological 'cycle. On the contrary, the phase of romanticism transcends the classical period, maintaining the sense of optimism and universal 'progress inherent in the notion of the emergence of the world spirit. Within this framework, however, each art has a beginning, a perfection, and an end, a growth, blossoming and decay. It is as if the cycle employed by Vasari and Winckelmann has become a spiral, or rather a helix, rising in a curve through space.

Along with this highly theoretical base, Hegel also considered a detailed knowledge of individual works of art essential to the study of the subject. He treated the analysis of formal values as indispensable, discussing paintings in terms, for example, of the fact that the architectural juxtaposition of figures can produce a sense of unity through the forming of a pyramidal shape. He consequently acknowledged the value of the work of connoisseurs, while criticizing them for limiting themselves to the external aspects of things.[1]

Hegel's ideas have been immensely influential, with Marx, for instance, transforming the defining spirit into the conditions of production. The main change which Hegelianism undergoes in the work of art historians such as Riegl, Wölfflin and Frankl, is one of secularization, the reduction in importance of the divine aspects of the world spirit and of the idea of 'progress, combined with a stress on the belief that social forms are all manifestations of a single essence. Panofsky was both fascinated by the ideas behind Hegel's scheme and increasingly sceptical about the value of many of their applications. His attitude of qualified admiration is perhaps best summed up in the telling

pun in which he described the master as a 'boa constructor'. Hegel's influence was also acknowledged by Foucault (see *discourse analysis), while T.J. Clark has considered his approach a fundamental basis for reform (text 21, 1974).[2]

1 G.W.F. Hegel, *Aesthetics, Lectures on Fine Art*, (from the posthumous publication of 1835 of the lectures delivered between 1823 and 1829), vol. 2, translated by T.M. Knox, Oxford, 1975, pp. 614 and 1064–5.

2 See E.H. Gombrich, '"The Father of Art History": a Reading of the *Lectures on Aesthetics* of G.W.F. Hegel (1770–1831)' (1977), in *Tributes: Interpreters of our Cultural Tradition*, Oxford, 1984, pp. 51–69; and Michael Podro, *The Critical Historians of Art*, New Haven and London, 1982, pp. 17–30; see also Riegl, text 9, 1901; Wölfflin, text 10, 1915; and Frankl, text 11, 1914.

HISTORY The term 'history' means both what happened in the past and the study of the past. History as the study of the past has also been traditionally identified with the study of written documents as opposed to artefacts, hence the use of the label 'prehistory' for periods before writing and of the label 'historian' for those who work primarily or exclusively with written documents, as opposed to those like archaeologists and art historians who focus on the material evidence and use the written word in conjunction (see *archaeology and *art history). The concept of a document has more recently been extended to include evidence in any form, whether written or material. Despite this, the distinction is deeply embedded in Western institutions and has some basis in the application of different forms of expertise, but it obscures the greater truth that we are all engaged in attempting to understand the past.

343

It is probably impossible to think about the past without giving it a metaphorical shape, such as a map or a road, or images of strata from archaeology, or sequences of rooms and spaces from architecture. The character of the model being used needs to be acknowledged and understood, as it carries assumptions which can affect the way in which historical problems are handled. Thus a river or an archaeological section appears to present the past as indeterminate and open-ended, whereas a road or a building may be more systematic and *Hegelian in its implications. We also have at least two views of the past, our own memories and everything else before and apart from them, each of which can affect the model in a different way, by producing, for instance, a myopically close structure for the first and something much more abstract for the second.

There is a sense in which all history is contemporary history, that is, that we can only be aware of the past in so far as it has survived into and is experienced in the present.

HUMANISM 'Humanism … is not so much a movement as an attitude which can be defined as the conviction of the dignity of man, based on both the insistence on human values (rationality and freedom) and the acceptance of human limitations (fallibility and frailty); from these two postulates result – responsibility and tolerance' (Panofsky, text 15, 1940). This definition of humanism is one description of the way in which human beings have related themselves to the world since the Enlightenment and in some respects since the Renaissance.[1] The part of most importance for an understanding of the difficulties which the concept has faced in the last 150 years are the words 'rationality' and 'freedom'. First Marx reduced the sphere of imagined human freedom by establishing the importance of the economic structure of a society in determining the actions of its members. Then in the twentieth century Freud called attention to the irrational bases of human behaviour, while totalitarian political structures graphically illustrated the inadequacy of an optimistic rationalism. And finally, in the late twentieth century, poststructuralists and others have criticized the humanist belief in individual consciousness, the possibility of communicating meaning,

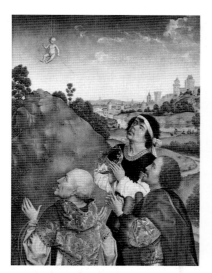

344

59 Roger van der Weyden, *The Vision of the Three Magi*, c.1450. Oil on panel, 91 × 40 cm. Staatliche Museen zu Berlin, Preussischer Kulturbesitz Gemäldegalerie, Berlin
A comparison between this fifteenth-century Flemish painting and an eleventh-century German manuscript (fig. 60) illustrates Panofsky's observation that our understanding of the degree of naturalism of an image, and hence our ability to analyse it iconographically, depends on our knowledge of the context in which it was produced. The Christ Child in *The Vision of the Three Magi* is shown suspended in mid-air, suggesting it is meant to be an apparition. This, however, is only evident because of the naturalistic character of the painting. Conversely, the city in the medieval manuscript (fig. 60), despite being shown apparently suspended in mid-air, is simply an indication of place in an image produced outside a naturalistic tradition.

60 *Christ Resurrecting the Youth of Nain*, c.1000. Bayerische Stadtbibliotek, Munich, Clm. 4453 (previously Clm 58), fol. 155v
See fig. 59.

and the relevance of the author (see *Marxism, *psychoanalysis, *poststructuralism, *cultural history and *subjects/disciplines).[2]

The arguments for and against the ability of human beings to act rationally and to communicate meaning in the face of economic structures, subconscious urges and a weakened belief in individual identity, bear many similarities to the old conundrum concerning free will and determinism. In both cases experience on the whole supports one alternative (free will and meaning) and argument the other (determinism and social context). In both, in addition, acceptance of the argument in favour of determinism/social context/*death-of-the-author involves the paradox that the argument itself must then have been determined and is therefore neither true nor untrue, but simply a statement (or if it is true it is so only coincidentally and in the eye of God).

1 The phrase attributed to the Greek writer Protagoras, 'man the scale and measure of all things', was quoted by Alberti already in 1435 in Leon Battista Alberti, *On Painting and Sculpture*, translated by Cecil Grayson, London, 1972, pp. 52–4.
2 See E.H. Gombrich's humanist's credo, in his 'The Tradition of General Knowledge' (1961), in *Ideals and Idols: Essays on Values in History and in Art* (1979), reprinted, London, 1994, pp. 22–3.

61 Jan van Eyck, *The Marriage of Giovanni Arnolfini*, 1438. Oil on panel, 81.8 x 59.7 cm. National Gallery, London Panofsky has interpreted almost every feature in this painting as having a symbolic significance on his second level of meaning. Thus the dog stands for fidelity, the single candle burning in broad daylight for marital fidelity and the presence of Christ, the sandles and unshod feet for hallowed ground, the fruit for innocence, the mirror for purity and the statue of St Margaret for childbirth. (Erwin Panofsky, *Early Netherlandish Painting: its Origins and Character*, Cambridge, MA, 1953, pp. 201–3.)

345

ICONOGRAPHY Iconography is the study of the meanings of images. It extends from the most specific instances such as the attributes which identify figures from classical mythology or Christian doctrine (such as winged sandals for Mercury or an eagle, book or chalice for St John the Evangelist), to the most general, such as the significance which a particular composition can have for a whole culture. Riegl defined iconography as an auxiliary subject, like numismatics, that is, as part of the foundations of the discipline of art history and not part of its edifice. Panofsky, however, gave it a new status by analysing it theoretically and hence relating it to sign theory (see *semiotics).

He divided visual material into three levels of meaning: primary, secondary, and intrinsic, which triplet he also described with the terms natural, conventional and symbolic, and pre-iconographic, iconographic and iconological. The primary/natural/pre-iconographic level involves description which is as straightforward as possible, that is, which requires a minimum amount of specialized knowledge. The secondary/conventional/iconographic level involves a greater degree of specificity, with identifications and labels. The intrinsic/symbolical/iconological level is less specific than the other two, and involves establishing the meaning which inheres in the overall character of the work. Examples of the three are: a figure of a man; a figure of a man holding a knife, which indicates that he represents St Bartholomew; and a painting of St Bartholomew in a particular style, indicating the character of an artist, society or age. In order to answer the criticism that the third level led to loose generalizations separated from detailed scholarship Panofsky later substituted the phrase 'iconographical interpretation in a wider sense', thus avoiding the vagueness of 'iconology'.[1] The term seems, however, to be indispensible.

Panofsky pointed out that description is difficult on all of these levels, and illustrated the problems of embarking upon even primary description by contrasting two images depicted as if floating in space: the naturalistic Christ child in a fifteenth-century panel by Roger van der Weyden, and the stylized city in an Ottonian manuscript of *c.*1000 (figs. 59 and 60). We can only know that the naturalistically depicted child is intended to be an apparition and the stylized city a straightforward representation of a location if we understand the traditional contexts and styles of the respective

images, that is, the assumptions which their contemporaries would have made. For an example of Panofsky's iconographic analysis, see fig. 61.

1 Erwin Panofsky, 'Introductory' to *Studies in Iconology: Humanistic Themes in the Art of the Renaissance*, New York, 1939, pp. 3–31; reprinted in *Meaning in the Visual Arts*, Garden City, NY, 1955, pp. 26–41. See also E.H. Gombrich, 'The Aims and Limits of Iconology', in *Symbolic Images: Studies in the Art of the Renaissance* (1972), 3rd edn, reprinted, London, 1993, pp. 1–25; and Donald Preziosi, *Rethinking Art History: Meditations on a Coy Science*, New Haven and London, 1989, pp. 111–21.

ICONOLOGY see ICONOGRAPHY

IDEOLOGY Ideologies are those bodies of beliefs, images and values which provide our understanding of the world (German *Weltanschauung*, literally 'world-view'). The term is now used almost exclusively in the *Marxist sense in which the picture is a false one constructed to enable classes to gain, hold and manipulate power in society. Our beliefs about the world are therefore presented to us as if they were natural and inevitable, and not as determined by *culture. Art historians use visual means including *stylistic analysis to establish the extent to which an ideology is evident in an image. (See Clark, text 21, 1974; the section on modernism in Baldwin, Harrison and Ramsden, text 23, 1981; and Pollock, text 26, 1988.)

INTENTION It is commonly assumed that the author of a text had an intention in writing it and that that intention is at least partially accessible to the reader. This view has been criticized as untenable by writers such as Roland Barthes and Jacques Derrida on the grounds that texts are nothing but assemblages of conventional signs which are given meaning only by the act of reading them. Related writers such as Foucault have not gone as far, retaining the concept of the author, not as a fixed creator, but in the form of a source of the text constituted by language, ideology and social relations. (For Barthes and Derrida see *poststructuralism, under the death of the author and deconstruction respectively; for Foucault see *discourse analysis).[1]

The destruction of the author is more problematic in the case of the visual arts than it is with literature: while form, like text, can only be read as a series of signs, the work of art none the less has an independent, physical and unique existence (at least, that is, the work of art in the traditional sense, in the form of paintings, sculptures or buildings). Thus the marks which a sculptor makes on a piece of stone are (workshop practice, survival and restoration allowing) those which are also perceived by the viewer, and the meaning of the object lies at least in part in its form (see *reception theory).

It is largely because of this physical uniqueness of the traditional art object that a case has been made for the view that, in contradiction to the criticisms of Barthes and Derrida, it is impossible for the art historian to avoid taking account of the intention of the maker of the object under investigation. Michael Baxandall has provided a statement of this argument, which can be paraphrased as follows.[2]

When we try to explain how an object acquired its form we cannot avoid thinking of it as a product of purposeful activity and therefore about the intentions of its maker. Because this thinking is unavoidable, to deny the relevance of the maker or author is an unhelpful way of approaching an explanation of the object. Instead one should concentrate on purposefulness, on the solving of problems while stressing the circumstances which appear to have played a part in the designer's conception of the object. The *problem* is a task, which Baxandall exemplifies by the wish to build a bridge. The *circumstances* are the given facts of the problem, such as the width of the river to be bridged, the situations, both personal and national, obtaining in the place and at the time in which

the maker lives, and the range of culturally determined possibilities or resources from which the solution has to be found. The *object* is the solution to the problem which is finally selected or produced, in this case the bridge. The intention of the builder of the bridge presents itself to us in the form of the triangle made up of the problem, the circumstances and the object. If we want to know about the intention we play a conceptual game inside the triangle.

In addition to this main point Baxandall also argues that the object cannot be apprehended directly, but must be described, that is, translated into words and concepts, before it can be explained. This conceptualizing of the object also enables us to relate it to the problem, the circumstances and the maker's intention, since those too are concepts.

Baxandall used a bridge as an example because it appears to present the difficulties surrounding the question of intention in a simpler form than, for example, a painting. A painting raises difficulties such as the impossibility of separating conception from execution, because the very process of painting affects the result. He believes, however, that differences of this kind do not place the two objects in completely different categories, and that the argument about intention applies equally to the bridge and the painting. One might add that the architect provides a link between the modes of working of the engineer on the one hand and of the painter on the other.

347

1 See also Janet Wolff, *The Social Production of Art*, London, 1981, p. 136.

2 Michael Baxandall, *Patterns of Intention: on the Historical Investigation of Pictures*, New Haven and London, 1985, especially the Preface and Introduction.

MARXISM The ideas of Karl Marx (1818–83) can be divided into two main categories: on the one hand there are those critical tools and principles which he applied to analysing the evidence of history, and on the other there is his theory of the shape of history, past and future, based on the ascendency of successive classes and ending in the triumph of the proletariat.

The critical tools have proved to be of fundamental importance for the study of history. Like most aspects of Marx's philosophy they are based on the ideas of *Hegel. In Hegel's system the cultural forms which change through history are all manifestations of a single underlying world spirit. Marx replaced the spirit with the economic base as a material equivalent for the principle which produces the cultural forms, hence the label 'historical materialism' which is used to describe his approach. Hegel also argued that history represented the progress of the world spirit towards self-realization, so that whatever exists is as it should be. Contradictions therefore only appear to exist, and their constituent parts can be merged into a higher truth by a process of argument, by the play of hidden rules. He called this process 'dialectics', from 'dialectic' or the pursuit of truth by discussion, hence Marx's use of the label 'dialectical materialism' in order to distinguish his version of this method of argument from that of Hegel.

Marx also derived the all-inclusiveness of his world view from Hegel, although he was the first to formulate explicitly the idea that everything about us is influenced by our background and our class interests, and that every aspect of truth is viewed from a perspective of social interest and is correspondingly restricted and distorted. Lastly Marx used the concept of *ideology to indicate a false understanding of the relationship between self and context, that is, he took ideology to be concerned with manipulation and power. (Pollock, text 26, 1988, provides an example of the application of Marxist tools to a variety of questions, while Clark, text 21, 1974, quotes an example of dialectical thinking. See also Sontag, text 18, 1964.)

Marx's distinction between base and superstructure, between economy and culture, implies that social manifestations such as works of art cannot be satisfactorily explained apart from the

economic structures which support the society by which and for which they are made. Such ideas lie behind the stress on social production rather than individual consumption in the writings of, for example, Walter Benjamin (1892–1940) and Theodor Adorno (1903–69); while Benjamin attempted to remove the contradiction which he perceived between Marxism and aesthetics, Adorno took him to task, in reply, for appearing to espouse the bourgeois view that works of art are autonomous objects, that is they are unconnected with and unconditioned by the economic base. The view expounded by Clement Greenberg that art can be an independent source of value has been criticized by T.J. Clark and others on similar grounds.[1] The usefulness and applicability of critical Marxism is also evident in publications such as Greenberg's article on the nature of kitsch, as well as a genre of original analyses of film.[2]

The wide acceptance which Marx's theory of the shape of history once enjoyed has not survived far into the second half of the twentieth century, because almost all of his predictions have been proved wrong by events, a significant outcome since he presented his analysis as a severely practical one to be judged on practical grounds. Scholars none the less on occasion continue to use his historical model, referring without argument to our living in the period of 'late' capitalism. This phrase carries the implication that the future development of our society will be essentially as predicted by Marx. Yet there is no obvious objection to the notion that we could be entering no more than the mature phase of what can still usefully be called capitalism, or even the conclusion of its early phase. As Frederic Jameson says, 'the expression "late capitalism" ... is by now clearly identified as a kind of leftist logo which is ideologically and politically booby-trapped, so that the very act of using it constitutes tacit agreement about a whole range of essentially Marxian social and economic propositions the other side may be far from wanting to endorse.' Yet Jameson wants to have it both ways as he goes on to say that the qualifier 'late' 'rarely means anything so silly as the ultimate senescence, breakdown, and death of the system as such ... What "late" generally conveys is rather the sense that something has changed.'[3]

Other Marxists have adapted the theoretical model in response to the evidence. Thus in 1981 Greenberg called attention to the undiminished vigour of Western urban high culture, which he saw as entering a new global phase and as now standing alone as the only culture available to us. He argued that this is due in large part to the quality of Western science and technology, which are two constituents of culture which have never been known to thrive in periods of decline.[4]

1 See Charles Harrison and Paul Wood, *Art in Theory: an Anthology of Changing Ideas*, Oxford, 1992, which includes essays by Walter Benjamin, 'The Author as Producer' (1934), pp. 483–9 and 'The Work of Art in the Age of Mechanical Reproduction' (1936), pp. 512–20: Theodor Adorno, 'Letter to Benjamin' (1936), pp. 520–3. See also T.J. Clark, 'Clement Greenberg's Theory of Art', *Critical Inquiry*, 9, September 1982, pp. 139–56; reprinted in Francis Frascina, ed., *Pollock and After: the Critical Debate*, London, 1985, pp. 55 and 57.

2 Clement Greenberg, 'Avant-garde and Kitsch', *Partisan Review*, 6 (5), 1939, pp. 34–49, reprinted in Frascina, op. cit., pp. 21–33; James H. Kavanagh, 'Feminism, Humanism and Science in *Alien*', in Annette Kuhn, ed., *Alien Zone: Cultural Theory and Contemporary Science Fiction Cinema*, London, 1990, pp. 73–81. For an overview of Marxist critical theory from 1968 to the collapse of political Marxism in central and eastern Europe, see O.K. Werkmeister, 'A Working Perspective for Marxist Art History Today', *Oxford Art Journal*, 14, 1991, pp. 83–7.

3 Frederic Jameson, *Postmodernism, or, The Cultural Logic of Late Capitalism*, London, 1991, p. xxi. The difficulty here is that 'late' does not mean 'changed', and to use it with this meaning can only imply a nostalgia for Marx's predicted phases of economic development.

4 Clement Greenberg, 'To Cope with Decadence', in B.H. Buchloh, S. Guilbaut, and D. Solkin, eds., *Modernism and Modernity, the Vancouver Conference Papers* (1981), Nova Scotia College, 1983, pp. 161–4.

MODERNISM The adjective 'modern' has two chief meanings. The general one describes what is up-to-date, contemporary or of the present age, and is therefore defined directly in relation to the

lifetime of the person using the term.[1]

The second meaning derives from the fact that the period which has been considered the contemporary age for most of the twentieth century has retained the label 'modern' even after we have defined ourselves as having moved into a subsequent contemporary age, as is indicated by the use of the label "postmodern' to describe the 1970s, 1980s and 1990s. This phenomenon indicates the power of the ideas encapsulated in the concept of modernism, acknowledging the fundamental changes which have taken place in the history of the West over the last 150 to 200 years. These changes include political developments in both practice and theory (such as the French Revolution and 'Marxism), industrialization, scientific advances, and new forms in the visual arts.[2]

The label 'modern art' is shorthand for a kaleidoscope of 'isms' representing the directions and forms of the visual arts from the mid-nineteenth century to the mid-twentieth. Modern art is characterized by a change of direction away from naturalism. According to Vasari and most subsequent historians, one of the main tasks facing Western art since Giotto was that of depicting the visible world as accurately as possible. This project reached its final stage in the work of painters of the second half of the nineteenth century such as Manet and the Impressionists, whose paintings could be read as entirely representational of that world. They could also, however, be seen as abstract surfaces devoid of content, and the growing possibilities inherent in this dual perception led painters away from the outside world and towards an exploration of pure form. See, for example the sequence formed by the paintings of Manet, Cézanne and Pollock, from the second half of the nineteenth century and the middle of the twentieth century respectively.

349

While modernism in the visual arts is a very varied movement, there is a case for claiming that it is most fully represented by abstraction. The ethos of abstraction sets visual and aesthetic experience above all else (such as narrative, illusion, or moral effect) and stresses the importance of the individual creative artist and the independence of the artist from society. Art is autonomous and should only concern itself with art, and the only guide for a modernist painter is the flatness of the surface to which the paint is applied.[3] Architecture can be said to have aspired to the same condition in that architects rejected the use of features from earlier styles and designed in terms of 'abstract' form.[4]

The two meanings of the word 'modern' are sometimes distinguished by the use of lower and upper case initial letters, so that 'modern' means 'up-to-date' and 'Modern' describes the period or style. However, because of a wish to define modernity as a philosophical concept in its own right independent of the 'Modern' period from which it derives, many writers now prefer to use the lower case initial for all meanings of the word. As there seems to be little chance of ambiguity the lower case initial letter has been used consistently in the historical essay, the introductions and concept entries in this book, but the original conventions used by the authors have been retained in the texts.

1 Thus for Vasari the Renaissance constituted the modern age, in contrast to antiquity. For many later writers even up to the early twentieth century (such as Riegl, Wölfflin and Frankl) the Renaissance continued to represent the start of the age in which they considered themselves as living. See also the *Cambridge Modern History* series, which starts with the late fifteenth century.

2 On modernism in general see Marshall Berman, *All That is Solid Melts into Air: the Experience of Modernity*, London, 1983.

3 For a statement of modernist principles in the visual arts see Fry (text 12, 1920), as well as references to Greenberg's work at 'avant-garde; and for critiques of this modernism from a variety of angles see Baldwin, Harrison and Ramsden (text 23, 1981), Belting (text 25, 1984), Pollock (text 26, 1988), and Oguibe (text 27, 1993), as well as 'postmodernism.

4 In so doing they also rejected the theory expounded by writers such as Vasari (text 1, 1568) and Bellori (text 3, 1672) that architecture, in imitating the buildings of antiquity, was an imitative art like painting and sculpture.

NATURALISM see REPRESENTATION

NEW ART HISTORIES see ART HISTORY

PATRONAGE Patrons have two roles. The primary one is to pay, but to be successful as patrons they also have to develop a means of distinguishing what they think is good from what they think is bad. Patrons have been drawn from different social groups at different times, so that since the end of antiquity artists have had to please, broadly speaking, first the Church, then the rich and, now, along with the rich, the bureaucracy of the public art world. Patrons act either by commissioning or by buying works already made, the first mode broadly characterizing the centuries before the eighteenth century and the second the years thereafter. Patronage is the chief area of social context which art historians have traditionally taken into account.

PERIODS There are no overwhelming arguments in favour of the past being divisible into periods as opposed to being an uninterrupted flow of events, but, as Wölfflin noted, we have to divide it up in order to maintain our sanity.

350

Periods as concepts come in a number of different forms, including 'cycles, 'progressive stages, 'styles, centuries and things such as reigns, all of which may be divided into early, middle and late phases. Of the units of time in everyday use only the day and the year are natural; all the others are artificial, including multiples of days and years. Despite the obvious truth of this, centuries are often treated as if they had the same sort of reality as days and years, as in 'a nineteenth-century style' or 'twentieth-century culture'. Centuries give the appearance of having an objective reality chiefly because we as players are aware of them and hence establish concepts like the *fin de siècle* or the millennium, which in turn influence our behaviour. They can also create a sense of distance, as when an event 101 years ago appears to have happened very much further in the past than one of 99 years ago when a change of century occurs between them. One can contrast 1899 and 1901, or the resonance and immediacy which most nineteenth-century ideas retain with the more distant character of those of the eighteenth century. The effect is also evident in the value of antiques which tends to increase disproportionately with the passing of a single year marking the turn of a century.

POLITICS Politics, or, as one definition has it, the means by which social ends are sought, is one of the most important factors accounting for artistic decisions, as well as for the decision to study the results. Historical research thus involves issues deriving on the one hand from the politics of those being studied and on the other from the politics of the researchers themselves (although the definition of the first depends of course on the character of the second). An example of the impact of the politics of those being studied is provided by the art of the Nazi era in Germany. The exhibition of twentieth-century German art in 1985 at the Royal Academy in London had no works of the period, considering it entirely separate from the identifiable tradition of modernism in German art, while the National Galleries of Scotland's exhibition of German Romanticism in 1994 included a section on painting between 1933 and 1945, and raised as much controversy as the earlier decision of the Royal Academy.[1] Concerning the perspectives of the researcher, since it is probably impossible to avoid having political bias in the context of conducting our research, it can be argued that the more overtly the aim is expressed the better. One then has to determine how one handles the evidence in relation to that aim. Scholars can seek out a case which suits their political aims, but only consider the case worth having if it is based on convincing evidence; or they can

reject evidence on the grounds that the consequences would be disadvantageous to their political cause.[2]

1 *German Art in the Twentieth Century. Painting and Sculpture 1905–1985*, exhibition catalogue, Royal Academy, London, 1985; Keith Hartley ed., *The Romantic Spirit in German Art, 1790–1990*, National Galleries of Scotland, Edinburgh, 1994.

2 For an example of the latter alternative see Chris Weedon, *Feminist Practice and Poststructuralist Theory* (1987), reprinted, Oxford, 1989, pp. 64–5, 157, 163 and 168ff. See also Edward Said, *Orientalism*, London, 1978.

POST- This prefix can have the straightforward meaning of 'after', but it also has shades of meanings which are ambiguous and even obfuscatory. At its clearest it refers to anything which happened after a particular event. Thus all art movements and styles in the Western tradition after c.1600 are included in the phrase 'post-Renaissance art'. 'Postimpressionism' is more restricted because it refers to only one movement after Impressionism rather than to all of them. It also carries the inference that the new movement depends on and grows out of the older one. Even if this may be disputed and the new movement seen as a denial of the values of the older one ('anti-Impressionism' has been suggested as a preferable alternative), it is still universally taken as following Impressionism.

351

Examples such as 'post-Freudian' introduce an element of ambiguity, as the term can mean *either* 'after Freud the man but in the age of the influence of Freud's ideas', *or* the very different notion of 'after the age of Freudianism, when Freud's ideas no longer have the influence which they once did'. 'Post-industrial society' is ambiguous in a similar way.

Because of this ambiguity 'post-' can also be used to obfuscate and confuse. The Italian political party called the *Movimento Sociale Italiano* is usually referred to as 'neo-fascist' by commentators and politicians of other parties, suggesting that it is an up-dated version of the fascist party of the 1920s and 1930s. The members of the *MSI*, however, reject this label and prefer instead to call themselves 'post-fascist'. In doing so they cannot intend that 'post-' should have its simple meaning of 'after', otherwise it would include any political movement or institution later than the Second World War such as the European Community, the Green Party, or Thatcherism. Instead it appears to be intended to imply that their party bears no more than a distant relationship to historical fascism, with the aim of attracting one set of voters without frightening another.

Finally, in some readings of the label "postmodernism' the prefix loses its connotation of 'after' entirely: 'Yet for Lyotard and others, postmodernity sometimes figures as a recurring condition, fixed to no historical time period, which can give rise to modernism…'[1]

1 Jean E. Howard, 'Towards a Postmodern, Politically Committed, Historical Practice', in F. Barker, P. Hulme and M. Iversen, eds., *Uses of History: Marxism, postmodernism and the Renaissance*, Manchester, 1991, p. 103.

POSTMODERNISM Postmodernism is a word which is, as it were, intentionally difficult to define. Its meaning is clearest if one starts with its application to architecture. The modern movement can be described as standing for such principles as truth to materials and a rejection of revivalism, whereas contrariwise the Post-Modern style represents the principle of no principles, a rejection of the purity of vision of modernism, and a return to features like the pediment borrowed from other styles, producing designs which are whimsical and ironic.[1] The term has consequently been used to describe a potential political state (Australia), in which qualities such as multiculturalism will be the identifying characteristics rather than a unitary or 'modernist' sense of national identity. These diverse characteristics contrast with the supposed certainties of modernism in the same

way as "poststructuralism stands in opposition to "humanism.² (See also Belting, text 25, 1984 and "discourse analysis).

The label is sometimes written with initial capital letters to indicate that it refers to the architectural style, and with a lower case initial letter to describe the philosophical concept. (See also "post-)

1 Charles Jencks, *The Language of Post-modernist Architecture*, London, 1991.

2 On postmodernism see Frederic Jameson, *Postmodernism, or, The Cultural Logic of Late Capitalism*, London, 1991; and Victor Burgin, *The End of Art Theory: Criticism and Postmodernity*, Basingstoke and London, 1986, pp. 140–204; and Jean E. Howard, 'Towards a Postmodern, Politically Committed, Historical Practice', in F. Barker, P. Hulme and M. Iversen, eds., *Uses of History: Marxism, postmodernism and the Renaissance*, Manchester, 1991, pp. 101–22.

POSTSTRUCTURALISM Poststructuralism is primarily a critique of the "humanist consensus of the nineteenth and twentieth centuries, via a concerted analysis of the meaning of meaning. It is therefore worthwhile beginning this discussion with a brief statement of what poststructuralists are most opposed to in the concept of humanism. According to poststructuralist critics the humanist consensus is based on the belief that the individual and the world exist as identifiable entities: human beings have an ability to analyse and understand the world, and to reach disinterested knowledge through rational, empirical investigation. Thus meaning for the humanist is created by individuals and communicated by them to others, using a language which is transparent and which expresses already fixed meanings. This leads to a belief in the central importance of the author or artist as creator, and in the degree of success of the work being measurable against the maker's intention. Works are then arranged in a hierarchy, forming a "canon of pieces whose study enriches the experience and improves the lot of humanity.

Poststructuralists reject the central position given to the human subject in this model. They deny that meaning is created by individuals with specific intentions which can be used to measure the success of the communication, or that quality in writing or anything else can be based on objective judgements, arguing on the contrary that canons are constructed by interest groups with the aim of maintaining positions of power within their institutions and other overlapping social contexts.

STRUCTURALISM Poststructuralism is so named because it follows and is a development out of structuralism, which includes the roots of the above critique of humanism. Ferdinand de Saussure, the inventor of structural linguistics in the early years of the twentieth century, described language as consisting of signs and their meanings, or, as he put it, signifiers and their signifieds; signifiers only get their meaning from being different from other signifiers. He therefore proposed that language should be studied in terms of its structure rather than its content. To this end he grouped signifiers in pairs such as light/dark, high/low, as the most direct way of establishing significance via comparison. These ideas were first applied in another field when in the 1950s the anthropologist Claude Lévi-Strauss used structuralism to describe the character of myths. Since these only get their meaning from a network of assumptions in the same way as signifiers in language, they deny the individual human participant a central role in establishing the meaning of the myth.

Structuralism in the broadest sense can therefore be defined as the establishing and examining of the general and particular laws by which structures work. The structuralist extracts principles of classification from the confusion of individual messages. Since structuralists are not interested in immediate or surface content they are not primarily concerned with the world at large, with what people actually say or with the making and using of things. (See also "semiotics.)

Poststructuralism presses this move away from meaning much further, to the point where the possibility of communication itself is called into question. The key concerns can be identified with

352

the work in the 1960s and 1970s of Jacques Derrida (1930–), Roland Barthes (1915–80) and Michel Foucault (1926–84), concerning deconstruction, the death of the author and discourse analysis respectively (for 'discourse analysis see separate headword).

DECONSTRUCTION Derrida criticizes structuralism for depending on a circular argument in order to establish the meaning of the signifier. He points out that (a) the dependence of the signifier for its meaning on simply being different from other signifiers, and (b) the insubstantiality of the exercise of tracking signifiers (through a dictionary, for example) must together lead to the conclusion that meaning is not situated in any one particular place in a text. Meaning on the contrary is like a web of presences and absences none of which can be absolutely defined. Every act of reading produces a new meaning, and 'the meaning of meaning ... is infinite implication, the indefinite referral of signifier to signifier.'[1] While structuralists believe that there are meanings for the critic to decipher (those in the structure behind the content), the deconstructionist sees the search for meaning as endless and the content as something of pure ambiguity. Similarly with signs: for a sign to be a sign it must be repeatable, but in being so it will also be infinitely variable in meaning, because meaning changes with context and no two contexts are the same. All traces of Saussure's structure have thus evaporated.

Derrida also calls attention to the construction in our culture of opposites such as man/woman and culture/nature which, unlike Saussure's pairs, are assumed by those using them to have a positive and a negative value respectively. By reversing each pair of positive and negative values he shows how such constructions achieve their social effects, and how they may be weakened. His aim is to undermine the Western tradition of either/or by proclaiming that either/or exists simultaneously with neither/nor. He argues that any thought system which depends on a structure as a first principle is metaphysical and hence reactionary. He goes on to observe that first principles are commonly defined as much by what they exclude as by what they include, the idea of inclusion/exclusion being one of his basic pairs of opposites. The pairs can be laid open by deconstruction and the unreal nature of their basis revealed. Derrida challenges structure and hence structuralism because structure presumes hierarchy.[2] As a result, to 'deconstruct' has come to mean to analyse in an aggressively critical way.

DEATH OF THE AUTHOR Whereas 'humanists preoccupy themselves with the importance of the author and structuralists focus their attention firmly on the text, poststructuralists argue that we cannot know anything of the author's intentions, as even when writers give an account of them we cannot be certain that they are telling the truth or are not mistaken. Poststructuralists thus move the stress from the author to the reader: everyone who reads a text brings to it different experiences and degrees of competence, and hence will take different things away from it, reinventing it. Meaning, in so far as it can be established at all, exists in the space between the reader and the text. The result is what Barthes calls the death of the author: 'We know now that a text is not a line of words releasing a single "theological" meaning (the "message" of the Author-God), but a multi-dimensional space in which a variety of writings, none of them original, blend and clash.'[3]

Starting from the view that the value of a sign is determined by convention, Barthes also argues that signs should make their own conventionality or arbitrariness evident, and concludes that authoritarian and ideological signs always try to disguise this fact by presenting themselves as natural. Realist novels, for example, are frequently guilty of pretending that the signs by which they communicate are natural rather than invented. Systematic thought for Barthes is part of the repressive mechanism of the state, so that his way of writing was an attempt at subversion. Poststructuralism has therefore been used in the history of art, not so much as a tool for solving

problems, but as a means of calling into question the notion of genius and the central importance of the individual artist.

Poststructuralism is full of paradoxes, as for example in the writing of an essay to propagate the idea of the death of the author, or acknowledging that the deconstructionist explanation of the insubstantiality of meaning itself depends on the written word bearing a communicable (and therefore at least relatively fixed) meaning. It is ironic that Derrida, in defending himself against criticism, has claimed that his meaning should have been clear to an attentive reader.[4] Poststructuralists acknowledge that their own thought is also produced by the web of circumstances in which it finds itself. Thus in always seeking to undermine, subvert and challenge the traditional order they could be considered as much a manifestation of their time as Victorian patriarchs defending the middle-class virtues were of theirs.

The poststructuralist account of humanism makes it appear more definitive than most humanists would claim it to be. Thus, for example, Panofsky's definition of the concept (see *humanism) speaks of it in open-ended and undogmatic terms, as an attitude and a conviction based on concepts such as acceptance and tolerance. Poststructuralist criticism thus appears to be directed against what one might call popular humanism. This is a justifiable target, but it needs to be defined for what it is. The deconstructionist practice of creating polar opposites pushes characteristics to extremes: in describing in such terms the pole which he wishes to attack Derrida, for example, may be accurately presenting a widely held 'public' view which he believes should be challenged, but in doing so he ceases to deal with the original philosophical proposition.

These simplifications could be explained as the result of an understandable wish on the part of poststructuralists to exaggerate their case in the face of the strength of the traditional acceptance of the individuality of the author, and the gulf between poststructuralism and humanism could be narrowed as a result. There is, however, a problem in proceeding in this way, as it is a classic humanist strategy to co-opt an opposing position. If one accepts the arguments as the poststructuralists have presented them, then they are incompatible with a humanist approach. (See also *intention, *reception theory, *psychoanalysis.)[5]

1 Jacques Derrida, *Writing and Difference*, translated by A. Bass, London, 1978, p. 25.

2 For an earlier expression of ideas of this kind in terms of Gestalt *psychology, see, for example, Robert Sheckley's short story *Warm*, in H.L. Gold, ed., *The Galaxy Science Fiction Omnibus*, London, 1955, pp. 264–72.

3 Roland Barthes, 'The Death of the Author' (1968), in *Image, Music, Text*, translated by Stephen Heath, London, 1977, p. 146.

4 Jacques Derrida, 'Limited Inc, abc …', *Glyph*, 2, 1977, pp. 179, 183, 187, 188, 189, 191 and 193.

5 For works which apply poststructuralism see for example Terry Eagleton, *Literary Theory: an Introduction*, Oxford, 1983, *passim*, and Chris Weedon, *Feminist Practice and Poststructuralist Theory* (1987), reprinted, Oxford, 1989.

PROGRESS The concept of progress in the history of art is at its most straightforward when applied to practical techniques, as when an artist is claimed as the first to have made a lost-wax bronze casting, to have used oil paint, or to have established the rules of perspective. These instances form part of an overall notion of progress involving naturalistic standards of representation, or a less easily defined move towards ideal beauty. This occurs in, for example, the context of the early and mature phases of Vasari's model of the biological cycle. With Hegel progress becomes a less straightforward but more fundamental element in the system – the world spirit moving towards self-realization through successive ages. This model shares a number of features with the way in which the concept of *evolution has been used by art historians.

PSYCHOANALYSIS 'Psychology is the science of behaviour and experience, psychiatry is the branch of medicine which concerns the study and treatment of disordered behaviour, and psychoanalysis is the psychiatric approach which is based on the study of unconscious mental processes. Psychoanalysis was developed by Sigmund Freud (1856–1939), using the free association of ideas and the analysis of such things as slips of the tongue and dreams to unravel the metaphors through which the mind expresses its hidden fears and desires, and so to expose its conflicts and defence mechanisms. Out of this he formed his theory of the tripartite character of the self, with the id (the unconscious mind, the reservoir of basic impulses), the ego (conscious mind), and the superego (the censor, user of received ideas), as well as the Oedipal character of the relationship of the male child to his mother and subsequently his father, and the relevance of this to the patriarchal character of society.

Those studying literature and the visual arts have made extensive use of the analytical techniques of psychoanalysis, in order to explore meaning in imagery which can be shown to differ from that consciously expressed by the author or artist. Freud himself initiated this genre with his explanation of Leonardo's *Virgin and Child with St Anne* as an expression of the fact that as a result of his illegitimacy the artist had had two mothers. Although this thesis foundered on Freud's lack of knowledge of the iconographic tradition within which Leonardo was working, his ideas have proved to be of great importance for the analysis of individual works of art, especially for the works of the Surrealists of the 1930s (which were of course also influenced by psychoanalysis), and also for other genres such as the science-fiction films of more recent years.[1]

In a major development which had a marked influence on cultural history (for example in the work of Aby Warburg), as well as on *feminism and *poststructuralism, the object of analysis was shifted from the individual artist and the individual painting, sculpture or building, to the structure of society as a whole. Psychoanalysis in this sense is used to explore the distinction between what appears to be socially 'natural' and what is in fact *ideologically or *culturally determined, which for feminists in particular means an analysis of the patriarchal character of society.[2]

The patriarchal structure of Freudian psychoanalysis does however pose a problem for feminists, who wish to undermine this same structure in society at large. This can be overcome by treating Freudianism as a description of such a structure rather than a prescription for one, and, following Lacan, by denying that human nature has a fixed form and instead assuming that an awareness of gender is culturally constituted.

Julia Kristeva has confronted this problem by stressing the pre-Oedipal, pre-symbolic period of life, that before the acquisition of language, when the character of the child is not primarily centred on its gender, when its relationship is primarily with its mother and before its entry into an awareness of patriarchy. She then applies the Freudian notion of repression to this stage of human development, proposing that it continues as an anarchic force, like the unconscious, beneath or within the structure imposed by the acquisition of language and an awareness of the role of gender classification and of the father. She is in other words using psychoanalytic theory to seek ways of reducing the perceived difference between the sexes, while at the same time relating these pre-Oedipal characteristics more closely to the feminine than the masculine in our society. These ideas have been used as aesthetic strategies to subvert logic, reason and patriarchy, in the hope that they may release 'the repressed voice of those who are silenced'.[3] (See also Pollock, text 26, 1988.)

1 See Richard Wollheim, 'Freud and the Understanding of Art', in *On Art and the Mind, Essays and Lectures*, London, 1973, pp. 202–19 and Laura Mulvey, *Visual and Other Pleasures*, London, 1989.

2 See Chris Weedon, *Feminist Practice and Poststructuralist Theory* (1987), reprinted, Oxford, 1989, pp. 147–52; Terry Eagleton, *Literary Theory: an Introduction*, Oxford, 1983, chapter 5; and Rozsika Parker and Griselda Pollock, *Old*

Mistresses: Women, Art and Ideology, (1981), reprinted London, 1987, pp. 130–2. See also *Art History*, 17 (3), 1994 (a special issue devoted to psychoanalysis), pp. 301–463 and 476–82.

3 See Juliet Mitchell, *Psychoanalysis and Feminism* (1974), reprinted, Harmondsworth, 1982; Julia Kristeva, *Revolution in Poetic Language* (1974), abridged version translated by M. Waller, New York, 1984, especially part I, 'The Semiotic and the Symbolic', and chapters 2 and 6. See also Janet Wolff, *Feminine Sentences: Essays on Women and Culture*, Cambridge, 1990, pp. 52–68 (p.62 for the phrase quoted); and Terry Eagleton, *Literary Theory: an Introduction*, Oxford, 1983, pp. 187–91.

PSYCHOLOGY Psychology is literally the study of the mind, and more accurately the science of behaviour and experience. It therefore has a key role to play in our understanding of the character of vision, analysing both the physical operation of the eye, or how images are registered, and the relationship between the eye and the mind, or how images are perceived.

There is an almost unlimited number of ways in which psychology can help to explain images, including how individual forms are identified and visual experience structured and how it is possible to see two images in one form (visual tricks such as those of Maurice Escher). This involves the use of Gestalt psychology, which is based on the view that mental phenomena have a structure or pattern and that there are wholes which cannot be expressed in terms of their parts. Psychological studies can also help to explain how movement is expressed in a static medium such as painting, how colours appear to recede different distances despite being on the same plane, how perspective works, how emotions and states of mind are communicated by different facial types, gestures and colours, and how the visible world relates to the map, the mirror and the photograph.

These aspects of psychology, and in particular behaviourism, are susceptible to a high degree of measurement and corroboration; *psychoanalysis is a more speculative but highly influential development of psychology. (See also Hauser, text 17, 1959, Sontag, text 18, 1964, and Gombrich, text 19, 1967.)[1]

I The relevance of psychology to the history of art has been most thoroughly and clearly explored by E.H. Gombrich. See especially his *Art and Illusion: a Study in the Psychology of Pictorial Representation* (1960), 5th edn, reprinted, London, 1994; the essays arising from this study collected in *The Image and the Eye: Further Studies in the Psychology of Pictorial Representation* (1982), reprinted, London, 1994; and *The Sense of Order: a Study in the Psychology of Decorative Art* (1979), 2nd edn, reprinted, London, 1994. See also Rudolf Arnheim, *Art and Visual Perception: a Psychology of the Creative Eye*, Berkeley and Los Angeles, 1974, and, for an earlier work on the subject, Wilhelm Worringer, *Abstraction and Empathy, a Contribution to the Psychology of Style* (1908), translated by M. Bullock, London, 1953.

QUALITY Judgements of quality can be claimed to be either absolute or relative, that is they can be seen as having an objective validity or a subjective status. Art historians have traditionally claimed to be making absolute, objective judgements, describing artists as belonging to the highest rank in the same sense as they would classify the span of the dome of Florence Cathedral as one of the widest in the world. This practice has been criticized on the grounds that all judgements are subjective, and relative to and conditioned by the social context in which they are made (including the moral and aesthetic criteria by which they are made). Thus the prominence of Michelangelo, for example, in the history of art could be due solely to factors such as Vasari's assessment of his standing, and the interests involving money, position and power vested in the continuation of that judgement ever since. The power of reputation is evident in the arts as in all areas of life, as when, for example, visitors to an exhibition react differently to an anonymous image and to the same image provided with the name of a famous artist.

Setting aside the claim for absolute judgements of quality as irrelevant, it none the less remains that assessments of quality (like assessments of *intention) appear to be so much a part of the human condition that they should not be ignored, and in order to treat them at all one has to

come to terms with one's own reactions to the works in question. It is therefore worth concentrating on the extent to which the character of the work itself can be said to have an influence on our reactions to it. The following two observations are intended to indicate that this character cannot be excluded from explanations of reactions to the work in question.

Firstly judgements are not always the result of manipulation. This is more easily illustrated in contemporary popular culture, in which mass response can be more clearly identified, than in the case of the fine arts. The blockbuster film *Star Wars* (1977), for example, was promoted by a previously unrivalled advertising campaign, so that its subsequent success could be attributed, if one wished, entirely to manipulation on the part of the promoters, that is, audiences were appreciating what they were told they ought to appreciate regardless of the form of the film. *Batman Returns* (1992), however, having been given an equally expensive promotion and having achieved even greater success immediately upon its release, turned into a financial disaster when audiences were choosing to see it on the basis of first-hand reports. The judgements being made by those who had just seen the film were a response to the film rather than the advertising. This is not to say that the film will provoke the same opinion from all who comment on it (the critics may have loved it), but to claim that the object plays a part, along with reputation and peer pressure, in the audience's reaction.

Secondly the experience of works of art can be overwhelming, to the extent that it is necessary to ask whether such powerful aesthetic responses could be summoned by any image whatsoever, given only the right suggestions and regardless of any characteristics of the object itself. When such positive responses are produced by particular pieces over generations it is reasonable to propose that this is due at least in part to something in the works themselves.

The problems raised by these and similar questions have been expressed as follows by Charles Harrison:

> '... it remains true that the most interesting and difficult thing about the best works of art is that they are so good, and that we don't know why or how (though we may know much else about them). The traditional tendency to mystify and to control this area of ignorance has certainly served some authoritarian and obscurantist ends. But unless we can somehow acknowledge the great importance of this limit on our explanatory systems, we might as well give up. What would giving up be like? I suspect it would be like becoming a social anthropologist.'[1]

Janet Wolff, while denying that quality is transcendental, also acknowledges the problem: 'I do not know the answers to the problem of "beauty", or of "artistic merit", and will only state that I do not believe this is reducible to political and social factors ...' In addition she rejects the 'crude, reductionist work on the sociology of literature', which abandons sensitivity to textual and literary features.[2] (See also Baldwin, Harrison and Ramsden, text 23, 1981, and Fagg, text 20, 1973. Panofsky, text 15, 1940, proposes an 'organic' solution to similar problems.)

1 Charles Harrison, 'Taste and Tendency', in A.L. Rees and F. Borzello, eds., *The New Art History*, London, 1986, p. 81.
2 Janet Wolff, *The Social Production of Art*, London, 1981, pp. 7 and 56.

RECEPTION THEORY Hans Robert Jauss's reception theory is a response to what he calls the 'subjective arbitrariness' opened up by Roland Barthes's critique of meaning, that is, his announcing of the death of the author (see 'poststructuralism). Following a lead provided by Walter Benjamin, Jauss re-examines the meaning of the reception of the work of art, and proposes that there is a 'question' implicit in the work which is what first awakens our interest, and that we also see the

357

work of art as a kind of answer. Being in the present, within a changed horizon of aesthetic experi-
ence, the question is no longer asked as it was when the text was new. All of this is possible
because 'literary works … remain "speaking" to the extent that they attempt to solve problems of
form and content, and so extend far beyond the silent relics of the past.' Jauss believes that, pro-
vided with this perception, art history has the capability of rejuvenating 'the great wealth of human
experience perceived in past art' and of making it 'accessible to the perception of the present age'.
This reply to what might be called Barthes's counsel of joyful despair is in some ways symmetrical
to Baxandall's reconsideration of 'intention.'[1]

 The character of reception was being reassessed already in the 1950s in the work of the psy-
chophysicist Roland Harper in the field of consumer preference, which provides us with a parallel
between the presence of meaning in the text and the psychophysical properties in materials. The
received view among chemists was that what was perceived by sight, smell, touch and taste were
properties inherent in the material, whereas Harper took into account the observer's state of
mind, context, and experience. He applied his method to the assessments of skilled cheese
graders and to consumers' attitudes to vegetables and odours.[2]

1 Hans Robert Jauss, 'History of Art and Pragmatic Theory' (1970), in *Towards an Aesthetic of Reception*, translated by
T. Bahti, Brighton, 1982, pp. 46–75, especially pp. 62ff. See also Roland Barthes, 'The Death of the Author' (1968), in
Image, Music, Text, translated by Stephen Heath, London, 1977, pp. 142–8. Arnold Hauser, *The Philosophy of Art
History*, London, 1959, pp. 294–9, uses the phrase 'reception theory' with a very different meaning, to describe his
exploration of the relationship between 'high' art and folk art.

2 R. Harper, E.C. Bates, and D.G. Land, *Odour Description and Odour Classification: a Multidisciplinary Examination*,
London, 1968, chapter 4, which includes the phrases 'pure sensation is itself an artifact of analysis' (p. 100) and the
'frame of reference' of the perceiver (p. 115); 'Tribute to Roland Harper', in *Food Acceptability*, D.M.H. Thomson, ed.,
London and New York, 1988, pp. 3–25; see also *The Times* obituary of Roland Harper, who died on 28 January 1992.

REPRESENTATION The concept of representation is central to the history of art. It has been
used most often by art historians to refer to the representation of the visible world, a practice
often referred to as 'naturalism'. Despite the apparently straightforward character of the claim that
the eye knows what it recognizes, an understanding of the visible world always involves the use of
conventions, both when one is discussing physical vision and even more so in the case of the ren-
dering of one image in the medium of another, as for example with the translation of patterns of
light (what is seen) into patterns of paint and line (the image on the support). The point is well illus-
trated by the story of the Japanese artist who, on first seeing a perspectival drawing representing a
cube, concluded that they made oddly-shaped boxes in the West.

 Naturalism in a painting or sculpture is often described as 'realism'. This term, however, has a
number of very different meanings, including, confusingly, a position in philosophy in which ideas
are paramount, while in a literary context it conjures up images of the kitchen sink. It is conse-
quently safer to avoid realism as a synonym for naturalism in discussing the visual arts.

 From the fifteenth century to the early twentieth for the most part the purpose of painting and
sculpture was assumed by both artists and art historians to be representational in the sense that
they reflected the visible world (for an indication that this by no means restricted artists to simple
relationships with the visible world see Alpers, text 24, 1983). In the late nineteenth and early
twentieth centuries artists introduced ways of seeing which increasingly departed from easily rec-
ognizable forms (compare the paintings by Holman Hunt and Paul Cézanne respectively in figures
34 and 35), until the images in their works appeared to bear no relationship to the visible world, as,
for example, in the mid-twentieth-century paintings of Jackson Pollock. This last kind of painting is
most commonly described as 'abstract'. While this term is most often used in contradistinction to

'representational' there is also a view that such images are representations of inward states, of ideas or expressions which are not accessible through or based on what we think our eyes perceive. (One of the attendant problems with this issue is that the abstract paintings themselves are of course part of 'the visible world'. There is also the fact that all of the apparently recognizable forms of the visible world can themselves be seen as abstract, as illustrated by the difficulty one has in recognizing everyday objects photographed from unexpected angles, such as a bundle of pencils seen point-on.)[1]

The idea of abstraction has also been used in its more literal sense of 'abstracted from' the visible world. The paintings of Mondrian of around 1920 fall into this category: although they appear completely abstract in the first sense, when seen as part of a sequence from the preceding decade they can be shown to be based on and derived from the shapes of trees and other objects.

Because of the development of this second meaning for the word 'abstract' the term 'non-objective' has been coined to describe an image without any connections with the visible world, but it has failed to replace 'abstract' in both everyday and scholarly usage. The two meanings of 'abstraction' as 'moving away from the visible world' and 'unconnected with the visible world' describe respectively a process and a state.

The move from a more naturalistic to a more abstract formulation also occurred, though with a vastly different significance, in late antiquity. Compare, for example, the re-used, classicizing roundels of the second century with the late antique panels of the fourth century on the Arch of Constantine in Rome in fig. 5, and the Roman and Germanic brooches of the second to sixth centuries grouped together in fig. 68.

359

I On representation see E.H. Gombrich, *Art and Illusion: a Study in the Psychology of Pictorial Representation* (1960), 5th edn, reprinted, London, 1994; Richard Wollheim, *Art and its Objects* (1968), 2nd edn, Cambridge, 1992, especially pp. 12–22 and 205–26; and Martin Kemp, *The Science of Art: Optical Themes in Western Art from Brunelleschi to Seurat*, New Haven and London, 1990.

SEMIOTICS Semiotics or semiology is *structuralism applied to signs instead of language, and is the study of how sign systems produce meanings. It contains three categories of signs: the iconic, where the sign resembles what it stands for, as with a picture of an object; the indexical, where the sign is related to what it stands for by association, as with lightning and speed; and the symbolic, where the link with the referend is purely conventional.[1] Semiotics is therefore closely related to some of the methods of the history of art, since it is possible to describe aspects of such traditional art-historical methods as *iconography and *connoisseurship as types of sign systems.

The label is, however, used to cover a wide variety of concepts, as is indicated by the ways it has been used by, for example, Roland Barthes and Julia Kristeva. Barthes's definition can be condensed as follows. (1) The aim of semiotics is to apply structuralist techniques to systems of signs (or 'objects') other than language. (2) Structuralism works by building a model (or *simulacrum*) of the objects to be investigated (that is, by concentrating on structure rather than content), (3) and does so by limiting itself to one viewpoint only. (4) That viewpoint should as far as possible be the one most appropriate or relevant to the messages or signification of the objects being analysed. (5) It should also be restricted to the signs themselves and their meaning and should exclude consideration of all other factors which determine the objects. (6) These other factors must also be treated in semiological terms, but separately. (7) That is to say that their place and function in the overall system of meaning represented by the objects must be determined. (8) Fashion, for instance, evidently has economic and sociological implications; but the semiologist will treat neither the economics nor the sociology of fashion: he will only say at which level of the semantic

360

62 Stefan Lochner, *Virgin of the Rose-garden*, c.1440. Oil on panel, 51.1 × 40 cm. Wallraf-Richartz Museum, Cologne

Analysis of the fashions in which people in paintings are dressed can provide information about the culture in which the image was made. In this painting the Virgin Mary is represented as a fashionable young woman richly dressed and with a high, plucked forehead, despite the fact that she is the Mother of God. The contrast with the sombre and dignified Byzantine *Virgin of Vladimir* (fig. 63) could hardly be greater, even though she too is represented as a loving mother.

63 *Virgin of Vladimir*, c.1125. Tempera on panel, 78 × 55 cm. Tretyakov Gallery, Moscow. See fig. 62.

system of fashion economics and sociology acquire semiological relevance…'[2]

Julia Kristeva uses the term 'semiotic' to describe the character of communication available to the pre-Oedipal, pre-language, child, which survives in repressed form in the adult, and which can in turn be used as a means of analysis of texts and images (see *psychoanalysis, and for signifiers and signifieds, see *structuralism).[3]

1 For a presentation of the philosophical basis of these definitions see Charles S. Peirce, *Collected Papers*, 8 vols., Cambridge, MA, 1965, ii, pp. 156–73, Bk 2, Ch. 3, especially pp. 168–9 (paragraph 299) and p. 170 (paragraph 304). See also G. Broadbent, ed., *Signs, Symbols and Architecture*, London, 1980, which includes Umberto Eco, 'Function and Sign: the Semiotics of Architecture' (1968); Terry Eagleton, *Literary Theory: an Introduction*, Oxford, 1983, pp. 100–1; W.J.T. Mitchell, 'Nature and Convention: Gombrich's Illusions', *Iconology: Image, Text, Ideology*, Chicago, IL, 1986, pp. 75–94; Margaret Iversen, 'Meyer Schapiro and the Semiotics of Visual Art', *Block*, 1, 1979, pp. 50–2; and 'Saussure versus Peirce: Models for a Semiotics of Visual Art', in A.L. Rees and F. Borzello, eds., *The New Art History*, London, 1986, pp. 82–94; Norman Bryson, ed., *Calligram: Essays in New Art History from France*, Cambridge, 1988, which includes Jan Mukarovsky, 'Art as a Semiological Fact' (1934), pp. 1–7; M. Bal and Norman Bryson, 'Semiotics and Art History', *Art Bulletin*, 73, 1991, pp. 174–208; and Donald Preziosi, *Rethinking Art History: Meditations on a Coy Science*, New Haven, 1989, *passim*.

2 See Roland Barthes, *Elements of Semiology* (1964), translated by A. Lavers and C. Smith, London, 1967, pp. 95–6.

3 Julia Kristeva, *Revolution in Poetic Language* (1974), abridged version translated by M. Waller, New York, 1984, especially part I, 'The Semiotic and the Symbolic' and chapters 2 and 6.

SOCIAL HISTORY OF ART see ART HISTORY

SOURCES/INFLUENCES When historical material is treated as part of a chronological sequence it can be studied by working forwards (establishing how one thing influences another), or backwards (establishing what its sources are) or, of course, using a mixture of both. The diagram of arrows is one of the most widely used means of summarizing these methods (see Barr, text 14, 1936).

The tracing of sources carries the temptation of succumbing to the wisdom of hindsight, as well as the risk of over-analysis. When an analysis of an artist's life, for example, is conducted chiefly in terms of a search for sources it can be carried to such an extreme that, like the claims of religion faced with the advances of science, the creative element in an artist's work becomes merely what is left over when the art historian has finished the search. Tracing influences has the advantage of moving in the same direction as the events themselves and hence of avoiding the dangers of hindsight, but conversely it runs the risk of undervaluing the role of the artist, in that it makes the influence into the dynamic agent, and the person influenced into a passive recipient, whereas it is in one sense the person influenced who does all the work, choosing, adapting, altering and re-using in order to produce something new.

361

STRUCTURALISM see POSTSTRUCTURALISM

STYLE Style is a distinctive manner which permits the grouping of works into related categories. The analysis of style is one of the defining methods of the history of art. The uses of stylistic analysis and the kinds of knowledge which can be gained from it can best be outlined by means of a number of examples.[1]

GROUPING The primary use of style in art history has been to identify the character of works produced in particular places and at particular times, enabling the historian to define "periods, "cycles and "cultures, as well as the *œuvre* of an individual artist. This application lies behind the establishing of the two cycles of development in antiquity and the Renaissance which form the basis of most art-historical writing from Vasari to the early twentieth century. (See the texts of Vasari, Riegl, Wölfflin, Frankl, Focillon, Hauser and Gombrich.)

AUTHENTICATION This involves the application to particular objects of the techniques used in establishing groups of objects. The study of any body of visual material requires a reliable corpus of works, and stylistic analysis is essential for the identification of fakes, especially where chemical and similar tests are not applicable. The building up of a corpus of reliable works in this way has formed part of art-historical method since Vasari, and has proved particularly fruitful in the study of tribal art (see, for example, Fagg, text 20, 1973, as well as "empiricism and "connoisseurship).

FASHION Style in the form of fashion constitutes one of the most important aspects of social relationships, in which people show great sensitivity to minute variations in design, from the cut of a collar or the sit of a hat to an assessment of whether a table lamp is considered in vogue or just out of date. This applies as much in the past as to the present, as in late medieval images showing the Virgin dressed in attractive clothes and with a fashionably high plucked forehead, an image which makes an eloquent comment on attitudes to religion at the time (figs. 62 and 63). Consumers practise stylistic analysis in all of these situations, and the art historian has to do the same in order to attempt to understand their taste.

FASHION AND IDEOLOGY One of the differences between the otherwise similar totalitarian systems of Nazism and Stalinism lies in the chic character of the uniforms of the Nazis as opposed to the lower-quality tailoring of the Soviet military.[2] The psychological and political significance of this observation may be unclear (though the contrast may represent differences between the

64 Nike trainers, c.1993.
These trainers have a very different function from a
motorcycle (fig. 65) and yet they are very similar in form,
decoration and colouring. This suggests that there is a
close relationship between the two in terms of the psy-
chological function they perform, that is, in this case, the
dreams they sell.

65 Honda 750cc motorcycle, 1990.

ideologies of elitism and egalitarianism respectively), but the point is only accessible in the first
place through stylistic analysis.

ART AND ILLUSION Style is powerful enough to provide an illusion of a characteristic which is not
actually present. Thus objects can be made to look as if they are efficient by characteristics of
design which are themselves irrelevant to efficiency or are even positively inimical to it. This can be
illustrated by the food-mixer which Panofsky characterized as looking as if it had been designed in
a wind tunnel to enable it to exceed the speed of sound; or by Nike sports shoes which look like
the winged sandals of a mechanized god (fig. 64), and which appropriately bear a close resem-
blance in pattern and colour to models of the Honda 750 cc motorbike (fig. 65), but which are
worn by people who may not even be planning to run, let alone to challenge the gods.

THE EFFECT OF THE IDEA OF ART An awareness on the part of the artist or patron that the object
being made falls into the category of Art can radically affect its character. Thus while German

66 'Riders of the Range'. From *Eagle*, vol. 3, no. 34, 1953.

This British comic strip exploits few if any of the possibilities offered by the medium. The frames present the scenes in narrative sequence, making little distinction between talking heads and a violent fight in dangerous circumstances: the words control the images.

Conversely the strip from *Captain America* (fig. 67) is based on the premise that this is a visual representation of the physical and emotional adventures of the characters, so that the figure of the superhero dominates the page, ignoring the proprieties of frames and rows, and plunging out towards the reader/viewer, who is thereby closely involved in the action.

67 *Captain America*, 114, 1969. See fig. 66.

painting of the Nazi era is almost universally cloying, sentimental and banal, a form like the SS symbol, which appears not to have been thought of in the same category as easel painting, can be seen, from the perspective of the late twentieth century and when removed from its brutal associations, as a highly successful piece of Art Deco design.

APPROPRIATENESS As within high °culture, so within popular culture different forms of expression or styles are appropriate to different art forms, and a judgement about the medium can only be made via stylistic analysis. Taking the example of comic strips, there are those which present all the action as taking place at the same distance from the viewer as if seen through a window, ignoring the character of the medium, and those which exploit the frames and the speech bubbles to create a completely new environment appropriate to the action and to the page of the comic (contrast figs. 66 and 67).[3] (On this consideration with regard to film, see Sontag, text 18, 1964.) For similar distinctions in painting and industrial design see figs. 34 and 35, 37 and 38.

SCALE To take the final instance from architecture, the Lego building system considered as a toy is an example of 'modernism, in that it is as clear and structured as a Mies skyscraper. As a possible influence on architecture, however, it might be identified with the 'Post-Modern.

In the early 1970s the use of stylistic analysis began to be criticized as compromised and irrelevant. It was pointed out that the authentication of works of art was closely bound up with maintaining the value of artistic property, and that with anonymous pieces style was used as if it were a chronological Geiger counter (point your stylistic model at the form and read off the date on the dial), providing results which were neither accurate nor interesting. Because it was felt that these techniques made art historians into either court jesters or technicians, this critique led to a call for the abandoning of all interest in style.[4] Such criticisms have to be met, but following the principle that all the available evidence should be used, style and its analysis remain among the richest seams of exploration for the art historian, and relevant to every aspect of visual culture.

1 On style in general see especially Meyer Schapiro, 'Style' (1953), in *Anthropology Today: Selections*, S. Tax, ed., Chicago, IL, 1962, pp. 278–303. See also Susan Sontag, 'On Style' (1965), in *Against Interpretation and Other Essays*, London, 1987, pp. 15–36; and R. Layton, *The Anthropology of Art*, London, 1981, chapter 4.

2 Susan Sontag, 'Fascinating Fascism', in Brandon Taylor and Wilfried van der Will, eds., *The Nazification of Art*, Winchester, 1990, pp. 204–18. This is an instance of style used as a means of understanding 'ideology; see also Clark, text 21, 1974.

3 Scott McCloud, *Understanding Comics: the Invisible Art*, New York, 1993, is of relevance beyond the issues of style and indeed of comics.

4 'In discrediting the old art history, words like connoisseurship, quality, style and genius have become taboo, utterable only with scorn or mirth. Such terms, they [the new art historians] assert, serve only to obscure a whole (old) world of assumptions about what art is.' A.L. Rees and F. Borzello, eds., *The New Art History*, London, 1986, p. 4.

SUBJECTS/DISCIPLINES When we pursue a particular subject at some point we need to ask ourselves why we do so. There are of course no simple answers to this, but two of the most important subjective ones are: first, because of our curiosity, which is the start of all scholarship, and second, however interrelated all things might be, since we cannot do everything we have to select an area, an aspect or a subject. In deciding what we can contribute one of the best places to start (even if not to finish) is with the institutional divisions which have grown up over time in the academic world.

University departments are normally identified by the subjects which they teach, such as literature or biology. It is, however, useful in the more specialized context of this book to distinguish between subjects defined as bodies of material on the one hand and disciplines as the means of studying such bodies on the other. Thus human beings form the subject matter of the disciplines of anthropology and psychology, and the remains of the past form the subject matter of the disciplines of history and archaeology.[1]

In this sense the only headwords in this section of the book which refer directly to subjects are those dealing with architecture, art, culture, politics and vocabulary. The remainder can be described as disciplines, or variously as methods, approaches, techniques, theories or models. Some can be described as methods masquerading as subjects, since, as noted in the preface, the dividing line between the two is often blurred. Renaissance art, for instance, is a subject, but the act of defining it is based on an assumption that the past has a particular shape, which implies the use of a method.

Methods can be defined in terms of contrasting pairs of concepts, such as general and particular, theoretical and object-based, systematic and pragmatic, deductive and inductive, subjective and objective, and idealist and empiricist. Approaches such as Hegelianism and Marxism can then be seen to have more in common with the general, theoretical, systematic, deductive, subjective,

idealist pole, and archaeological and geographical approaches with the particular, object-based, pragmatic, inductive, objective, empiricist pole, while the methods used by anthropology, psychology and history lie between the two. This is certainly a crude model, as aspects of almost every single discipline will stretch all the way from one pole to the other, but the picture it presents may still be useful as an indication of how the history of art relates to the other disciplines with which it has the most overlap and contact. The following two arguments are cases in point, one directed at those who can be identified with the 'hard' empiricist pole and the other at those who can be identified with the theoretical and idealist pole.

Because of their involvement with aesthetic responses, art historians more than other scholars tend to straddle the divide between objectivity and subjectivity (see Panofsky, text 15, 1940). In defending the propriety of this stance the art historian can ask two questions of those who believe objectivity to be the only acceptable approach for real scholarship. First, is it possible to understand the human beings who make the art objects without taking account of subjective factors such as their motives or the basis on which they arrive at their judgements? And second, is it possible even to attempt to understand the subjective judgements made by others without developing an understanding of one's own?

365

Those °poststructuralists who see all forms of human response as entirely formed by culture and not at all by nature run the risk of ignoring the half of anthropology which deals with the physical history of the human species. This raises the question of the extent to which we share our behaviour patterns with animals, and how much of their behaviour is socially constructed rather than determined by instinct. There are, for example, the gardens laid out by the male bower bird in order to attract a mate, in which the criteria at work appear to be learned and to include the possibility of innovation. Similarly there are the claims that chimpanzees have shown an interest in painting, or that they can be taught to speak, something which is a possibility if Noam Chomsky is right in describing language ability as a function of the structure of the human brain, and hence something potentially traceable in species related to humankind.[2] Even though human experience, like our idea of nature, must be an artificial construction, that does not belie the fact that there is some sort of nature out there, beyond the nurture. The project which is intended to establish the complete sequence of DNA elements that make up all the genes in the human body, the human genome project, will fundamentally alter the basis on which this argument is conducted, and indeed parts of the current debate about its significance bear a close resemblance to that between humanism and poststructuralism outlined elsewhere in this book.[3]

1 There is strong pressure to blur the differences between these disciplines, based on the need to maintain access to funding (it can be argued on these grounds, for example, that the study of literature requires as much fieldwork as that of archaeology or anthropology), but the traditional divisions remain one of the surest means of focusing on a separate identity.

2 Jared Diamond, *The Rise and Fall of the Third Chimpanzee*, London, 1992, pp. 156–7 and chapter 9, 'Animal Origins of Art'; Noam Chomsky, *Language and Responsibility*, Hassocks, 1979, pp. 84 and 94–9. See also Ellen Dissanayake, *Homo Aestheticus: Where Art Comes From and Why*, New York and Toronto, 1992.

3 See, for example, R.C. Lewontin, *The Doctrine of DNA: Biology as Ideology*, London, 1993.

TELEOLOGY A teleological concept is one in which the end of a sequence is presumed to be implicit in its beginning. This can apply to sequences which occur as it were in a straight line, like the °Hegelian stages of progress, or to °cycles, which are all teleological in the sense that each phrase ends in pre-determined fashion before the start of the next (as, most unequivocally, with the death at the end of the life cycle of the butterfly). Examples of teleological analysis in the history of art

68 Three related groups of brooches of Roman or Germanic provenance. From Bernhard Salin, *Altgermanische Thieromamentik*, Stockholm, 1935, figs. 184–8.

The two assumptions behind the dating and hence the arrangement of these six brooches are that the most naturalistic (top left) is the earliest or Roman one, and that the remainder, or at least the next three, which are Germanic in origin, derive from the first one in a process of creeping abstraction.

include the theory that Greek sculptors from the archaic period onwards were striving towards the naturalism of the Hellenistic age (figs. 48, 49 and 50), and the presentation of the Romanesque architectural style as if it were a failed attempt at the Gothic.

Teleological explanations therefore tend to raise more problems than they solve, but they do none the less pinpoint a real difficulty: how, for instance, does one explain the gradual increase in naturalism in Greek sculpture, as if each artist knew his place in the sequence? Is it sufficient to say that each example by a first-rate sculptor appeared 'naturalistic' to its audience? What would a sculptor early in the sequence have thought of a piece from later in the sequence? (This is not an anachronistic question, as societies have been known to find themselves confronted with work introduced from other cultures which could be considered more 'advanced' in their own terms.)(See also *form and *evolution.)

THEORY A theory is a speculative attempt to explain a number of apparently disparate factors. The theory underlying a particular approach is often unacknowledged and taken for granted, as if it were simply a part of the way things work. Eagleton puts this point as follows: 'J.M. Keynes once remarked that those economists who disliked theory, or claimed to get along without it, were simply in the grip of an older theory … Hostility to theory usually means an opposition to other people's theories and an oblivion of one's own.'[1] The point that theory is unavoidable is unanswerable: to be aware of what one's theoretical position is and to be able to defend it represents a minimum fulfilment of one's obligations.

This, however, leaves open the question of how theory should be combined with practice, that is with the study of the material which forms the immediate subject of the discipline of art history, or, to put it in terms of organizing a degree course, how class hours should be apportioned between time spent on objects and time spent on words. If the best incentive to work is passion, then as far as possible it is wise to pursue what you want to pursue. The same is true of ability: we usually want to do what we do well, and not everyone has the aptitude or inclination to make as the centre of their education either, for instance, an archaeological study of the physical minutiae of the object, or conversely a philosophical study of the ideological context in which it was produced and used. Yet the more one narrows the field of enquiry by 'not going beyond the facts', then the more the exercise approximates to a behaviourist-like reductionism and denies the social context, while the more one broadens it into aspects of theory the more it approximates to the study of philosophy and retreats from the works themselves. There will thus always be a problem of balance and a need for reassessment: theory should be made to work by being tied to practice and practice illuminated by being questioned by theory. (See *subjects/disciplines.)

Finally, there is the question of the relative importance of different kinds of theory. There is, for example, a good case to be made for the view that one cannot really understand the culture of the twentieth century without a proper grasp of the theory of relativity, and that this is as important for an understanding of the Western philosophical tradition as a knowledge of phenomenology or the theories in general of, for example, Husserl or Heidegger.

I Terry Eagleton, *Literary Theory: an Introduction*, Oxford, 1983, preface, pp. vii–viii. See also Terry Eagleton, 'Discourse and Discos: Theory in the Space between Culture and Capitalism', *Times Literary Supplement*, 15 July 1994, pp. 3–4.

TYPOLOGY Typology is a means of arranging objects of related but varying form in such a way that each contiguous pair is more closely related than any other two items in the sequence. The technique can be used for classifying any category of things, from animal bones to manufactured goods. Sequences are most frequently based on an assumption of change from simple to complex (fig. 51), or in representational images, from abstract to naturalistic forms or vice versa (for an example of the latter see fig. 68). (See *evolution and *forms.)

367

The setting up of this sort of sequence can be a revealing exercise with any body of material, but it is particularly useful where no other means is available for dating the objects. The difficulty is to know what conclusions to draw from the resulting sequences. A typological sequence is not a historical one: it is based purely on the character of the forms, and its use for historical analysis rests on the assumption, or rather the hope, that this in some way reflects what actually happened. Thus, for example, objects arranged from simple to complex may have been made in that order, but equally a thousand other factors could have caused them to be produced in a different sequence. The typological arrangement is therefore only a first step, an exercise which may provide a hypothesis.

Another problem with typology derives from the fact that in the standard art-historical *cycle the three phases of early, classic and baroque move from simple to complex, as in one of the most common typological sequences. If, however, the frame of reference is moved so as to include only the last phase of one cycle and the first phase of the next, then the baroque phase of the earlier cycle precedes the early phase of the later cycle, with the *forms 'developing' from complex to simple (as for example with late Gothic and early Renaissance architecture). (See also *cycles.)

VOCABULARY All social groups have their own vocabularies or registers. They do so to identify their fellow members, to save time, or to mystify. Examples from the educational world include Quality Assurance Control (that is, in the terminology of a different social group, the maintenance of academic standards), Client Services Co-ordinator (the person in a school who deals with parents and visitors) and Enterprise and World Resources Directorate (departments of history and geography), each of which probably involves all three purposes, though aimed at different audiences.

Such differences in the forms of language can also exist in the smallest elements. For example, starting a word with a capital letter places it in a different register from the same word with a lower-case initial letter, as in idea and Idea, or art and Art (as well as in the examples in the preceding paragraph). The names of periods, styles and movements have traditionally been given initial capital letters, as with the Renaissance, Mannerism, Impressionism and Minimalism. In some instances lower- and upper-case initial letters can be used to distinguish a concept of broad applicability from the more specific period, style or movement, as with 'renaissance'/'Renaissance', and 'baroque'/'Baroque' (but 'modern' and 'Modern' are problematical: see *modernism). In most

cases, however, the reason for the use of the capital letter appears to be a wish to reify, that is to turn a thought (such as 'cubism') into a thing (Cubism) and thereby to make it more concrete and credible. Art-historical usage in this regard has possibly been influenced by the German practice of starting all nouns with a capital, so that terms like *Zeitgeist* come to us already capitalized.

Choice of vocabulary can determine whether a text appears accessible or opaque to a reader. Some disciplines, such as mathematics, require an arcane language because of the character of their subject matter, but in the case of a discipline like the history of art the use of arcane language is more often a matter of choice. Since the 1970s traditional and new approaches to the history of art have often been distinguished by the use of different vocabularies, with radicals accusing traditionalists of using inadequate terms to express inadequate ideas, and traditionalists asking why the radicals' terminology is often so obscure.

An example of this divide was provided at the conference of the Association of Art Historians in 1981 when one participant criticized traditional art historians for 'the marginalization of megavisual discourses'. When challenged by the other side to rephrase the statement, the speaker said it meant that they had paid insufficient attention to film and television. Other examples of 'new' terms and phrases (though some are almost thirty years old) which are likely to confuse readers who are new to the subject are 'exerque', 'structurations', 'scopic field', 'matrices privileged in Marxism', 'articulating with other sites of representation', and 'the construction and subjection of the sexualized body of the bourgeoisie' (see, for example, Pollock, text 26, 1988).

The concept of decoding illustrates another aspect of the point, as it is now widely used by historians and commentators as a synonym for analysing. (See Panofsky, text 15, 1940 and Pollock, text 26, 1988.)[1] Decoding retains from espionage the glamorous overtones of a battle of wits against a conscious attempt to mislead and thwart the investigator, overtones which may not be relevant to the material in hand.

It is not a simple matter of supporting one side or the other. Like those who are opposed to it, those who support the use of arcane terminology also have limits beyond which they will not go. Eagleton, for example, who defends the new terminology in literary theory, none the less describes one critic as being guilty of an 'outlandish spawning of esoteric terms.'[2]

To those inside a register their terminology has a special purpose, but the terminology for that very reason can evade a wider audience. Writers need therefore to define their audience and ask what comparative benefits may flow from, for example, addressing a different group as opposed to reinforcing the identity of a known one.

368

[1] David Dimbleby, for example (*Panorama*, 19 August 1991), commenting on the coup against Mikhail Gorbachev, announced that he intended to 'decode' the signals coming out of the Soviet Union. For other examples see Terry Eagleton, *Literary Theory: an Introduction*, Oxford, 1983, pp. 78ff.

[2] Eagleton, op. cit., p. 184.

Select Bibliography

This bibliography contains the most important publications mentioned in the book apart from those from which the extracts have been chosen. As the book is intended for English-speaking students, only publications available in English have been cited. The type of bibliography employed affects the type of referencing system which can be used in the body of a book. A select bibliography is by definition restricted to items which the author thinks are directly relevant to the subject. This type of bibliography cannot be used with the Harvard system of referencing, in which the bibliography has to include every publication quoted. With end- or footnotes the choice as to what to include or leave out of the bibliography remains with the author. End- or footnotes are usually considered the more old fashioned and the Harvard system the more scientific and modern, but this may be an outdated view as the advent of sophisticated word-processing packages has made footnoting as easy as typing.

ROLAND BARTHES 'Rhetoric of the Image' (1964), 'Introduction to the Structural Analysis of Narratives' (1966), 'The Death of the Author' (1968), in *Image, Music, Text*, translated by Stephen Heath, London, 1977, pp. 32–51, 79–124 and 142–8.

T.J. CLARK *Image of the People: Gustave Courbet and the 1848 Revolution*, London, 1973.

TERRY EAGLETON, *Literary Theory: an Introduction*, Oxford, 1983.

MICHEL FOUCAULT *The Archaeology of Knowledge* (1969), translated by A.M. Sheridan Smith, London, 1974.

ROGER FRY, 'Reflections', in *Vision and Design* (1920), 5th edn, London, 1957, pp. 284–302.

E.H. GOMBRICH 'The Tradition of General Knowledge' (1961), in *Ideals and Idols: Essays on Values in History and in Art* (1979), reprinted, London, 1994, pp. 9–23.

E.H. GOMBRICH 'The Ambivalence of the Classical Tradition: the Cultural Psychology of Aby Warburg' (1966), in *Tributes: Interpreters of our Cultural Tradition*, Oxford, 1984, pp. 116–37.

E.H. GOMBRICH '"The Father of Art History"; a reading of the *Lectures on Aesthetics* of G.W.F. Hegel (1770–1831)' (1977), in *Tributes: Interpreters of our Cultural Tradition*, Oxford, 1984, pp. 51–69.

E.H. GOMBRICH *Reflections on the History of Art: Views and Reviews*, Richard Woodfield, ed., Oxford, 1987.

CHARLES HARRISON 'Taste and Tendency', in A.L. Rees and F. Borzello, eds., *The New Art History*, London, 1986, pp. 75–81.

CHARLES HARRISON AND PAUL WOOD *Art in Theory: an Anthology of Changing Ideas*, Oxford, 1992.

ARNOLD HAUSER *The Philosophy of Art History*, London, 1959.

E.G. HOLT *A Documentary History of Art, I: The Middle Ages and the Renaissance*, Garden City, NY, 1957; *II: Michelangelo and the Mannerists, the Baroque and the Eighteenth Century*, Garden City, NY, 1958.

EUGENE KLEINBAUER *Modern Perspectives in Western Art History: an Anthology of Twentieth-century Writings on the Visual Arts*, New York, 1971.

GEORGE KUBLER, *The Shape of Time: Remarks on the History of Things* (1962), reprinted, New Haven, CT, 1973.

ERWIN PANOFSKY 'Introductory' to *Studies in Iconology: Humanistic Themes in the Art of the Renaissance*, Oxford and New York, 1939, pp. 3–31; reprinted in *Meaning in the Visual Arts*, Garden City, NY, 1955, pp. 26–41.

MICHAEL PODRO *The Critical Historians of Art*, New Haven and London, 1982.

DONALD PREZIOSI *Rethinking Art History: Meditations on a Coy Science*, New Haven, 1989.

A.L. REES AND F. BORZELLO eds., *The New Art History*, London, 1986.

MEYER SCHAPIRO 'Style' (1953), in *Anthropology Today: Selections*, S. Tax, ed., Chicago, IL, 1962, pp. 278–303.

CHRIS WEEDON *Feminist Practice and Poststructuralist Theory* (1987), reprinted, Oxford, 1989.

RAYMOND WILLIAMS *Keywords: a Vocabulary of Culture and Society* (1968), 2nd edn, London, 1983.

RICHARD WOLLHEIM *Art and its Objects* (1968), 2nd edn, reprinted, Cambridge, 1992.

Acknowledgements

384

The publishers wish to thank all private
owners, museums, galleries, libraries and
other institutions for permission to reproduce
works in their collections. Further acknowl-
edgement is made to the following:

Archivi Alinari, Florence: 59, 60, 105, 128t,
131t, 131b, 333l; © British Museum: 283;
Geoffrey Clements, New York: 338b;
Courtauld Institute of Art: 78, 128b; Duke
of Sutherland Collection (on loan to the
National Gallery of Scotland): 61; A.F.
Kersting: 93; Mansell Collection: 197; photo-
graph courtesy The Museum of Modern Art,
New York: 180; National Gallery of Art,
Washington (Mellon Collection 1937): 44;
© Olivetti/photo Mr Quattrone, Florence:
25t; Rheinisches Bildarchiv, Cologne: 360l;
Royal Commission on the Historical
Monuments of England: 94; Staatliche
Museen zu Berlin-Preussischer Kulturbesitz
Gemäldegalerie/photo Jörg P. Anders: 203,
344l; Mike Wilson: 340, 341.